OUR NATURAL WORLD HERITAGE

**50 of the Most Beautiful and
Biodiverse Places**

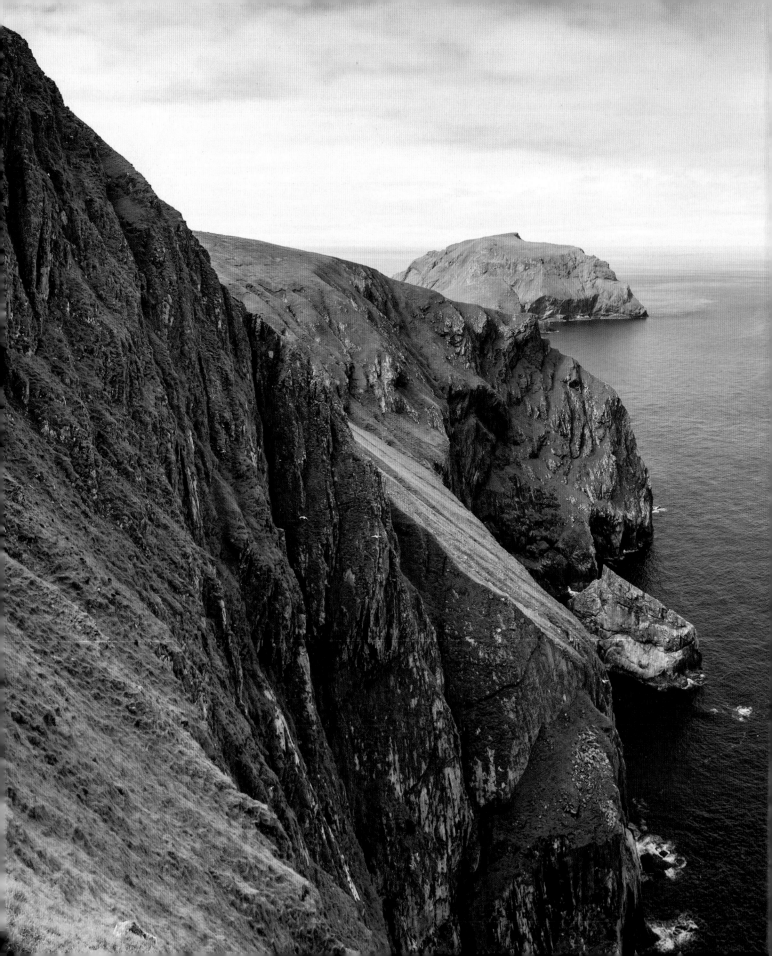

OUR NATURAL
WORLD HERITAGE

50 of the Most Beautiful and
Biodiverse Places

CHRISTOPHER WOODS

foreword by Lazare Eloundou Assomo

TIMBER PRESS · PORTLAND, OREGON

Frontispiece: St. Kilda, United Kingdom of Great Britain and Northern Ireland

Published by the United Nations Educational, Scientific and Cultural Organization (UNESCO), 7, place de Fontenoy, 75352 Paris 07 SP, France, and Timber Press, Inc., a subsidiary of Workman Publishing Co., Inc., a subsidiary of Hachette Book Group, Inc., 1290 Avenue of the Americas, New York, NY 10104, timberpress.com.

Printed in China on responsibly sourced paper

UNESCO ISBN 978-9-23100-575-6

Timber Press ISBN 978-1-64326-105-8

Text design by Stacy Wakefield Forte

The publisher is not responsible for websites (or their content) that are not owned by the publisher.

The Hachette Speakers Bureau provides a wide range of authors for speaking events. To find out more, go to HachetteSpeakersBureau.com or email HachetteSpeakers@hbgusa.com.

Catalog records for this book are available from the Library of Congress and the British Library.

This book is dedicated to the many botanists working with UNESCO, geologists, ornithologists, entomologists, anthropologists, and many other brilliant scientists who have spent years observing and documenting the flora, fauna, and the human culture of each site. To those scientists, I am deeply grateful.

To my sister Diana, the best of us. To my dear departed friend Piers Forestier-Walker, who helped me to love the wild. And to Julie, tú eres mi corazón.

Contents

9 Foreword

10 Introduction

Oceania

17 Kakadu National Park, Australia

25 Tongariro National Park, New Zealand

33 Lagoons of New Caledonia: Reef Diversity and Associated Ecosystems, France

The Americas

45 Waterton Glacier International Peace Park, Canada and the United States of America

53 Redwood National and State Parks, United States

63 El Pinacate and Gran Desierto de Altar Biosphere Reserve, Mexico

71 Ancient Maya City and Protected Tropical Forests of Calakmul, Campeche, Mexico

77 Belize Barrier Reef Reserve System, Belize

85 Alejandro de Humboldt National Park, Cuba

93 Talamanca Range-La Amistad Reserves / La Amistad National Park, Costa Rica and Panama

103 Darién National Park, Panama

113 Sangay National Park, Ecuador

121 Historic Sanctuary of Machu Picchu, Peru

127 Central Suriname Nature Reserve, Suriname

135 Pantanal Conservation Area, Brazil

Europe

143 Vatnajökull National Park—Dynamic Nature of Fire and Ice, Iceland

153 St. Kilda, United Kingdom of Great Britain and Northern Ireland

161 Doñana National Park, Spain

169 Pyrénées—Mont Perdu, France and Spain

175 Wadden Sea, Denmark, Germany, and The Netherlands

181 Ancient and Primeval Beech Forests of the Carpathians and Other Regions of Europe

191 Aeolian Islands, Italy

197 West Norwegian Fjords—Geirangerfjord and Nærøyfjord, Norway

203 Plitvice Lakes National Park, Croatia

211 Natural and Cultural Heritage of the Ohrid Region, Albania and North Macedonia

217 Laurisilva of Madeira, Portugal

Africa

227 Niokolo-Koba National Park, Senegal

237 Mount Nimba Strict Nature Reserve, Côte d'Ivoire and Guinea

245 Dja Faunal Reserve, Cameroon

253 Okavango Delta, Botswana

261 Cape Floral Region Protected Areas, South Africa

271 Ngorongoro Conservation Area, United Republic of Tanzania

277 Lake Malawi National Park, Malawi

283 Rainforests of the Atsinanana, Madagascar

The Middle East & Asia

293 Göreme National Park and the Rock Sites of Cappadocia, Turkey

299 Wadi Rum Protected Area, Jordan

307 The Ahwar of Southern Iraq: Refuge of Biodiversity and the Relict Landscape of the Mesopotamian cities, Iraq

313 Hyrcanian Forests, Islamic Republic of Iran

321 Saryarka—Steppe and Lakes of Northern Kazakhstan, Kazakhstan

329 Nanda Devi and Valley of Flowers National Parks, India

339 Sinharaja Forest Reserve, Sri Lanka

347 Xinjiang Tianshan, China

353 Mount Emei Scenic Area, Including Leshan Giant Buddha Scenic Area, China

359 Don Phayayen-Khao Yai Forest Complex, Thailand

367 Ha Long Bay, Vietnam

373 Tropical Rainforest Heritage of Sumatra, Indonesia

379 Gunung Mulu National Park, Malaysia

389 Puerto-Princesa Subterranean River National Park, Philippines

397 Tubbataha Reefs Natural Park, Philippines

403 Shirakami-Sanchi, Japan

411 Acknowledgments

412 Further Resources

413 Photography Credits

422 Index

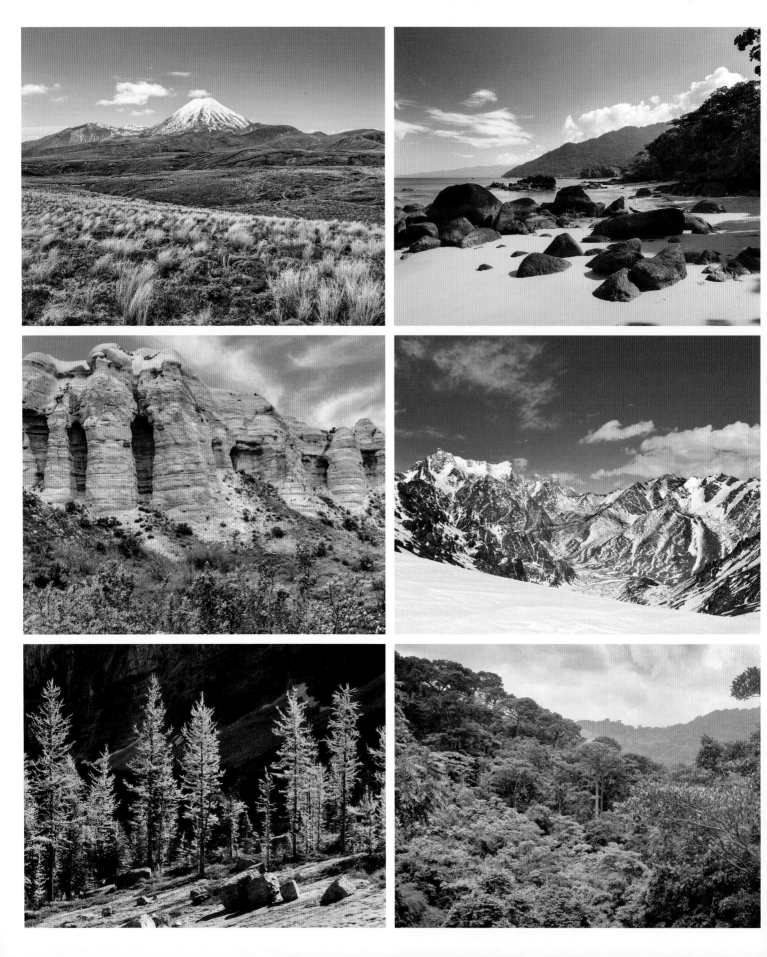

Foreword

Our natural world today is increasingly under threat from climate change, natural disasters, and pressures from extraction and development. If we want to protect it, the first step is to get to know it.

This book presents the botanical treasures of 50 natural World Heritage Sites around the world, observed with care and an expert eye. This is a rich and delightful voyage for plant lovers everywhere.

The 50 sites here are just a sample of the 257 natural sites on the World Heritage List that are found in 110 countries around the world. Natural World Heritage Sites are not just beautiful places but include the most important sites on our planet for biodiversity, clean water, and the health of our planet and ourselves. Two-thirds of natural World Heritage Sites are crucial sources of water, and over 90 percent of natural sites create jobs and provide income from tourism and recreational activities.

At the same time, the grim truth is that more than a third of natural World Heritage Sites are currently threatened by the effects of climate change.

At UNESCO, World Heritage properties serve as climate change observatories to gather and share information on applied and tested monitoring, mitigation, and adaptation practices. The global network of World Heritage also helps raise awareness on the impacts of climate change on human societies and cultural diversity, biodiversity and ecosystem services, and the world's natural and cultural heritage.

As World Heritage Sites, these places are recognized as being of outstanding value to all of humanity. Safeguarding these sites concerns every one of us. I hope you enjoy this voyage through this selection of the national parks, rainforests, deserts, valleys, and many other stunning landscapes that make up our shared natural heritage.

—Lazare Eloundou Assomo,
 Director of World Heritage, UNESCO

Clockwise from top left: Tongariro National Park, New Zealand. The park is crisscrossed with hiking paths, some are easy walking while others are gaspers. • Masoala Beach in the Rainforests of the Atsinanana, Madagascar. • Bogda Peak in Xinjiang Tianshan, China • The dense green world of the rainforest in Darién National Park, Panama. • Alpine larch (*Larix lyallii*) turns burnt orange as winter approaches in Glacier International Peace Park in North America. • Göreme National Park in Cappadocia, Turkey

Canopy walk at Gunung Mulu
National Park, Malaysia.

deforestation, and global heating. Protected areas such as Yosemite National Park in the United States, the Greater Blue Mountains Area in Australia, and the Tropical Rainforest Heritage of Sumatra in Indonesia are among the sites that have emitted more carbon than they absorbed since 2001 as a result of human activities, according to research by the World Resources Institute, the International Union for Conservation of Nature (IUCN), and UNESCO. The analysis found more sites were expected to switch from sinks to sources of carbon in the coming decades.

UNESCO World Heritage Sites still represent an enormous carbon bank, comprising a forested area twice the size of Germany and storing the carbon equivalent of Kuwait's recoverable oil reserves. Tales Carvalho Resende, a UNESCO project officer and report coauthor said, "What is happening at a World Heritage Site level is only the tip of the iceberg. Even in what are supposed to be the best and most protected areas, they are currently under pressure from climate change."

From Dominica to Malaysia, extreme temperatures, land-clearing for agriculture, and wildfires have driven the increase in emissions at 10 UNESCO sites, which include Río Plátano Biosphere Reserve in Honduras, Waterton Glacier International Peace Park in Canada and the United States, and Uvs Nuur Basin in the Russian Federation and Mongolia.

"One of the things that really got our attention was the impact of wildfires. Some sites flipped into sources because of one or two wildfires that were so intense they represented the annual emissions of many countries in the world," Carvalho Resende said. "It's a vicious cycle. With global warming, you have more fires. With more fires, there's more CO_2. More CO_2 means temperatures continue to increase."

This is depressing news, and what is more depressing is the epidemic of depression. Now, in a time of unprecedented luxury, depression has become the leading cause of disability worldwide. Approximately 280 million people in the world

suffer from depression. It is estimated that more than 75 percent of people suffering from mental disorders in low- and middle-income countries do not receive treatment. What is doubly alarming is the rise of anxiety and depression in young people. In the United States, 7.1 percent of children aged 3 to 7 years (approximately 4.4 million) have diagnosed anxiety and 3.2 percent of children aged 3 to 17 years (approximately 1.9 million) have diagnosed depression. Depression may well be the most appropriate response to the devastation of nature. This is the world we have created. We can change it. We have the knowledge; we must have the will.

In the words of David Suzuki:

The way we see the world shapes the way we treat it. If a mountain is a deity, not a pile of ore; if a river is one of the veins of the land, not potential irrigation water; if a forest is a sacred grove, not timber; if other species are biological kin, not resources; or if the planet is our mother, not an opportunity—then we will treat each other with greater respect. Thus is the challenge, to look at the world from a different perspective.

The New Caledonian barrier reef is the longest continuous barrier reef in the world and the third largest after the Great Barrier Reef of Australia and the Mesoamerican Barrier Reef.

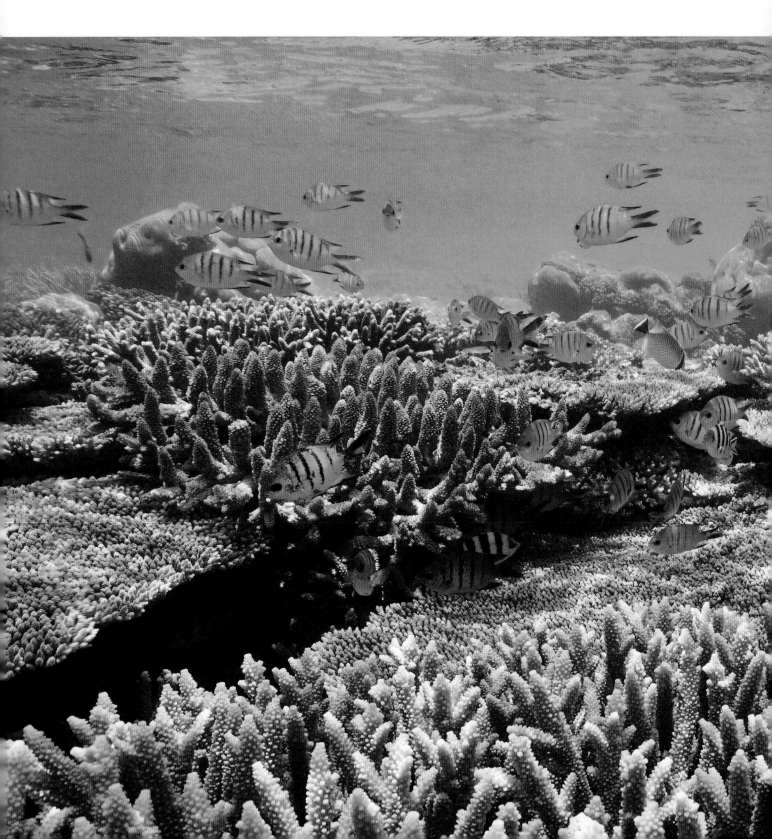

Oceania

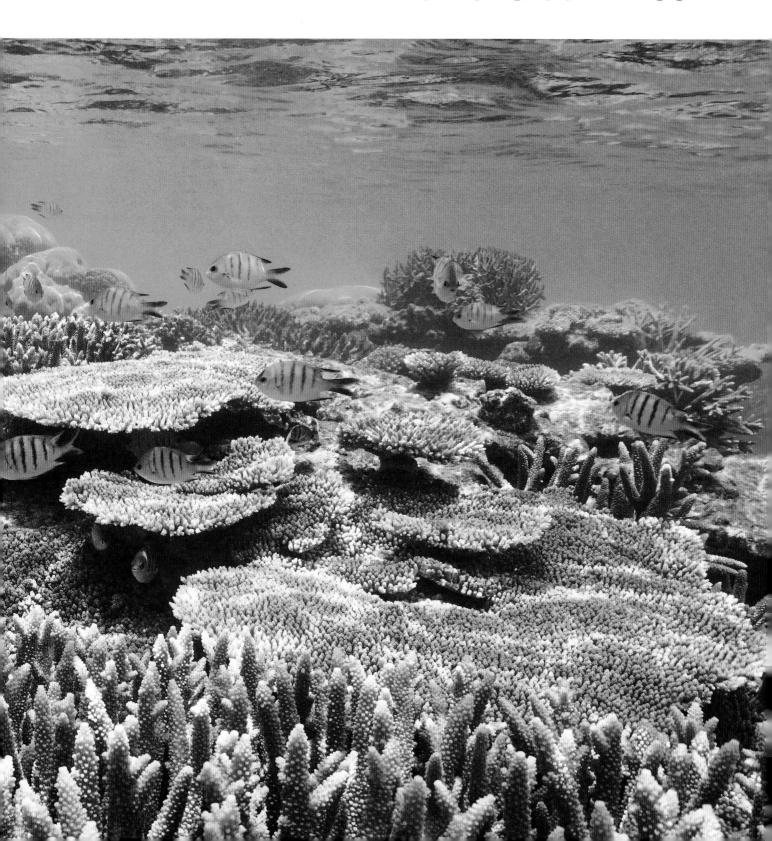

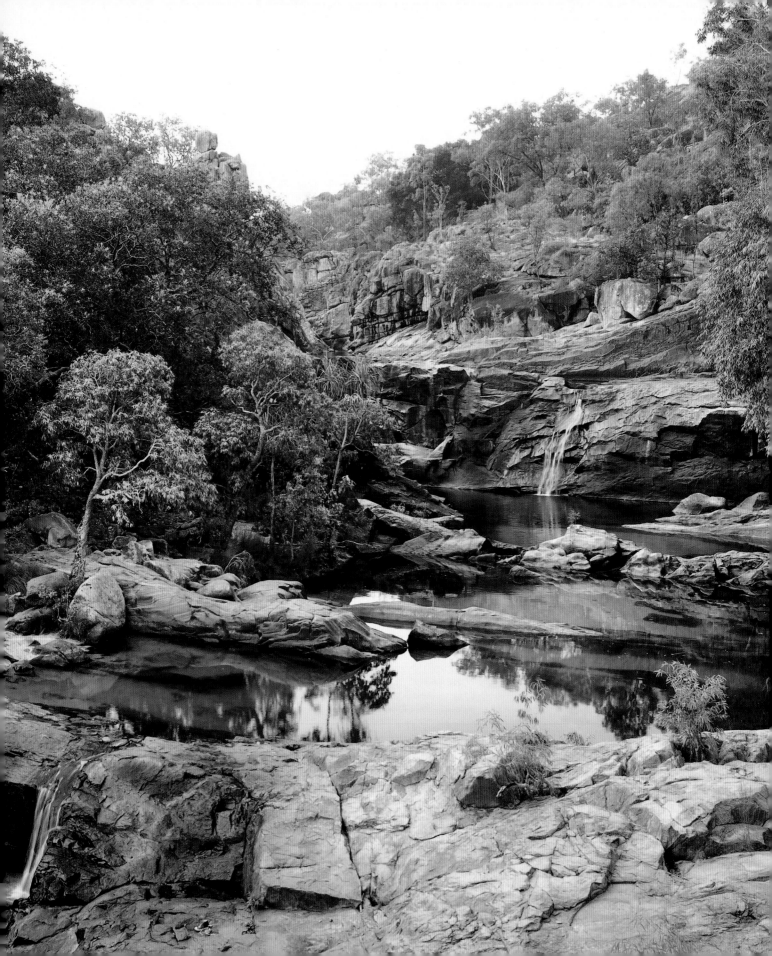

This unique archaeological and ethnological reserve, located in the Northern Territory, has been inhabited continuously for more than 40,000 years. The cave paintings, rock carvings, and archaeological sites record the skills and way of life of the region's inhabitants, from the hunter-gatherers of prehistoric times to the Aboriginal people still living there. It is a unique example of a complex of ecosystems, including tidal flats, floodplains, lowlands, and plateaus, and provides a habitat for a wide range of rare or endemic species of plants and animals.

Kakadu National Park

AUSTRALIA

Until 2015 it was thought that the Aboriginal people inhabited the land beginning 40,000 years ago. It has now been determined that they lived there for much longer. Artifacts including stone axes, seed-grinding tools, and stone weapons have been found by researchers from various Australian universities in a rock shelter called Madjedbebe near the park. They estimate that some of the items are 65,000 years old. "The site contains the oldest ground-edge stone axe technology in the world, the oldest known seed grinding tools in Australia and evidence of finely made stone points

A cascading waterfall that, depending on the time of year, can roar with water or titter with a trickle.

17

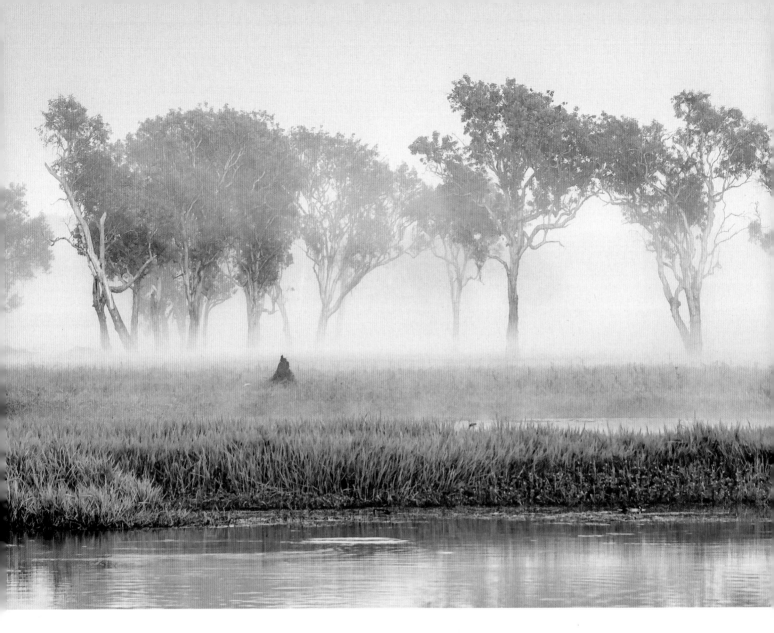

which may have served as spear tips," said lead researcher University of Queensland professor Chris Clarkson.

Kakadu is home to the oldest living human culture on earth.

Inscribed as a World Heritage Site in 1981, the park covers almost 7722 square miles (20,000 square kilometers) and is managed by the traditional owners in partnership with Parks Australia. There are three primary landscapes: stone country, coastal plains, and lowlands. Within each landscape are variants based on geology and the seasonal,

monsoon climate. The dry season lasts from May to September, the wet season from December to March. There are two transitional seasons, October and November are hot and humid with many storms. Europeans have named this the build-up. April is called the knock-em-downs, when storms flatten the tall grasses. The Alligator Rivers region which surrounds the park is the most floristically diverse part of monsoonal northern Australia with around 1600 recorded plant species. Over half the region is forest or open woodland but it includes savannas, spinifex plateau—a landscape of spiny-leaved,

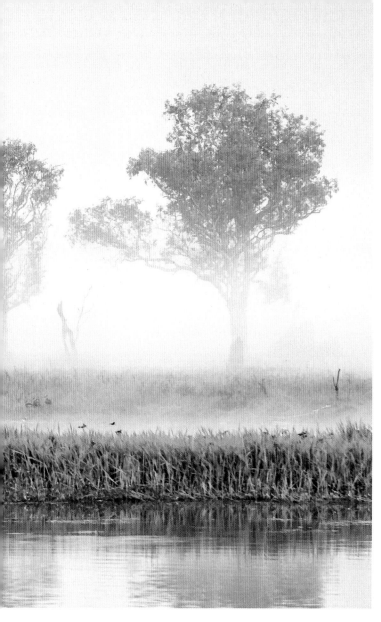

The Yellow Water (Ngurrungurrudjba) wetlands are in the center of the park and are part of the South Alligator River floodplain.

19

plain, and sandstone rainforest. The seven eucalyptus-dominated open forest and woodland categories, typically with a grassy understory, are the dominant vegetation. Mangroves grow along the tidal reaches of the major coastal river systems. Samphire, a sparse low shrubland, occurs on tidal salt flats between mangroves and the above high tide fringe. Lowland rainforests occur as small habitat pockets with *Eucalyptus* species, itchytree (*Barringtonia acutangula*), and white paperbark (*Melaleuca leucadendra*).

The lowlands—the Koolpinyah Surface—is a series of gently undulating lowland plains from Darwin to the Arnhem land escarpment, constituting about 64 percent of the park, with open forests and woodland, freshwater streams, flood plains, coastal monsoon forest, and mangrove communities. The forests and woodland contain about 15 *Eucalyptus* species, with Darwin woollybutt (*E. miniata*) and Darwin stringybark (*E. tetrodonta*) the most common. *Eucalyptus miniata* usually grows to 66 feet (20 meters) and has rough bark. The upper limbs develop smooth, grayish bark. Bright orange flowers appear in the dry season. *Eucalyptus tetrodonta* is an erect tree growing 33 to 98 feet (10 to 30 meters) tall with light cream-yellow flowers and stringy, rough bark. Silky grevillea (*Grevillea pteridifolia*) is a striking small tree with silvery leaves and black bark and bright orange flowers at the end of the

tussock-forming grasses—river-fringe forest, wetlands, floodplains, monsoon forests, and tidal, coastal, aquatic, and marine habitats, as well as the southern hills and basins. There are numerous microhabitats, and the biota of the plateau is ecologically remarkably diverse. Some 60 plant species in the park are considered rare or threatened.

The vegetation can be classified into 13 broad categories, seven of which are dominated by a distinct species of eucalyptus. Other categories comprise mangrove, samphire, lowland rainforest, paperbark swamp, seasonal flood

From left: The park has one of the greatest concentrations of rock art in the world. Some are 20,000 years old. • Home to 2000 plant species, Kakadu is one of the largest national parks in the world's tropics. • Stone country is one of three primary landscapes in Kakadu.

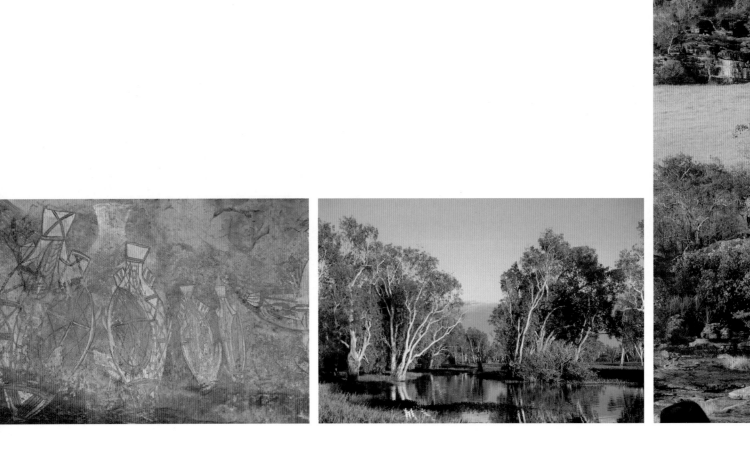

branches. There are two species of fan palm in the lowlands, *Livistona humilis* and *L. inermis*, both have yellow flowers on long vertical stems. Kurrajong (*Brachychiton paradoxus*) is a small tree with bright red bell-shaped flowers on bare branches. It flowers when the lobed leaves drop in the dry season. *Vitex glabrata* is a widespread small tree with pinkish white flowers followed by black fruit. The fruit is high in vitamin C and is a local component of wild food or "bush tucker." Swamp banksia (*Banksia dentata*) grows in ground that floods during the wet season. It has hollylike leaves and flowers of a dull honey color. Silver-leaved paperbark (*Melaleuca argentea*) grows on the banks of freshwater streams

and has brilliant silver leaves with new growth in June. It often flowers heavily with pale yellow spikes producing a strong sweet fragrance. Growing underneath the trees and throughout much of the lowlands is spear grass (*Sorghum intrans*). It gets its common name from the sharply pointed seeds held on 6½-foot (2-meter) stems. The seeds can pierce skin—uncomfortable for humans—but are essential food for the many species of ants. By the end of the summer, the grass is tall. It is then knocked down by storms (the knock-em-downs) to create a flat mulch for next season's growth.

The coastal plains consist of seasonal floodplains, coastal monsoon forest, and mangrove habitats.

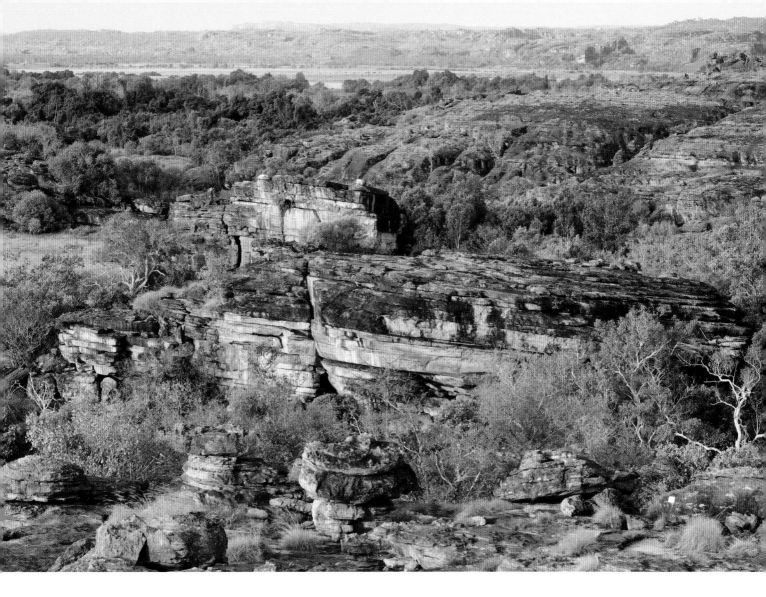

The floodplains are saturated in the wet season and become baked mud in the dry season. When wet, the beautiful blue water lily (*Nymphaea violacea*) comes to life. The violet, blue, or white flowers are borne on long stalks up to 12 inches (30 centimeters) above the water surface. On the margins of the swamps, three species of *Melaleuca*, white paperbark (*M. leucadendra*), cajaput tree (*M. cajaputi*), and broad-leaved paperbark (*M. viridiflora*) grow in great abundance. Scrub turpentine (*Canarium australianum*), *Bombax ceiba*, and white fig (*Ficus virens*) grow in isolated pockets of coastal monsoon forest.

Mangroves are a major ecosystem within the park, providing coastal protection and high biodiversity. Thirty-nine of the 47 Northern Territory species of mangrove occur in Kakadu. The spider mangrove (*Rhizophora stylosa*) can grow up to 49 feet (15 meters) tall but is usually half that height. Numerous roots, like thick spider's legs, hold the plant above the tide as well as allowing gas exchange in oxygen poor sediments. They are both legs and lungs. *Avicennia marina*, the white mangrove, inhabits tidal flats and has similar "breathing roots." The leaves excrete excess salt, and salt crystals are commonly present on the leaves.

Rising in the east and south from the coastal plains and the lowlands is stone country. Tectonic

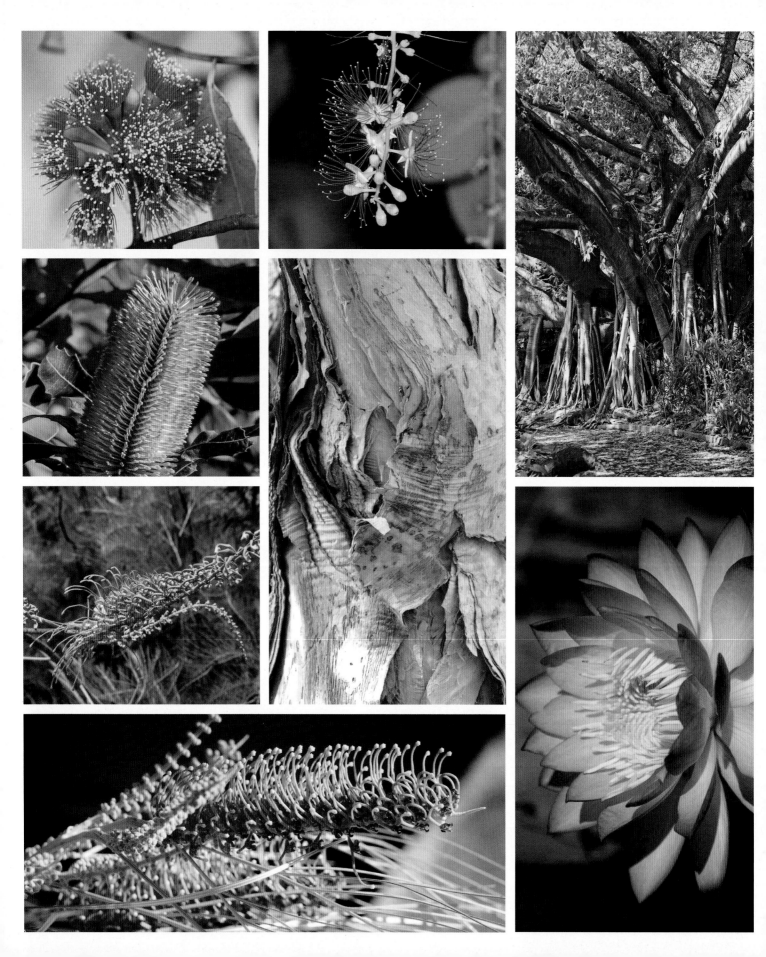

First column: Darwin woollybutt (*Eucalyptus miniata*) has woolly bark at its base turning to smooth and white toward the crown. The flowers are scarlet or bright orange and attract numerous butterflies. • Swamp banksia (*Banksia dentata*) has large green leaves with dentate (toothed) margins. The cylindrical inflorescences are yellow and attract many species of birds. It is one of four *Banksia* species collected by Sir Joseph Banks in 1770. • Dryander's grevillea (*Grevillea dryandri*) is an iconic shrub of northern Australia with red-pink flowers that are magnets for birds and butterflies. • Silky grevillea (*Grevillea pteridifolia*) has silvery fern leaves and bright orange flowers with sweet nectar. It's a real beauty. *Second column:* Itchytree (*Barringtonia acutangula*) has long drooping flower stalks. The flowers are scarlet red. The fruit is small and buoyant. • White paperbark (*Melaleuca leucadendra*) has just that, a papery white bark. The white flowers are borne in threes and have a strong sweet fragrance. *Third column:* White fig (*Ficus virens*) is found in Pakistan and India and into northern Australia. It often begins life as an epiphyte, growing in the branches of another tree and sending down roots that feed the epiphyte, eventually strangling or consuming the host tree. • A ripper of a plant. The blue water lily (*Nymphaea violacea*) grows in billabongs and rivers. Most parts of the plant are edible.

stability means that there are old rocks as well as recent landforms and because of its great age of over 2 billion years, much of the area is deeply weathered and has soils that are leached and infertile. On the plateau the stripping away of most of the late Cretaceous rocks has produced a rugged landscape of quartzite sandstones with areas that have been deeply eroded into a maze of narrow valleys and gorges.

The sandstone plateaus are harsh environments for plants. Temperatures are often extreme, there is little soil, and flash flooding is common. Where there is adequate soil and moisture, trees and shrubs cluster. The scarlet gum (*Eucalyptus phoenicea*) is a medium-sized, multistemmed tree with yellowish bark and orange flowers. Wild peach (*Terminalia carpentariae*) grows from 20 to 33 feet (6 to 10 meters) high and produces edible green fruits. There are many species of wattles and spider flowers—*Acacia* and *Grevillea* species—notably *A. conspersa*, growing up to 5 feet (1.5 meters), with a slightly weeping habit and spikes of bright yellow flowers, and *A. sublanata*, with triangular spiny leaves and globular golden flowers. *Grevillea*, that splendid genus, is most represented by Dryander's grevillea (*G. dryandri*) with striking red or apricot flowers, *G. angulata* with holly-shaped leaves and yellow flowers, and *G. heliosperma*, a spreading tree

to 26 feet (8 meters) in height with deeply lobed leaves. The flowers are borne in great profusion and are red or pink.

Narrow gorges with spectacular waterfalls provide a protective environment within the sandstone lands. A seasonally monsoon forest exists with *Allosyncarpia ternata* the predominant species. It is an evergreen tree growing to 98 feet (30 meters) with shiny dark green leaves that grow in sets of three. Nondescript cream flowers are produced every 3 to 7 years. Its size, lush foliage, and large grouping provide a rare glimpse of a majestic forest, an oasis of sorts, in what is largely an open and apparently sparse landscape.

No words, no list of plants, can articulate what it is like to set your feet on this ground. And to do so, barefoot, is to walk on land millions of years old where people have lived for tens of thousands of years. To walk among tall eucalyptus and hear the cackle of red-tailed black cockatoos or the strange laugh of blue-winged kookaburras, is one of the great wonders of this world. We name the plants with botanical Latin, but the plants are named an-dadjek, an-marrenarnak, guibuk, gun-god, and barradjungga, in a language far older than Latin—the Gundjehmi dialect of the Bininj Mungguy people.

Kakadu is an Aboriginal place first and foremost.

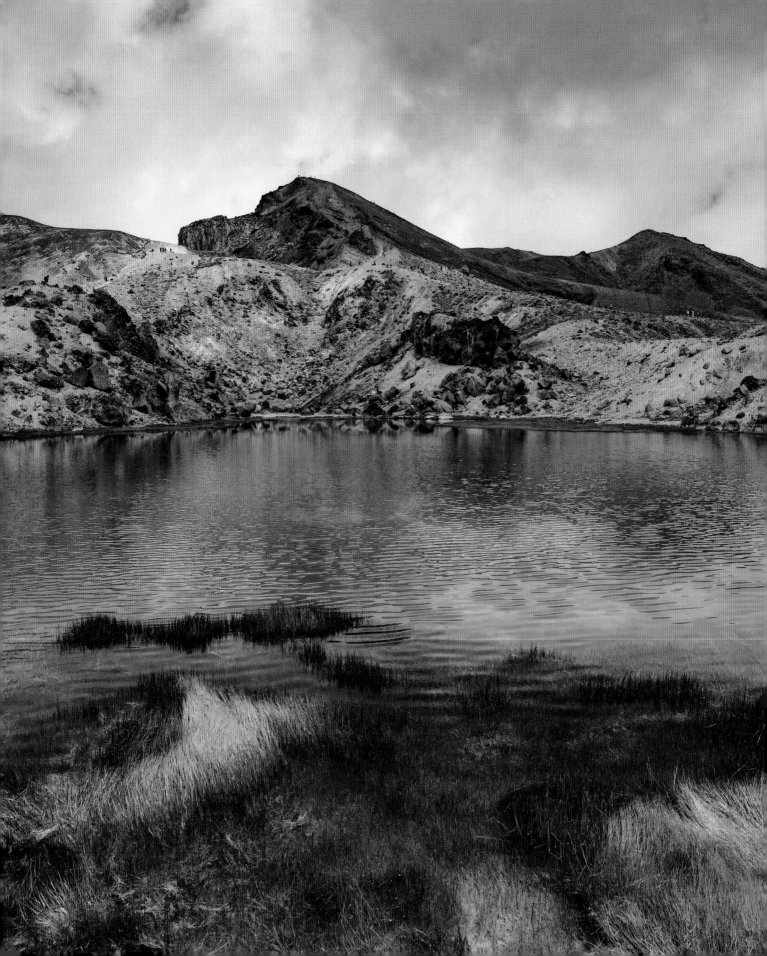

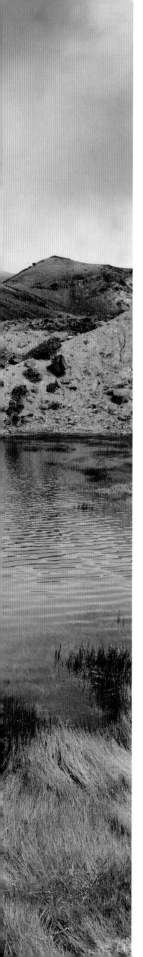

In 1993 Tongariro became the first property to be inscribed on the World Heritage List under the revised criteria describing cultural landscapes. The mountains at the heart of the park have cultural and religious significance for the Māori people and symbolize the spiritual links between this community and its environment. The park has active and extinct volcanoes, a diverse range of ecosystems, and some spectacular landscapes.

Tongariro National Park

Seventy-five percent of New Zealand is mountainous or hilly, Mount Cook is the highest at 12,218 feet (3724 meters). The fjordlike coastline is 9300 miles (15,000 kilometers) long. About 15 percent of the land is covered in plants, and 80 percent of the plants are endemic to the country, including some of the world's oldest plant forms. It is this high rate of endemism plus its geographical isolation that helps make New Zealand one of the most botanically interesting countries on earth.

The greenstone-hued lakes here are created by sunlight reflecting off a layer of calcium carbonate on the lake bed. This magical combination gives the lakes their beautiful green glow.

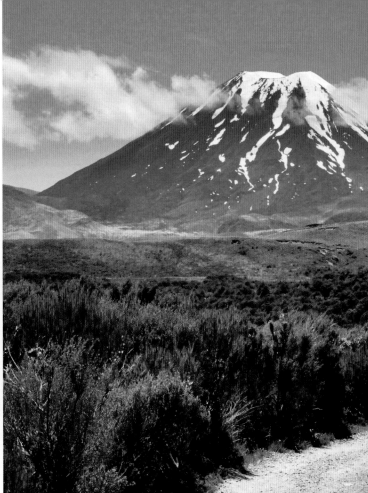

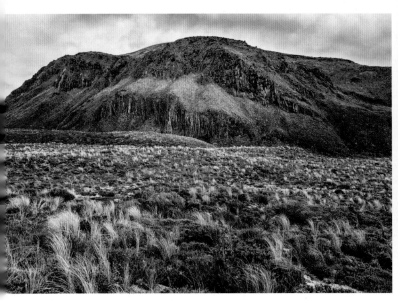

Crumpled like an unmade bed—there may be no better description of this geologically dynamic country. New Zealand lies in the collision zone between the Indo-Australian and Pacific tectonic plates, and more than 15,000 earthquakes a year take place, although few are strong enough to be felt. A major exception was the Kaikoura earthquake of November 2016, which buckled the east coast of the South Island and moved the northeastern tip of the island north by over 6½ feet (2 meters). It was the most complex earthquake ever studied, ripping through 25 fault lines and changing the way fault ruptures are now measured.

As pleasantly benign as New Zealand appears, with its English-style gardens, safely grazing sheep, and rivers of sauvignon blanc, it is a violent country; heaving and swaying, rising and falling through geological time. Those of us who don't

know, and that is most, may think of plate tectonics as a series of dinner plates rubbing up against each other rather politely until something breaks. In New Zealand the plates are broken crockery hurled by violent forces.

And what we humans feel is just the surface. Underneath, it is a different story. New Zealand as we think we know it keeps bouncing above and below the water line like a rubber duck in a child's bathtub. What we see today is just a remnant of a continent formed about 83 million years ago, the continent of Zealandia. Now we know that New Zealand, Stewart Island, New Caledonia, the Chatham Islands, and other small islands are the tops of a submerged continent 1,900,000 square miles (4,920,000 square kilometers) in size.

Culturally and ethnographically the country is a combination of Māori and British. The Māori

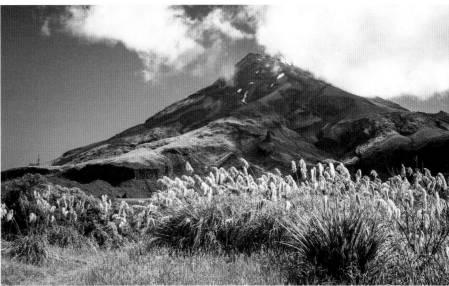

From left: Tussock grasses, bog plants, rock plants—a plant worshipper's dream in the high altitudes of this magnificent natural landscape. • An active stratovolcano, Mount Ngauruhoe is a secondary cone of Mount Tongariro. • The beauty of the park is in its diverse habitats formed by volcanoes, ice and snow, rivers, and you.

people arrived on the modern-day North Island in the 14th century and named it Aotearoa (land of the long white cloud). The first European to sight the islands was the Dutchman Abel Tasman in 1642. Captain James Cook made landfall in 1769. Land-eating European settlers followed, and enormous, cultural, political, and environmental changes began.

Tongariro National Park covers 303 square miles (786 square kilometers) in the heart of North Island. It is just a few miles west-southwest of Lake Taupo, which 26,500 years ago produced the world's largest known volcanic eruption of the past 70,000 years. A paved road leads to Whakapapa Village and the National Park Visitor Centre. The road continues to Whakapapa, on Mount Ruapehu's western slopes, and to a gondola leading to New Zealand's highest café.

The Tongariro Alpine Crossing, a world-renowned trek 12 miles (19.4 kilometers) in length, follows lava flows over a mountain saddle and past lakes and hot springs. Crowded at times, it is still the best way to get a closer look at subalpine and alpine flora. Stick to the trails, be silent, open your eyes, and let it absorb you.

There are several Māori religious sites within the park, and they are sacred, or tapu, to the Māori people. The active volcanic mountains Ruapehu, Ngauruhoe, and Tongariro are in the center of the park. They, too, are tapu. According to Māori belief, the mountains were once gods and warriors. All the mountains were male except for Pihanga. The other mountains were deeply in love with her. The mountains decided to fight for the right to win her. The warrior mountains fought with violent eruptions, smoke, fire, and hot rocks. When the

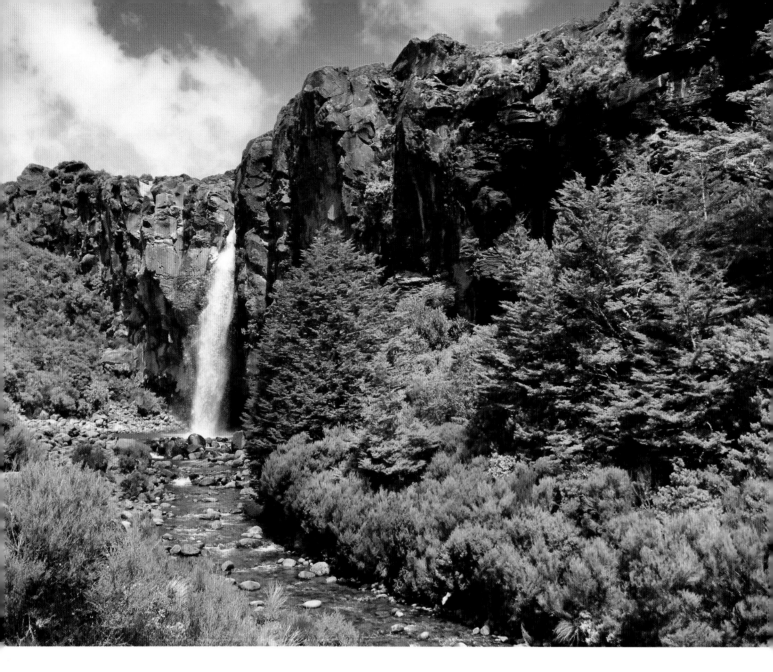

fighting ceased, Tongariro was the victor. The defeated warrior mountains would be eternally fixed to the place where they rested.

Tongariro, Ngauruhoe, and Ruapehu remain active, while the park's two northernmost volcanoes, Pihanga and the Kakaramea-Tihia Massif, last erupted over 20,000 years ago. These mountains determine what plants grow and where.

There are two key genera of trees in New Zealand—*Podocarpus* and *Nothofagus*—and both are widely represented in the park. Both have significant flora associated with them and both connect to species elsewhere on the planet. Members of the genus *Podocarpus* grow up to up to an elevation of 3280 feet (1000 meters) at Tongariro and are part of a podocarp-hardwood forest that has been severely reduced by logging in the last 100 years. Hall's totara (*Podocarpus laetus*) is a slow-growing coniferous tree with thin, papery bark, and grows up to 66 feet (20 meters). *Dacrycarpus dacrydioides*,

From left: The jewelled arc of the waterfall. •
Snowmelt-supplied rivers are essential and
beautiful elements of this magnificent place.

29

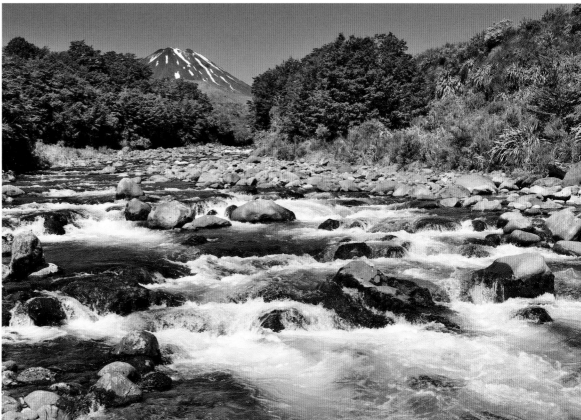

a conifer, grows to a height of 180 feet (55 meters) and is a highly prized timber tree, unfortunately for it. Commonly known as kahikatea (from the Māori language), it has a buttressed base and scalelike leaves. *Weinmannia racemosa*, a tall shrub or small tree has racemes of small, pink, or white flowers, and reaches up into the podocarp forest. Another coniferous evergreen, mountain cedar (*Libocedrus bidwillii*), a pyramidal and handsome tree, is also dominant here. The higher the altitude, the smaller it becomes until, at its highest range, it becomes little more than a large bush.

The southern beeches, *Nothofagus*, consist of 37 species of deciduous and evergreen trees only found in Australia, Chile, Argentina, Papua New Guinea, Indonesia, New Zealand, and New Caledonia. New Guinea has the most species (14), while New Zealand has 4 with one additional variety: silver beech (*N. menziesii*); red beech (*N. fusca*); hard beech (*N. truncata*); black beech (*N. solandri*

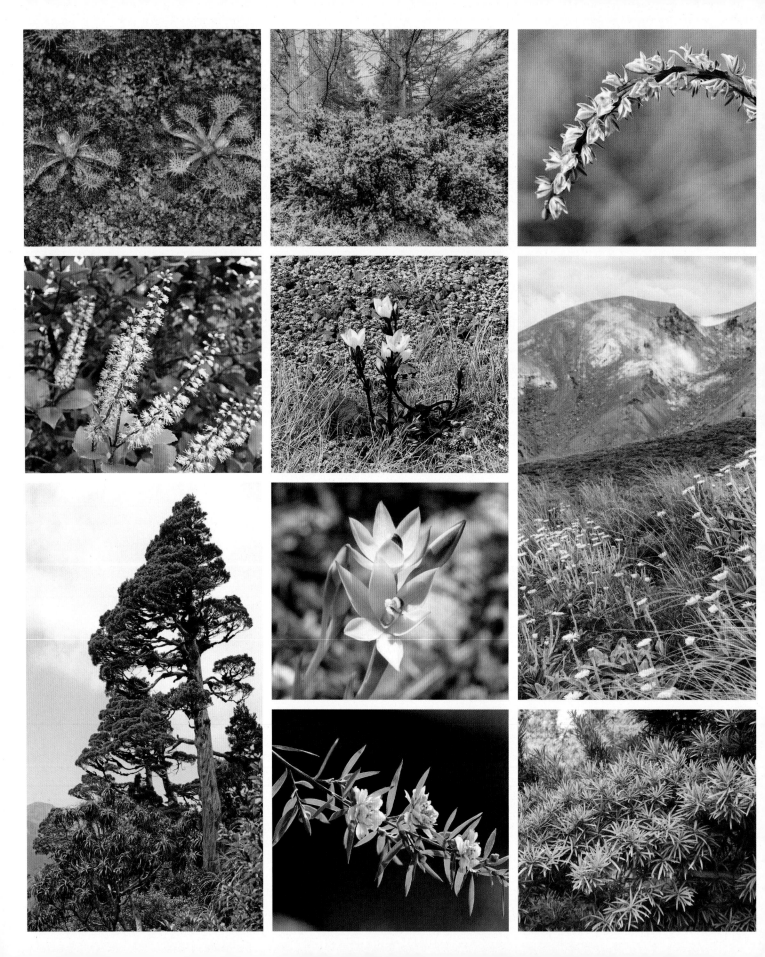

First column: *Drosera spatulata* is very hardy and produces many seeds. It is one of the most widespread in nature. • Such a lovely tree with leathery evergreen leaves and white to pink hermaphrodite flowers, *Weinmannia racemosa* is one of the most abundant trees in New Zealand. • Mountain cedar (*Libocedrus bidwillii*) is a handsome and distinctive evergreen coniferous tree with foliage arranged in flattened sprays. It is quite stately. *Second column:* The snow totara (*Podocarpus nivalis*) is a small evergreen shrub that grows close to the snow line. • A subalpine to alpine gentian found in tussock grassland, with green or purple-black tinted leaves and white flowers. It is one of the lovely gems of Tongariro. • The white sun orchid (*Thelymitra longifolia*) is a spring to summer green perennial herb with a wide range of habitats from open ultramafic talus to dense forest. It is most common in shrublands. • Manuka (*Leptospermum scoparium*) is a widespread evergreen shrub or small tree with showy pink, red, or white flowers in late spring and summer. Manuka honey is made by bees that appear to get intoxicated by the sweetness of the flowers. *Third column:* *Prasophyllum*, commonly known as leek orchids, is a genus of about 140 species of flowering plants in the orchid family (Orchidaceae) and is found in Australia and New Zealand. This species produces up to 20 yellow green to red-brown flowers. • *Celmisia incana* forms tight clumps of short gray-green leaves and white flowers in the brief but brilliant summer. • Kahikatea (*Dacrycarpus dacrydioides*) is a coniferous tree with spirally arranged leaves on young plants, scalelike on mature plants. It is a member of the Podocarpaceae.

var. *solandri*); and mountain beech (*N. solandri* var. *cliffortioides*). There's an old bushman saying about southern beeches, "You've got three types of beeches—red, brown, and black. The bark of the red is silver, and the wood of the red is pink when its green. The brown quite often has black bark, but the green timber is red. Sometimes the bark of the black is white, but the timber is yellow and sometimes brown when it's green." Red beech, silver beech, and mountain beech are the dominant *Nothofagus* species in the park.

As you climb or drive through the park, the snow-covered, sharp peaks of the mountains come into focus. Steam rises from fumaroles and crevices. Volcanic rock, like tumbling chocolate, is covered in tussock shrubland and alpine hummocks. A vegetative toupee of *Raoulia albosericea*, a plant of the rocks with a crust of tiny silver leaves and tiny white flowers in summer is interspersed amid the plains of tussock grasses. Red tussock grass (*Chionochloa rubra*), rusty against the rocks and covering much of the pumice soil from 2952 to 3937 feet (900 to 1200 meters), and two other grasses, *Festuca novaezelandiae* and *Poa colensoi*, dominate the high mountain slopes. *Empodisma minus* is a tangled green wire of a plant growing in poor wet soils and with the pale brown and green moss

Sphagnum cristatum forms large peat bogs, while communities of carnivorous sundews including *Drosera arcturi*, *D. binata*, and *D. spatulata* slowly digest seduced hoverflies. Low-growing forms of manuka (*Leptospermum scoparium*) with white or pink five-petalled flowers, prettily punctuate the harsh mountain slopes.

Closer to the mountain peak and a growing inhospitality there is an occasional gentian (*Gentiana bellidifolia*), a lovely little thing with white flowers, species of *Parahebe*, particularly the parahebe snowcap (*Parahebe cataractae*), with white flowers marked with rose-purple lines, and the snow totara (*Podocarpus nivalis*), a prostrate shrub with spreading branches and spirally arranged thick leaves, hugging the ground to protect itself from the cold wind. Higher still, medallions of multicolored crustose lichens grow in and on the rocks.

Then, on the gondola, to as high as you can go. To wind and sky and swirling clouds. Descend to home amid fields of white foxglove (*Digitalis alba*), native orchids, leek orchid (*Prasophyllum colensoi*), the striped sun orchid (*Thelymitra cyanea*), the white sun orchid (*T. longifolia*), and the Whakapapa sun orchid (*T.* "Whakapapa") and celebrate that New Zealand and UNESCO are responsible for the protection of this precious place.

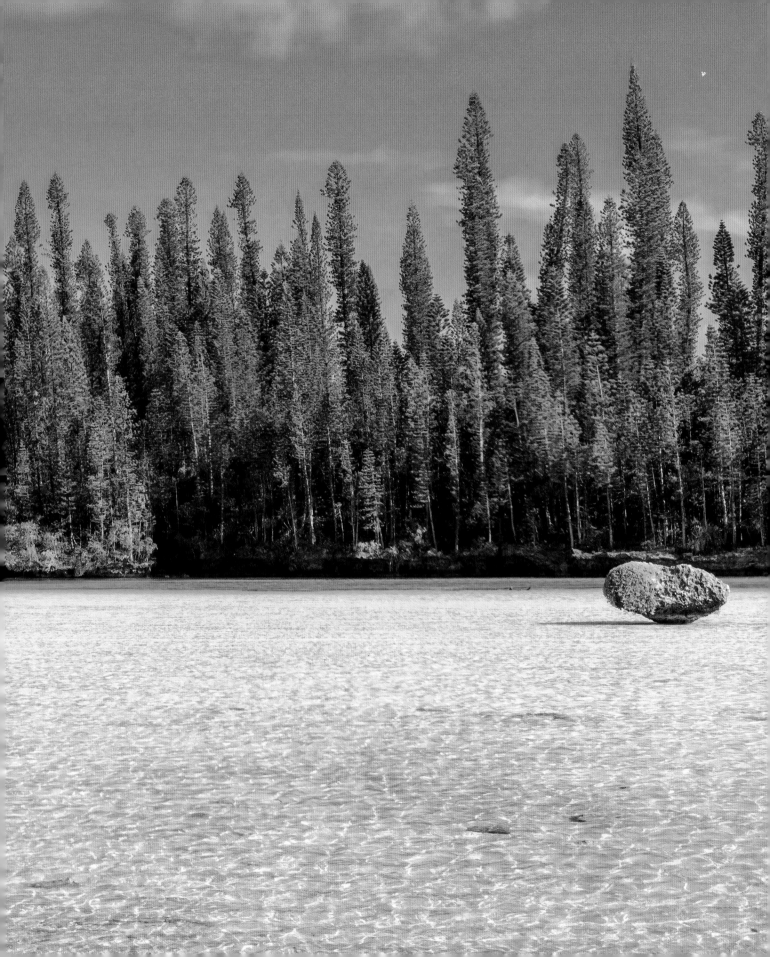

This serial site comprises six marine clusters that represent the main diversity of coral reefs and associated ecosystems in the French Pacific Ocean archipelago of New Caledonia and one of the three most extensive reef systems in the world. These lagoons are of exceptional natural beauty. They feature an exceptional diversity of coral and fish species and a continuum of habitats from mangroves to seagrasses with the world's most diverse concentration of reef structures. The Lagoons of New Caledonia display intact ecosystems with healthy populations of large predators and a great number and diversity of big fish. They provide habitat to a number of emblematic or threatened marine species such as turtles, whales, and dugongs, whose population here is the third largest in the world.

Lagoons of New Caledonia: Reef Diversity and Associated Ecosystems

FRANCE

New Caledonia and the Loyalty Islands to their east lie in the Coral Sea of the southwestern Pacific, 1056 miles (1700 kilometers) west of Queensland and 870 miles (1400 kilometers) north-northwest of New Zealand. A tropical archipelago of islands and a French Overseas Territory, it has been called the Jurassic Park of the botanical world. Many vegetal taxons of the current New Caledonian flora appear, because of their archaic characteristics, as primitive forms belonging to ancient groups which have lasted

A tropical bay with a backdrop of *Araucaria.*

Below, from left: One of the rarest palms in the world, *Saribus jeanneneyi.* •
Sometimes called the triangle tree, *Auracaria heterophylla* showcases its
regular and beautiful geometry against a tropical sky. • Koghis kauri, the
giant god of the New Caledonian Forest.

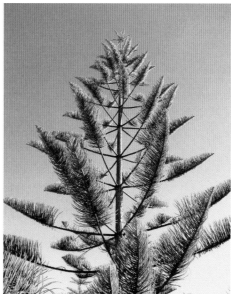

without important changes until today. They are
the remnants of ancient lineage, true relics of
Gondwanaland Cretaceous flora and can be quali-
fied as living fossils. But are they? If New Caledonia
had stayed above sea level, this would certainly be
true, but it was submerged for 20 million years and
reemerged between 33 and 38 million years ago.
And so, New Caledonia was recolonized by plants
from relatively nearby landmasses, and specia-
tion and adaptive radiation ensued, giving us the
certainly ancient lineage, but not Gondwanan, of
plants present on the island today. The lagoons of
New Caledonia and their associated ecosystems
were inscribed as a World Heritage Site in 2008.

New Caledonia is unusually rich in mineral
deposits. Twenty-five percent of the known global
reserves of nickel exist on the main island. The
unusual metal-rich soils support about 3270 species
of vascular plants, of which 74 percent are endemic.
The island has the world's largest number and diver-
sity of conifers for its area despite the subtropical
location, 43 out of 44 being endemic. Araucariaceae
and Podocarpaceae predominate.

There are five endemic flowering plant (angio-
sperms) families and *Amborella trichopoda,* an
evergreen shrub up to 26 feet (8 meters) high. The
creamy white flowers are borne on the axils of the
leaves. What is truly important about this shrub
is that it is the world's earliest living ancestor
of all flowering plants on the evolutionary tree.
There are fossils of older extinct plants but this
one is alive and, as such, is described as at the

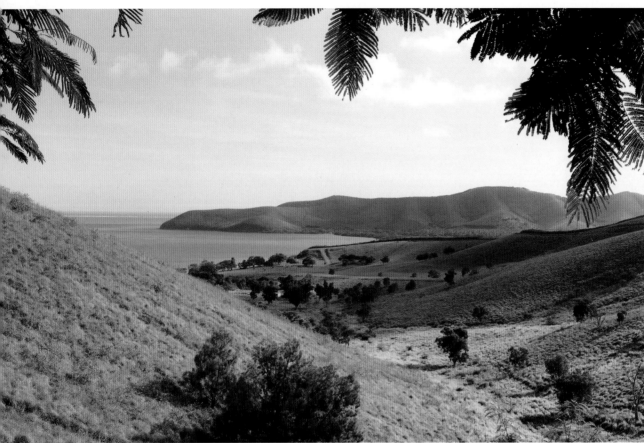

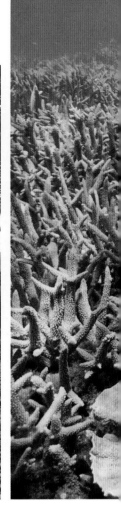

base—the beginning—of the tree of life of all flowering plants.

There are five main terrestrial habitats. The most extensive is evergreen wet tropical lowland forest. Other vegetation types are the very fragmented hard-leaved (sclerophyllous) forest on the west of the island, low- to midlevel maquis, high altitude wet maquis forest, man-made savanna, and marsh.

Along 50 percent of the coast, principally on the west side, mangroves of 16 species cover 66,718 acres (27,000 hectares). *Rhizophora* species, common where mangroves meet the sea, have stilt roots, while *Avicennia marina*, the white mangrove, in estuaries, has aerial roots called pneumatophores that emerge out of the mud. The nine main forms of reef contain a wealth of habitats: reef fronts, slopes, passes, terraces, and pinnacles, and muddy, sandy, platy, and rocky lagoon basins, as well as combinations of these at various levels. The marine vegetation are seagrasses and algal beds. Twelve species of

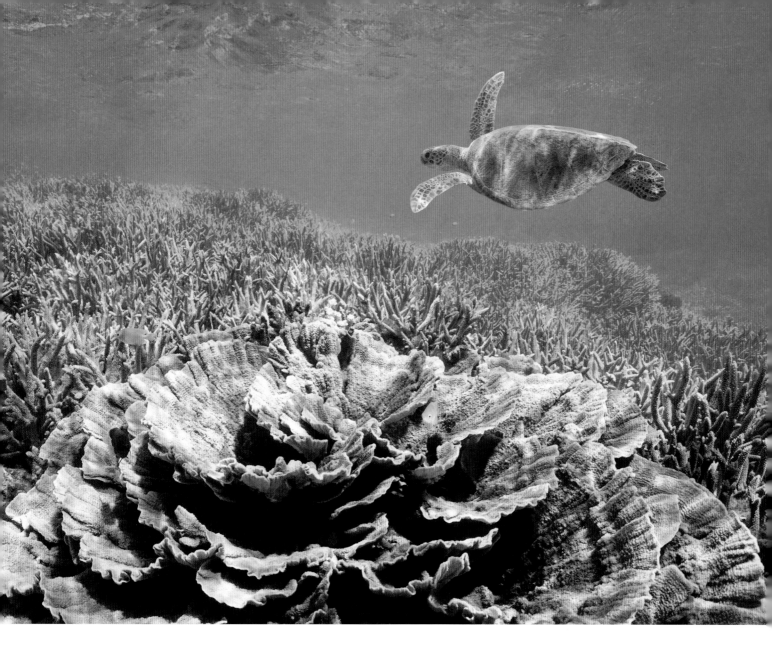

seagrasses are found, mainly on the muddy sands of shallow lagoons and inlets—neptune grass (*Cymodocea*) species predominant in the north, and turtlegrass (*Thalassia*) species in the south. Over 320 species from 46 families of algae are recorded, but it is estimated that 1000 species may exist.

There are 18 species of the family Araucariaceae family native to New Caledonia, 5 *Agathis* and 13 *Araucaria*, and all are in danger of extinction in the wild to varying degrees, due to bush fires, urban expansion, and mining. *Araucaria columnaris*

is native to the coast and to Isle of Pines and the Loyalty Islands. It is a narrowly conical tree to 197 feet (60 meters) tall. The bark is rough and gray and exfoliates in strips. The young leaves are needlelike, while the adult leaves are triangular and scalelike. *Araucaria nemorosa* grows to 49 feet (15 meters) tall with an oval or conical crown. The young leaves are needlelike and curved inward. The adult leaves are narrowly lanceolate with a prominent midrib.

In Blue River Provincial Park, a 1000-year-old koghis kauri (*Agathis lanceolata*) stands 131 feet

(40 meters) tall and presides over the rainforest like a god. The bark is red-brown, the leaves are dark green and lanceolate. It is an unmistakable tree due to its size. The species is protected in the park but elsewhere is vulnerable to extinction due to habitat loss. Screw pine (*Pandanus balansae*) also grows in this forest. It is a palmlike plant that is neither a palm nor a pine. It does, however, have a palmlike crown of glossy green leaves and is exceedingly rare. Rare, too, is *Saribus jeanneneyi*, a palm with only one mature specimen in its native habitat. There is one in cultivation now, grown from seed. It flowered for the first time in 2004. Thirty-seven

palms of 16 genera are known in New Caledonia, 15 of the genera are endemic to the archipelago. Some species are widely distributed, like *Chambeyronia macrocarpa*, a feathery palm to about 20 feet (6 meters), with a spectacular, bright red new leaf and *Basselinia gracilis*, a highly variable palm with a black-spotted stem in many colors—gray, purple, yellow, green, and orange. In the northeast of the island grows one of the rarest palms in the world, *Clinosperma macrocarpa*, which is a vigorous palm to 49 feet (15 meters) tall, with a crown of six to seven dark green leaves, covered with brown scales. Only a handful of trees remain in its native habitat.

The red earth contrasts with the green forests
and the blue sky in the Blue River Provincial Park.

39

To walk in the park is to get a taste of the diversity of New Caledonia's extraordinary plant diversity. It includes maquis shrubland and tropical rainforest, three rivers—Blue, White, and Month of May Rivers—Lake Yaté, and an eerily sculptural drowned forest. Walking from the great koghis kauri, through the rainforest and out into the sunlight of the shrubland is to get a small glimpse of what New Caledonia really is, a world beyond the resorts and the open cast mining. In the forest it is quiet, the only sounds are birds and insects, and plants straining for light. The light is watery green. If there are flowers, they are at the top of the canopy with only a few, such as *Deplanchea speciosa* with its bouquet of golden flowers, visible from the ground. *Spathoglottis plicata*, a large purple evergreen ground orchid, grows in wet soil in the shade of a tree trunk, while *Grevillea gillivrayi*, a large shrub—up to 23 feet (7 meters) in height—with light green leathery leaves and brilliant salmon-colored flowers on the end of the branches grows in sunnier areas along with dense clusters of bright yellow pea flowers of *Storckiella pancheri*.

In the mountains, the giant tree fern (*Sphaeropteris intermedia*) grows on forested

First column: Storckiella pancheri is native to maquis vegetation and forests in New Caledonia. Its golden yellow flowers are absolutely marvellous. • *Amborella trichopoda,* the world's most ancient existing flowering plant. • The sea mango (*Cerbera manghas*) with its tubular five-lobed corolla. The flowers are very fragrant. • All grevilleas have wonderful Proteaceae flowers and *Grevillea gillivrayi* is one of the finest. *Second column:* Adiantum novae-caledoniae, often found growing among water-saturated rocks. • The common name of large purple orchid is a rather banal and less than poetic name for this wonderful specimen. • White mangrove (*Avicennia marina*) has aerial roots (pneumatophores) allowing the plant to absorb oxygen, as well as anchoring the plant during the frequent inundation of seawater. • The red fronds give *Chambeyronia macrocarpa* the common name of flamethrower palm. *Third column:* Acropogon bullatus is a spectacular tree found in dry and dense humid forest. The star-shaped red flowers are surprising. • Fresh new growth on the koghis kauri. • Tight new growth on *Araucaria nemerosa,* a small, shade-tolerant understory conifer. • Sea mango fruit turns bright red when fully mature. Unfortunately, they are extremely poisonous.

Below: Sphaeropteris intermedia waving its distinctive branches above other native vegetation.

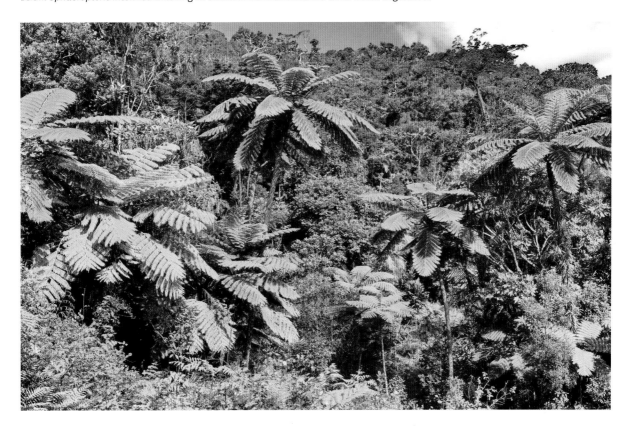

slopes. It is the world's tallest tree fern at up to 98 feet (30 meters) and is said to grow 3 feet (1 meter) a year. Growing on rocks *Adiantum novae-caledoniae,* a maidenhair fern, has 6- to 8-inch (15- to 20-centimeter) long and wide, somewhat pentagonal and glossy leaves.

Through savanna filled with broad-leaved paperbark (*Melaleuca quinquenervia*) down to the coast and through stands of the coral reef araucaria (*Araucaria columnaris*) and to the hot and humid beach where *Cerbera manghas,* the sea mango, grows. It is a small evergreen coastal tree growing up to 39 feet (12 meters) tall. The leaves and the fruits are poisonous. It is sometimes called suicide apple. More beneficial plants grow in the sandy soil. *Acropogon bullatus* is a spectacular tree with large, rounded leaves and star-shaped, striped, red flowers. It is, sadly, critically endangered.

The beautiful simplicity of a mountain
meadow in bloom at Waterton Glacier
International Peace Park

The Americas

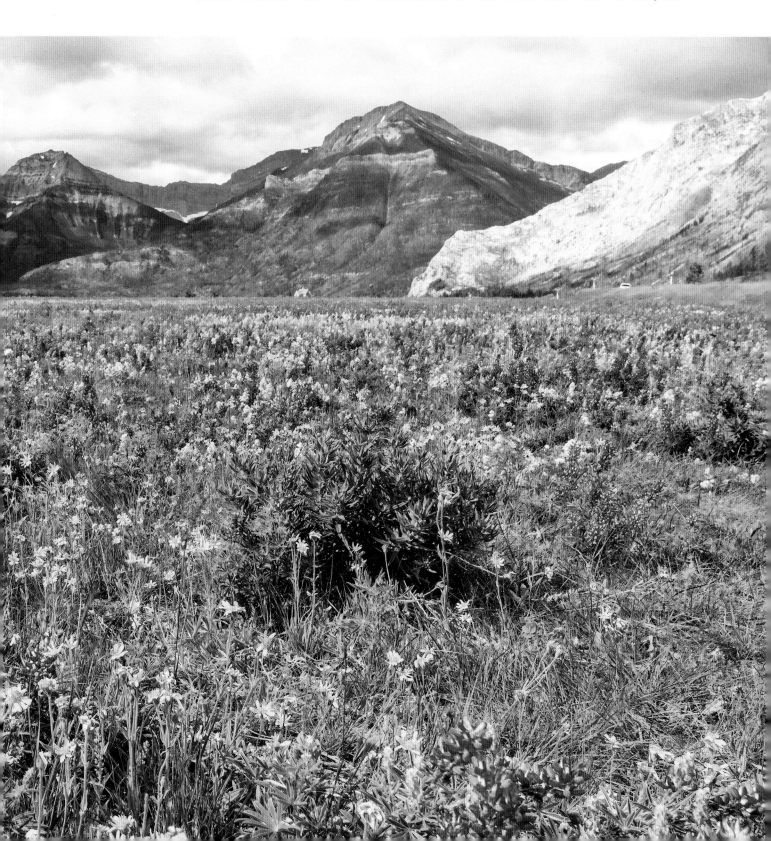

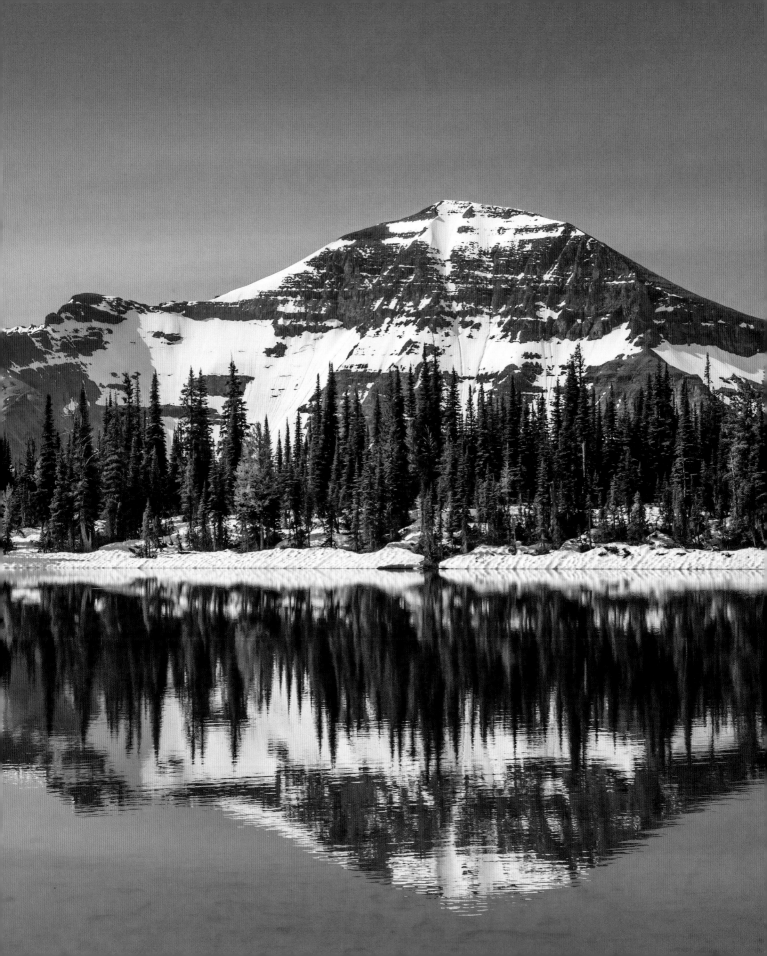

In 1932 Waterton Lakes National Park (Alberta, Canada) was combined with the Glacier National Park (Montana, United States) to form the world's first International Peace Park. Situated on the border between the two countries and offering outstanding scenery, the park is exceptionally rich in plant and mammal species as well as prairie, forest, alpine, and glacial features.

Waterton Glacier International Peace Park

CANADA AND
THE UNITED STATES
OF AMERICA

Rolling, golden hills smoothly swelling down from sharp arêtes. Ambrosial forests of hemlock and cedar turning to woodlands of quivering aspen. Glacial icy blue lakes; churning rivers twisting through canyons; meltwater lakes filling the cirques; beaver dam pools; and nomadic vernal seeps. Bull moose grazing water weeds. Black bear nosing their way along secret trails. The high cry of bald eagles and the honking of tundra swans.

Cold mountain lake and crystal sky. A snowdust day.

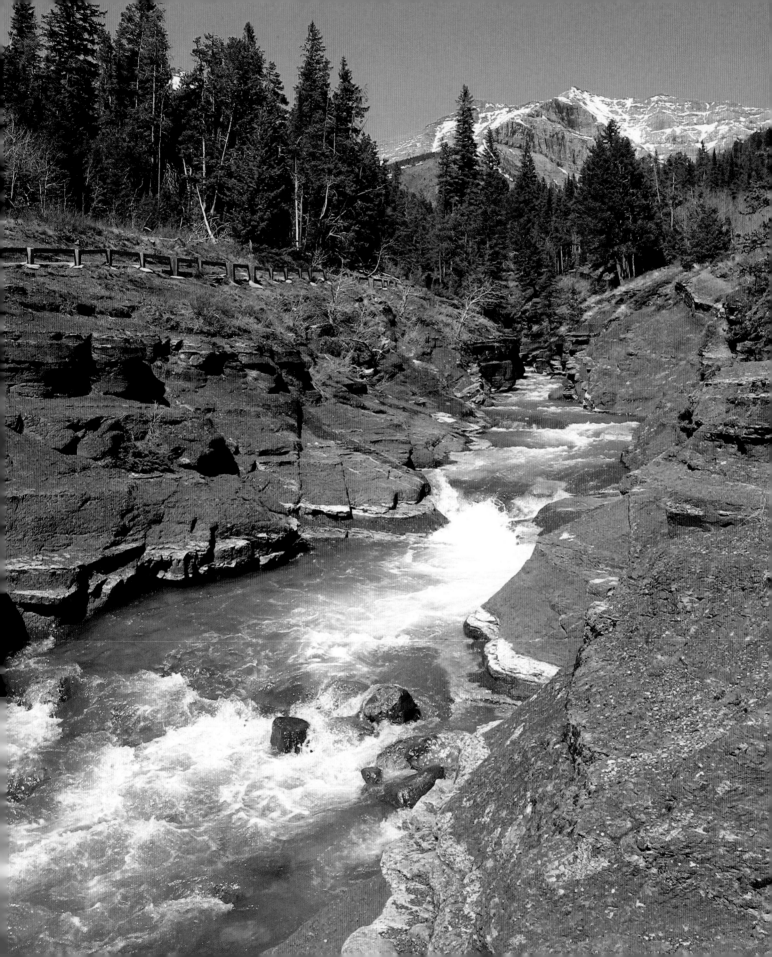

Waterton Lakes National Park was created in 1895, a 54-square-mile (140-square-kilometer) area protected by the Canadian federal government as a Forest Park Reserve. Glacier National Park was created in 1910 in the United States and encompasses over 1544 square miles (4000 square kilometers). Both parks were inscribed as a World Heritage Site in 1995. In 2017 the International Dark-Sky Association, a US-based organization whose principal approach is "to raise awareness about the value of dark, star-filled night skies and encourage their protection and restoration" designated the park as an International Dark Sky Park, the first spanning an international border.

Part of the traditional territory of the Niitsitapi (Blackfoot) and Ktunaxa (Kootenai) peoples, the park is 1720 square miles (4455 square kilometers) in size and consists of two climatic zones, Pacific maritime and arctic continental with forests in the west and dry foothills in the east. The mountains create an assortment of habitats, from drier south and west slopes to moist north and east slopes.

There are five floristic ecoregions: alpine meadows and tundra, subalpine forest, mountain fir-whitebark pine forest, aspen woodland, and fescue prairie. It is the southern limit for many northern species of plants and is the northern limit for several southern alpine species. It is also the eastern limit for many western species. Thus, it is a crucial convergence point for North American flora, with complex ecosystems found nowhere else. It is also one of the most beautiful places in North America.

The park is part of the Rocky Mountains. Many peaks are over 7874 feet (2400 meters) in three mountain ranges—Clark Range, Lewis Range, and Livingston Range. Mount Cleveland is the highest at 10,479 feet (3194 meters). On the Canadian side, Mount Blakiston is the highest at 9547 feet (2910 meters). They are sharply rugged, notable, among other things, for the fact that the oldest rocks, from the Proterozoic Eon (2500 to 541 million years ago), are on top of the youngest rocks, formed in the Cretaceous period (145 to 66 million years ago). This is due to the Lewis Overthrust, a collision of tectonic plates about 170 million years ago.

Alpine tundra is found above 7381 feet (2250 meters). It is dry and windy in the summer with a 2-month growing season. It is cold, snowy, and windy in the winter. In addition to tundra, there are alpine meadows, high-altitude islands with compact, low-growing, mat-forming plant communities, and rare alpine bogs. It is a largely treeless biome but those that do grow in the high altitudes are often stunted and deformed (krummholz) due to the high winds. The two most common trees are arctic willow (*Salix arctica*) and diamond leaf willow (*S. planifolia*).

WATERTON GLACIER INTERNATIONAL PEACE PARK

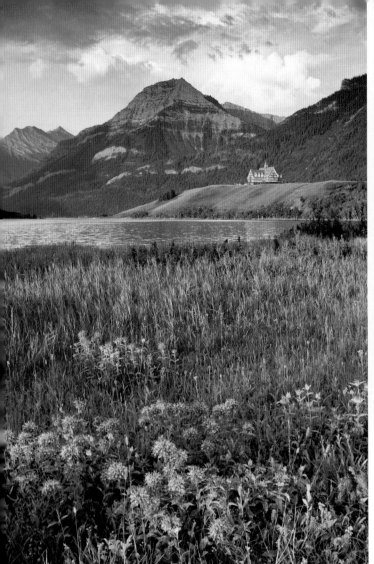

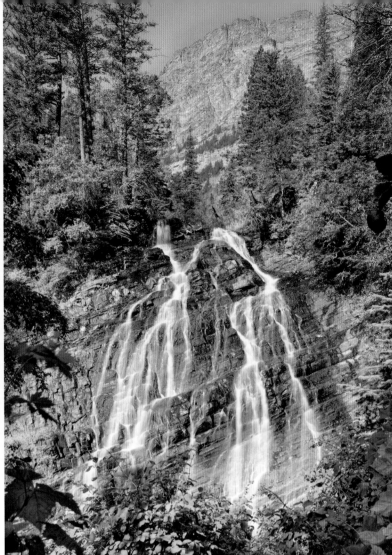

The brief summer brings many flowers. Mountain avens (*Dryas octopetala*) is a low-growing—4 inches (10 centimeters) high—evergreen, mat-forming plant with leathery leaves and eight-petalled white flowers with yellow centers. Alpine glacier poppy (*Papaver pygmaeum*) grows on scree slopes quite near permanent snow fields. It is a short-lived perennial with blue-green leaves and yellow, orange-pink, or orange flowers ¾ inch (2 centimeters) wide. Sky pilot (*Polemonium viscosum*) is a compact perennial growing to 12 inches (30 centimeters) tall with sticky, feathery leaves up to 6 inches (15 centimeters) long, made up of many spoon-shaped leaflets, and soft blue-purple flowers.

For a short time, the high alpine flora is spectacular. The sun comes over the sharp mountains and floods the white, orange, and blue with gold. Racing down into the valleys, lighting the dark forests and bright woodlands, the diamond light seems to rest in the sparkling lakes before moving on.

Below the tundra, the subalpine forest extends between 7381 feet (2250 meters) and 5413 feet (1650 meters) in two zones: upper and lower. Less dense and with a drier climate, the upper forest is populated with dwarf birch (*Betula glandulosa*), a multistemmed shrub growing 3 to 10 feet (1 to 3 meters) tall, often found in impenetrable thickets next to snowmelt streams. It is an important food

From left: Wild bergamot, Upper Waterton Lake, and the Prince of Wales Hotel. • Bertha Falls, Alberta. • Waterton trees and grasslands color the lower reaches of the park's mountains.

49

to 148 feet (45 meters), sometimes higher. The blue-green needles are four sided. It is often seen at the highest ranges of the timberline, often stunted, and sculpted by the wind into fantastic bonsai-like shapes. Lower in altitude, it grows tall and elegant and associates with Rocky Mountain fir (*Abies lasiocarpa*). At its tallest, Rocky Mountain fir can grow to 164 feet (50 meters) but it is often much smaller, particularly at higher elevations. When young, it is a conical tree, often seen in clumps, but as it ages it often takes on a ragged, rugged, and characterful look. Descending in elevation, the forest becomes mixed, with Douglas fir (*Pseudotsuga menziesii*), scrub limber pine (*Pinus flexilis*), lodgepole pine (*P. contorta*), and whitebark pine (*Pinus albicaulis*).

Descending farther, as the whitebark pine forest thins, single clumps of one of the most beautiful flowers in the mountains starts to appear. Beargrass (*Xerophyllum tenax*) is not a grass but a member of the corn lily family (Melanthiaceae). Bear do not appear to be interested in it. The flowers grow on a stalk about 4 feet (1.2 meters) in height and are creamy white and sweetly scented. The wiry leaves are grasslike, hence the misnomer. As the forests open and turn into meadows, thousands of beargrass bloom, their sweet aroma filling the valleys, lifting the heart.

The more light, the more wildflowers. Out into the sunny meadows, the rocky ridges, and the

source for moose and elk, while grizzly bear use it in the construction of their dens. Alpine larch (*Larix lyallii*), a deciduous conifer, can grow up into the tundra as well as down into evergreen forests, although it is not tolerant of shade. Its deciduous habit makes it resistant to winter desiccation. In spring the needles are soft green, becoming deeper green in the summer and then golden against the ice blue sky of autumn.

The subalpine forest is an evergreen world of pines, firs, and spruce. Engelmann spruce (*Picea engelmannii*), a stately tree, has a pyramidal crown with a slightly rounded top with branches extending to the ground in long green skirts. It grows

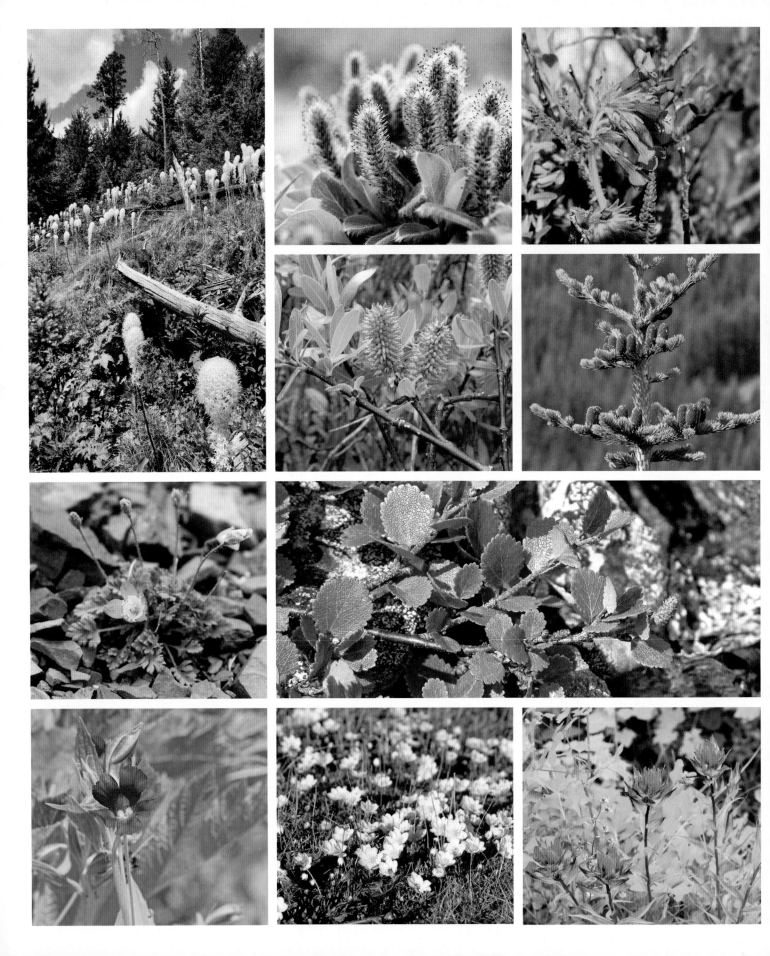

First column: Beautiful bear grass. Not a grass and the association with bears is unclear, but that's its name. • Alpine glacier poppy (*Papaver pygmaeum*). • Lewis's monkeyflower (*Erythranthe lewisii*) is named in honor of explorer Meriwether Lewis. *Second column:* Female flowers of the arctic willow (*Salix arctica*). • Diamond leaf willow (*Salix planifolia*). • Dwarf birch (*Betula glandulosa*) is a tough shrub, perfectly adapted to the rigors of mountain existence. • Eight-petalled mountain avens (*Dryas integrifolia*) in all its creamy glory. *Third column:* Sky pilot (*Polemonium viscosum*). • A Rocky Mountain fir (*Abies lasiocarpa*), recognizable by its dark purple cones. • The mountains are painted with Indian paintbrush (*Castilleja miniata*) every summer.

aspen groves. Indian paintbrush (*Castilleja miniata*), a partly parasitic plant in that it only takes some nutrients from a host plant, has green to dark purple lance-shaped leaves. The red-orange inflorescences are modified leaves—leaf bracts—and each tubular flower has red sepals and green petals. *Erythranthe lewisii*, Lewis's monkey flower, is a beautiful perennial with erect stems 12 to 31 inches (30 to 80 centimeters) high and flowers that are pinkish purple with yellowish throats. It is an important pollinator plant and is often found along streams.

Fire is an important element in the park, with dry lightning causing large forest and grass fires. After the fires are gone, often burning hundreds of acres, perennial and annual plants spring up from the newly fertilized soil and ground free from shadow. Willowherb (*Chamaenerion angustifolium*), often called fireweed, takes advantage of the burnt ground, and colonizes quickly. The inflorescence opens from top to bottom with bright magenta flowers. It is often seen at the edges of aspen groves. Quaking aspen (*Populus tremuloides*) is a deciduous tree, 39 to 49 feet (12 to 15 meters) tall, with gray bark in old trees. The egg-shaped leaves are connected to the branches by flattened leaf stems allowing the leaves to quake with the slightest wind. The leaves turn golden in the autumn and the sight of a woodland trembling

and fluttering is one of the most uplifting sights of the world.

The dry foothills are the relics of the fescue-wheatgrass prairies. Rough fescue (*Festuca altaica*) and Idaho fescue (*F. idahoensis*) is widespread and common. Needlegrass (*Nassella* spp.), Junegrass (*Koeleria macrantha*), and bluebunch wheatgrass (*Pseudoroegneria spicata*) are the common grasses of this prairie. This where the deer and the antelope play.

The park protects one of the most biodiverse sites in North America. There is, however, one major threat to life in this extraordinary place—climate change. It is ironic that the park in the United States is named Glacier National Park. According to the US National Park Service, "In 1850, there were about 80 glaciers in what would eventually become Glacier National Park. In 2015, the last year with satellite imagery available, there were 26 named glaciers that met the size criteria of 0.1 square kilometer, nine fewer than in 1966. Of the 26 remaining in 2015, some may now already be too small to be considered glaciers. . . . While the decrease of glaciers since the end of the Little Ice Age is due to both natural and human-caused climate change, the retreat seen in recent decades can be increasingly attributed to anthropogenic causes." With glaciers gone, what will be the future for life in the park?

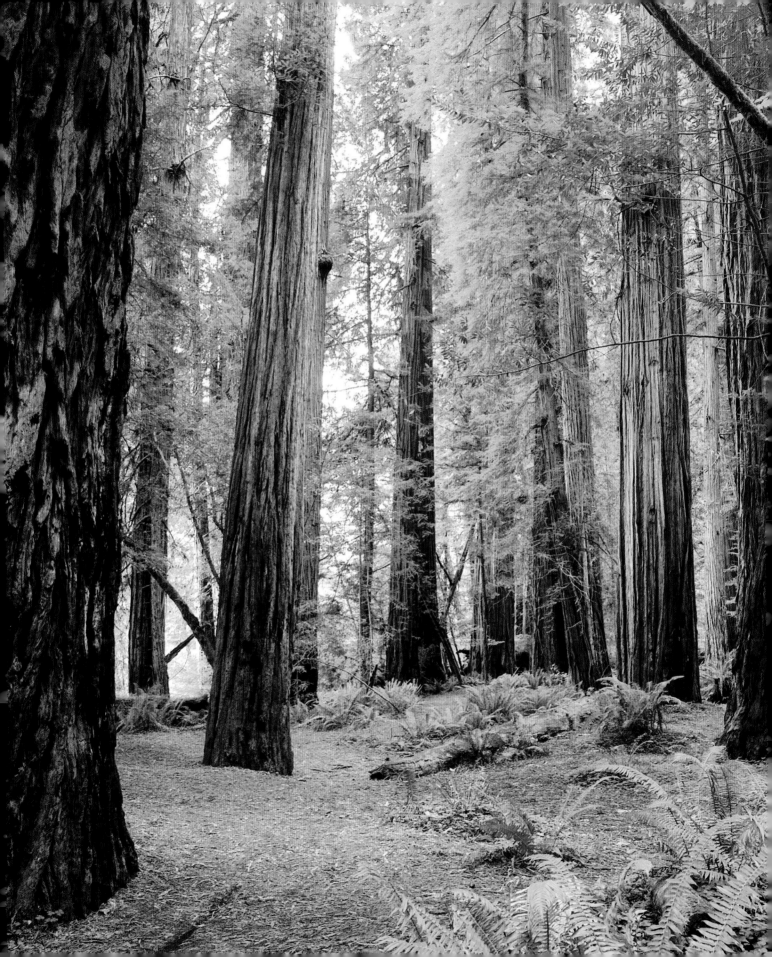

Redwood National and State Parks comprise a region of coastal mountains bordering the Pacific Ocean north of San Francisco. They are covered with a magnificent forest of coastal redwood trees, the tallest and most impressive trees in the world. The marine and land life are equally remarkable, in particular the sea lions, the bald eagle and the endangered California brown pelican.

Redwood National and State Parks

Inscribed as a World Heritage Site in 1980, the parks' primary feature is the coastal redwood forest, a surviving remnant of the group of trees that has existed for 160 million years and was once found throughout many of the moist temperate regions of the world but is now confined to the wet regions of the west coast of North America. The parks contain some of the tallest and oldest known trees in the world. Rich intertidal, marine, and freshwater stream flora and fauna are also present in the two distinctive physiographic environments of coastline and coastal mountains

Walk through the cathedral of redwoods.

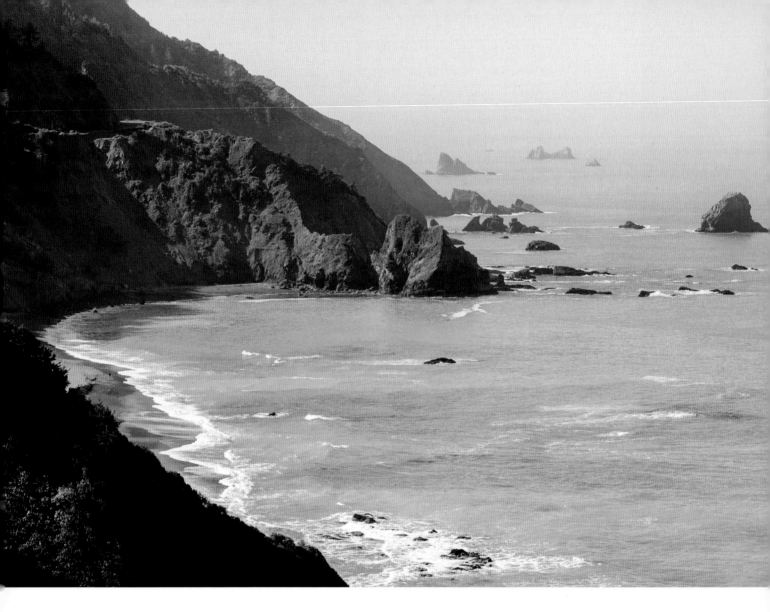

that include the old-growth forest and stream communities.

California's long sinuous body has its head in the cool coniferous forests of the north and its feet in the deserts of the south and east. The land undulates in callipygian and voluptuous waves from the eastern High Sierras down to one of the world's largest valleys, the Central Valley, and over the Coast Ranges to end, in craggy drama or smooth sand, in the Pacific Ocean.

With a Mediterranean climate, rain in the winter and none in the summer, and more biomes than any other state in the US, it is botanically rich territory. More than half of California's native plants are found nowhere else in the world. Along the 840-mile (1351-kilometer) long coast, sea spray, fog, and geology determine what grows where. Ecological niches such as canyons, serpentine outcroppings, vernal pools, and chaparral and oak woodlands provide an entire community of specific and endemic plants. Its seasons do not correspond to the calendar, spring begins in winter and may have three or four incarnations, stepping backward and forward between warm and cool. Summer comes in late spring, quickly turning green grass to gold. Autumn and early winter can be hot, the cool

Opposite: The Coast Ranges and the Pacific Ocean.

Below, from left: Lace lichen drapes over coast live oak. • California bay (*Umbellularia californica*).

winds from the coast turning to searing winds roaring down through the canyons and blowing sparks into devastating wildfires. Winter on the coast is brief and beautiful. Eyes look to the clear skies—let there be rain. California is cold and damp, at least along the coast in winter and, in summer when the interior lands are scorching, the cool coastal fog rolls in, making tourists complain but providing 25 to 40 percent of all water needed by coast redwoods and other plants. Locals call it the June gloom, trees do not.

The richest habitat along the coast is in the sea. Seaweeds, in many forms and colors, 800 species in California alone, populate the coastal waters. Giant kelp (*Macrocystis pyrifera*) grows in forests in the ocean and is home to invertebrates, fish, and mammals. Sea palm (*Postelsia palmaeformis*),

a species of kelp, grows on rocks in the intertidal zone. Easily seen from beach and cliff, battered by waves, they look like tiny palm trees in a storm. Kelps are a cold-water species covering a quarter of the world's coasts. With global sea temperatures rising and ocean acidification having increased by 30 percent since the industrial revolution, concern for the stability of seaweed biomes and their ability to be a pH refuge for marine organisms is high. With 75 percent of kelp in California waters having disappeared due to human activity in the last 100 years, concern is a temperate word.

It is the great land plants, the tall trees, that define much of California's flora. The coast redwood (*Sequoia sempervirens*) is the world's tallest tree and grows in partly protected, fragmented forests along the northern coast. Less than 5 percent of

Opposite: Monterey pine (*Pinus radiata*), the most widely planted pine in the world.

Below, from left: Monterey cypress (*Hesperocyparis macrocarpa*). • Sea palm (*Postelsia palmaeformis*), a species of kelp.

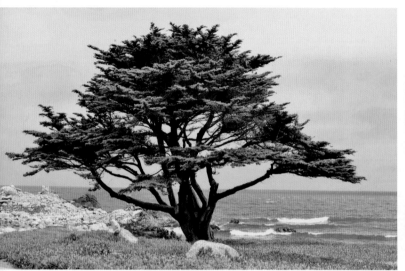

the original 2 million acres (809,371 hectares) of old-growth forest exists today. The parks comprise 131,983 acres (53,412 hectares) and contain 45 percent of the remaining protected old-growth redwoods in California. The tallest tree is 379 feet (116 meters) high.

Underneath the big redwoods there are Douglas fir (*Pseudotsuga menziesii*) and Sitka spruce (*Picea sitchensis*). The understory is also rich with shrubs and herbaceous plants. Redwood sorrel (*Oxalis oregana*) is abundant, as is the western sword fern (*Polystichum munitum*). The fortunate may see the fairy slipper (*Calypso bulbosa*), an endangered orchid growing under the sweet and spicy fragrance of the western azalea (*Rhododendron occidentale*). Or among giant trillium (*Trillium chloropetalum*), with its sweet-smelling three-petaled flowers luminescent in the dappled shade of big-leaf maple (*Acer macrophyllum*), California bay (*Umbellularia californica*), and, along the streams, red alder (*Alnus rubra*).

Lace lichen (*Ramalina menziesii*) hangs from the trees in long, ghostly strands like pieces of Miss Havisham's wedding dress. Lace lichen and red algae (*Trentepohlia* spp.) cover the branches of coast live oak (*Quercus agrifolia*), Monterey pine (*Pinus radiata*), and Monterey cypress (*Hesperocyparis macrocarpa*). Beneath are Douglas iris (*Iris douglasiana*) in a variety of colors from dark purple to white, and Monterey ceanothus (*Ceanothus rigidus*) with a profusion of white flowers. The coastal wood fern (*Dryopteris arguta*) is common under the trees and, in sunlight, the early spring flowers of Fremont's star lily, a poisonous plant with the relevant name of *Toxicoscordion fremontii*, blooming in starry clusters.

The parks are famous not only for their stately conifers. There are approximately 20 species of oaks native to California, some range as far as Oregon in the north and Mexico in the south. Nine are endemic to California. Varieties of coast live oaks (*Quercus agrifolia*), so called because they are

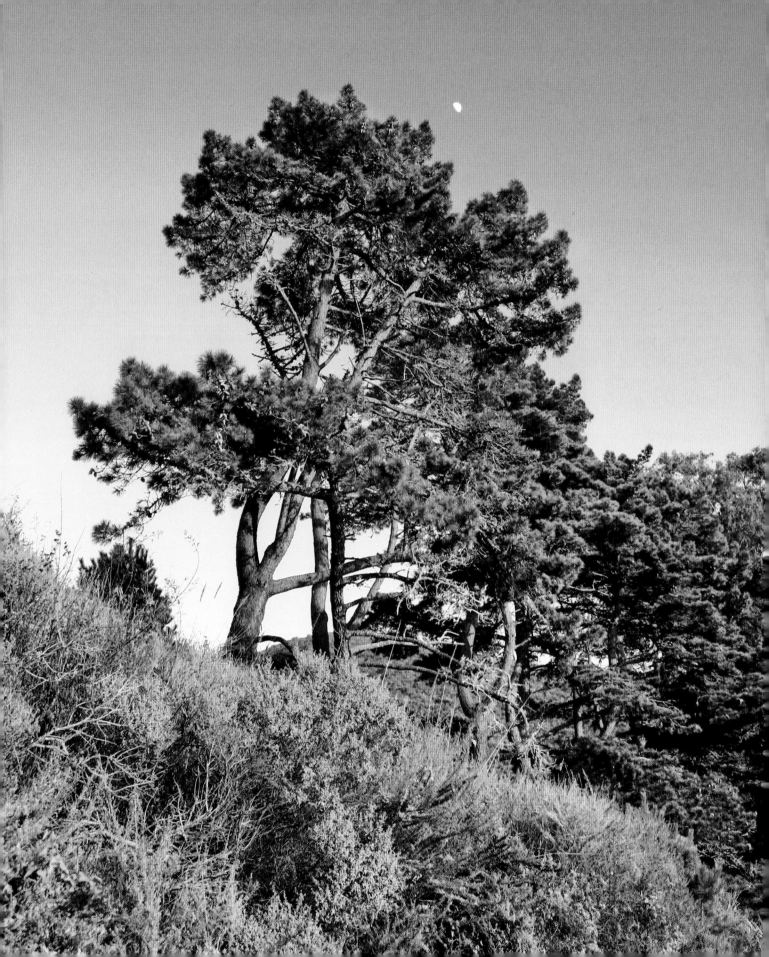

evergreen, punctuate the green then golden grassy hills with heavy solemnity. The deciduous valley oak (*Q. lobata*) spreads its massive frame of gold leaves in spring. Oak savanna, a distinct biome, is found in large areas in the Coast Ranges and in the foothills of the Sierra Nevada, above the low grasslands and beneath the higher elevation pine forests. Intolerant of shade, and resistant to and aided by occasional grass fires that keep competitors at bay, oaks can reach considerable age and size. "They take a hundred years to grow, a hundred years to live, and a hundred years to die" is a saying bandied around by dendrologists. The valley oak is the largest of North America's oaks; one, in the foothills of the Sierras is 153 feet (46 meters) high with a spread of 98 feet (30 meters). A person of religious inclination could worship it.

Informally referred to as soft chaparral, coastal sage scrub is the plant habitat most visible as you travel along the coast. It is generally low growing and a mixture of shrubs and herbaceous plants. It rolls its way like a continuing wave from the coast uphill and, as it does so, picks up larger plants on the way, eventually changing to full-blown chaparral. Dependent on summer fog, it is species rich with a textural quality all its own. Plants tend to be round and wind-sculpted, particularly the buckwheats (*Eriogonum* spp.). *Eriogonum* consists of about 250 shrubs, subshrubs, or herbs in North America. In California they grow from the seashore to the heights of the Sierra Nevada, for the most part in arid environments. They are host plants for butterflies, especially blue and hairstreak, skippers, ringlets, and satyrs. Black sage (*Salvia mellifera*), the most common of the California sages, has white to pale blue flowers in the spring and early summer and highly aromatic foliage. The clusters of flowers ride high on plants that can grow to 6½ feet (2 meters). It is an important nectar producer for butterflies and hummingbirds and its seeds are food for California quail (*Callipepla californica*), a rotund bird with characteristic forward-drooping head

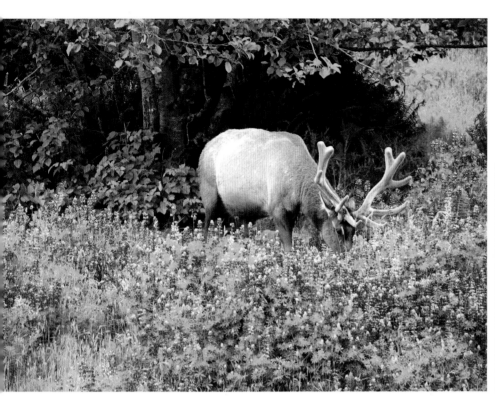

plumage. White sage (*S. apiana*) has dramatically soft white foliage and white flowers in spikes up to 5 feet (1.5 meters) tall. It grows on dry slopes in the scrub and chaparral. It is dried, bundled, and burned in native American Indian purification rituals and in yoga studios throughout California.

You cannot, and should not, miss manzanitas and madrone. Manzanitas (*Arctostaphylos* spp.) are among the world's most beautiful shrubs, with many growing to a great age and displaying lithe, sculpted stems twisted in peeling colors of red, burgundy, black, and gray. How many species grow in California is a matter of debate. If you include cultivars, subspecies, and hybrids it could be hundreds. They are members of the heath family (Ericaceae) with small, downward-hanging bell-shaped flowers. Columbia manzanita (*A. columbiana*) has particularly psychedelic peeling bark and tiny white flowers in early spring. It can be found growing in coastal uplands, maritime chaparral, and conifer forests. Common manzanita (*A. manzanita*) is the most

widespread of the genus, particularly in lower elevations. Often found growing with blue oak (*Quercus douglasii*), chaparral, and coniferous forests, it can create almost impenetrable masses.

While there are so many contenders for most beautiful plant, the madrone (*Arbutus menziesii*) is high on the list. The largest may reach a height of 98 feet (30 meters) but most are much shorter. They have the most appealing bark that is cinnamon colored on young growth and peeling in dark, thin sheets on mature wood, revealing pink underneath. The leaves are glossy and evergreen and the bell-like flowers, typical of the heath family (Ericaceae), produce red berries in the fall. Madrones growing in association with manzanitas and the beauty of the pink and red-lacquer bark, nodding white flowers, and elegant foliage, all set in a land of mountains and rivers, is to be seen to be believed.

And one more genus—*Ceanothus*—the California lilac. It is not a lilac but a member of the

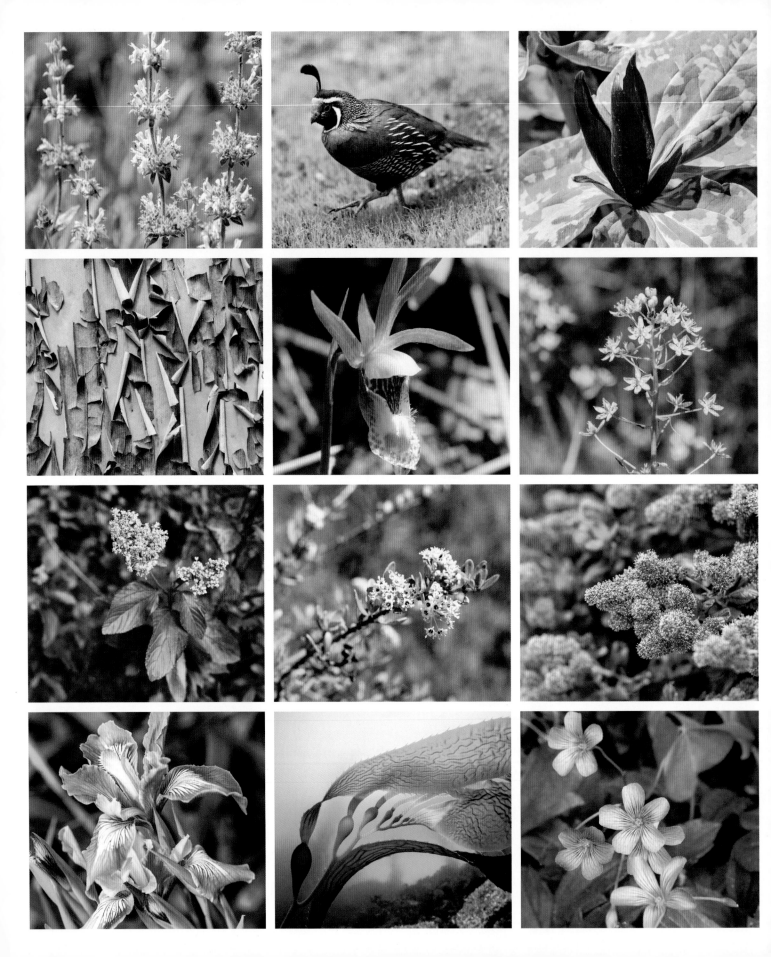

First column: Black sage (*Salvia mellifera*), so called because the leaves turn dark during times of drought. • Peeling madrone. • Feltleaf ceanothus (*Ceanothus arboreus*). • Pacific coast irises come in many colors. Here, a common pale *Iris douglasiana. Second column:* The comma-shaped crest of a male California quail. • Fairy slipper (*Calypso bulbosa*). • White-flowering buckbrush (*Ceanothus cuneatus*). • Giant kelp (*Macrocystis pyrifera*), a large brown algae. *Third column:* Marbled foliage and burgundy flowers of the giant trillium (*Trillium chloropetalum*). • Fremont's star lily (*Toxicoscordion fremontii*). Such a pretty poison. • Blueblossom ceanothus (*Ceanothus thyrsiflorus*). • Redwood sorrel (*Oxalis oregana*).

Below: The many streams, rivers, and seeps provide a diversity of habitats for the plants of the redwoods.

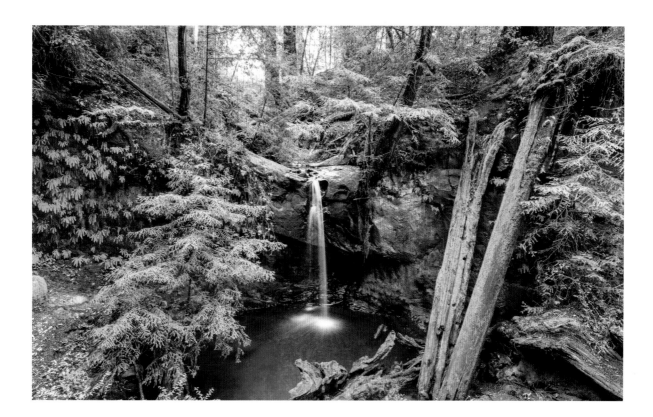

buckthorn family (Rhamnaceae). Ceanothus are often sweetly and intensely fragrant, evergreen and tough. Several hybrids and cultivars are grown in gardens, but it is in the wild, flowering in the mountains and by the ocean where they are their best. There are about 60 species, all but a few growing in California. Buckbrush (*C. cuneatus*) is common in the mountains, flowering in spring with masses of tiny white to pale blue flowers. The feltleaf ceanothus (*C. arboreus*) is an impressive plant growing up to 20 feet (6 meters). It has large, glossy leaves and panicles of blue flowers from February to April. At Point Reyes, a few miles north of San Francisco, grows *C. gloriosus*, a low-growing mound-forming shrub up to 6 feet (1.8 meters) wide with toothed leaf margins and deep blue, almost purple, flowers in early spring. Many species have been crossed to create garden-worthy hybrids, but to see them in the wild along with their companion plants is a different and more fulfilling experience.

The coast redwood is the queen of the forest. Growing in great columns, there is a cathedral, a temple, a mosque quality about the sacred groves. The bell-like tinkle of a stream adds to the sense of worship. We walk, small things that we are, among quiet gods.

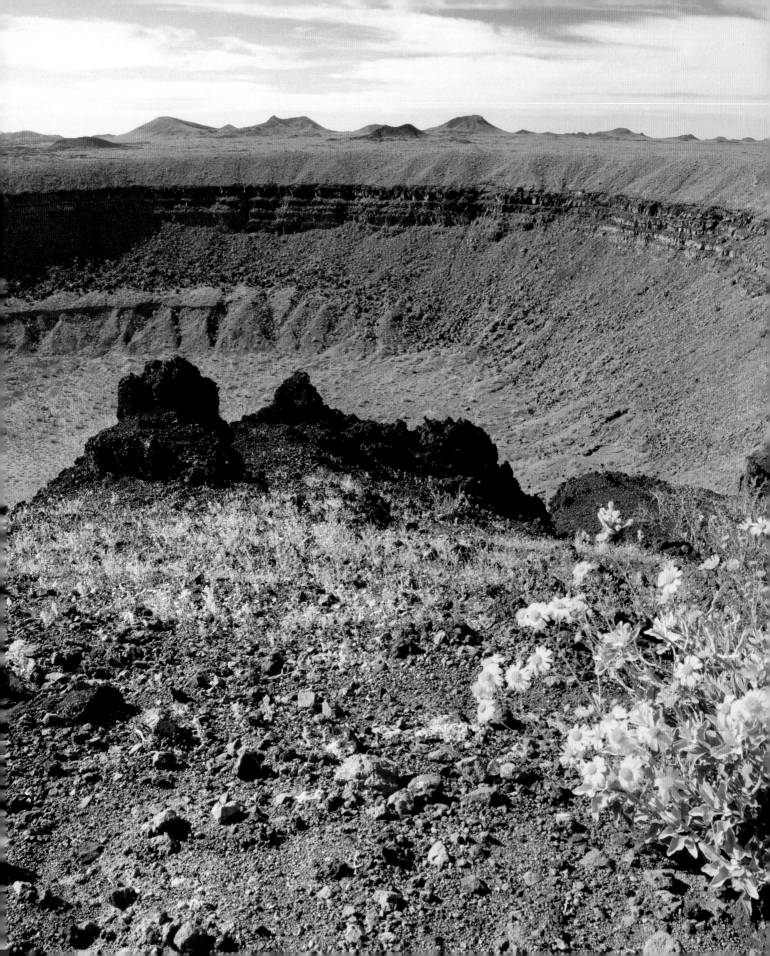

The 1,765,731-acre (714,566-hectare) site comprises two distinct parts: the dormant volcanic Pinacate Shield of black and red lava flows and desert pavements to the east, and, in the west, the Gran Altar Desert with its ever-changing and varied sand dunes that can reach a height of 656 feet (200 meters). This landscape of dramatic contrast notably features linear, star, and dome dunes, as well as several arid granite massifs, some as high as 2132 feet (650 meters). The dunes emerge like islands from the sea of sand and harbor distinct and highly diverse plant and wildlife communities, including endemic freshwater fish species and the endemic Sonoran pronghorn, which is only to be found in northwestern Sonora and in southwestern Arizona. Ten enormous, deep, and almost perfectly circular craters, believed to have been formed by a combination of eruptions and collapses, also contribute to the dramatic beauty of the site whose exceptional combination of features are of great scientific interest. The site is also a UNESCO Biosphere Reserve.

El Pinacate and Gran Desierto de Altar Biosphere Reserve

MEXICO

El Pinacate and Gran Desierto de Altar Biosphere Reserve is part of the Sonoran Desert, one of four great North American deserts, along with the Chihuahuan Desert, the Great Basin Desert, and the Mojave Desert. The reserve is 1,765,731 acres (714,566 hectares) with 876,905 acres (354,871 hectares) of buffer zone. It is a large and relatively undisturbed protected area that comprises two very distinct broad landscape types. To the east, there is a dormant volcanic area of around 494,210 acres (200,000 hectares), comprised of the Pinacate Shield with extensive black and

The desert is rich with plants.

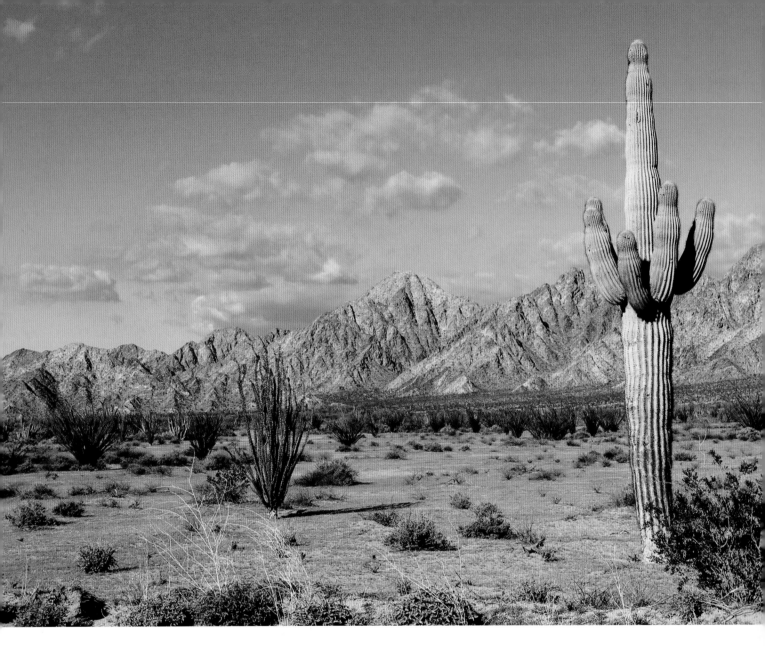

red lava flows and desert pavement. The volcanic shield boasts a wide array of volcanic phenomena and geological formations, including a small shield-type volcano. The most visually striking feature is the concentration of a total of 10 enormous almost perfectly circular craters (maars) created when groundwater came into contact with hot lava. In the west toward the Colorado River delta and south toward the Gulf of California, the Gran Altar Desert is North America's largest field of active sand dunes. The dunes originate from sediments from the

nearby Colorado delta. In addition, there are several arid granite massifs emerging like islands from the sandy desert flats, which represent another remarkable landscape feature harboring distinct plant communities.

The reserve is part of a more than 7,413,161-acre (3-million-hectare) combination of reserves in Baja California, Sonora Province, Arizona, and southern California created to protect the Sonoran Desert ecosystem, 40 percent of which is covered by the site and its buffer zones. It occupies most of the

From left: Sentinel in the desert. • El Trebol crater and the surrounding geologically unique landscape.

65

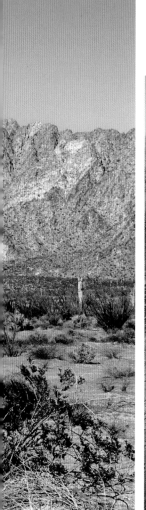

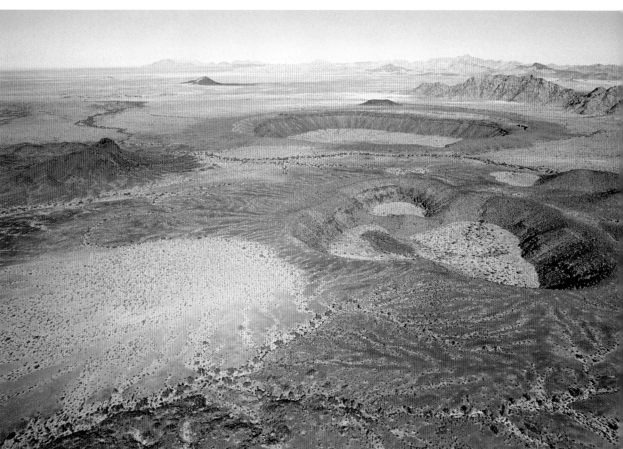

coastal plain between the US border and the Gulf of California. It was inscribed as a World Heritage Site in 2013.

The Pinacate Shield, culminating in the Sierra del Pinacate, first erupted 15 to 12 million years ago and again 10 to 1.5 million years ago. Lava last flowed 13,000 years ago but the present shield volcano is dormant. It rises gently from a pavement of Tertiary and Quaternary sediments and was formed by the gradual extrusion of fluid basalt lavas from fissures in the rock. The rolling sandy plain is punctuated by many small volcanic eruptive forms: over 400 cinder and ash cones, the result of lesser explosions of gas and pyroclastic debris; domed mounds of ejecta; cindery debris; and 10 huge quite circular maar craters formed by the explosion of steam from underground water superheated by rising magma, with ensuing implosion of the core.

The various soils are loess or volcanic in origin but are too dry to be fertile except for a brilliant flush mainly of annuals in spring and in alluvial streambeds. Although hyperarid, the area has some

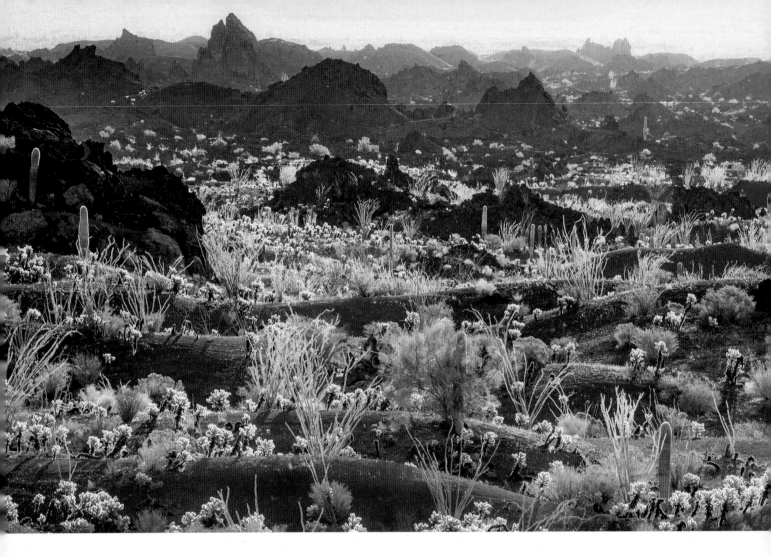

23 semipermanent rain-fed waterholes (tinajas) in the lava and rocks, often lasting year-round due to the biseasonal rainfall. In the northeast, a short length of the Sonoyta River, the Agua Dulce, is also permanent. Both sources are invaluable to wildlife and were also essential to man in the past. In the south, there are artesian wells drawing on underground runoff from the lava sheet.

The subtropical climate is extremely hot. In June and July maximum temperatures average 120°F (49°C). Solar radiation is intense, evaporation high, and relative humidity low. The average annual precipitation is less than 8 inches (20 centimeters), most falling in winter, making this desert the driest part of the Sonoran Desert and one of the driest places in the world.

The wide range of physical conditions in the two deserts harbors an unexpected diversity of life: 560 species of vascular plants in 315 genera and 85 families, with several Sonoran endemics. The dominant vegetation is xerophytic scrub with small areas of chaparral and mesquite. The families with the most species are the composites, grasses, legumes, euphorbias, chenopods, and cacti.

The Pinacate Shield has a flora of 314 species including one endemic—*Senecio pinacatensis*, a short-lived perennial up to 5 feet (1.5 meters) tall with bright yellow flowers. Buckhorn cholla (*Cylindropuntia acanthocarpa*) grows in large groups that are almost forests. It has gray-green stems, each with a cluster of stiff spines. It blooms in April and May with flowers ranging from yellow

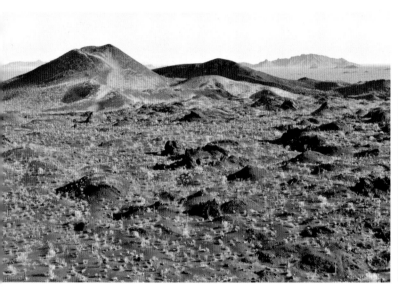

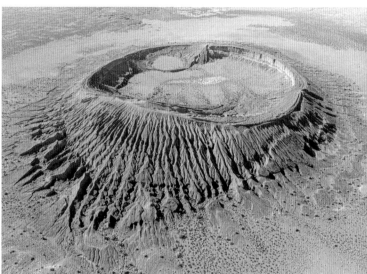

to red. The fruits are round and covered with long barbed spines. It can reach 13 feet (4 meters) in height but generally grows to about 6½ feet (2 meters). The jumping cholla (*C. fulgida*) does not jump but the spiny stems detach easily, to be carried, sometimes painfully, by humans and other animals. Treelike in appearance with multibranched light green stems and silvery yellow spines. It, too, grows in large numbers and, when the light is right, the cholla desert glows silver and gold.

There are forests of saguaro (*Carnegiea gigantea*), the great and wonderful treelike cactus that grows to be over 39 feet (12 meters). Long-lived, some over 150 years old, they often begin life under nurse trees such as desert ironwood (*Olneya tesota*) and blue palo verde (*Parkinsonia florida*). Saguaros grow slowly, producing a single, ribbed column covered in sharp spines up to 2¾ inches (7 centimeters) long. Branches (arms) grow as the cactus matures, often after decades. The flowers are white and waxy, opening in the evening and closing in the afternoon, with bats, bees, and doves pollinating the flowers in the cool of the night and early morning. The juicy fruits are ruby red and edible. *Pachycereus pringlei*, the Mexican giant cactus, may be the largest cactus in the world. It can grow to a height of almost 66 feet (20 meters) and spread 16 feet (5 meters), with a trunk diameter of 6½ feet (2 meters). This is another columnar treelike cactus but with branches near the base, eventually forming as many as 30 fluted blue-green, becoming yellow-green branches. The flowers are bell-shaped and open both night and day. The fruits are round and covered with brown felt bristles.

When ocotillo (*Fouquieria splendens*) blooms, it is always a surprise. On what at first appear to be a group of dead sticks, bright crimson flowers appear. On closer examination the sticks are green and soon, after a little rain, small round leaves appear. The leaf stalks harden into spines, and new leaves grow from the base of the spine. The polelike branches can reach up to 33 feet (10 meters) high.

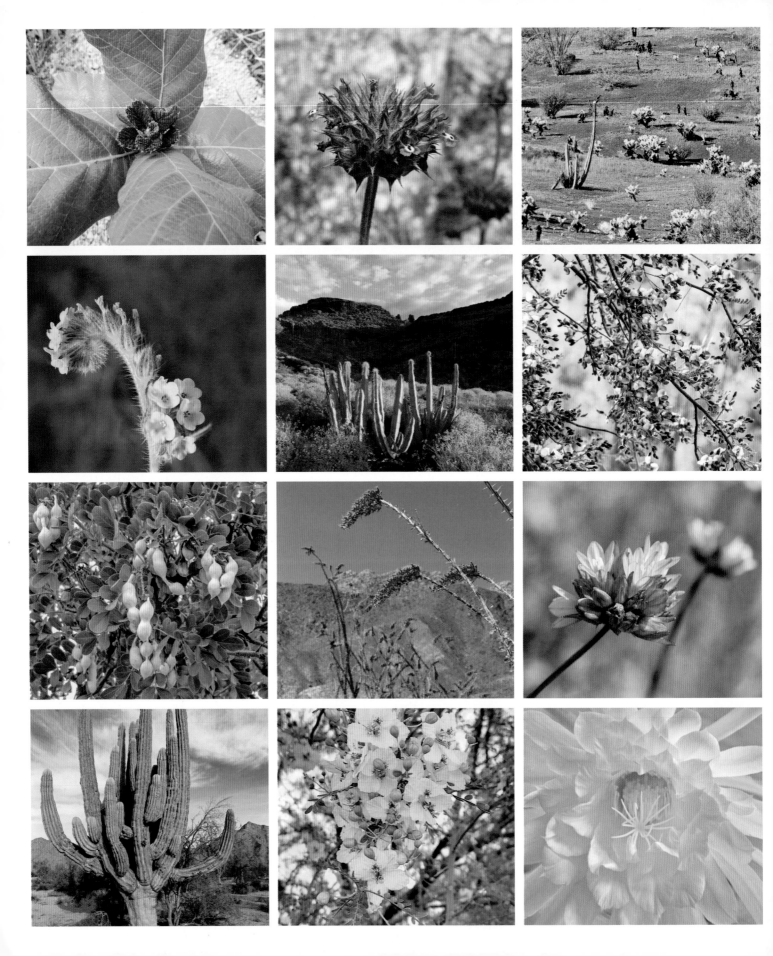

First column: Quercus tarahumara, a desert oak named after the Tarahumara people. • Fiddleneck-shaped blossom on *Amsinckia menziesii.* • Seedpods of desert ironwood. • With a lifespan measured in hundreds of years, *Pachycereus pringlei* is one of the most regal plants in the world. *Second column:* Salvia columbariae. • Brittlebrush and cactus. • The bright crimson flowers of ocotillo (*Fouquieria splendens*) appear after the spring rains. • Blue palo verde (*Parkinsonia florida*) covered in bright yellow flowers. *Third column:* Teddy bear cholla and an abundance of wildflowers. • Desert ironwood (*Olneya tesota*). • Bluedicks (*Dichelostemma capitatum*). • Nightblooming cereus (*Peniocereus greggii*).

Below, from left: Variable in flower color, the buckhorn cholla blooms in spring and early summer. • Many birds nest in the numerous desert cacti. • Desert barrel cactus (*Ferocactus cylindraceus*).

Parts of the desert have hundreds of ocotillo growing out of the dry, rocky soil, creating a crimson haze against the red rocks and blue sky.

Desert ironwood (*Olneya tesota*) is a keystone tree species; its seeds and leaves are important food sources for countless insects, rodents, and birds, and it forms a nurse tree for small cactus species. The purple flowers, blooming in late spring to summer, are a soft relief under the desert sun. Desert ironwood can be evergreen or, in a very dry season, semideciduous. It grows to a height of 33 feet (10 meters) and has pinnately compound soft blue-green leaves.

A ribbon of tropical dry forest runs from southern Sonora south to Panama. One of its primary constituents is Tarahumara oak (*Quercus tarahumara*), a large tree growing up to 33 feet (10 meters), with stiff leaves that are green on top and tan underneath.

Four plants in the reserve have special federal protection: acuña cactus (*Echinomastus erectocentrus* var. *acunensis*), growing to around 16 inches (40 centimeters) tall, with maroon spines and lavender, rose, or pink flowers; desert barrel cactus (*Ferocactus cylindraceus*), which has a dense lattice of yellow or red spines, yellow flowers, and yellow fruit; desert ironwood (*Olneya tesota*); and nightblooming cereus (*Peniocereus greggii*), whose white flowers bloom once a year and for one night.

Every few years there is enough winter rain to precipitate a superbloom of annual spring flowers. Seed that has lain dormant for several years germinates quickly and plants burst from the ground in a frenzy of flowers before summer sun dries everything out. Yellow, purple, silver, and blue cover the desert ground: fiddleneck (*Amsinckia menziesii*) with yellow-orange flowers in an inflorescence shaped like a violin, bluedicks (*Dichelostemma capitatum*) with purple-pink flowers, brittlebrush (*Encelia farinosa*) with yellow flowers held above silvery foliage, and *Salvia columbariae*, a desert sage with blue flowers. Millions of flowers for a brief moment.

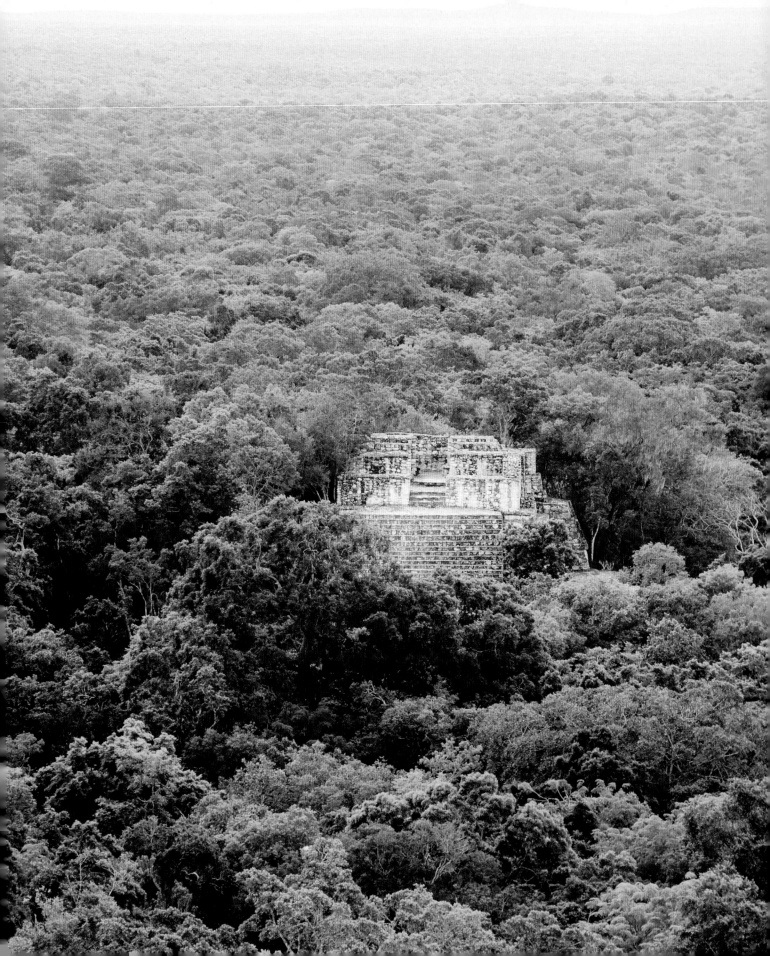

The site is located in the central southern portion of the Yucatán Peninsula, in southern Mexico, and includes the remains of the important Maya city Calakmul, set deep in the tropical forest of the Tierras Bajas. The city played a key role in the history of this region for more than 12 centuries and is characterized by well-preserved structures providing a vivid picture of life in an ancient Maya capital. The property also falls within the Mesoamerica biodiversity hotspot, the third largest in the world, encompassing all subtropical and tropical ecosystems from central Mexico to the Panama Canal.

Ancient Maya City and Protected Tropical Forests of Calakmul, Campeche

MEXICO

While nowadays completely uninhabited and covered by tropical forest, from the mid-1st millennium BCE to about 1000 CE, Calakmul was the heartland of one of the most splendid civilizations in human history. After reaching its climax, it suffered a dramatic downfall, resulting in an almost complete abandonment of formerly flourishing settlements.

Being located at the core of the second largest expanse of tropical forests in America, only surpassed by the Amazon jungle in South America, the area represents a

Deep in the Tierras Bajas forest, Calakmul temple stands out from the surrounding jungle.

71

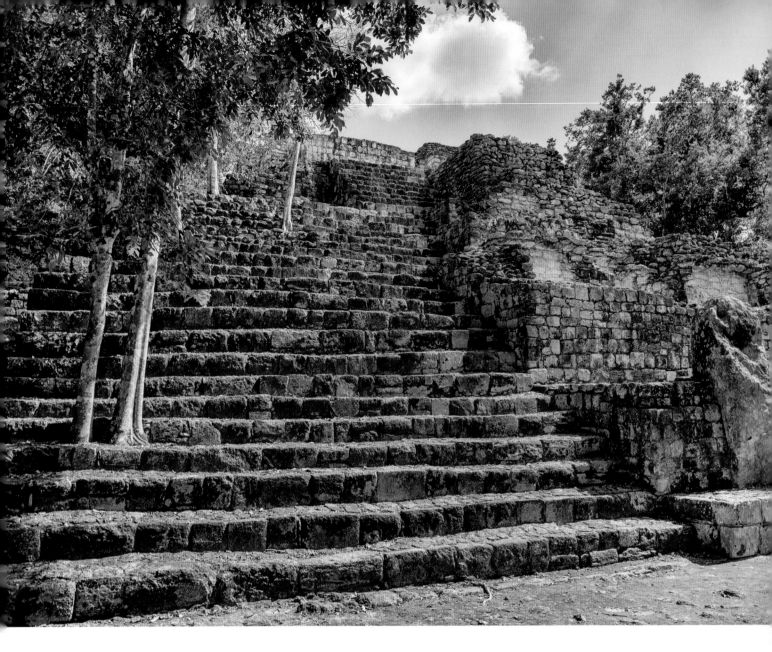

singular case of adaptation to, and management of, a natural environment that, at a first glance, seems little appropriate for the development of urban civilization. The colonization of the territory, the population growth and the evolution of complex, state-organized societies are attested in a wide variety of material vestiges. Apart from Calakmul, the largest archaeological site, where the Kaan, one of the most powerful Maya dynasties, had its seat during the Late Classic (600 to 900 CE), remains of dozens of other ancient settlements have been found in the area, including several major urban centers with huge architectural complexes and sculpted monuments. Along with settlement remains, the intersite and intrasite roads, defensive systems, quarries, water-management features (such as reservoirs and artificially modified water ponds), agricultural terraces and other land modifications related with subsistence strategies are also constituent parts of the extremely rich and exceptionally well-preserved ancient cultural landscape.

From the mid-1st millennium BCE to about 1000 CE, Calakmul was one of the most splendid civilizations in human history.

73

During excavations carried out at Calakmul and Uxul spectacular stucco friezes and mural paintings have been found in some of the massive temple pyramids and palaces, as well as burials of kings and other members of nobility containing a rich variety of body ornaments and other accompanying objects, such as elaborate jade masks, ear spools, and exquisite polychrome pottery vessels. The hieroglyphic inscriptions on stelae, altars, and building elements reveal important facts about the territorial organization and political history, and some epigraphic records are entirely unique, providing information that has not been found anywhere else in the Maya Area.

The mature forests of Calakmul, with their current structure and floristic composition, are extraordinary evidence of the long interaction between man and nature. These humid and sub-humid tropical forests developed in a geological province under seasonal dry conditions. Given the environmental conditions, such as reduced availability of water and moisture, presence of fire and hurricanes, and karst soils, the flora and fauna of wetland ecosystems have developed adaptations to the seasonal dry conditions. For such factors, the tropical forests of Calakmul could be considered one of the most resilient ecosystems in the continent.

The location also increases its importance as the center of the connectivity of the Selva Maya, with corridors that provide ecological continuity to forests in the region (Mexico, Guatemala, and Belize) and allow the conservation of biodiversity and development of dynamic ecological and evolutionary processes of species.

The property, designated a World Heritage Site in 2002, is the most extensive and well-preserved rainforest in Mexico, maintaining widespread good-quality forest cover. The vegetation is composed of a mosaic of different plant communities. In the wettest areas, usually in the southern part of Calakmul, the vegetation consists of rainforests where trees grow over 82 feet (25 meters) in height. Comparatively, the drier areas support shorter vegetation communities where trees tend to grow to 16 to 50 feet (5 to 15.3 meters). These drier areas do not receive sufficient precipitation to support rainforest and, therefore, in severe dry seasons plants may lose foliage. Of the nine distinct plant community types recorded on the property, the most ubiquitous is medium semi-evergreen tropical forest.

The tall semi-evergreen tropical forests are predominantly located toward the south near Guatemala. The forest is characterized by a dominant and tall canopy, which is represented with species such as *Aspidosperma spruceanum*, an evergreen tree with a dense, roundish crown and *Pouteria amygdalina*, a tree with turquoise green

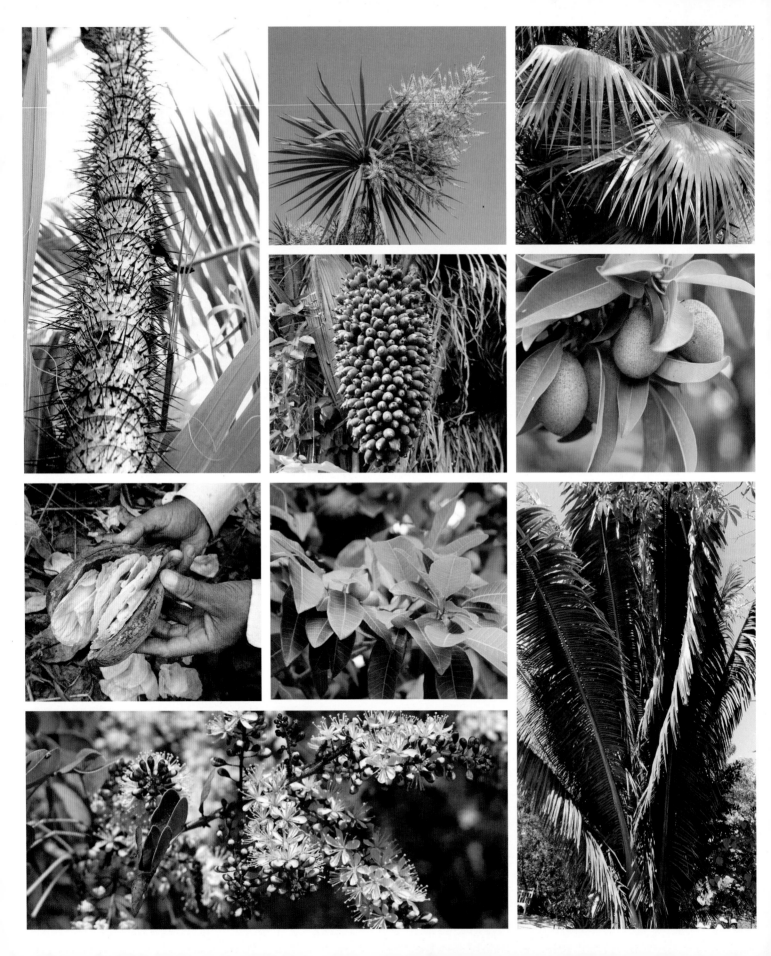

First column: The vicious spines of *Acrocomia aculeata*. • The orbicular seeds of *Aspidosperma spruceanum,* from which Indigenous antiparasitic medicines are derived. • The beautiful flowers of Campeche logwood. Second column: Flowers of the Mexican ponytail palm (*Beaucarnea pliabilis*). • Manaca palm. • Breadnut (*Brosimum alicastrum*). Third column: *Aceolorraphe wrightii* produces big fans in clusters. • The sweet fruits of sapodilla (*Manilkara zapota*). Chicle from the bark is used to make chewing gum. • *Attalea cohune* features fronds that can grow up to 33 feet (10 meters) long.

75

edible fruits. This forest habitat is also rich in epiphytes of the Bromeliaceae such as *Aechmea* and *Tillandsia* species, and Orchidaceae such as *Epidendrum, Habenaria,* and *Campylocentrum* species. The medium semi-evergreen tropical forest differs from the tall semi-evergreen forest by a change in arboreal composition to species such as sapodilla (*Manilkara zapota*), which has a berry with sweet orange-yellow flesh, and breadnut (*Brosimum alicastrum*), which produces nuts that can be boiled or dried and ground into a meal for porridge or flatbread. This ecosystem type is found in the wetter components of the forest.

Low semi-evergreen tropical forest, as the name would suggest, has an even lower canopy that is usually only up to 49 feet (15 meters) tall and is dominated by *Terminalia buceras,* commonly called black olive although it is not an olive but is in the white mangrove family (Combretaceae), and blood-wood (*Haematoxylum campechianum*), a tree used as a natural source of dye for paper and textiles.

The low semi-evergreen flooded tropical forests tend to be flooded between 2 and 6 months a year and are locally known as *bajos.* The arboreal species remain under 33 feet (10 meters) due to poor drainage and are usually found in low-lying areas at the edge of gullies and waterholes where they associate with water pollinated plants. The medium semideciduous tropical forest has five distinct subtypes of various botanical assemblages whereas the low semideciduous tropical forest has only two. One subtype of note is the Mexican ponytail palm (*Beaucarnea pliabilis*), a low semideciduous tropical forest that remains leafless during the dry season between February and March. *Beaucarnea pliabilis* is not a palm, it is a member of the asparagus family (Asparagaceae). It can reach a height of 33 feet (10 meters), and has a swollen base—a thickened caudex—blue-green linear leaves, and panicles of cream flowers. The palm groves and savanna plant communities represent additional types of vegetation within the region. There are three main types of palms in the groves: the coyol *Acrocomia aculeata,* growing to 66 feet (20 meters) tall, with numerous slender, black, viciously sharp spines that jut out 4 inches (10 centimeters) from the trunk; the corozal *Attalea cohune,* a majestic tree with a massive crown of dark green feather-shaped fronds that grow up to 33 feet (10 meters) long; and the tasistal *Acoelorrhaphe wrightii,* a clustering palm with trunks covered in brown fiber, fan-shaped leaves that are light green on top and silvery underneath, and petioles that are finely thorny, something you find out if you run your hand along the leaf stem.

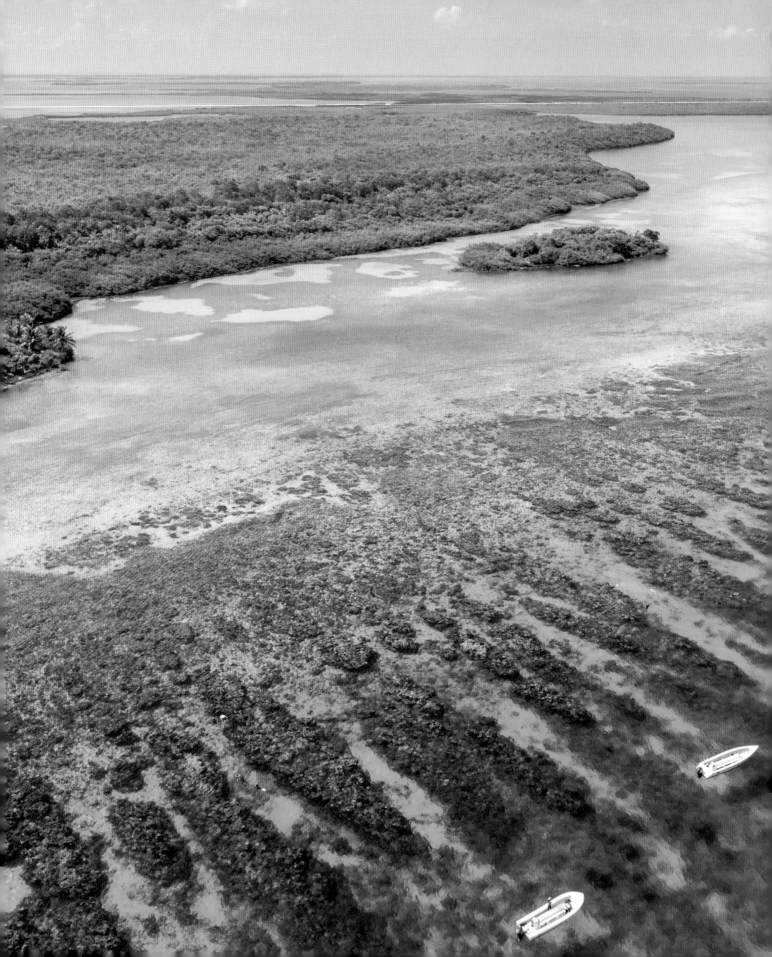

The coastal area of Belize is an outstanding natural system consisting of the largest barrier reef in the Northern Hemisphere, offshore atolls, several hundred sand cays, mangrove forests, coastal lagoons, and estuaries. The system's seven sites illustrate the evolutionary history of reef development and are a significant habitat for threatened species, including marine turtles, manatees, and the American marine crocodile.

Belize Barrier Reef Reserve System

BELIZE

Inscribed as a World Heritage Site in 1996, the Belize Barrier Reef lies off the Caribbean coast of Belize, extending 146 miles (235 kilometers) between the Mexican and Guatemalan borders and between 1640 feet to 50 miles (500 meters to 80 kilometers) from the mainland. The reserve combines seven of the biologically most valuable sites of the Belize shelf: Bacalar Chico National Park and Marine Reserve, Laughing Bird Caye National Park, Half Moon Caye Natural Monument, Blue Hole Natural

Protected by the Barrier Reef, the gentle waters wash against the mangroved shore.

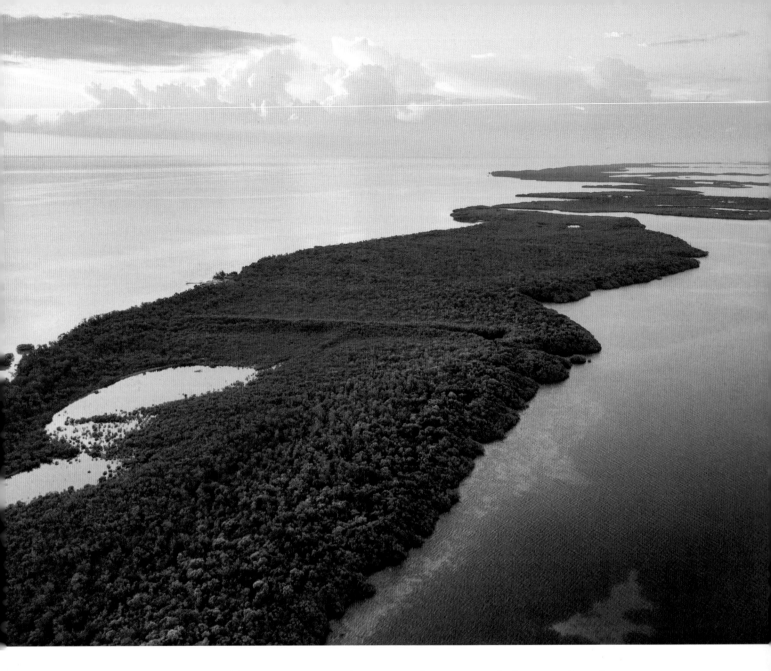

Monument, Glovers Reef Marine Reserve, South Water Caye Marine Reserve, and Sapodilla Cayes Marine Reserve.

The Belize shelf is a submarine extension of the Yucatán Platform, a low-relief karst surface with drowned river channels and sinkholes such as the Blue Hole. The limestone ranges in age from 135 million to less than 2 million years old and has been laid down in shelflike layers, a process which is still taking place. The northern part of the reef and Ambergris Caye, the largest and northernmost cay, lie on one block; the Turneffe Islands and the central reef lie on a second; and the outer shelf atolls of Lighthouse Reef and Glover's Reef, on a third. There are approximately 450 sand and mangrove cays within the barrier that range in size from small ephemeral sand spits to large, settled islands.

Many of the South Water cays are mangrove dominated, although some have sand with shrub and coconut vegetation. Half Moon Caye

From left: Mangroves dominate undisturbed atolls. • A marine sinkhole off the coast of Belize.

79

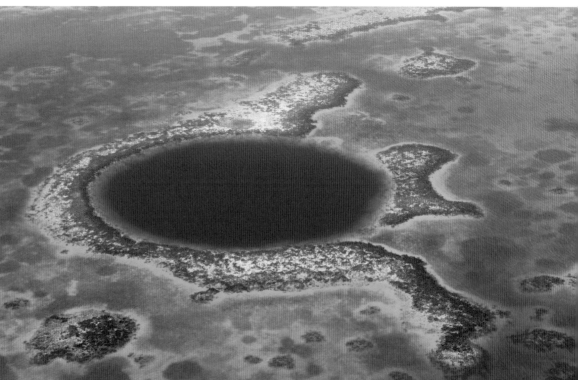

has a well-developed forest with 40 species of trees. There are three major types of mangrove forest: a *Conocarpus erectus-Rhizophora mangle-Laguncularia racemosa* association on land periodically inundated with sea water; permanently inundated *R. mangle*; and a *R. mangle-L. racemosa* association with occasional *Avicennia germinans* where salt water intrudes infrequently. Mangroves may form a narrow coastal fringe, a concentric ring around small mainland lagoons, or colonize the lagoon side of offshore cays as in South Water Caye, which has several mangrove cays.

Several cays have stands of seashore forest with Geiger tree (*Cordia sebestena*), a rounded, evergreen tree growing to a height of 25 feet (7.6 meters) with an equal spread. The large—7 inches (17.7 centimeters) long—stiff, dark green leaves are rough and hairy. In spring and summer, dark orange, 2-inch (5- centimeter) flowers appear in clusters at branch tips. Southern wax myrtle (*Myrica cerifera*) is a

From left: Ambergris Caye is Belize's largest island; much of the flora is made up of mangrove species. • Belize has some of the best snorkeling and scuba diving in the world.

tough evergreen tree, growing in brackish water and along freshwater streams. It can reach 20 feet (6 meters) tall, but often is shorter. The light olive green leaves, with yellow resin dots on both surfaces, have a spicy aromatic odor when crushed. In spring, small male and female flowers mature, the female flowers producing bluish white waxy fruit in clusters on short stalks. The waxy fruit is used in the making of bayberry candles. Gumbo-limbo (*Bursera simaruba*) can reach 59 feet (18 meters) in height but is usually 20 to 39 feet (6 to 12 meters) tall. It is semi-evergreen with inconspicuous green flowers. What is conspicuous is the dark red peeling bark. Coco plum (*Chrysobalanus icaco*) may grow along the sandy ground, or up into a small tree up to 20 feet (6 meters). It has oval leathery leaves and greenish white flowers followed by small round fruits that are edible, to some degree.

The cays are fringed by sea grape (*Coccoloba uvifera*), an evergreen shrub, sometimes a tree, with

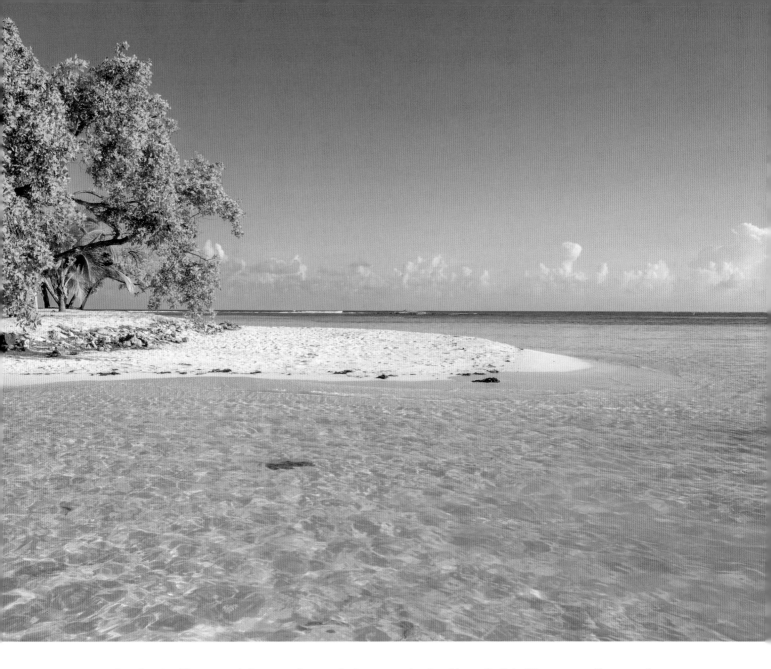

round, red-veined leaves and clusters of green fruit that turn purple. It is not a true grape but a member of the buckwheat family (Polygonaceae). Bay cedar (*Suriana maritima*) isn't a cedar but rather an evergreen shrub with gray-green succulent leaves that smell like cedar when crushed. It has solitary yellow flowers throughout the year.

Seagrasses host many organisms: seaweeds, crustaceans, mollusks, shoals of grass- and algae-eating fish, turtles, manatees, and huge schools of juvenile fish. They trap sediment and nutrients and stabilize the sea floor. There are meadows of turtle seagrass (*Thalassia testudinum*), long leaves waving underwater, and shoalgrass (*Halodule wrightii*), flat leaves appearing at low tide.

Sit quietly in the warm water, mangroves at your back, and feel the underwater meadow grasses tickle your feet. Slip deeper into the blue sea, the reef sharks won't come around until the sun goes down. If you are fortunate, a rare spotted eagle ray

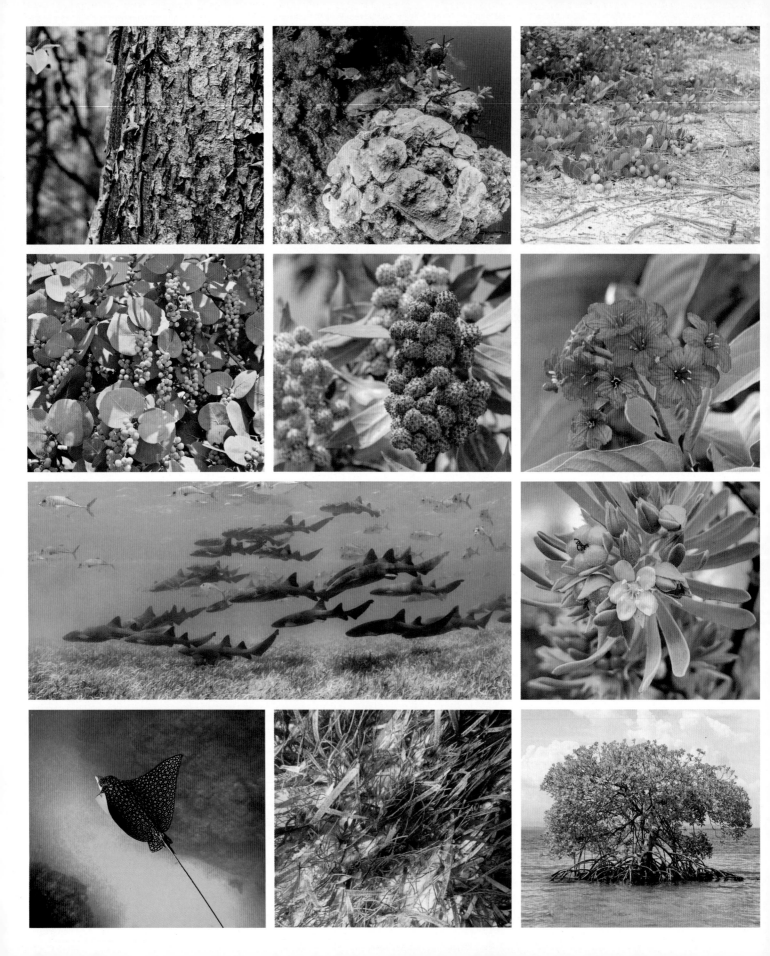

First column: Gumbo-limbo (*Bursera simaruba*), called the tourist tree because of its red peeling bark. • Sea grape (*Coccoloba uvifera*). • Nurse sharks and horse-eye jacks. • If you are fortunate, you may see an eagle ray breach the water and fly for a moment. *Second column:* A series of coral reefs make up the Belize Barrier Reef. In 1842 Charles Darwin described it as "the most remarkable reef in the West Indies." • *Conocarpus erectus* is a mangrove shrub in the family Combretaceae. • Turtle seagrass and manatee grass. *Third column:* Coco plum (*Chrysobalanus icaco*). • Geiger tree (after Key West wrecker John Geiger). • Bay cedar (*Suriana maritima*). • Red mangrove (*Rhizophora mangle*).

Below: Blue sky, palm trees to the beach, and clear blue water—paradise incarnate.

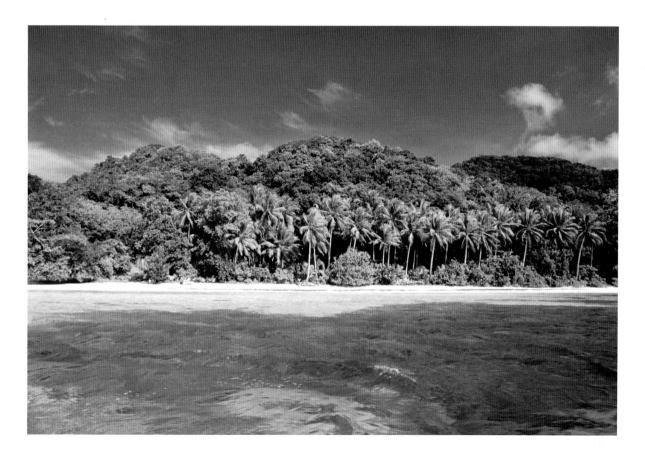

will breach, flying into the air, its deep blue back spotted with white, its white underbelly flashing as it turns, plunging back into the sea.

Despite its enormous economic value to the overall economy of Belize, the Barrier Reef ecosystem is threatened by overexploitation of reef resources by the fishing and tourist industries. Pressures are also mounting from a whole range of other impacts. There is increasing shoreline erosion through the removal of vegetation, nutrient enrichment by fertilizer runoff from citrus and banana plantations, sewage pollution from tourist resorts and housing, and coral-choking sediments from dredging, sand mining, and the escalating residential, hotel, and marina construction on many cays. Much of the native cay vegetation, including mangroves, has been disturbed or eliminated for coconut plantations and urban developments. Bleaching, climatic warming, and hurricanes are also degrading the high quality of the coral reef.

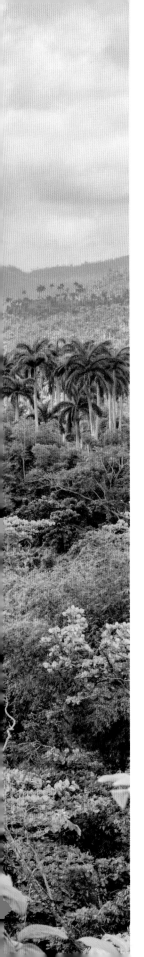

Complex geology and varied topography have given rise to a diversity of ecosystems and species unmatched in the insular Caribbean and created one of the most biologically diverse tropical island sites on earth. Many of the underlying rocks are toxic to plants so species have had to adapt to survive in these hostile conditions. This unique process of evolution has resulted in the development of many new species and the park is one of the most important sites in the Western Hemisphere for the conservation of endemic flora. Endemism of vertebrates and invertebrates is also very high.

Alejandro de Humboldt National Park

CUBA

Part of the Cuchillas del Toa Biosphere Reserve, Alejandro de Humboldt National Park is in the Cuban provinces of Holguín and Guantánamo. It is named after the German scientist Alexander von Humboldt (1769–1859), who first visited the island from 19 December 1800 to 15 March 1801, and then again from 7 January until 29 April 1804. Von Humboldt was a geographer, naturalist, and explorer who, between 1799 and 1804, travelled extensively in Latin America, describing it for the first time from a Western scientific point of view. His description of the journey

The wet tropics are centers of biodiversity.

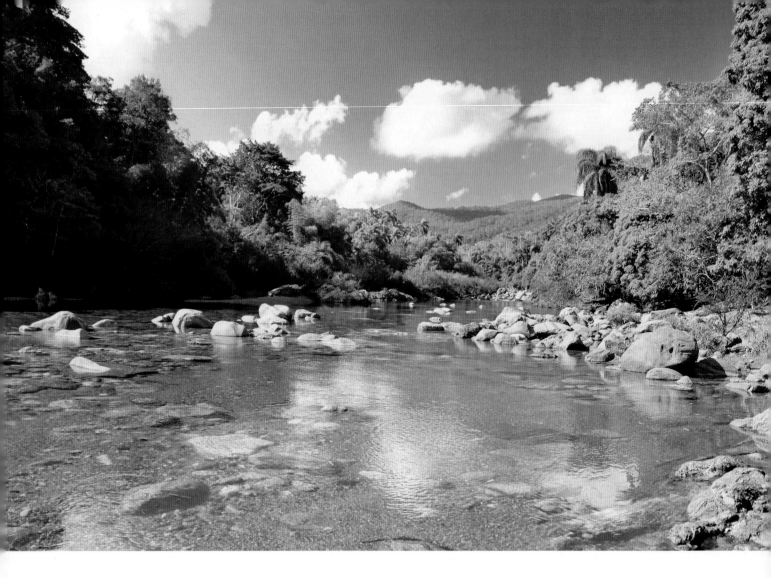

was written up and included and published in an enormous set of volumes over 21 years. He was the first person to describe the phenomenon and cause of human-induced climate change and was a vocal and active critic of slavery, although many of his hosts in Cuba were active slave owners and traders. With the considerable help of Hispanic-Cubans who were knowledgeable about the flora, Scottish botanist John Fraser, and Aimé Bonpland, a French explorer and botanist, he documented much of Cuba's flora and fauna and eventually published his findings in 1826 as "Essai politique sur l'île de Cuba."

The park, located in the Sagu-Baracoa mountain range, covers one of the most extensive and well-preserved mountain ecosystems in the West Indies, in a landscape that also includes tablelands, coastal plains, bays, and coral reefs. Its varied and rugged topography is underlain by a complex geology that has created the most biologically diverse area of any island in the Caribbean, and one of the most diverse on earth. It was formed by the tectonic creation of a sea shelf on an ancient Oligocene-Pleistocene island arc combined with a transformed oceanic crust (ophiolite) thrust up from the Earth's mantle at the subduction zone. The site is partly composed of magnesium-rich basic and ultrabasic serpentine rocks that have remained exposed for 40 million years. It is the oldest massif in the Caribbean.

Below, from left: The park is a lush and mountainous marvel. • Here, plants grow on plants that grow on plants.

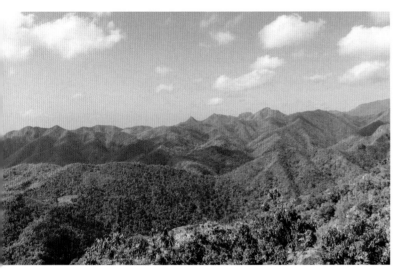

The coastal plains are the highest most elongated system of planation surfaces in the caribbean, with large weathering crusts formed during tectonic uplift and changes in sea level related to past climatic fluctuations. Embedded in them is the uncommon pseudokarst limestone island block containing the great cave of Farallones de Moa. The serpentine, peridotite, and pseudokarst geology contribute to the site's great variety of soils and habitats, and by their singular local and undisturbed character, to its endemism. The soils are largely lateritic and acidic except in the karstic area, which has many flooded dolines, swallow-holes, closed basins, and caves. Several clear-water rivers flow from the park, through pools and over cascades, including the Toa, Jaguani, Duaba, Jiguani, Nibujon, and Moa.

The park has a hot subtropical climate year-round. Most rain falls between May and October and it is subject to hurricanes between August and October. Humidity is high, varying between 75 and 95 percent. The cooler months are January to April when the least rain falls. The maximum temperature is 90°F (32°C), the minimum is 59°F (15°C).

The Cuban archipelago has a unique flora, with an estimated of 7000 to 7500 species, which makes it the fourth richest island territory worldwide plantwise, and it has the most number of plant species per square mile of any island.

ALEJANDRO DE HUMBOLDT NATIONAL PARK

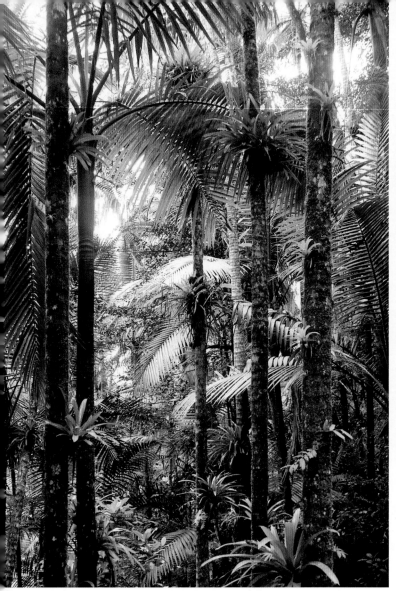

Moreover, the Cuban flora has about 53 percent of plants unique to the country. The park, declared a World Heritage Site in 2001, is a local center of plant diversity and endemism, and for species that have had to adapt to soils derived from serpentinite and peridotite, which are usually toxic or limiting to plants. The result has been exceptional speciation. Plant endemism in the region is over 70 percent, the highest in Cuba and one of the highest in the world. There are 1302 spermatophytes (seed plants)—comprising 69 percent of Cuba's endemic species—and 145 pteridophytes (ferns and relatives). In total, 905 of the area's species are endemic (29 percent of all the country's endemics), of which 343 grow exclusively in the park.

It is one of the most extensive and well-preserved mountain ecosystems in the West Indies. Its transect from cloud forest to coast has sufficient area, elevational, and climatic range to support the existing diversity in a warmer future. The park lies within a Conservation International–designated Conservation Hotspot and in WWF Global 200 Marine and Freshwater Ecoregions. It is also a UNESCO MAB Biosphere Reserve and a BirdLife-designated Endemic Bird Area. However, Cuba is the Caribbean

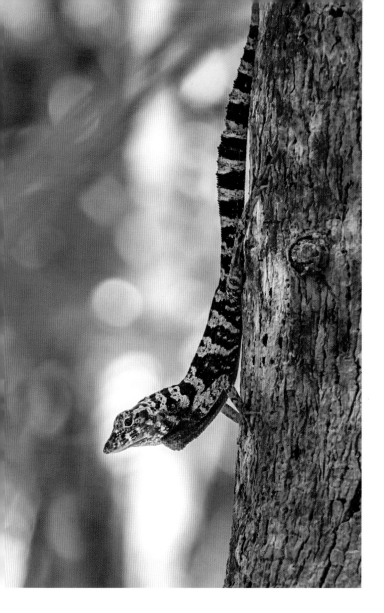

From left: Mountain palm (*Prestoea acuminata* var. *montana*). • *Carapa guianensis* is related to mahogany. • The banded tree anole.

89

Island with the highest percentage of threatened species relative to its total assessed flora and presents as many endangered species as Madagascar.

Containing one of the most complete neotropical wet island forests, the park's terrestrial vegetation contains 16 of the 28 plant formations of the island, including lowland rainforest, submontane rainforest, montane rainforest, and cloud forest, with associated Cuban pine (*Pinus cubensis*) forest—a two-needled (sometimes three-needled) pine that grows to mature heights of 98 to 131 feet (30 to 40 meters), with a conical crown when young, becoming bowl-shaped and open with age. The bark is

grayish brown, and the branches are slender and sparsely clothed with foliage. Growing along with the pine is *Podocarpus angustifolius*, a multitrunked evergreen, up to 33 feet (10 meters) tall, with whorls of twigs and shiny dark green narrow leaves. Aguacatillo (*Alchornea latifolia*) is sometimes grown to provide shade in coffee plantations; in the park it grows naturally in areas of high rainfall. It is an evergreen tree growing up to about 66 feet (20 meters), often with a buttressed trunk and egg-shaped blunt-toothed leaves and nondescript flowers producing red capsules of seed. *Carapa guianensis* is a fast-growing mostly semideciduous tree growing to 115 feet (35 meters) with fragrant pale green and white flowers. The seed capsules are pale brown and bitter to the taste. Epiphytic vegetation is abundant and varied. West Indian tongue fern (*Elaphoglossum crinitum*) does look like a tongue, albeit a hairy green one. At maturity, the fronds grow up to 12 inches (30 centimeters) and appear in large bunches nestled in the trees. *Oleandra articulata* is a fern with spear-shaped evergreen glossy leaves that hang down from the tree-climbing stems.

This writer cannot leave Cuba without mentioning palms and heliconias, two magnolias, and a little something about an orchid. Mountain palm (*Prestoea acuminata* var. *montana*) is a thin and tall palm, reaching heights of 45 feet (13.7 meters). It grows with a single stem or tufts of stems and

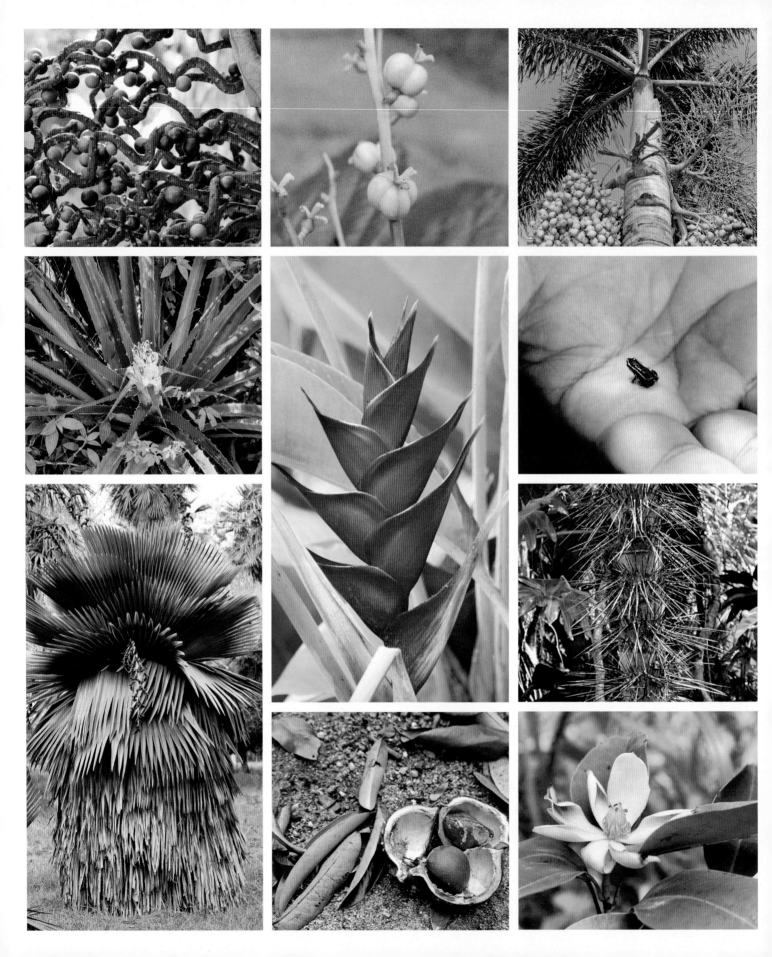

First column: Mountain palm produces black seed held in a purple-red reticule. • Similar to the pineapple, the center of *Bromelia balansae* becomes bright red when about to bloom. • Petticoat palm (*Copernicia macroglossa*). *Second column:* *Aparisthmium cordatum.* • Heliconias—such geometric beauty. • The oil and fats of the nuts of *Carapa guianensis* are extracted and used to produce insect repellent. *Third column:* The Cuban royal palm (*Roystonea regia*). • *Eleutherodactylus* is a genus of frogs in the family Eleutherodactylidae. Many of the 200 species of the genus are commonly known as "rain frogs" or "robber frogs" due to their sharp, high-pitched, insectlike calls. • Impossible to climb, the trunk of *Bactris cubensis.* • *Magnolia cubensis*, critically endangered and found nowhere else in the world.

with 4 to 10 fronds per stem. It is found in the more steeply mountainous areas of the park. *Bactris cubensis* is a medium-sized clustering palm, growing 21 feet (6.4 meters), in clusters of between 6 and 12 stems. It has long spines covering the stems, and light green, feathery leaves. *Copernicia* is a genus of fan palms with 22 of the 27 known species endemic to Cuba. Petticoat palm (*Copernicia macroglossa*) is perhaps the most widely known. It has a solitary trunk that grows up to 30 feet (9 meters) high. The fan-shaped leaves are erect and grow in a spiral. Arising from the trunk, with almost no petiole (leaf stem), the older leaves form a "skirt" or "petticoat" around the trunk. *Roystonea regia*, the Cuban royal palm, is widely planted throughout the subtropical and tropical world. It is an elegant palm with a gray-white trunk and a bright green crownshaft and is found on hillsides and valleys in Cuba where it grows to a height of 66 feet (20 meters). It is the national tree of Cuba.

The genus *Heliconia* has perhaps 225 species distributed primarily in the neotropics. The flowers are inverted, have a single stamen, and are surrounded by waxy colorful bracts often in colors of red, yellow, and green. The banana-like leaves of some species can reach 10 feet (3 meters) long. *Heliconia caribaea* has leathery, dark green leaves that are borne on long petioles arising directly from the ground. It can reach a height of 15 feet (4.5 meters) tall. The flowers appear on 2-year-old stalks and are enclosed by brilliant scarlet or yellow bracts. There are seven endemic species of *Magnolia* in Cuba. *Magnolia cubensis*, an evergreen magnolia, has smooth and leathery leaves. The flowers are creamy white, about 1 inch (2.5 centimeters) across. The seed coat is a distinct reddish orange. *Magnolia cristalensis* is a rare species growing in serpentine soils in the rainforest. Like many of its fellows, it has creamy white flowers and glossy, leathery evergreen leaves. Cuba has the highest number of the orchid genus *Encyclia* in the Caribbean. *Encyclia navarroi* grows on cliffs close to the sea. It has scented tepals of apple-green to orange with violet to brown spots, with lateral lobes salmon to yellow, and a central lobe white to pink, lined with purple. It can be identified by the suberose margin of the leaves. It has only recently been discovered. What a wonderful island.

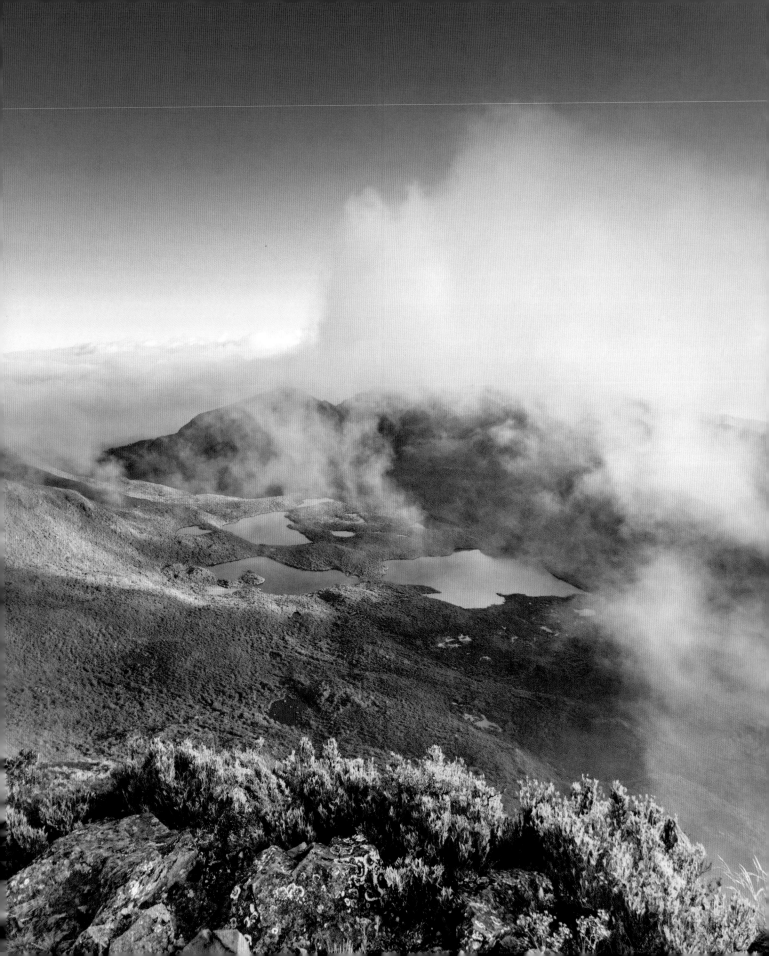

The location of this unique site in Central America, where Quaternary glaciers have left their mark, has allowed the fauna and flora of North and South America to interbreed. Tropical rainforests cover most of the area. Four different Amerindian tribes inhabit this property, which benefits from close cooperation between Costa Rica and Panama.

Talamanca Range-La Amistad Reserves / La Amistad National Park

COSTA RICA
AND PANAMA

Inscribed as a World Heritage Site in 1983, the Talamanca Range-La Amistad Reserves / La Amistad National Park extends along the border between Panama and Costa Rica. The transboundary property covers large tracts of the highest and wildest nonvolcanic mountain range in Central America and is one of the region's outstanding conservation areas. The Talamanca Mountains contain one of the major remaining blocks of natural forest in Central America with no other protected area complex containing a comparable altitudinal variation. The surface area of the

Cerro Chirripó is the highest mountain in Costa Rica.

property is 1,408,611 acres (87,570,045 hectares), of which 546,102 acres (221,000 hectares) are on the Panamanian side. The beautiful and rugged mountain landscape harbors extraordinary biological and cultural diversity. Preceramic archaeological sites indicate that the Talamanca Range has a history of many millennia of human occupation. There are several Indigenous peoples on both sides of the border within and near the property. In terms of biological diversity, there is a wide range of ecosystems, an unusual richness of species per area unit, and an extraordinary degree of endemism.

The scenic mountains and foothills contain impressive footprints of Quaternary glaciation, such as glacial cirques, lakes, and valleys shaped by glaciers, phenomena not found elsewhere in the region. The property is a large and mostly intact part of the land bridge where the faunas and floras of North and South America have met. The enormous variety of environmental conditions, such as microclimate and altitude, lead to an impressive spectrum of ecosystems. The many forest types include tropical lowland rainforest, montane forest, cloud forest, and oak forest. Other particularities of major conservation value include high altitude bogs and isthmus páramo in the highest elevations, a rare tropical alpine grassland. Long-standing isolation of what can be described as an archipelago of mountain islands has favored remarkable speciation and endemism. Many of the region's large mammals have important populations within the property; overall 215 species of mammals have been recorded. Around 600 species of birds have been documented, as well as some 250 species of reptiles and amphibians and 115 species of

From left: Such a delicious *Monstera deliciosa*. • The largest of the *Gunnera, Gunnera insignis*. • *Anthurium caperatum* is recognized by its large, ovate leaves that have sunken veins on the upper surface, causing a puckered look. • The leaves of *Escallonia myrtilloides* grow horizontally and look, with some imagination, like a Chinese pagoda.

freshwater fish. Most taxonomic groups show a high degree of endemism. The large extension and the transboundary conservation approach entail a great potential for the management and conservation of an extraordinary large-scale mountain ecosystem shared by Costa Rica and Panama.

Howler monkeys begin their earthy growl just before dawn and, as the sun rises, the sound becomes louder and more urgent. Their guttural territorial declaration, "this is me; this is mine," can be heard from miles away, echoing through the valleys from the deep protection of the forest. As night creatures return to nests and burrows, the howlers start the day.

Pairs of scarlet macaws (*Ara macao*) appear, screaming through the sky, flashes of red against the brightening sky. Large flocks of blue-headed parrots (*Pionus menstruus*) wheel and tumble in the air, noisy in their affirmation that the day has begun and there is food to find. As the sun rises higher—and temperature, too—an electric buzz of thousands of insects begins, wings and legs rubbing, reaching a crescendo of sexual invitation. Tribes of white-faced capuchin monkeys (*Cebus imitator*) leap from tree to tree, and on the ground the southern tamandua (*Tamandua tetradactyla*), seemingly indifferent to its surroundings but not indifferent to a nest-of-ants breakfast. Above a stream, a blue morpho butterfly (*Morpho menelaus*), its iridescent wings of blue with black edges and a brown underside, appears and disappears, the blue bright, the brown a camouflage. With a wingspan between 5 and 8 inches (12.7 and 20 centimeters), it is one of the largest butterflies in the world.

LA AMISTAD NATIONAL PARK

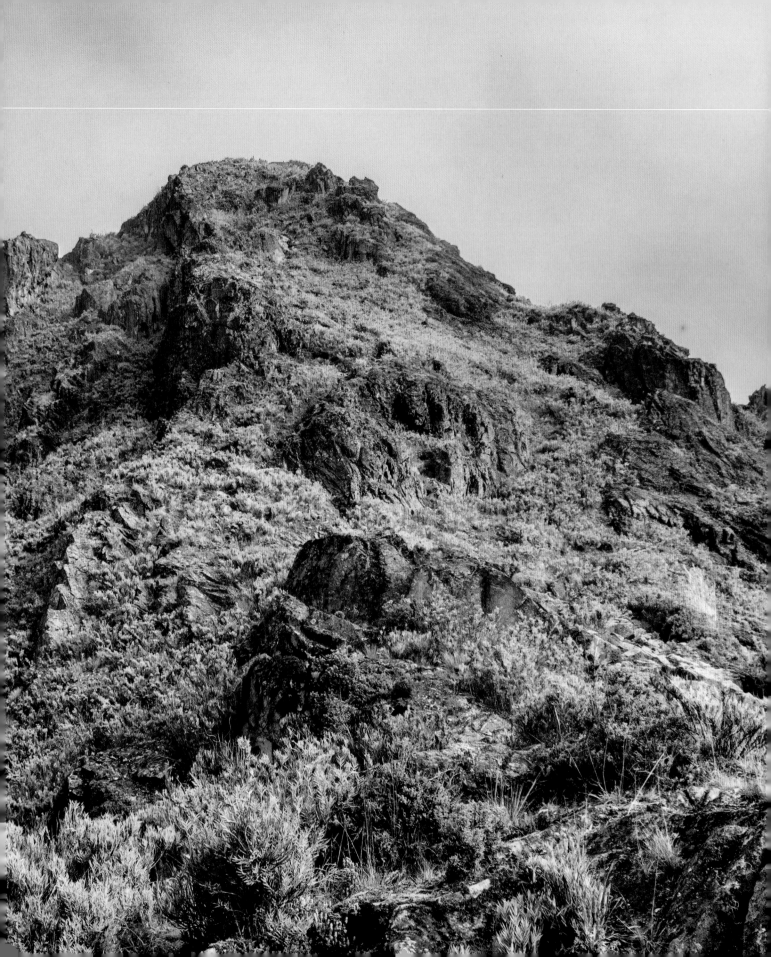

Below, from left: **Chusquea subtessellata**, a bamboo, dominates the grasslands of the páramo. • *Chamaedorea linearis*, one of the largest of the *Chamaedorea* species.

Swooping from a tree full of soft orange figs to one full of small green avocados, a pair of resplendent quetzal (*Pharomachrus mocinno*), a bird of the family Trogonidae, with a green body, red breast, and iridescent blue tail feathers up to 26 inches (65 centimeters) long, hurry to feed their young burrowed in a deep hole in the trunk of a large oak. Then, with everything seemingly satiated, the forest is quiet. It is time for the silence of the trees.

The park is a resplendent place. It is the largest reserve in Central America. Its biomes consist of tropical lowland rainforest, cloud forest, tropical upland rainforest, and páramo, an alpine ecosystem above the tree line. Spanning the border between Costa Rica and Panama, it is an important part of a larger span, the land bridge between North and South America.

While many biologists have studied it, it is rarely visited, being difficult to get to and even more difficult to explore due to the difficulty of the terrain. It is estimated that 4 percent of the world's biodiversity is found in the park. On the Costa Rican side of the border, the park contains 9 of the 12 identified life zones, holding about 90 percent of Costa Rica's flora. In Panama, the park is largely virgin forest, the last of its kind in that country. Montane wet forest is only found in the Panamanian parts of the park.

The Talamanca Mountains, which constitute the spine of the park, reach a maximum height of

LA AMISTAD NATIONAL PARK

12,536 feet (3821 meters) at Cerro Chirripó—the highest elevation in Costa Rica and all of southern Central America—with many peaks in the 9842-foot (3000-meter) range on both sides of the border. Rising dramatically, they are subject to the warm rain from the Atlantic, making rainforests, and seasonal dry air from the Pacific, making tropical dry forests. To add to the climatic diversity, clouds often cover the tops of the mountains, creating cloud forests, while above the tree line areas of páramo consist of shrubs and grasses. The mountains are islands—isolation provides speciation and endemism—with 10,000 flowering plants, about 1000 species of ferns, and 900 lichens. Climate, altitude, and soil are the essential ingredients, with the extraordinary diversity of flora and fauna expressing the perfection of this biological wonderland.

Páramo, the tropical subalpine ecosystem found in Latin America, Africa, and Southeast Asia, has its westernmost example in the Talamanca Mountains. *Chusquea subtessellata*, a small, shrubby clumping bamboo rarely more than 8 feet (2.5 meters) tall with yellowish culms and upright, triangular, pale green leaves, dominates

Opposite: Water, luminous and grand, falls fast and only once to the dark pool below.

99

Below, from left: The southern tamandua (*Tamandua tetradactyla*). • The resplendent quetzal.

the grasslands, covering up to 60 percent of the total páramo. With tussock grasses like *Festuca*, *Calamagrostis*, and *Muhlenbergia*, small shrubs such as the Costa Rican blueberry (*Vaccinium consanguineum*), herbaceous plants including *Lupinus*, *Draba*, *Senecio*, *Westoniella*, and *Ageratina*, and orchids in the genus *Telipogon*, these alpine meadows, winter at night, summer in the day, are some of the fastest evolving habitats on the planet.

In the subpáramo shrublands, small trees and shrubs such as *Buddleja nitida*, 13 to 49 feet (4 to 15 meters) tall, with yellow-orange flowers, *Escallonia myrtilloides*, 6½ to 20 feet (2 to 6 meters) high, with pale yellow flowers, and *Comarostaphylis arbutoides*, an evergreen shrub with rust-colored leaf undersides (tomentum) and cream flowers begin to intermingle with the oak forests of the lower elevations. *Hypericum costaricense*, with brown stems

up to 6½ feet (2 meters) and bright yellow flowers is a signature species, as is *Pernettya prostrata*, with white flowers turning to blue-black berries. In the numerous peat bogs of the mountains, a cycad-like tree fern, *Blechnum buchtienii* grows with the blue-flowering bromeliad *Puya dasylirioides*.

The primary threat to the páramo is increasing temperatures due to climate change. The warmer it gets on the tops of the mountains, the greater the opportunity for shrubs and forest trees to climb the mountain. There may come a time when páramo plants have nowhere to go.

Tropical upland forest, cloud forest, and tropical lowland rainforest constitute the rest of the park, although to label the area with just three headings reduces the complexity and diversity of the biomes and their relationship to each other to superficial chapter headings. But we go forward.

First column: The paniculate inflorescence of *Buddleja nitida*. • *Quercus copeyensis*. • The vocalization of the howler monkey is one of the deepest, most primeval mammalian sounds you can ever hear. It is wonderful to wake up to. • Costa Rican blueberry (*Vaccinium consanguineum*). Second column: A firecracker pink *Fuchsia paniculata*. • Yellow flowers of *Hypericum costaricense*. • Flowering poor man's umbrella (*Gunnera talamancana*). • Known as guayabo de charco, *Terminalia amazonia* grows up to 230 feet (70 meters) in height. Third column: One of the most beautiful butterflies in the world, the blue morpho (*Morpho menelaus*). • Acorns of *Quercus costaricensis*. • Fresh growth on *Podocarpus oleifolius*. • *Rytidostylis gracilis*, an annual climbing vine that usually climbs over shrubs, supporting itself by means of tendrils.

Above elevations of 5906 feet (1800 meters) the tropical upland and cloud forests are dominated by large oaks, *Quercus costaricensis* and *Q. copeyensis*. *Quercus costaricensis* is an evergreen with thick, leathery, bubbled leaves. It may reach 164 feet (50 meters) tall and is often festooned with red, yellow, orange, and green bromeliads—particularly *Androlepis skinneri*, with thick, waxy leaves forming a bowl for catching rainwater—and beards of lichens and mosses. *Qurecus copeyensis* is deciduous and reaches a height of 115 feet (35 meters). The leaves are often at the end of the branches.

The lowland rainforest becomes more diverse as you descend and includes *Podocarpus oleifolius*, an evergreen tree growing 66 to 98 feet (20 to 30 meters) or more with a densely branched crown. The hard wood of *Terminalia amazonia* makes it vulnerable to illegal logging. There are several globally threatened plants in the reserve including *Myrrhidendron maxonii*, *Ilex chiriquensis*, *Chamaedorea linearis*, *Begonia brevicyma*, *Ipomoea chiriquiensis*, and *Pilea rugosissima*.

There are two species of *Gunnera*—often called poor man's umbrella—in the park: *Gunnera insignis*, known for its extremely large leaves, which can grow to 11 feet (3.4 meters) long; and the smaller *Gunnera talamancana*, with leaves 5 feet (1.5 meters) in diameter. Both are dramatic plants with their huge leaves and large inflorescences of small red flowers. Fuchsias are plentiful and *Fuchsia paniculata* grows as a tree up to 10 to 26 feet (3 to 8 meters). Clusters of narrow rose pink–lavender tubular flowers appear in summer, followed by shiny purple-red berries. *Rytidostylis gracilis* is a plant of the gourd family Cucurbitaceae. It is an herbaceous climbing vine with young fruits eaten as a vegetable.

Monstera deliciosa, known as Swiss cheese plant and often found in corporate offices around the world, is a common epiphyte that can be found climbing on trunks up to 49 feet (15 meters) off the ground. There are about 62 species of *Philodendron* in Costa Rica and Panama. *Anthurium caperatum* is one of 87 species of *Anthurium* growing from Costa Rica to Panama from sea level to 6561 feet (2000 meters), most commonly in tropical wet forest. It is recognized by its large, egg-shaped leaves with sunken upper surface veins, green, brittle spathe, and pale green spadix.

Squeezed between two continents, the reserves are sacred lands. Lands to be protected, even worshipped as gardens of Eden. Certainly, they are to be studied. We know so much; we know so little.

"Pura vida" is a saying often heard in Costa Rica. Ticos use it to say hello and goodbye. Simply translated, it means "simple life" or "pure life." Perhaps what the howler monkeys are really saying in their early morning and evening calls is "pura vida, pura vida."

Forming a bridge between the two continents of the New World, Darién National Park contains an exceptional variety of habitats—sandy beaches, rocky coasts, mangroves, swamps, and lowland and upland tropical forests containing remarkable wildlife. Two Amerindian tribes live in the park.

Darién National Park

PANAMA

This is one of the world's most species-rich areas of moist lowland-highland rainforest, with exceptional endemism over a broad range of taxa. It has a number of different habitats, outstanding biodiversity and is culturally rich, with two Amerindian tribes living in the park. Inscribed as a World Heritage Site in 1981, it lies within a Conservation International-designated Conservation Hotspot, a WWF Global 200 Marine Ecoregion, a WWF/IUCN Centre of Plant Diversity and in two of the world's Endemic Bird Areas. It is also a UNESCO Biosphere Reserve.

The sun rises above the rainforest at Cerro Pirre.

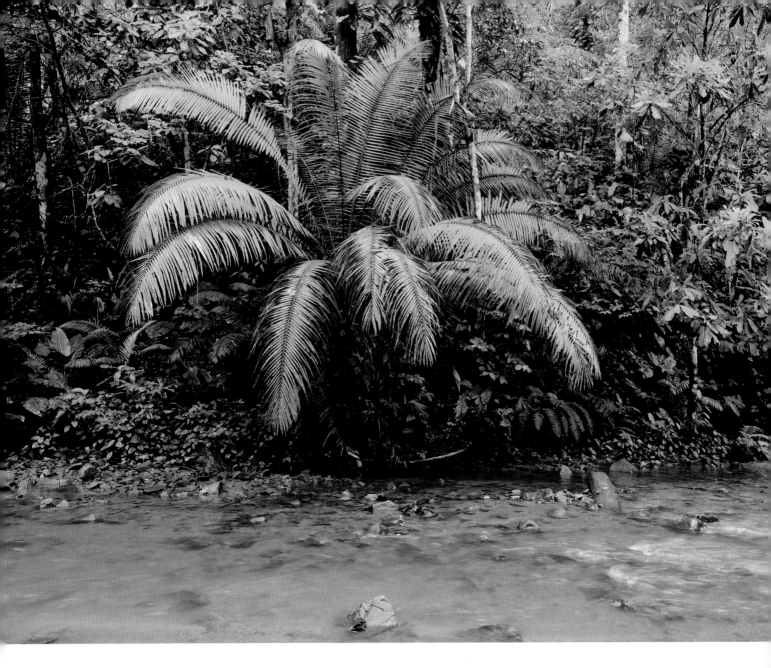

Darién National Park is at the southernmost end of the land bridge between Central and South America. The park, which is the largest protected tropical forest in Central America, extends from mountains on the continental divide only 10 miles (16 kilometers) from the Caribbean, along the border with Columbia to the Pacific coast. The center of Darién Province is a long flat lowland valley fringed by mountains: on the northeast, the Serranía del Darién; on the southwest, the Serranía del Jungurudó, Cordillera de Juradó, and the coastal Serranía del Sapo; and, discontinuously across the south, the isolated ranges of the Serranía de Pirre, Serranía de Setetule, and Altos de Quía. Tributaries flow from these mountains through the wide central valleys of the Tuira, Balsas, and Sambú Rivers flowing northwest into the Gulf of San Miguel. In the southeast, Cerro Tacarcuna in the Serranía del Darién rises to 6151 feet (1875 meters) and is the highest mountain between the Andes and western

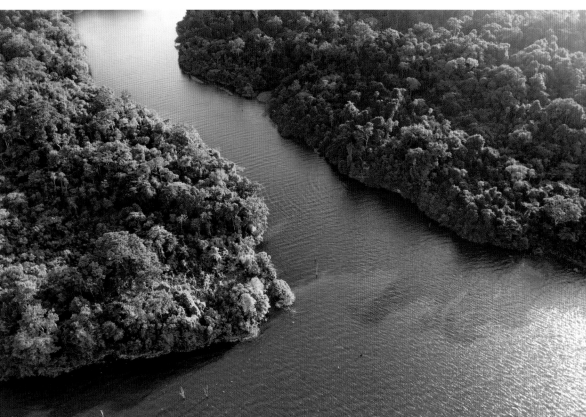

Panama. It is only 20 miles (32 kilometers) inland from the Caribbean coast of the Gulf of Urabá, into which flows the vast lowland swamps and lagoons of the Atrato River over the Colombian border. The park's southwestern coast on the Pacific comprises around 31 miles (50 kilometers) of rocky shores and sandy beaches.

Most of the mountains originated in a volcanic island arc that emerged during the Middle Eocene. The region's lowlands emerged in the Late Pliocene through tectonic activity. The southern mountains and the Caribbean slope of the northeastern mountains are largely of volcanic origin, while the inland slope of the Serranía del Darién is of Cenozoic sediments. Natural erosion has resulted in numerous landslides with deep cuts and gorges. Where not alluvial the lowland clay soils are lateritic, generally derived from Late Miocene shale with layers of dolomite and calcareous sandstone. Where sloping, the soils are leached of nutrients by the high rainfall.

DARIÉN NATIONAL PARK

Almost half of the park's lands are unsuitable for agriculture and forestry.

The forests of Darién Province are relatively undisturbed and contain the most diverse and species-rich terrestrial ecosystems of tropical Central America. Some samples suggest that they are as rich as Amazonian forests. The park includes nine major vegetation types: rocky coasts and sandy beaches, occasional mangroves, coastal dry forests, riverine forests, palm forest swamps, lowland forests to premontane, lower montane rainforests, cloud forests, and low-elevation elfin forest on Cerro Pirre. The province has a characteristic flora. In the mountains this reflects the region's past geological insularity and isolation—upland elements show affinities with Costa Rica, and during Pleistocene

From left: *Cavanillesia platanifolia*, known as pijio, bongo, pretino, petrino, cuipo, hameli, or hamelí in Spanish. • Guanacaste (*Enterolobium cyclocarpum*). • Forest swamp.

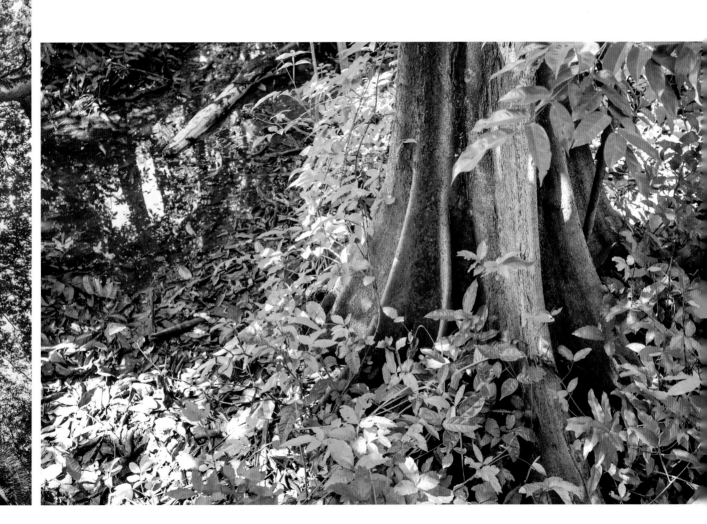

climatic shifts it may have been a refugium. In the relatively recently formed lowlands, the trees and lianas have affinities with Amazonian forests, with the flora of the neighboring Chocó region of Colombia, and even with the ancient Guayanan region; and the epiphytes and understory shrubs have northern Andean affinities. The Missouri Botanical Garden has recorded 2440 species for Darién Province, and since 1970, collecting in the wetter forests of Panama has revealed many new species.

Occasional mangroves occur along the coast: Black mangrove (*Avicennia germinans*); red mangrove (*Rhizophora mangle*); the saltwater-tolerant *Mora oleifera*; and, growing close to the mangroves, the yellow-flowering *Pterocarpus officinalis*, but

DARIÉN NATIONAL PARK

they are nowhere luxuriant as in the Gulf of San Miguel. In the west there is an isolated strip of thorn woodland and seasonally deciduous to semideciduous trees such as the pioneer species *Albizia niopoides* var. *niopoides*, red ceiba (*Bombacopsis quinata*), Brazilian rose (*Cochlospermum vitifolium*), *Prosopis juliflora*, and *Sabal mauritiiformis*, a fan palm 49 to 66 feet (15 to 20 meters) tall.

Along the Tuira and Balsas rivers there is an evergreen riparian forest of over 220 identified species, including 66 trees, many understory palms, and pure stands of cativo (*Prioria copaifera*), which can reach 180 feet (55 meters) tall and is the most utilized timber tree in the region. Freshwater marshes and swamp forests often have stands of *Copaifera aromatica*, a fast-growing tree that can reach up to 98 to 115 feet (30 to 35 meters) in height, with reddish brown bark that has a distinct aromatic scent when cut. There is also, *C. panamensis* commonly known as cabimo, and various canopy

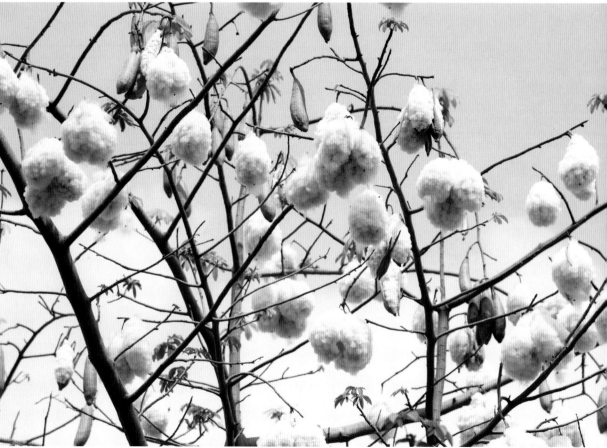

dominants including the pink- to purple-flowering *Tabebuia rosea* and *Swartzia panamensis*, an evergreen tree growing 49 to 98 feet (15 to 30 meters) tall. *Pachira aquatica* grows in the swamps and by the riversides. It can grow up to 59 feet (18 meters) in height in the wild and produces one of the largest tree flowers in the world. Yellowish white flowers have cream petals surrounding 200 to 250 red-tipped stamens resembling a shaving brush. The flowers bloom for 1 day and are fragrant at night.

The semideciduous lowland tropical forest of the unflooded areas of the Tuira and Balsas basins is the most extensive on the Central American Pacific coast. Ten percent of the park is in this life zone. Much of it may be secondary growth on savanna created by Amerindians but abandoned after the coming of the Spanish some 500 years ago. The most abundant species in the area is the deciduous *Cavanillesia platanifolia*, which grows up to 131 feet (40 meters).

DARIÉN NATIONAL PARK

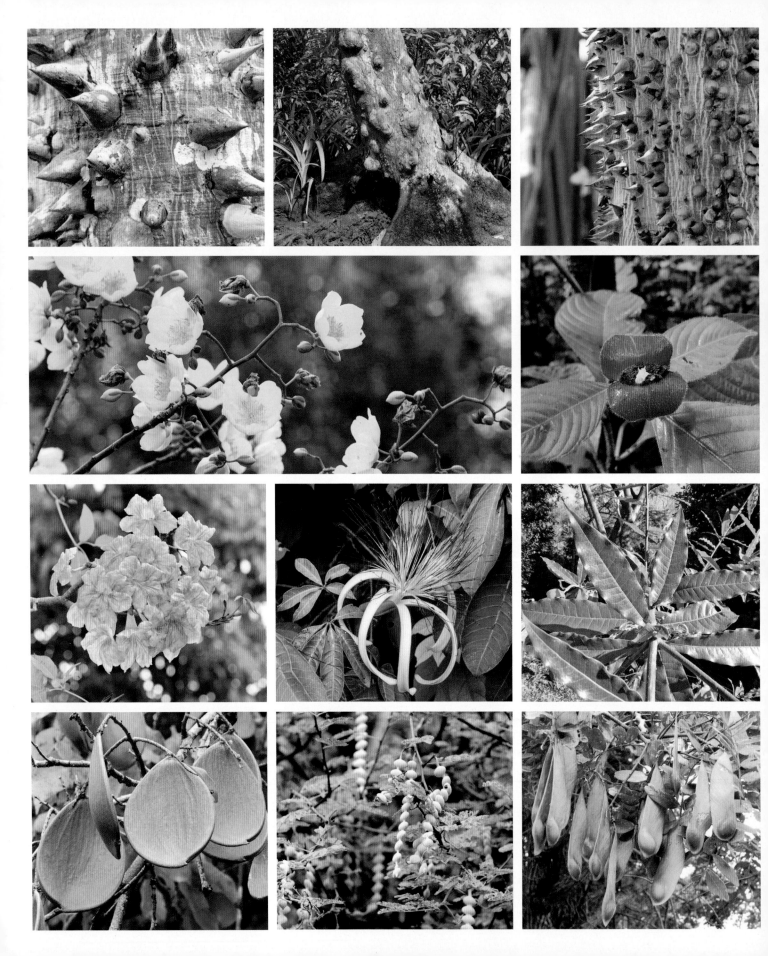

First column: Red ceiba (*Bombacopsis quinata*) is often planted as a living fence post. • Commonly known as yellow rose, *Cochlospermum vitifolium* is actually a member of the mallow family. • Tabebuia. • Cativo (*Prioria copaifera*). *Second column:* *Mora oleifera* is a tree known for having one of the largest seed embryos. • *Pachira aquatica*, a distinctive tropical wetland tree. • Fruits of *Prosopis juliflora*. *Third column:* The trunk of *Ceiba pentandra* is often crowded with large thorns. • Hot lips plant (*Palicoura elata*). • Humboldt oak (*Quercus humboldtii*). • The graceful *Platypodium elegans*.

Below: *Albizia niopoides*, a beautiful tree with silky pink flowers and fine foliage.

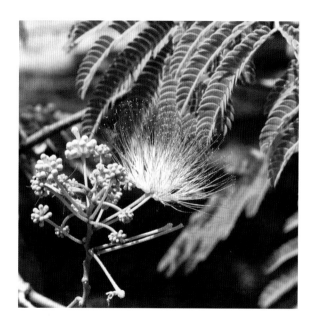

Some 400 species, including over 200 canopy and subcanopy trees have been identified in the tropical moist forest. The dominant emergents are *Cavanillesia platanifolia*, kapok tree (*Ceiba pentandra*), and the equally tall wild cashew (*Anacardium excelsum*). Frequent canopy trees include *Bombacopsis quinata*, *Pachira sessilis*, guanacaste (*Enterolobium cyclocarpum*), *Licania hypoleuca*, the leguminous *Platypodium elegans*, and the fruit tree *Vitex cymosa*.

In the subcanopy *Mouriri parviflora* is dominant and palms such as *Sabal mauritiiformis* are frequent. The dominant shrubs are *Faramea luteovirens*, the euphorb *Mabea occidentalis*, and *Piper pinoganense*.

Premontane wet-warm transitional forest and montane forests in slightly higher and/or wetter areas show several botanically interesting ecosystems. About 60 percent of the park is in these two life zones. Major tracts of primary and secondary forests cover most of the terrain and eroded landslides and associated gorges host successional plant communities. Dense low premontane rainforest occurs to 1640 feet (500 meters), with many subcanopy palms; lianas are common, and the hot lips plant (*Palicourea elata*) is a dominant shrub. The bracts around the small white flowers are bright red and resemble a pair of lips. The seasonal yet evergreen tropical wet forest which extends into the northern Chocó region of Colombia is dominated by *Anacardium excelsum* and *Dipteryx panamensis* among others. The main subcanopy tree is the palm *Oenocarpus mapora*.

On the highest peaks and ridges lower montane rainforest occurs. A distinctive montane oak forest of the evergreen *Quercus humboldtii* is present on Cerro Malí, and on the summit of nearby Cerro Tacarcuna a relatively newly discovered plant, *Tacarcuna gentryi*, a member of the Euphorbiaceae, and three specimens only of the tree *Freziera forerorum* are found.

DARIÉN NATIONAL PARK

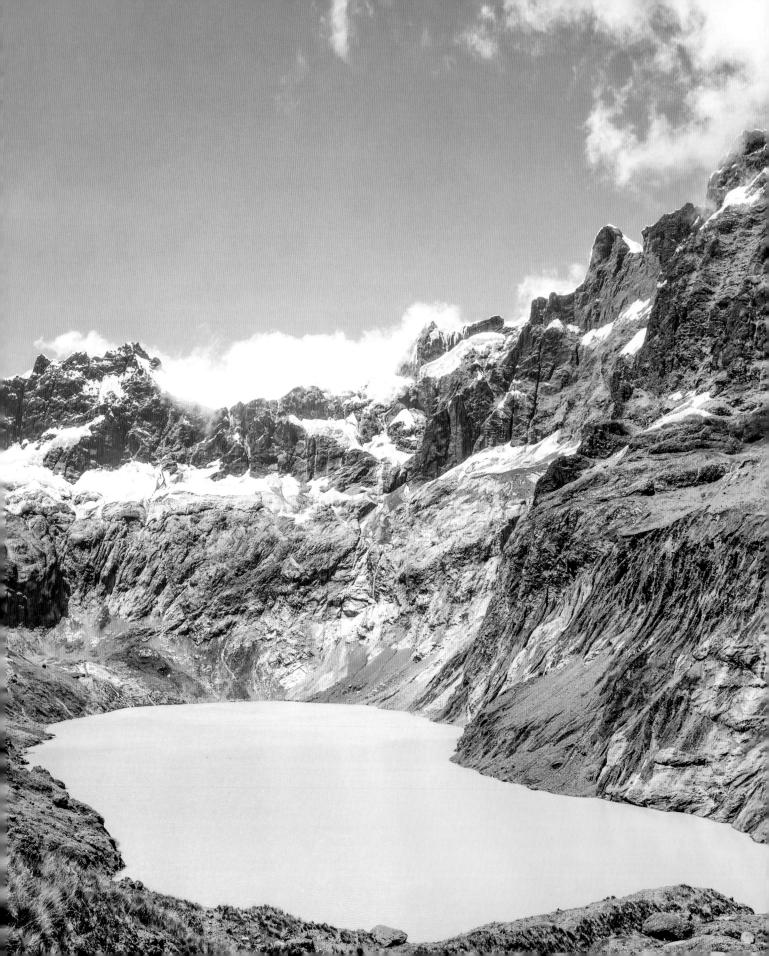

With its outstanding natural beauty and two active volcanoes, the park illustrates the entire spectrum of ecosystems, ranging from tropical rainforests to glaciers, with striking contrasts between the snowcapped peaks and the forests of the plains. Its isolation has encouraged the survival of indigenous species such as the mountain tapir and the Andean condor.

Sangay National Park

ECUADOR

The park comprises three zones: the volcanic High Andes, the eastern foothills, and alluvial fans. The highlands rise from 6561 to 16,404 feet (2000 to 5000 meters) and contain three stratovolcanoes: Tungurahua 16,479 feet (5023 meters) and El Altar 17,450 feet (5319 meters) in the northwest and Sangay 17,158 feet (5230 meters) in the west center of the park. All three are still active. Sangay, the most active, regularly ejects hot rocks and gasses and since 1934 has been one of the world's most continuously active

Basalts make numerous lagoons of different colors appear in the volcano.

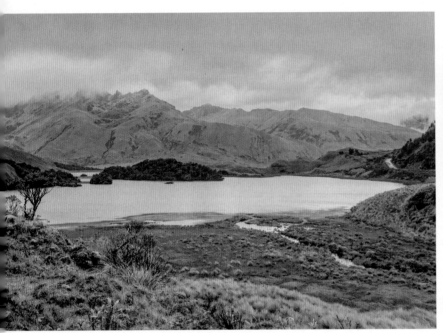

volcanoes. Tungurahua ("throat of fire" in Quechua) violently erupted between 1916 and 1925, and has frequently erupted since 2002—disastrously in 2006, and again in 2010. El Altar has an eroded and glaciated caldera to the west and was thought extinct until a single eruption in 2000.

The High Andes zone and its volcanoes in Ecuador result from the subduction of the Nazca Plate under the South American Plate. It lies in the intermediate and upper Cordillera Oriental, an area of rugged topography with deep steep-sided valleys, abundant cliffs, and many rocky jagged peaks. There are three subzones: subglacial, a glaciated subzone with arêtes, cirques, and U-shaped valleys with meandering rivers, and a volcanic subzone dominated by lava and volcanic ash deposited during more recent times on the cones and flanks of the three volcanoes.

The major rivers drain east to the Amazon basin. They fall with rapid and dramatic variations in level. Runoff is extremely rapid due to high rainfall and steep slopes, and erosion is substantial, although controlled by thick forest vegetation. There are numerous waterfalls, especially in the hanging valleys of the glaciated zone and along the eastern edge of the Cordillera, and many lakes, including Laguna Pintada near El Altar, which is 3 miles (5 kilometers) long.

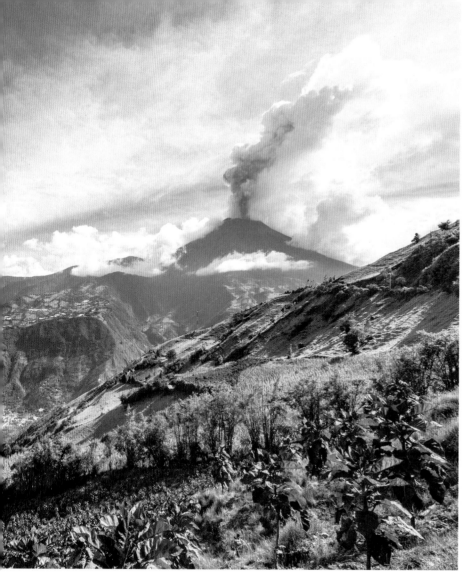

The park is just south of the Equator, but being high, has a subtropical and temperate climate. The eastern slopes of the Cordillera receive the most rainfall as moist warm air from the Amazon basin moves up over the Andes, creating a cloud forest belt. But the western boundary is in the rain shadow of the Western Cordillera. A permanent snow line occurs at about 15,748 feet (4800 meters).

The natural vegetation covers 84 percent of Sangay. The park has a high percentage of páramo and montane grassland, which has the greatest hydrological and soil carbon sequestration potential in Ecuador. Inscribed as a World Heritage Site in 1983, it lies within a WWF/IUCN Centre of Plant Diversity: at least 3000 plant species are known to occur in the park. Some 93 families, 292 genera and 1566 species have been identified in the Andean forests of Ecuador above 7874 feet (2400 meters), and most of these genera are represented in Sangay. The vegetation has three main zones: alpine and subalpine in the high páramo, montane cloud and wet forests, and subtropical and wet rainforests in the upper Amazon basin. It is principally influenced by altitude and rainfall, with the most luxuriant vegetation growing on the wetter eastern slopes.

Alpine rain tundra has formed between 14,763 feet (4500 meters) and the snow line, dominated by lichens and bryophytes. A subalpine

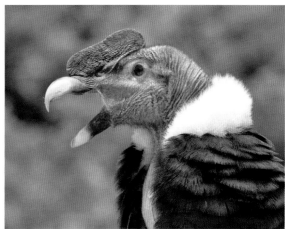

rain-páramo zone occurs between 11,154 and 13,123 feet (3400 and 4000 meters). Tussock grassland has species of *Poa, Calamagrostis, Festuca, Agrostis, Stipa,* and undisturbed stands of the clumping bamboo *Chusquea tovarii*. Rocky areas and areas of swamp, bog, or marsh have unique floras. *Chuquiraga* is a genus of evergreen shrubs in the aster family and *C. jussieui,* the flower of the Andes, is one of the most beautiful. It is a low shrub, reaching a height of about 29 inches (75 centimeters) with pale yellow or orange flowers. *Lupinus alope-curoides* is a woody-based perennial 24½ inches (62 centimeters) tall or more. It is covered in white woolly hairs and produces numerous whorls of blue flowers. To hike in the Andes and come upon a valley with masses of these woolly blue candles is one of the great pleasures of botanical travel. Less dramatic but no less precious is *Xenophyllum humile,* a cushion plant often found growing with *Plantago rigida,* creating a carpet of colors.

Montane rainforest grows on the wetter eastern slopes. The vegetation of the upper half of this zone grows about 16 feet (5 meters) high and consists of *Polylepis tomentella,* the yellow-flowering *Buddleja incana,* the shrub *Miconia salicifolia, Myrtus communis* associated with the blue-violet-flowering *Monnina crassifolia,* and other plants.

Between 6561 and 9842 feet (2000 and 3000 meters) lower montane rainforest occurs on steep-sided valleys. Forests on its upper slopes are up to 39 feet (12 meters) high. Lower down, the canopy grows to 131 feet (40 meters) with the conifer *Podocarpus oleifolius,* Spanish cedar (*Cedrela odorata*), and Andean alder (*Alnus acuminata* subsp. *acuminata*). The understory layer is formed of small trees such as *Miconia cernuiflora, M. cinnabarina, M. dimorphotheca, M. dulcis,* and a third layer of *Piper ecuadorense* and *Bocconia frutescens,* the plume poppy.

SANGAY NATIONAL PARK

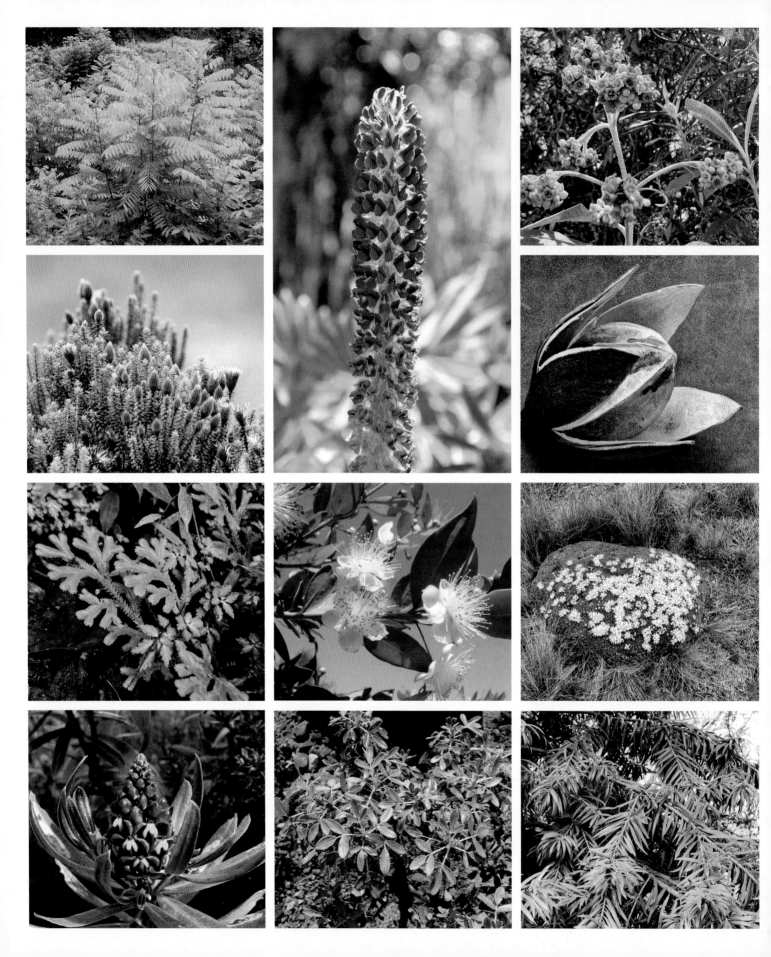

First column: Spanish cedar (*Cedrela odorata*). • The endangered flower of the Andes (*Chuquiraga jussieui*). • Endangered *Selaginella*, threatened by habitat loss. • An extraordinary butterfly-shaped, blue-violet flower of *Monnina crassifolia*; one of the petals, the "keel," has a yellow tip. Second column: *Lupinus alopecuroides*. • *Myrtus communis*. • *Polylepis tomentella*. Third column: *Buddleja incana*. • Seeds from *Cedrela odorata*. • *Plantago rigida*. • *Podocarpus oleifolius*.

Below: Páramo and river flow on El Altar.

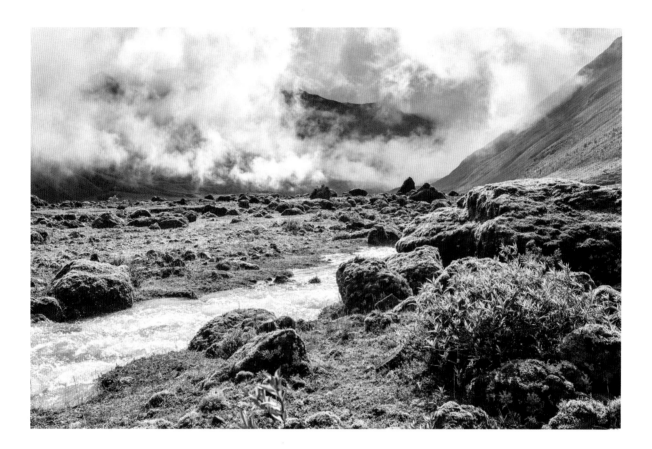

Subtropical rainforest occurs below 6561 feet (2000 meters). Species diversity is very high and members of the Lauraceae and Moraceae, such as *Ficus* species and *Cedrela odorata*, occur. Undergrowth species such as the spikemoss *Selaginella sericea* are common. This formation receives less rainfall in the south, forming a sub-tropical wet forest. Species include the Ecuador laurel (*Cordia alliodora*), the balsa tree (*Ochroma lagopus*), and *Centropogon trachyanthus*, a tree with tubular pink flowers.

High above the páramo, the cloud forest and rainforest, flies the Andean condor (*Vultur gryphus*), its 10-foot (3-meter) wingspan keeping it aloft with soaring grace. In the dense green forest, Andean cock-of-the-rock (*Rupicola peruvianus aequatorialis*) pecks on forest figs, while the red-faced parrot (*Hapalopsittaca pyrrhops*), close to extinction, forages for fruit in the canopy of trees.

SANGAY NATIONAL PARK

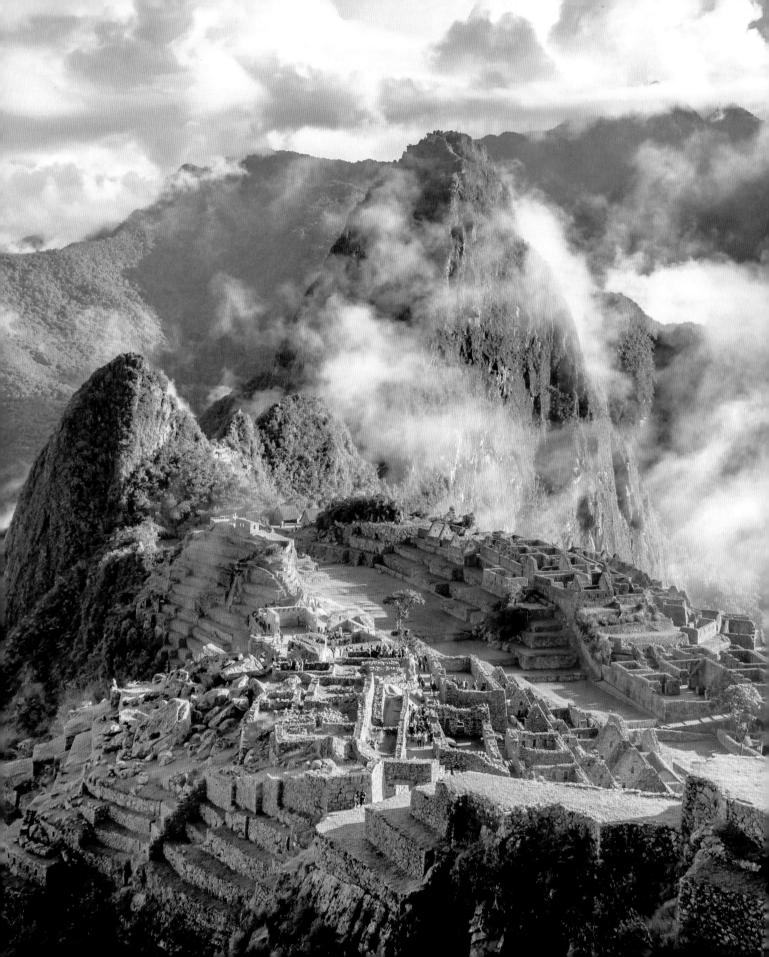

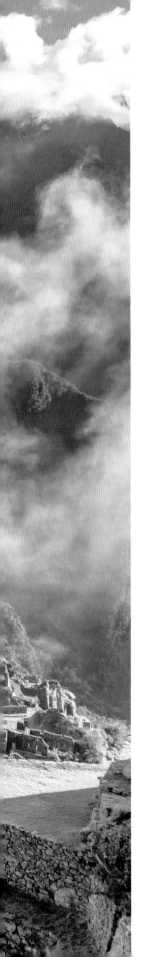

Machu Picchu stands 7972 feet (2430 meters) above sea level, in the middle of a tropical mountain forest, in an extraordinarily beautiful setting. It was probably the most amazing urban creation of the Inca Empire at its height; its giant walls, terraces, and ramps seem as if they have been cut naturally in the continuous rock escarpments. The natural setting, on the eastern slopes of the Andes, encompasses the upper Amazon basin with its rich diversity of flora and fauna.

Historic Sanctuary of Machu Picchu

PERU

It is ironic that when Christopher Columbus "discovered" the Americas, the Inca Empire was probably the largest in the world. Centered in the city of Cusco, Peru, it began in the early 13th century and was ended by the Spanish in 1572. Notable for extraordinary architecture and stonework, its system of roads, elaborate spiritual life, and refined artworks, the Inca are now regarded as one of the great civilizations in human history. The discovery of Machu Picchu and its subsequent exposure to the world has done much to intrigue us and tell us about this extraordinary empire.

The famous hilltop view over Machu Picchu.

From left: **One of the most extraordinary ruins in the world.** •
The Urubamba River runs through the valley far below the ruins
of the city. • Inca bridge.

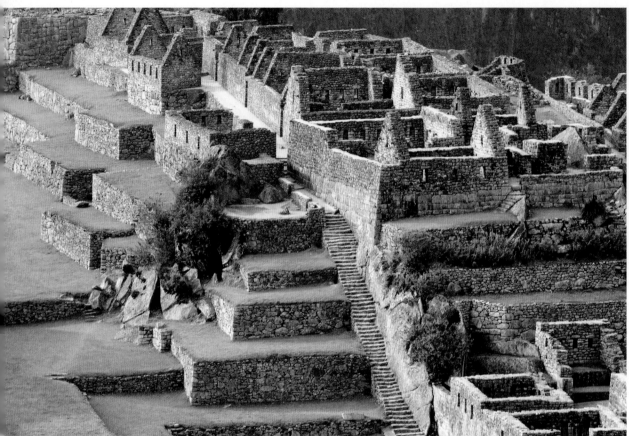

Built around the middle 15th century, Machu Picchu is one of the most important and most visited Pre-Columbian sites in the Americas. It was a royal winter retreat and a religious sanctuary until it was abandoned, sometime in the mid-16th century.

Its sheltered and remote location has preserved an extraordinarily rich endemic and relict flora. The park lies within a Conservation International–designated Conservation Hotspot, a WWF Global 200 Freshwater Ecoregion, a WWF/IUCN Centre of Plant Diversity, and is one of the world's Endemic Bird Areas. It was designated a World Heritage Site in 1983.

Machu Picchu is at the junction of the humid lower Urubamba basin and the fertile Vilcanota Valley. The site sits on a narrow saddle between the humpbacked lower Machu Picchu ("old mountain" in Quechua) and the pinnacle of Huayna Picchu ("young mountain"). It was never found by the Spanish and, concealed by forest, was only discovered in 1911 by the American Hiram Bingham of Yale University.

The site lies on the upper edge of the humid subtropical high-altitude forest. These forests form

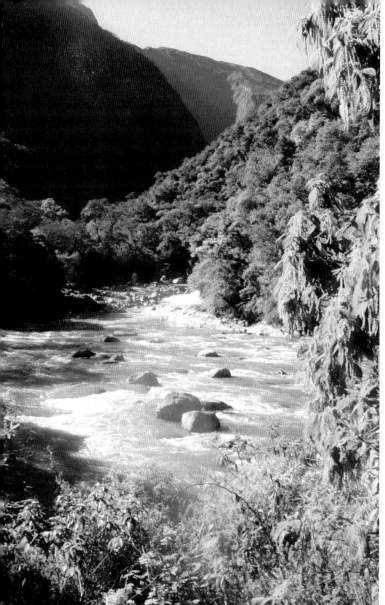

the transition zone along the eastern slopes of the Peruvian Andes between the high, dry treeless plateau and wetter páramo grasslands and the lowland humid forest. The vegetation is lush with high species diversity and high endemism. There are more than 3000 plant species in and around Machu Picchu.

Between 6561 and 9842 feet (2000 and 3000 meters), the evergreen forest is draped with epiphytic bromeliads, begonia species, ferns and mosses, and about 80 genera with 400 species of orchids. Rumored to have been cultivated by the Inca, Veitch's masdevallia (*Masdevallia veitchiana*) is a terrestrial, sometimes rock-growing orchid, blooming in the spring and early summer with an erect, single-flowered inflorescence of iridescent vermilion flowers with fine purple hairs held high above the leaves. The outer whorls are bright orange or cinnabar. Once common, the population has been decimated by illegal poaching for the horticulture market. *Sobralia dichotoma*, the flower of paradise, grows on granite outcrops and has stems up to 16 feet (5 meters) high with bouquets of five to eight fuchsia and bright orange flowers. It is the most prominent orchid growing within the ruins.

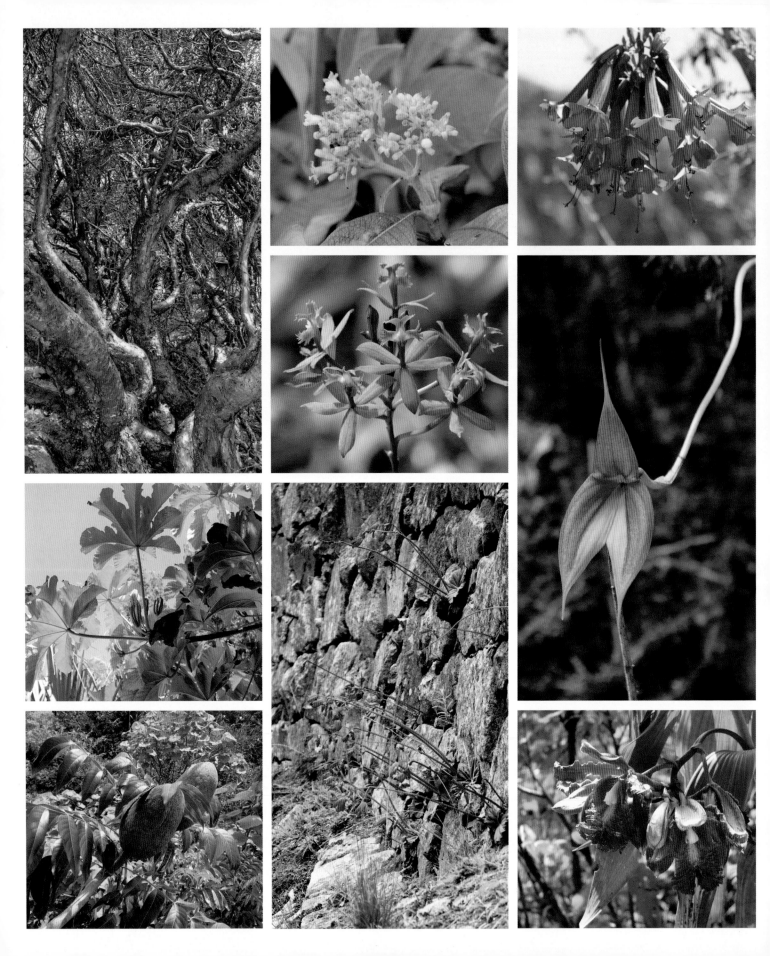

Epidendrum secundum is one of the crucifix orchids and is an epiphyte. The flower is variable in color but is often bright orange, purple, yellow, or red and has a three-lobed lip at the bottom of the flower.

Growing out of the ruin's walls and steps is Veitch's begonia (*Begonia veitchii*) with heart-shaped evergreen leaves and bright red flowers. Sir Joseph Dalton Hooker (1817–1911), the eminent British botanist and explorer said, "Of all the species of *Begonia* known, this [*Begonia veitchii*] is, I think, the finest. With the habit of *Saxifraga ciliata*, immense flowers of a vivid vermilion cinnabar-red, that no colorist can reproduce."

Begonia veitchii was collected from Peru by Richard Pierce, a 19th-century plant explorer who worked for James Veitch & Sons of Chelsea, London. This species was hybridized with others to create a large range of tuberous begonias so beloved by those people who love that sort of thing. From the ruins of an Inca temple to the conservatories of suburban England.

Aside from the begonia, there is little growing within the ruins themselves. Erosion from millions of feet and the grazing of resident llamas have seen to that. Where llama and feet do not reach, *Puya herrerae* grows. Puyas, members of the pineapple family (Bromeliaceae) with 226 species, are native to the Andes and the mountains of Central America. *Puya herrerae* has a rosette of pointed, hooked leaves, from which a spike of bright green flowers with yellow stamens grows almost 5 feet (1.5 meters). The flower spike is covered in white woolly fibers. It is highly endangered. Rarely seen but growing not far from the sanctuary is the tallest bromeliad and one of the most impressive plants in the world, *P. raimondii*, which reaches up to 49 feet (15 meters) in height.

The steep cut valleys and protected mountains are green with the endangered, high-altitude endemic *Polylepis pepei* and *P. subsericans*, as well as *Weinmannnia*, *Nectandra*, and *Cedrela*, particularly *C. angustifolia* and *C. odorata*, a tall-growing tree ranging in height from 33 to 98 feet (10 to 30 meters). In the deep stream valleys grow willows (*Salix* spp.) and alders (*Alnus* spp.) Trees also include the locally endangered mahogany (*Swietenia macrophylla*), the Andean walnut (*Juglans neotropica*), the coniferous *Podocarpus glomeratus*, the white-flowering *Buddleja incana*, *Cecropia* species such as trumpetwood (*C. peltata*), quinine (*Cinchona* spp.), and palm species. And then there are *Fuchsia*, *Brugmansia*, *Passiflora*, and the Peruvian magic tree (*Cantua buxifolia*), with its pink or red tubular flowers. It is a dense forest singing with life. A dense forest in danger of being overrun by tourists and plant thieves, by illegal logging, and people simply needing firewood. Let us forbear, please, from trampling this precious place into mud or dust.

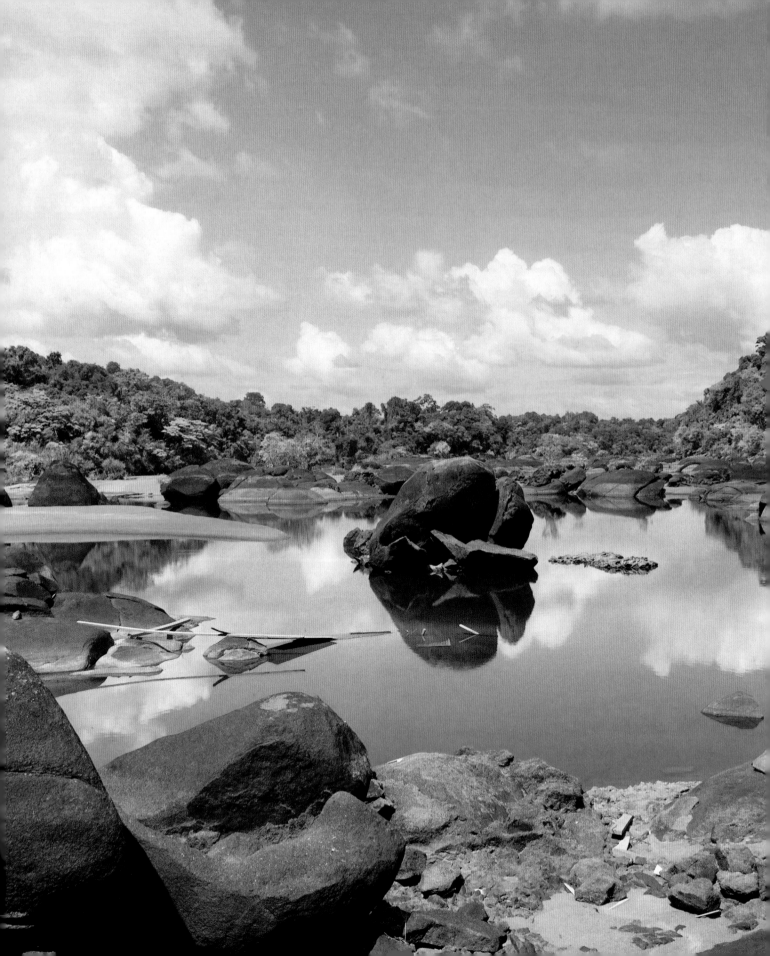

The Central Suriname Nature Reserve comprises 3,953,686 acres (1.6 million hectares) of primary tropical forest of west-central Suriname. It protects the upper watershed of the Coppename River and the headwaters of the Lucie, Oost, Zuid, Saramaccz, and Gran Rio Rivers and covers a range of topography and ecosystems of notable conservation value due to its pristine state. Its montane and lowland forests contain a high diversity of plant life with more than 5000 vascular plant species collected to date. The reserve's animals are typical of the region and include the jaguar, giant armadillo, giant river otter, tapir, sloths, 8 species of primates, and 400 bird species such as harpy eagle, Guiana cock-of-the-rock, and scarlet macaw.

Central Suriname Nature Reserve

SURINAME

Suriname is a country on the northeastern Atlantic coast of South America. It has an area of 63,251 square miles (163,820 square kilometers). Paramaribo City is its capital and largest city. Dutch is its official language. Its land-bordering countries are French Guiana, Brazil, and Guyana.

In 1998 the government of Suriname and the American nonprofit environmental organization Conservation International came together and created the Central Suriname Nature Reserve by combining three already existing nature reserves in Suriname: Elierts de Haan

The Coppename River runs through the reserve.

127

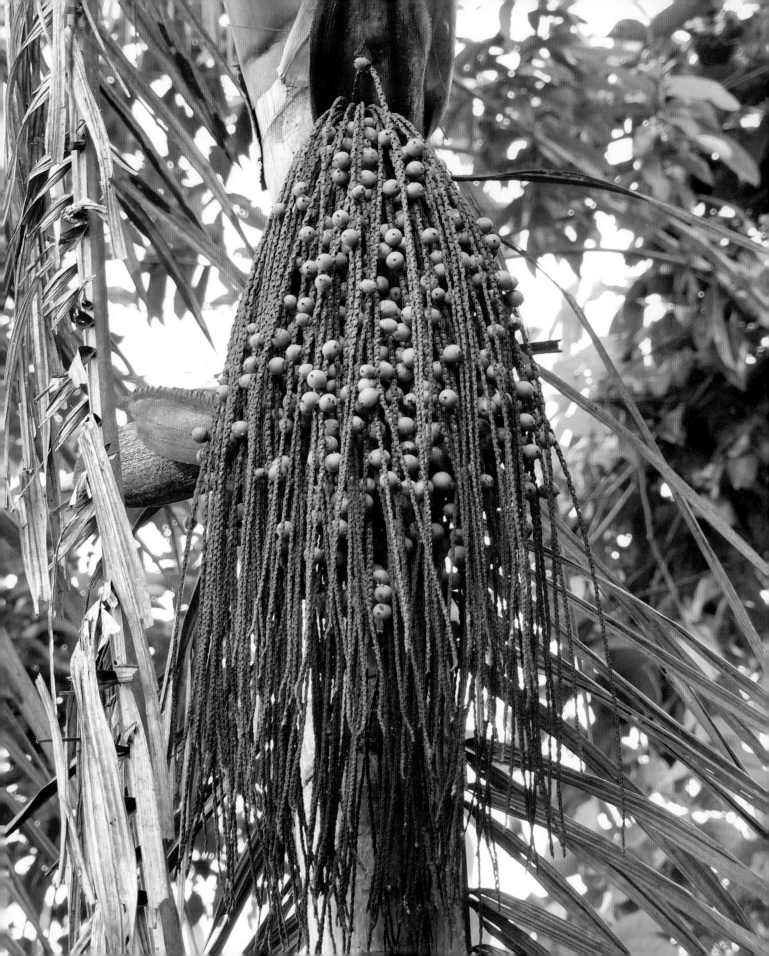

Oenocarpus bacaba is important for its fruits that can be cooked into juice or eaten whole, with a flavor reminiscent of avocado.

129

Gebergte, Ralleighvallen, and Tafelberg. In 2000 the Central Suriname Nature Reserve was designated a World Heritage Site because of the nature reserve's impeccable tropical rainforest ecosystem. Currently, the reserve spans 6178 square miles (16,000 square kilometers) of land that is made up of lowland and montane primary tropical rainforest, as well some sections of the higher elevation areas of the Guiana Shield, which are known as the Guiana Highlands.

Suriname is mostly covered by Amazonian basin vegetation. It has four broad ecological zones: the recent coastal plain, the old coastal plain, the savanna belt, and the forested interior, which covers about 90 percent of the country, equivalent in area to three-quarters the area of all the forests of Central America.

The reserve is dominated by moist lowland and mountain neotropical rainforest, and is one of the largest tracts of uninhabited and undisturbed primary forest in the entire tropics. Small fragments of marsh forest exist along rivers and creeks and there are isolated savannas. More than 5000 vascular plant species—75 percent of the country's total—have been collected from the reserve, with 5 endemic plant species on the Voltzberg Dome, and 42 endemic species in other areas. The former Raleighvallen Nature Reserve contains most of the forest systems present in the whole site. Moist forest predominates, although swamp forest, marsh forest, liana forest, savanna forest, and mountain savanna forest also exist. The canopy of the moist and humid forest typically extends to 98 feet (30 meters) high, and sometimes to 164 feet (50 meters), with the kapok tree (*Ceiba pentandra*) reaching 240 feet (73 meters). *Ceiba pentandra* is the tallest tree in the forest swooping up toward the sky from a buttressed flaring trunk, arborescent and priapic. It spreads into a majestic and wide canopy, bearing several hundred seedpods surrounded by a fluffy cottonlike fiber that is kapok. Tauari (*Couratari guianensis*) is a deciduous tree with a rounded crown, that can grow up to 197 feet (60 meters) tall. It has seedpods that resemble an oak acorn although it is a member of the Lecythidaceae, a family of about 20 genera and 250 to 300 species of woody plants native to the tropics. In Central America and Brazil, it is overexploited for its timber and is classified as vulnerable in the IUCN Red List of Threatened Species. It is protected in Suriname.

Another tree of the Suriname forest is the extraordinary cannonball tree (*Couroupita guianensis*). *Couroupita guianensis* reaches heights of up to 115 feet (35 meters). The flowers are borne in clusters (racemes) up to 31 inches (80 centimeters) long. Often, the entire trunk is covered with the fragrant pink, red, and yellow flowers. The fruits are round with a woody shell thus the common name.

From left: Voltzberg Mountain's granite dome looms high over the lush tropical lowlands. • The extravagant flare of kapok tree (*Ceiba pentandra*).

Calliandra surinamensis is an evergreen understory shrub, growing to a height of about 10 feet (3 meters). It flowers most of the year with a powder-puff arrangement of protruding pink stamens. The leaves have pairs of leaflets. Each pair of leaflets are in turn divided into about six pairs of leaflets. The leaves close and droop as the sun goes down. They open in the morning.

The understory is thick with the spiny and often impenetrable *Astrocaryum paramaca*, a trunkless palm heavily armed with needlelike thorns. The yellow inflorescence is surrounded by a brown

sheath with thorns, with the male flowers above and the female flowers below. *Oenocarpus bacaba* is a tall, single-stemmed feather palm growing 23 to 66 feet (7 to 20 meters) tall, with spreading leaves that can each be 20 feet (6 meters) long. The fruits are round and dark red to purple and are made into a kind of palm wine. Maripa palm (*Attalea maripa*) is a single-stemmed palm growing 23 to 79 feet (7 to 24 meters) tall. The unbranched stem is ringed when young and has a crown of 10 to 22 large leaves that can be up to 36 feet (11 meters) long. The edible fruits are popular throughout Suriname.

CENTRAL SURINAME NATURE RESERVE

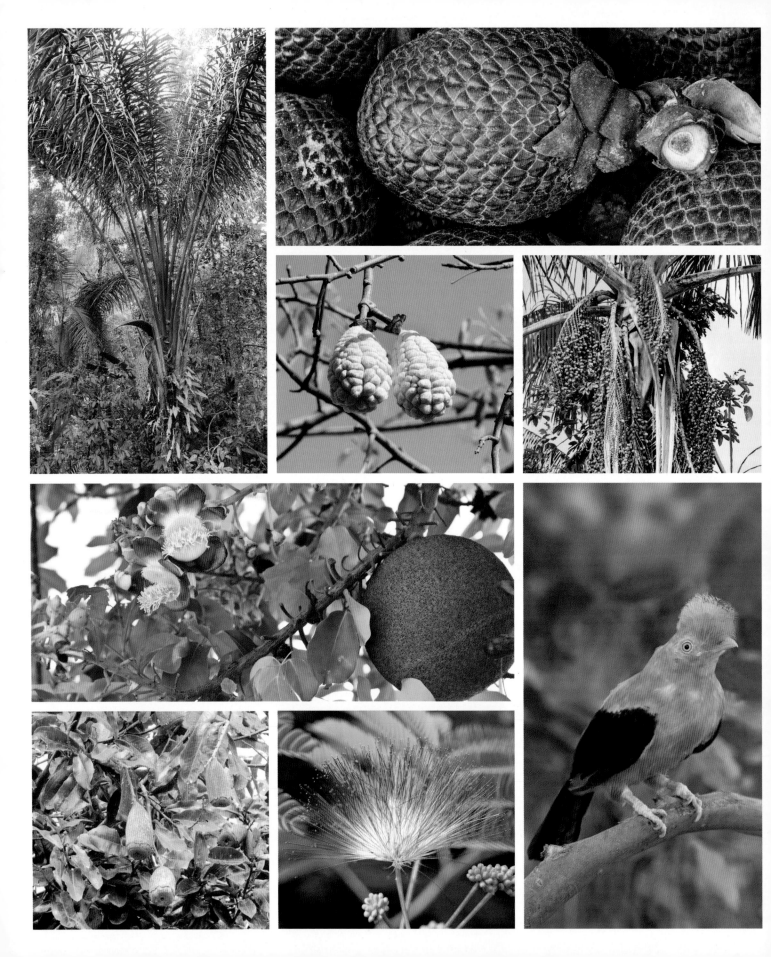

First column: Maripa palm (*Attalea maripa*). • Cannonball tree (*Couroupita guianensis*), aptly named for its heavy fruits. • Fine-leaf wadara, a *Couratari* species. Second column: Moriche palm fruit. • Kapok tree's cotton-ball-like seedpods. • *Calliandra surinamensis*. Third column: Moriche palm (*Mauritia flexuosa*). • Andean cock-of-the-rock (*Rupicola peruvianus*).

133

Mauritia flexuosa, known as the moriche palm, ité palm, ita, buriti, muriti, miriti, canangucho, or aguaje, grows in and near swamps and other wet areas. It can reach up to 115 feet (35 meters) in height. The crown is rounded. The yellow flowers appear from December to April. The fruit is a chestnut color and is covered with shiny scales. The seeds float and settle in the mud, creating high-density palm forests along the water.

An uncommon ecosystem is the Roraima sandstone savanna in the Tafelberg Reserve, the only one of its type in the country. A dry belt, known as Kappel savanna, extends over 2471 acres (1000 hectares), at an elevation of 984 feet (300 meters) scattered among semiopen forest. The savanna and tableland isolated in the pristine forest mark the area as a center of plant diversity. The vegetation on and around the granite outcrops is predominantly from the families Bromeliaceae, Orchidaceae, and Poaceae.

The Voltzberg Dome is a granite dome that stands at 804 feet (245 meters) tall. It is a monolith consisting of 1.8 to 2 billion years old biotite granite. The Julianatop stands at 3366 feet (1026 meters) tall and is the tallest mountain in Suriname. Rising out of the dense, moist forest, these granite domes are islands of rock savannas and are home to a few rare dry-loving plants and to the Guianan cock-of-the-rock (*Rupicola rupicola*), a passerine bird. The male is bright orange. Both the male and the less colorful female have a half-moon crest on the head.

Any reference to the natural history of Suriname would be incomplete without mention of the extraordinary Maria Sibylla Merian (1647–1717). She was a German-born naturalist and scientific illustrator. In 1699, at the age of 52, she traveled with her youngest daughter to Dutch Surinam to study the indigenous flora and fauna. She was prodigious, accurate and artistic. Her paintings are scientifically accurate as well as romantic and evocative. In 1705, she published *Metamorphosis insectorum Surinamensium*. A genus of flowering plants was named after her, *Meriania*, in the family Melastomataceae.

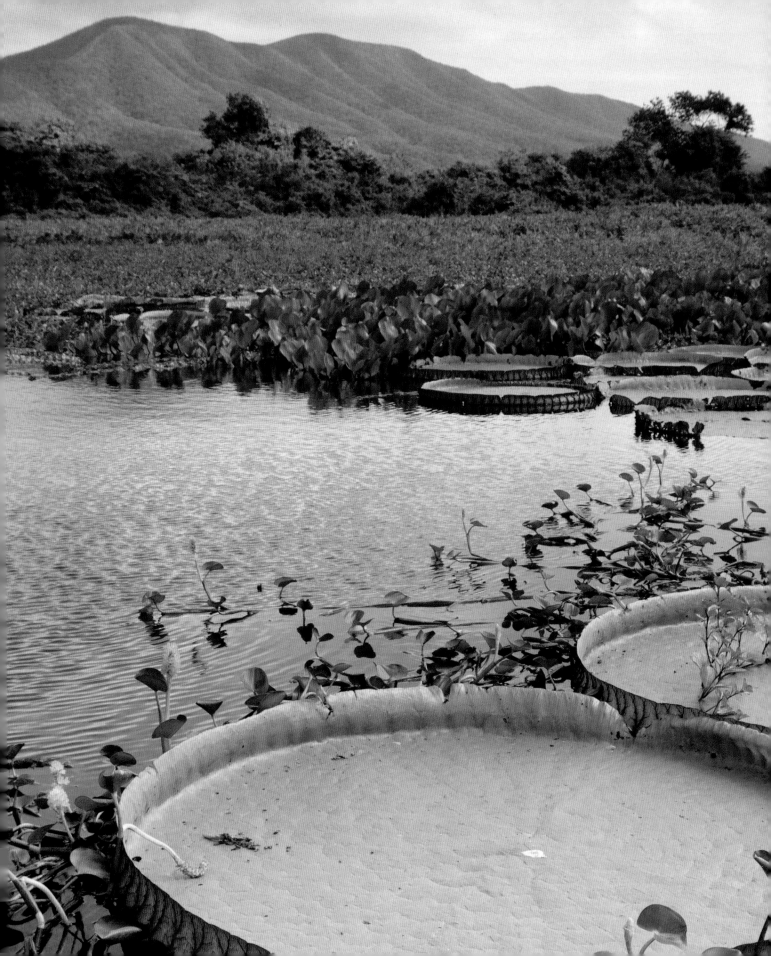

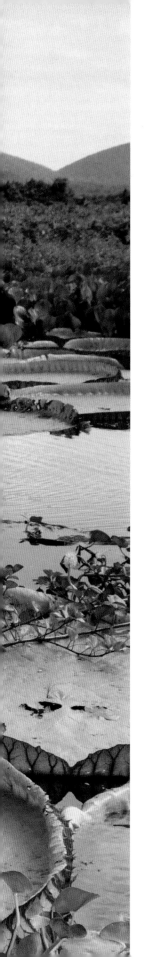

The Pantanal Conservation Area consists of a cluster of four protected areas with a total area of 464,108 acres (187,818 hectares). Located in western central Brazil at the southwest corner of the State of Mato Grosso, the site represents 1.3 percent of Brazil's Pantanal region, one of the world's largest freshwater wetland ecosystems. The headwaters of the region's two major river systems, the Cuiabá and the Paraguay Rivers, are located here, and the abundance and diversity of its vegetation and animal life are spectacular.

Pantanal Conservation Area

BRAZIL

Inscribed as a World Heritage Site in 2000, the conservation area is a part of the Pantanal region, sprawling nearly 81,081 square miles (210,000 square kilometers) across Brazil, Bolivia, and Paraguay. Normally, the Pantanal is drenched by heavy rains between October and April, which flood about 80 percent of the region, turning it into a maze of marshes and streams. But a prolonged drought has spelled disaster for the region, with searing temperatures and high winds making the parched land highly susceptible to fires. Natural wildfires are not uncommon in the Pantanal

One of the largest water lilies in the world, *Victoria amazonica*.

From left: Caranday palm often forms dense woodlands. • The pink trumpet tree is highly visible against the lush and wet green of the Pantanal. • The Pantanal is the world's largest flooded grassland.

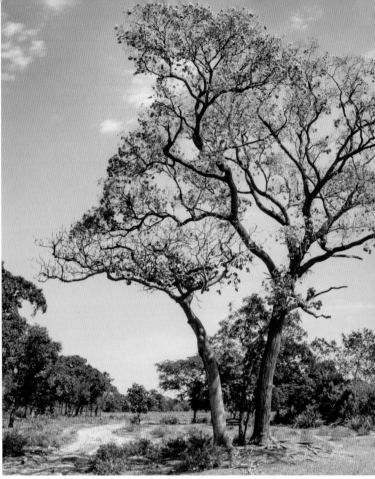

during wetter months, when lightning storms can easily set ablaze the peat soil, which is made up of layers of highly combustible decomposed organic matter. Now very few of the fires start because of natural causes, slash-and-burn agricultural blazes during the dry season spread into the Pantanal causing untold havoc. Fires in the Pantanal tend to burn just below the surface of the earth, fueled by peat. These low-intensity fires can burn for longer and are often particularly difficult to extinguish. The world's largest tropical wetland burned in 2021. Nearly 11,119,742 acres (4.5 million hectares) across the Pantanal—totaling about 30 percent of the biome—were consumed.

Its wide variety of ecosystems, seasonal cycles, and successional changes make the Pantanal one of the most biologically diverse systems in the world. Owing to its location in the center of South America, the Greater Pantanal has fauna and flora typical of the Amazon, the dry cerrado savanna of the surrounding hills, the Bolivian Chaco and Chiquitana dry forest, and Atlantic forest ecosystems. The region is a wetland between the dry savanna of central Brazil and the semideciduous forest to its south, but the site has examples of both ecological regions adjoining the floodplain in the Amolar Mountains. Cerrado occurs on seasonally flooded lowlands and in relatively open fields dominated by grasses of Wright's paspalum (*Paspalum wrightii*), canoegrass (*Paspalum acuminatum*), fingergrasses (*Digitaria* spp.), and carpetgrasses including *Axonopus purpusii* and *Axonopus fusiformis*.

In areas to the west grow jatobá trees (*Hymenaea courbaril*), called stinking toe because of the malodorous nature of the edible pulp of its seedpods, although if you can hold your nose, the pulp tastes sweet. It is an evergreen tree with large spreading branches and a heavy, umbrella-shaped crown.

Usually growing to around 98 feet (30 meters) tall, some specimens reach up to 148 feet (45 meters).

The trumpet trees ipê-amarelo (*Handroanthus chrysanthus*) and ipê-roxo-damata (*H. impetiginosus*) spread throughout the Pantanal. Ipê-amarelo has 2-inch (5-centimeter) long, tubular-shaped flowers, with a broadening corolla of deep yellow color; they come out in masses in what February to April before the leaves. Ipê-roxo-damata has pink to magenta flowers in great numbers. Both species are glorious flowering trees and are commonly used as street trees. Taperabá (*Spondias mombin*) is a deciduous tree that grows up to 66 feet (20 meters) high. Its bark is thick, corky, and deeply fissured. The flowers bloom January to May and are sweet scented, in large terminal panicles of small white flowers. The fruits appear July to September and are ovoid and yellow. They have a sharp, acid taste and are edible.

Near water grow two palm species, the urucuri and caranday palms (*Attalea phalerata* and *Copernicia alba*). Urucuri, a feather-leaved palm, grows up to 59 feet (18 meters) tall, the trunk rarely reaching more than 13 feet (4 meters). It has up to 30 leaves with a full and feathery appearance, held erect in a shuttlecock-like crown. It has large bunches of bright yellow, oily fruits. Caranday grows up to 82 feet (25 meters) in height with a crown of 50 arching fan-shaped fronds. The plant is known for the high-quality wax obtained from its leaves. The leaves are also used as thatch material and for weaving mats, baskets, and hats. The white wood is resistant and durable, and used for poles, fencing, and building. The fruits are eaten fresh or used for juice and alcoholic drinks. Tips of young plants are also edible.

In the 33- to 49-foot (10- to 15-meter) high semideciduous alluvial forest the two dominant species are garapa (*Apuleia leiocarpa*) and

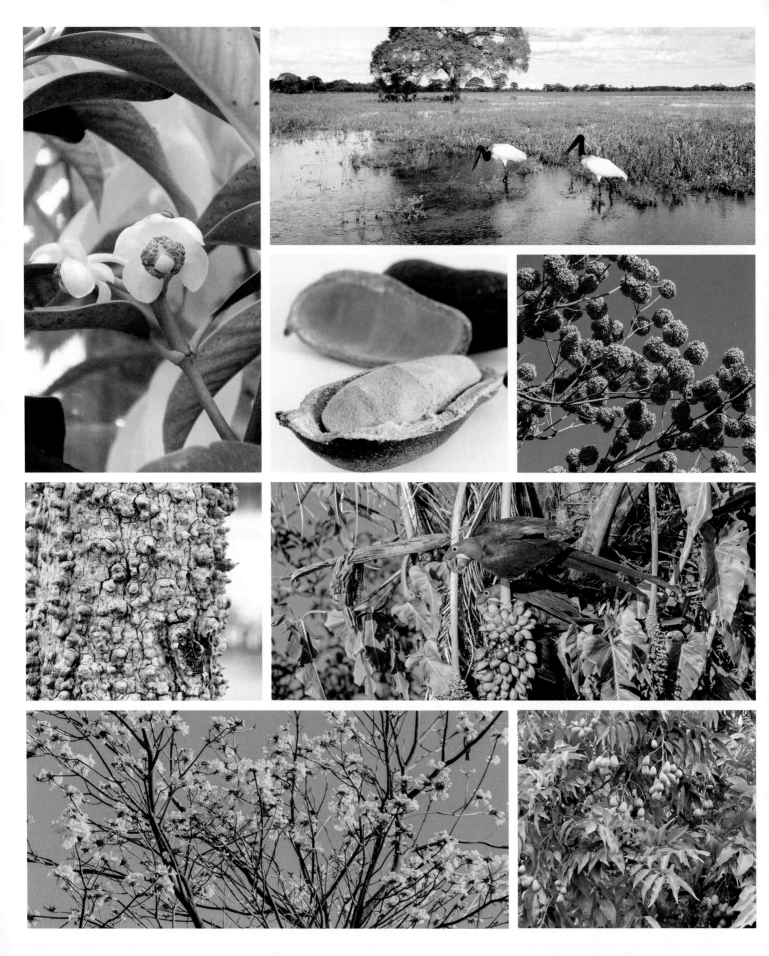

First column: Pungara (*Garcinia macrophylla*) produces white fragrant flowers from which ovoid fruits are produced. The fruit pulp is white and juicy. • The corky bark of Taperabá (*Spondias mombim*). • *Handroanthus chrysanthus* is one of the most floriferous and beautiful trees of the tropics. *Second column:* The jabiru is commonly found in the Pantanal. • The large seeds of the jatobá tree (*Hymenaea courbaril*) have given rise to its names "stinking toe" and "old man's toe" because of the unpleasant odor of the edible pulp of its pods. • Urucuri palm seeds are an important food for blue macaw. *Third column:* Pink ipê flowers before the leaves appear. • The fruits of Taperabá.

Below: The Cuiabá River flows into the Pantanal and is a tributary of the Paraguay River.

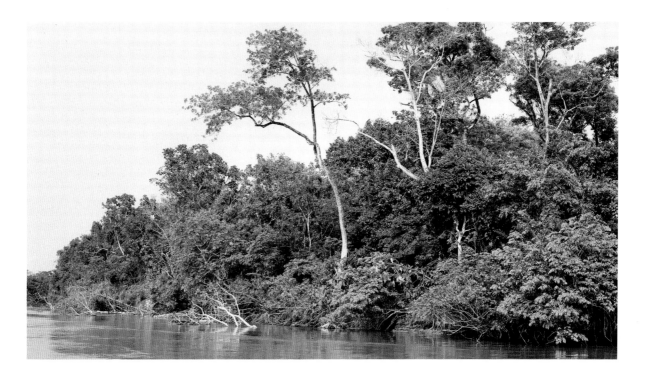

Virola glaziovii. Garapa is a tall tree up to 131 feet (40 meters) with a long trunk and high crown of large branches. Small white pealike flowers appear from September to November. *Virola glaziovii*, related to nutmeg (*Myristica fragrans*), has glossy, dark green leaves with clusters of tiny yellow flowers that emit a pungent odor. The dark red resin of the tree bark contains several hallucinogenic alkaloids.

In the lowlands grows a semideciduous forest of taller trees 49 to 59 feet (15 to 18 meters) high that includes pungara (*Garcinia macrophylla*), an evergreen tree growing 26 to 39 feet (8 to 12 meters) with stiff, leathery leaves and round yellow-ringed fruit; *Nectandra reticulata*, growing up to 66 feet (20 meters); and many others.

In one of the world's most extensive freshwater wetlands is the world's second largest water lily, *Victoria amazonica*. The large round leaves have a diameter of up to 10 feet (3 meters) and float on water, and the submerged stalk is up to 26 feet (8 meters) long. On the underside, the leaves are red and have sharp spines; on the top, the leaves are bright green and glossy. The white flowers attract a species of scarab beetle that pollinates the plant. Once pollinated, the flowers turn pink. The beetle then moves on to another flower. After this process, the flower closes, descending below the water surface, to drop seed into the Pantanal mud. The genus is named after Queen Victoria.

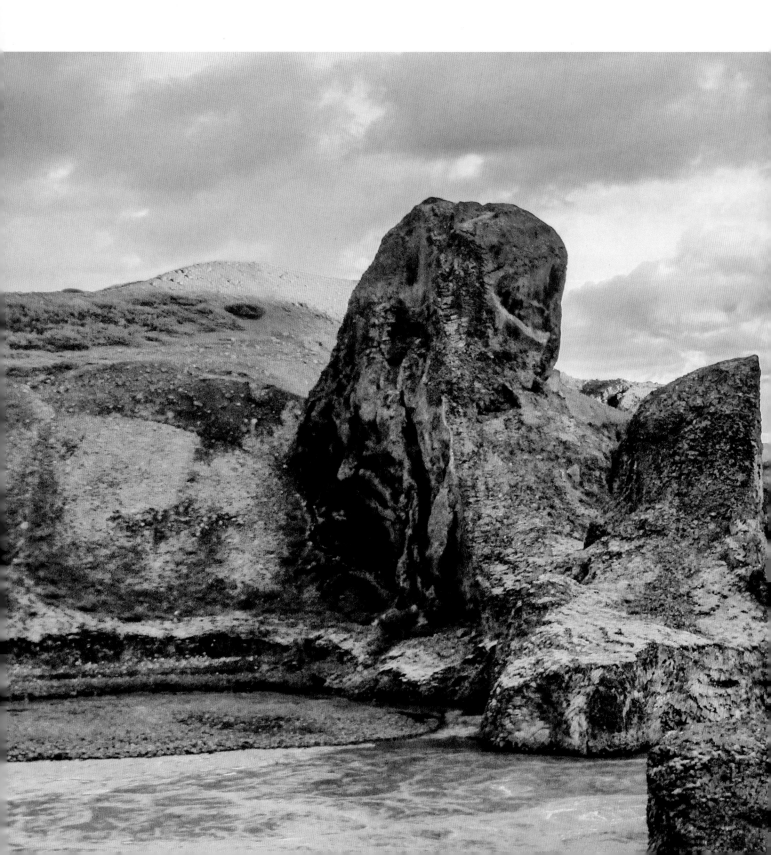

A view down into the Vesturdalur Valley in Vatnajökull
National Park, Iceland.

Europe

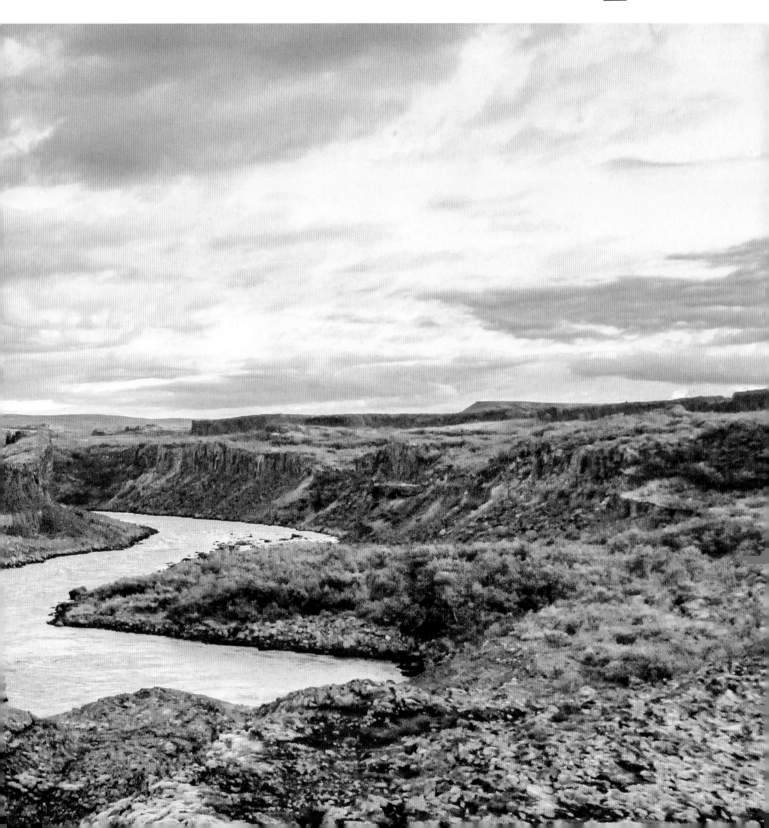

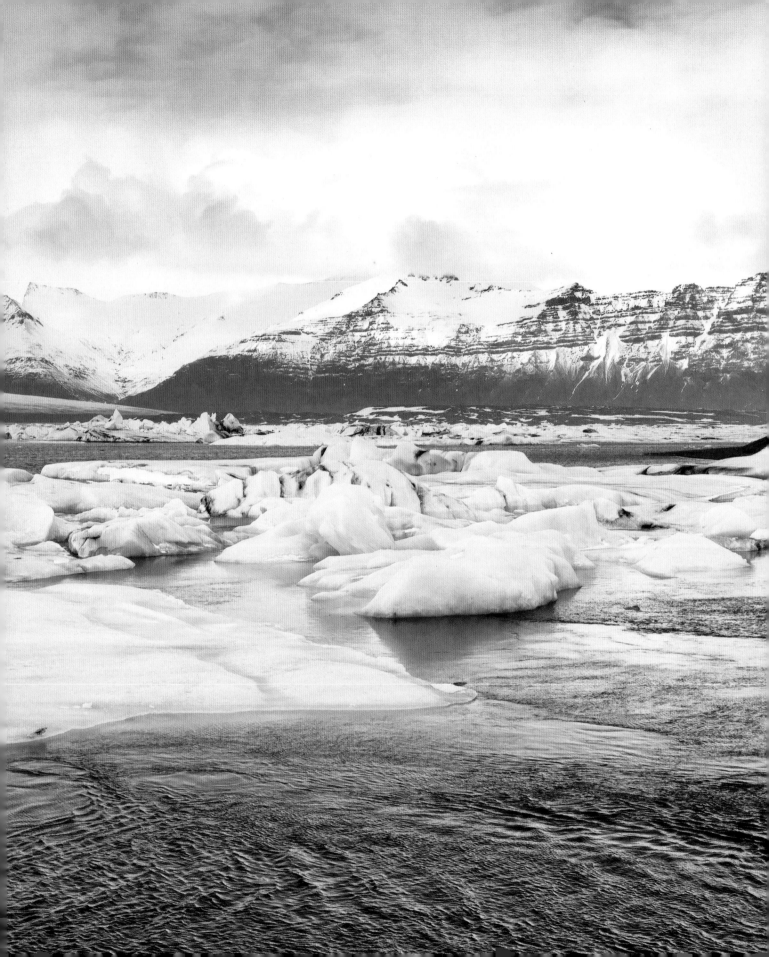

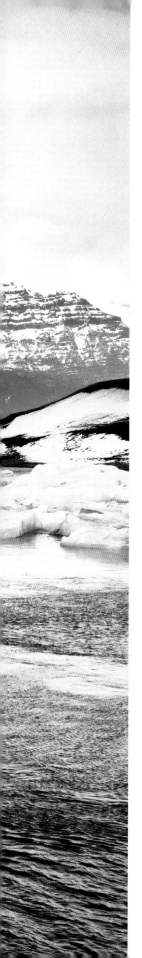

This iconic volcanic region covers an area of over 3,459,475 acres (1,400,000 hectares), nearly 14 percent of Iceland's territory. It numbers 10 central volcanoes, 8 of which are subglacial. Two of these are among the most active in Iceland. The interaction between volcanoes and the rifts that underlie the Vatnajökull ice cap takes many forms, the most spectacular of which is the jökulhlaup—a sudden flood caused by the breach of the margin of a glacier during an eruption. This recurrent phenomenon has led to the emergence of unique sandur plains, river systems, and rapidly evolving canyons. Volcanic areas are home to endemic groundwater fauna that has survived the Ice Age.

Vatnajökull National Park—Dynamic Nature of Fire and Ice

ICELAND

In Icelandic *vatn* means "water" and *jökull* means "glacier." Vatnajökull is the name of the ice cap. It is Europe's largest ice cap by volume, although it has lost more than 15 percent of its volume during the last century. Generally measuring 1312 to 1968 feet (400 to 600 meters) in thickness, the glacial ice conceals several mountains, valleys, plateaus, and active central volcanoes, of which Bárðarbunga is the largest and Grímsvötn the most active. While the ice cap rises at its highest to over 6561 feet (2000 meters) above sea level, the glacier base reaches its lowest point 984 feet

With few air bubbles trapped in this ice, red wavelengths are absorbed, with only blue light being scattered and escaping the iceberg to create the intense color we see.

143

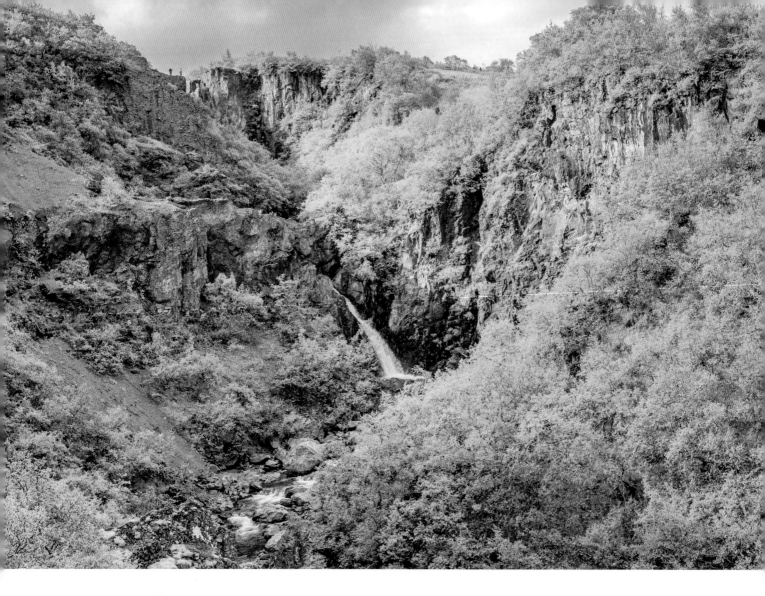

(300 meters) below sea level. The coexistence and ongoing interaction of an ocean rift on land, a mantle plume, and the atmosphere of an ice cap make this park unique in a global context, and it was inscribed as a World Heritage Site in 2019.

The scenery encircling the glacier is extremely varied. Toward the north, the highland plateau is divided by glacial rivers, with powerful flows in summer. The volcanoes of Askja, Kverkfjöll, and Snæfell tower over this region, together with the volcanic table mountain Herðubreið. Long ago, huge glacial floods carved out the canyon of Jökulsárgljúfur in the northern reaches of this plateau. The mighty Dettifoss waterfall

still thunders into the upper end of this canyon, while the scenic formations at Hljóðaklettar and the horseshoe-curved cliffs of Ásbyrgi are found farther north. Broad wetlands and expansive ranges distinguish the areas near the glacier and farther east, around Snæfell. These are an important habitat for reindeer (*Rangifer tarandus*) and pink-footed geese (*Anser brachyrhynchus*). The south side of Vatnajökull is characterized by many high, majestic mountain ridges, with outlet glaciers descending between them onto the lowlands. The southernmost part of the glacier envelops the central volcano, Öræfajökull, and Iceland's highest peak, Hvannadalshnjúkur. Sheltered by the high ice,

Opposite: Downy birch colonizing the sheltered environment of Skaftafell.

Below, from left: A trail through birch woodlands; birch wood was used for building houses, as firewood, and for the grazing of livestock. • Reindeer are one of the island's classic fauna.

the vegetated oasis of Skaftafell overlooks the black sands deposited to its west by the river Skeiðará. These sands are mostly composed of ash, which stems from the frequent eruptions at Grímsvötn and is brought to the coast by glacial floods known as *jökulhlaups*.

An abundance of plant life is not the first thing that comes to mind when thinking about Iceland. The number of plant species is about 540—a low number. Endemic species are low in number too. But biomes are not about numbers, they are about complexity, and Iceland has deeply complex ecological and geological niches that support the interweaving web of life.

Iceland is a young island, about 20 million years old. It emerged from the last ice age about 10,000 years ago. By the time the first people settled in the country around 847 CE in a place named Reykjavík (meaning "Smoke Cove"), the island was thickly

wooded with birch forests and other colonizing trees, as well as large areas of mosses and lichens. In the summer it was a green land. The settlers—largely from Norway—quickly chopped down the trees for shipbuilding, firewood, and housebuilding, and introduced livestock, further degrading the land and leading to considerable soil erosion. Native woody plants that survived and continue to prosper in their individual ways are heather (*Calluna vulgaris*), downy birch (*Betula pubescens*), bog bilberry (*Vaccinium uliginosum*), European blueberry (*V. myrtillus*), black crowberry (*Empetrum nigrum*), rowan (*Sorbus aucuparia*), and tea-leaved willow (*Salix phylicifolia*).

Tea-leaved willow (*Salix phylicifolia*), is common in Iceland. Growing in wet areas, it is identified by its narrow, completely hairless leaves, and "twiggy" appearance. Downy birch (*Betula pubescens*) once covered an estimated 30 percent

VATNAJÖKULL NATIONAL PARK

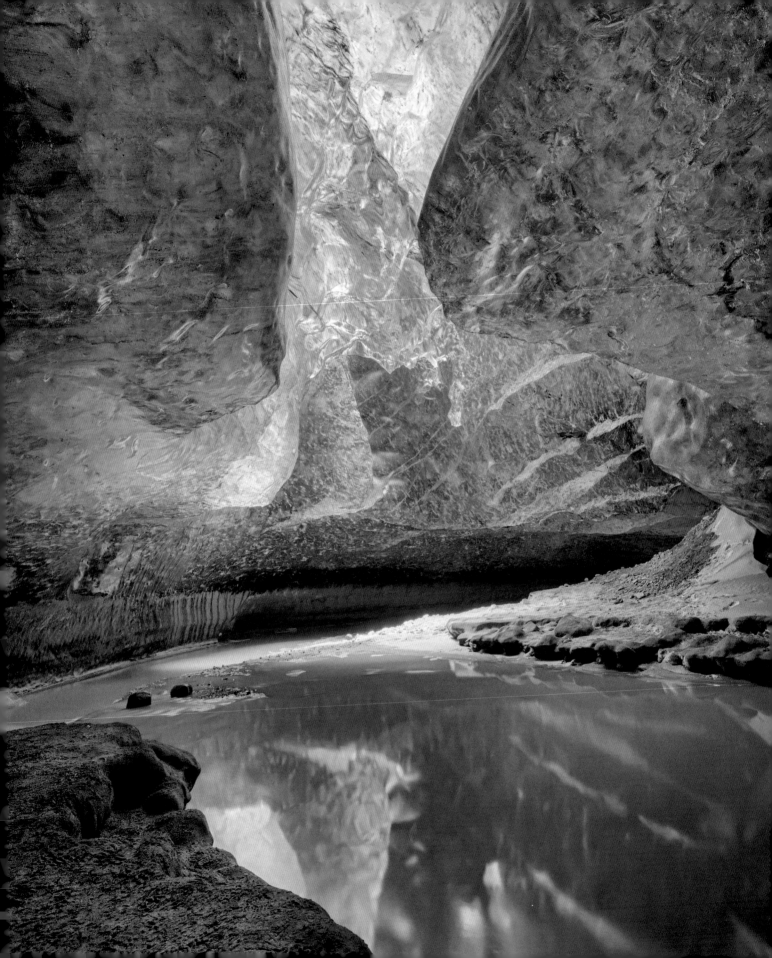

Below, clockwise from top left: Vatnajökull glacier covers 8 percent of Iceland's landmass. • Vatnajökull is the largest and most voluminous ice cap in Iceland. • And when the green prevails, the flowers bloom. • Víti is a geo-thermal crater lake found in Askja Caldera in Iceland's Central Highlands.

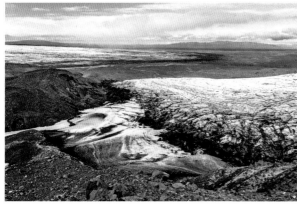

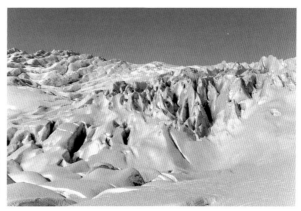

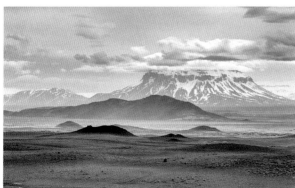

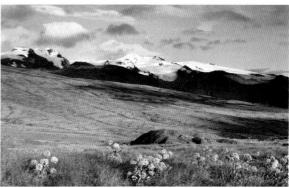

of Iceland. Today it forms just 1 percent. On the European continent it can reach a height of 66 feet (20 meters), on Iceland 6½ feet (2 meters) is the norm. *Betula pubescens* is closely related to the silver birch (*B. pendula*). Rowan (*Sorbus aucuparia*) grows to a height 6½ feet (2 meters) in poor conditions and 33 feet (10 meters) in favorable conditions. It is found as a single tree growing among birch woodlands, where its umbels of white flowers followed by bright red berries makes it stand out from the birches. Bog bilberry (*Vaccinium uliginosum*), not surprisingly, grows in bogs and is common in Iceland. It has tubular white flowers and edible blue berries. It has smooth leaf margins unlike

the fine-toothed leaf margins of its close relative *V. myrtillus.*

A characteristic herbaceous endemic species is the Icelandic hawkweed (*Pilosella islandica*). Closely related to the dandelion, it has long black hairs along the stem and golden yellow flowers. The semi-endemic *Alchemilla faroensis* grows in eastern Iceland and is like the common lady's mantle (*A. mollis*), only with more of a split between the leaf lobes. It has lime green flowers in the summer. The northern green orchid (*Platanthera hyperborea*) is a common orchid of heath and grassland. It has a short, leafy stem and flower spike of small, yellowish green flowers.

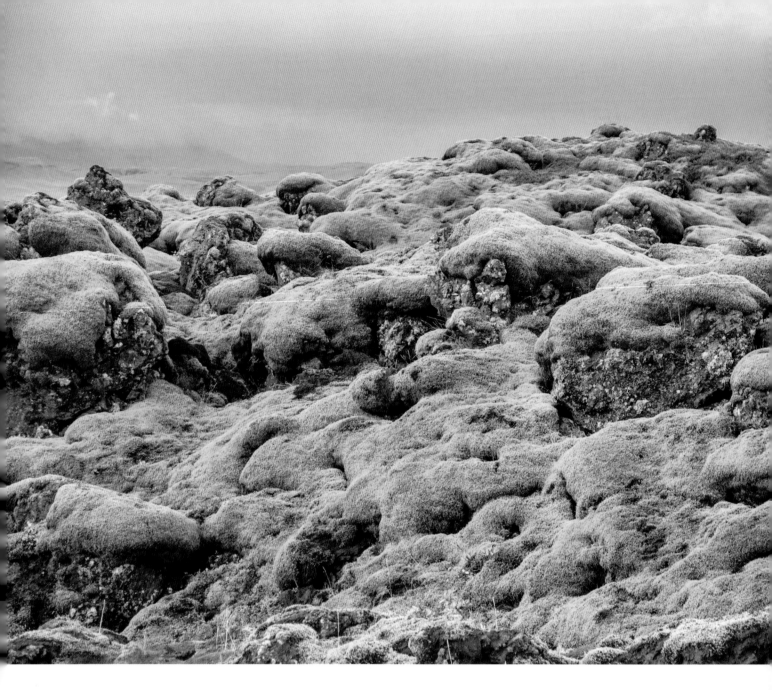

Mountain avens (*Dryas octopetala*) is common in gravel and sandy soils. It is an evergreen mat-forming plant growing to a height of 4 inches (10 centimeters). The leaves are shiny and look like tiny oak leaves. The white eight-petalled flowers open in early summer, followed by silky seed heads. It flowers at the same time as arctic thyme (*Thymus praecox* subsp. *arcticus*) and, as they grow together, grasslands and gravel slopes are covered in the white of the avens and the hot pink of the thyme. They are gorgeous together.

Bryophytes are a group consisting of three types of nonvascular land plants: mosses, hornworts, and liverworts. In Iceland, 606 species of bryophytes have been recorded, with a total of 460 moss species. Three species of woolly fringed moss (*Racomitrium lanuginosum, R. ericoides,* and *R. canescens*) are among the most common plant

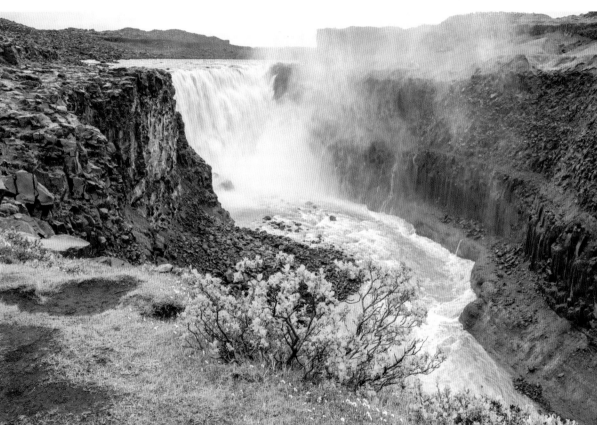

From left: Woolly fringe moss (*Racomitrium languinosum*). • Dettifoss Waterfall is fed by the powerful glacial river Jökulsá á Fjöllum, which flows from Vatnajökull.

species found in Iceland. Woolly fringed moss grows in large mats, dominating the lava fields across south and west Iceland. Its stems are up to 4¾ inches (12 centimeters) long and irregularly branched. The leaves end in a long, thin hairpoint. When dry, the hairpoints have a woolly appearance, hence the common name.

Iceland moss (*Cetraria islandica*) looks like a moss, but is actually a lichen. It is tough, shrublike, and bushy and grows to a height of 3 to 4 inches (7.6 to 10 centimeters) with thin, branched tubes that end in flattened lobes fringed with tiny papillae. The color is variable, ranging from white-spotted light chestnut to grayish white. Reindeer moss (*Cladonia rangiferina*) is also not a moss but a lichen. About 550 species of lichen have been recorded in Iceland and this is one that is more easily identified and one of the most beautiful.

VATNAJÖKULL NATIONAL PARK

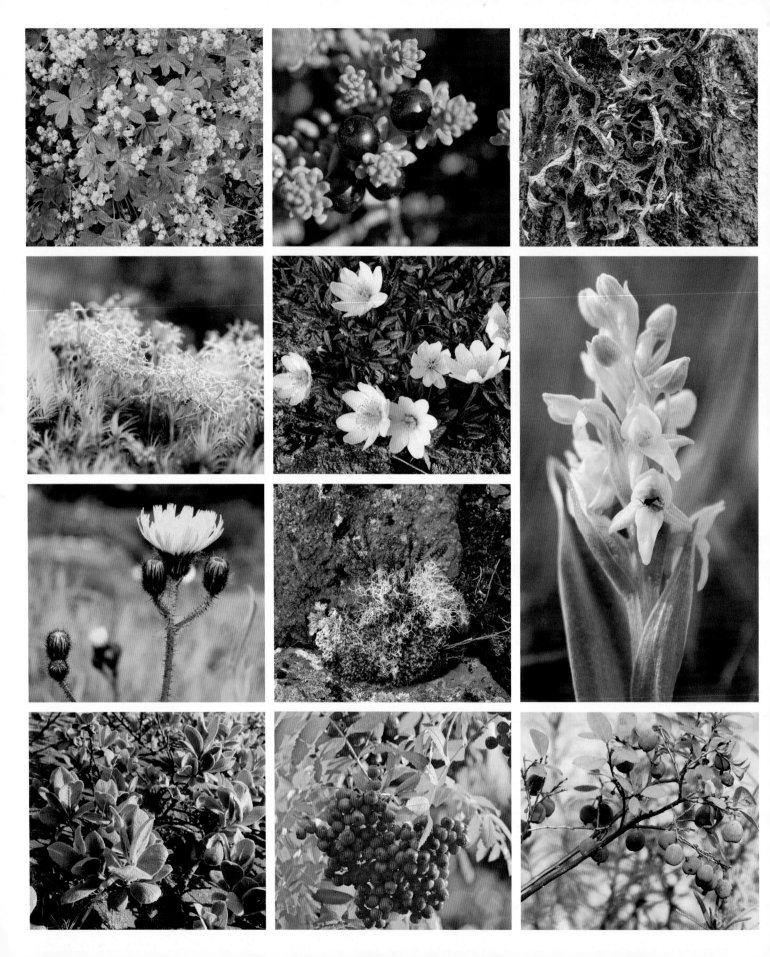

First column: Native to Iceland, a lovely species of lady's mantle (*Alchemilla faeroensis*). • Reindeer lichen (*Cladonia rangiferina*). • Icelandic hawkweed (*Pilosella islandica*). • Tea-leaved willow. *Second column:* Black crowberry (*Empetrum nigrum*). • Eight-petalled mountain avens (*Dryas octopetala*). • Life here is not frozen, life here is not barren, life is everywhere here. • Rowan berries. *Third column:* Iceland moss (*Cetraria islandica*), which is not a moss but actually a lichen. • Northern green orchid (*Platanthera hyperborea*). • Bog bilberry (*Vaccinium uliginosum*).

Below: When the snow melts, the green prevails.

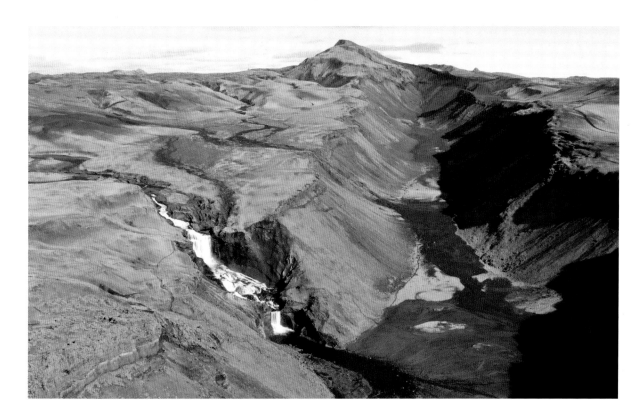

It is a slow-growing, erect, branched lichen with each branch subdivided into three or four smaller branches, creating a lacy, thick spiderweb effect. It is mostly white in color but also pale green or a chestnut white. It often covers miles of woodland floor and rocky ground.

Lichens are an organism and an ecosystem unto themselves. Until recently, it was though that lichens were made up of two partners—a fungus and an alga. But recent thinking is that many lichens are made up of three partners—two fungi and an alga. Quite what the relationships between the fungi and alga have are still to be determined. Lichens are formed through fusion, creating many forms. Some look like mosses, some look like green and yellow crusts. Some look like spiderwebs strung between rocks and trees.

When summer comes and the snow recedes from the lower slopes of Vatnajökull National Park, green life reappears. The moss and lichens cover the ground like a green and white mist, the small birches are in leaf, green against the backdrop of ice. Arctic thyme, a seemingly incongruous hot pink, is buzzing with bees. Blue ice caves, exploding hot geysers, roaring waterfalls, quiescent lava flows, and floating icebergs. It is a land of fire and ice, and green, green, green.

VATNAJÖKULL NATIONAL PARK

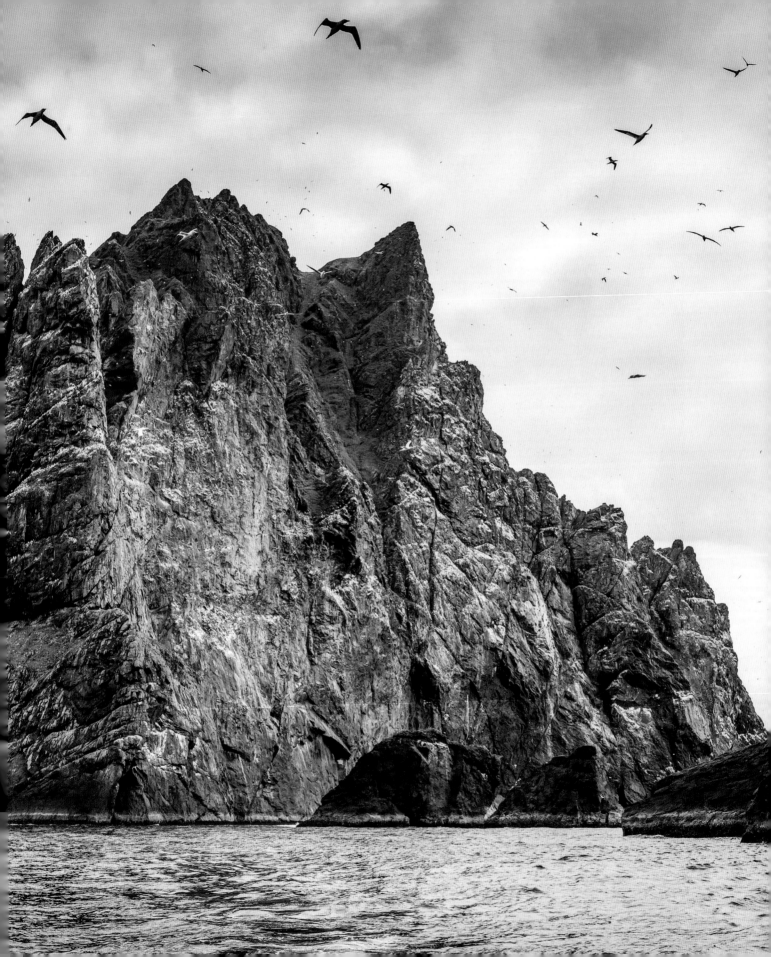

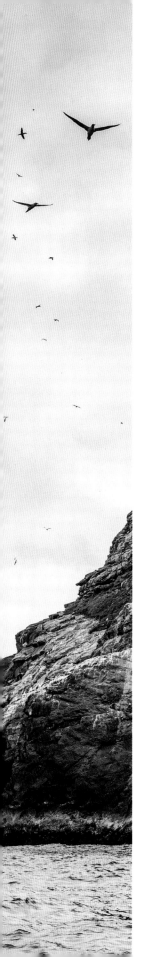

This volcanic archipelago, with its spectacular landscapes, is situated off the coast of the Hebrides and comprises the islands of Hirta, Dun, Soay, and Boreray. It has some of the highest cliffs in Europe, which have large colonies of rare and endangered species of birds, especially puffins and gannets. The archipelago, uninhabited since 1930, bears the evidence of more than 2000 years of human occupation in the extreme conditions prevalent in the Hebrides. Human vestiges include built structures and field systems, cleits, and the traditional Highland stone houses. They feature the vulnerable remains of a subsistence economy based on the products of birds, agriculture, and sheep farming.

UNITED
KINGDOM
OF GREAT
BRITAIN AND
NORTHERN
IRELAND

St. Kilda

The National Trust for Scotland owns this entire archipelago. It became one of Scotland's six World Heritage Sites in 1986 and covers a total area of 59,802 acres (24,201 hectares) including the land and sea. St. Kilda contains the westernmost islands of the Outer Hebrides—Hirta, Boreray, Dun, and Soay—and the sea stacks Levenish, Stac an Armin, and Stac Lee.

There are no trees. Wicked cold winds, vicious salt spray, and acidic soil ensure that. There were trees in the past. In the Early Atlantic period (8000 to 7000 years

St. Kilda, rugged and constantly buffeted by the harsh weather but home to nearly one million seabirds.

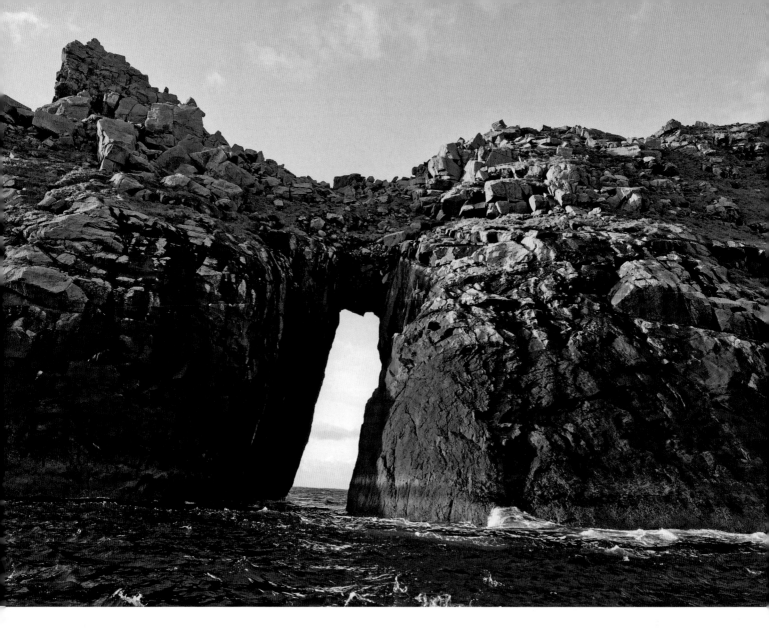

before present) the climate was warmer and pollen records tell us there was woodland scrub consisting of hazel (*Corylus*) and birch (*Betula*) with alder (*Alnus*), elm (*Ulmus*), and oak (*Quercus*). No more.

The absence of trees does not mean that there are not highly complex grass communities as well as large areas of heather (*Calluna vulgaris*), and bell heather (*Erica cinerea*). Fragrant hills of purple heather on the edge of the world. And to add to the fragrance and the color, wild thyme's lemon scent wafts on the wind, with purple-pink flowers nestled close to the ground. Wild thyme's botanical name is

Thymus praecox subsp. *britannicus* and it grows just up to 2 inches (5 centimeters) and flowers in June to September.

As for grasses, there are *Holcus lanatus*, with hairy, gray-green leaves and a purple-tinged inflorescence, creeping bent grass (*Agrostis stolonifera*), fine-textured bent grass (*Agrostis capillaris*), the vigorous and often dominant red fescue (*Festuca rubra*), and sweet vernal grass (*Anthoxanthum odoratum*) with its honied smell of coumarin, the first to flower.

Cottongrass (*Eriophorum vaginatum*), a sedge, not a grass, grows in the numerous bogs, and has

Below, from left: The most remote location in the British Isles, 50 miles west of the Outer Hebrides, and abandoned since the 1930s. • A shelter likely used by a former herdsman.

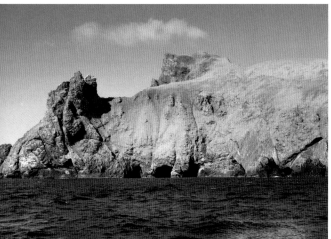

very narrow hairlike leaves and single spikes of cottony flowers. The great woodrush (*Luzula sylvatica*), its glossy bright green leaves 12 inches (30 centimeters) long, grows along stream banks and on the peaty moors, particularly in the shade of rocks covered with woolly fringe moss (*Racomitrium lanuginosum*). Moonwort (*Botrychium lunaria*), a fern, appears in the drier meadows. The lower, infertile portion of the stem supports leaves that are half-moon shaped; the upper, fertile part produces a cluster of rounded spores. It is a small plant, growing to around 3 inches (7.6 centimeters) in height. Adder's tongue (*Ophioglossum vulgatum*), is another fern, although it doesn't look like one. It grows on peat and in between rocks and has a two-part frond. One part, a sheaf, looks like an adder's tongue, the other part is a narrow spore-bearing spike. Field

gentian (*Gentianella campestris*) grows in the grassland once used for grazing. Field gentian has 5 to 15 bluish purple flowers on 12-inch (30-centimeter) stems in July and August. One of the rarest plants in Scotland and endemic only to Hirta, the St. Kilda dandelion (*Taraxacum pankhurstianum*) is smaller than the common dandelion with hairy exterior bracts on the flower. The species was named for Richard Pankhurst, a retired staff member of the Royal Botanic Garden Edinburgh.

The great yellow bumblebee (*Bombus distinguendus*) has declined by 80 percent in the last century, making it one of the United Kingdom's rarest bumblebees. It is now only found in the north Highlands and the Islands of Scotland, particularly St. Kilda. Three rare breeds of sheep inhabit the archipelago: Soay sheep, a short-tailed four-horned breed that is

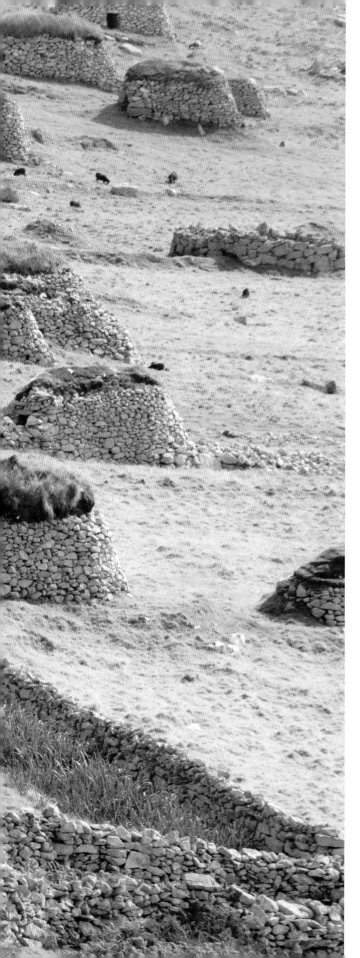

From left: Ancient wall structures and shelters. •
Stac an Armin, home to one of the largest gannet
colonies in the world.

157

extremely hardy and is generally dark brown with a
white underbelly, the Boreray blackface, and the St.
Kilda, now called Hebridean sheep.

One would be remiss not to mention seabirds.
Not just about their numbers but the secondary
value they bring to the islands. Guano is a highly
important fertilizer for the plants that grow in
poor soil, and millions of eggshells, deposited over
millennia, add to the soil. One million seabirds
have been recorded: an estimated 300,000 pairs

First column: Agrostis capillaris. • Pink heather. • Millions of cottongrass pods blow in the constant wind. • Great woodrush (*Luzula sylvatica*), the largest of the woodrushes. *Second column:* Sweet vernal grass (*Anthoxanthum odoratum*). • The bells of *Erica cinerea.* • Field gentian (*Gentianella campestris*) can have four or five petals. • It's clear why *Ophioglossum vulgatum* is called adder's tongue. *Third column:* Moonwort (*Botrychium lunaria*). • Red fescue (*Festuca rubra*). • *Holcus lanatus.* • *Thymus praecox.*

Below, clockwise from top left: These rams originated on the St. Kilda archipelago and survive as a feral animal on Boreray. • A Hebridean sheep, likely introduced by the Vikings and known for its hardiness. • Soay, a short-tailed breed of sheep. • The great yellow bumblebee (*Bombus distinguendus*) only exists in the United Kingdom on its most northern locations and is one of a few crucial pollinators for the archipelago.

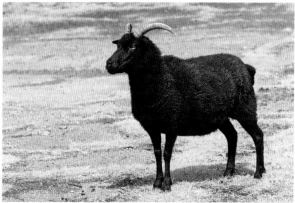

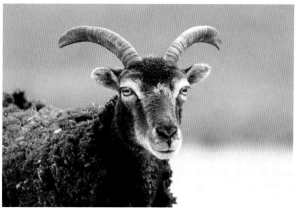

of puffins, 60,000 pairs of gannets, 40,000 pairs of fulmars, 20,000 pairs of guillemots, 10,000 pairs of kittiwakes, plus Manx shearwaters, storm petrels, Leach's petrels, and great skuas. And, while not a seabird, there is also the endemic St. Kilda wren (*Troglodytes troglodytes hirtensis*), which has evolved into a much larger subspecies of the mainland wren.

From the Bronze Age to the 20th century, humans lived on the islands. They fished, they farmed, they ate a lot of seabirds. As much barley, oats, and potatoes as they could grow were eaten and stored to last the winter. They were evacuated in 1930 because life on St. Kilda was too harsh. Now the islands are left to the birds and the plants. And to the sea and the wind.

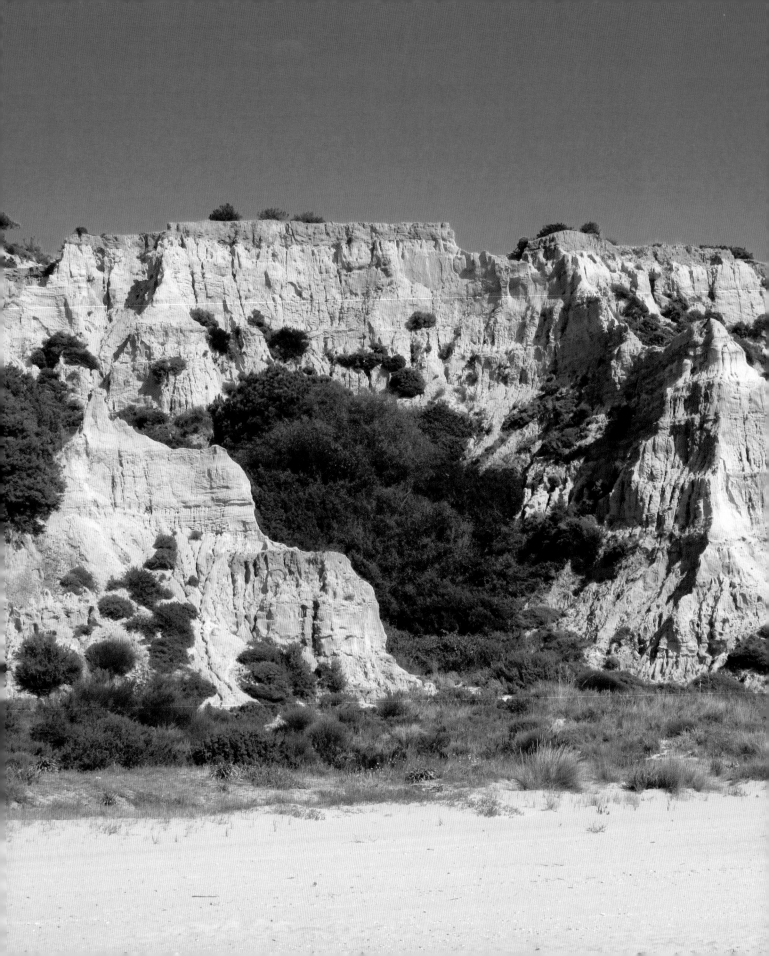

Doñana National Park in Andalusia occupies the right bank of the Guadalquivir River at its estuary on the Atlantic Ocean. It is notable for the great diversity of its biotopes, especially lagoons, marshlands, fixed and mobile dunes, scrub woodland, and maquis. It is home to five threatened bird species. It is one of the largest heronries in the Mediterranean region and is the wintering site for more than 500,000 waterfowl each year.

Doñana National Park SPAIN

On the southern Atlantic coast of Spain in Andalusia, 31 miles (50 kilometers) southwest of Seville, between the coastal towns of Huelva and Sanlucar de Barrameda and the right bank of the Guadalquivir River, the park is in a Conservation International–designated Conservation Hotspot, a WWF Global 200 Marine Ecoregion, and a WWF/IUCN Centre of Plant Diversity, and overlaps a Ramsar wetland and a UNESCO Biosphere Reserve. It was inscribed as a World Heritage Site in 1994.

Eroded sandstone cliffs, a crucial habitat.

Opposite: Lagoons and hollows provide important habitat.

Below, from left: These wetlands are key to the survival of five threatened bird species and serve as a wintering site for 500,000 waterfowl. • Stone pine, a tree most evocative of the Mediterranean.

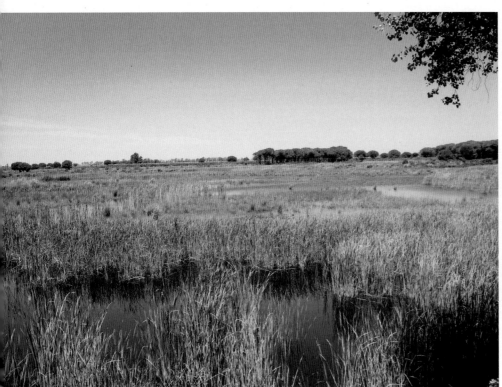

Doñana National Park is a vast undeveloped coastal marshland on the right bank of the Guadalquivir estuary, cut off from the Atlantic by extensive dunes and subject to seasonal variations in water level and salinity. During the summer it is a dry plain, in the winter it becomes a wide shallow lake. It comprises three main areas: marsh with watercourses and ponds, coastal and inland dunes, and heath scrub and woodland. Over half the park's area was originally marismas—freshwater marshes on accumulated clayey silt. These have been reduced by more than 80 percent over the past century. More than half the water used to come from the Guadalquivir River, which runs through the center of the marshes, but the chief present source is rainfall. The water table is perched near the surface,

creating the great biological richness of the park. Low-lying areas are filled with deep organic matter and the clay is rich in calcium and magnesium. The marshes are fed by the Arroyo de la Madre de las Marismas del Rocio, which flows parallel with the coastal dunes, and by the Guadalquivir River. There are also flowing interfluves carved by natural drainage, depressions that hold wet-season lagoons, and hollows with upwelling groundwater, which together form a mosaic of microhabitats: pools, streams, mudflats, reedbeds, banks, and islands.

The coastal dunes, each about 1¼ miles (2 kilometers) long by 656 feet (200 meters) across and up to 131 feet (40 meters) high, parallel the coast for 15 miles (25 kilometers). The seaward dunes are mobile, moving from 13 to 20 feet (4 to 6 meters) a

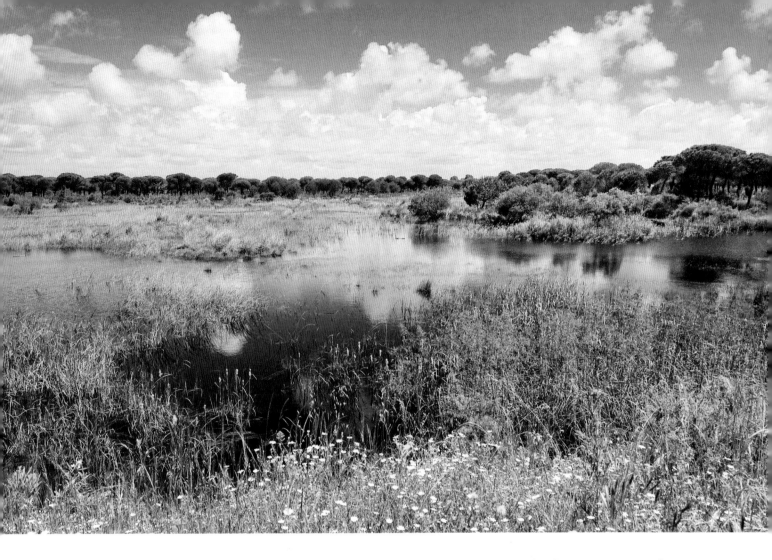

year before the southwesterly winds, burying pine woods as they go. The inland dunes are stabilized by scrub vegetation and in the hollows between them are lagoons and marshes. The heathland banks are a series of low ridges and hollows that form a narrow ecotone between the dunes and the marsh and cover the land farthest from the Guadalquiver. This is the most stable and biologically rich area of the park.

The great variety of sedimentary deposits has created a great variety of habitats. There are four main types of vegetation: marshland/aquatic, salt-tolerant, open forest, and heathland. The marsh vegetation depends on the degree of soil salinity and the duration of flooding. The higher zones support salt-tolerant plants such as glasswort (*Salicornia ramosissima*), seepweed (*Suaeda vera*),

and perennial glasswort (*Arthrocnemum perenne*). All three are members of the amaranth family (Amaranthaceae).

The seasonally flooded hollows are covered with sea clubrush (*Bolboschoenus maritimus*), lakeshore bulrush (*Schoenoplectus lacustris*), and crowfoot (*Ranunculus baudotii*), a buttercup with white petals with a yellow base at the center.

Plant communities on the dunes have a notable degree of endemism. The outer dunes are sparsely vegetated with marram grass (*Ammophila arenaria*), growing to a height of 4 feet (1.2 meters) from a network of thick rhizomes, and white blueberry (*Corema album*), a small shrub in the heath family (Ericaceae), with whorled leaves and edible white or pink-white fruits in the summer.

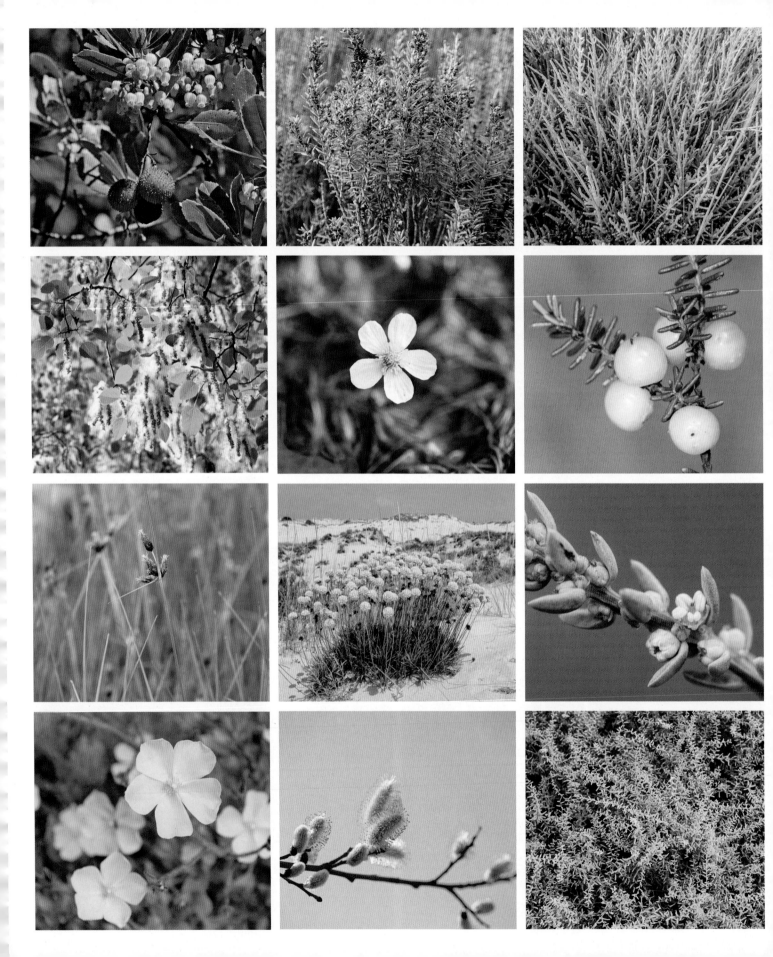

First column: The strawberry tree (*Arbutus unedo*). If only there was a cream tree . . . • The summer snow of white poplar's cotton. • Sea clubrush (*Bolboschoenus maritimus*). • Buttercup yellow rockrose (*Halimium commutatum*). *Second column:* Green heather (*Erica scoparia*). • *Ranunculus peltatus* subsp. *baudotii*. • Sea thrift growing in pure sand. • Gray willow (*Salix atrocinerea*), a pioneer species. *Third column:* Salt-tolerant *Salicornia ramosissima* grows in the marshes. • White blueberry (*Corema album*) ripening in the late summer sun. • Seepweed flowers. • Seepweed (*Suaeda vera*), an important succulent in the park.

Below, from left: Conifers here are dwarfed by nutrient-poor soil, rushes and marshes, and ever-shifting sands. • Plant communities on the dunes have a notable degree of endemism.

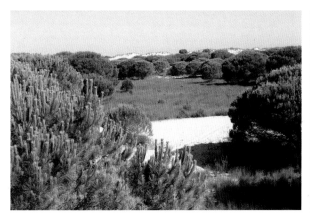
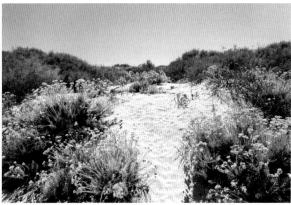

evergreen shrub with pale green leaves and masses of saucer-shaped golden yellow flowers in May and June. *Halimium halimifolium* has yellow flowers, sometimes with a red blotch at the base of each petal. Rosemary (*Salvia rosmarinus*), an aromatic evergreen shrub with blue flowers, and Spanish lavender (*Lavandula stoechas*), with round heads of small purple flowers topped with a tuft of purple bracts, bloom together in spring and summer.

There are four strictly protected plants in the park, all national endemics. Three are grasses—*Micropyropsis tuberosa*, *Gaudinia hispanica*, and *Vulpia fontquerana*—and one, *Linaria tursica*, is an annual toadflax.

Bring a good pair of binoculars when you visit Doñana National Park, for when you are not looking at the plants, you will be looking at the birds. In winter: barn swallows, the greater spotted cuckoo,

greater flamingo, common cranes, lapwings, shanks, ruffs, godwits, small plovers, and dunlins. In spring: short-toed eagles and ospreys, wheatear, common redstart, whinchat, and willow warbler. In summer: Sardinian warblers, Cetti's warblers, short-toed treecrepers, chaffinches, serins, goldfinches, and greenfinches. And in fall: white storks, spoonbills, gray herons, little egrets, cattle egrets, black-winged stilts, black-tailed godwits, red kites, black kites, and lesser kestrels. To name but a few.

If you are particularly fortunate, you may see the Spanish imperial eagle (*Aquila adalberti*), one of the rarest raptors in the world. It is very similar to the golden eagle, but slightly smaller in body length and wingspan. About 10 pairs nest in the park, and on occasion can be seen soaring over the golden marshlands looking for prey. Wouldn't it be wonderful to see them?

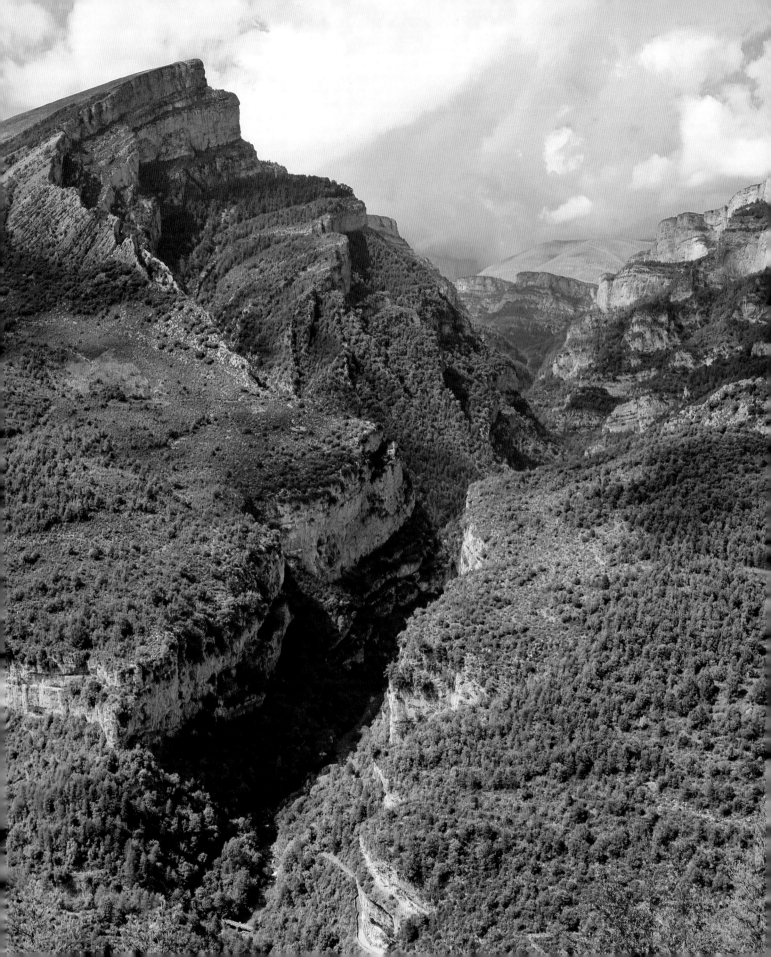

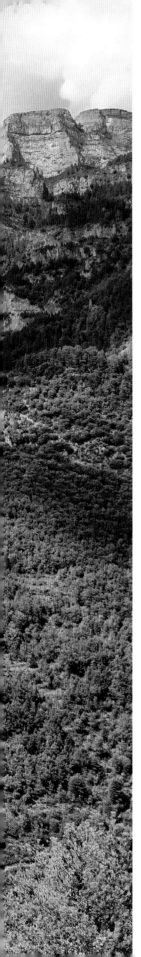

This outstanding mountain landscape, which spans the contemporary national borders of France and Spain, is centred around the peak of Mont Perdu, a calcareous massif that rises to 11,000 feet (3352 meters). The site, with a total area of 75,710 acres (30,639 hectareds), includes two of Europe's largest and deepest canyons on the Spanish side and three major cirque walls on the more abrupt northern slopes with France—classic presentations of these geological landforms. The site is also a pastoral landscape reflecting an agricultural way of life that was once widespread in the upland regions of Europe but now survives only in this part of the Pyrénées. Thus, it provides exceptional insights into past European society through its landscape of villages, farms, fields, upland pastures, and mountain roads.

Pyrénées—
Mont Perdu

FRANCE
AND SPAIN

The calcareous massif of the Pyrénées—Mont Perdu—located on the border between France and Spain, is composed of classical geological landforms, notably the deeply incised canyons on the southern Spanish side and spectacular cirque walls on the northern slopes within France. Centered around the peak of Mont Perdu, which rises to 10,984 feet (3348 meters), and covering a total area of 75,710 acres (30,639 hectares), it is an exceptional landscape with meadows, lakes, caves, and forests on the mountain slopes. The northern slopes have a humid

A deep gorge sculpted for centuries by the intense erosion of the Bellós River.

169

From left: Cirque of Soaso. • Mont Perdu. • The cirque of Gavarnie, described by Victor Hugo as "the Colosseum of nature" due to its enormous size and horseshoe shape resembling an ancient amphitheatre.

maritime climate while the southern slopes have a drier Mediterranean climate. It was inscribed as a World Heritage Site in 1997.

Human settlement in the region dates to the Upper Paleolithic period (40,000 to 10,000 BCE) as the sites of the Añisclo and Escuain Caves, the stone circles at Gavarnie, and the dolmen at Tella bear witness. Documents from the Middle Ages have recorded these sedentary settlements in history. They were located on the slopes of the massif and neighboring valleys, formed by a river network that irrigated the fields along the valleys in the north. These settlements were at the center of an agropastoral system based on the movement of livestock to higher pastures during the summer months.

The site extends over some 12½ miles (20 kilometers) of the High Pyrénées. In this part of the range, the precipitous northern slopes are carved into three sheer-walled glacial cirques with high intervening ridges cascading with waterfalls, towering spectacularly above farmed and forested valleys. The barren less steep southern slopes are a high arid steppe deeply fissured by two of Europe's largest and deepest canyons, Ordesa and Añisclo; two deep valleys, Pineta and the gorge of Escuaín, separated by three mountain spurs; and the cirque of Soaso. The valleys run parallel to the main range, open to oceanic influences from the west. On the ridge between is Mont Perdu, the third-highest peak in the Pyrénées and one of three jagged peaks formed from a 9842-foot (3000-meter) ridge of limestone 50 million years old. The name Perdu, which means "lost," was given because the peak is invisible from the north. It is a country of

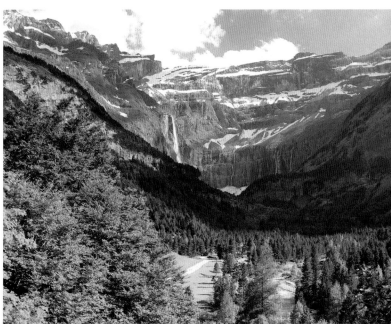

fast-receding glaciers—the Mont Perdu glacier shrank by 85 percent during the 20th century.

Most probably know of edelweiss from the saccharine song from the *Sound of Music*. Comparatively few have seen it in the wild. *Leontopodium alpinum* is a charming plant with starry white flowers carried above a clump of silvery green leaves. It grows about 12 inches (30 centimeters) tall. The leaves and flowers are covered in white hairs, the better to protect itself from intense radiation, cold, and dryness. It is one of the symbols of the park and grows between rocks and on scree high on the mountain. Rock jasmine (*Androsace pyrenaica*) grows with edelweiss. A compact rosette of tiny evergreen gray-green leaves with small, pure white, yellow-eyed flowers appears in midsummer. Together, they are quite lovely.

The endemic Pyrenean violet (*Ramonda myconi*) is not without charm too. It is a rosette-forming evergreen perennial growing to 4 inches (10 centimeters) high by 8 inches (20 centimeters) wide, and has round, crinkled leaves and five-petalled purple flowers with prominent yellow anthers appearing in spring. Pyrenean saxifrage (*Saxifraga longifolia*) has been called the king of saxifrages. It is a mat-forming evergreen that produces a whirling rosette of lime-encrusted leaves 4 inches (10 centimeters) long. The leaves are edged with silver. It produces a 24-inch (60-centimeter) high flowering stem with many white flowers. It is monocarpic—it dies after flowering but often seeds prolifically. Growing on shady, wet, limestone rocks is an unusual carnivorous plant, *Pinguicula longifolia*, the long-leaved butterwort. The first carnivorous

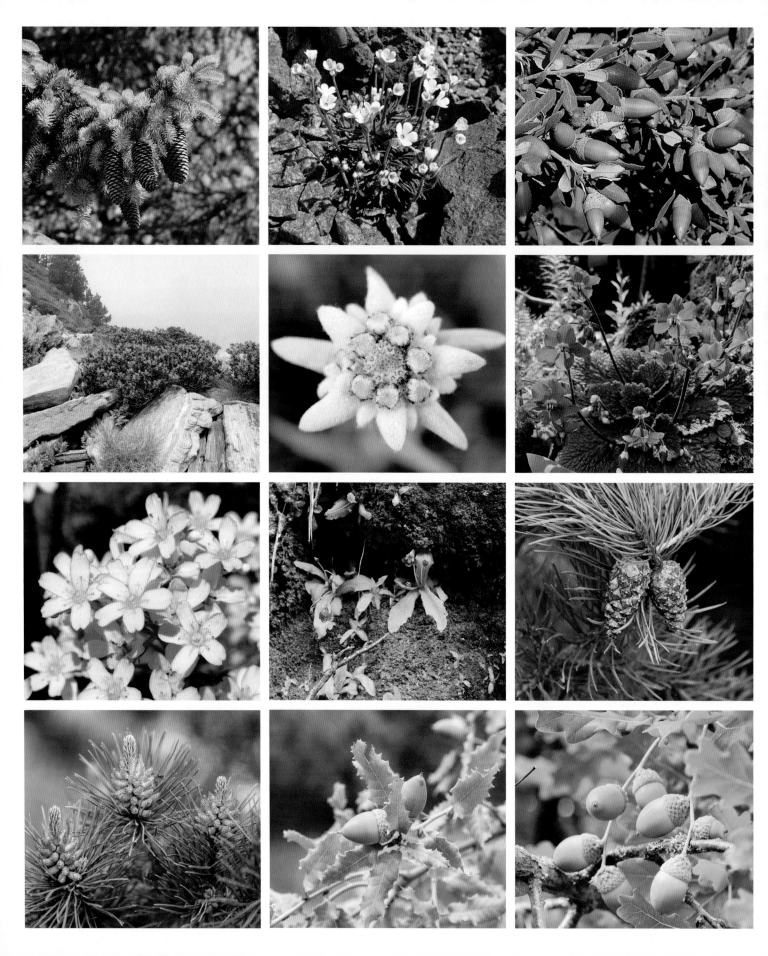

First column: Silver fir (*Abies alba*) features cones that disintegrate to release the seeds. • *Rhododendron ferrugineum* nestled in high-altitude rocks. • Pyrenean saxifrage (*Saxifraga longifolia*). • Mountain pine (*Pinus uncinata*). *Second column:* The captivating rock jasmine (*Androsace pyrenaica*) with pure white, yellow-eyed flowers. • Edelweiss, one of the more recognizable alpine flowers. • Long-leaved butterwort (*Pinguicula longifola*). • Portuguese oak (*Quercus faginea*). *Third column:* Holm oak (*Quercus rotundifolia*). • Pyrenean violet (*Ramonda myconi*). • Scots pine (*Pinus sylvestris*). • Sessile oak (*Quercus petraea*).

Below: Alpenrose (*Rhododendron ferrugineum*) growing close to the tree line.

leaves are produced in spring. In summer, the leaves can reach a length of 5½ inches (14 centimeters) and have mucilaginous stalks that trap spiders and other unwary prey.

The original forest at the lower levels was removed by burning and cutting so that the present forest, though dense, is not primary growth. There is nevertheless a rich mosaic of vegetation in contrasting zones within the site: sub-Mediterranean, montane, subalpine, alpine, and rock with scree. The sub-Mediterranean type is mostly found in valleys in the south and is dominated by holm oak (*Quercus rotundifolia*), an evergreen oak with small, dark green round leaves with a gray-blue underside. It can reach a height of 39 feet (12 meters). It flowers in spring and sometimes in the autumn. In deep soils there are stands of Portugese oak (*Q. faginea*). It is a large semi-evergreen tree, up to 69 feet (21 meters) high, with leathery oblong or elliptic leaves.

The montane vegetation is dominated by sessile oak (*Quercus petraea*), a deciduous oak growing to a height of 131 feet (40 meters). The leaves are dark green and lobed with a wavy edge, and the acorns are without stalks (sessile). The mountain areas are populated by European beech (*Fagus sylvatica*), silver fir (*Abies alba*), and Scots pine (*Pinus sylvestris*). The subalpine vegetation has large numbers of mountain pine (*Pinus mugo*

subsp. *uncinata*), dwarfed by the absence of soil, cold climate, and sharp wind. Above the tree line, alpenrose (*Rhododendron ferrugineum*) blooms with tubular pink-red flowers. It has glossy, dark green leaves with the underneath covered in rusty spots and, high on the mountain, grows to about 3 feet (1 meter).

Poor Princess Pyrene, the lover of Hercules. Bearing his child, she ran away to the forest. Attacked by a bear, she died in pain. She was buried in the Lombrives Cave. With words of farewell, Hercules spoke, "Your name, beloved Pyrene, will forever remain in our hearts. These mountains, where you fall asleep for forever, in honor of you will be called the Pyrénées."

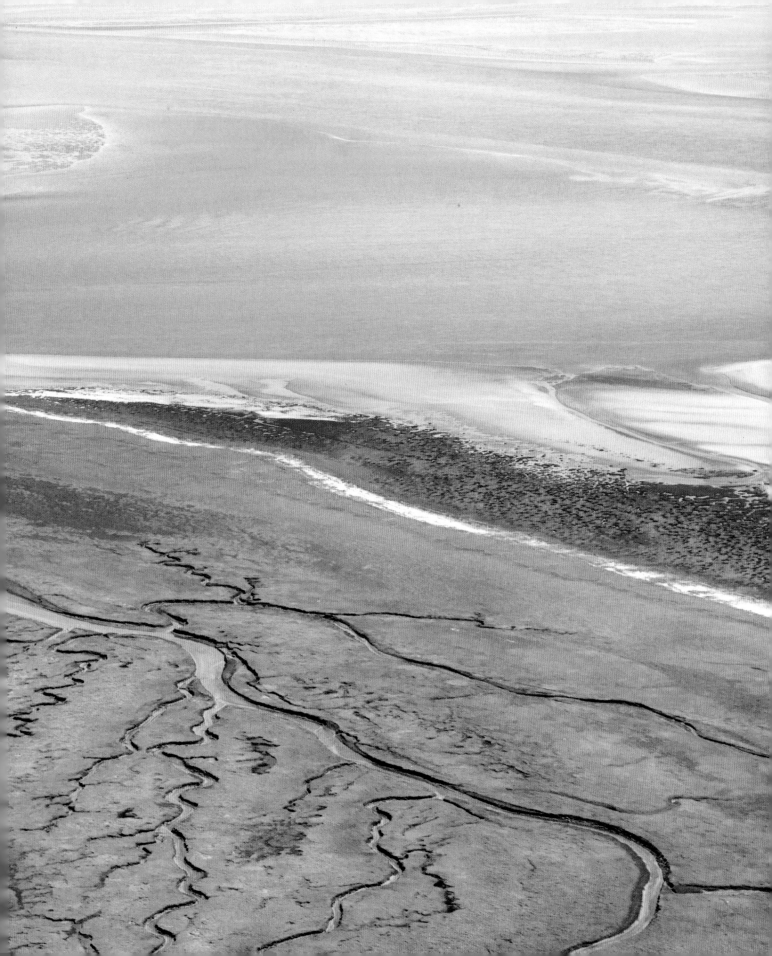

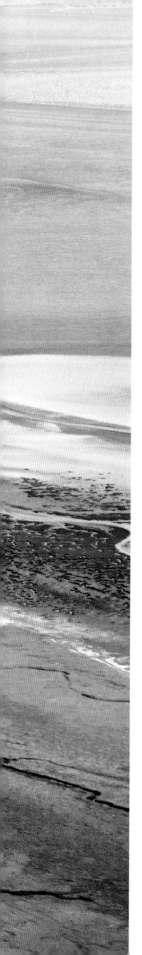

The Wadden Sea is the largest unbroken system of intertidal sand and mud flats in the world. The site covers the Dutch Wadden Sea Conservation Area, the German Wadden Sea National Parks of Lower Saxony and Schleswig-Holstein, and most of the Danish Wadden Sea maritime conservation area. It is a large, temperate, relatively flat coastal wetland environment, formed by the intricate interactions between physical and biological factors that have given rise to a multitude of transitional habitats with tidal channels, sandy shoals, seagrass meadows, mussel beds, sandbars, mudflats, salt marshes, estuaries, beaches, and dunes. The area is home to numerous plant and animal species, including marine mammals such as the harbor seal, gray seal, and harbor porpoise. Wadden Sea is one of the last remaining large-scale intertidal ecosystems where natural processes continue to function largely undisturbed.

Wadden Sea

DENMARK,
GERMANY,
AND THE
NETHERLANDS

Mud matters. Waddenzee, Wattenmeer, Vadehavet, Waadsee. The word *wad* is Frisian and Dutch for "mud flat." The Wadden Sea is located right at the center of the southeastern continental coastline of the North Sea, which stretches from Cape Cris Nez near Calais over a length of 745 miles (1200 kilometers) to Skagen, the northern tip of Jutland. The seven component parts of the property extend 403 miles (650 kilometers) along the southeastern coast of the North Sea between the islands of Texel and Sylt.

Aerial view of the Wadden Sea National Park in Germany.

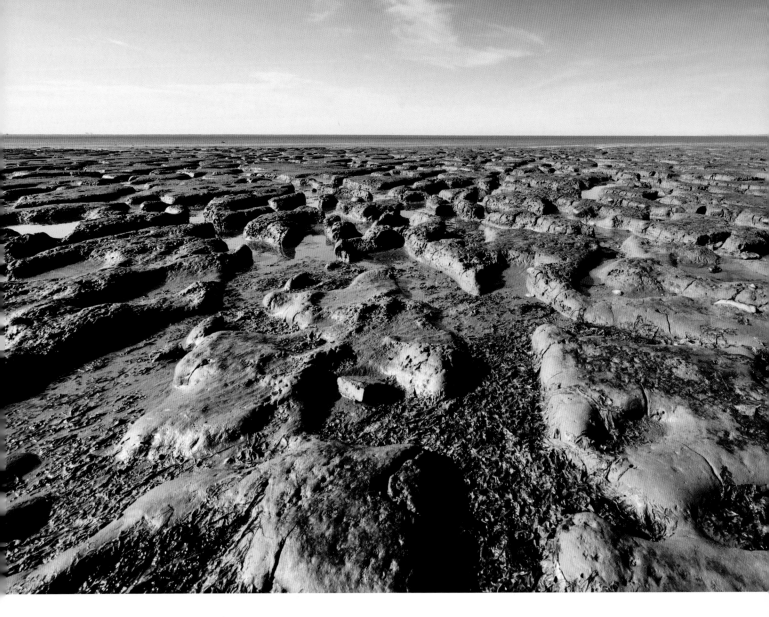

Inscribed as a World Heritage Site in 2009, the Wadden Sea comprises a vast system of intertidal sand and mud flats. It encompasses a multitude of transitional zones between land, sea, and freshwater environment, and is rich in species specially adapted to demanding environmental conditions. It is considered one of the most important areas for migratory birds in the world and is connected to a network of other key sites for migratory birds. Its importance is not only in the context of the East

Atlantic Flyway but also in the critical role it plays in the conservation of African-Eurasian migratory waterbirds. In the Wadden Sea up to 6.1 million birds can be present at the same time, and an average of 10 to 12 million pass through it each year.

The Wadden Sea is home to 2300 species of flora. The vegetation is predominantly related to salt marshes with the highest biodiversity found in sandy salt marshes and in the transition zone to dunes and dune grasslands. The marine vegetation

EUROPE

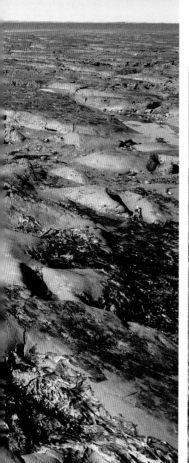

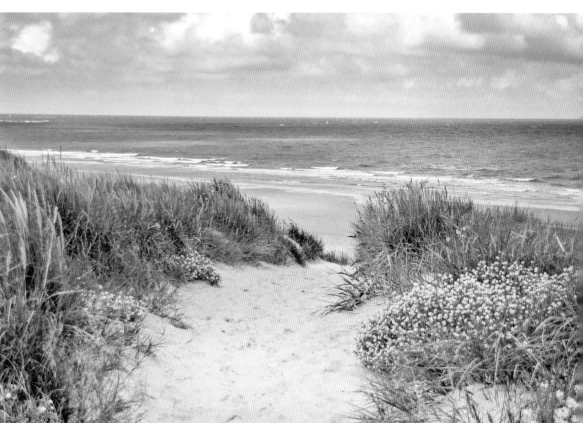

is characterized by seagrasses that occur in mixed stands on the tidal flats.

Some of the salt marsh halophytes are succulents, compensating for a high salt content by extending the vacuoles in their cells (*Salicornia* species and *Suaeda maritima*). Plants such as sea lavender (*Limonium vulgare*) and cordgrass (*Sporobolus anglicus*) are capable of excreting salt through special glands. Others excrete salt through bladder cells that fill with salt, then burst, releasing salt from the plant, or, like saltmarsh rush (*Juncus gerardii*), accumulate salt in their leaves until they die at the end of the season. Depending on sediment supply and wave action, the seaward edge of salt marshes may show a variable width of pioneer zone composed mainly of glasswort (*Salicornia* spp.) and cordgrass.

Cordgrass was planted extensively in the marshes of the Wadden Sea during the 1920s and 1930s. After establishment it colonized as a pioneer

WADDEN SEA

First column: Corn buntings were once common, now rare. • Sea lavender (Limonium vulgare). • The succulent leaves of Suaeda maritima are edible but extremely salty. Second column: Paddyfield warbler. • Black-headed gull. • Redshanks have a loud, piping call. Third column: Suaeda maritima thrives even in areas full of salt. • The northern lapwing, also known as the peewit. • Saltmarsh rush (Juncus gerardii).

Below, from left: Beautiful plains of wildflowers lead to tidal mud flats that lead to the sea. • Seals are recovering from hunting and habitat loss.

plant in the upper tidal zone, but due to its invasive habit, is now considered a potential threat to the biodiversity of the Wadden Sea ecosystem.

There are many other threats. In a report published in 1996, a total of 248 species of vascular plants were threatened in at least one subregion. Of these, 216 were threatened in the entire area. Seventeen are probably extinct. The status of 47 is probably critical; 61 are probably endangered; the status of 65 is probably vulnerable; and that of 26 species susceptible. Eelgrass (*Zostera marina*) and dwarf eelgrass (*Z. noltii*) are crucial to the healthy ecology of the sea. Populations have fluctuated over the last century. In 1932 a wasting disease due to *Labyrinthula zosterae* caused populations of *Z. marina* to perish. In 1965, it was observed that *Z. noltii* was in decline because of increasing pollution. Agricultural fertilizer runoff promoted green macroalgae that buried and suffocated eelgrass.

The Wadden Sea is a fundamentally changed ecosystem. Where once there were substantial populations of small cetaceans—harbor porpoise and bottlenose dolphin—they are now rare visitors. Gray seals were once abundant, then became extremely rare until the mid-20th century. Recent habitat protection and reduced hunting have enabled the seal to partially recover; this has been an animal conservation success, but the population is far from what it was a hundred years ago.

It is true, too, for some bird species, although almost one million ground-breeding birds belonging to 31 species use the site. The northern lapwing (*Vanellus vanellus*) has decreased 80 percent over the past 20 years. The common redshank (*Tringa totanus*) is not so common anymore, with its population down 60 percent. Black-headed gull (*Larus ridibundus*), corn bunting (*Miliaria calandra*), and paddyfield warbler (*Acrocephalus agricola*) have all seen substantial drops in population.

This transnational property includes 94 component parts in 18 countries. Since the end of the last ice age, European beech spread from a few isolated refuge areas in the Alps, Carpathians, Dinarides, Mediterranean, and Pyrenees over a short period of a few thousand years in a process that is still ongoing. The successful expansion across a whole continent is related to the tree's adaptability and tolerance of different climatic, geographical, and physical conditions.

Ancient and Primeval Beech Forests of the Carpathians and Other Regions of Europe

EUROPE

This transboundary property, inscribed as a World Heritage Site in 2007, stretches over 18 countries: Albania, Austria, Belgium, Bosnia and Herzegovina, Bulgaria, Czech Republic, Croatia, France, Germany, Italy, North Macedonia, Poland, Romania, Slovakia, Slovenia, Spain, Switzerland, and Ukraine. The Primeval Beech Forests of the Carpathians and the Ancient Beech Forests of Germany are indispensable to understanding the history and evolution of the genus *Fagus*, which, given its wide distribution in the Northern Hemisphere and its ecological importance, is globally

Dramatic chalk cliffs topped with forest on the island of Rügen, Germany.

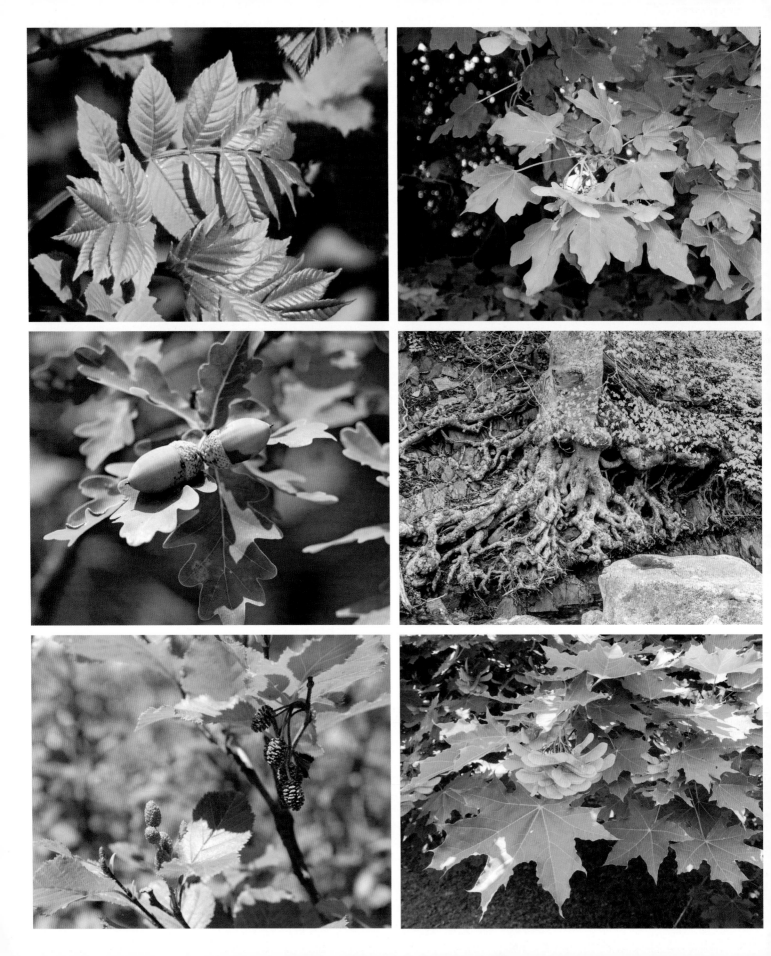

Opposite, clockwise from top left: European ash (*Fraxinus excelsior*). • Field maple (*Acer campestre*). • Ancient roots in the Albera Massif. • Norway maple (*Acer platanoides*). • Green alder (*Alnus viridis*). • Common oak (*Quercus robur*).

Below: The Albera Massif in the National Natural Reserve of Massane, France.

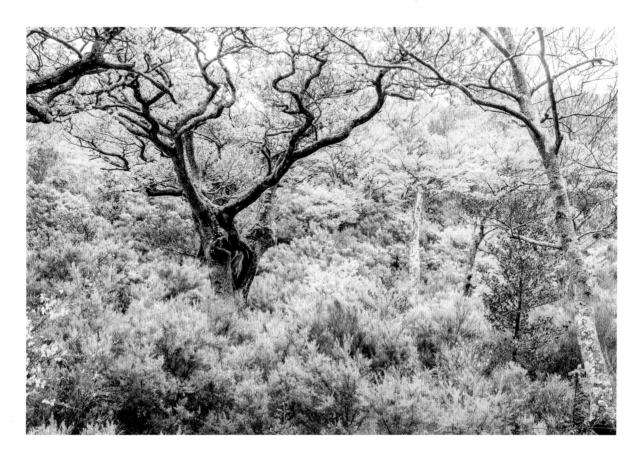

significant. European beech (*F. sylvatica*) is one of the most important elements of forests in the temperate broad-leaved forest biome and represents an outstanding example of the recolonization after the end of last ice age, about 11,550 years ago.

Beech trees survived the last ice age in small refuges in the south and southeast of Europe and, within the last 4000 years, went on to colonize large parts of the continent. Beech forests thrive in a wide spectrum of locations and are part of diverse forest communities from the seacoast of northwest Europe to the main European mountain ranges. They provide a natural habitat for more than 10,000 species of animals, plants, and fungi.

The 10 sites in Slovakia and Ukraine are in the East Carpathian Mountains, 5 in eastern Slovakia and southwestern Ukraine near the Polish border, and 5 in southwest Ukraine near where the mountains pass into Romania. The East Carpathian Mountains extend 621 miles (1000 kilometers) through Poland, Slovakia, Ukraine, and Romania. In Slovakia they are called Bukovske Vrchy (Beech Hills). They form a rolling ridge and valley landscape underlain by Upper Cretaceous and Early Tertiary sandstones and clay stones. The dominant soils are acidic and rocky brown forest soils with alluvium and some peat in the valleys. The many headwater streams flow south toward the Danube.

ANCIENT AND PRIMEVAL BEECH FORESTS

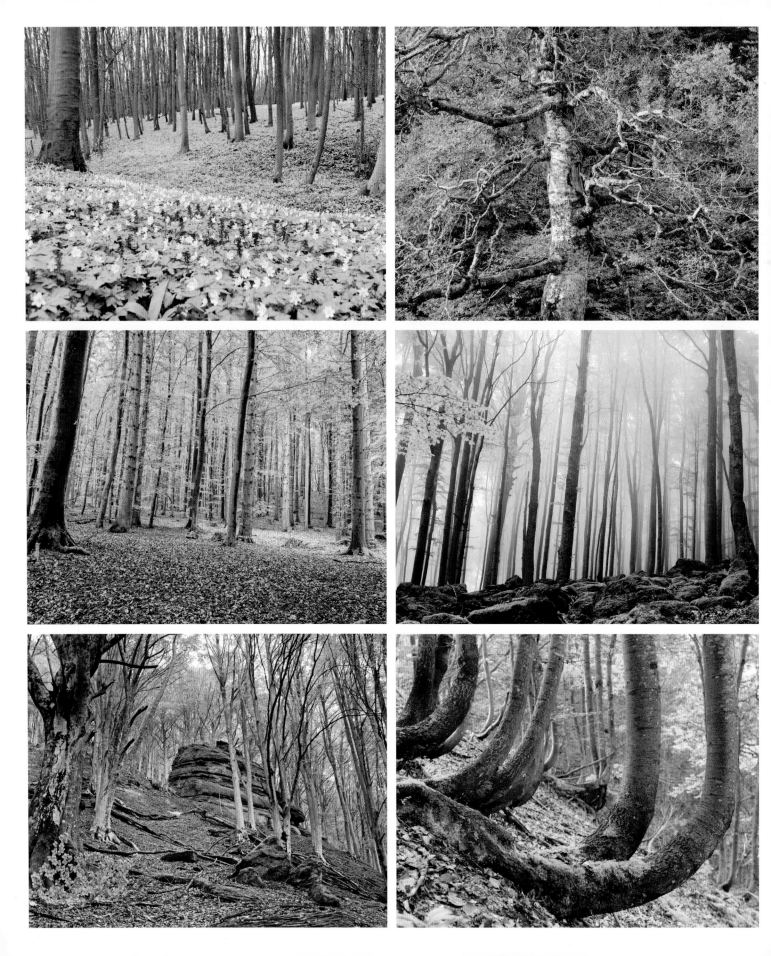

Opposite, clockwise from top left: Wildflowers carpet a beech forest in Hainich National Park, Germany. • An ancient beech near Abruzzo, Italy. • Green and watery light beneath the beech forest of the Central Balkans. • Sinuous trunks in the beech forest of Kalkalpen National Park, Austria. • As leaves turn golden in the autumn, the forest in the Casentinesi Nature Reserve turns almost blissful. • Sessile oak (*Quercus petraea*).

Below, from left: Small herbs cling to limestone rocks in the highest areas of the beech forest lands. • Paklenica National Park in Central Europe.

In Germany, the five forest sites are scattered from Thuringia and Hesse in central Germany to Brandenburg and Mecklenburg-West Pomerania in northeastern Germany. They illustrate a range of beech forest ecosystems from chalk sea cliffs and lowlands to low hills and acidic mountainsides. Jasmund on Rügen Island in the Baltic is a largely flat landscape over Upper Cretaceous chalk covered by sands and bouldery marl soils forested to the sea edge. Serrahn is an undulating glaciated lowland with lakes, mires, and bogs. Grumsin is part of a wide lowland landscape of moraines covered by fens, mires, and lakes. Hainich is an incised hilly plateau of marine limestone (muschelkalk). Kellerwald rises to 2053 feet (626 meters) as a part of a dissected mountain massif. It is underlain by 300- to 400-million-year-old Lower Carboniferous marine sediments.

The largest virgin beech forest in Europe is on the Uholka-Shyrokyi Luh massif in Ukraine. It is a relict of the forests that used to cover two-fifths of temperate Europe. The area is exceptional in the extent, integrity, and age of its forests of beech. Past the foothill oak groves (656 to 1935 feet; 200 to 590 meters) there are five main vegetation types: beech forest (1640 to 3937 feet; 500 to 1200 meters), beech-fir forest (3608 to 3937 feet; 1100 to 1200 meters), pine-alder alpine dwarf woodland unique to the region, subalpine and alpine meadows, and upland rocky-lichen landscapes.

Oak-beech forests are found on the lowest and warmest sites, dominated by common oak (*Quercus robur*), sessile oak (*Q. petraea*), and European hornbeam (*Carpinus betulus*), but including Norway maple (*Acer platanoides*), field maple (*A. campestre*), and the lindens *Tilia platyphylla* and

ANCIENT AND PRIMEVAL BEECH FORESTS

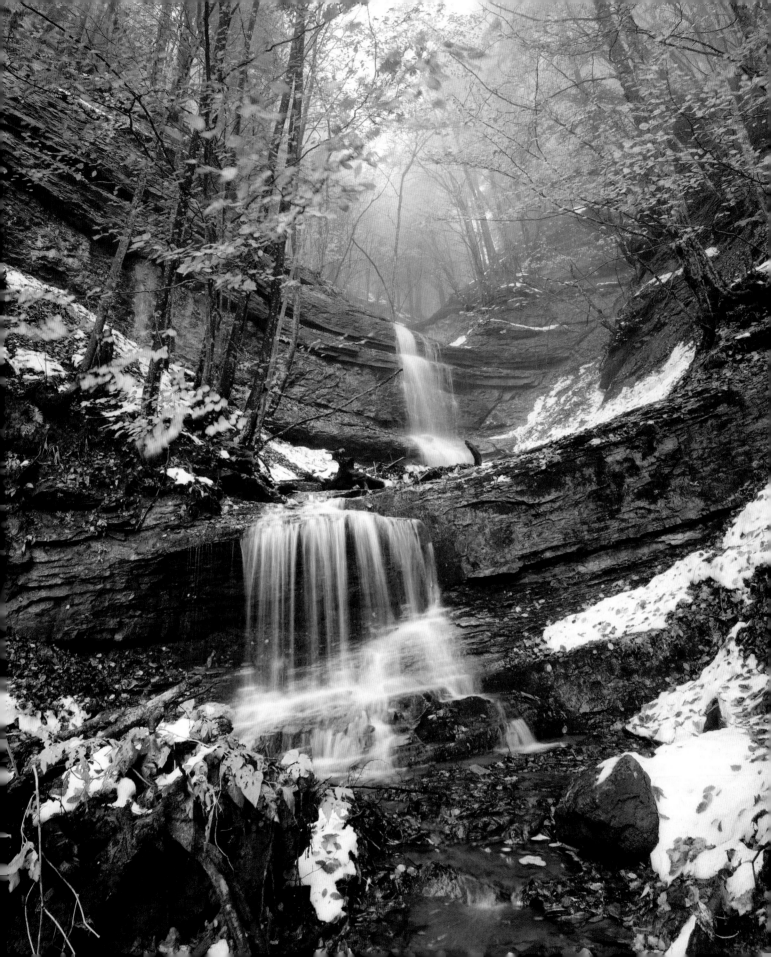

T. cordata. The herb layer is dominated by hairy sedge (*Carex pilosa*). On sites with more humus and on talus, there are wych elm (*Ulmus glabra*), European ash (*Fraxinus excelsior*), and sycamore (*Acer pseudoplatanus*). Maple-beech forests grow between 3280 and 3904 feet (1000 and 1190 meters). Silver fir (*Abies alba*) occurs at higher and wetter levels and dwarf pine (*Pinus mugo*) and green alder (*Alnus viridis*) above them. The banks of brooks are lined by eared willow (*Salix aurita*) and Carpathian willow (*S. silesiaca*).

Deforested sites at lower and middle levels are usually overgrown by scrub associations. Rare varieties and forms of birch (*Betula*) occur. There is a great range of nonforest communities: soaks, mires, meadows, pastures, and the timberline grasslands. The latter is a species-rich and local mountain vegetation type created mostly by grazing cattle on the mountain ridges and dominated by matgrass (*Nardus stricta*), tufted hairgrass (*Deschampsia caespitosa*), and red fescue (*Festuca rubra*).

In Germany, beech forests are rich with species indicating old-growth or undisturbed deciduous forests. Commonly accompanying them are sessile oak (*Quercus petraea*) and wood melick (*Melica uniflora*), a grass. Jasmund forest is 80 percent beech-dominated and has a rich ground cover of bulbs in spring. The Serrahn forest grows in wet acidic soils above a high watertable and is

intermixed with pine, alder, and birch. Over 150 species of fungi have been listed as growing there. Grumsin is part of the largest old beech forest in the country. In Hainich, growing on muschelkalk, it is part of the country's largest mixed forest with 1167 species of plants, 812 ferns, 221 mosses, and

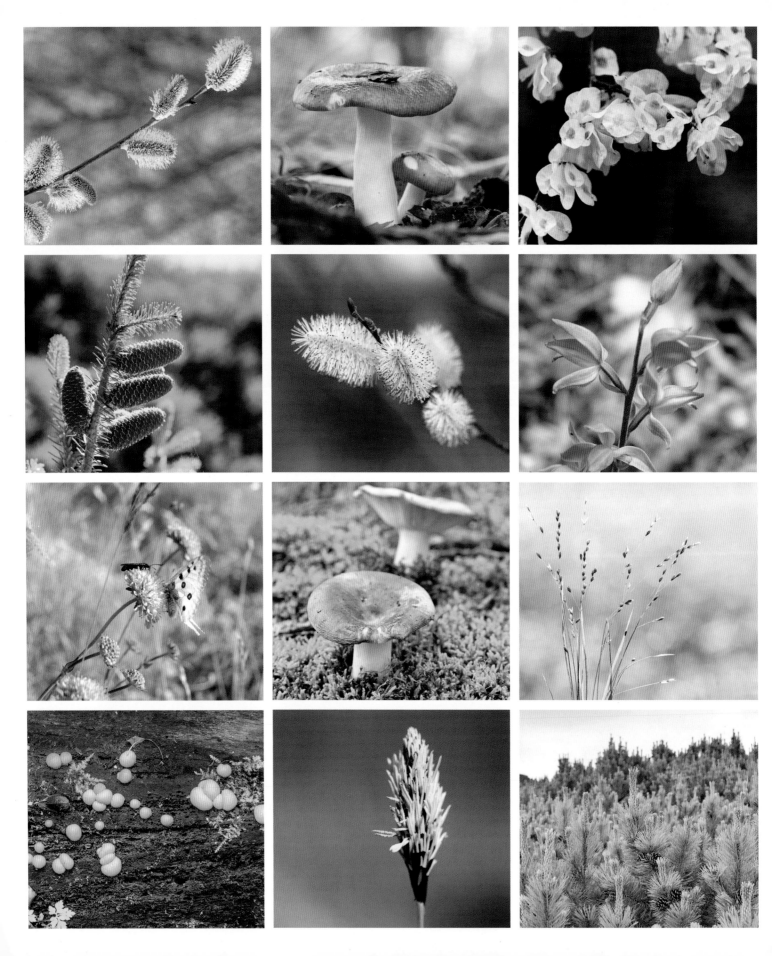

First column: The furry buds of the eared willow (*Salix aurita*). • Silver fir cones. • Beetles and butterflies feed on the rich nectar of flowering meadow plants. • Beech woodwart (*Hypoxylon fragiforme*), a critical part of a forest's ecosystem. *Second column:* Beechwood sickener (*Russula nobilis*). • Silesian willow (*Salix silesiaca*). • Charcoal burner (*Russula cyanoxantha*). • Fine flowers of hairy sedge (*Carex pilosa*). *Third column:* Wych elm (*Ulmus glabra*). • Flowers in Paklenica National Park, a protected area in Croatia. • Wood melick (*Melica uniflora*). • Dwarf mountain pine (*Pinus mugo*).

Below: Beeches turning orange in the autumn sun in Kalkalpen National Park, Austria.

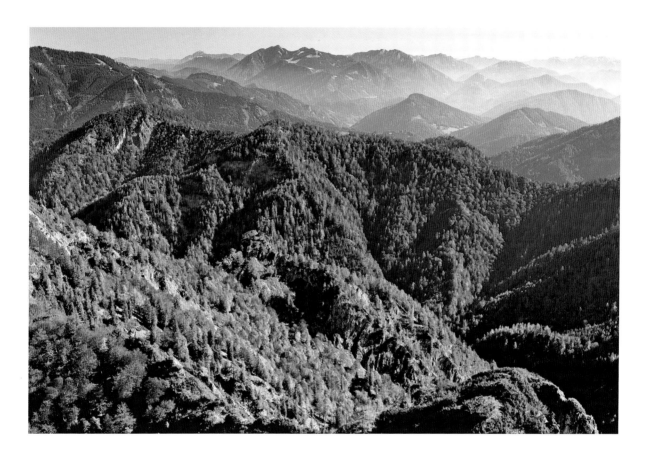

134 lichens. The steep acidic mountainside forests of Kellerwald have never been disturbed.

It is estimated that there are between 2.2 to 3.8 million species of fungi worldwide. Currently, 120,000 are accepted but disagreements abound. Beech forests are rich in fungi. Three of the most common are beechwood sickener (*Russula nobilis*), which is toxic to humans, grows under beech trees, and has a bright red convex cap about 2¾ inches (7 centimeters) across; beech woodwart (*Hypoxylon fragiforme*), which grows on dead beeches and has rusty red stomas (fruiting bodies); and charcoal burner (*Russula cyanoxantha*), which appears in scattered groups and has a 6-inch (15-centimeter) wide dull lilac cap.

As an afterword, the word "book" comes from the Old English *boc*, and boc comes from the Proto-Germanic *bokiz* meaning "beech." It is thought that the earliest European books were made from the wood of the beech tree.

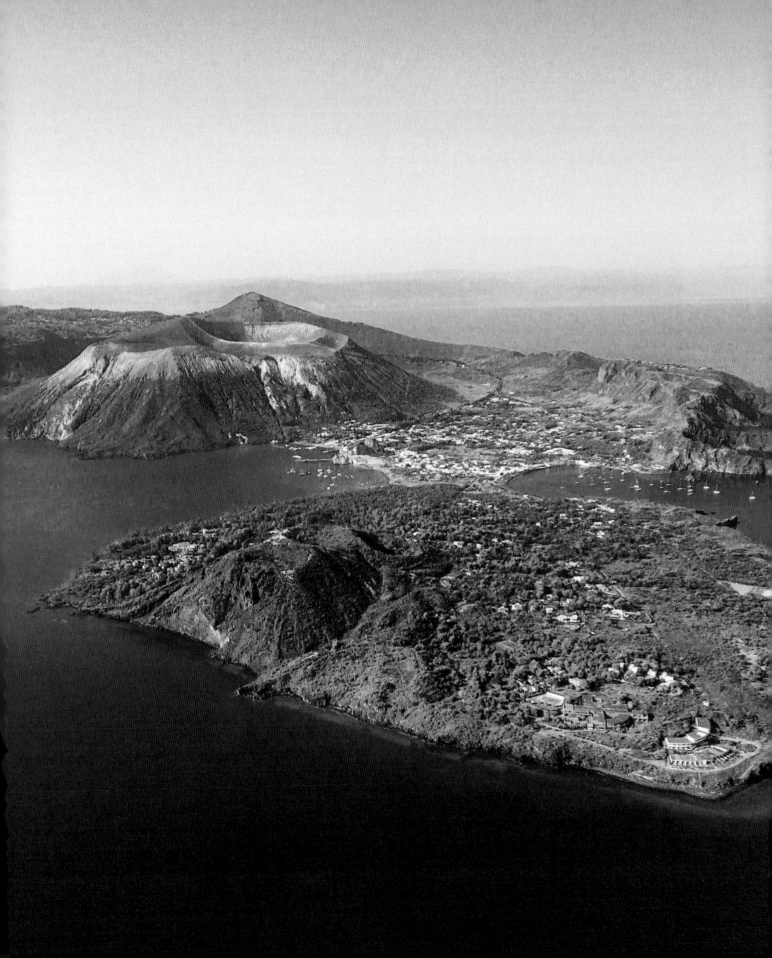

The Aeolian Islands provide an outstanding record of volcanic island-building and destruction, and ongoing volcanic phenomena. Studied since at least the 18th century, the islands have provided the science of volcanology with examples of two types of eruption (Vulcanian and Strombolian) and thus have featured prominently in the education of geologists for more than 200 years. The site continues to enrich the field of volcanology.

Aeolian Islands

ITALY

Inscribed as a World Heritage Site in 2000, the Aeolian Islands, a volcanic arc, lie in the Tyrrhenian Sea, 12½ miles (20 kilometers) off the north coast of Sicily and 34 miles (55 kilometers) from the Italian mainland. The group consists of seven main islands (Lipari, Salina, Vulcano, Stromboli, Filicudi, Alicudi, and Panarea) and five islets (Basiluzzo, Dattilo, Bottaro, Lisca Nera, and Lisca Bianca), all steep-sided volcanoes either active or dormant. They were created due to volcanic activity over a period of 260,000 years. A geothermal field underlies the group and

Lipari is the largest of the Aeolian Islands.

191

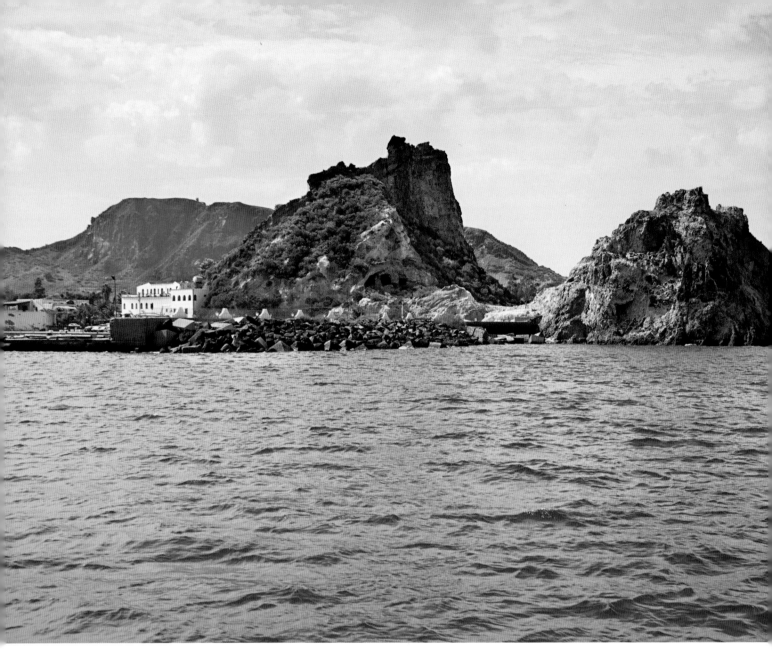

there are fumaroles and hot springs, particularly on the island of Vulcano.

Archaeological remains reveal a Neolithic trade in obsidian. There is a Bronze Age necropolis and different layers reveal subsequent occupations by Greeks, Phoenicians, Romans, Arabs, Normans, and Spanish, who built the castle of Lipari in the 16th century.

Aeolia, the floating island, was the realm of King Aeolus. He had six sons and six daughters who were married to one another, and the entire family lived in peace and comfort—if you can believe that. There is more in Homer's *Odyssey*.

The islands were terraced for the cultivation of wheat and olives, but these were abandoned, especially in the late 19th and early 20th centuries when there was large-scale emigration mainly to the Americas. The traditional ancient industry was pumice mining, now it is tourism.

The volcanic soils, where there is soil, are fertile. Winter brings rain but rain does not linger on

From left: This was once a volcano, now a flooded crater. • Mythic home of Aeolus, the divine keeper of the winds.

193

the steep, rocky slopes, which are sharply drained and dry and hot in the summer. The terrain provides a variety of microclimates that host many species found on mainland Italy and Sicily. Most areas are dominated by a man-modified landscape of former vine and olive orchards and dry grassland. The many abandoned terraces are reverting to Mediterranean maquis and the vegetation is dominated by plants typical of this vegetation. *Anthemis aeolica, Centaurea aeolica* subsp. *aeolica, Cytisus*

aeolicus, Erysimum brulloi, Genista tyrrhena subsp. *tyrrhena,* and *Silene hicesiae* are strictly endemic plants of the Aeolian Islands. *Anthemis aeolica* is a chamomile, a mat-forming plant with finely divided, dark gray-green leaves and white, daisylike flowers from late spring into summer. *Centaurea aeolica* subsp. *aeolica* is characterized by deeply divided greenish gray lower leaves. The flowers, in summer, are pinkish to purple and gathered into a compact head. *Cytisus aeolicus* is genetically

AEOLIAN ISLANDS

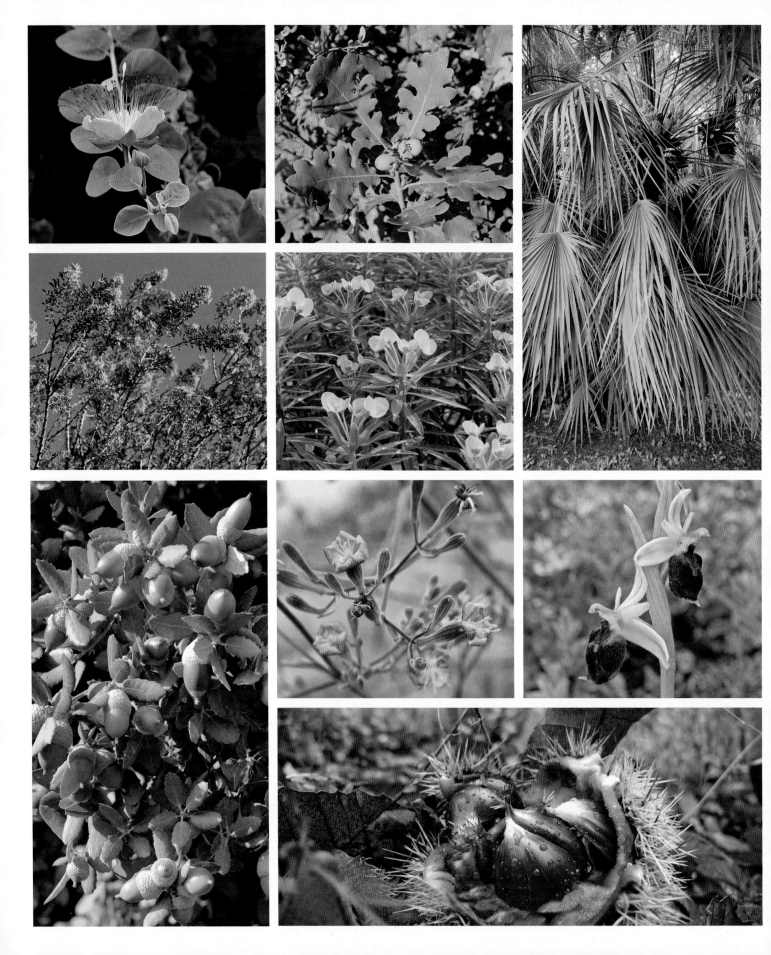

First column: Caper in flower. • *Cytisus aeolicus,* endemic to Stromboli. • Holly oak (*Quercus ilex*). *Second column:* Oak of Virgil (*Quercus virgiliana*). • Tree spurge (*Euphorbia dendroides*). • Threatened with extinction, the delicate *Silene hicesiae.* • Sweet chestnut (*Castanea sativa*). *Third column:* European fan palm (*Chamaerops humilis*). • Moon orchid (*Ophrys lunulata*).

195

distant from its nearest relatives, making it one of the most evolutionarily isolated plants in the Mediterranean flora. It is an evergreen woody shrub with bright yellow pealike flowers and long whiplike green stems. It grows on and colonizes steep slopes. *Erysimum brulloi* is endemic to the island of Alicudi and only grows on volcanic soil. It flowers from May to June with bright yellow "wallflowers." *Genista tyrrhena* subsp. *tyrrhena,* the Tyrrhenian broom, is a leguminous shrub growing to a height of 8 feet (2.5 meters). It has yellow flowers and leaves divided into three leaflets (trifoliate). *Silene hicesiae* is endemic to rocky areas of Panarea and Alicudi. It is a low-growing shrub up to 20 inches (50 centimeters) tall. It has densely hairy, elliptical leaves and bunches of pink five-petalled flowers in May.

Bassia saxicola is quite rare and is an endangered endemic of the sea cliffs. The leaves look a little like rosemary although it is in the amaranth family. It has greenish white flowers along the stems. *Ophrys lunulata,* the moon orchid, is a terrestrial orchid with green-striped pink flowers and a hairy, chestnut brown lip.

Most of the woodland on the islands is now depleted climax woodland. The evergreen holly oak (*Quercus ilex*), the deciduous oak of Virgil (*Q. virgiliana*), sweet chestnut (*Castanea sativa*), and the European fan palm (*Chamaerops humilis*) occur sparsely. Tree spurge (*Euphorbia dendroides*) is widely distributed throughout the Mediterranean. It is a semisucculent shrub up to 10 feet (3 meters) high, with red stems, bright green leaves and terminal chartreuse flowers. The leaves turn red in summer, before summer dormancy commences, and burst into life again with autumnal rains.

Salina is famed for its caper production. Capers are the immature, dark green flower buds of the caper bush (*Capparis spinosa*), a perennial pendulous shrub with round, fleshy leaves, native to the Mediterranean and some parts of Asia. Salina capers are picked by hand and covered with sea salt and later with oil. They make a particularly fine salad by blending some of the thoroughly rinsed capers in a blender, adding herbs to taste, vinegar, and extra-virgin olive oil until a creamy consistency is obtained. The sauce is then poured over boiled and peeled potatoes, and more of the rinsed capers are added. This with caciocavallo cheese and a glass of dry Malvasia wine from Salina, is the perfect complement to the contemplation of endemic plants of the Aeolian Islands.

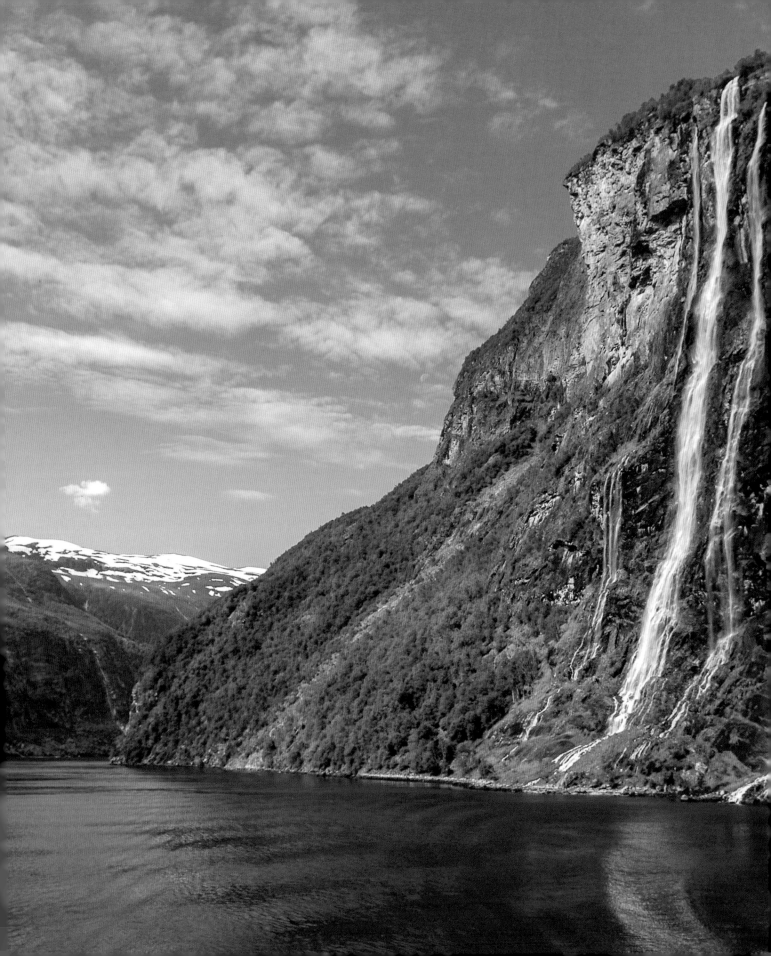

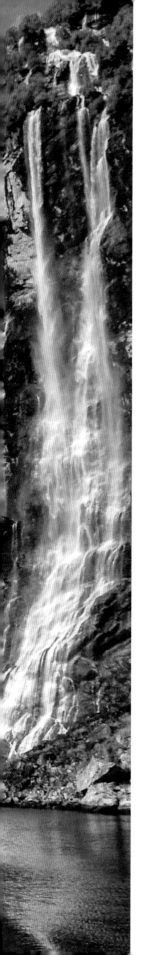

Situated in southwestern Norway, northeast of Bergen, Geirangerfjord and Nærøyfjord, set 75 miles (120 kilometers) from one another, are part of the west Norwegian fjord landscape, which stretches from Stavanger in the south to Andalsnes, 310 miles (500 kilometers) to the northeast. The two fjords, among the world's longest and deepest, are considered as archetypical fjord landscapes and among the most scenically outstanding anywhere. Their exceptional natural beauty is derived from their narrow and steep-sided crystalline rock walls that rise up to 4593 feet (1400 meters) from the Norwegian Sea and extend 1640 feet (500 meters) below sea level. The sheer walls of the fjords have numerous waterfalls while free-flowing rivers cross their deciduous and coniferous forests to glacial lakes, glaciers, and rugged mountains. The landscape features a range of supporting natural phenomena, both terrestrial and marine, such as submarine moraines and marine mammals.

West Norwegian Fjords— Geirangerfjord and Nærøyfjord

NORWAY

The dramatic landscapes of Geirangerfjord, 9 miles (15 kilometers) long and 4921 feet (1500 meters) wide at its widest point, and Nærøyfjord, 11 miles (18 kilometers) long and only 1640 feet (500 meters) in some parts, are exceptional in scale and grandeur in a country of spectacular fjords. They are pristine examples of a classic fjord and glaciated landscape which is still actively evolving. The West Gneiss region is among the most important reference landscapes of its type in Europe. The fjords lie within a WWF Global 2000 Ecoregion and the sites are recorded on a National

The Seven Sisters Waterfall in Geirangerfjord.

197

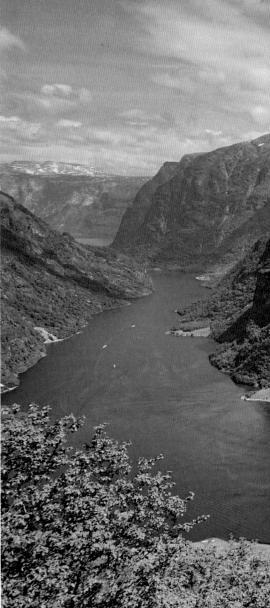

Register of Valuable Cultural Landscapes. The West Norwegian fjords became a World Heritage site in 2005 and comprise 168,886 acres (68,346 hectares) of protected land.

The vegetation changes due to altitude between forests containing both deciduous and evergreen trees in the valleys to subarctic forest (taiga) on the plateaus. Pockets of peridotite (a generic name used for coarse-grained, dark-colored, igneous rocks) and serpentinite rocks in the Geirangerfjord area provide nutrient-rich soil. Its main vegetation types are temperate woodland, rock and scree, alpine grassland, and man-made meadows. The woodland includes old deciduous woods, pinewoods, wooded pasture, and small patches of diverse deciduous woods on warm south-facing slopes. The Alpine flora of the Geirangerfjord area is dependent on snow cover and ranges from *Betula nana* and polar willow (*Salix polaris*) to herb-rich grassland. Above the tree line between 2624 and 2952 feet (800 and 900 meters) are scree, blockfields, snow fields, and glaciers.

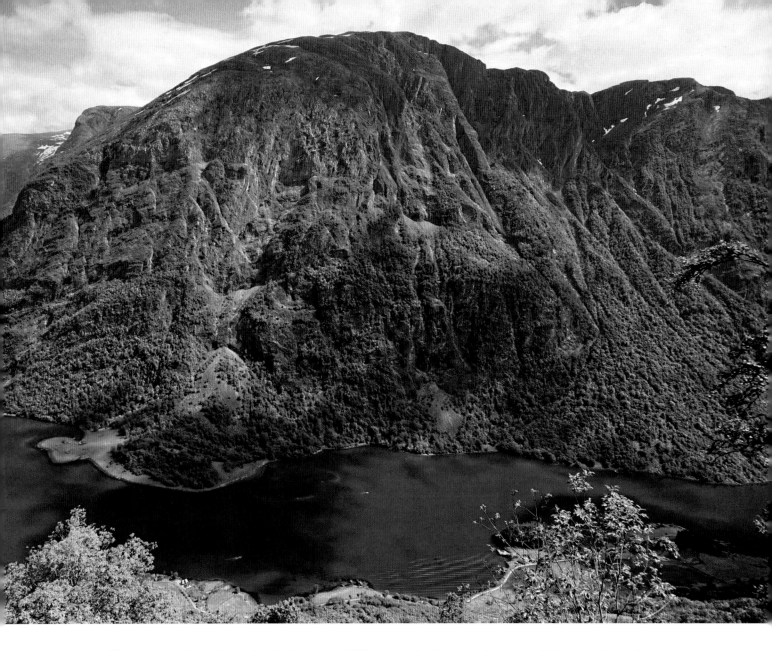

The tree line above Nærøyfjord is between 2952 and 3608 feet (900 and 1100 meters). Half the alpine flora of Norway is found on its mountains. In the ungrazed highland of Bleia there is natural grassland and, on its screes, the rare arctic poppy (*Papaver radicatum*). The flowers are pale yellow to white on 4- to 6-inch (10- to 15-centimeter) hairy stems and are heliotropic (they follow the path of the sun). The flowers are also parabolic; temperatures are highest in the center of the flowers, as the sun's rays are directed inward. The arctic bumblebee (*Bombus polaris*) takes advantage of this warmth and is one of the main pollinators.

Around Nærøyfjord there are large natural woods of Scots pine (*Pinus sylvestris*) and Norway spruce (*Picea abies*), but birch (*Betula* spp.) woodland communities are the most common. A somewhat richer gray alder (*Alnus incana*) community dominates on avalanche fans beside the fjords. The Scots Pine has blue-green needles in bundles of two and is easily identified by its scaly dark gray trunk that turns to amber on the upper trunk and branches. It is the

First column: *Betula nana.* • Foxglove (*Digitalis purpurea*). • The fresh beauty of rowan (*Sorbus aucuparia*).
Second column: Arctic poppy (*Papaver radicatum*). • Norway spruce (*Picea abies*). • Gray alder (*Alnus incana*).
Third column: Scots pine (*Pinus sylvestris*). • The rare arctic bumblebee (*Bombus polaris*).

201

only pine native to Northern Europe. Gray alder is a fast-growing medium-sized tree with a pyramidal form. The mature branches are smooth and gray. It is distinguished from the common alder (*A. glutinosa*) by the acutely pointed tip of the leaf.

The Norway spruce (*Picea abies*) is a conical tree that grows up to 131 feet (40 meters) in height. Its needles have blunt tips and are dark green. The cylindrical brown cones, the longest of any spruce, hang down. The bark is grayish brown with a rusty tint. It is native throughout Europe—from Norway in the northwest and Poland eastward, the mountains of central Europe, southwest to the western end of the Alps, and southeast to the Carpathians, Balkans, and extreme north of Greece. It hybridizes with *Picea obovata*, the Siberian spruce (some treat *P. obovata* as a subspecies or variety of *P. abies*). It is grown commercially as a Christmas tree, even though it begins to drop its needles minutes after being brought indoors and continues to do so throughout the 12 days of Christmas. The species is expanding its range in Norway—this is partly due to its colonizing nature, and partly due to climate change.

Betula nana, a dwarf, shrubby bush grows 24 to 48 inches (60 to 120 centimeters) high, with young growth covered in minute hairs. The leaves are round with round-toothed margins and are glossy dark green. It can be seen growing along mountain streams and near the Seven Sisters Waterfall in Geirangerfjord. Polar willow (*Salix polaris*) is a dwarf species of willow, circumpolar in distribution, and found in the mountains of Norway. It is one of the smallest willows in the world, growing to a height of 3½ inches (9 centimeters) tall. The leaves are round to egg-shaped and are dark green. The catkins flower as the leaves emerge. It grows in large mats, the long runners rooting as it grows.

Down from the mountain and often below the great swathe of conifers, the rowans grow. Rowan (*Sorbus aucuparia*), also called mountain ash, commonly grows with or on the edges of Norway spruce forests. A deciduous tree, around 30 feet (9 meters) high, the flowers are white, and are produced in large numbers in 5-inch (12.7-centimeter) corymbs. Beautiful as the flowers are, their scent is that of stale urine. However, the fruits are bright red berries produced in large clusters. It is a lovely tree despite the odor.

Through the trees and along the shady edges of meadows, foxgloves (*Digitalis purpurea*) grow. The endemic Norddal lady's mantle (*Alchemilla semidivisa*) is vulnerable to extinction but where it does grow—near misty waterfalls—its chartreuse flowers glow against the gray of rocks. In the meadows, Siberian garlic (*Allium sibiricum*), a white-flowering form of chive, is reputed to make cow's milk onion flavored. It makes great cheese.

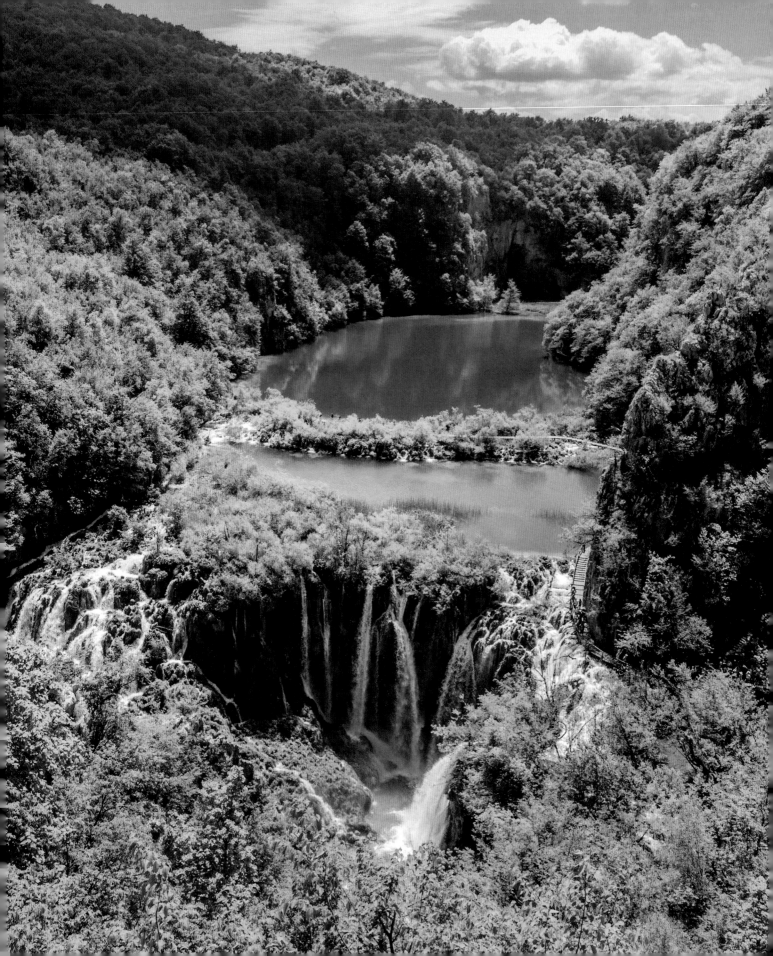

The waters flowing over the limestone and chalk have, over thousands of years, deposited travertine barriers, creating natural dams, which in turn have created a series of beautiful lakes, caves, and waterfalls. These geological processes continue today. The forests in the park are home to bears, wolves, and many rare bird species.

Plitvice Lakes National Park

CROATIA

Plitvice Lakes National Park is the oldest and largest national park in Croatia. On 8 April 1949 it was proclaimed Croatia's first national park, and on 26 October 1979 it was internationally recognized as a World Heritage Site.

Close to the Bosnia-Herzegovina border in the Dinaric mountains, 12½ miles (20 kilometers) northwest of Bihac in Bosnia and 68 miles (110 kilometers) south of Zagreb, Plitvice Plateau lies at 2132 to 2296 feet (650 to 700 meters) between the Licka Pljesevica (5380 feet; 1640 meters) and

The park's lower lakes.

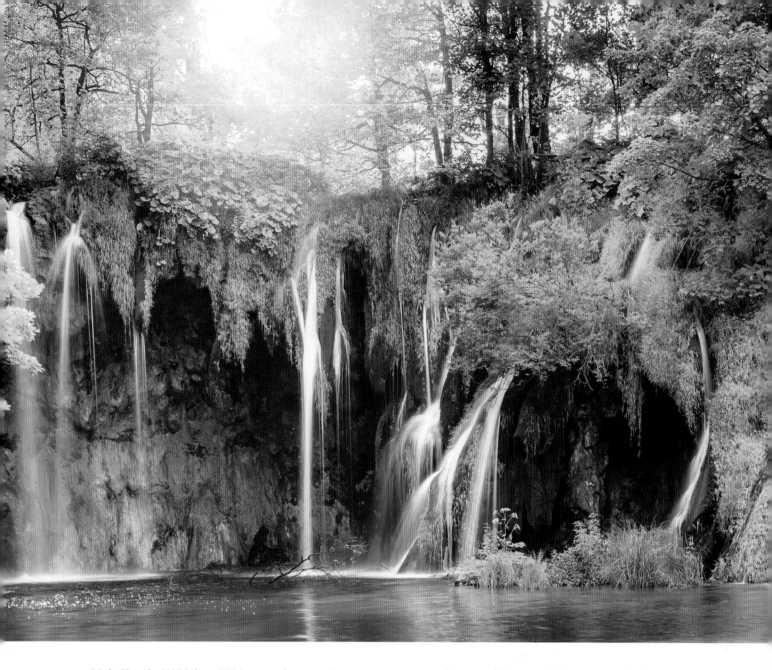

Mala Kapela (4199 feet; 1280 meters) mountains and is intersected by the headwaters of the Korana, Black, and White Rivers. The upper end of the Korana Valley is a wide basin holding the upper lakes while the lower lakes occupy a narrow limestone canyon. The Plitvice Lakes basin is a formation of biological origin, a karst river basin of limestone and dolomite, with some sixteen lakes, behind dams created during the last 4000 years by the deposition of chalk in solution and encrustation of two genera of mosses (*Bryum* and *Cratoneuron*), algae, and aquatic bacteria. This resulted in the building of lakes of various sizes linked by cascades and waterfalls, ending in the impressive Sastavci Waterfall, with the Korana River springing under the base of the falls. The Plitvice Lakes National Park offers visitors seven different routes to tour the lake system and four hiking trails.

The park is 75 percent forested and has 17,191 acres (6957 hectares) of meadow and 536 acres

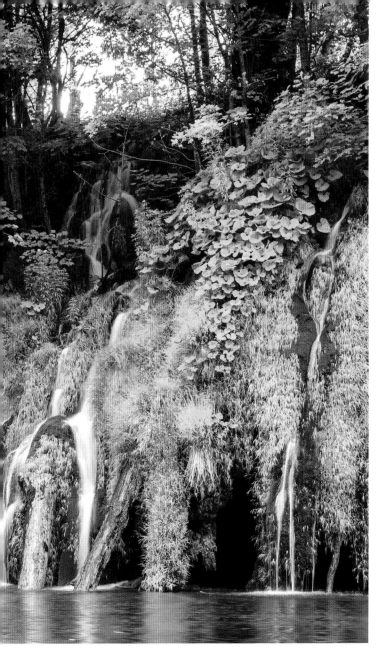

hop-hornbeam (*Ostrya carpinifolia*), spruce, and beech-fir forests.

The limestone communities have a smaller number of forest types but cover a larger area with communities of spruce and ferns, spruce and beech, and hop-hornbeam with European smoke-tree (*Cotinus coggygria*), a large, bushy, deciduous shrub to 16 feet (5 meters) with feathery plumes of flowers that look smokey. The leaves are oval with a bluish tint, turning yellow, orange, and red in autumn. Bosnian maple (*Acer opalus* subsp. *obtusatum*) is a deciduous medium-sized tree or dense shrub to about 33 to 42 feet (10 to 13 meters) tall with a broad, rounded crown. The leaves are dark green above, gray-green underneath, and five-lobed with short and blunt lobes. Small yellow flowers are followed by samaras with the wings held at right angles. Along the streams and around the lakes, willows and the water-loving black alder (*Alnus glutinosa*), a conical deciduous tree up to 92 feet (28 meters) high with purple twigs with orange lenticels, and conelike female catkins year-round.

The moist valley meadows contain several endemic plants, notably *Edraianthus tenuifolius*, in the bellflower family (Campanulaceae), with grass-like green leaves and upward-facing purple flower clusters. *Ranunculus thora*, a poisonous little buttercup, and meadow squill (*Scilla litardierei*), which has masses of blue, grape hyacinth–like flowers on

(217 hectares) of lakes. The forest comprises pure stands of European beech (*Fagus sylvatica*) at lower altitudes and mixed stands of beech and silver fir (*Abies alba*) with European spruce (*Picea excelsa*) and Scots pine (*Pinus sylvestris*) higher up. One area of 207 acres (84 hectares) has never been cut and contains trees up to 700 years old.

The forest can also be classified in terms of its underlying dolomite and limestone strata. The dolomite communities comprise Tertiary pine, European

each plant in late spring. In the wetlands, Siberian ligularia (*Ligularia sibirica*), endangered in most of Europe, is abundant. It has large, toothed leaves and a 4-foot (1.2-meter) spikelike cluster of deep yellow flowers.

In the boggy habitats, there are carnivorous plants. *Drosera rotundifolia*, the round-leaved sundew, has circular leaves on stalks forming a rosette around 2 inches (5 centimeters) across. The leaves are covered with sticky, red-tipped, gland-bearing hairs for trapping small insects. Butterwort (*Pinguicula vulgaris*) and bladderwort (*Utricularia minor*) have interesting names and are interesting plants. "Wort" derives from the Old English *wyrt*,

which simply means "plant." Butterwort has a rosette of yellow-green sticky leaves that trap a struggling insect and curl around it. When the insect is digested, the leaf uncurls. It blooms from May to August with light purple funnel-shaped flowers. Bladderwort has underwater leaves divided fanwise into linear segments. Some of the stems have colorless bladders into which small organisms are sucked when hairs at opening are triggered.

Protected native plants include the beautiful lady's slipper orchid (*Cypripedium calceolus*). It is an herbaceous perennial that produces new growths from a rhizome each season. It grows up to 24 inches (60 centimeters) tall. Each hairy stem has

From left: Scots pine on the shore. • Rock silt suspended in the water makes the lakes appear turquoise. • The lakes are famed for their clarity as well as color.

207

three to four leaves that are strongly pleated. The flower stalk carries one to two blossoms with leaf-like bracts. The sepals and petals are maroon while the slipper is yellow, and spotted inside with red. *Daphne blagayana* is an evergreen spreading shrub no more than 12 inches (30 centimers) high. The fragrant flowers are creamy white and produced in March and April on a crowded head of 20 to 30 blossoms at the end of the branches. Golden apple (*Lilium carniolicum*) has a very wide range of colors running from red to golden yellow but yellow is the dominant color. It is a woodland Turk's-cap lily with flowers on 18-inch (45-centimeter) stems in July. *Primula kitaibeliana* is a sweetheart of a primula,

growing just 3 inches (7.6 centimeters) high with magenta flowers with a white eye. *Primula wulfeniana* grows to 2¼ inches (6 centimeters) in limestone meadows and has cartilaginous leathery leaves and reddish lilac flowers with a white eye. *Paeonia mascula*, a wild peony reaches about 20 inches (50 centimeters) high. It has bluish green leaves divided into nine leaflets, and scented, deep purplish red or rose-pink flowers with dark yellow stamens, in spring.

The Croatian flora is the third richest in Europe, measured by the total number of species and the total surface area of the country. The flora is beautiful, the country is beautiful.

PLITVICE LAKES NATIONAL PARK

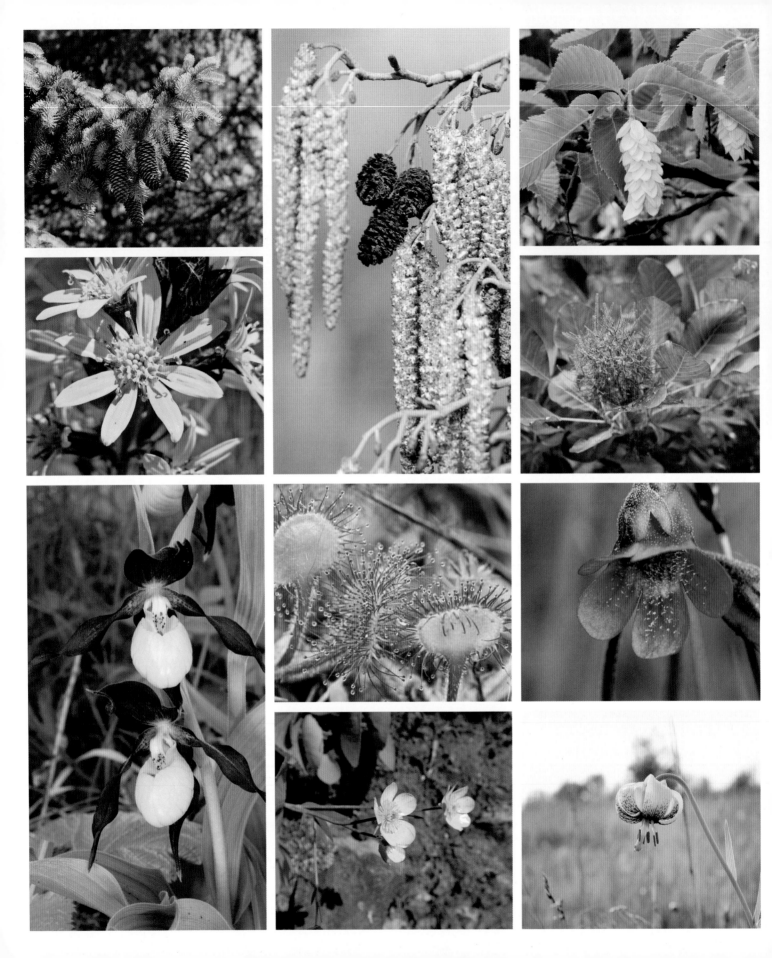

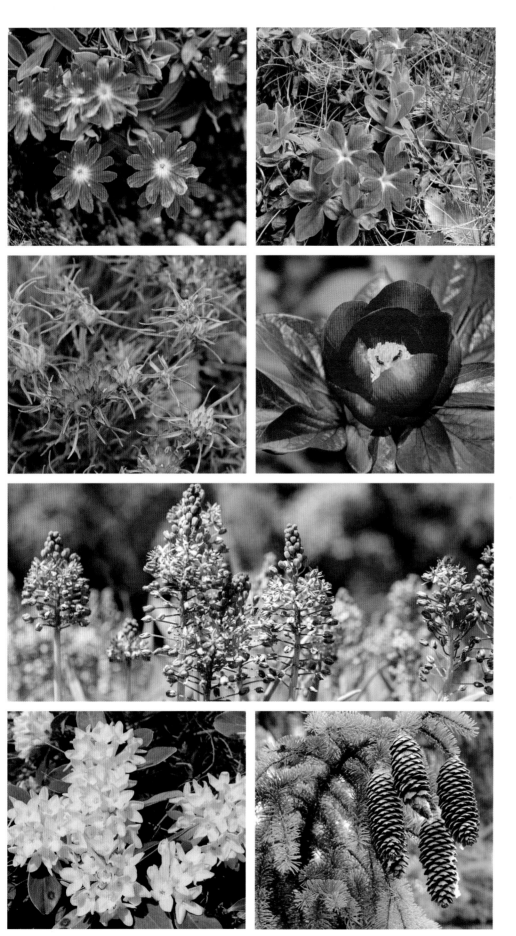

209

First column: Silver fir (*Abies alba*).
• Siberian ligularia (*Ligularia sibirica*). • Lady's slipper orchid (*Cypripedium calceolus*). *Second column:* Black alder (*Alnus glutinosa*). • Round-leaved sundew (*Drosera rotundifolia*). • *Ranunculus thora.* *Third column:* European hop-hornbeam (*Ostrya carpinifolia*). • European smoketree (*Cotinus coggygria*). • Butterwort (*Pinguicula vulgaris*). • Golden apple lily (*Lilium carniolicum*). *Fourth column:* White-eyed and lilac, *Primula wulfeniana.* • *Edraianthus tenuifolius.* • Amethyst meadow squill (*Scilla litardiere*). • The fragrant flowers of *Daphne blagayana. Fifth column:* A beautiful primula. • *Paeonia mascula.* • European spruce (*Picea excelsa*).

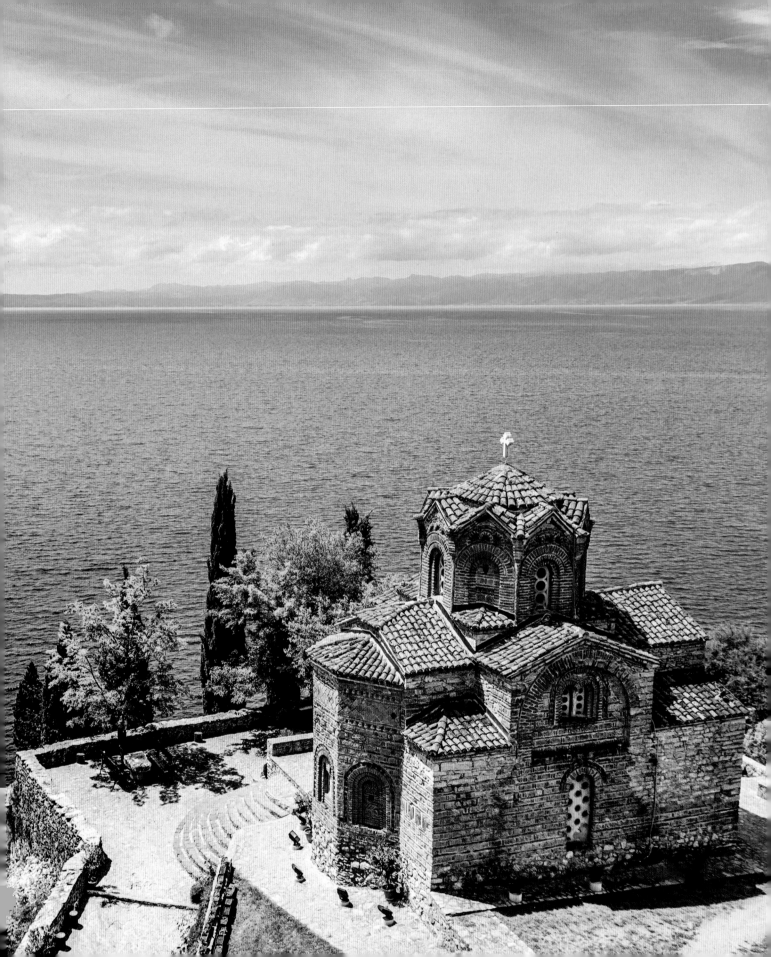

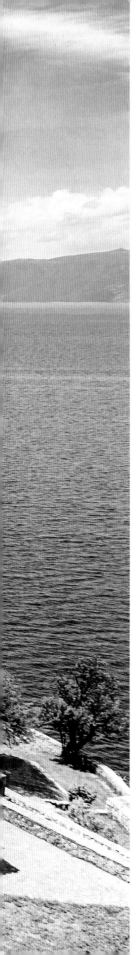

A superlative natural phenomenon, Lake Ohrid provides a refuge for numerous endemic species of freshwater fauna and flora dating from the Tertiary period. Situated on the shores of the lake, the town of Ohrid is one of the oldest human settlements in Europe. Built mainly between the 7th and 19th centuries, it has the oldest Slav monastery (St. Pantelejmon) and more than 800 Byzantine-style icons dating from the 11th to the end of the 14th century. In the shallow waters near the shores of the lake, three sites testify to the presence of prehistoric pile dwellings, and the small Lin Peninsula is the site of the remains of an Early Christian church founded in the middle of the 6th century.

Natural and Cultural Heritage of the Ohrid Region

ALBANIA
AND NORTH
MACEDONIA

Lake Ohrid is in far southwestern North Macedonia, a third of the lake being in Albania. Its southern shore is within 12½ miles (20 kilometers) of Greece. The town of Ohrid is on its northeast shore adjoining the Mount Galichica National Park. Neolithic settlements have been found on the lake shores and a town known as Lychnidos existed on the site in classical and Hellenistic Greek times. It was peopled by ancestral Phrygians and Illyrians before subjugation by Macedonians and then by Rome. It was important as a major crossroads on the Roman Via Egnatia

Church of St. John at Kaneo, built in the 15th century.

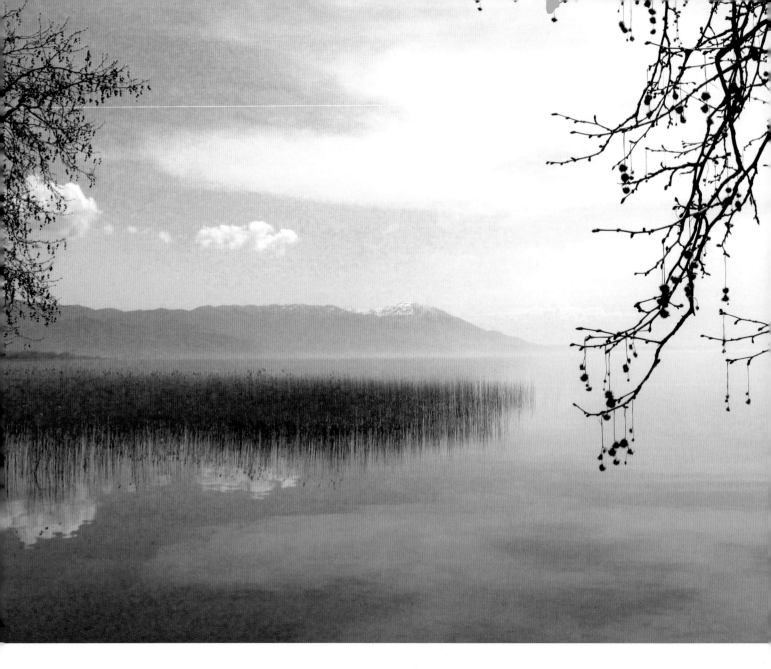

from the Adriatic to Constantinople. The Cyrillic alphabet was developed there and it had a university in the 9th century. For some 8 centuries, from early Byzantine times through its domination by Slav tribes, Ohrid was a major Christian center. It has the oldest Slav monastery (St. Pantelejmon) and many churches that flourished even under the Ottomans. There are still at least 30 churches in the Ohrid area alone, several of them specifically listed in the World Heritage Site that was declared in 1979. They are decorated with more than 800 icons painted between the 11th and the late 14th century in a distinct style that forms an artistic bridge between Byzantine and Italian art. Ohrid has the most important collection of icons in the world outside Moscow.

Ohrid is a very ancient lake that lies in a deep trench formed by tectonic subsidence in the Late Tertiary period (3.5 to 4 million years ago). It is 19 miles (31 kilometers) long by 9 miles

From left: Romantic Lake Ohrid, one of the world's most biodiverse. • Natural spring water emerges near the lake.

213

(15 kilometers) wide. Its watershed of 1514 square miles (3921 square kilometers) extends over three countries. It draws almost half its water via shoreline or underwater springs from Lake Prespa, which lies on the other side of Mount Galichica east of the lake. This lake, which is partly in Greece, is 518 feet (158 meters) higher in level. It is almost as large as Lake Ohrid, and greatly enlarges the catchment area. The strongest spring, at Sveti Naum on the southeast coast of Lake Ohrid, has 15 outlets that spring above and 30 that rise below the water level, providing a quarter of the lake's total inflow. It is, therefore, fairly free from enriching sediments and is extremely clear, with a very slow water turnover rate of 60 to 70 years and temperatures at depth of around 43°F (6°C), conditions that until last century had not changed for millennia. However, the catchment was enlarged by diversion of the Sateska River in the north into the lake. This was formerly a tributary of the main outflow

First column: Spring gentian. • *Lilium chalcedonicum.* • *Scilla bifolia. Second column:* Plantain-leaved leopard's-bane (*Doronicum plantagineum*). • Elder-flowered orchid (*Dactylorhiza sambucina*). *Third column: Salvia jurisicii.* • Macedonian pine (*Pinus peuce*).

215

stream, the Black Drim. It now contributes a high sediment load to the lake from riverbed sand and gravel workings.

Despite the low concentrations of nitrates, iron, and phosphates, the shorelines are nevertheless a rich biotope for waterbirds and young fish. These are flanked by belts dominated by aquatic freshwater plants in the genus *Potamogeton* and by green algae in the genus *Chara*. Neighboring Galichica National Park contains more than 1500 species of plants on the slopes of Mount Galichica. High on the mountain, close to the tree line, Macedonian pine (*Pinus peuce*) grows in large sweeping forests. It is a five-needled pine growing up to 131 feet (40 meters). The mature cones are yellow brown with flat to downcurved scales. Beneath the pines and in the lower altitude meadows is a wealth of bulbs. In the spring, as soon as the snow melts, *Crocus jablanicensis*, a recently identified endemic, and *Crocus cvijicii* bloom. The first with white styles and stigmas and a glabrous, white perianth throat; the second with yellow flowers with an orange stigma. A little later, the upward-facing bright blue starry flowers of *Scilla bifolia* appear—in the millions. In the summer, the Turk's-cap-shaped, scented flowers of *Lilium chalcedonicum* bloom red orange in the shade of woodland and tall grasses. *Viola*

allchariensis blooms in the spring and early summer with flowers of violet blue. There is a white form. Both this species and *Viola arsenica* are bioaccumulators of arsenic present in the mountain soil. The spring gentian (*Gentiana verna*), widely distributed throughout Europe and parts of Asia, also finds a home here. The vivid blue flowers on short stems—barely above the soil line—bloom throughout the grassy meadows. Elder-flowered orchid (*Dactylorhiza sambucina*), a terrestrial orchid, blooms with colors varying from yellow with light reddish stains or purple speckled with darker spots. It is common in dry meadows. Critically endangered in the wild, *Salvia jurisicii* has olive green hairy leaves and hairy violet to white flowers. It is a small bushy plant about 12 inches (30 centimeters) tall and wide. The plantain-leaved leopard's-bane (*Doronicum plantagineum*) is a delightful member of the sunflower family growing up to 31 inches (80 centimeters) tall with round leaves and yellow flowers.

If you sit by the lake and watch the common goldeneyes and the black-necked grebes, listen to the sound of bumblebees bouncing from one flower to another, see Ohrid trout feeding in the streams, then perhaps you have discovered a piece of earthly paradise.

The Laurisilva of Madeira is an outstanding relict of a previously widespread laurel forest type. It is the largest surviving area of laurel forest and is believed to be 90 percent primary forest. It contains a unique suite of plants and animals, including many endemic species such as the Madeiran long-toed pigeon.

Laurisilva of Madeira PORTUGAL

The Madeiran archipelago is located about 435 miles (700 kilometers) from Africa, 279 miles (450 kilometers) from the Canary Islands, and 559 miles (900 kilometers) from mainland Portugal. It consists of two inhabited islands, Madeira, and Porto Santo, and two subarchipelagos, the Nature Reserves of Desertas and Selvagens islands, occupying a total area of around 1930 square miles (5000 square kilometers) of the Atlantic Ocean. The laurel forest occupies about 20 percent of the island. Scientists believe it to be 90 percent primary forest.

The ancient laurel forest covered in moss.

217

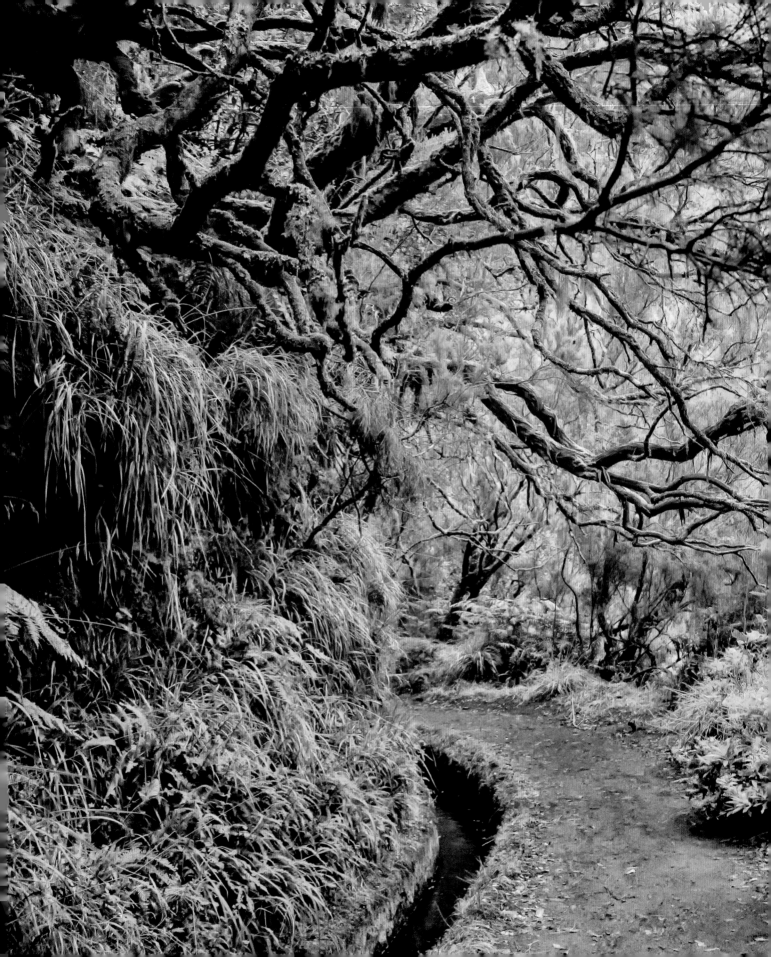

The Laurisilva of Madeira is an outstanding relict of a previously widespread laurel forest type, which covered much of southern Europe 15 to 40 million years ago. The forests completely cover a series of very steep, V-shaped valleys leading from the plateau and east-west ridge in the center of the island to the north coast. The forests and their associated biological and ecological process are largely undisturbed and play a predominant role in the island's hydrological balance. The forest is mainly comprised of evergreen trees and bushes with flat, dark green leaves. Laurisilva provides a wealth of ecological niches, complex food webs, and examples of coevolution of species. It is a Biogenetic Reserve of the Council of Europe, a World Heritage Site since 1999, and is part of the Natura 2000 Network.

A range of climax vegetation communities have been identified, notably Laurissilva do Barbusano, Laurissilva do Til, and Laurissilva do Vinhático. Laurissilva do Barbusano, covering the most sloping and inaccessible areas, is dominated by *Apollonias barbujana*. It is a large evergreen tree, growing up to 98 feet (30 meters) tall. The bark is smooth and red in young trees but becomes gray-brown and rough in mature specimens. The mature leaves are shiny and dark green while the new ones are reddish in color. The abundant flowers are small (½ inch; 1 centimeter), with six greenish white petals and a sweet soft fragrance. The fruits look like small olives.

LAURISILVA OF MADEIRA

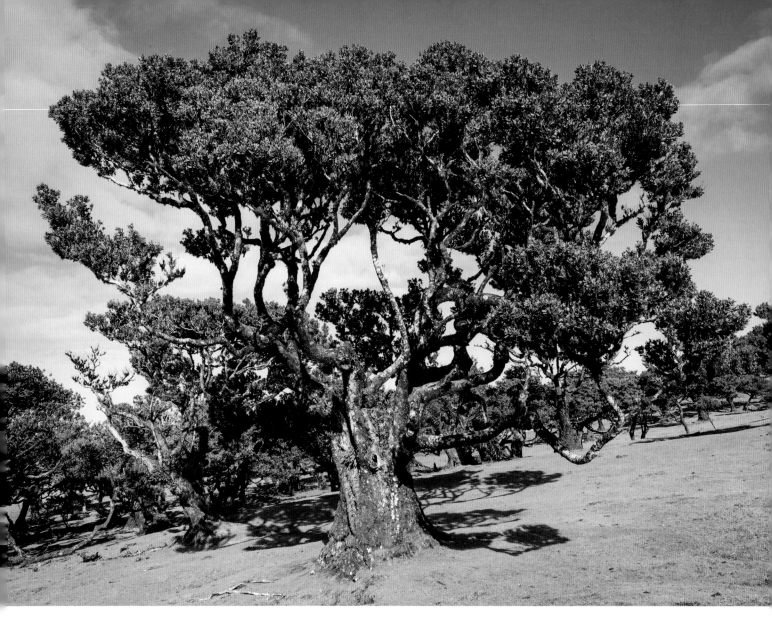

Two other tree species are also common. *Laurus novocanariensis* is an evergreen reaching up to 66 feet (20 meters) in height, with lance-shaped leaves, creamy yellow flowers and black fruits. The small-leaved holly (*Ilex canariensis*) can reach up to 66 feet (20 meters) but usually grows to 33 feet (10 meters). The leaves are leathery and shiny, slightly paler underneath.

Vines are common, seemingly connecting the trees like telegraph wires. *Semele androgyna*, the climbing butcher's broom, is an evergreen climber reaching high into the canopy. What is interesting about this plant is that what appear to be leaves are not; they are flattened stems (cladodes) that bear creamy white flowers becoming pea-sized, orange-red berries along the edges of the cladodes. The true leaves are barely discernible paperlike structures at the base of the flattened stems.

Found in the cooler areas of the forest is the Laurissilva do Til. Stinkwood (*Ocotea foetens*) covers much of this forest. It is recognizable by the unpleasant odor of the wood when freshly cut, hence the common name. The tree can grow 66 to 98 feet (20 to 30 meters) tall. The crown is wide

and rounded. The dark gray-brown bark is covered by small, round, whitish bumps (lenticels). The leaves are leathery and shiny. During the summer, yellowish white flowers appear. Stinkwood is easily differentiated from other species as its olivelike fruits look like small acorns.

Also found in this part of the forest is *Clethra arborea*, the lily-of-the-valley tree. The flowers are small, white, and fragrant, and hang in terminal panicles and bloom in early to midsummer. It is a bright whiteness against the backdrop of deep evergreen.

The understory is full of ferns: Madeira wood fern (*Dryopteris maderensis*), button fern (*Woodwardia radicans*), and woolly tree fern (*Culcita macrocarpa*), a 6½-foot (2-meter) tall tree fern, to name just three. Along the edges there are many species of herbaceous plants. *Geranium palmatum* is an evergreen perennial forming a large rosette of divided leaves with dark-centered purplish pink flowers in large, branched flower clusters up to 4 feet (1.2 meters) tall. Rare in the wild and often confused with *G. palmatum* is *G. maderense.* Growing to 5 feet (1.5 meters) tall and wide, it is

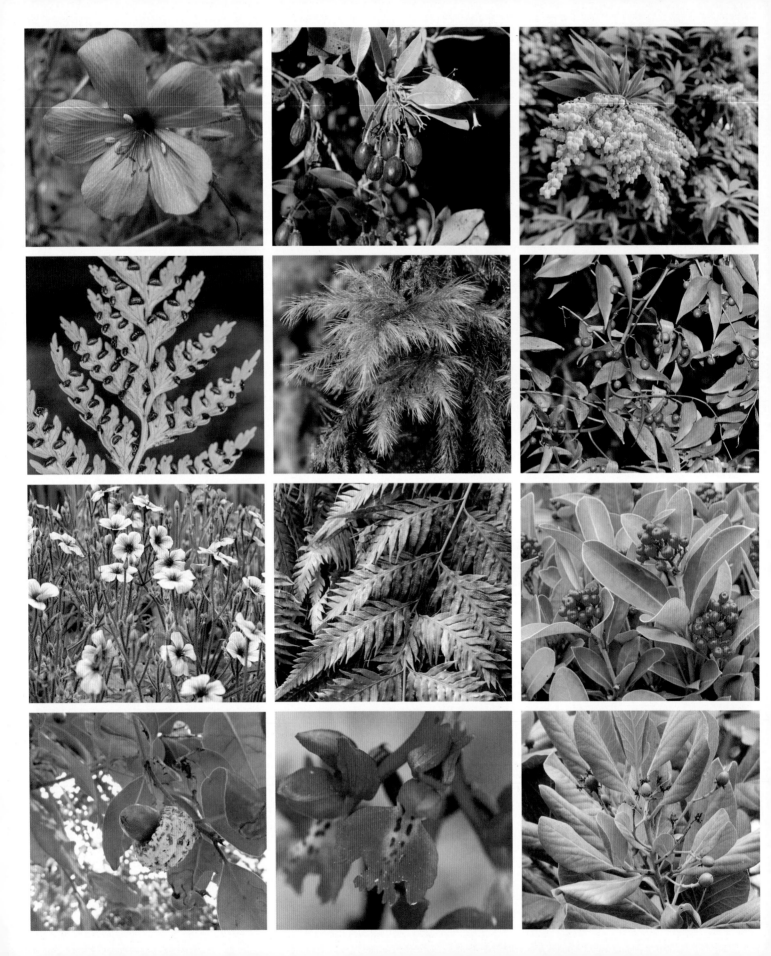

First column: Geranium palmatum is a longer-lasting perennial than G. madarense. • Woolly tree fern (Culcita macrocarpa). • Geranium maderense. • Stinkwood (Ocotea foetens). Second column: Apollonias barbujana. • A rare pleurocarp moss, Echinodium setigerum. • Button fern (Woodwardia radicans). • Rock orchid (Orchis mascula). Third column: Lily-of-the-valley tree (Clethra arborea). A lovely plant that is poisonous to humans. • Climbing butcher's broom (Semele androgyna). • Small-leaved holly (Ilex canariensis). • Persea indica.

a mound-forming plant with deeply divided ferny leaves. The purple-pink flowers on hairy red stems are produced in large panicles in summer. The Madeira orchid (*Dactylorhiza foliosa*) grows away from the edges of the forest in grassland. It grows in large clumps and has large spikes of purple flowers with dotted, darker lips. The rock orchid (*Orchis mascula*) is a rare orchid growing high in the mountains on rocky outcrops. It blooms in the spring with fragrant violet, purple, and white flowers. *Goodyera macrophylla*, a rare endemic terrestrial orchid has dark green, shiny, white-veined leaves, and inflorescences bearing 40 to 60 white flowers with a fleshy lip.

Growing on many of the oldest laurel trees is the endemic fungus *Laurobasidium lauri*, commonly known as "mother of laurel." It grows in clusters of what look like brown-yellow aerial roots on the trunks of the trees. Traditional medicine practitioners use it as a sedative and analgesic.

Laurissilva do Vinhático is identified by the large population of *Persea indica*, a relative of the avocado (*Persea americana*). It is a large evergreen tree that can grow to 66 feet (20 meters). It is usually found in misty river valleys and is intolerant of dry and windy conditions. It has a sturdy trunk, frequently surrounded by shoots at the base that quickly branch into a wide, dense crown. The aromatic leaves are dark green on the upper side and somewhat paler on the underside. As they age, their color changes to yellow or red-orange.

The forest is constantly wet from high rainfall or persistent mist. The trees and rocks are covered in mosses, some are rare. *Echinodium setigerum*, a medium-sized, branched, light to dark green pleurocarp moss is found in only 10 localities in the forest, and then only in small numbers; *Fissidens nobreganus* is an epiphytic moss growing on the bark of stinkwood; and the extinction-threatened *Thamnobryum fernandesii* is a glossy moss with creeping stolons, found growing around the numerous waterfalls.

The forests are dark and dense and filled with ancient evergreen life. The steep valleys and fast-flowing waters, the mist, the apparent mystery of it, makes the forests feel impenetrable. But the laurisilva is accessible by walking beside the lavadas, 870 miles (1400 kilometers) of irrigation canals built to bring water from the wet mountains to the drier southeast. They are footpaths into the mountains and valleys and are accessible from the municipalities of São Vicente, Porto Moniz, and Santana.

The Gambia River runs through
Niokolo-Koba National Park.

Africa

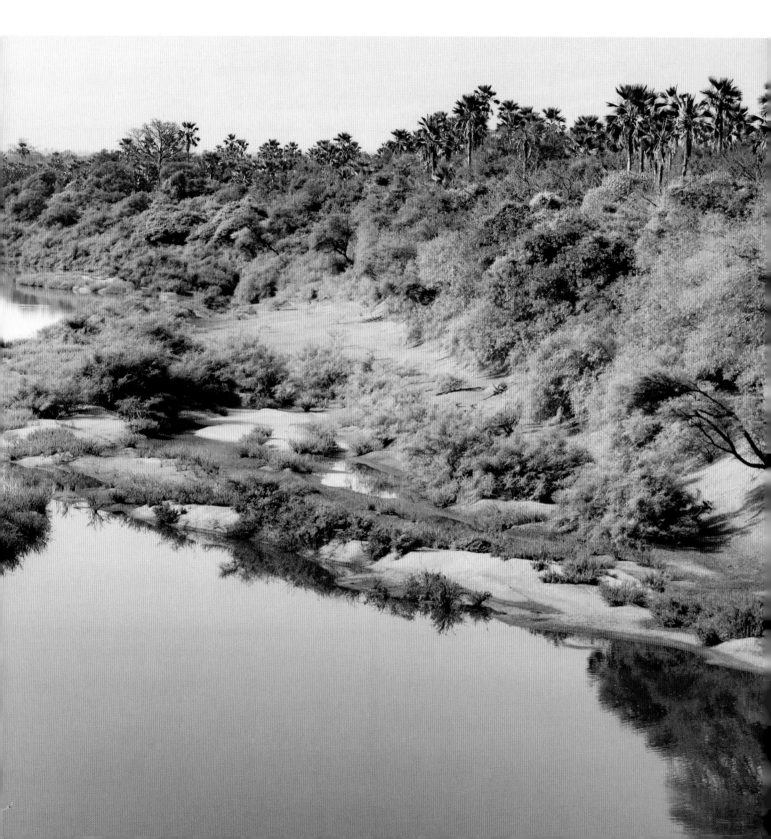

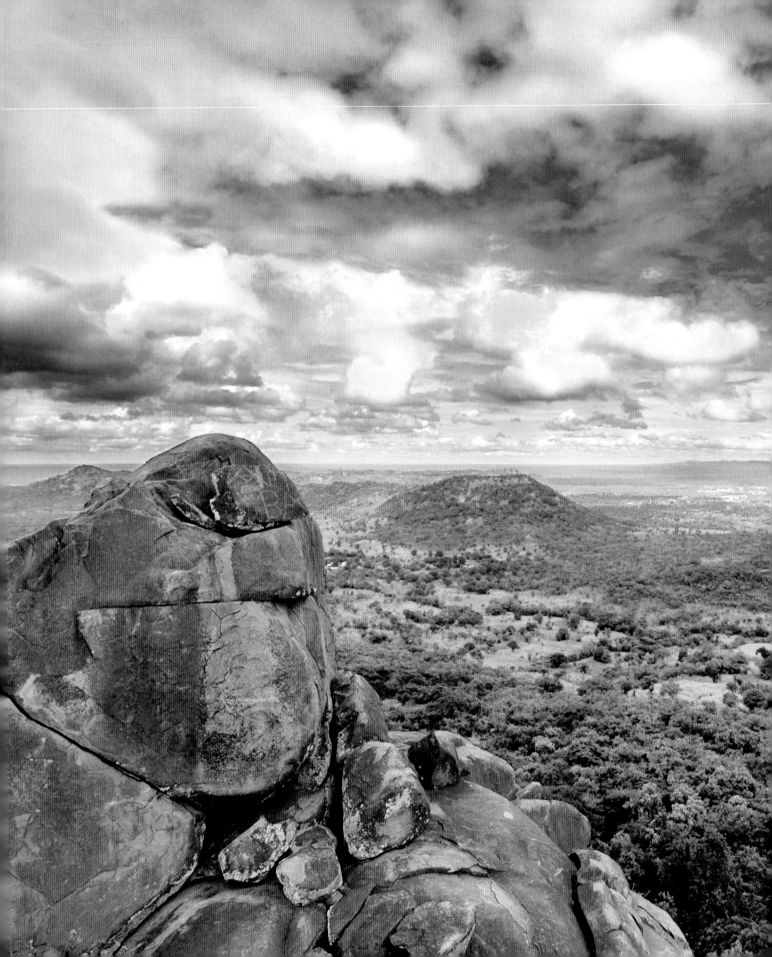

Located in a well-watered area along the banks of the Gambia river, the gallery forests and savannas of Niokolo-Koba National Park have a very rich fauna, among them Derby elands (largest of the antelopes), chimpanzees, lions, leopards, and a large population of elephants, as well as many birds, reptiles, and amphibians.

Niokolo-Koba
National Park

SENEGAL

The eastern half of Niokolo-Koba National Park is dry scrub savanna with a varying cover of trees and bushes. On better soils to the west the savanna is more wooded. Along the rivers riparian vegetation and luxuriant gallery forest occur. At least 1500 plant species have been recorded, 78 percent of them being from the gallery forest. Designated a World Heritage Site in 1987, the park contains all the ecosystems of the Sudanese bioclimatic zone.

The vegetation differs according to its location on slopes and hills, rock outcrops, alluvial sands, or iron

A view of Niokolo-Koba National Park.

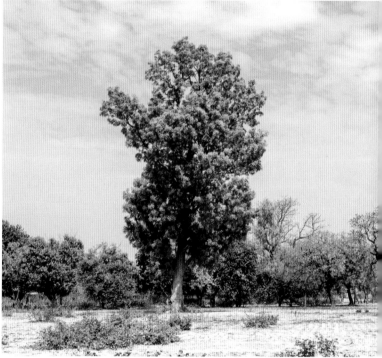

pans. In the valleys and plains there are vast areas of vetiver (*Chrysopogon zizanioides*), a bunch grass native to India that can reach 10 feet (3 meters) in height, and herbaceous savannas dominated by gamba grass (*Andropogon gayanus*), occasionally associated with *Panicum anabaptistum*. Seasonally flooded grassland is typically composed of *Paspalum orbiculare* and species of millet (*Echinochloa*). Dry forest is comprised of Sudanian species, such as camel's foot tree (*Piliostigma thonningii*), the endangered *Pterocarpus erinaceus*, the highly endangered afromosia (*Pericopsis elata*), *Bombax costatum*, wild syringa (*Burkea africana*), African mesquite (*Prosopis africana*), *Sterculia setigera*, red-leaved fig (*Ficus ingens*), and African birch (*Anogeissus leiocarpa*). There are also areas of savanna bamboo (*Oxytenanthera abyssinica*).

N I O K O L O - K O B A N A T I O N A L P A R K

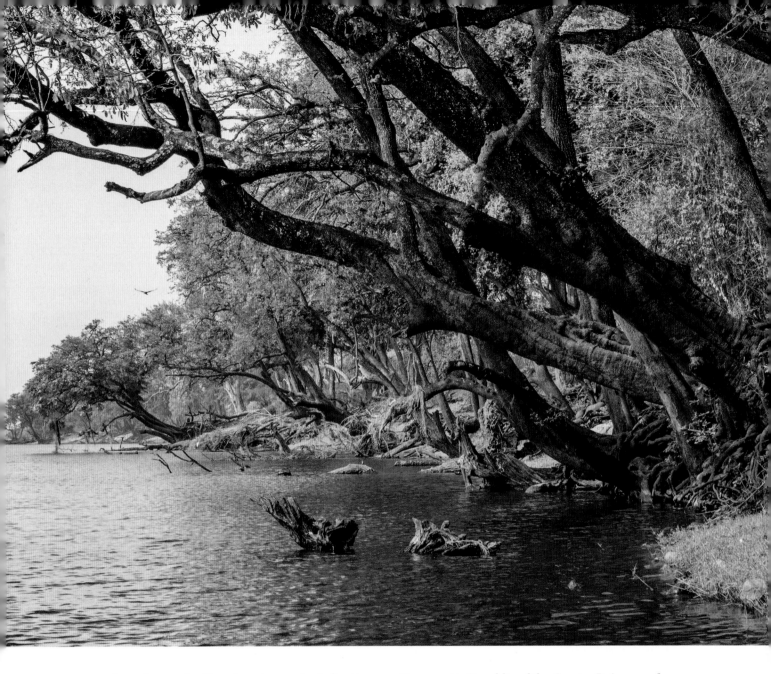

In ravines and gallery forests, species indicative of a south Guinean climate are present, with lianas very abundant, and thickets of northern African raffia (*Raphia sudanica*), a palm that may reach 25 feet (7.6 meters) high but usually grows 10 feet (3 meters). It is recognizable by its stiff, rather upright, leaves, its spadix with greatly condensed, solid branches, and its blunt-nosed, mahogany red fruits. The raffia is used to make Kuba cloth, the traditional fabric made by the Kuba people of the Democratic Republic of the Congo. *Baissea multiflora* is a shrub growing up to 20 feet (6 meters) tall, but often adopts a climbing habit with stems up to 98 feet (30 meters) long that twine into the surrounding vegetation for support. It produces multitudes of white or pale pink sweet-scented flowers. African peach (*Nauclea latifolia*), a deciduous shrub or tree with an open canopy, produces red or pinkish fruit with a deep red, sweet-flavored pulp. *Landolphia dulcis* is a climber with a stout

From left: Jackalberry trees with their roots in the river. • Gum arabic tree (*Vachellia nilotica*).

231

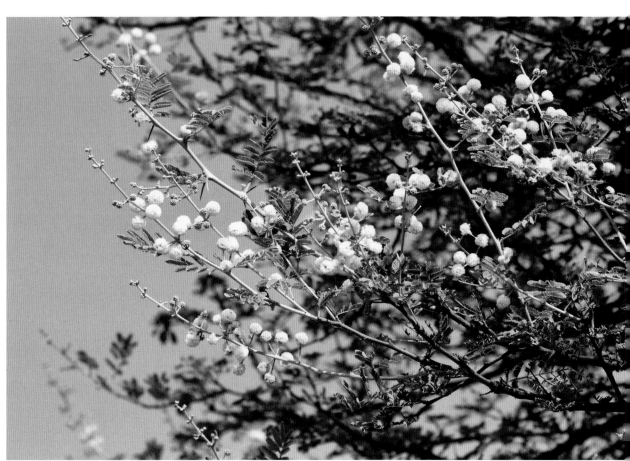

stem to 33 feet (10 meters) long. The orange fruit is edible but of variable palatability.

On the edges of rivers there are semiaquatic species such as *Rotula aquatica*, an aromatic shrub growing to a height of 6½ feet (2 meters) with purple-pink flowers. It can be found growing in fast-moving streams, a rare environment for a shrub. In and around the marshes, most of which are situated in abandoned riverbeds or behind the levees, the vegetation is very variable, depending on the height of the depression, water level, origins, soil structure, and subsoil. Certain ponds are bordered by dry forests, or herbaceous savannas, with grass species such as *Arundinella nepalensis*, *Eriochrysis brachypogon*, and *Hemarthria altissima*. Occasionally the center of a marsh is occupied by thick thorn bushes of *Mimosa pigra*, a sensitive shrub in that the leaves fold up when touched or when the sun goes down.

Marshes on higher ground are smaller, with scanty, very acid and peaty soil. Vegetation includes

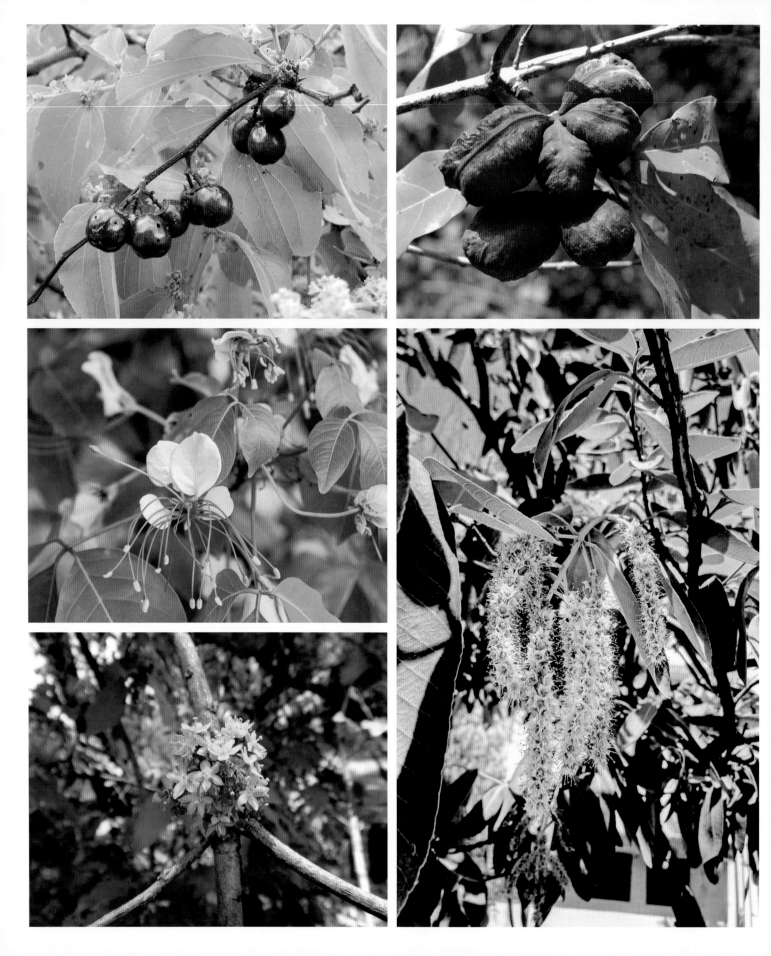

Opposite, clockwise from top left: **Buffalo thorn** (*Ziziphus mucronata*). • Seed preparations of *Cola laurifolia* are used to treat diarrhea and dysentery. • The fluffy flowers of *Erythophleum*. • Cola flowers. • Sacred garlic pear (*Crateva religiosa*).

Below, from left: Baboons inhabit the park. • Antelope are a regular fixture of the park. • Red-throated-bee-eater.

233

Oryza brachyantha, a wild rice distantly related to cultivated rice (*O. sativa*); *Bryaspis lupulina*, a yellow pea; bird plum (*Berchemia discolor*), a broadleaf tree growing to 59 feet (18 meters), with datelike fruits; and the carnivorous plant *Genlisea africana*, with purplish flowers with white spots on the lower corolla lip.

On high banks gum arabic tree (*Vachellia nilotica*), the sacred garlic pear (*Crateva religiosa*), jackalberry (*Diospyros mespiliformis*)—a tall, upright tree that can reach a height of 82 feet (25 meters) and produces yellow to orange fleshy berries—and buffalo thorn (*Ziziphus mucronata*) are dominant. Localized species such as *Cola laurifolia*, an 89-foot (27-meter) tree with yellow flowers, *Cynometra vogelii*, a small tree with white

or rose flowers, and the shrub *Symmeria paniculata*, occur on constantly humid low banks. Riverbank species also include Senegal mahogany (*Khaya senegalensis*), *Erythrophleum suaveolens*, with fluffy yellow flowers, and *Borassus akeassii*, a large fan palm whose fruits are used for making palm wine, while the leaves are used for thatch and weaving.

Let us not forget the animals, if only to mourn their loss. The disastrous increase of poaching has drastically reduced the numbers of large animals which, in an ORSTOM survey in 1990 to 1991 numbered 46,500. According to a census in 2006 by the African Parks Foundation they now number less than 900. The area is said to have been the last refuge in Senegal of the western giraffe (*Giraffa camelopardalis peralta*), now no longer present.

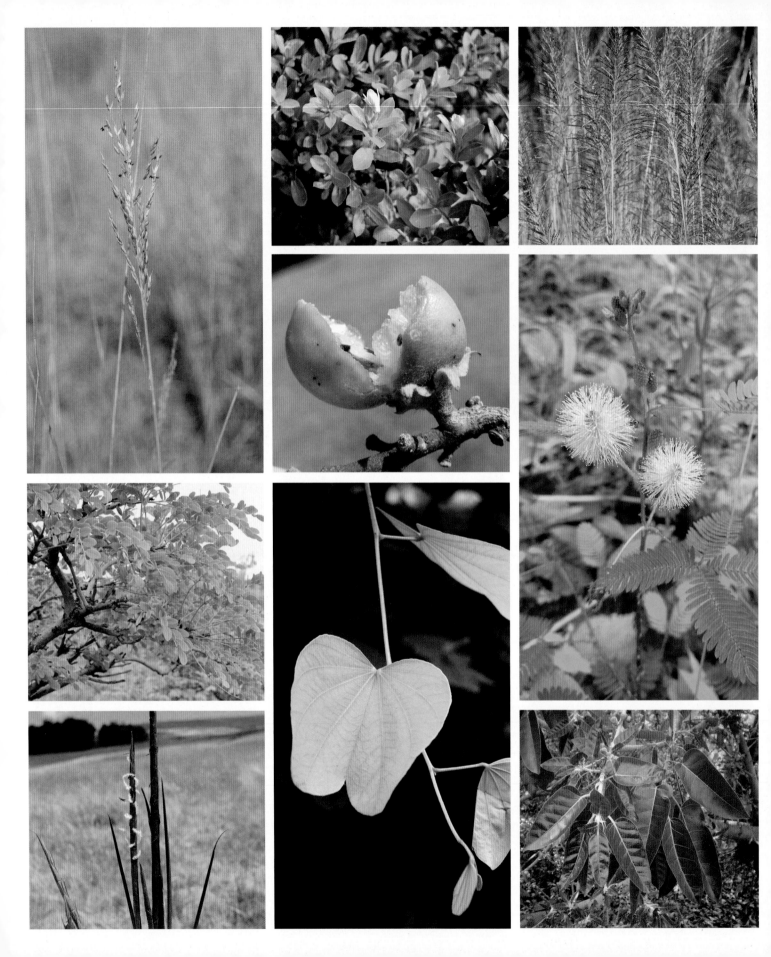

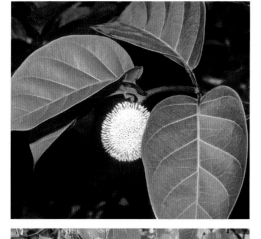

First column: Arundinella (*Arundinella nepalensis*) is used for thatching. • Wild syringa (*Burkea africana*). • Limpo grass (*Hemarthria altissima*). *Second column:* Rotula aquatica. • Jackalberry (*Diospyros mespiliformis*). • One of the most important indigenous multipurpose trees, *Piliostigma thonningii. Third column:* Vetiver (*Vetiveria zizanioides*). • *Mimosa pigra.* • Red-leaved fig (*Ficus ingens*). *Fourth column:* African peach (*Nauclea latifolia*). • African birch (*Anogeissus leiocarpa*). • Bird plum. *Fifth column: Sterculia setigera.* • The orange flowers of *Bombax costatum.*

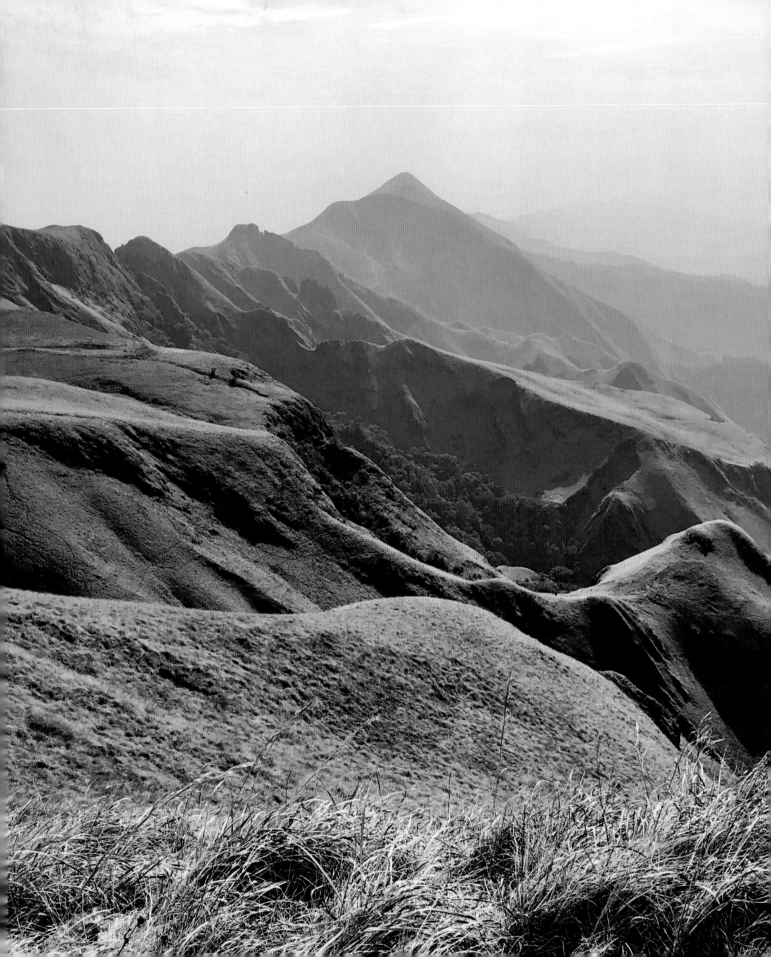

Located on the borders of Guinea, Liberia, and Côte d'Ivoire, Mount Nimba rises above the surrounding savanna. Its slopes are covered by dense forest at the foot of grassy mountain pastures. They harbor an especially rich flora and fauna, with endemic species such as the viviparous toad and chimpanzees that use stones as tools.

Mount Nimba Strict Nature Reserve

CÔTE D'IVOIRE
AND GUINEA

Mount Nimba lies between the tropical forest and the West African savanna belt. It is part of an archipelago of peaks and plateaus, an isolated refugium covered by the Upper Guinean montane forest, which rises steeply above undulating lowland forest plains. It is known as a WWF/IUCN Centre of Plant Diversity mostly for its forests, although its distinctiveness is predominantly in the montane grassland zone. There are over 2000 species of vascular plants with 16 considered strictly endemic to the region, most of which are forest species. There are three

Mount Nimba in the distance.

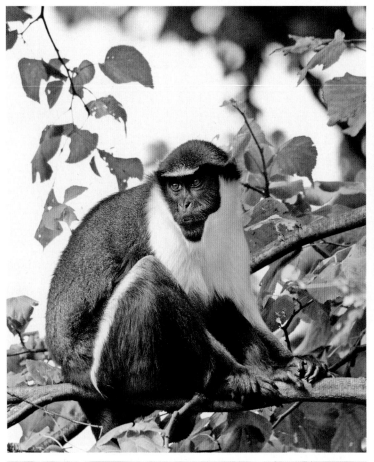
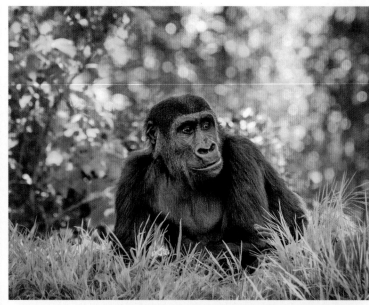
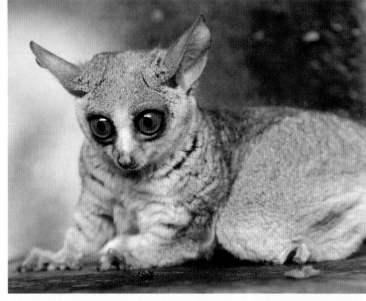
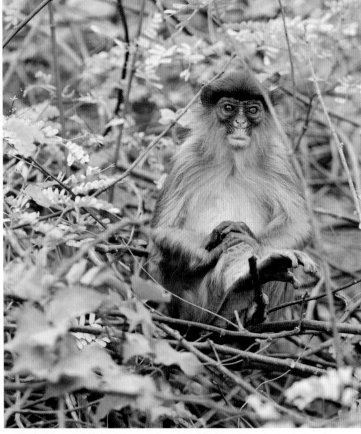

Clockwise from top left: Diana Monkey, named for its white brow which is said to resemble the bow of the Roman goddess. • West African chimpanzee. • Senegal bushbaby (*Galago senegalensis*). • Rock hyrax. • Red colobus monkey.

239

major vegetation types: high altitude grassland with relict highland forest, piedmont savanna from 1804 to 1968 feet (550 to 600 meters) with gallery forest between 3280 and 5249 feet (1000 and 1600 meters), and primary forest in the foothills between 1968 and 3280 feet (600 and 1000 meters), all possessing a high diversity of plants.

The unique high-altitude grassland or montane savanna is naturally occurring and is dominated by *Loudetia kagerensis*, a wiry grass with fine leaves. Other grasses, such as species of *Anadelphia* and *Tristachya*, also grow there. On the slopes there are woody plants such as the regional endemic *Protea madiensis* subsp. *occidentalis*, the woodland sugarbush. Large clumps of *Afrotrilepis pilosa*, a sedge, grow on rocks along with *Disa welwitschii*, a perennial with bright orange flowers, *Polystachya microbambusa*, a yellow-flowering orchid, and *Swertia mannii*, a gentian. A veritable rock garden.

The remnants of montane forest are dominated by myrtle family (Myrtaceae) species and in the highest valleys by the spiny tree fern (*Alsophila manniana*), a species that grows up to 23 feet (7 meters), with leathery fronds and rust red spines along the stems. Another tree fern, *A. dregei*, has a thick trunk and reaches a height of 16 feet (5 meters), with large, arching fronds.

In the submontane cloud forest the Guinea plum (*Parinari excelsa*), a fast-growing evergreen tree with a thick, rounded crown, grows up to 148 feet (45 meters) tall. The pink flowers produce a yellowish fruit not unlike avocado. *Hibiscus noldeae*, a shrubby perennial with yellow flowers with a deep red center, and *Canthium henriquesianum*, a shrub with shiny leaves and yellow-green flowers, are just two of the understory species. In these midaltitude forests above 3937 feet (1200 meters) there are abundant lianas, orchids, epiphytes, ferns, lycopods, lichens, fungi, and mosses.

Drier semideciduous midaltitude forests with trees such as African whitewood (*Triplochiton scleroxylon*), a deciduous tree growing to 148 feet (45 meters) with large buttresses and saucer-shaped white flowers that are red-purple at the base; *Piptadeniastrum africanum*, a large shrub or small tree with copper-colored leaves when young, and yellow flowers producing a dark red fruit; and *Parkia bicolor*, the African locust-bean, a deciduous tree in the pea family (Fabaceae) with an umbrella-shaped crown that has small flowers followed by large pods dangling from the branches.

The dense, moist, predominantly primary lowland forest is in the foothills and lower valleys. The dominant species include *Lophira procera*, the red ironwood tree, a 197-foot (60-meter) tall tree with red-brown bark, and white flowers in loose, branched, terminal inflorescences, and *Heritiera*

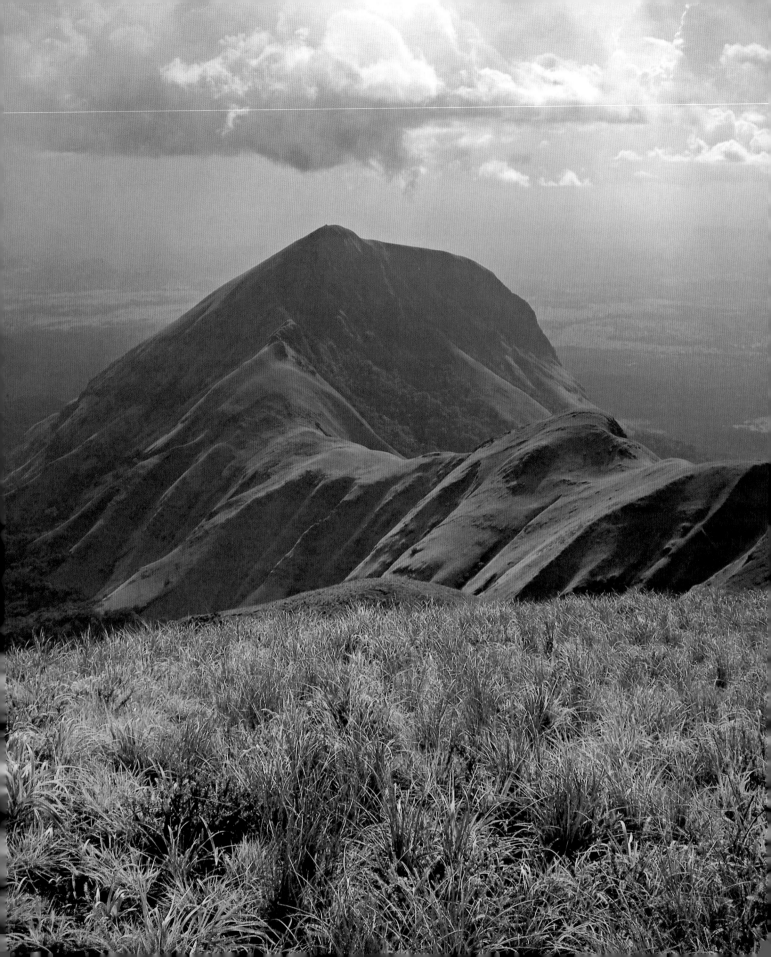

utilis, a large evergreen tree. Both species are highly prized for their lumber, a fact that imperils the future of wild populations.

With such a highly diverse flora, a diverse number of animals follows. More than 500 new species of fauna have been described in the Guinean-Ivorian Mount Nimba Reserve, and more than 200 presumed endemic species have been described from the Liberian end of Mount Nimba. Three hundred seventeen vertebrate species are recorded of an exceptionally rich diversity because of the many habitats created by the interfingering grasslands and forests, and wide variety of microclimatic niches. There are small primate populations of diana monkey (*Cercopithecus diana*), West African red colobus (*Piliocolobus badius*), western pied colobus (*Colobus polykomos*), potto (*Perodicticus potto*), Senegalese bushbaby (*Galago senegalensis*), and West African chimpanzees (*Pan troglodytes verus*). There is also an isolated population of the rock

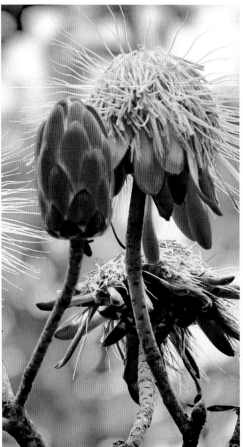

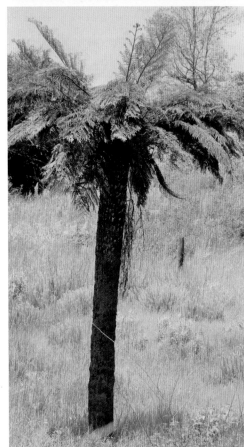

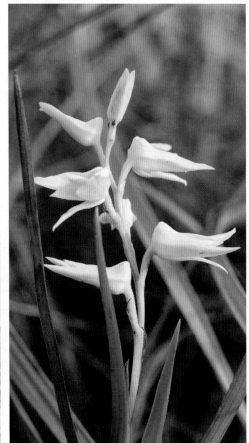

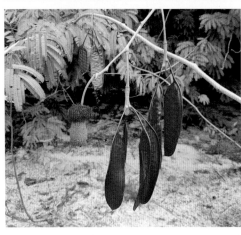

hyrax (*Procavia capensis*), as well as western tree hyrax (*Dendrohyrax dorsalis*).

The principal threats to this World Heritage Site are mining, poaching, deforestation, encroachment by grazing cattle, bush fires, inadequate management, funding and staff, and lack of transboundary cooperation. The Liberian and Ivorian civil wars led to short-term refugee influxes, the effects of which are no longer visible. However, they halted all management activity, already minimal, as well as trinational negotiations and NGO activity. Habitat destruction is a major threat, principally through slash-and-burn farming and the ensuing fires set by farmers to clear farmland for pasture; also by logging to clear more land. In the dry season hundreds of grazing cattle invade the Guinean part of the site.

The large-scale mining of iron ore is a considerable threat. Based on a 2015 report by the United States Geological Survey, Nimba holds roughly 6 billion tons of high-grade iron ore. The area was classified as a strict nature reserve in 1944 and then as a World Heritage Site in 1981. As a result of some confusion on the exact area which was inscribed as a World Heritage Site, the boundary of the reserve and World Heritage Site was clarified in 1993, which resulted in the exclusion of a keyhole-shaped area where a mining concession was attributed.

Mining from the 1963 to 1992 did enormous damage to the Liberian part of the range until civil war caused activity to cease. The present World Heritage Site excludes both the Liberian part of the mountain, disturbed by past iron mining and intensively poached to the present, and the mining enclave in the northern end in Guinea. In 2010 the Guinean Government issued a decree that aligns the Mount Nimba Strict Nature Reserve boundary with those of the Mount Nimba World Heritage Site, classifies the Bossou Hills and Déré Forest as strict nature reserves, and classifies the Buffer Zone and the "Mining Perimeter"—the area inside the keyhole reserved for mining in 1993 but outside the mining concession—as managed nature reserves.

In addition to the protection statuses of areas of the Biosphere Reserve in Guinea and the Ivoirian Strict Nature Reserves, the Liberian portion of the Nimba Mountain range has been officially protected since 2003 as the East Nimba Nature Reserve.

No mining has started yet in the enclave and the proposed mining project is undergoing a rigorous Environmental Impact Assessment to investigate if mining can happen without impacting the values of the site. This assessment will need to be a submitted to the World Heritage Committee before the mining project can go ahead.

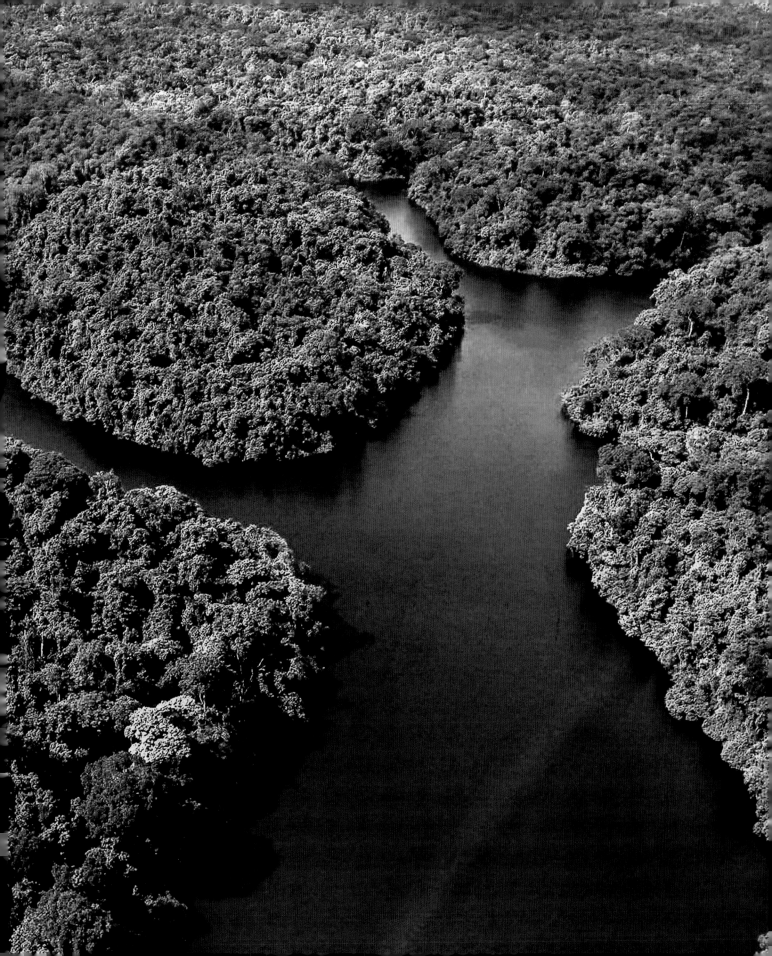

This is one of the largest and best-protected rainforests in Africa, with 90 percent of its area left undisturbed. Almost completely surrounded by the Dja River, which forms a natural boundary, the reserve is especially noted for its biodiversity and a wide variety of primates. It contains 107 mammal species, 5 of which are threatened.

Dja Faunal Reserve

CAMEROON

Designated as a World Heritage Site in 1987, the Dja Faunal Reserve is one of Africa's most species-rich rainforests. It is located between the Gulf of Guinea and the Congo Basin in a transitional zone between the Atlantic equatorial coastal forests of southern Nigeria and western Cameroon and the evergreen forests of the northwestern Congo lowlands. There are four main forest types: Atlantic, semideciduous, Congolese, and monospecific. The forests of the region have long been a resource to local people and were even farmed in places, now secondary forest, but have remained

The Dja Faunal Reserve.

90 percent entire. Its tree cover is as almost much semideciduous as evergreen but is dominated by the dense semi-evergreen Congo rainforest.

The climate is equatorial in type, with four seasons: the long rains from mid-September to December, a 3-month dry season, the small rains between mid-March and June, and a short dry season from July to September.

Some 43 species of trees form the canopy, legumes being particularly common. *Afzelia bipindensis* is a large tree growing to 131 feet (40 meters) tall with flowers that have petals of red-purple claws and white crumpled lamina turning pink.

Piptadeniastrum africanum grows up to 164 feet (50 meters) high, with a buttressed base and smooth, usually gray bark. African whitewood (*Triplochiton scleroxylon*), is a deciduous tree with pale yellow wood. It is one of the most exploited species for timber. African pearwood (*Baillonella toxisperma*) can reach up to 197 feet (60 meters) high. The creamy white flowers are held in dense fascicles at the ends of branches. *Afrostyrax lepidophyllus* smells of garlic. The bark is pale colored, and the leaves when fresh are a very bright green on their upper surface. On the lower surface they are dull, pale brown to matte white due to a dense covering of tiny white

From left: A young gorilla eating leaves of *Gilbertiodendron dewevrei.* • Chimpanzees roam the reserve. • West African slender-snouted crocodile.

scales. It is often found with *Gilbertiodendron dewevrei*, a large, evergreen tree growing up to 148 feet (45 meters). The fragrant flowers are purple-red.

The shrub layer contains species of *Diospyros*, *Drypetes*, and *Cola*; and *Pachylobus buettneri*, which can be a large shrub or tree with fleshy light purple fruits. The herbaceous layer is composed principally of the arrowroot family (Marantaceae) and *Mapania*, a genus in the sedge family Cyperaceae. Arrowroot (*Maranta arundinacea*) is a perennial growing to a height of 5 feet (1.5 meters). Its leaves are lance-shaped and clusters of small white flowers bloom almost continuously. Another member

of Marantaceae, *Sarcophrynium brachystachyum* is used to makes plates, pots, cups, funnels, fans, and parasols. The stems are used for making cords, fish traps, and baskets. *Trachyphrynium braunianum* is a thicket-forming herbaceous species with a bamboolike stem up to 25 feet (7.6 meters) high. *Marantochloa purpurea* is a large, climbing plant that grows to a height of 10 feet (3 meters) or more. The leaves are borne on petioles up to 31 inches (80 centimeters) long, which wrap around the stem for about half of their length. The leaf blades are large and ovate, but asymmetrical, with rounded bases and pointed tips, the undersurfaces

DJA FAUNAL RESERVE

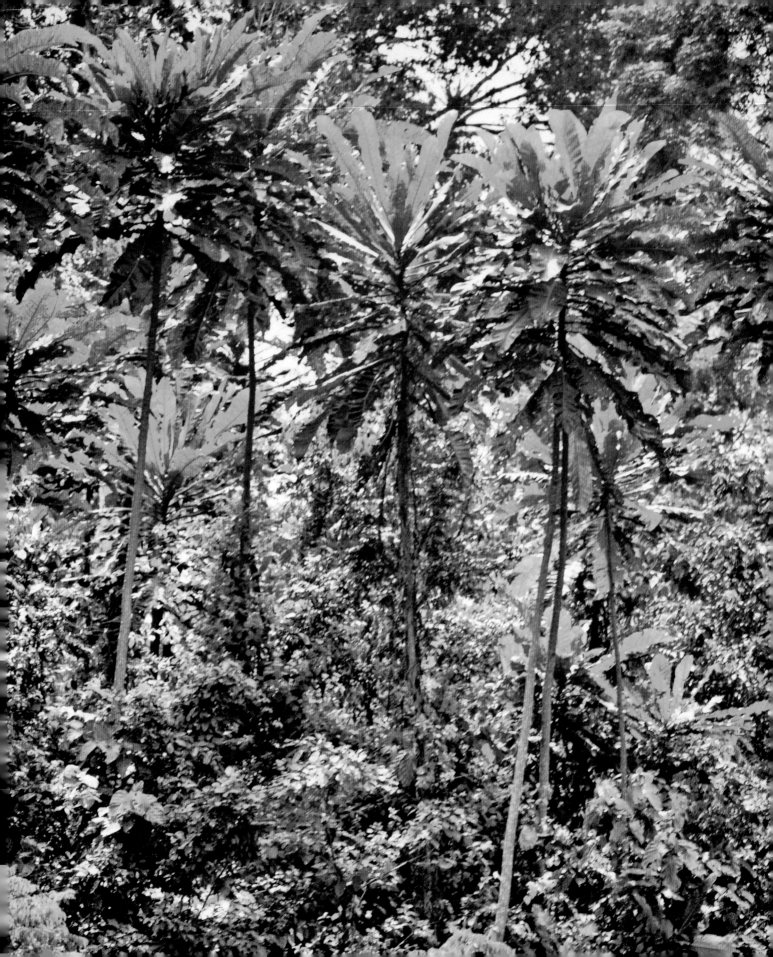

Opposite: Cabbage palm (*Anthocleista nobilis*). The local name for this plant is wudifokete or bontodee.

Below: Gray parrot.

sometimes being purplish. The purple flowers are borne in branching panicles. The leaves are used for thatching.

Other main vegetation types are riverine and swamp vegetation with the cabbage palm (*Antho-cleista nobilis*), *Raphia hookeri*, and *Alstonia congensis*, a small to medium-sized tree up to 49 feet (15 meters) tall, with leaves in whorls and cream, pale yellow or pale pink flowers.

Bitter leaf (*Vernonia amygdalina*) is a small shrub that typically grows to a height of 6½ to 16 feet (2 to 5 meters). It has dark green bitter-tasting leaves, rough bark, and intense purple flowers. The leaves are used in the making of Ndolé, a Cameroonian dish consisting of stewed nuts and fish, beef, or shrimp. It is traditionally eaten with plantains, bobolo—a preparation of fermented ground manioc—or cassava and wrapped in leaves. Eru (*Gnetum africanum*) is a vining gymnosperm that, despite having leaves, is related to conifers. It grows to 33 feet (10 meters) long, with thick paperlike leaves growing in groups of three. The leaves may grow approximately 3¼ inch (8 centi-meters) long, and at maturity the vine will produce

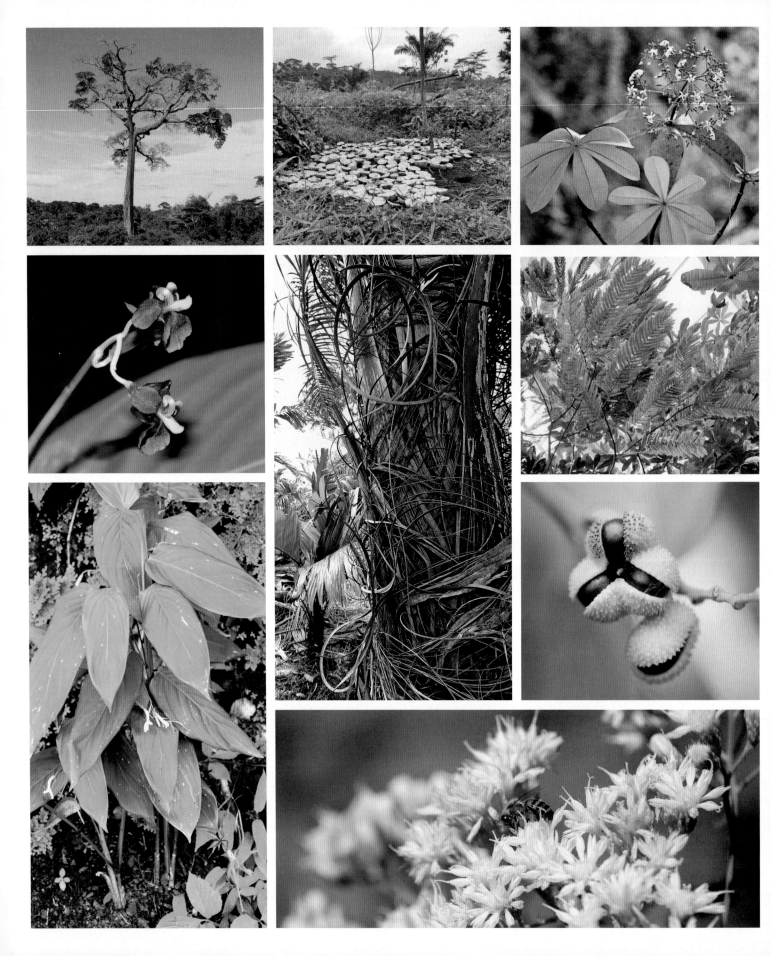

First column: *Baillonella toxisperma*. • *Marantochloa purpurea*. • Arrowroot (*Maranta arundinacea*). *Second column:* Egusi (*Cucumeropsis mannii*). • Ivory *Raphia hookeri*. • Bitter leaf (*Vernonia amygdalina*). *Third column:* *Alstonia congensis* is often harevested for medicinal purposes. • *Piptadeniastrum africanum*. • *Trachyphrynium braunianum*.

small conelike reproductive structures. Eru soup is made by stewing the finely shredded leaves with waterleaf or spinach, palm oil, and either smoked fish, cow skin, or beef. Egusi (*Cucumeropsis mannii*) is a species of melon with oily seeds that are used in soup with leaf vegetables, including bitter leaf, pumpkin leaf, celosia, and spinach, palm oil, seasonings, and meat.

The Guinean-Congolian forests have the highest biodiversity in Africa, and Dja, owing to its inaccessibility, is one of the last Cameroonian wilderness forest ecosystems to be barely disturbed by man. Dja is one of the least peopled, least exploited, and most diverse tropical forests in Africa. Its transitional climate, floristic diversity, and borderline location has resulted in the persistence of a rich, often rare, vertebrate fauna. The area has a wide range of primate species including western lowland gorilla (*Gorilla gorilla gorilla*) and western chimpanzee (*Pan troglodytes troglodytes*).

The reserve is designated an Important Bird Area by BirdLife International. A 1993 inventory of the avifauna recorded 349 resident species and some 80 more or less regular migrants including Bates's weaver (*Ploceus batesi*), which is endemic to southern Cameroon. The gray-necked rockfowl (*Picathartes oreas*) probably also occurs in this reserve. The African gray parrot (*Psittacus erithacus*) is threatened, being a target of the wildlife trade. Reptiles include python, lizard, and two species of crocodile, one being the African long-snouted crocodile (*Crocodylus cataphractus*). Sixty species of fish are known, only one being endemic, the Dja river catfish (*Synodontis pardalis*).

With the adjoining forests it is one of IUCN's fifteen critical zones for the conservation of central African biodiversity. The Reserve lies within a WWF Global 200 Freshwater Ecoregion, a UNESCO MAB Biosphere Reserve and a WWF/IUCN Centre of Plant Diversity.

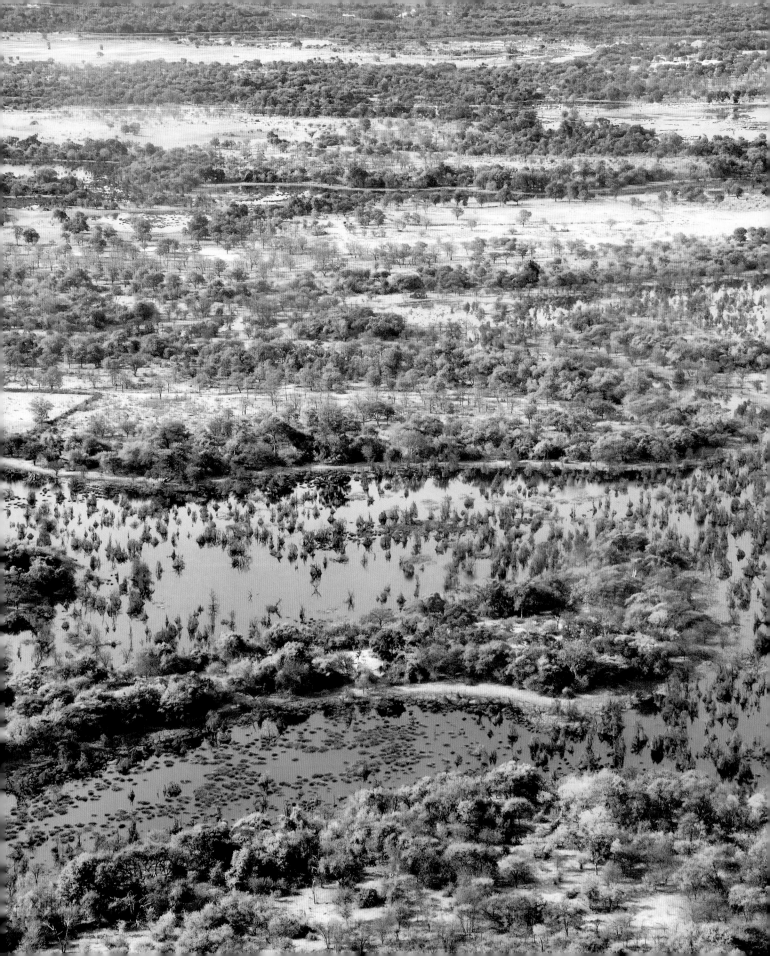

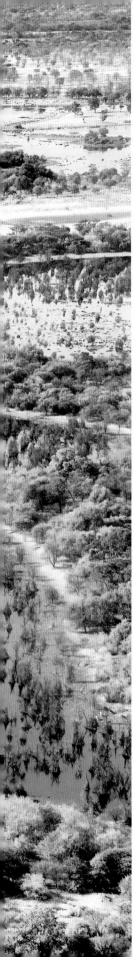

This delta in northwest Botswana comprises permanent marshlands and seasonally flooded plains. It is one of the very few major interior delta systems that do not flow into a sea or ocean, with a wetland system that is almost intact. One of the unique characteristics of the site is that the annual flooding from the Okavango River occurs during the dry season, with the result that the native plants and animals have synchronized their biological cycles with these seasonal rains and floods. It is an exceptional example of the interaction between climatic, hydrological, and biological processes. The Okavango Delta is home to some of the world's most endangered species of large mammals, such as the cheetah, white rhinoceros, black rhinoceros, African wild dog, and lion.

Okavango Delta

BOTSWANA

The source of water is the highland plateaus of central Angola. The Okavango River then flows through Angola's semiarid rangelands and into Namibia and then to Botswana, creating meandering seasonal rivers and lagoons, swamps, marshes, flooded grasslands, riparian forests, and island communities. The shining diamond of water is swallowed up by the sands of the Kalahari Desert before it reaches the sea. It takes about 9 months from the water from Angola to reach the floodplain of the delta, and so the high-water levels are in the dry winter

The wetlands of the Okavango Delta.

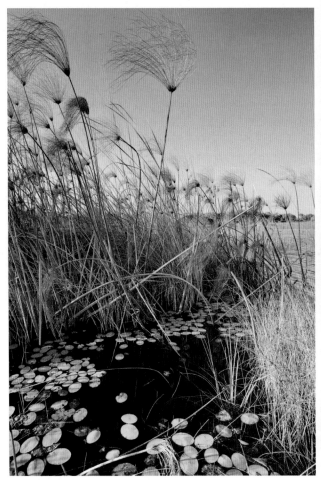

months and the low-water levels are in the wet summer months.

On 22 June 2014 the Okavango Delta became the one thousandth site to be officially inscribed as a World Heritage Site. The delta has a rich assemblage of animal species with more than 480 species of birds, 130 species of mammals including leopard, roan antelope, sitatunga, cheetah, African wild dogs, lions, and 18,000 elephants. There are 85 recorded species of fish including tigerfish, tilapia, and catfish. Over 1000 species of flowering plants and 10 species of ferns, both covering 530 genera, provide habitat, food, and shelter for all. Large numbers of antelope graze on the grasses, and in turn are hunted and devoured by carnivores. Elephants feed on shrubs and trees. Hippos, grazing at night, feed on short grasses, tearing them with their horny lips.

There are five important plant communities in the perennial swamp: papyrus (*Cyperus papyrus*) in the deeper waters, *Miscanthus* in the shallow-flooded sites, and between these two the reed *Phragmites australis*, bulrush (*Typha capensis*), and *Cyperus polystachyos*, the many-spiked

From left: Reedbeds form a crucial part of the delta's ecosystem. • To see the sun set over the delta is an almost unimaginable gift.

255

It is a medium-sized to large, deciduous to semideciduous tree up to 49 feet (15 meters) tall with a wide-spreading crown. The bark is gray and flaking on older branches and stem, but smooth, light gray and covered with dense hairs on younger branches, exuding a sticky red sap when cut. The leaves are hard and rough in texture, shiny or glossy above and gray-green beneath, with prominent midribs. The sweet-scented flowers are usually borne in dense terminal sprays at the tips of the branches and vary in color from white and pink to bluish pink, mauve, or deep violet. They appear from September to December, before or together with the new leaves.

Trees restricted to islands within the perennial swamp are a mixture of *Hyphaene petersiana* and many species that used to be in the genus *Acacia*. *Hyphaene petersiana* is a palm with gray-green fan-shaped leaves up to 6½ feet (2 meters) long with spiny petioles. It can reach 59 feet (18 meters) in height but is often much smaller, especially when suckering and forming clumps. Camel thorn (*Vachellia erioloba*) is a common small tree, although it can reach 66 feet (20 meters). The light gray thorns often sparkle in the sunlight and when hot, the bipinnate leaves close. The wood is very dense and dark brown in color. The ear-shaped seedpods are an important food for giraffe, rhinoceros, antelope, and elephant. It is

sedge. The swamp-dominant species, which are usually found in perennial swamps, also extend far into the seasonally inundated areas. *Phragmites australis* reed beds grow best in slow-flowing waters of medium depth and are prominent at channel sides. On the islands and mainland edges above the flooded grasslands different communities of flora are found. These species are located according to their water preference, for example *Philenoptera violacea* requires little water, is found at the highest elevations in the perennial swamps, and is common on drier seasonal swamp islands.

OKAVANGO DELTA

an emblematic tree of southern African countries. The young branches of *V. luederitzii* are covered in pale gray hairs. The spines come in pairs and the leaflets are softly hairy. The creamy white flowers are borne in spherical heads. *Senegalia fleckii* is a multistemmed shrub or small tree growing up to 33 feet (10 meters). The thorns are hooked, the leaflets velvety. The white flowers are borne in spikes. *Senegalia nigrescens* has almost black bark and the main trunk and branches are covered in knobs tipped with a hook. The flowers are produced before the leaves, in long, fragrant, white spikes. The umbrella thorn (*V. tortilis*) is a very drought-resistant tree and has the classic umbrella shape of the African deserts and dry savanna. It can grow to heights of between 16 and 66 feet (5 and 20 meters). The leaves are green and hairy. A green or brown domed gland can be found at the base of each petiole. The almost inconspicuous flowers are globose and white. The seedpods are rolled up in a circle or in the shape of a coiled spring.

In the alluvial soils created by the river grows mopane (*Colophospermum mopane*). It has butterfly-shaped leaves and seedpods containing seeds that smell like turpentine. The wood is hard and heavy and resistant to termites. The tree is

Below, clockwise from top left: Camel thorn (*Vachellia erioloba*). • The iconic African tree, umbrella thorn (*Vachellia tortilis*). • Elephants are a hallmark species of the Okavango. • Water lilies in the dark waters of the delta.

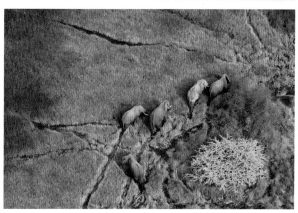

a major food source for the mopane worm, the caterpillar of the moth *Gonimbrasia belina*. The caterpillars are rich in protein and are eaten by people. Leadwood (*Combretum imberbe*) is reputed to be the heaviest wood in the world. It typically grows 23 to 49 feet (7 to 15 meters) tall; the small gray-green leaves and yellow-green samaras are carried on spiny branchlets.

The wildflowers and grasses of the delta are something to behold. Best seen from a traditional dugout canoe, paddling between the reeds and rushes, past hippo and crocodile, fish eagles, kingfishers, and saddle-billed storks, pushing aside the yellow flowers of water lettuce (*Ottelia ulvifolia*) and the light blue flowers of frog's pulpit (*Nymphaea nouchali* var. *caerulea*), a water lily. Passing small islands full of wild date palm (*Phoenix reclinata*) and waterberry (*Syzygium guineense*) while the shrubby water fig (*Ficus verruculosa*) lines the lower reaches of river channels, and at eye level, partially submerged basket grass (*Schoenoplectus corymbosus*) giving way to the tall grass stems of *Miscanthus junceus*.

On higher, drier ground creeping panic grass (*Panicum repens*) grows with devil's grass (*Cynodon dactylon*), kunai grass (*Imperata cylindrica*),

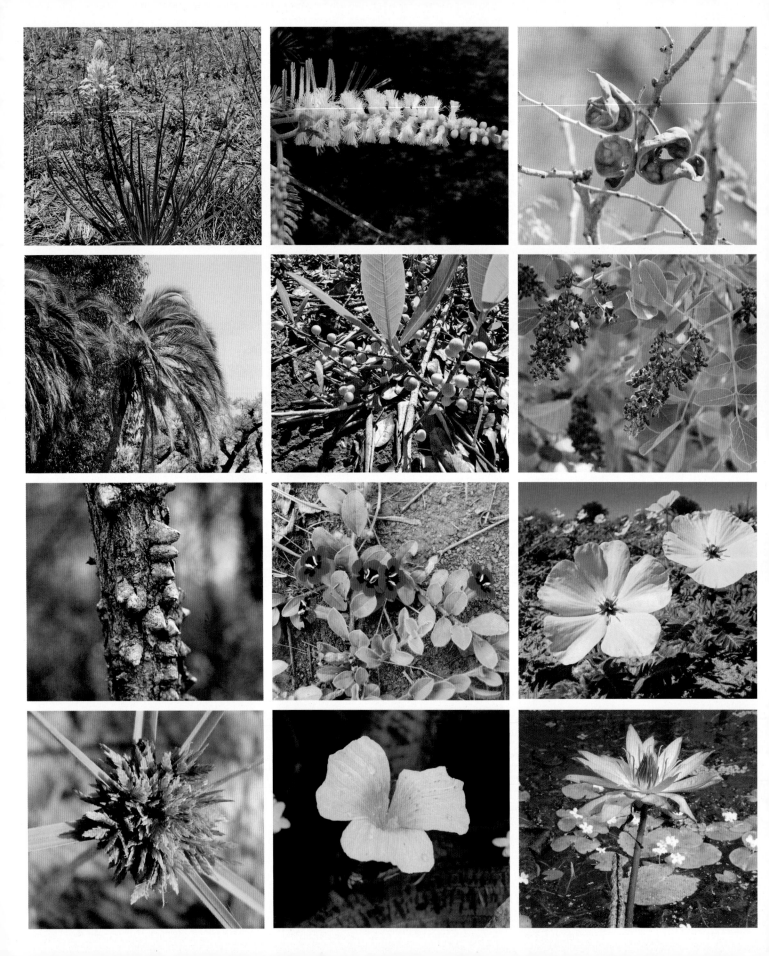

First column: *Bulbine abyssinica.* • Wild date palm (*Phoenix reclinata*). • *Senegalia nigrescens.* • *Cyperus polystachyos.* Second column: *Senegalia fleckii.* • Water fig (*Ficus verruculosa*). • A ground-covering scroph with intense blue flowers, *Aptosimum elongatum.* • Water lettuce (*Ottelia ulvifolia*). Third column: Umbrella thorn seedpods. • *Philenoptera violacea.* • Devil thorn (*Tribulus zeyheri*), a heavy name for a demure flower. • Frog's pulpit (*Nymphaea nouchali* var. *caerulea*).

Below: Hippo mother and baby.

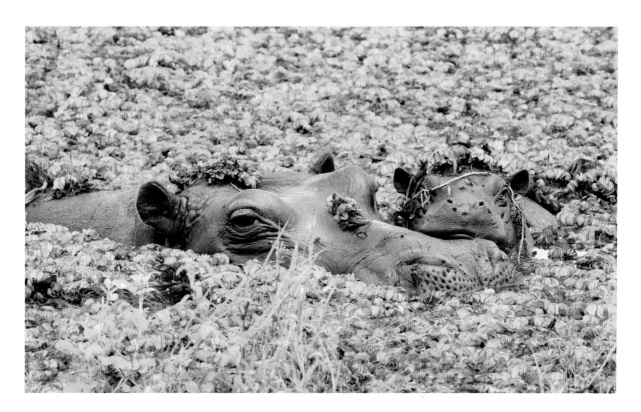

African bristlegrass (*Setaria sphacelata*), and salt grass (*Sporobolus spicatus*).

When the rains come, they are light. The annual rainfall is 18 inches (45 centimeters) but when it does fall, there are flowers in the oasis. *Cienfuegosia digitata* can be a small shrub but is usually a perennial with a woody rootstock with suborbicular leaves and solitary yellow flowers with a purple center. The deep blue flowers of *Aptosimum elongatum* are easily seen against the grasses and red soil. It is a procumbent plant, not quite a shrub. *Bulbine abyssinica* is a succulent herb that grows in small clusters. It has bright green grasslike leaves and produces several many-flowered, spikelike inflorescences with star-shaped bright yellow flowers. Devil thorn (*Tribulus zeyheri*) grows in the most arid parts of the Okavango. It is a prostrate perennial covered in long bristlelike hairs. The leaves are paripinnate, one leaf in a pair often longer than the other. The flowers are bright yellow or white with a yellow center.

The Okavango Delta is under threat from increasing water abstraction, agriculture, fishing, and bushmeat hunting. About 100,000 tourists visit the delta each year, primarily to see the wildlife. This has its own consequences, but responsible tourism brings much-needed money to the local communities.

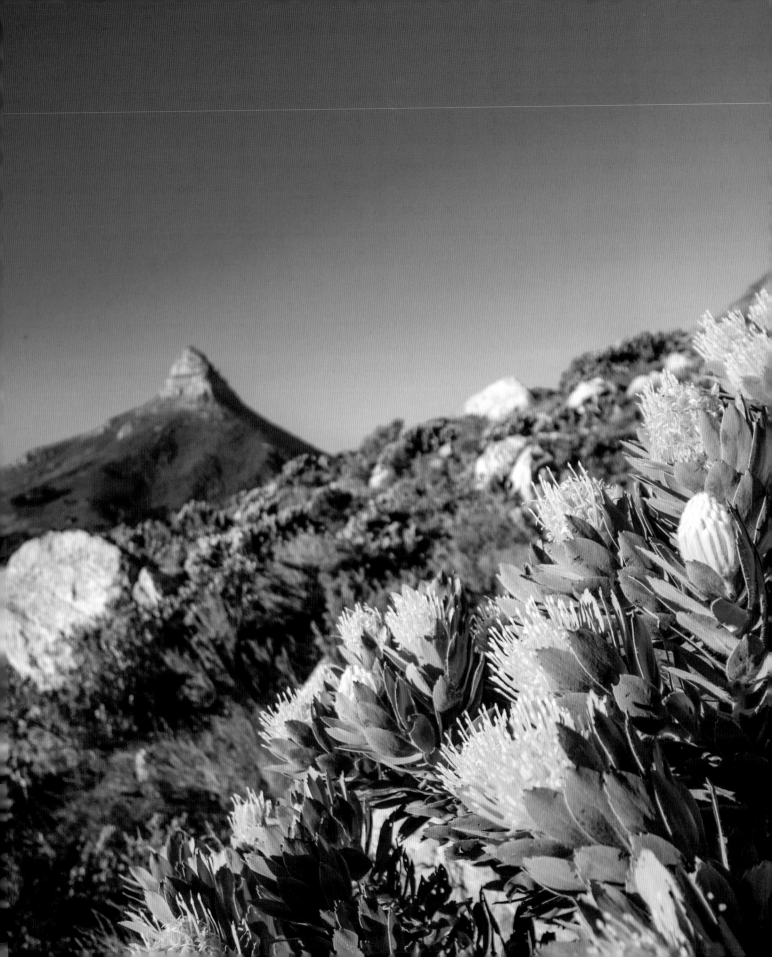

Inscribed on the World Heritage List in 2004, the property is located at the southwestern extremity of South Africa. It is one of the world's great centers of terrestrial biodiversity. The extended property includes national parks, nature reserves, wilderness areas, state forests, and mountain catchment areas. These elements add a significant number of endemic species associated with the fynbos vegetation, a fine-leaved sclerophyllic shrubland adapted to both a Mediterranean climate and periodic fires, which is unique to the Cape Floral Region.

Cape Floral Region Protected Areas

SOUTH AFRICA

The Cape Floral Region has been called the world's hottest hotspot for plant diversity and endemism and it has been identified as one of the Global Centers of Plant Diversity. Although the smallest of the world's six principal floristic regions and in a temperate zone, it has by far the highest species density and species rarity of any Mediterranean-type climatic region. In less than 0.38 percent of the area of Africa it has nearly 20 percent of its flora and 5 of the continent's 12 endemic families. In less than 4 percent of the area of southern Africa it has nearly

The kasteelspoort hiking trail on Table Mountain.

From left: Cederberg rocks, as artful as abstract sculpture. •
The cracks into the Cederberg Wilderness Area. •
The biodiversity of Table Mountain, a flora to behold.

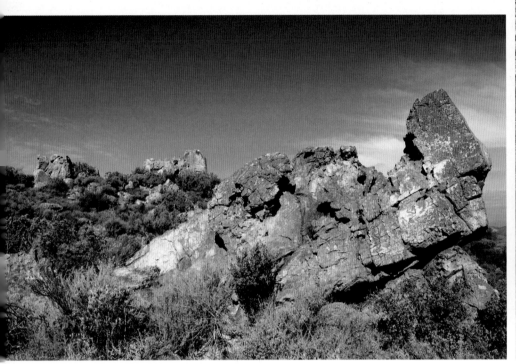

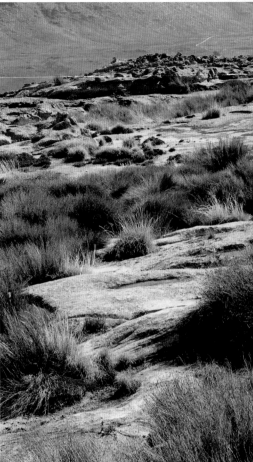

44 percent of the subcontinental flora of 20,367 species. Almost three-quarters of its vascular plant species do not occur naturally anywhere else in the world.

The property lies between the ocean and the L-shaped mountain chains that parallel the coast. Many of the protected area clusters, including Table Mountain National Park, are predominantly mountainous in nature. The Cederberg, Groot Winterhoek, Cape Peninsula, and north half of the Boland Mountain Complex just east of Cape Town lie in north-south ranges running parallel to the Atlantic Ocean. The Cederberg and Groot Winterhoek extensions are primarily montane, though they also include lowland habitats.

The ranges of the Cape Fold Mountain belt, reaching over 6561 feet (2000 meters) high, are formed of the rugged, highly sculptured Table Mountain and Witteberg Groups of barren quartzitic sandstone intermixed with Bokkeveld Group shales and overlie the sometimes exposed and eroded Cape Granite. These form a scenic backdrop to the entire region, with beautiful mountain passes, and along the Olifants River, rapids, cascades, and pools. The predominant soils, derived from the sandstone, are shallow, sandy, nutrient poor, and acidic, characteristic of fynbos.

The region has a semi-Mediterranean climate of cool wet winters and hot dry summers in the west with somewhat rainier summers in the east. However, it is highly sensitive to climate change and may lose much of its northern limits over the next few decades, with powerful effects on its unique vegetation.

Artifacts and fossils show that the region was occupied by humans at least 250,000 years ago.

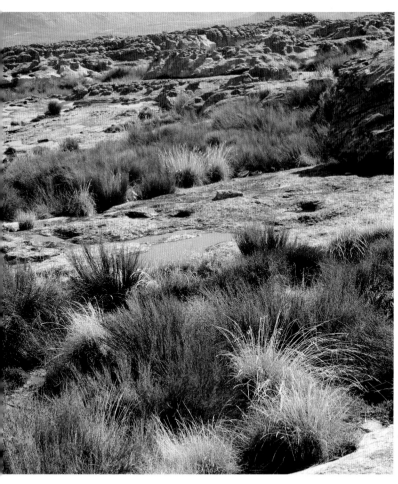

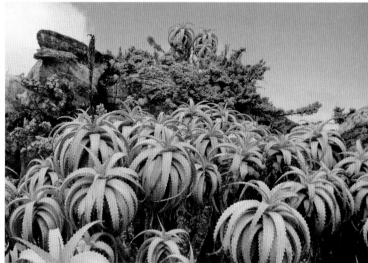

Stone tools from the Early Stone Age and hundreds of shell middens have been found. Twenty thousand years ago it was inhabited by Khoisan hunter-gatherers who left striking rock art, some of which is 5000 years old.

The distinctive flora of the region is a shrubland known as fynbos—from *Fijnboch*, an Afrikaans word meaning "fine bush"—a fine-leaved vegetation adapted to both the Mediterranean type of climate and to periodic fires. It is defined by location or by dominant species such as coastal, mountain, grassy, or proteoid fynbos. Its four main components are the Proteaceae, heaths (Ericaceae), Restionaceae, and bulbs, tubers, and corms (geophytes), including many in the iris family. Soils are predominantly coarse sand and nutrient poor. There are pockets of evergreen forest dominated by the butterspoon tree (*Cunonia capensis*), Cape beech (*Rapanea melanophloeos*), and Cape holly (*Ilex mitis*), in fire-protected riverine gorges and on deeper soils; in the east are valley thicket and succulent thicket, which are less fire-dependent; and in the drier north, low succulent Karoo shrubland, which has an unparalleled diversity of species, and is a distinct subject in itself. The flora includes spectacular proteas, irises, gladioli, pelargoniums, and a wide array of flowering succulents, mainly ice plants (Aizoaceae), many orchids, and species of the bean family (Fabaceae).

In the fynbos there is one plant that stands out above all, the king protea (*Protea cynaroides*). The flower is magnificent and has 6 to 10 globe-shaped flower heads, up to 12 inches (30 centimeters) in diameter consisting of many tubular-shaped flowers of pink or crimson surrounded by large, stiff, pointed bracts of a silvery gray flushed with pink. It

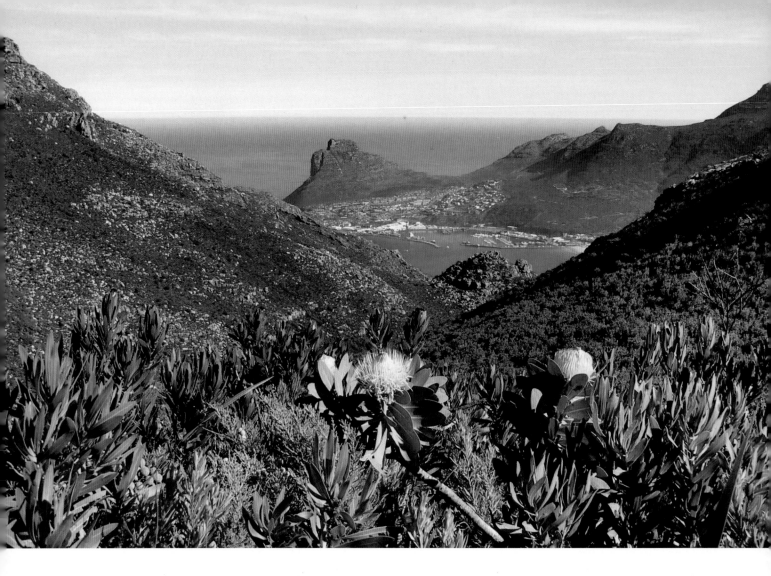

is as if a rose met a globe artichoke and they went on a spree. It is a woody shrub with thick stems and large dark green, glossy, flattened, paddle-shaped leaves. Birds such as sugarbirds and sunbirds pollinate the flowers. Bees and beetles feed on the nectar. It has one of the widest distribution ranges of all the Proteaceae and grows throughout the Cape Floral Region. Its ability to regrow after fires from underground stems (lignotubers), and its ability to inhabit a large range of habitats within the Cape, makes it relatively safe from endangerment. It is the national flower of South Africa.

Proteaceae is a largely Southern Hemisphere family consisting of 79 genera and around 1700 species with southern Africa and Australia as centers of greatest diversity. In the Cape Floral Region, the most common genera are *Protea*, *Leucadendron*, *Leucospermum*, *Mimetes*, and *Serruria*.

There are about 89 species of *Protea*. *Protea nitida* forms a large tree, sometimes up to 33 feet (10 meters) in height but most often growing to 16 feet (5 meters). The young leaves are crimson, maturing to a sea green color. Greenish white flower heads appear year-round with a peak in the cooler rainy season. Where abundant, *P. nitida* forms open woodlands.

Sugarbush (*Protea repens*) is aptly named as it produces a richness of nectar, attracting birds and bees and other insects. The nectar used to be collected by humans and boiled into a syrup

called bossiestroop, meaning "bush syrup." The chalice-shaped flower heads vary in color, from a creamy white to soft pink, to deep red. Although *repens* means creeping, it does not. It is an erect shrub growing from 3 to 13 feet (1 to 4 meters), and has hard, leathery leaves.

There are about 85 species of *Leucadendron* endemic to the western and southwestern Cape, and silver tree (*Leucadendron argenteum*) may well be the most spectacular of them. It once covered large areas of the Cape Peninsula. Now it grows in isolated patches and is in danger of becoming extinct in the wild. Silver tree is an erect tree, 23 to 33 feet (7 to 10 meters) tall, with thick, gray bark. The upright branches are covered with overlapping lance-shaped silver-gray and hairy leaves, producing a silvery sheen effect. As with all *Leucadendron*, male and female flowers are borne on separate plants (dioecious) and it is the male plants that have the showier flowers, the bracts shining silver and the flower heads bright balls of yellow. The sunshine conebush (*Leucadendron salignum*) is an evergreen multistemmed shrub growing up to 6½ feet (2 meters), with colorful bracts ranging from deep red to light

yellow. Its ability to resprout after a fire makes it the most widespread species of Proteaceae on the Cape.

Leucospermum cordifolium explodes into colors of orange, red, and yellow from late July to November. Its common name is pincushion, a reference to the protruding styles of the globe-shaped flowers. It is an upright, spreading shrub of up to 5 feet (1.5 meters) high, with arching upward-bending stems producing spherical flower heads up to 4¾ inches (12 centimeters) across. The flowers are not self-pollinating and depend on the protea scarab beetle, sugarbirds, and sunbirds for pollination.

Catherine-wheel pincushion (*Leucospermum catherinae*) is an evergreen, upright shrub growing up to 10 feet (3 meters) and spreading with age. The flowers are large, up to 6 inches (15 centimeters) across and are orange, turning coppery bronze with a thickened magenta tip that is bent clockwise, giving the appearance of a whirling pincushion.

Golden pagoda (*Mimetes chrysanthus*), one of the most beautiful fynbos shrubs, has golden yellow sweet-scented flowers appearing near the tip of the branches, with the cylinder-shaped inflorescence

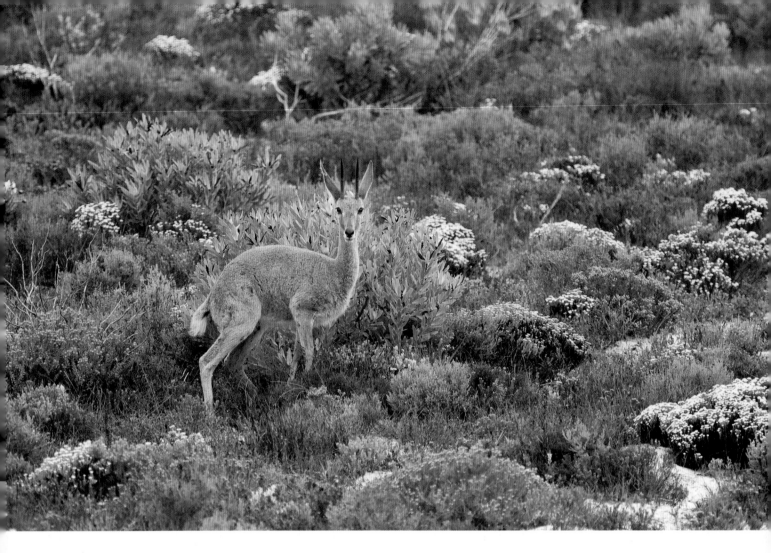

of 25 to 35 flowers appearing from the leaf axil. Blushing bride (*Serruria florida*) is widely cultivated as a cut flower but is critically endangered in the wild due to invasive Australian plants and too-frequent fires. It is an evergreen shrub growing 3 feet (1 meter) tall and wide and has finely cut foliage covering the branches. During late winter and spring, the branches are tipped with ivory to pink flowers of a great and delicate beauty.

Oh, to be in South Africa when the heathers bloom. There are 600 or so species native to the Cape. The South African heaths range from ground-hugging shrubs to multistemmed small trees. *Erica cerinthoides* grows from sea level to the mountains. It is called fire heath because it sprouts easily after a bush fire, creating a

luxuriant plant growing up to 5 feet (1.5 meters) tall, with tubular red flowers at the ends of the branches. The pinkish white cup-shaped flowers of *E. quadrangularis* cover the shrub from late winter to early summer. It is an upright shrub up to 18 inches (45 centimeters) and forms dense colonies in areas of seepage and moist clay sails. Hairy gray heather (*E. canaliculata*) grows to become a multitrunked tree up to 16 feet (5 meters) tall, with small, dark green leaves and masses of cup-shaped pink flowers with protruding styles. The blossoms have a soapy scent. It is common along the southern Cape coastal plains and along forest margins.

There are over 500 species in 58 genera of the family Restionaceae that occur in the winter rainfall regions of South Africa and Australia,

Opposite: Gray rhebok. **267**

Below, from left: *Elegia capensis.* • Sunbird,
a hallmark species of the area.

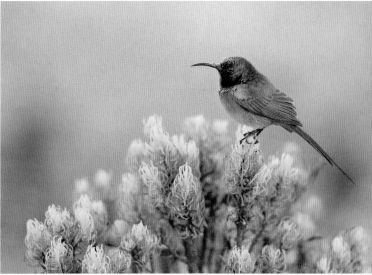

with outliers in New Zealand, Africa, Madagascar, Indochina, and Chile. Growing in the Cape, these reedlike plants date back to the Cretaceous period (145 to 66 million years ago), long before grasses and sedges appeared. Many species look like horsetails (*Equisetum* spp.) but they have solid rather than hollow stems and are drought adapted rather than the water-loving horsetails. *Elegia capensis* has lush, green bamboolike stems that form dense clumps up to 3 feet (1 meter) across. The feathery foliage is arranged in whorls while chestnut and white sheaths clasp the culms. *Elegia tectorum* has a reedlike appearance with dark green stems with dark brown flowers in slender spikes. It may reach up to 5 feet (1.5 meters) in height with a spread of 6½ to 10 feet (2 to 3 meters). *Restio multiflorus* looks like a reed with strong, upright stems growing in a large tuft. The young stems are bright light green with flowering stems spouting like a fountain from the base of the plant.

It would be remiss to ignore the bulbs, corms, and herbaceous plants of the Cape. *Lachenalia, Sparaxis, Babiana, Crocosmia, Dierama, Ixia, Brunsvigia, Haemanthus,* and *Moraea* are just a few of the genera growing in the Cape. Peacock moraea (*M. villosa*) is a striking plant growing up to 16 inches (40 centimeters) tall, with a single, narrow leaf and a large flower consisting of iridescent violet tepals with a bright blue eye and orange center. *Moraea villosa* subsp. *elandsmontana* has bright orange flowers with a lustrous sheen worthy of a noblewoman's gown at the court of Louis XIV.

Where once *Moraea villosa* was common it is now listed as vulnerable. Eighty percent of its habitat has been lost to agriculture, urban expansion, and invasive alien plants, particularly grasses. Much the same could be said of other fynbos species. Many have gone from common to vulnerable, rare, or endangered. About 1700 fynbos plant species are threatened with extinction. These plants simply must not be allowed to slip away forever.

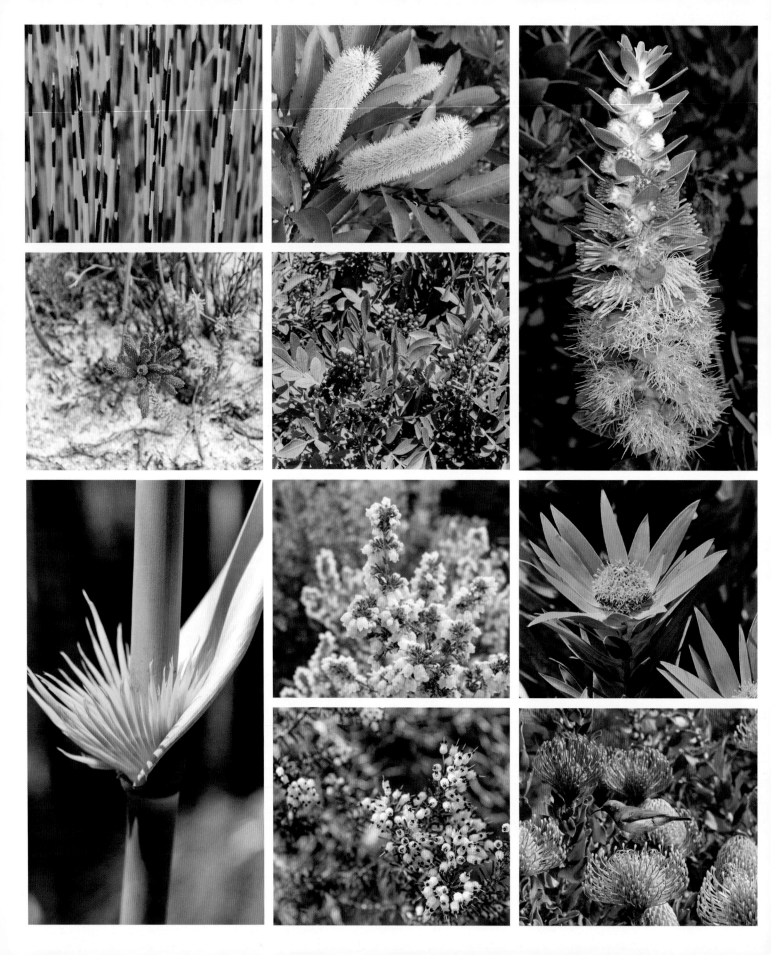

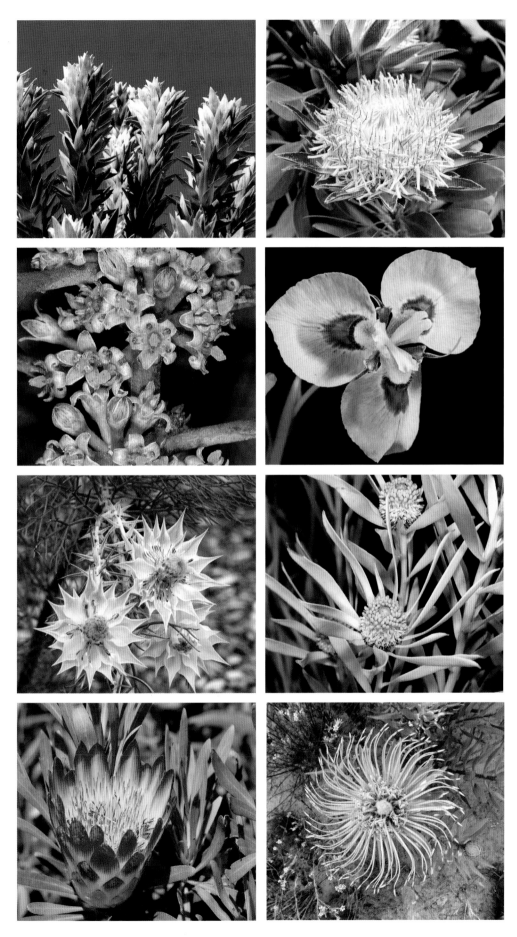

First column: *Chondropetalum tectorum.* • Fire heath (*Erica cerinthoides*). • The papery sheaths of *Elegia capensis* are pleasurably decorative. Second column: Butterspoon tree (*Cunonia capensis*). • Cape holly (*Ilex mitis*). • *Erica quadrangularis.* • Hairy gray heather (*Erica canaliculata*), a far more beautiful plant than its common name suggests. Third column: Golden pagoda (*Mimetes chrysanthus*). • The magnificent and endangered silver tree (*Leucadendron argenteum*). • *Leucospermum cordifolium*—"ornamental pincushion" in English and "bobbejaanklou" in Afrikaans. Fourth column: The silver tree is aptly named. • Cape beech (*Rapanea melanophloeos*). • Blushing bride (*Serruria florida*). • Sugarbush (*Protea repens*). Fifth column: King protea (*Protea cynaroides*). • The extraordinary beauty of the peacock moraea (*Moraea villosa*). • Sunshine conebush (*Leucadendron salignum*). • Catherine-wheel pincushion (*Leucospermum catherinae*).

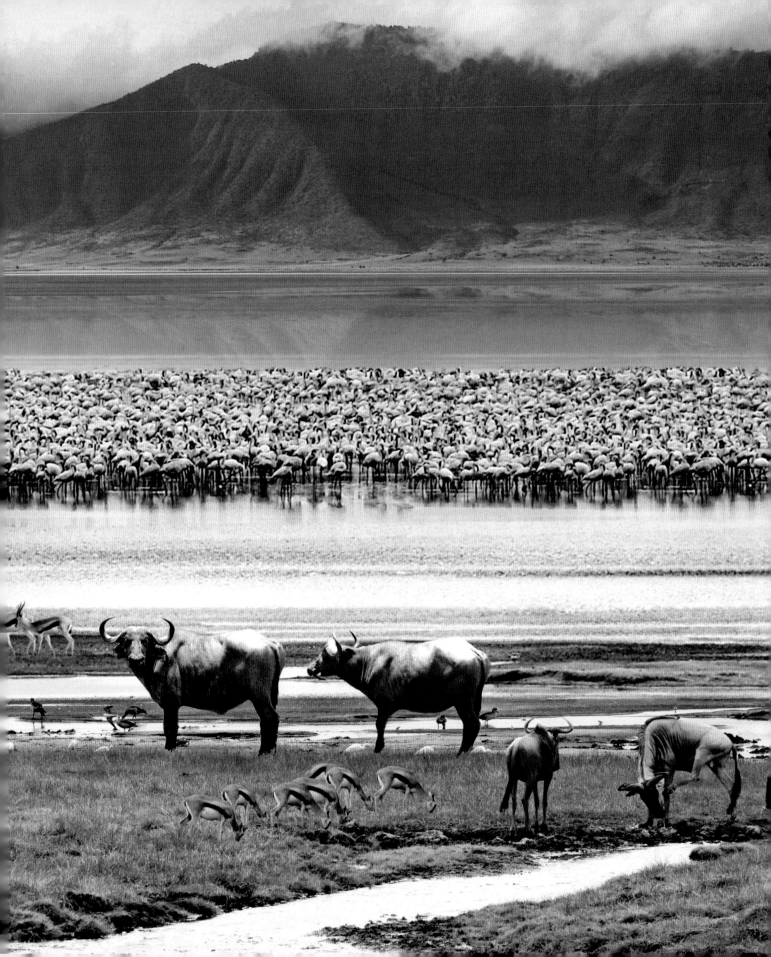

The Ngorongoro Conservation Area spans vast expanses of highland plains, savanna, savanna woodlands, and forests. Established in 1959 as a multiple land use area, with wildlife coexisting with seminomadic Maasai pastoralists practicing traditional livestock grazing, it includes the spectacular Ngorongoro Crater, the world's largest caldera. The property has global importance for biodiversity conservation due to the presence of globally threatened species, the density of wildlife inhabiting the area, and the annual migration of wildebeest, zebra, gazelles, and other animals into the northern plains. Extensive archaeological research has also yielded a long sequence of evidence of human evolution and human-environment dynamics, including early hominid footprints dating back 3.6 million years.

Ngorongoro Conservation Area

Ngorongoro Crater is the largest unbroken caldera in the world. It is neither active nor flooded, though it contains a small saline lake, Lake Makat, and the Gorigor Swamp. The Ngorongoro Conservation Area rises 3280 feet (1000 meters) from the plains of the eastern Serengeti, over the Ngorongoro Crater Highlands to the western edge of the Great Rift Valley. Its highlands have four extinct volcanic peaks including the massifs of Loolmalasin, Oldeani, and Lomagrut, the volcanism of which dates from the Late Cretaceous or Early Tertiary periods. The formation of the

Hundreds of thousands of flamingo arrive here during the wet season.

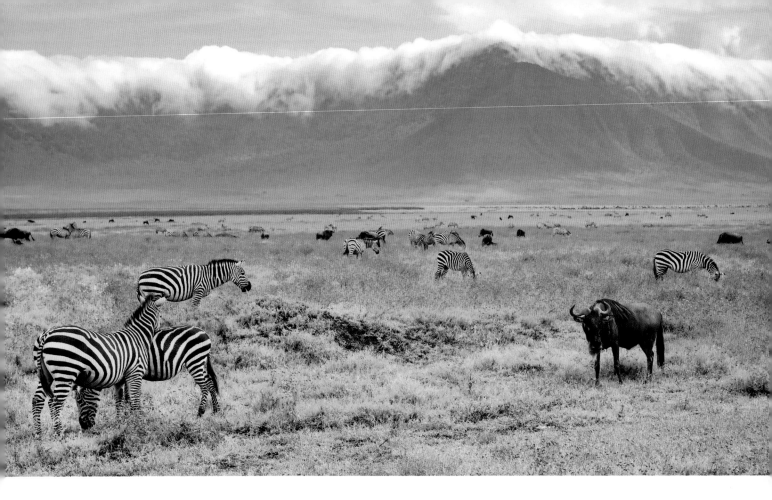

crater and highlands were created by massive rifting
that occurred to the west of the Great Rift Valley.
The area also includes Empakaai Crater, Laetoli,
and Oldupai Gorge, famous for their geology and the
associated paleontological studies, and borders the
large Lake Eyasi in the south. The highland forests
form an important water catchment for surround-
ing agricultural communities. To the north is the
Loliondo Game Control Reserve, and to the south
are densely populated farmlands.

Some 3.6 million years ago in Laetoli, three close
relatives of humans, probably *Australopithecus
afarensis*, walked through volcanic ash. Subsequent
layers of ash covered and preserved their footprints.
Discovered in 1974 by British paleoanthropologist
Mary Leakey, they are the oldest known footprints
of early humans. It wasn't until 1978, however,
when Paul Abell joined Leakey's team, that the
88-foot (27-meter) long footprint trail referred to

now as "The Laetoli Footprints," which includes
about 70 early hominid footprints, was found.
Australopithecus afarensis may have descended
from *A. anamensis* and possibly gave rise to the
genus *Homo*, although this hypothesis is not without
disagreement. Humans first evolved in Africa, that
much we know. How wonderful to tread where
they trod.

The variations in climate, landforms, and altitude
have resulted in several overlapping ecosystems
and distinct habitats. Within Tanzania the area is
important for retaining uncultivated lowland vege-
tation, for the arid and semiarid plant communities
below 4265 feet (1300 meters), for its abundant
shortgrass grazing, and for the water-catching
highland forests. Scrub heath, montane long grass-
lands, high open moorland, and the remains of dense
evergreen montane forests cover the steep slopes.
Highland trees include the peacock flower (*Albizia*

From left: Lush meadows feed the many animals of the crater. • Mud, mud, glorious mud. There's nothing quite like it for cooling the blood. • The crater in the green season.

273

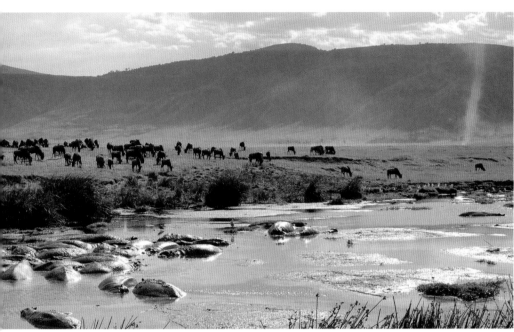

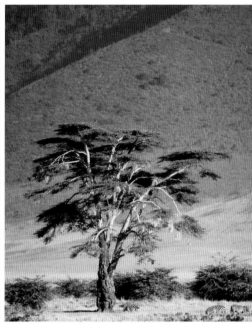

gummifera), so named because its semispherical flowers are flamboyantly white with bright crimson stamens. It is a 98-foot (30-meter) tall, deciduous, flat-topped tree with smooth bark. Yellowwood (*Podocarpus latifolius*), is a large evergreen tree up to 115 feet (35 meters) high with strap-shaped foliage that is silvery green when young turning to dark green when mature. Red thorn (*Vachellia lahai*) is a flat-topped acacia with creamy white flowers and prominent paired straight spines. East African redwood (*Hagenia abyssinica*) is a highly ornamental tree species with an umbrella-shaped crown and large attractive flowers. The male flowers are an orange to brown or white, the female flowers are red. This species grows up to 82 feet (25 meters) in height. The reddish brown bark often peels from the tree trunk and branches.

The upland woodlands of red thorn and red acacia (*Vachellia seyal*) are critical for protecting the watershed. There is an extensive stand of the bamboo *Oldeania alpina* with a height of 20 to 26 feet (6 to 8 meters) on Oldeani Mountain and of pencil cedar (*Juniperus procera*) on Makarut Mountain in the west.

The crater floor is mainly open shortgrass plains with fresh and brackish water lakes, marshes, swamps, and two patches of acacia woodland: Lerai Forest, with codominants yellow fever tree (*Vachellia xanthophloea*) and African quinine (*Rauvolfia caffra*); and Laiyanai Forest, with onionwood (*Cassipourea malosana*), peacock flower, and red thorn. The undulating plains to the west are grass covered with occasional umbrella thorn (*V. tortilis*) and African myrrh (*Commiphora africana*) trees, and become almost desert during periods of severe drought. Blackthorn (*Senegalia mellifera*) and African blackwood (*Dalbergia melanoxylon*) dominate in the drier conditions beside Lake Eyasi.

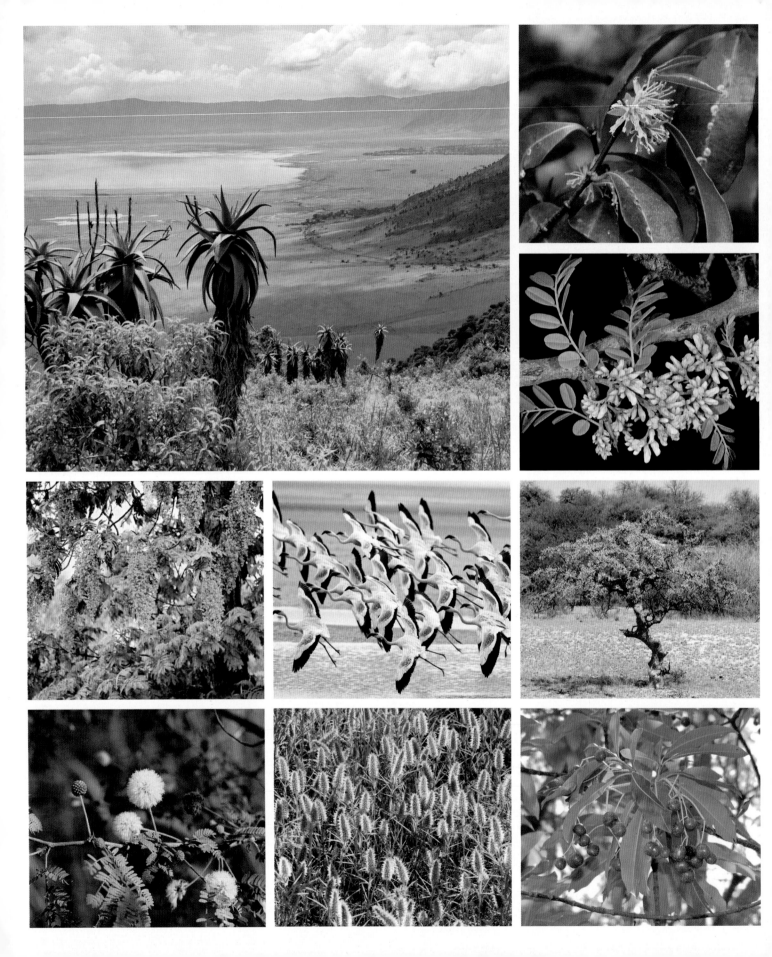

First column: Lake Magadi is the southernmost lake in the Kenyan Rift Valley. • East African redwood (*Hagenia abyssinica*). • Red acacia (*Acacia seyal*). Second column: Ngorongo crater flamingos; their feeding habit is unique—they eat with their heads upside down. • Buffel grass (*Cenchrus ciliaris*). Third column: Onionwood (*Cassipourea malosana*), although not a mangrove, it's in the mangrove family. • African blackwood (*Dalbergia melanoxylon*). • Myrrh (*Commiphora myrrha*). • African quinine (*Rauvolfia caffra*).

Below, from left: The crater supports large vegetation as well as multitudes of smaller shrubs and grasses. • The honey-scented blackthorn (*Senegalia mellifera*).

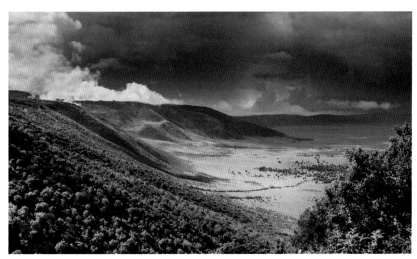

African blackwood is a small, spiny, deciduous tree that grows to 23 feet (7 meters) tall. It is often multistemmed and much branched, forming a low, irregularly shaped crown. Fragrant, white, pealike flowers appear in dense clusters in early summer.

The extensive grasslands and bush are rich, relatively untouched by cultivation, and support very large animal populations. The shortgrass savanna fills the great bowl of the crater with buffel grass (*Cenchrus ciliaris*), giant star grass (*Cynodon plectostachyus*), blue panic grass (*Panicum coloratum*), and salt grass (*Sporobolus spicatus*), to name just a few.

The area is best known as the ecosystem with the greatest concentration of large mammals in the world, both grazers and browsers, and the carnivores that live off them, totaling more than 2.5 million animals. Many of these migrate between seasonal water sources and grasslands; starting in May and June from the central plains to the western corridor and then northward across the Mara River into Kenya in July to September, dispersing to the southeast in October and November to calve in midsummer in the south. It is dominated by wildebeest in enormous numbers, also by plains zebra, Thomson's gazelle, eland, and topi, each harvesting the grass most suited to it. The herds are followed by prides of lion, spotted hyena, striped hyena, and golden jackal. There are large herds of antelope of many species. On the grasslands are eland, lesser kudu, roan antelope, oribi, Grant's gazelle, hartebeest, and buffalo, as well as ungulates including giraffe and elephant. It is iconic Africa. Grassy plains, umbrellalike thorn trees, millions of grazing animals, the sharp eyes of predators, and tourists bouncing around in open-topped vans with their long lens cameras pointing at everything.

The area lies within a WWF Global 200 Freshwater Ecoregion, is in one of the world's Endemic Bird Areas and overlaps a UNESCO Biosphere Reserve. It was inscribed as a World Heritage Site in 1979.

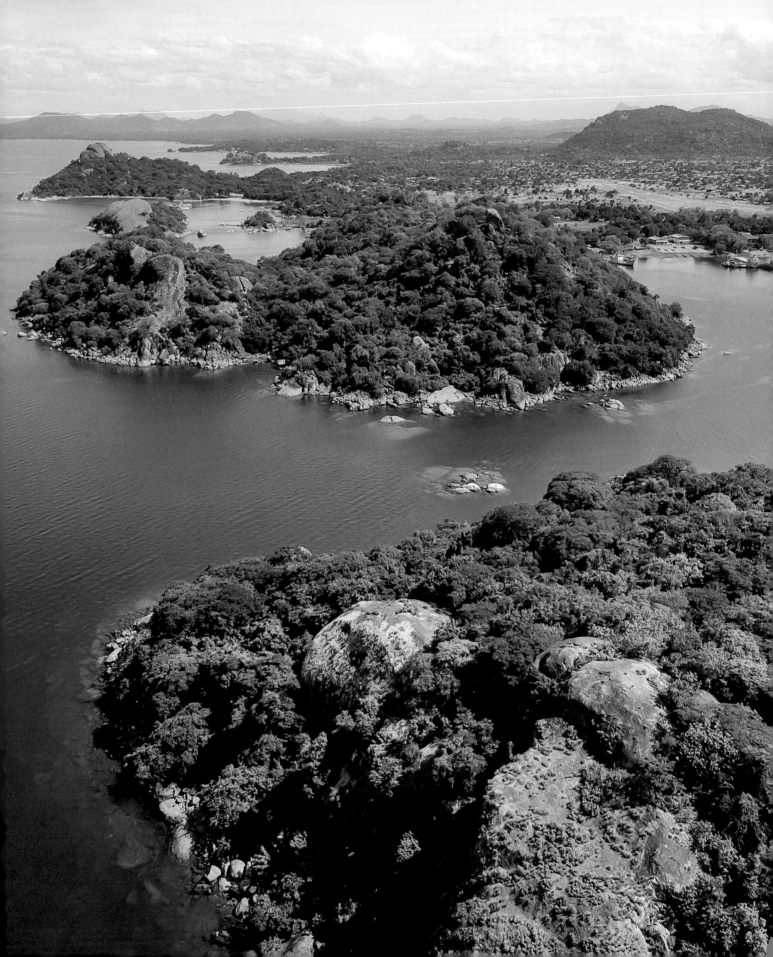

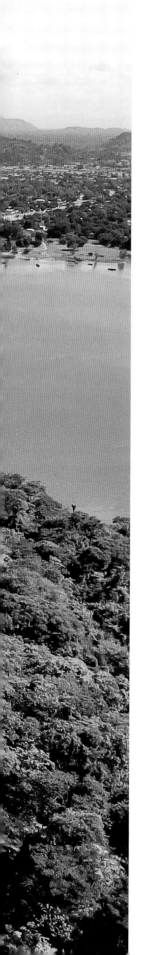

Located at the southern end of the great expanse of Lake Malawi, with its deep, clear waters and mountain backdrop, the national park is home to many hundreds of fish species, nearly all endemic. Its importance for the study of evolution is comparable to that of the finches of the Galapagos Islands.

Lake Malawi National Park

MALAWI

Lake Malawi National Park is a small park covering 36 square miles (94 square kilometers). It was specifically created to protect fish and aquatic habitats but also includes areas along the mainland and several small islands in Lake Malawi. It was inscribed as a World Heritage Site in 1984.

The park is at the southern end of Lake Malawi on and around the Nankhumba Peninsula. It includes the separate Mwenya Hills, Nkhudzi Hills, and Nkhudzi Point at the eastern base of the peninsula, also Boadzulu Island, Mpande

Monkey Bay.

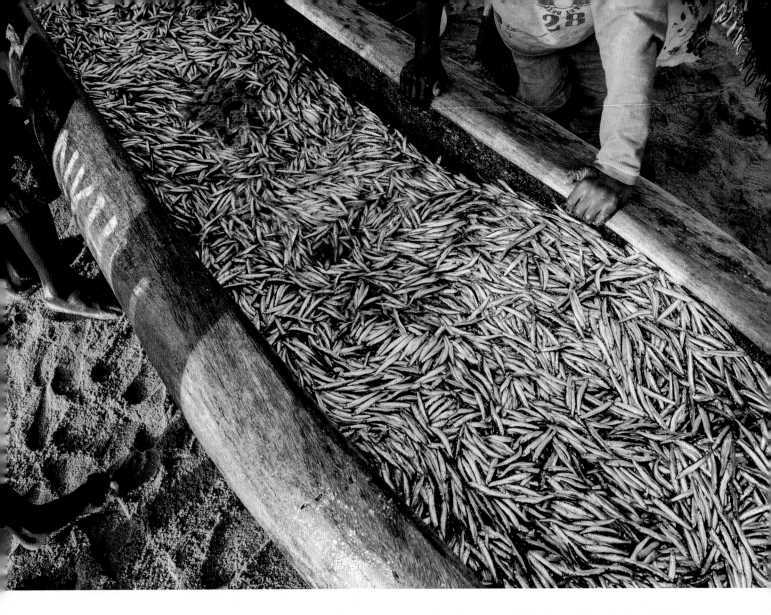

Island, the Maleri Islands with seven other offshore islets, and an aquatic zone that extends 328 feet (100 meters) offshore of all these areas. The lake is a unique inland sea 362 miles (584 kilometers) long and 2296 feet (700 meters) deep in places, and lies within the Western Rift Valley, formed during Miocene tectonic activity. The lake's water temperatures range between 73 and 82°F (23 and 28°C), with a pH of 7.8 to 8.5. There are marked seasonal variations in wind, temperature, and rainfall. The water level fluctuates according to season with a long-term cycle of fluctuation over years. Recent years have seen increases to the highest levels since recording began, probably due to increased rainfall and to forest clearing on the high plateau above.

In general, the hills of the Nankumba peninsula are wooded and rise steeply from the lakeshore. Cape Maclear at the north end is rocky, predominantly biotite-granite. In general the soils are poor, rocky, and very susceptible to erosion. There are several sandy bays including a fine beach near Chembe and Otter Point. The islands are mainly or entirely rocky, separated from each other and from the mainland by sandy flats and deep water. Habitat types vary from cliffs and boulder shores to pebbly and sandy beaches and from wooded hillsides to

From left: Lake Malawi freshwater sardines are a major food source. • Cape Maclear.

279

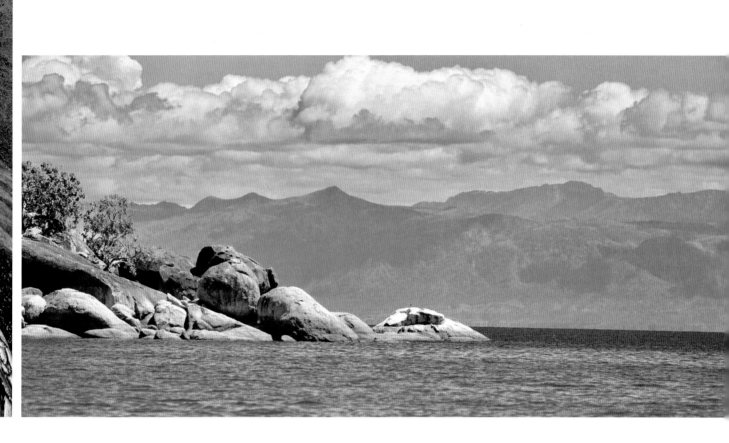

occasional swamps and lagoons. There is a range of underwater habitats—sandy, weedy, rocky, rock-sand interface, and reed beds—which has encouraged the unusually high degree of speciation among the lake's fishes.

The park was established primarily to protect Lake Malawi's rich aquatic life, especially the small, brightly colored rocky shore tilapiine cichlids known as mbuna (rockfish) and the larger haplochromine cichlids that, being more plentiful, provide most of the food fish. The lake contains the largest number of fish species of any lake in the world: 3000 in all with more than 800 species of

Cichlidae, of which the lake contains 30 percent of all known species. Of these, all but five species are endemic to the lake: the endemism exceeds 99 percent and the degree of adaptive radiation and the explosiveness of the speciation is remarkable and not yet wholly explained. More than 70 percent of these fish are not described and the taxonomic affinities of many of them are uncertain. Mbuna are tolerant of relatively high and fluctuating pH levels, very specialized in their habitats, and highly territorial. Most species of the dominant haplochromines are mouthbreeders, and being beautifully colored are targeted by the aquarium

LAKE MALAWI NATIONAL PARK

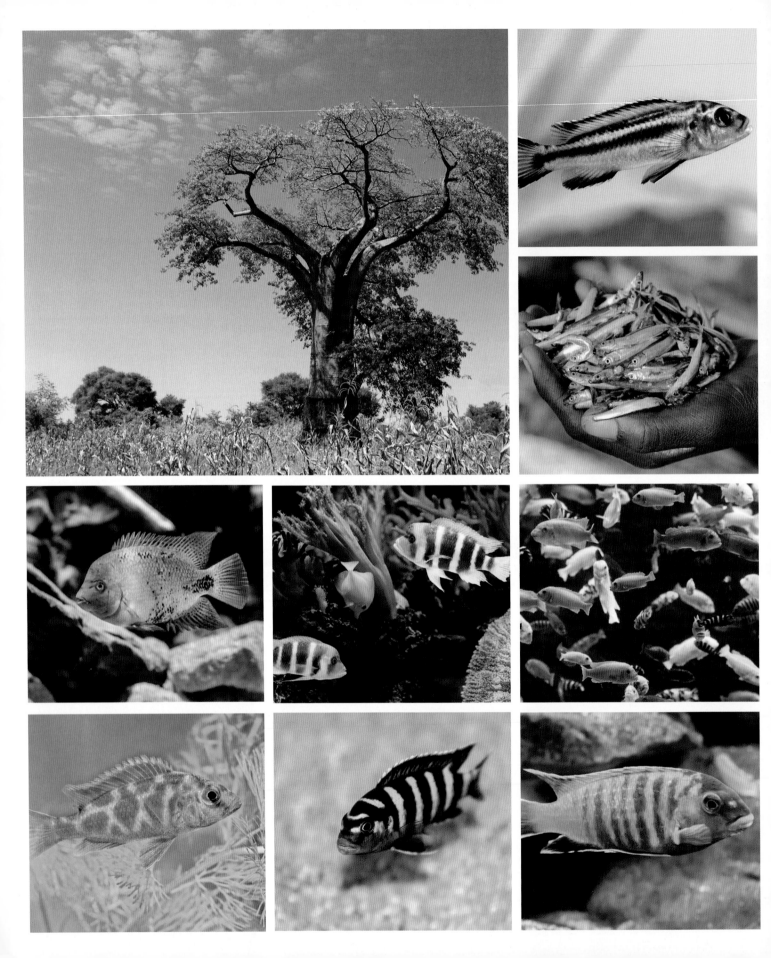

First column: Baobab (*Adansonia digitata*). • Colorful mbuna. • A giraffe cichlid. *Second column:* More colorful cichlids. • Demanson's Cichlid. *Third column:* Bluegray mbuna. • A handful of cichlids. • More Lake Malawi cichlids, and plenty of them. • Giraffe cichlid.

281

trade. The diversity of mollusk species and other invertebrates is also high.

The terrestrial areas of the park, except for the smallest islands, were once heavily wooded. Originally, this community comprised baobab (*Adansonia digitata*), the great tree of Africa. There are eight species of *Adansonia*, seven are native to Madagascar, and one, *A. digitata*, native to western, northeastern, central, and southern Africa. The baobab tree has been variously estimated as being several hundred to several thousand years old. The French botanist Michel Adanson (1727–1806), after whom the tree was named, contended that some specimens were as much as 5000 years old. He was wrong. Baobab populations appear to be much younger than has generally been believed and only very few trees live to ages more than 400 years. However, radiocarbon dating of a baobab in Namibia indicated an age of about 1275 years. According to a post in the Royal Botanic Gardens, Kew Plants of the World Online, "it has recently been proposed that the African baobab consists of two species—one very widely distributed lowland species with four sets of chromosomes (*A. digitata*), and a second,

more montane species with just two sets of chromosomes (*A. kilima*). Some floral differences can be observed, but the hypothesis needs to be tested with wider geographic coverage."

Baobabs can grow up to 82 feet (25 meters) high, with the trunk up to 46 feet (14 meters) in diameter. It is a deciduous tree often being leafless for up to 8 months. During the early summer the tree bears large, heavy, white, pungent flowers. They are pollinated by fruit bats and bushbabies. The tree provides food, clothing, and medicine as well as raw material for many useful items. The leaves can be used as relish, the pods when dissolved in water or milk, make a refreshing drink. Medicinally, the pulp is consumed to treat fever, diarrhea, and malaria. They are believed to be shelters of great ancestral spirits.

The trees are under threat from the sooty baobab disease, with affected trees exhibiting a strikingly blackened or burnt appearance. Although the blackening is caused by growth of a sooty mold fungus (possibly *Antennulariella* or its *Capnodendron* state) it is highly possible that it is a secondary manifestation caused by drought.

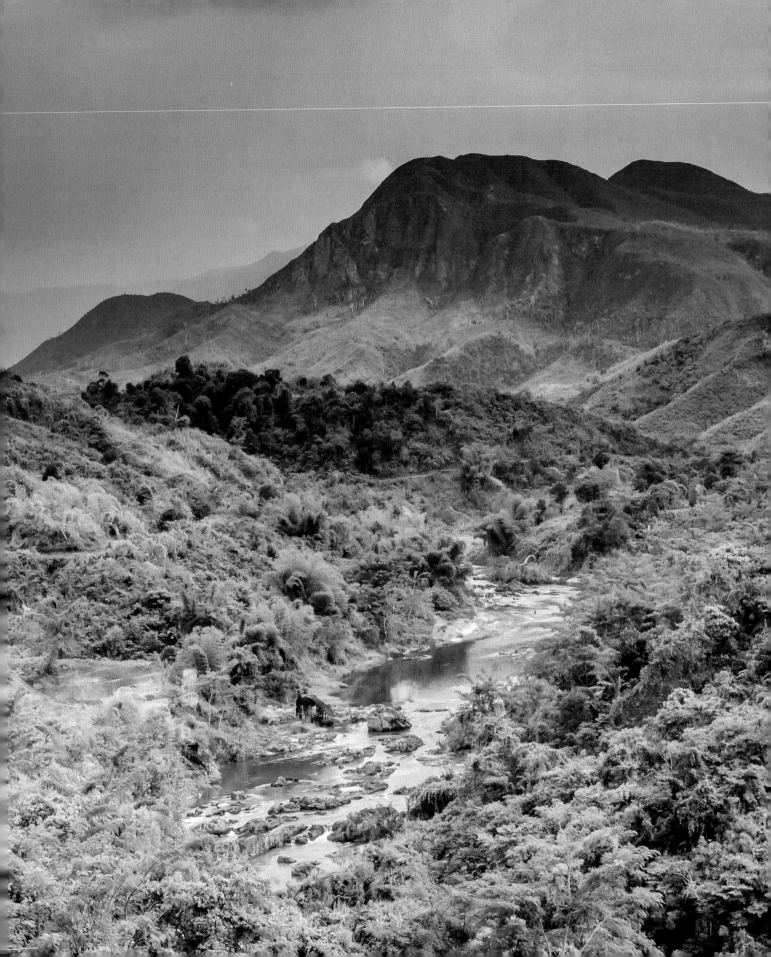

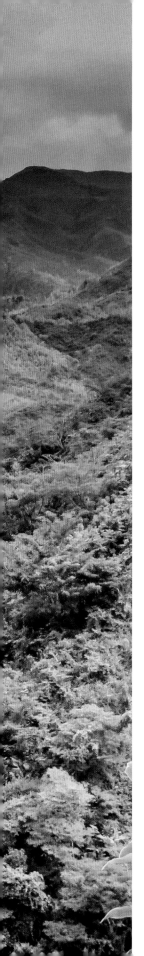

The Rainforests of the Atsinanana comprise six national parks distributed along the eastern part of the island. These relict forests are critically important for maintaining ongoing ecological processes necessary for the survival of Madagascar's unique biodiversity, which reflects the island's geological history. Having completed its separation from all other land masses more than 60 million years ago, Madagascar's plant and animal life evolved in isolation. The rainforests are inscribed for their importance to both ecological and biological processes as well as their biodiversity and the threatened species they support. Many species are rare and threatened especially primates and lemurs.

Rainforests of
the Atsinanana

MADAGASCAR

The Indo-Madagascar continent began to separate from Gondwanaland about 165 million years ago, and India from mainland Africa beginning about 70 million years ago. Madagascar's flora and fauna evolved in isolation from Africa for at least 60 million years and are uniquely endemic as a result. Its species record the region's phytogeographic relation to the floras of Malaya, India, and Australia. It is an evolutionary laboratory of taxonomic groups and ecological communities that have disappeared elsewhere in the world. The speciation and adaptive radiation resulting from this

The Maroantsetra-to-Antalaha Trail.

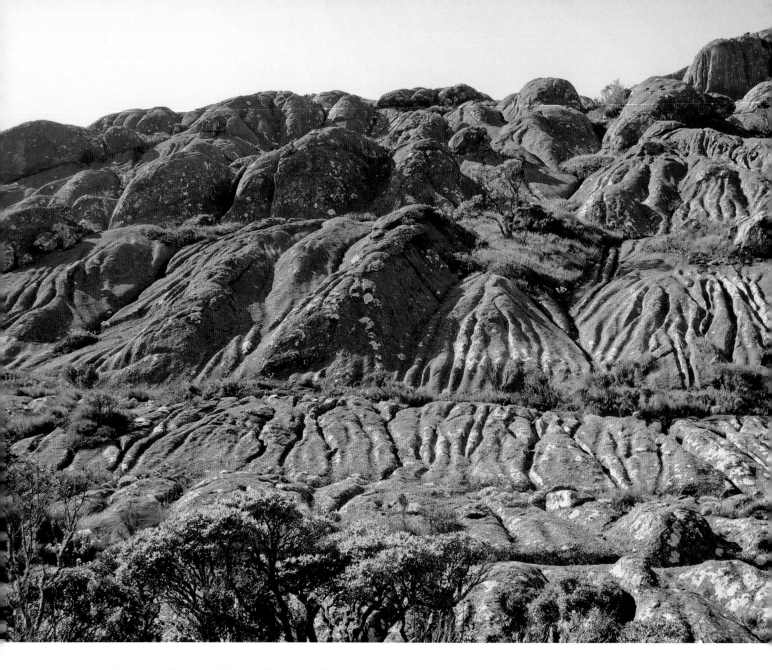

combination of topographic and climatic isolation have made this the world's third most biodiverse region after the tropical Andes and Sundaland. Of 13,000 to 14,000 species of all groups for the whole country, 85 percent are endemic.

The region is the world's second center of dispersal for the Bignoniaceae; it has over 200 species of Rubiaceae in 7 genera; and 170 species of palms in the Arecaceae. Since over 90 percent—*90 percent*—of the more accessible original forest has

been destroyed, much of the remaining diversity is concentrated in the range of habitats on the mountain slopes between the coast and the central plateau. The differences in altitude, latitude, climate, topography, bedrock types, and soils are greatest in this combination of dense rainforest and highland.

Designated as a World Heritage Site in 2007, the Rainforests of the Atsinanana comprise coastal rainforest in Masoala National Park; lowland

From left: The relict forests of Atsinanana contain globally outstanding biodiversity. • Andringitra National Park.

285

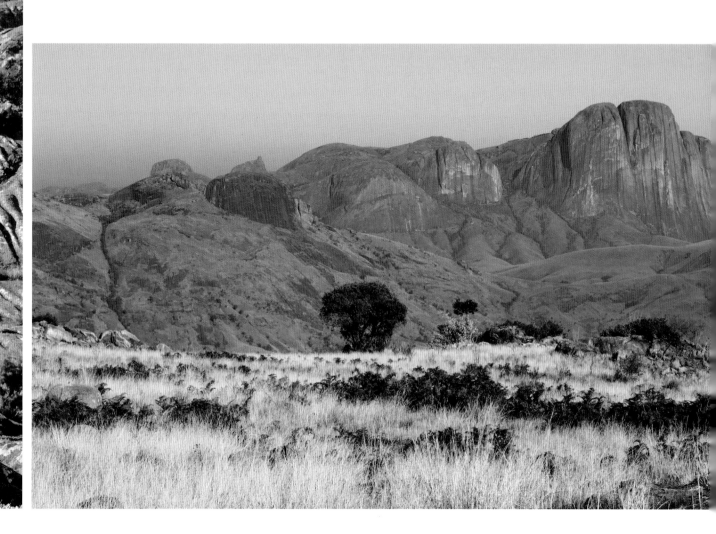

rainforest in Marojejy, Masoala, Zahamena, Befotaka-Midongy, and Andohahela Parks; mid-level grading to montane rainforest, found in all the parks; and lower sclerophyllous montane forest in Marojejy, Andringitra, and Andohahela Parks. There is a little transitional and dry forest in Andohahela and small areas of swamp vegetation in Ranomafana. With altitude and its cooler and wetter climate the canopy height is lower, becomes less stratified and harbors more epiphytes, bryophytes, and lichens; the herb layer is also richer. The coastal forest, being accessible and protected only in parts, is the most threatened by encroachment. The lowland forest is the most diverse but is underrepresented and much threatened by encroachment. The midlevel forest is well represented but a little less vulnerable to the same pressures. The montane rainforests where pandanus and bamboo flourish, and the open-grazed areas, are subject to fires as well as human disturbance.

RAINFORESTS OF THE ATSINANANA

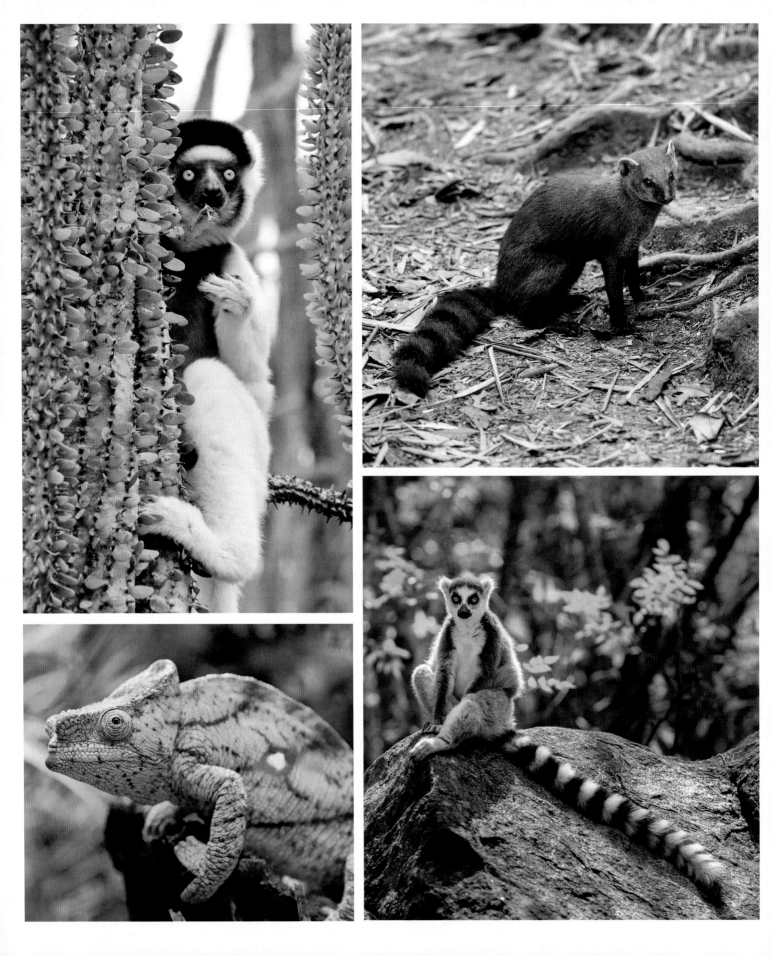

Clockwise from top left: A lemur looks out from the spiny forest. • Ring-tailed vontsira. • Ring-tailed lemur. • Green chameleon.

287

Marojejy is 92 percent dense rainforest, the only large massif in Madagascar where most of the forest remains intact. Its three main ecosystems are evergreen lowland rainforest, much of it secondary, midlevel rainforest, and stunted montane forest (in this case, cloud forest), a pattern typical of nearly all the sites. Above about 6561 feet (2000 meters) there is a well-preserved area of ericoid montane bush with some peat bogs. The lowland forest is formed predominantly of species of *Dalbergia*, *Diospyros*, *Ocotea*, *Symphonia*, and *Tambourissa*, with bamboo—*Valiha diffusa*, *V. perrieri*, *Cathariostachys capitata*, and *C. madagascariensis*—*Albizia*, *Brochoneura acuminata*, a 49-foot (15-meter) tall tree with elliptical and obovate evergreen leaves, and emergents of 33 species of *Canarium*, 27 of them new to science. It has more than 50 species of palms, 6 being endemic, and 305 species of ferns, 6 also endemic.

Masoala is one of the largest remaining natural forests in the country and has many globally threatened species. It covers two-thirds of the Masoala peninsula, which alone has 2000 species. Its dense lowland rainforest is the largest remaining in the country. This forest is the most biodiverse, with over 1100 species of plants in 100 families and 400 genera. Its emergent trees can reach 164 feet (50 meters). Fifteen out of 20 species of the island's palms are found only there. It has 155 pteridophytes in 50 genera, comprising 27 percent of Madagascar's ferns, and is a center for their dispersal. Among the endangered are *Marojejya darianii*, *Voanioala gerardii*, *Asteropeia multiflora*, and the red lemur palm (*Lemurophoenix halleuxii*).

The two dominant ecosystems of Zahamena are the dense evergreen forest—lowland, midlevel and high level—and its streams and marshes. The highest vegetation includes montane sclerophylls, ericaceous brush, and grassy savanna. There are 511 species of evergreen woody plants, 85 percent being endemic: 151 pteridophytes, 60 orchids, 22 palms, and 10 pandanus species. The lowland forest is dominated by species of *Tambourissa*, *Weinmannia*, *Diospyros*, *Cryptocarya*, and *Dalbergia*. The montane forest is dominated by Podocarpaceae, Cunoniaceae, and Pandanaceae and the thickets by tree ferns (*Cyathea* spp.), Asteraceae, Ericaceae, Podocarpaceae, Rhamnaceae, and Rubiaceae. The palms include *Asteropeia multiflora*, *A. rhopaloides*, and *Leptolaena abrahami*.

Ranomafana is also predominantly dense lowland, midlevel, and sclerophyllous forest with bamboo, part of a much fragmented and degraded central plateau vegetation. Both the bamboo and the lowland forest are being encroached on. There is also an area of flooded valleys and swamp forest, coveted for rice cultivation, containing rare species including the palm *Leptolaena abrahami*.

RAINFORESTS OF THE ATSINANANA

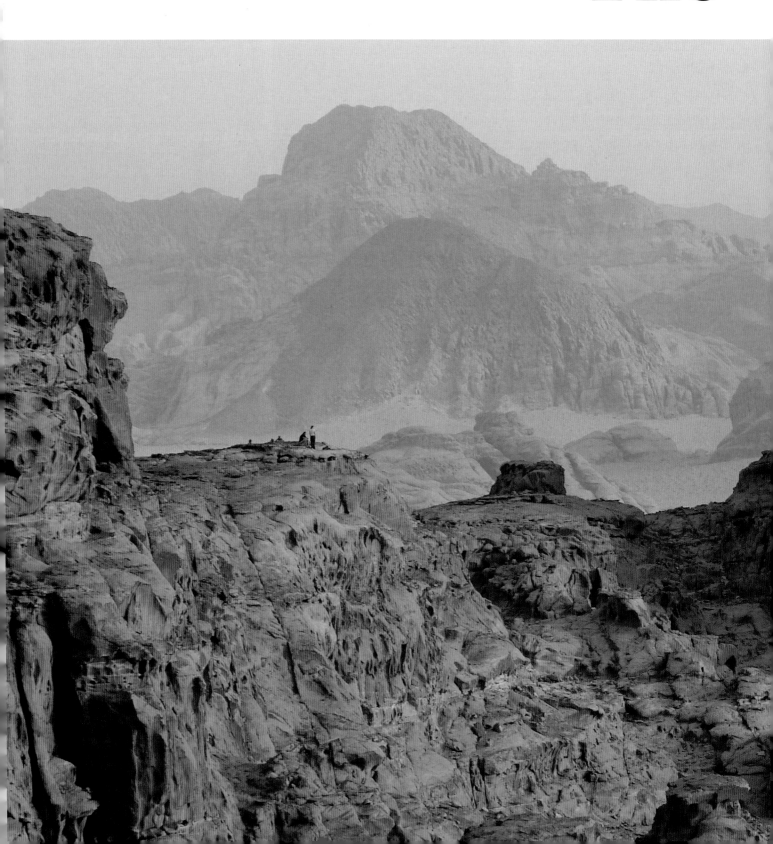

Wadi Rum at sunset.

The

Middle East & Asia

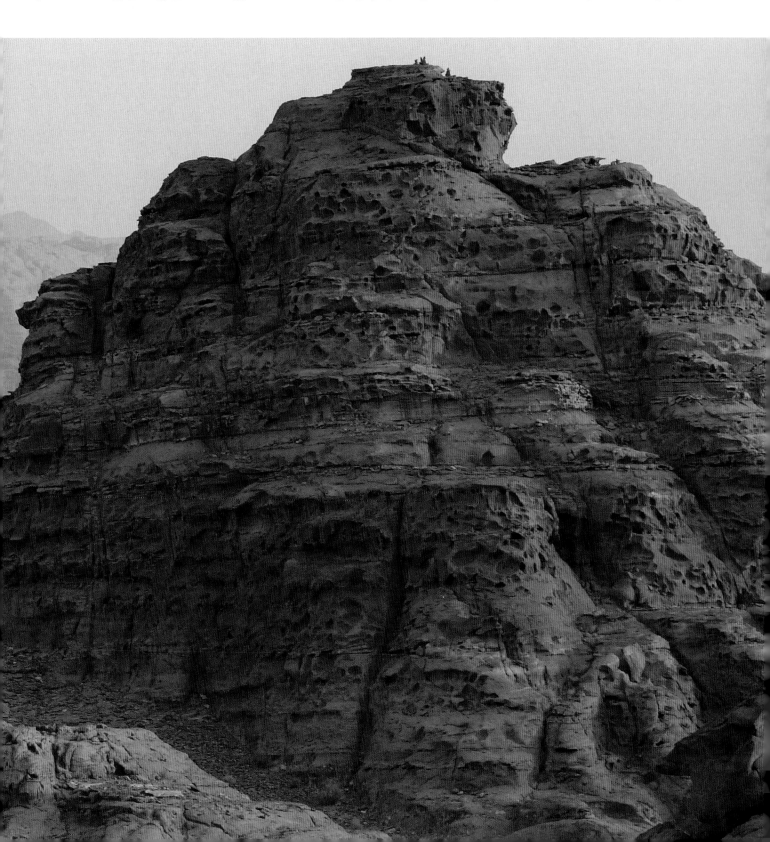

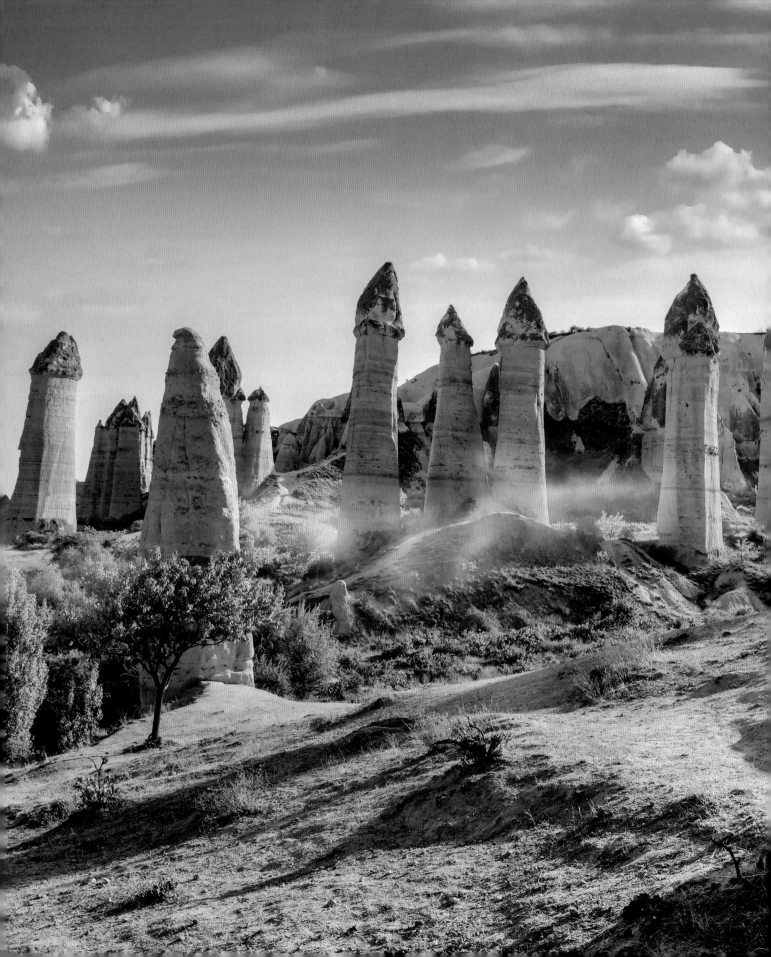

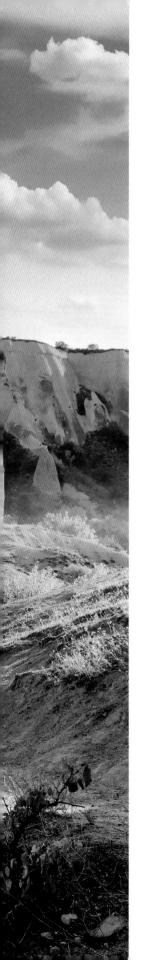

In a spectacular landscape, entirely sculpted by erosion, the Göreme valley and its surroundings contain rock-hewn sanctuaries that provide unique evidence of Byzantine art in the post-Iconoclastic period. Dwellings, troglodyte villages, and underground towns—the remains of a traditional human habitat dating back to the 4th century—can also be seen there.

Göreme National Park and the Rock Sites of Cappadocia

TURKEY

Göreme National Park is an area of nearly 39 square miles (100 square kilometers) in Nevşehir Province in central Turkey. It became a World Heritage Site in 1985. The valley of pinnacles at Göreme is carved from a broad 3280 foot (1000 meter) high plateau of lava-covered tuff—a fine-grained rock of consolidated volcanic ash—which has been deeply eroded into a surreal landscape of hundreds of cones and lava-capped pillars. It lies 31 miles (50 kilometers) from the snow-covered volcanic peak of Erciyas Dag, which erupted 2 million years ago but is now almost

Eroded rock chimneys.

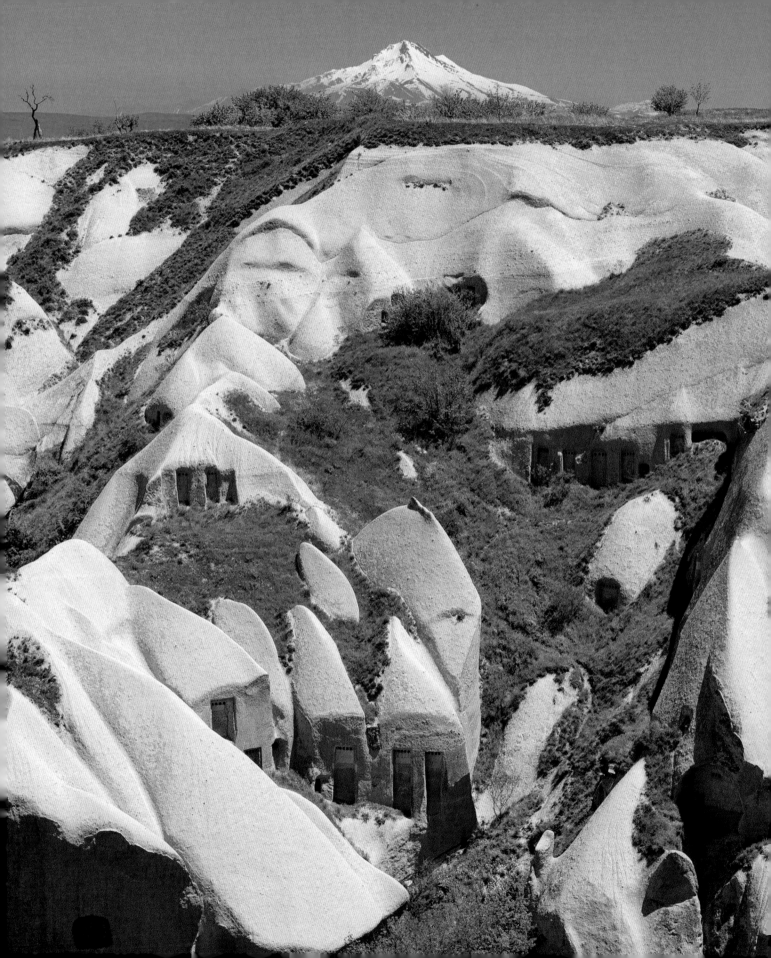

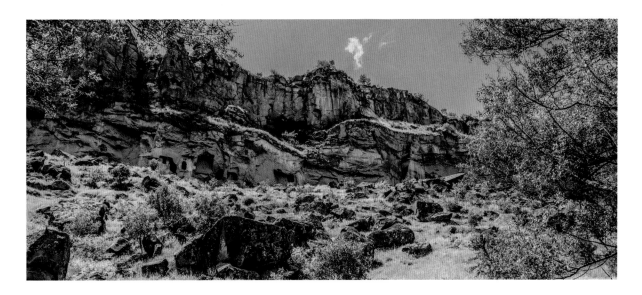

dormant. This deep, soft homogenous underlying layer of tuff was weathered by wind, water, and temperature change into a spectacular landscape of smooth cones capped by a layer of lava. Typical shapes are pinnacles, pillars, columns and towers, mushrooms and cones, obelisks, and needles, sometimes 131 feet (40 meters) high. These fantastic sculptures have been further pockmarked and honeycombed by warrens of man-made caves, living quarters, and underground churches, of which there are hundreds in central Cappadocia. The valley floors between the steep eroded slopes are fertile farmland.

This area has been inhabited since Hittite times (1600–1180 BCE), when the first caves were excavated. Under Assyrian and Roman rule the nearby town now called Kayseri was an important provincial center (Caesaria Mazaca). The area was a sanctuary for Christian anchorites fleeing Roman persecution, which became a monastic community in the 4th century CE. For the next 9 centuries, an urbanized landscape developed. The fresco painting in the chapels, which began in the 7th century by monks too remote to be much affected by Iconoclasm, are a colorful rare testimony to the civilization of a province of the Byzantine Empire that persisted even into Ottoman times.

Turkey is a floristically rich country with over 12,000 taxa of plants, including 4000 endemic species, some of which are critically endangered. It is the center of distribution for the genus *Verbascum*, with 249 species and 22 hybrids. It includes *Centaurea* (Asteraceae; 156 taxa), *Hieracium* (Asteraceae; 69 taxa), *Onosma* (Boraginaceae; 52 taxa), *Salvia* (Lamiaceae; 50 taxa), *Anthemis* (Asteraceae; 47 taxa), *Stachys* (Lamiaceae; 44 taxa), and *Scorzonera* (Asteraceae; 35 taxa).

In the park, *Acantholimon saxifragiforme* grows on the rocky limestone slopes. It is a cushion-forming plant with blue-gray linear leaves to ¾ inch (2 centimeters) and deep pink flowers. *Acanthus hirsutus* is a clump-forming perennial with spiny, dark green leaves and 16-inch (40-centimeter) spikes of pale yellow to greenish white flowers

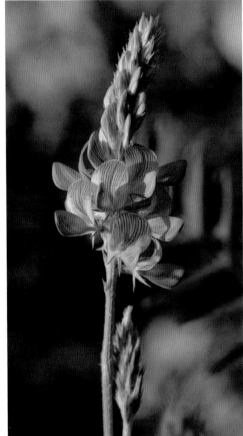

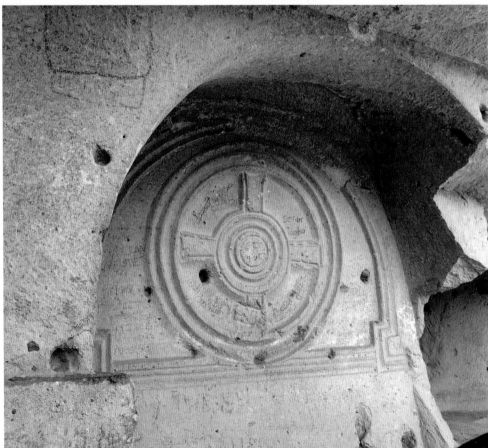

First column: The yellow form of *Alkanna orientalis.* • The highly nutritious sainfoin (*Onobrychis* sp.). *Onobrychis* means "devoured by donkeys." • *Acanthus hirsutus.* *Second column:* Cappadocian maple (*Acer cappadocium*). • Religious and ornamental rock carving.

Below: The park's famous so-called fairy chimneys.

297

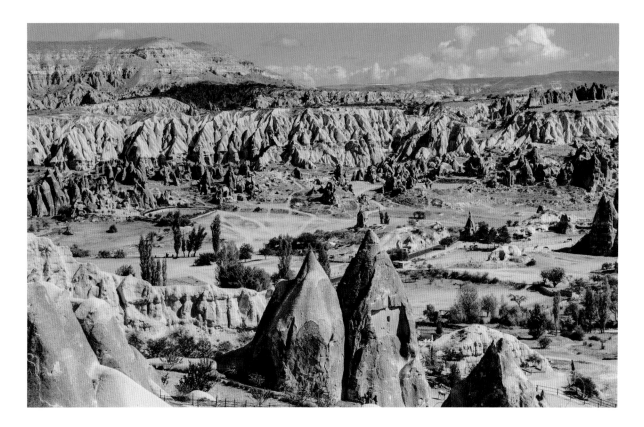

with hairy, spiny, yellowish green bracts. *Alkanna orientalis* var. *leucantha* is a drought-tolerant white-flowering borage growing up to 20 inches (50 centimeters) tall with hairy glandular leaves. *Leontodon oxylepis* is a type of dandelion with lanceolate hairy leaves and yellow flowers in summer. *Onobrychis elata*, a grassland plant with pinnate leaves and linear leaflets, flowers pink-purple in summer. *Phryna ortegioides*, a perennial plant, is a member of the carnation family with white, purple-veined flowers. *Reseda armena*, a perennial herb, grows on cliff faces and produces light yellow flowers in summer. *Silene splendens* is another member of the carnation family, producing warm pink flowers in summer. Wild onions (*Allium* spp.)

can be found throughout Turkey. *Allium cappadocicum* is a drought-tolerant bulb with drumstick heads of pink-purple on stalks 16 inches (40 centimeters) tall.

There are few trees in the park but one, named after the area, stands out. Cappadocian maple (*Acer cappadocium*) is a medium-sized maple with a dense, spreading crown, growing up to 98 feet (30 meters) with palmate five- to seven-lobed leaves. The leaf stems bleed a milky latex when damaged. The seed is a double samara where two one-seeded wings join together. The tree often produces root suckers, a trait not common in maples. In the seemingly unrelenting Cappadocian summer sun, the shade from this large maple is a great blessing.

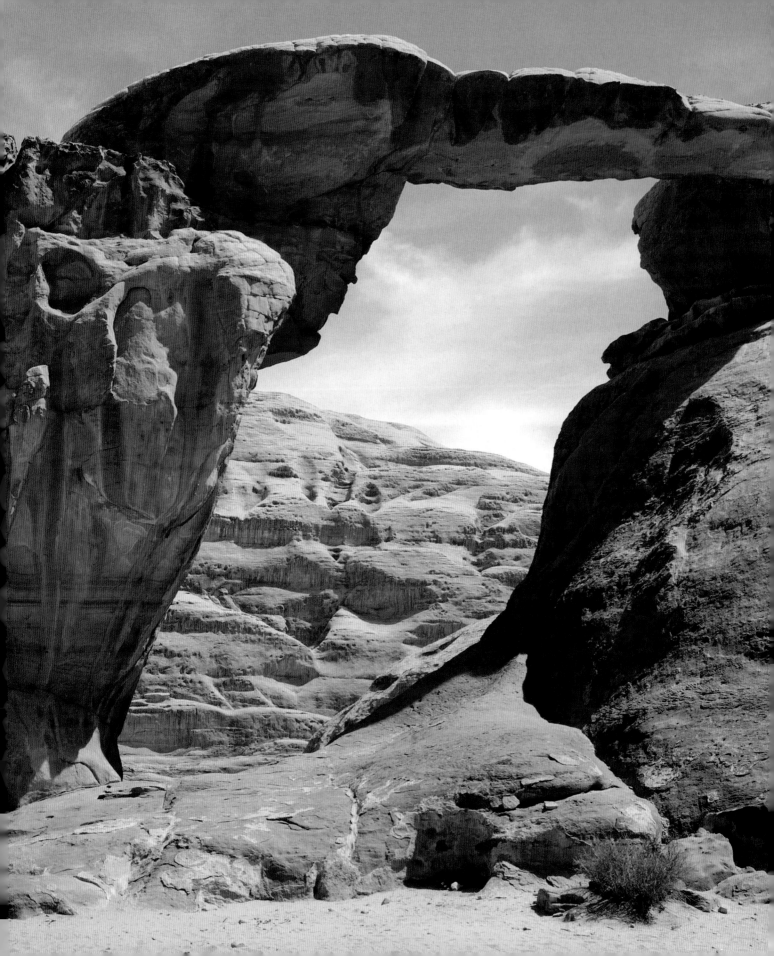

The 182,860-acre (74,000-hectare) property, inscribed as a mixed natural and cultural site, is situated in southern Jordan, near the border with Saudi Arabia. It features a varied desert landscape consisting of a range of narrow gorges, natural arches, towering cliffs, ramps, massive landslides, and caverns. Petroglyphs, inscriptions, and archaeological remains in the site testify to 12,000 years of human occupation and interaction with the natural environment. The combination of 25,000 rock carvings with 20,000 inscriptions trace the evolution of human thought and the early development of the alphabet. The site illustrates the evolution of pastoral, agricultural, and urban activity in the region.

Wadi Rum Protected Area

JORDAN

Designated a World Heritage Site in 2011, Wadi Rum is recognized globally as an iconic desert landscape, renowned for its spectacular series of sandstone mountains and valleys, natural arches, and the range of narrow gorges, towering cliffs, massive landslides, and dramatic caverns. Formed by Miocene and later tectonic faults that opened during the formation of the Dead Sea Fault, four major wadis—dry riverbeds or valleys—run north-south, cutting across earlier valleys running northwest-southeast in the southern half of the site. The flat-topped monoliths

A desert arch in sandstone.

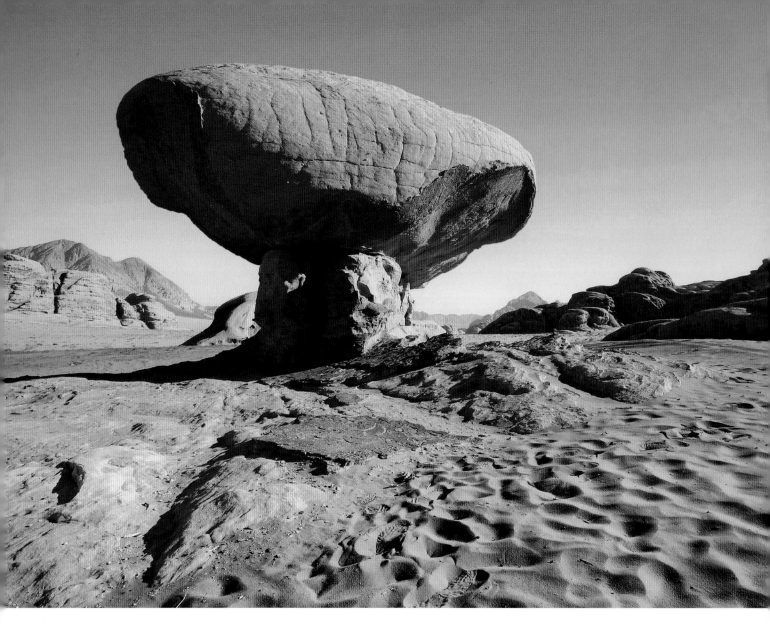

between the wadis are composed of 3280-foot (1000-meter) thick Rum group of quartz sandstones, composed of four major strata of sands deposited in north-flowing rivers and shallow bays of the Tethys Ocean 540 to 470 million years ago. Covering most of the wadis between them are Quaternary alluvial sediments of fans, dunes, mudflats, and wide sheets of sand.

The valley is believed to have been the site of Iram, a city of the tribe of 'Ad castigated in sura 89 of the Qu'ran. It has one of the world's richest collections of rock art—25,000 petroglyphs and 20,000 inscriptions cut into rocks and cliff faces document an ancient site of sustained cultural activity. There are signs of Paleolithic work and Neolithic foundations. Pictures of cattle from the Chalcolithic period (between 4500 and 3200 BCE) indicate a wetter climate, and of those goats in the succeeding Bronze Age (before 2000 BCE) indicate a drier one. Inscribed in the rock are pictures of ostriches, lions and leopards, oryx and wolves, and clans and activities: hunting, fighting, supplication, and dance. The ruins of a Nabatean temple remain. It is the pictorial and written record on rock of 12,000 years

Opposite: A million-plus years of erosion in this desert have caused a multitude of surprising rock formations.

301

of Bedouin life, which documents in four scripts, Thamudic, Kufic, Safaitic, and Nabatean, the emergence of alphabets from icons among these literate pastoral societies of early north Arabia.

There are three types of vegetation in the deserts of Wadi Rum. Over 60 percent of the desert has dune vegetation with the main species being White saxaul (*Haloxylon persicum*), an endangered small tree growing to a height of 16 feet (5 meters) with light gray bark and leaves that are actually succulent branches. It has a large underground root system and is used to stabilize sand dunes, and for firewood and forage for camels. It is a super xeriphyte, meaning that it is extremely tolerant of drought. It originated in the deserts of Central Asia and has spread naturally and by human beings in Afghanistan, Iran, and northwest China and near the eastern deserts. Arta (*Calligonum comosum*) is an almost leafless, evergreen shrub with many stiff, upright branches. The flowers, in long clusters, are silvery white and are followed by hairy yellow-green fruits. It is characteristic of deep sand and has a very long taproot reaching down to the water table. It is often seen growing in a hummock with the sand collected around it. Retem (*Retama raetam*) is a deciduous shrub with slender, drooping branches. It can grow up to 10 feet (3 meters) tall and 20 feet (6 meters) wide. It is leafless for most of the year. Palatable to domesticated animals it is also

used medicinally by humans to lower blood glucose and skin inflammations. *Neurada procumbens*, the creeping thorn rose, is a prostrate annual herb with flat, woolly blue-green stems and leaves and inconspicuous off-white flowers. The fruit is star-shaped and spiny. It is traditionally used to treat diarrhea, dysentery, diabetes, eczema, and rheumatism.

The second type of vegetation is acacia rocky Sudanian. *Acacia raddiana*, which may be *Vachellia tortilis* subsp. *raddiana*, has an umbrella shape branching into a flat crown. It has reddish brown bark and thorny branches. The leaves are alternate and bipinnate. Light yellow flowers are arranged in globules. The fruit is a bean common to members of the bean family (Fabaceae). The jointed anabis (*Anabasis articulata*) is a salt-tolerant perennial with jointed stems and fleshy leaves. The flowers are light yellow and papery. It grows in a large and conspicuous green mound. The Bedouin people use it for washing as it foams in a soapy way when rubbed in water.

The third type of vegetation is hammada—desert pavement—which includes the aforementioned *Anabasis articulata* and *Retama raetam*, as well as tarfa (*Tamarix nilotica*), a slow-growing tree reaching a height of 26 feet (8 meters). It is multistemmed, with gray-green foliage, and panicles of purple flowers appearing throughout much of the hot season. *Achillea fragrantissima,*

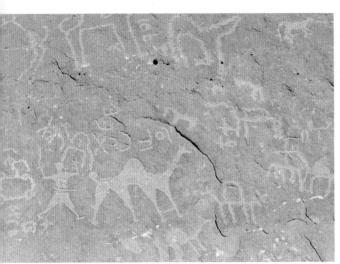

a yellow-flowering yarrow with white pubescent stems is rich in flavonoids and tannins is widely used in traditional medicine for gastrointestinal disorders. White wormwood (*Artemisia herba-alba*) is a woody perennial growing 8 to 16 inches (20 to 40 centimeters) with aromatic gray leaves and off-white flowers. It is used to treat cough, stomach and intestinal upset, the common cold, measles, and diabetes. Spiny zilla (*Zilla spinosa*) is a small, sometimes woody, plant in the cabbage family (Brassicaceae). It has spiny stems and branches, and light violet flowers. It is used to treat urinary tract diseases.

On the red cliff tops, Phoenician juniper (*Juniperus phoenicea*) grows in thin but welcome groups. A relict species, possibly 30 million years old, it reaches 26 feet (8 meters), has brown exfoliating bark and flat branches of whip and scale leaves common to the genus. The seed cones mature to a dark red.

Wadi Rum is not sparse or barren. With only 1 to 2 inches (2 to 5 centimeters) of rain a year it is one of the driest deserts in the world—and that is the miracle of its botany. With just a few drops of rain in the winter, bulbs bloom. *Crocus cancellatus* blooms in late autumn and winter with pale blue flowers

From left: Petroglyphs attest to 12,000 years of human occupation here; there are over 25,000 rock carvings in Wadi Rum. • *Acacia raddiana.* • Jointed anabis (*Anabasis articulata*).

striped dark violet on the outside. Meadow saffron (*Colchicum tunicatum*) is the earliest *Colchicum* to flower, starting in late August. The flowers are white or pale pink turning darker as they mature. Autumn crocus (*Sternbergia clusiana*) has greenish yellow flowers that emerge before the leaves, poking out from rocky crevices in late autumn. *Pancratium sickenbergeri* has curly leaves and delicately scented white flowers. Barbary nut (*Moraea sisyrinchium*) is an irislike plant with blue flowers that open late in the day. *Androcymbium palaestinum* is a low-growing lily with a rosette of gray-green leaves that emerge before the white flowers with reddish

purple stripes. *Iris postii*, a beautiful and rare Juno iris, has pale lavender flowers veined dark purple with a yellow crest. Black iris (*I. nigricans*) is the national flower of Jordan. The flowers are almost black, a dark deep purple, shocking against the rust of rocks.

And with a little more rain, the annuals bloom, from the white flowers of oxtongue (*Anchusa milleri*) to the yellow succulence of hureim (*Zygophyllum simplex*), an alphabet of flowers inscribed on the parchment of red soil and yellow sand.

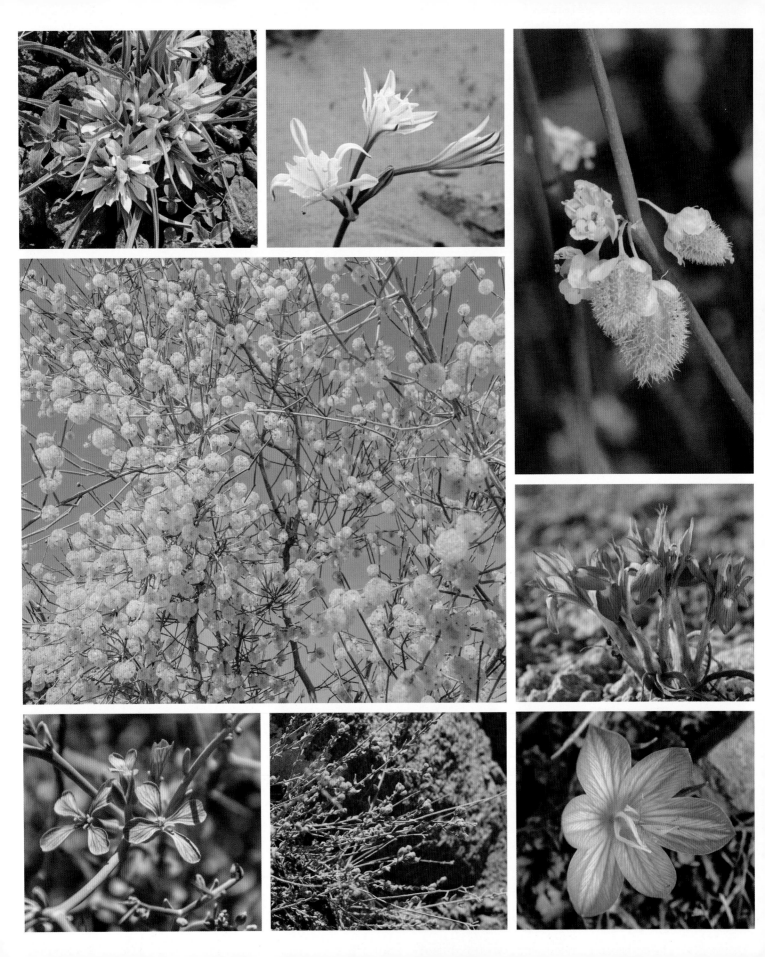

First column: *Androcymbium palaestinum.* • White saxaul (*Haloxylon persicum*). • Spiny zilla (*Zilla spinosa*). Second column: *Pancratium sickenbergeri.* • *Achillea fragrantissima.* Third column: Arta (*Calligonum comosum*). • Barbary nut (*Moraea sisyrinchium*). • Crocus in the desert. Fourth column: The curly leaves of *Pancratium sickenbergeri.* • White wormwood (*Artemisia herba-alba*). • Autumn crocus (*Sternbergia clusiana*). Fifth column: Retem, *Retama raetam.* • *Neurada procumbens.*

The Ahwar is made up of seven components: three archaeological sites and four wetland marsh areas in southern Iraq. The archaeological cities of Uruk and Ur and the Tell Eridu archaeological site form part of the remains of the Sumerian cities and settlements that developed in southern Mesopotamia between the 4th and the 3rd millennium BCE in the marshy delta of the Tigris and Euphrates rivers. The Ahwar of Southern Iraq—also known as the Iraqi Marshlands—are unique, as one of the world's largest inland delta systems, in an extremely hot and arid environment.

The Ahwar of Southern Iraq: Refuge of Biodiversity and the Relict Landscape of the Mesopotamian Cities

IRAQ

The Ahwar of Southern Iraq represents a unique combination of intertwining cultural and natural values. The property contains the remnants of some of the world's first cities, which were regional hubs of commerce, culture, religion, learning, and increasingly complex systems of societal administration. The earliest known piece of literature was found within the property, which itself refers to one of the component parts. The property is split into seven components so as to capture the dispersed cities and also the dynamically moving marshes. The dynamism of the

Iraqi reed house.

307

marshes, which are fed by the Tigris and Euphrates, underpins the rise and fall of the cities and also the natural value of the property. The changeability of the water courses creates a series of successional habitats and water courses that are of global importance for migratory bird species and of regional significance for other taxa. The property acts as an island rich in natural and cultural heritage, which though still at threat, is slowly being restored. It was inscribed as a World Heritage Site in 2016.

The marshlands evolved as part of the wider alluvial plain during the final stage of the alpine tectonic movement, which also lead to the evolvement of the Zagros Mountains. This took place during the Late Pliocene to Early Pleistocene. Sea level variation and climatic changes had a significant role in influencing the quantity and quality of water entering the Ahwar through rivers and their branches, in addition to advancement and regression of the sea,

and intrusion during dry to semidry to wet conditions during the last 18,000 years.

The marshy and moving landscape of this deltaic plain was the heartland where the first cities flourished. Uruk, Ur, and Eridu, the three cultural components of the site, were originally situated on the margins of freshwater marshes and developed into some of the most important urban centers of southern Mesopotamia. These cities saw the origin of writing, monumental architecture in the form of mudbrick temples and ziggurats, and complex technologies and societies. A vast corpus of cuneiform texts and archaeological evidence testifies to the centrality of the marshes for the economy, worldview, and religious beliefs of successive cultures in southern Mesopotamia.

Starting in the 2nd millennium BCE, the sea regressed toward the south. This led to another climatic change toward a more arid environment and

the drying up of the ancient marshes. Environmental change contributed to the decline of the great cities of southern Mesopotamia. Today the mudbrick ruins of Uruk, Ur, and Eridu are marked by the remains of ziggurats that still stand high above the arid but striking landscape of the desiccated alluvial plain. With the regression of the Gulf, new marshes formed to the southeast. The main components of the Ahwar as we know them today were formed during this period around 3000 years ago.

There are 86 plant species within the site, spanning 34 families, with the sedge family (Cyperaceae) being the most abundant. There are seven distinct types of vegetation types in the marshland's successional habitats.

Free-floating vegetation: This vegetation type is particularly evident in the flowering period in the summer is characterized by *Lemna* species—duckweeds—with four species, *L. gibba*, *L. minor*, *L. perpusilla*, and *L. trisulca*, and two related genera and species, *Spirodela polyrrhiza* and *Landoltia punctata*. *Lemna* species are small, not exceeding 3/16 inch (4 millimeters) in length and the stems (thalli) have a single root, while *Spirodela* and *Landoltia* have several roots but they are very similar, especially when growing together in a green mass that hides the water underneath.

Floating (rooted) leaved aquatic vegetation: Many of the species in this vegetation type are rooted to the underlying sediment and have floating leaves. *Nymphaea alba*, the white water lily, has cup-shaped, yellow-centered white flowers 8 inches (20 centimeters) across. The floating leaves are round and up to 12 inches (30 centimeters) in diameter.

Submerged aquatic vegetation: Considered one of the most common vegetation type within the property, it dominates inland water bodies whether

First column: Giant reed (*Arundo donax*). • Caper (*Capparis spinosa*). • *Lemna perpusilla*. • Tamarisk. *Second column:* *Atriplex holocarpa*. • *Lemna minor*. • Sago pondweed (*Stuckenia pectinata*). • Lesser bulrush (*Typha angustifolia*). *Third column:* Water hyssop (*Bacopa monnieri*). • White water lily (*Nymphaea alba*). • *Phragmites australis*. • A species of duckweed known, oddly, as duckmeat, *Spirodela polyrrhiza*.

311

stagnant or running, and includes abundant populations of sago pondweed (*Stuckenia pectinata*) and brittle naiad (*Najas minor*). Sago pondweed is a perennial with leaves that are 1¼ to 4½ inches (3 to 11.5 centimeters) long. They lack a stalk and are bright green to olive green in color. Leaves are variable in shape and may be linear or threadlike. Brittle naiad is a summer annual about 18 inches (45 centimeters) long. The smooth stems are medium green while young, becoming dark green and brittle with age. Pairs and pseudowhorls of leaves occur along these stems. The older leaves are usually curved inward, the leaf margins are toothed.

Halophytic vegetation: This salt-tolerant vegetation type spreads on the marsh areas bordering the water and the earth; the family Chenopodiaceae is particularly dominant in this vegetation type, with *Atriplex holocarpa*, *A. micrantha*, and species of *Bienertia*, *Cornulaca*, and *Salsola*.

Helophytic vegetation: Dominant in the marsh areas and spread widely across the marshes, this vegetation type is characterized by reed species, primarily lesser bulrush (*Typha angustifolia)*, growing 6 feet (1.8 meters) tall with narrow straplike leaves and dark brown cylindrical flower heads; *Phragmites australis* growing nearly 20 feet (6 meters) tall; and giant reed (*Arundo donax*), which can reach heights of 33 feet (10 meters).

Giant reed has been used for construction for thousands of years and, for the ear and the spirit, as a musical instrument. The ney is a flute made from the plant that has been played continually for 5000 years. Most woodwind instrument reeds, including those for the oboe and clarinet, are made from *A. donax*.

Riparian vegetation: Extending across the banks of inland water bodies and inland streams, this vegetation type contains predominantly perennial shrubs and annual species. *Tamarix gallica*, a deciduous shrub growing to 13 feet (4 meters) by 20 feet (6 meters), with sprays of small pink flowers. Caper (*Capparis spinosa*), known for its flavorful edible flower buds and fruit, is a perennial with round fleshy leaves and pinkish white flowers. Water hyssop (*Bacopa monnieri*), is a creeping herb with succulent oblong leaves and small white flowers. In traditional medicine it is used as a memory enhancer.

Trees: Away from the water, on the riverbanks, taller and more arboreal species develop in this vegetation type, mainly poplars and willows. Desert poplar (*Populus euphratica*), is a fast-growing deciduous tree growing to 49 feet (15 meters), and *Salix acmophylla*, the willow of the brook, is a large shrub or small tree that blooms in the spring with inflorescences made of a spike of tiny catkins.

Hyrcanian forests form a unique forested massif that stretches 528 miles (850 kilometers) along the southern coast of the Caspian Sea. The history of these broad-leaved forests dates back 25 to 50 million years, when they covered most of this northern temperate region. These ancient forest areas retreated during the Quaternary glaciations and then expanded again as the climate became milder. Their floristic biodiversity is remarkable: 44 percent of the vascular plants known in Iran are found in the Hyrcanian region, which only covers 7 percent of the country. To date, 180 species of birds typical of broad-leaved temperate forests and 58 mammal species have been recorded, including the iconic Persian leopard (Panthera pardus tulliana).

Hyrcanian Forests

ISLAMIC
REPUBLIC OF
IRAN

Iran, with a surface area of 636,000 square miles (1,648,000 square kilometers) is located between Central Asia and the Himalaya in the east and the Caucasus and Anatolia in the west. Hyrcania is a historical region composed of the land southeast of the Caspian Sea in modern-day Iran and Turkmenistan.

The Hyrcanian Forests form a green arc, covering around 7 percent of the remaining forests in Iran, separated from the Caucasus to the west and from semidesert areas to the east: a unique forested massif that extends from

The Alborz
Mountains of Iran.

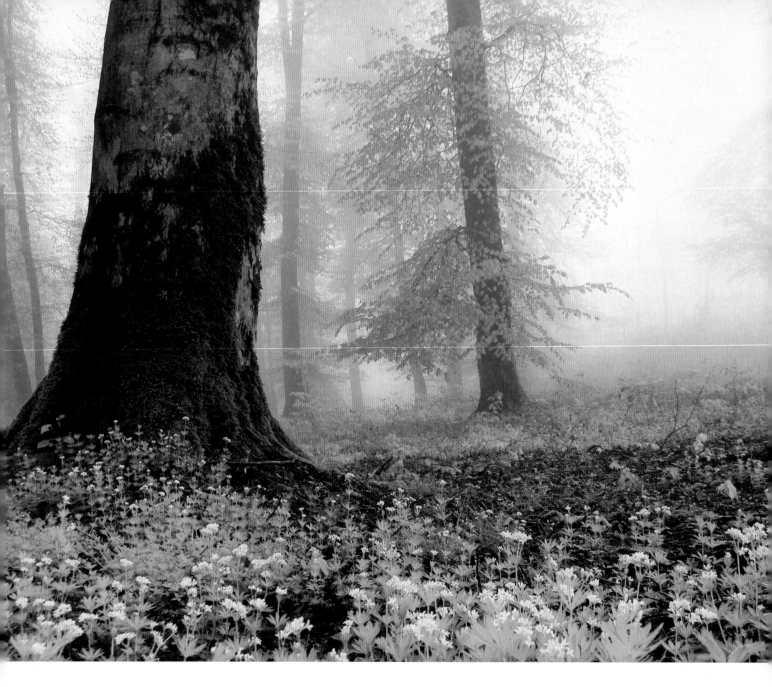

southeastern Azerbaijan eastward to the Golestan Province. Since 5 July 2019 the Hyrcanian Forests have been a World Heritage Site.

The property is a serial site with 15 component parts shared across three provinces (Gilan, Mazandaran, and Golestan) and represents examples of the various stages and features of Hyrcanian forest ecosystems. Most of the ecological characteristics that characterize the Caspian Hyrcanian mixed forests are represented in the property. A considerable part of the forest is inaccessible steep terrain. The property contains exceptional and ancient broad-leaved forests. These were formerly much more extensive, but they retreated during periods of glaciation and later expanded under milder climatic conditions. Due to its isolation, the property hosts many relict, endangered, and regionally and locally endemic species of flora,

Below, from left: Persian juniper (*Juniperus poly-carpos*). • Persian leopard, a native resident.

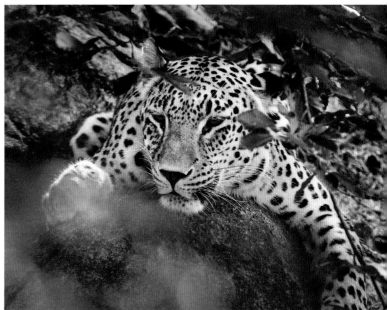

contributing to the high ecological value of the property and the Hyrcanian region in general.

The Iranian vascular flora includes a total of 2597 endemic or subendemic species—32 percent of all native species, belonging to 359 genera within 65 families. There are no endemic families, but 26 endemic and subendemic genera.

The natural forest vegetation is temperate deciduous broad-leaved, about 32 percent being Oriental beech (*Fagus orientalis*). Oriental beech is like European beech (*F. sylvatica*), to which it is closely related, except that the shape of the crown is more upright, with a more pointed top and straight trunk. The soft bark is thin and grayish in color. Young twigs and leaves are hairy. The almost diamond-shaped leaves are fresh green and turn yellow in the autumn. It is a large tree, capable of reaching heights of up to 148 feet (45 meters) tall, though more typically up to 115 feet (35 meters). Only relics of coniferous species grow in the forest: European yew (*Taxus baccata*), Persian juniper (*Juniperus polycarpos*), Mediterranean cypress (*Cupressus sempervirens* var. *horizontalis*), and Chinese arborvitae (*Platycladus orientalis*).

The Caspian Sea coastal plains were once covered by chestnut-leaved oak (*Quercus castaneifolia*), European box (*Buxus sempervirens*), black alder (*Alnus glutinosa* subsp. *barbata*), Caucasian alder (*Alnus subcordata*), Caspian poplar (*Populus caspica*), and Caucasian wingnut (*Pterocarya fraxinifolia*), but these forests have been almost entirely converted to urban and agricultural land.

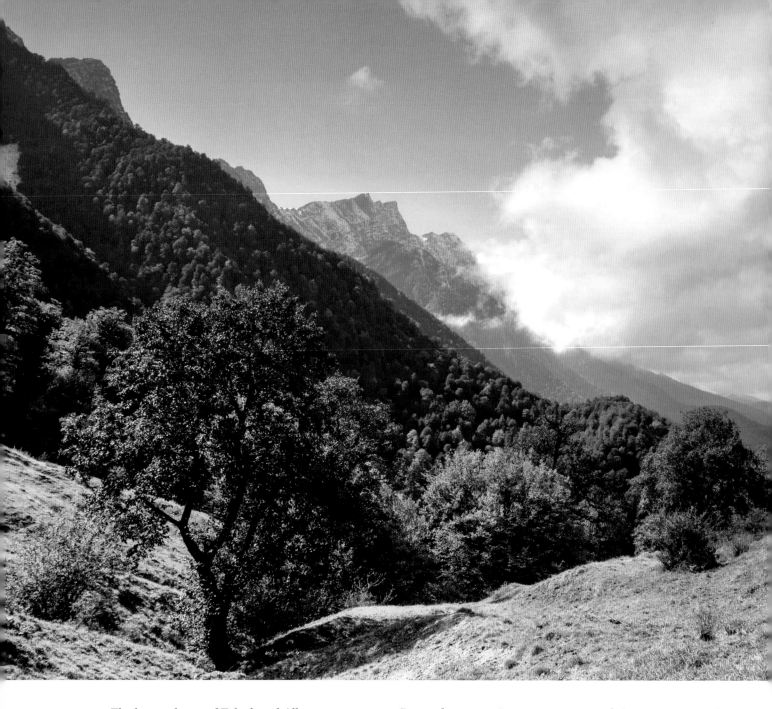

The lower slopes of Talysh and Alborz Mountains below 2296 feet (700 meters) harbor diverse humid forests containing chestnut-leaved oak, European hornbeam (*Carpinus betulus*), Persian ironwood (*Parrotia persica*), Caucasian zelkova (*Zelkova carpinifolia*), Persian silk tree (*Albizia julibrissin*), and date plum (*Diospyros lotus*) along with shrubs holly (*Ilex hyrcana*),

Ruscus hyrcanus, *Danae racemosa*, and *Atropa pallidiflora*.

Persian ironwood is endemic to the Talysh Mountains and northern Iran. It is a member of the family Hamamelidaceae and, as such, has flowers similar to witch hazel but dark red. It can grow up to 98 feet (30 meters) tall and 49 feet (15 meters) wide and is often multistemmed. The exfoliating bark

From left: Autumnal Hyrcanian landscape. •
Chestnut-leaved oak (*Quercus castaneifolia*).

317

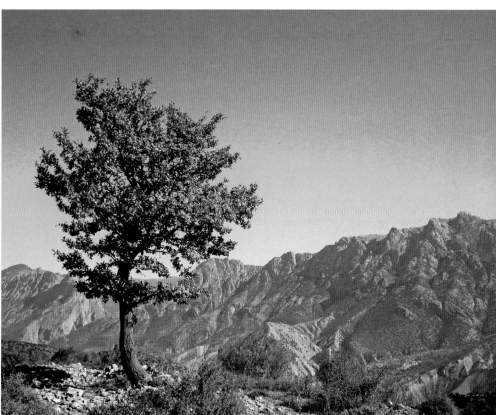

is smooth and pinkish brown, and peels to leave a montage of cinnamon, pink, green, and pale yellow patches. The leaves are alternate and ovate, often slightly lopsided, with wavy margins. Their autumn color is spectacular with the glossy green leaves, turning purple to orange and brilliant red.

In the cloudy zone at middle elevations between 2296 and 4921 feet (700 and 1500 meters), Oriental beech is the dominant tree species in pure and mixed stands with other noble hardwoods such as chestnut-leaved oak, Caucasian oak (*Quercus macranthera*), European hornbeam, Oriental hornbeam (*Carpinus orientalis*) and sweet chestnut (*Castanea sativa*).

Upper mountain and subalpine zones are characterized by Caucasian oak, Oriental

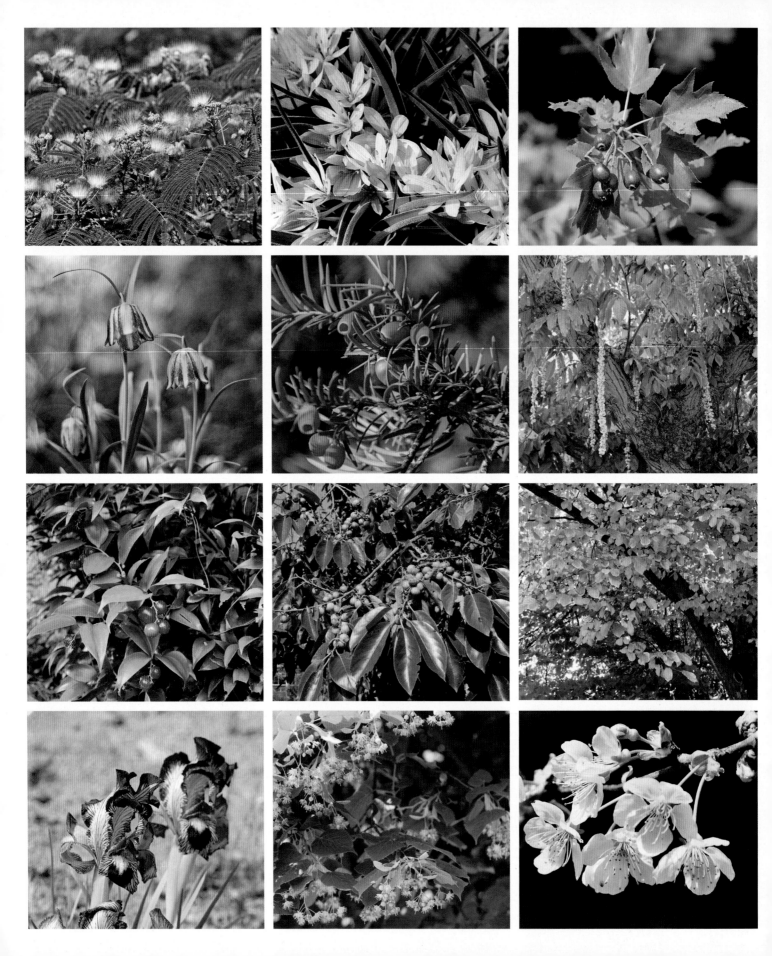

First column: Persian silk tree (*Albizia julibrissin*). • *Fritillaria olivieri.* • *Danae racemosa.* • *Oncocyclus* iris from Iran. **319**
Second column: The lovely *Crocus gilanicus* is common to northern Iran. • European yew (*Taxus baccata*). • Date plum
(*Diospyros lotus*). • Lime tree (*Tilia platyphyllos*). *Third column:* Wild service tree (*Sorbus torminalis*). • Caucasian wingnut
(*Pterocarya fraxinifolia*). • Persian ironwood (*Parrotia persica*). • Wild cherry (*Prunus avium*).

Below: An Alborz Mountain waterfall.

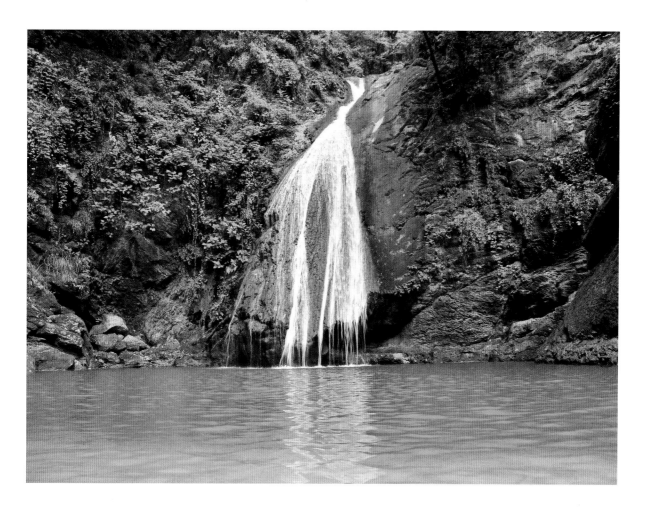

hornbeam, shrublands, and steppes. Alpine tundra and meadows occur at the highest elevations. Other native tree species include Caspian locust (*Gleditsia caspica*), velvet maple (*Acer velutinum*), Cappadocian maple (*Acer cappadocium*), European ash (*Fraxinus excelsior*), wych elm (*Ulmus glabra*), wild cherry (*Prunus avium*), wild service tree (*Sorbus torminalis*), and lime tree (*Tilia platyphyllos*).

Other endemic plants that are worthy of mention include *Fritillaria olivieri*, a bulb with nodding flowers of pale green lightly tessellated in brown; *Crocus gilanicus*, with white flowers with light purple veins; *Allium shelkovnikovi*, an onion with bright violet-purple flowers; and *Iris meda*, an *Oncocyclus* iris with long gray-green leaves with cream, pale yellow, or yellow flowers that have purple or dark brown patches and yellow beards.

Saryarka—Steppe and Lakes of Northern Kazakhstan comprises two protected areas: Naurzum State Nature Reserve and Korgalzhyn State Nature Reserve, totalling 1,112,824 acres (450,344 hectares). It features wetlands of outstanding importance for migratory waterbirds, including globally threatened species, among them the extremely rare Siberian white crane, the Dalmatian pelican, and Pallas's fish eagle, to name but a few. These wetlands are key stopover points and crossroads on the Central Asian flyway of birds from Africa, Europe, and south Asia to their breeding places in western and eastern Siberia. The 494,210-acre (200,000-hectare) Central Asian steppe areas included in the property provide a valuable refuge for over half the species of the region's steppe flora, a number of threatened bird species and the critically endangered Saiga antelope, formerly an abundant species much reduced by poaching. The property includes two groups of fresh and saltwater lakes situated on a watershed between rivers flowing north to the Arctic and south into the Aral-Irtysh basin.

Saryarka—Steppe and Lakes of Northern Kazakhstan

KAZAKHSTAN

Kazakhstan is the world's largest landlocked country, and the ninth-largest country in the world. The Turgay Plateau and Depression and the Kazakh Rolling Hills are in the Zauralsko (east-of-Ural) Turgay subprovince of the Eurasian steppes, which cover 44 percent of Kazakhstan. It is a fertile ecosystem that has been much modified by man. The reserves protect a 494,210-acre (200,000 hectare) swath of natural steppe, 60 percent of which is largely unaltered, in an unusually complete sequence of undisturbed ecosystems that support the highest biodiversity in the

Millions of tulips bloom in these grasslands.

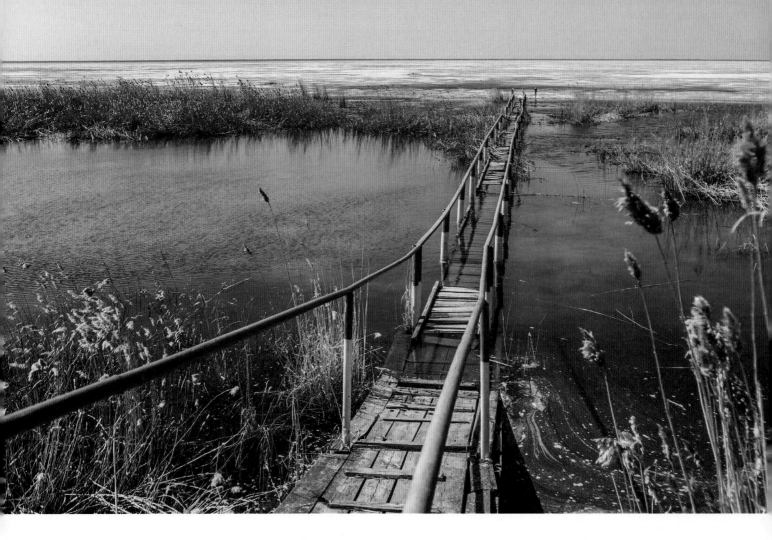

region. The vegetation is adapted to drought, fire, grazing, high winds, and long frosts. At Naurzum the northern pine forest reaches its southernmost point alongside the northernmost flora of semiarid desert. In all, the sites have nearly 770 species of plants—a third of Kazakhstan's plant species and over half of all the region's steppe and salt-tolerant floras. The property was inscribed as a World Heritage Site in 2008.

Naurzum has 687 plant species in six distinct biomes: dry steppe, semiarid sandy scrub steppe, boreal forest, meadows, salt tolerant, and aquatic. The dry steppe is dominated by feathergrass (*Stipa lessingiana*), a densely tufted, deciduous perennial grass with upright, narrowly linear, bright green leaves and narrow, arching, feathery panicles of pale yellow-brown flower spikelets in summer; *S. capillata*, which produces an upright clump of grayish green leaves and silvery green plumes from midsummer to early autumn; *S. sareptana*, a bunch grass with spiny leaves; *Festuca valesiaca*, a dense clumping grass with fine hairlike green leaves and straw-colored flowers; and *F. rupicola*, one of the sheep fescues, a tufted grass with bristlelike leaves.

Kazakhstan's dry steppe is the largest in the world. It is also the place for wild tulips. *Tulipa suaveolens* is likely to be the ancestor of the garden

From left: Lake Tengiz in Korgalzhyn State Nature Reserve. • Saiga antelope.

323

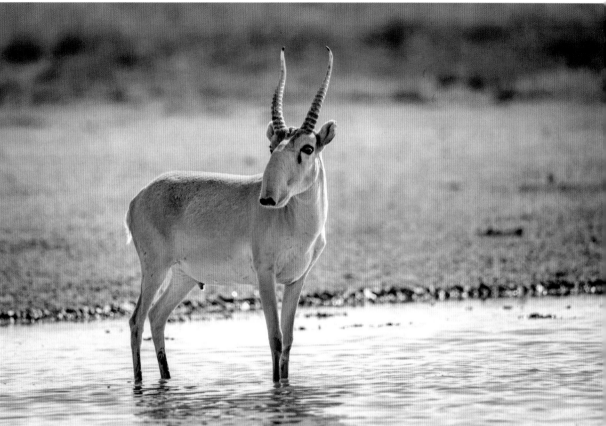

tulip. The flower color is variable but often it is red bordered in yellow. It grows by the millions, as far as the eye can see. *Tulipa greigii* has purple mottled leaves and red flowers. *Tulipa urumiensis* has bright yellow flowers edged white. Eleven species of tulip are endemic Kazakhstan (there may be more); *T. alberti*, with a scarlet-orange flower with a dark purple basal blotch, is one of them.

The semiarid sandy scrub steppe has plants that only grow in sand (psammophytes). The feathergrasses *Stipa capillata*, *S. zalesskii*, *S. pennata*, and *S. parviflora* are dominant with species of *Helichrysum*, *Artemisia*, *Silene*, and *Centaurea* growing, too. Silver spike (*Helichrysum thianschanicum*), has white pubescent linear leaves and florets of yellow flowers. *Artemisia lercheana* and *A. gracilescens*, sagebrushes with gray-green aromatic foliage and soft yellow-white flowers, are common. *Silene tatarica* is an endangered perennial with yellowish white flowers. *Centaurea behen* has large basal leaves becoming much smaller upon a stalk topped with small yellow flowers.

There are forests on the sandy and rocky soils. They are of Scots pine (*Pinus sylvestris*) and downy birch (*Betula pubescens*), silver birch (*B. pendula*), and the endemic Kirgiz birch (*B. kirghizorum*). Dwarf Russian almond (*Prunus tenella*) grows on scrub steppe. It is more closely related to plums

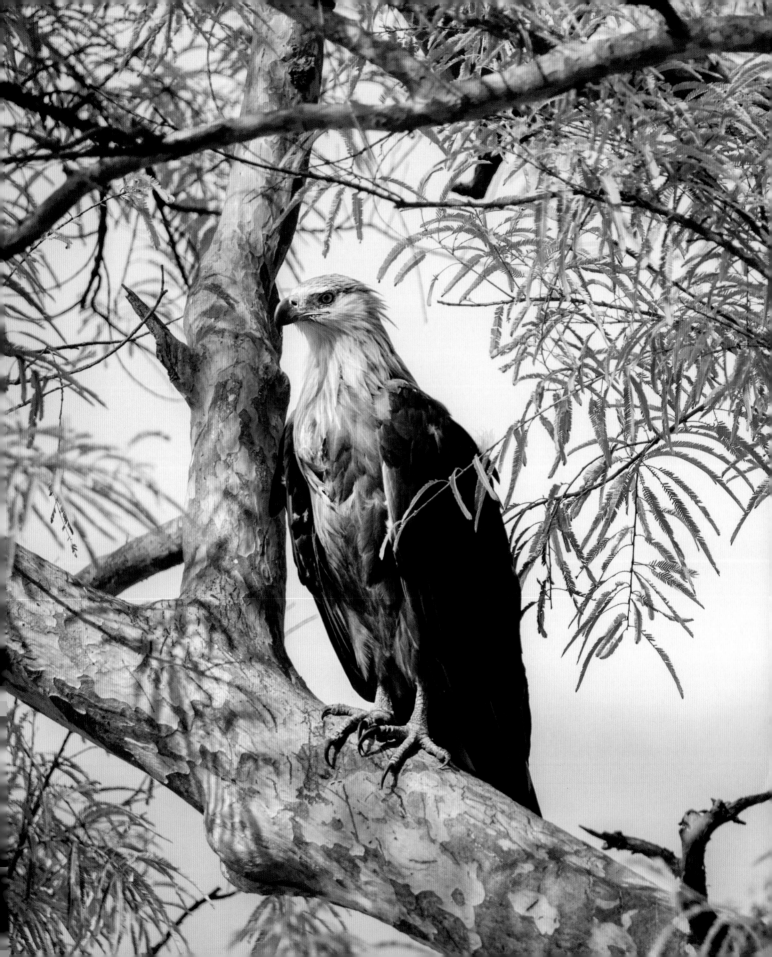

and apricots than almonds. It grows to about 5 feet (1.5 meters) and has purple-pink flowers. The white flowers of steppe cherry (*Prunus fruticosa*) appear in spring on shrubs growing to 6½ feet (2 meters) high and wide.

The meadows are full of grasses, as meadows are. Pink tamarisk (*Tamarix ramosissima*) grows on the edges of the lakes. A deciduous shrub to a height of 15 feet (4.5 meters), the stems have whorls of grayish green needles. In early summer, plumes of pink ostrich feather–like flowers appear, persisting until autumn. Saltmarsh rush (*Juncus gerardii*), a rush with dark brown blackish flowers, edges the water, and *Puccinellia tenuissima*, a grass, grows in the salty water. *Limonium gmelinii*, a vigorous statice, has clouds of papery, gray-blue flowers against blue-gray leaves, and blooms in late summer, growing among the meadow grasses and lakeside plants. It is almost a shock to see so much color as the grasses turn to tan and golden brown. Growing in the water are the reed *Phragmites australis*, lesser bulrush (*Typha angustifolia*), and lakeshore bulrush (*Scirpus lacustris*).

The salt-tolerant (halophyte) plants of the saline semidesert include wormwoods *Artemisia shrenkiana*, *A. nitrosa*, *A. pauciflora*, and

A. lessingiana and desert saltwort (*Atriplex cana*), a much-branched, cushion-shaped perennial with woody stems and terminal spikes of greenish white flowers. It is a common plant of the semidesert. Where soils are very salty, hyperhalophytic species such as jointed glasswort (*Halocnemum strobilaceum*) and seablite (*Suaeda corniculata*), an annual amaranth with rusty red flowers, create dense islands in the salty marsh.

Korgalzhyn, a complex of freshwater and saline lakes, has about 350 plant species, a quarter of the Rolling Hills flora and half of the area's halophytes. One species endemic to the Kazakh hills is the Kazakh milkvetch (*Astragalus kasachstanicus*) with pealike yellow flowers. The rare *Tulipa suaveolens* also grows in large numbers there. Relict species such as the yellow water lily (*Nuphar lutea*) and *Nymphaea candida*, a water lily with white flowers with yellow centers, bloom in their thousands on the surface of the lakes.

Endless waves of grass against a backdrop of snow-covered mountains. Lakes full of flowers and deserts blooming. How beautiful is the land of the Kazakhs. It is the birthplace of the apple. *Malus sieversii* is the originator species of the domestic apple (*Malus domestica*), but that is another story.

First column: Dwarf Russian almond (*Prunus tenella*). • Kazakh milkvetch (*Astragalus kasachstanicus*). • Saltmarsh rush (*Juncus gerardii*). *Second column:* Feather grass (*Stipa capillata*). • *Festuca rupicola*. • Yellow water lily (*Nuphar lutea*). • *Nymphaea candida*. *Third column:* Tulipa greigii. • Silver spike (*Helichrysum thianschanicumicicles*). • Jointed glasswort (*Halocnemum strobilaceum*). • *Limonium gmelinii*. *Fourth column:* The mother of apples, *Malus sieversii*. • Lakeshore bulrush (*Scirpus lacustris*). • *Tulipa suaveolens*. • *Tamarix ramosissima*. *Fifth column:* Silene tatarica. • *Tulipa alberti*. • *Tulipa urumiensis*.

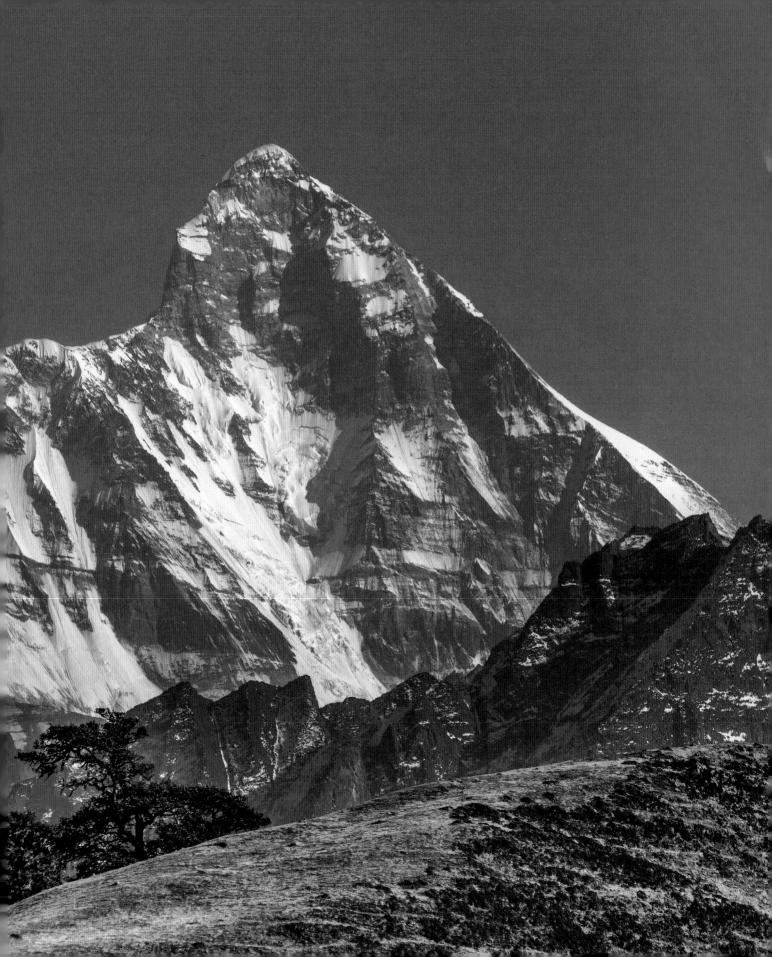

Nestled high in Western Himalayas, India's Valley of Flowers National Park is renowned for its meadows of endemic alpine flowers and outstanding natural beauty. This richly diverse area is also home to rare and endangered animals, including the Asiatic black bear, snow leopard, brown bear, and blue sheep. The gentle landscape of the Valley of Flowers National Park complements the rugged mountain wilderness of Nanda Devi National Park. Together they encompass a unique transition zone between the mountain ranges of the Zanskar and Great Himalaya, praised by mountaineers and botanists for over a century and in Hindu mythology for much longer.

Nanda Devi and Valley of Flowers National Parks

INDIA

At the entrance to the Valley of Flowers is a large sign with a list of plants to be found farther up the valley. At the bottom of the sign is a quote from the 16th-century French philosopher Michel de Montaigne, "Let us permit nature to have her way, she understands her business better than we do." It is a curiosity that a quote from a French philosopher is at the entrance of a valley in India, a country that established its main schools of philosophy 1500 years before Montaigne was born, and is 80 percent Hindu, 14 percent Muslim, and 1.7 percent Sikh. It is a sweet quote

The bliss-giving goddess, Nanda Devi peak.

Opposite: Lakshman Ganga, also known as Bhyundar Ganga, is a minor river that flows through the Bhyundar Valley,

nonetheless, softly asking the visitor to have respect for what will unfold as they hike into the valley.

In 1982 the national park was created to protect the catchment area of the Pushpavati River. Emerging from a glacier then flowing downward, over millennia it created a steep valley, the Bhyundar Valley (to give the Valley of Flowers its former and less romantic name), which leads to Hemkund Sahib, a glacial lake and a Sikh place of worship and pilgrimage. The water continues to cut through the mountains and flows on to join the Bhagirathi and Alaknanda Rivers where it becomes the Ganges proper—"where the Ganges falls from the foot of Vishnu like the slender thread of a lotus flower" as described in an ancient Vedic text—and flows for around 1569 miles (2525 kilometers) from the Himalayan Mountains to the Bay of Bengal.

British mountaineer Frank S. Smythe passed through the valley in 1931. His book *The Valley of Flowers*, published in 1938, brought this remote Himalayan meadow to the attention of the world and helped create many an English herbaceous border and Scottish rock garden. He writes, "There was no doubt about it; here was the ideal camping site. On three sides it was bounded by silver birches with a lower frieze of purple- and white-flowered rhododendrons. Never have I seen finer birches. In the westering sun their brilliant foliage and silver bark seemed to partake of the purity of earth and sky, whilst their leaves, rippling in a light breeze, suggested some pebble-floored pool of shimmering water."

The tents were pitched in the midst of flowers, prominent among which was the *Anemone polyanthes*. In between grew thousands of yellow *Nomocharis oxypetala* and and here and there the blue *N. nanum*. There were two kinds of geranium and a blue delphinium (*Delphinium brunnianum*). One of the loveliest of the taller plants was the *Polemonium caeruleum*, with wide, flattish flowers of amethyst blue.

Surrounding the valley is the Nanda Devi National Park or Nanda Devi Biosphere Reserve, situated around the peak of Nanda Devi (25,643 feet; 7816 meters), the second-highest peak in India and part of the Garwhal Himalayas. It is a twin-peaked mountain of great religious significance, the name meaning "bliss-giving Goddess."

The entire park lies at an elevation of more than 11,483 feet (3500 meters) above sea level. It was inscribed as a World Heritage Site in 1988. It was later expanded and renamed as Nanda Devi and Valley of Flowers National Parks in 2005.

Despite its remoteness, the Valley of Flowers receives thousands of visitors between the monsoon months of June and October. Starting from the town of Govindghat, where Hindus begin their pilgrimage to Sri Badrinathji Yatra, an important place of

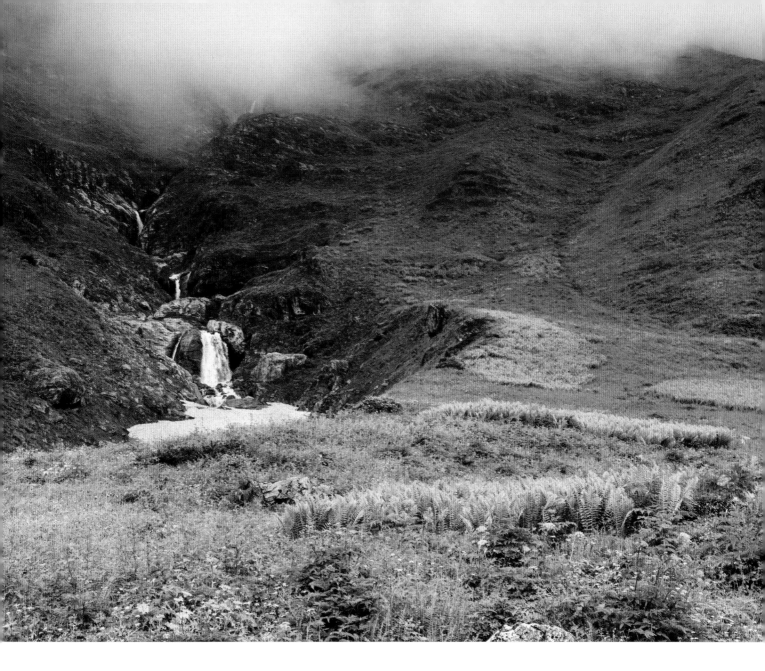

worship, Sikhs go to Hemkund Sahib, and others go to the valley, it is an 8-mile (13-kilometer) climb up the steep stone path to the base camp of Ghangria, and another 1¾ miles (3 kilometers) to the entrance of the valley. Many tourists from all over India, as well as wheezing westerners in search of floral wonder, experience the pleasure and at times the altitude sickness of the wonderful trail. It is not an easy place to get to and this difficulty protects the valley from overtourism, although there are days when the crowds jostle for space with mules and porters and it seems as busy and bustling as Rishikesh.

It is all about altitude. The valley is a glacial corridor 5 miles (8 kilometers) in length and 1¼ miles (2 kilometers) wide, and has three main vegetation zones: subalpine between 10,499 and 11,483 feet (3200 and 3500 meters), the limit for trees; lower alpine between 11,483 and 12,140 feet (3500 to 3700 meters); and higher alpine above 12,140 feet (3700 meters). The habitats include riverbed,

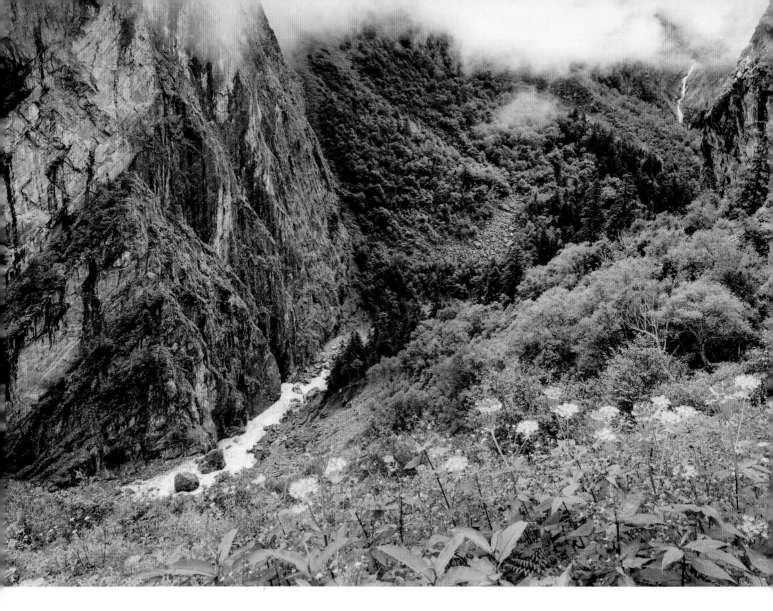

meadow, forest, moraine, plateau, and bog. The surrounding hills are thickly forested.

In 1992 the Forest Research Institute recorded 600 species of flowering plants and 30 fern and horsetail species in the valley. The dominant family is Asteraceae, and one rare and endangered species holds a special place in Hindu mythology. *Saussurea obvallata* is a perennial growing to 24 inches (30 centimeters) with purple, hermaphroditic flowers encased in a balloon of yellowish green papery bracts. Its common name, brahma kamal, is translated as the lotus of Brahma. Brahma is the creator of the universe. It is believed that seeing the flower blooming enables the observer to have all wishes fulfilled. The entire plant is used by Indigenous peoples for fevers, cough, cold, bone ache, and intestinal ailments, and harvesting for these purposes has contributed to its rarity in the wild.

Climbing up through the forests of tall, conical, dark green West Himalayan fir (*Abies pindrow*), with its needles up to 3½ inches (9 centimeters) long, large billows of *Rhododendron campanulatum*, with round bunches of rose-pink, growing beneath, and then large stands of the deciduous Himalayan birch (*Betula utilis*), with white bark burnished in the sunlight, is breathtaking.

And then a glimpse through the trees, down to a roiling river, and in a crevasse, moistened by the mist of a waterfall, the blue flowers of *Meconopsis aculeata*, the blue poppy of the Himalayas. Away from the mist and growing in rocks, too, is *Morina longifolia*, a fine thistle with rosettes of prickly foliage and tall stems, bearing jade green whirling tubes with white flowers changing to red as they age.

Along the path, by a seep of water, a glossy-leaved Himalayan bergenia (*Bergenia strachęyi*), surrounded by the evergreen triangular fronds of Himalayan maidenhair (*Adiantum venustum*), and the hairy leaves and blue flowers of *Geranium wallichianum*. Flowering above the geranium, 10 feet (3 meters) high, the purple flowers of giant Himalayan balsam (*Impatiens sulcata*), with *Arisaema jacquemontii*, its bright green white-striped spathes poking out from among the impatiens. Falling over rocks, a hardy ginger, *Roscoea purpurea*, with masses of tubular lilac-purple flowers. In a small space, a complete and wild garden.

Above the Himalayan birches and out into the open, into the silence of the high mountains, masses of flowers filling the elliptical bowl of the valley. Close to 500 species of flowering plants have been recorded. Here are a few unusual ones, not mentioned above, that stand out:

Anemone obtusiloba A tufted, clump-forming plant to 6 inches (15 centimeters) tall with dark green, toothed and slightly hairy leaves. The flowers are blue, rarely yellow, white, or pink, and are made up of four to six rounded petals.

Bupleurum candollei An erect, herbaceous perennial growing from a stout, woody tap-root. A single stem is produced, 16 to 39 inches (40 to 100 centimeters) tall with umbels of yellow, sometimes tinged green or purple flowers. The seeds are conspicuous and are brown-purple in color.

Clematis connata A deciduous climber of vigorous habit, growing 20 feet (6 meters) or higher. The leaves consist of three or five leaflets. The flowers are bell-shaped, slightly fragrant, and soft yellow.

Codonopsis viridis A late season flowering vine. The flower is bell-shaped with the tips of the petals curved outward. The corolla is pale green with dark red markings inside the bell.

Cypripedium himalaicum Himalayan slipper orchid is a terrestrial orchid. Its height varies from 8 to 10 inches (20 to 25 centimeters). The flowers are fragrant and are marked with purple and brown streaks. The flowers have an egg-shaped lip streaked with purple.

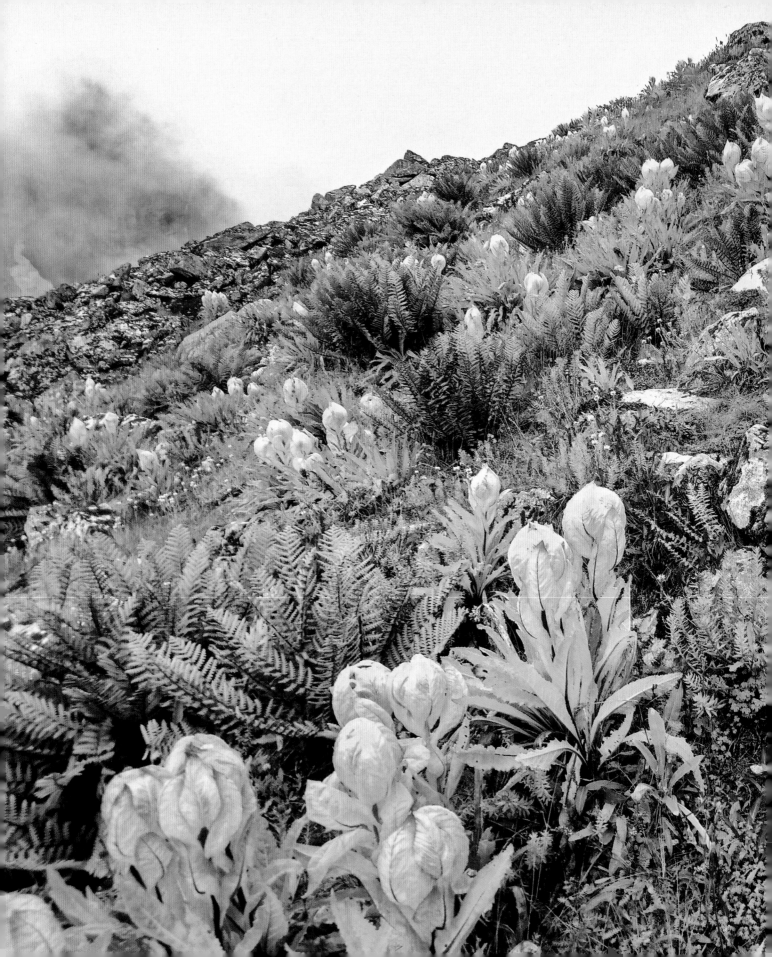

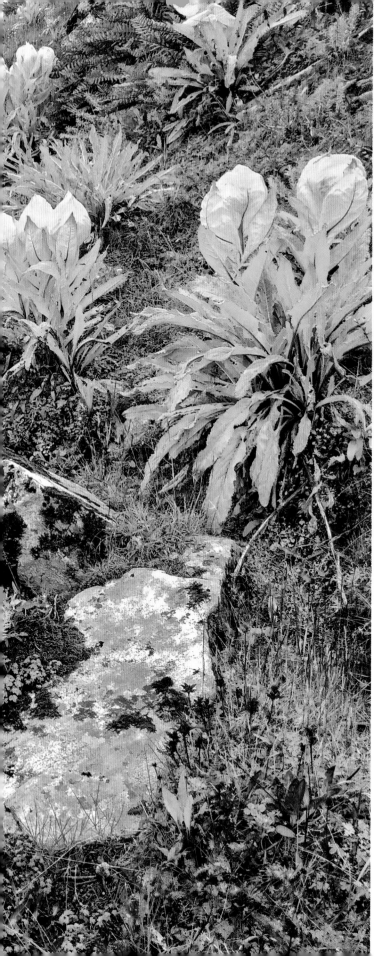

Fritillaria roylei A bulbous plant, it is 5 to 24 inches (12.7 to 60 centimeters) tall with opposite and whorled leaves, three to six per whorl. The bell-shaped, pendulous flowers are greenish yellow with a hint of pale purple, in a checkered pattern.

Gentiana sino-ornata A low-growing semi-evergreen perennial growing to 2 to 2¾ inches (5 to 7 centimeters) tall, with multiple stems 12 inches (30 centimeters) long, bearing single trumpet-shaped flowers of a pure blue with a white- and green-striped throat.

Primula wigramiana A delicate looking primula with soft hairy leaves and closed bells of six to seven funnel-shaped flowers on 10-inch (25-centimeter) stems.

Selinum vaginatum An attractive, erect, hairy herb reaching up to a height of 5 feet (1.5 meters), with clusters of small white flowers on long, thin stems. It is widely used in Ayurvedic medicine to treat high blood pressure, sleeping disorders, and neurological disorders.

Trillium govanianum Himalayan trillium has 6-inch (15-centimeter) purple-red stems with green leaves below a small, starry flower of deep oxblood red and green. The sepals and petals resemble each other, giving a six-petalled appearance, although there are only three petals as is common to the genus.

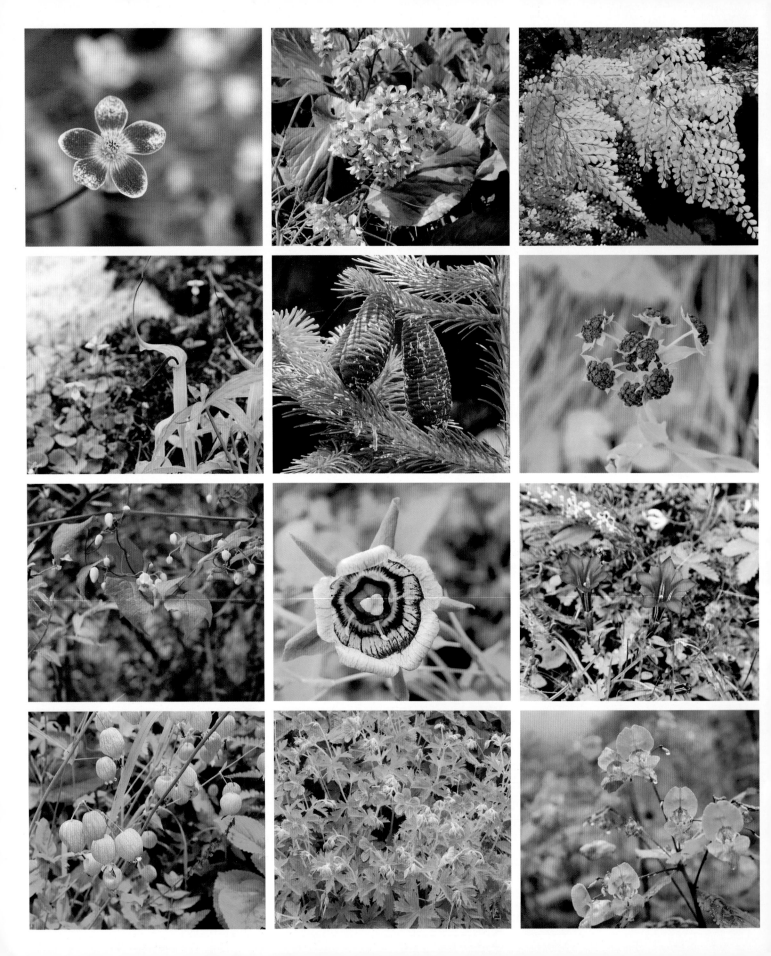

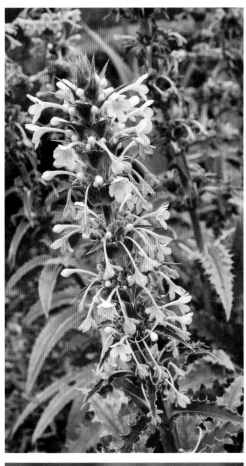
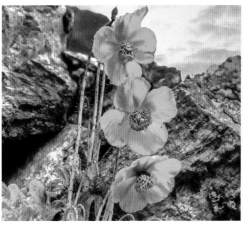
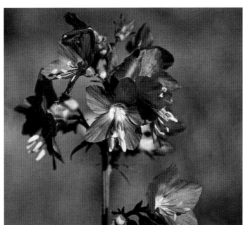

First column: *Anemone obtusiloba.* • *Arisaema jacquemontii.* • *Clematis connata.* • Bladder campion (*Silene vulgaris*). *Second column:* Himalayan bergenia (*Bergenia stracheyi*). • West Himalayan fir (*Abies pindrow*). • Roundleaf bellflower (*Codonopsis rotundifolia*). • *Geranium wallichianum.* *Third column:* Himalayan maidenhair (*Adiantum venustum*). • *Bupleurum candollei.* • *Gentiana sino-ornata.* • Giant Himalayan balsam (*Impatiens sulcata*). *Fourth column:* *Morina longifolia.* • Brown's saxifrage (*Saxifraga brunonis*). • *Rhododendron campanulatum.* *Fifth column:* *Meconopsis aculeata.* • *Polemonium caeruleum.* • *Roscoea purpurea.*

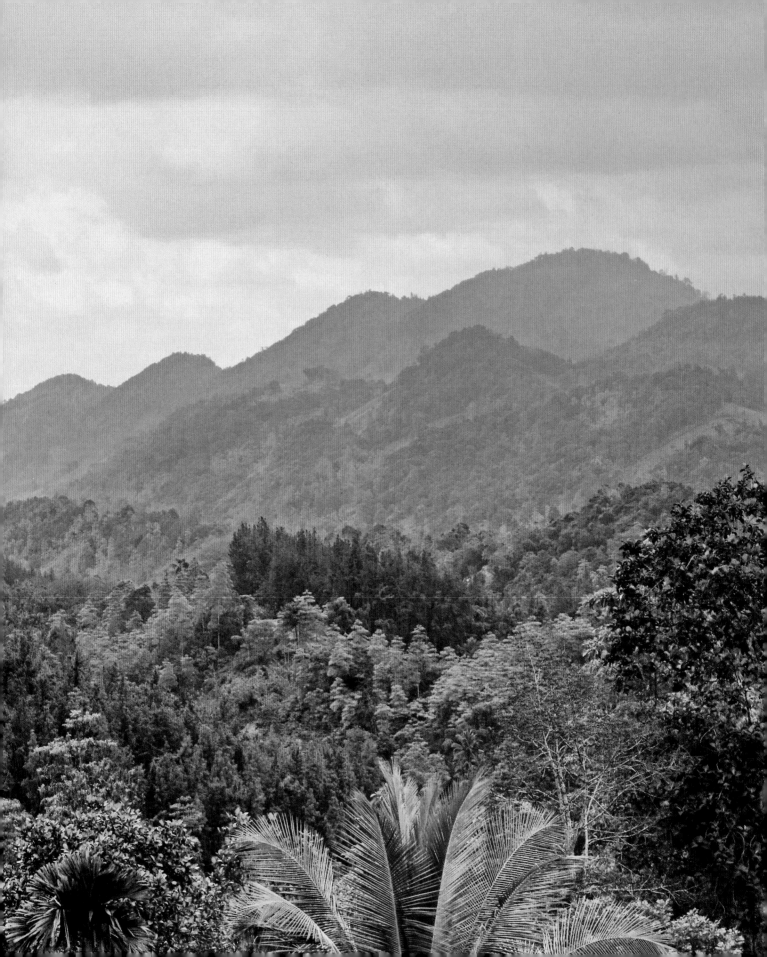

Located in southwest Sri Lanka, Sinharaja is the country's last viable area of primary tropical rainforest. More than 60 percent of the trees are endemic and many of them are considered rare. There is much endemic wildlife, especially birds, but the reserve is also home to over 50 percent of Sri Lanka's endemic species of mammals and butterflies, as well as many kinds of insects, reptiles, and rare amphibians.

Sinharaja Forest Reserve

SRI LANKA

The region has a history dating back to the ancient kings of Sinharaja and is featured in legends and lore. The name, literally meaning "lion king," may refer to the original royal forest of the Sinhala people. Their ancestors are traditionally believed to have come from northern India in the 5th century BCE.

Sinharaja forest is surrounded by 32 villages found on the southern, northeastern, northern, and northwestern margins of the forest. The main occupation is growing tea, rubber, coconut, and rice, and making chena (cheese curds).

The serrated mountains of Sinharaja.

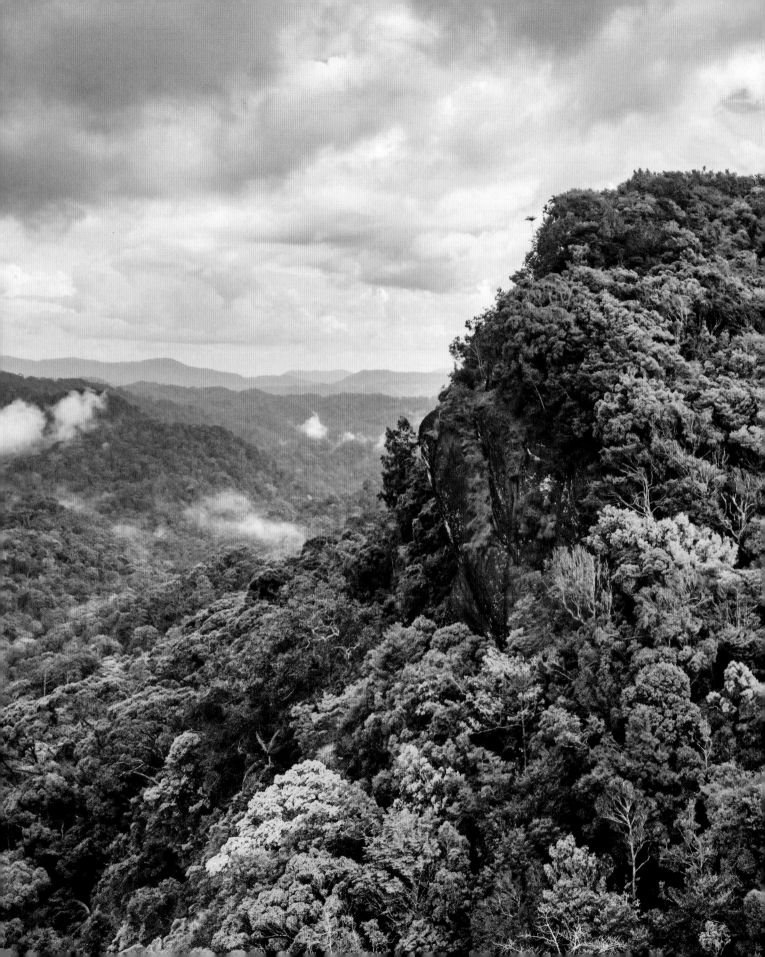

Opposite: A view of the densely wooded Sinhajara Rainforest Reserve.

341

Below, clockwise: Long-nosed whip snake. • Sri Lankan blue magpie. • A resident chameleon.

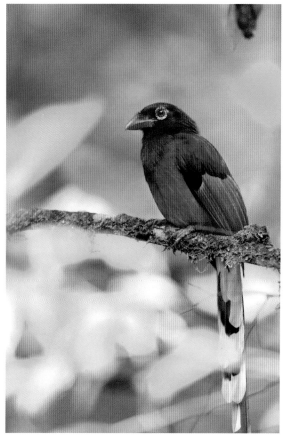

There is also a little livestock husbandry and some cultivation of cinnamon, cardamom, coffee, and cloves. In almost all the villages, cropland is being converted to tea cultivation. All around Sinharaja the main activity is kitul palm tapping and the preparation of treacle and jaggery—a dark brown sugar—for which there is a well-developed market of traders who visit the villages and buy it for sale in the towns. Other forest products collected are mushrooms, tree barks, rattan, wild cardamom, resins, honey, areca nut, and a range of medicinal plants.

The park lies within a Conservation International–designated Conservation Hotspot, in a WWF Global 200 Freshwater Ecoregion, and is one of the world's Endemic Bird Areas. It became a World Heritage Site in 1988.

Sinharaja is an undisturbed fragment of the ancient tropical rainforest of Sri Lanka, part of a 116,139-acre (47,000-hectare) dense lowland

forest, three-quarters of which was logged until recently. Of the 337 species that occur in the park, 116 are globally threatened. Three main types of forest are found there: remnant dipterocarp forest below about 1640 feet (500 meters), climax sho-rea forest over most of the reserve on the middle and upper slopes to 2952 feet (900 meters), and a transitional zone to tropical montane forest above about 2952 feet (900 meters). Two hunderd twenty species of trees and woody climbers are recorded, of which 40 percent have low population densities and 43 percent have restricted distribution, making them vulnerable to further encroachments into the reserve. Of Sri Lanka's 217 endemic wet lowland

trees and woody climbers, 139 (64 percent) have been recorded in Sinharaja, 16 of which are rare.

The forest is a 13- by 2½-mile (21- by 4-kilometer) strip of undulating piedmont consisting of a series of ridges and valleys around Rakwana Mountain. It is drained by an intricate trellis of streams, which flow into two major rivers: the Gin Ganga along the southern boundary and the Kalu Ganga to the north. The soils, which are largely red-yellow podzols (infertile acidic soils), except for alluvium in the valleys, are impermeable and have little organic matter. This is attributed to the combination of climatic conditions, a diverse soil microflora that rapidly breaks down organic matter

into its constituent nutrients, and to accelerated uptake and recycling of the nutrients by the trees. The forest receives rain from both the northeast monsoon between November and January and the southwest monsoon from May to July. At other times, it is just wet.

In the valleys and on the lower slopes the dominant canopy trees are *Dipterocarpus hispidus*, a large, evergreen tree, classified as critically endangered in the IUCN Red List of Threatened Species, and *D. zeylanicus*, which grows to a height of 148 feet (45 meters), with pinkish brown bark and big oval leaves 8 inches (20 centimeters) long. These species are endangered because of

encroachment by rubber and tea plantations. Other trees include Ceylon ironwood (*Mesua ferrea*), a beautiful tree with lance-shaped leaves emerging brilliant red, aging to pink, and then dark glossy green. The sweetly fragrant flowers are white with yellow centers. *Vitex altissima* is a large tree with a dense crown, growing up to 131 feet (40 meters) tall, with palmate leaves. The flowers are white, tinged with blue, borne in hairy panicles at the end of the branches.

On the upper slopes and ridges the vegetation is transitional between the tropical wet evergreen and tropical montane forests and trees decrease in size with a number of characteristic species.

SINHARAJA FOREST RESERVE

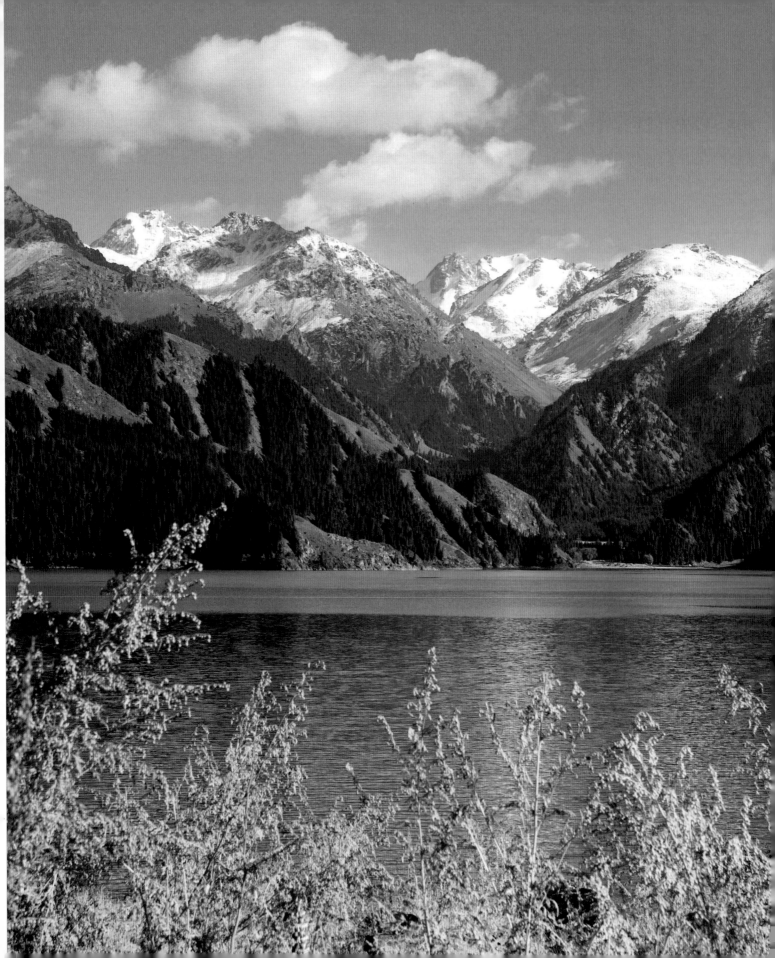

Xinjiang Tianshan comprises four components—Tomur, Kalajun-Kuerdening, Bayinbukuke and Bogda—that total 1,499,517 acres (606,833 hectares). They are part of the Tianshan mountain system of Central Asia, one of the largest mountain ranges in the world. Xinjiang Tianshan presents unique physical geographic features and scenically beautiful areas including spectacular snowy mountains and glacier-capped peaks, undisturbed forests and meadows, clear rivers and lakes, and red bed canyons. These landscapes contrast with the vast adjacent desert landscapes, creating a striking visual contrast between hot and cold environments, dry and wet, desolate and luxuriant. The landforms and ecosystems of the site have been preserved since the Pliocene epoch and present an outstanding example of ongoing biological and ecological evolutionary processes. The site also extends into the Taklimakan Desert, one of the world's largest and highest deserts, known for its large dune forms and great dust storms. Xinjiang Tianshan is, moreover, an important habitat for endemic and relict flora species, some rare and endangered.

Xinjiang Tianshan

CHINA

The snow-capped Tianshan, the Celestial Mountains, where western China penetrates Central Asia, are one of the largest temperate zone mountain ranges in the world. They run almost east-west 1553 miles (2500 kilometers) from the western edge of the Gobi Desert in China to the Kyzylkum Desert in Uzbekistan. Their beauty, biodiversity, and degree of endemism are outstanding. In Xinjiang, where they run for half their length between the arid steppes of Djungaria and the extreme desert of the Taklimakan, they are at their highest, most glaciated, and most diverse.

Lake Tianchi.

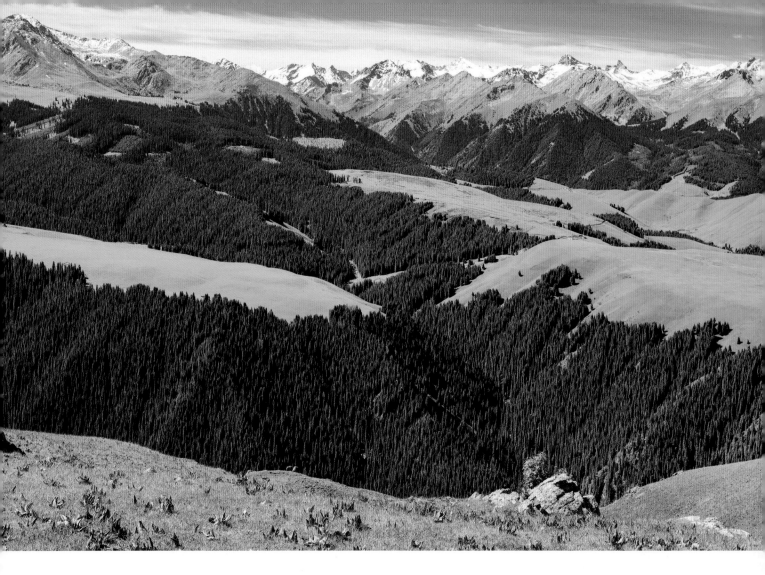

Inscribed as a World Heritage Site in 2013, Xinjiang Tianshan is a serial property consisting of four components totaling 1,499,517 acres (606,833 hectares), with buffer zones totaling 1,213,541 acres (491,103 hectares) located in China in the Xinjiang Tianshan, the eastern portion of the Tianshan mountain range. The four components are located along the 1093 miles (1760 kilometers) of the Xinjiang Tianshan, a temperate arid zone surrounded by Central Asian deserts.

The land is outstandingly scenic and has many superlative natural features—from red bed canyons to high peaks and glaciers to beautiful wetlands, meadows, and steppe. The visual impact of these features is magnified by the stark contrasts between the mountain areas and vast Central Asian deserts, and between the dry south slopes and the much wetter north slopes. Xinjiang Tianshan is also an outstanding example of ongoing biological and ecological evolutionary process in a temperate arid zone. Altitude, significant differences between north and south slopes, and diversity of flora all illustrate the biological and ecological evolution of the Pamir-Tian Shan Highlands. Xinjiang Tianshan has outstanding biodiversity and is important habitat for relict species, numerous rare and endangered species, and endemic species. It provides an excellent example of the gradual replacement of the original warm and wet flora by modern dry Mediterranean flora.

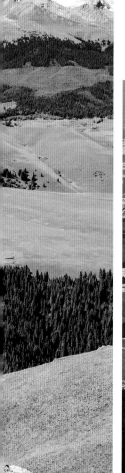

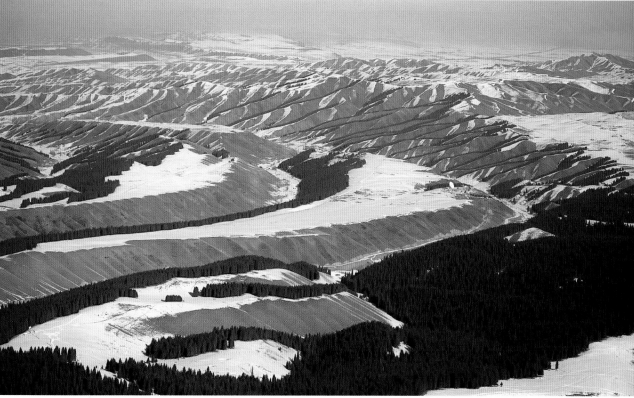

The Xinjiang Tianshan lie across two main floristic subregions: Eurasian forest and Asian desert; with influences from the Turanian steppes and Pamirs to the west, the Altai Mountains to the north and the dry Tibetan plateau to the south. Important ecosystems contained in the four sites include mountain evergreen and deciduous coniferous forests, mountain broad-leaved forest, wild fruit and riparian forests, scrub thickets, marshes, mountain meadows, alpine and subalpine meadows, cushion vegetation, alpine steppe, grassland steppe, dry steppe, desert steppe, and desert.

The sites have a high percentage of species of the Mountains of Central Asia biodiversity hotspot: 2622 species of 635 genera from 106 families of wild vascular plants, 94 relict species originating before the Quaternary glaciation, 118 endemic species, 110 nationally rare and endangered species, and 4 on the IUCN Red List of Threatened Species. Tianshan birch (*Betula tianschanica*) is a medium-sized deciduous tree with creamy pink, flaking bark. It grows to a height of 39 feet (12 meters). The double-toothed leaves turn yellow in the autumn. Xinjiang tulip (*Tulipa sinkiangensis*) is an early spring–flowering tulip endemic to the desert zone of the northern piedmont of the Tianshan Mountains. The tepals are yellow, dark red, or reddish yellow, with the outer ones tinged with purple, green, dark purple, or yellowish green and the inner ones streaked with dark color. It is

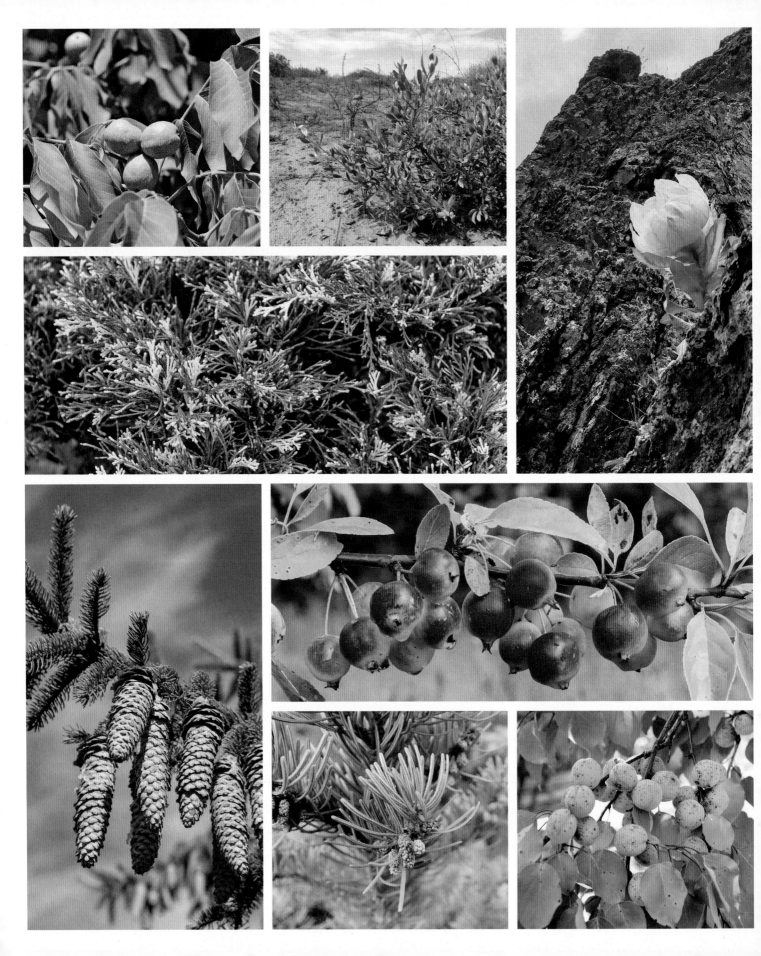

First column: Wild walnut (*Juglans regia*). • *Juniperus sabina.* • Asian spruce (*Picea schrenkiana*). *Second column:* *Ammopiptanthus mongolicus.* • *Malus sieversii,* the primary ancestor of today's domesticated apple. • Siberian fir (*Abies sibirica*). *Third column:* Snow lotus (*Saussurea involucrata*) growing high in the Tianshan Mountains. • Wild apricot (*Armeniaca vulgaris*).

Below, from left: The Nalati grassland. • Tianshan Mountain.

 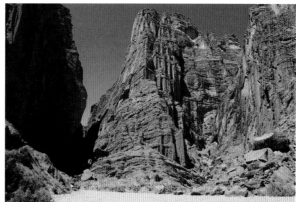

one of the parents of the multiflora tulips of horticulture. *Ammopiptanthus nanus* is an endangered broadleaf evergreen growing in the sandy desert. It is highly tolerant of drought and freezing. It was widespread when the climate was wetter and more temperate and is a relict of the Tertiary period (66 to 2.6 million years ago).

The Kalajun-Kuerdening has large areas of endemic Asian spruce (*Picea schrenkiana*) forest. It is a large conifer growing to 164 feet (50 meters) that has a conical crown with level branches and sometimes pendulous branchlets. The leaves are needlelike and dark green. The cones are purple when young, aging dark brown. Growing with it is Siberian fir (*Abies sibirica* subsp. *semenovii*), reaching to 98 feet (30 meters) tall. The aromatic needles are flat and light green with two white bands on the underside. The seed cones are yellow-brown, with broad bracts.

Due to its location and climate, Kalajun-Kuerdening became a refuge for now-relict species and is the mother of orchards with 52 species of wild fruit trees, notably wild apple (*Malus sieversii*), wild apricot (*Armeniaca vulgaris*), wild walnut (*Juglans regia*), and the highest number of endemic species of the four sites. The evergreen coniferous shrub communities include *Juniperus sabina*, pines, and spruces.

Bayinbukuke has the biggest subalpine wetland marshes in the mountains. The ranges hold more than 80 species of medicinal plants, including the valued snow lotus (*Saussurea involucrata*), an endangered member of the family Asteraceae. It is widely used in traditional Uyghur, Mongolian, and Kazakhstan medicine as well as in Traditional Chinese Medicine. It can promote blood circulation, diminishes inflammation, and invigorates, and strengthens Yin and Yang.

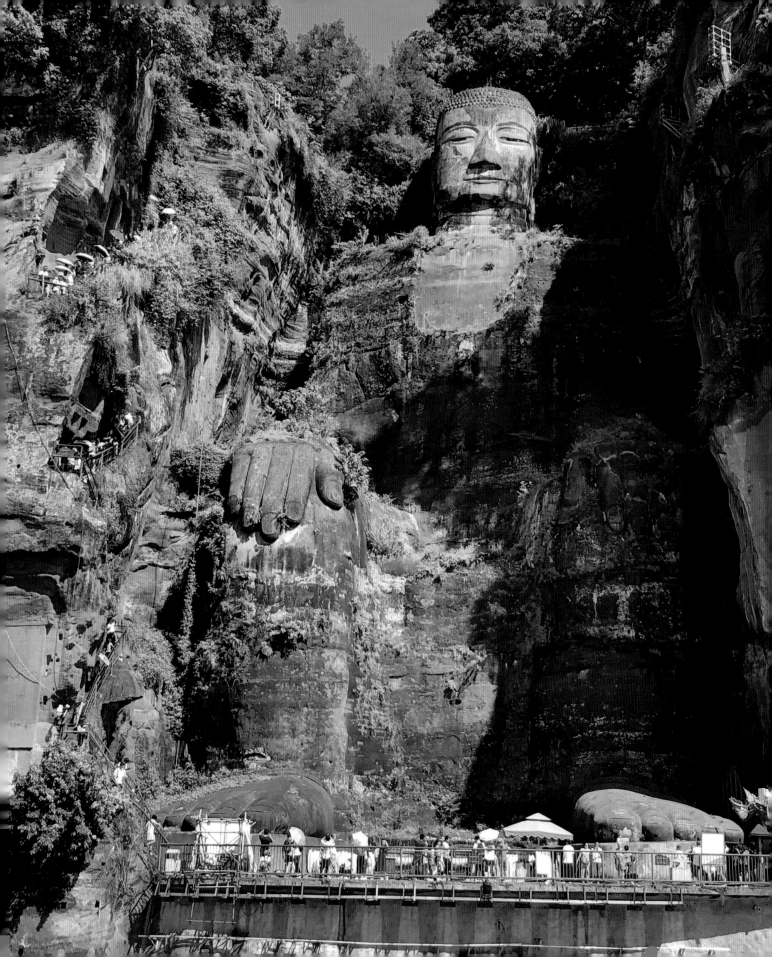

The first Buddhist temple in China was built in Sichuan Province in the 1st century CE in the beautiful surroundings of the summit Mount Emei. The addition of other temples turned the site into one of Buddhism's holiest sites. Over the centuries, the cultural treasures grew in number. The most remarkable is the Giant Buddha of Leshan, carved out of a hillside in the 8th century and looking down on the confluence of three rivers. At 233 feet (71 meters) high, it is the largest Buddha in the world. Mount Emei is also notable for its exceptionally diverse vegetation, ranging from subtropical to subalpine pine forests. Some of the trees are more than 1000 years old.

Mount Emei Scenic Area, Including Leshan Giant Buddha Scenic Area

CHINA

Located in south-central Sichuan Province, 93 miles (150 kilometers) south of Chengdu, the Mount Emei Scenic Area is 6 miles (10 kilometers) northwest of Emei City, and the Leshan Giant Buddha Scenic Area is 15 miles (25 kilometers) northeast of Emei City. Mount Emei rises abruptly 8530 feet (2600 meters) from the western edge of the Chengdu Plain. Its topography is a very varied and scenic range of undulating hills and valleys, deep gullies, and high peaks. The bedrock is of well-developed and easily identified Late Precambrian sedimentary strata. These contain

Leshan Giant Buddha.

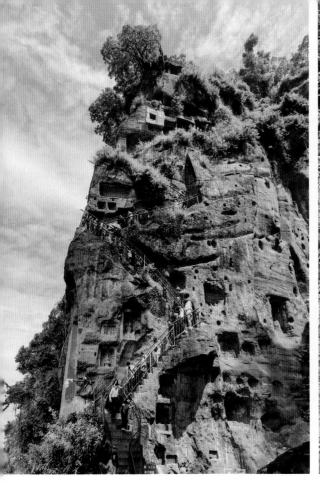
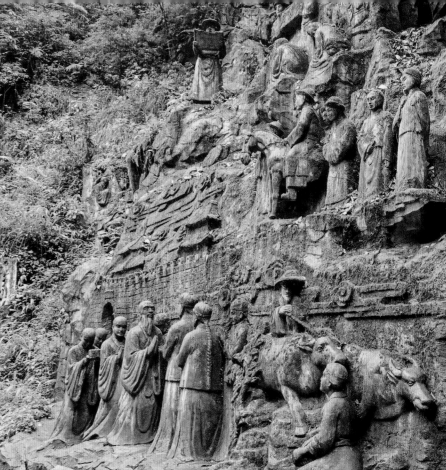

many fossils and are an important source of geological information. Of stratigraphic significance are the Late Precambrian to Cambrian Maidiping section, the Triassic Longmendong section, and the Mount Emei basalts. These are part of the extensive Emei flood basalts or volcanic trappe, widespread in southwest China, created by a mantle plume in the period of the Permian-Triassic boundary. A wide range of soils exists, the best represented being yellow earth, mountain yellow earth, yellow brown earth, mountain dark brown earth, and subalpine podzolic soil.

The principal rivers are the Black Dragon, Emei, and White Dragon. Longmendong and Yixiantian gorges are the direct result of water erosion. The abundant rainfall on carbonate rocks has developed a number of karstic features, including the Shisungou karst forest, Jiulaodong karst cavern, and Jiaopenba underground river. The 6-acre

(2.5-hectare) Leshan site is a mountainside cliff overlooking the confluence of two rivers, the Dadu and Qingyi, with the Minjiang, a tributary of the Yangtze River.

There is archaeological evidence that the area was inhabited as long as 10,000 years ago, but the mountain became of exceptional cultural significance as the place where Buddhism was first established in China, from where it spread widely throughout the east. It is a place of natural beauty and diverse wildlife, originally sacred to Taoists. Since the first Buddhist temple in China was built here in the 1st century CE, Mount Emei and later the Leshan Giant Buddha have been places of spiritual and historical importance as one of the four holy lands of Chinese Buddhism.

The Leshan Giant Buddha is 233 feet (71 meters) high, carved into the west cliff of Mount Lingyun overlooking the confluence of three rivers and made

From left: Steps to the giant buddha reflect the Noble Eightfold Path. • Chunyang Temple is said to be the earliest religious site built on Mount Emei. • Morning view over Mount Emei.

355

to placate the rivers' dangerous eddies. This is the largest carved stone Buddha in the world, begun in 713 CE and taking 90 years to complete. When new, the statue was covered with gold and bright paint. There are also more than 90 stone carvings in Buddhist shrines made during the Tang Dynasty; the Lidui, a large rock cut in the center of the river for irrigation purposes; Han dynasty tombs; and Tang and Sung dynasty Buddha statues, pagodas, and temples.

In addition to its exceptional cultural significance, the area has a high plant species diversity with a large number of endemic species, and it was inscribed as a mixed cultural and natural World Heritage Site in 1996. A place of geological beauty into which the human element has been integrated, the area of Mount Emei underlines the importance of the link between the tangible and intangible, the natural and the cultural.

The vegetation of Mount Emei has been spared deforestation because of its religious importance and, until the 1990s, because of inaccessibility. It is subtropical but on the cusp of the temperate zone, containing flora of both the Oriental deciduous and Chinese subtropical forest provinces, with altitudinal variety and relict vegetation as well. Its cloudy humidity, even in the alpine zone, creates the conditions for biological richness. As a result, both flora and fauna are exceptionally diverse—particularly the flora. The mountain is 87 percent forested. The vegetation grows in five belts defined by altitude: from subtropical evergreen broad-leaved forest below 4921 feet (1500 meters), through evergreen and deciduous broad-leaved mixed forest, coniferous and broad-leaved mixed forest, and subalpine coniferous forest to subalpine shrubland above 9186 feet (2800 meters). Some trees are said to be more than 1000 years old.

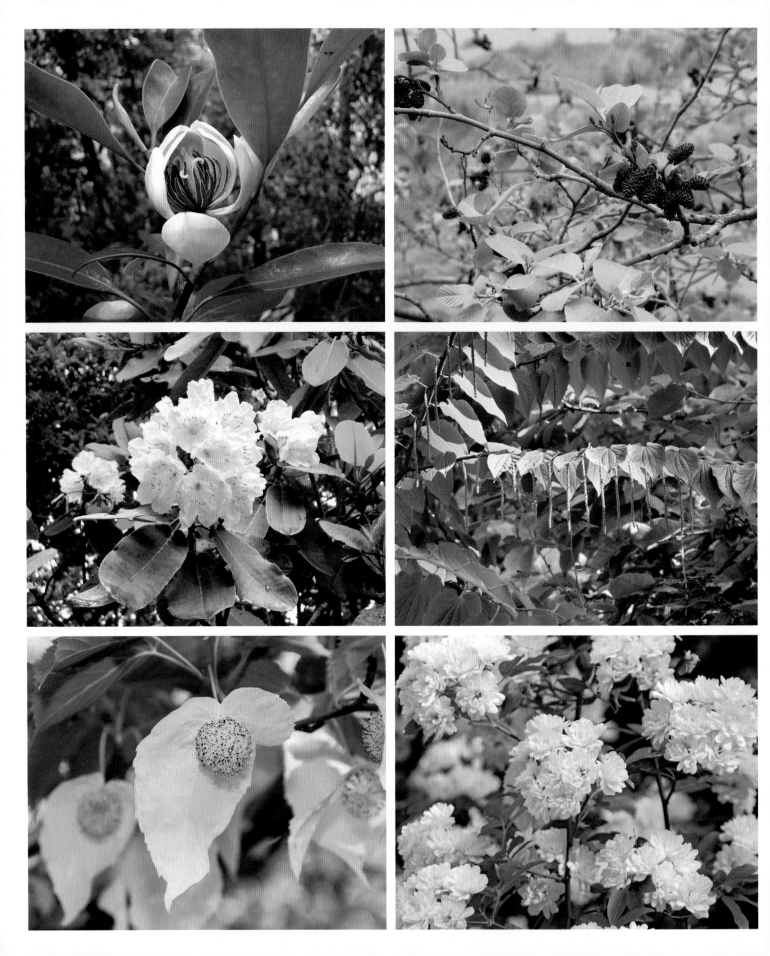

First column: The threatened *Magnolia omeiensis.* • *Rhododendron hemsleyanum* features beautiful fragrant white flowers sometimes tinged pink with a yellow green throat. • The beautiful dove tree (*Davidia involucrata*). *Second column:* Caucasian alder (*Alnus subcordata*). • *Tetracentron sinense.* • The yellow form of *Rosa banksiae.*

357

Some 3200 plant species in 242 families have been recorded, of which 31 are under state protection, and more than 100 species are endemic. These are approximately a third of the total number of plant species in Sichuan province and a tenth of those found in China. They include some 1600 species of medicinal plants, and 600 species of economic or scientific value.

Nearly half of the world's *Magnolia* species are threatened with extinction, and the endemic *M. omeiensis* is one of them. It is an evergreen tree reaching heights of 82 feet (25 meters), with pale yellow to milky white flowers with dark red filaments. In 2016 only 27 mature individuals were left on the mountain. Since then, in situ and ex situ conservation has taken place, and hundreds of saplings have been planted thanks to Botanic Gardens Conservation International and the Sichuan Provincial Institute of Natural Resource Sciences. While the *M. omeiensis* remains critically endangered, there is hope for its survival. Other endemics of note are *Parnassia omeiensis*, an herbaceous plant with white flowers spotted purple brown, *Salix omeiensis*, a shrubby willow, *Itea omeiensis*, a tree up to 33 feet (10 meters) tall with leathery leaves and racemes of white flowers in spring, and *Rhododendron hemsleyanum*, which grows up to 30 feet (9 meters), with leathery oblong leaves and fragrant white flowers in May and June.

Within the five nature reserves or protected management zones there are many notable plants. The dove tree (*Davidia involucrata*) is a most wonderful deciduous tree. It grows to about 66 feet (20 meters) and has bright green serrated leaves with a heart-shaped base, ending in a sharp tip. In April, dark green flowers appear, surrounded by large white bracts, like the wings of a dove. It is named after Father Armand David (1826–1900; "Père David"), a French naturalist and missionary. It was introduced to Europe and North America in 1904 and is a popular ornamental tree.

Tetracentron sinense grows to 89 feet (27 meters) with heart-shaped leaves on spurred branches. Hanging, catkinlike spikes bear numerous small yellow-green flowers from April to July. *Phoebe zhennan* is a large tree, up to 98 feet (30 meters) tall. It is vulnerable to extinction and is now protected under Chinese law. Many of the pillars in the buildings of the Forbidden City are made of its wood. *Rosa banksiae* is a scrambler over trees and shrubs in valleys and stream sides, growing over 20 feet (6 meters) tall or long. Practically thornless with evergreen leaves and masses and masses of fragrant yellow flowers in May, it is one of the earliest roses to flower and one of the most beautiful.

Mount Emei rises above the plains, its head high above the clouds, its body clothed by trees, its feet covered with roses.

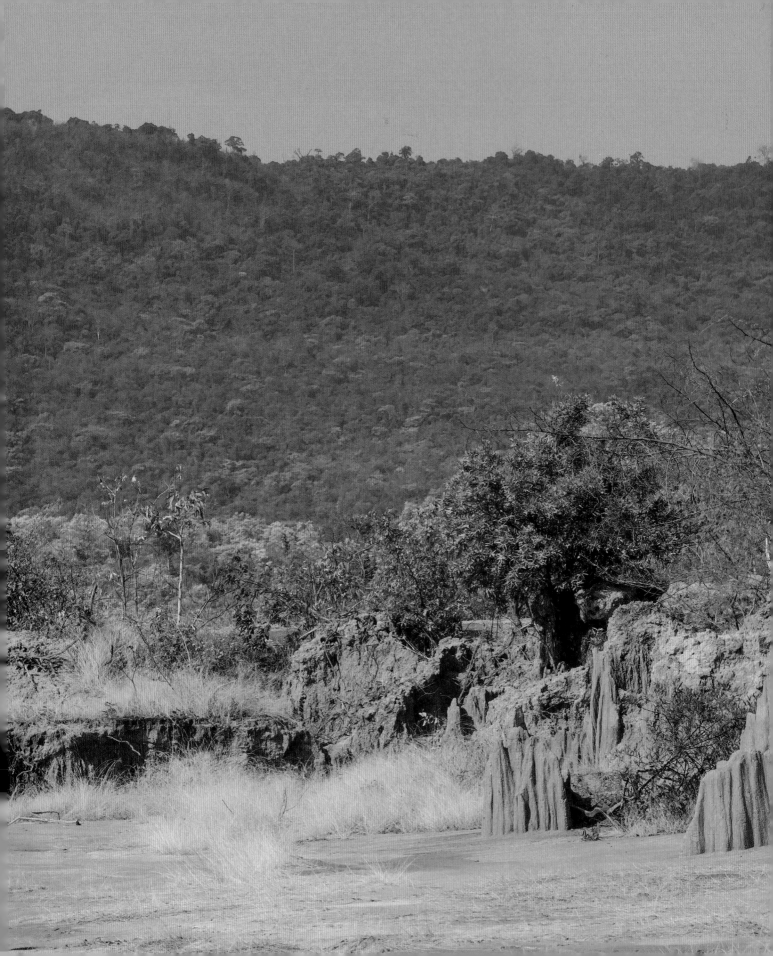

The Dong Phayayen-Khao Yai Forest Complex spans 142 miles (230 kilometers) between Ta Phraya National Park on the Cambodian border in the east, and Khao Yai National Park in the west. The site is home to more than 800 species of fauna, including 112 mammal species (among them 2 species of gibbon), 392 bird species, and 200 reptile and amphibian species. It is internationally important for the conservation of globally threatened and endangered mammal, bird, and reptile species, among them 19 that are vulnerable, 4 that are endangered, and 1 that is critically endangered. The area contains substantial and important tropical forest ecosystems that can provide a viable habitat for the long-term survival of these species.

Dong Phayayen-Khao Yai Forest Complex

THAILAND

The Dong Phayayen-Khao Yai Forest Complex comprises five almost contiguous protected areas running east-west some 142 miles (230 kilometers) to the Cambodian border. They are located along and below the Korat Plateau, the southern edge of which is formed by the almost unbroken Phanom Dongrek escarpment. Khao Yai National Park at the west end of the complex is the only mountainous section, with an elevational range between 328 and 4432 feet (100 and 1351 meters). It is rugged land with a steep south-facing scarp, at places 1640 feet (500 meters) high. The north side

Ta Phraya National Park.

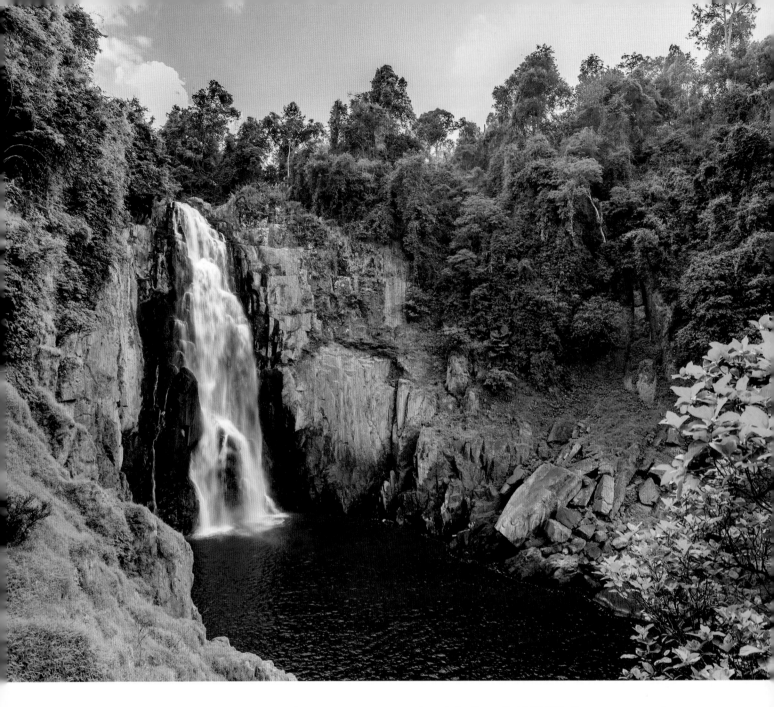

is drained by several tributaries into the Nam Mun River, a tributary of the Mekong River. The southern side is drained via numerous scenic waterfalls and gorges by four main fast-flowing streams into the Prachinburi River. Thap Lan National Park to its east drains mainly north to the Nam Mun river. Pang Sida National Park lies to its south across a watershed ridge, sloping south. Ta Phraya National Park and the Dong Yai Wildlife Sanctuary extend out to the east.

Geologically, the formation of the escarpment is attributed to crustal uptilting. The rugged western half of Khao Yai lies on Permo-Triassic igneous volcanic rocks. To the south and east this is replaced by Jurassic calcareous and micaceous siltstones and sandstones. In the northwest part of Khao Yai there

are small areas of limestone karst with steep cliffs, gorges, columns, and caves. All of Thap Lan as far as upland Ta Phraya is the rim of the quartz-rich sandstone Korat Plateau, edged by the Phanom Dongrek range and escarpment.

Inscribed as a World Heritage Site in 2005, the area is in the biogeographical Thailandian monsoon forest on the border of the Indochinese rainforest region. It contains the seven major rainforest habitat types of eastern Thailand and at least 2500 plant species are recorded. Within the forest complex three main types of vegetation are dominant: evergreen forests, mixed dipterocarp-deciduous forest, and deforested scrub, grassland, and secondary growth. The first two categories, with karst and riverine ecosystems, comprise the most significant

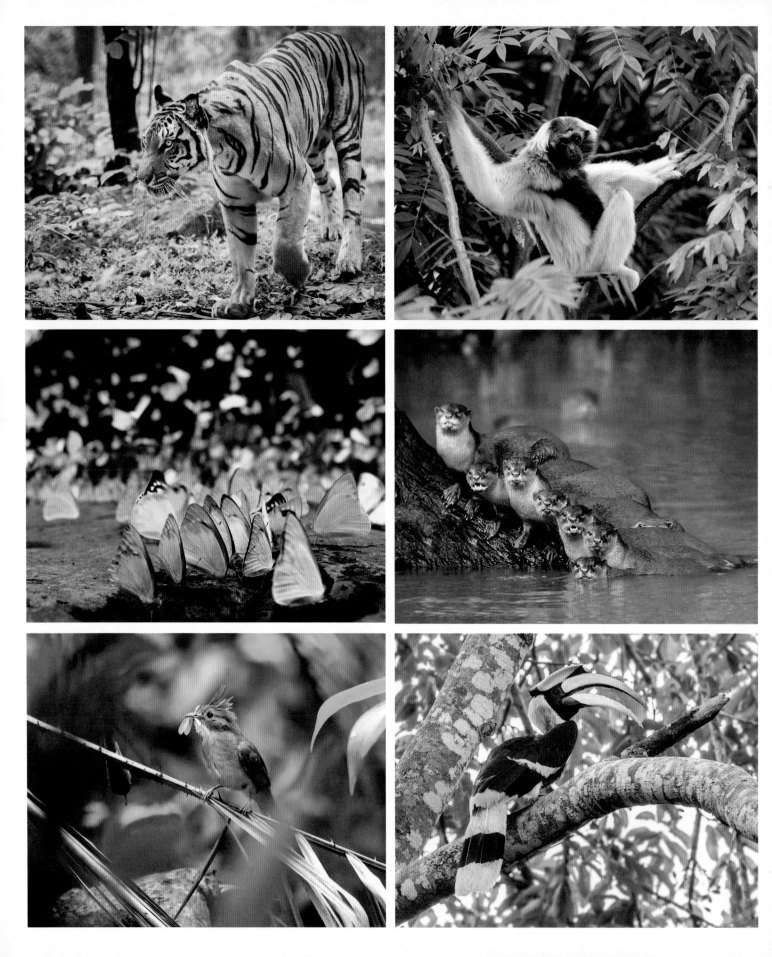

Clockwise from top left: Indochinese tigers roam here. •
Female pileated gibbon. • Smooth-coated otter family. •
Great hornbill. • Puff-throated bulbul. • There are 214
species of butterflies in Pang Sida National Park.

Below: Khao Yai National Park.

habitats. The evergreen forests are of three types:
dry, tropical rainforest, and hill and lower mon-
tane rainforests. Eighty-four percent of Khao Yai is
covered in evergreen or semi-evergreen forest. The
park contains over 2000 plant species including
agarwood (*Aquilaria malaccensis*), an evergreen
tree that grows up to 131 feet (40 meters) high. It
has a pale, thin and smooth trunk, and long, leath-
ery, sword-shaped leaves, and clusters of white
flowers and egg-shaped fruits. Its valuable resin,

used as incense, has been its downfall, and it is
listed as critically endangered.

The area has many notable tree species including
Haldina cordifolia, the heart-leaf adina, a deciduous
tree with a large crown; specimens up to 148 feet
(45 meters) tall have been recorded. The long,
straight, trunk is buttressed and fluted at the base
sometimes with irregular and fantastic shapes. It
blooms in the dry season with yellow flowers often
tinged with pink. Makha tree (*Afzelia xylocarpa*)

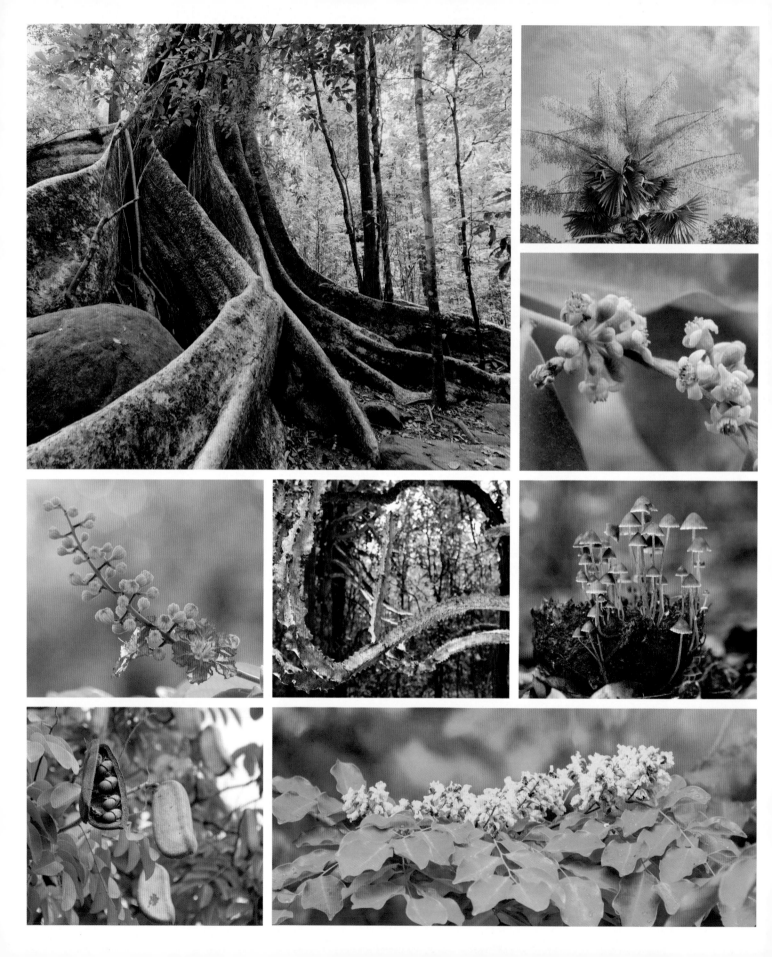

First column: Khao Yai National Park. • Guava crape myrtle (*Lagerstroemia calyculata*). • Seedpod of *Afzela xylocarpa.* *Second column:* The magic of the wild silver cactus growing unchecked in the jungle. • Burma padauk (*Pterocarpus macrocarpus*). *Third column:* Thi talipot palm (*Corypha lecomtei*). • Agarwood (*Aquilaria malaccensis*). • Delicate mushrooms growing on an indelicate host: elephant dung.

365

is a deciduous tree with a broad, rounded crown; usually growing 49 to 82 feet (15 to 25 meters) tall. As the tree grows, burls develop. The wood burls are specially valued and are used to make fine bowls and figurines. The tree is endangered in the wild. Axlewood (*Terminalia phillyreifolia*) is a 66-foot (20-meter) tall deciduous tree with a straight and cylindrical trunk, with pendulous branches and acuminate leaves. Clusters of yellow flowers are followed by fruits with a conspicuous bouk. Guava crape myrtle (*Lagerstroemia calyculata*) is, thankfully, a widespread tree in Thailand. It has the characteristic flaky and mottled bark of the genus and produces bunches of pink flowers. Burma padauk (*Pterocarpus macrocarpus*) drops its leaves in the dry season. The leaves are compound, the elliptical leaflets have pointed tips. Masses of panicles of bright yellow flowers are produced from February to April. The fruits are winged and classified as a samara. It is endangered.

Near Thap Lan National Park is a 1729-acre (700-hectare) forest of the Thai talipot palm (*Corypha lecomtei*). It is an extraordinary place, a temple of palms with a great choir of massive trees. *Corypha lecomtei* grows up to 20 feet (6 meters) tall, the with the old leaves forming a skirt. The leaves are costapalmate, that is they are intermediate between pinnate and palmate leaves, with the leaf blade being round to oval. The leaflets are joined

together for some or most of their length but are attached along a costa, an extension of the petiole into the leaf blade. The leaf itself is about 6½ feet (2 meters) long, on a 20-foot (6-meter) long thorny petiole. The 33-foot (10-meter) tall inflorescence, with whitish yellow flowers on a 6½-foot (2-meter) tall flower stalk, is simply huge. Buddhist monks inscribe teachings on the leaves and those palm leaf inscriptions are often to be found at the feet of statues of the Buddha in some temples. Once the palm has set fruit, it dies. Everything is impermanent.

With protection and conservation of the plants comes protection and conservation of the animals. A total of 112 mammal species is known from the forest complex including the Asian elephant (*Elephas maximus*), the Indochinese tiger (*Panthera tigris corbetti*), which is on the edge of extinction, and the pileated gibbon (*Hylobates pileatus*). The smooth-coated otter (*Lutrogale perspicillata*) is found in the rivers and the endangered relict Siamese crocodile (*Crocodylus siamensis*) was rediscovered in Pang Sida National Park in 1992.

A total of 392 species of birds has been recorded in the forest complex. Fifty-three species are considered nationally threatened or near threatened, including four species of hornbill, Siamese fireback pheasant (*Lophura diardi*), the rare silver pheasant (*L. nycthemera*), and the mountain imperial pigeon (*Ducula badia*).

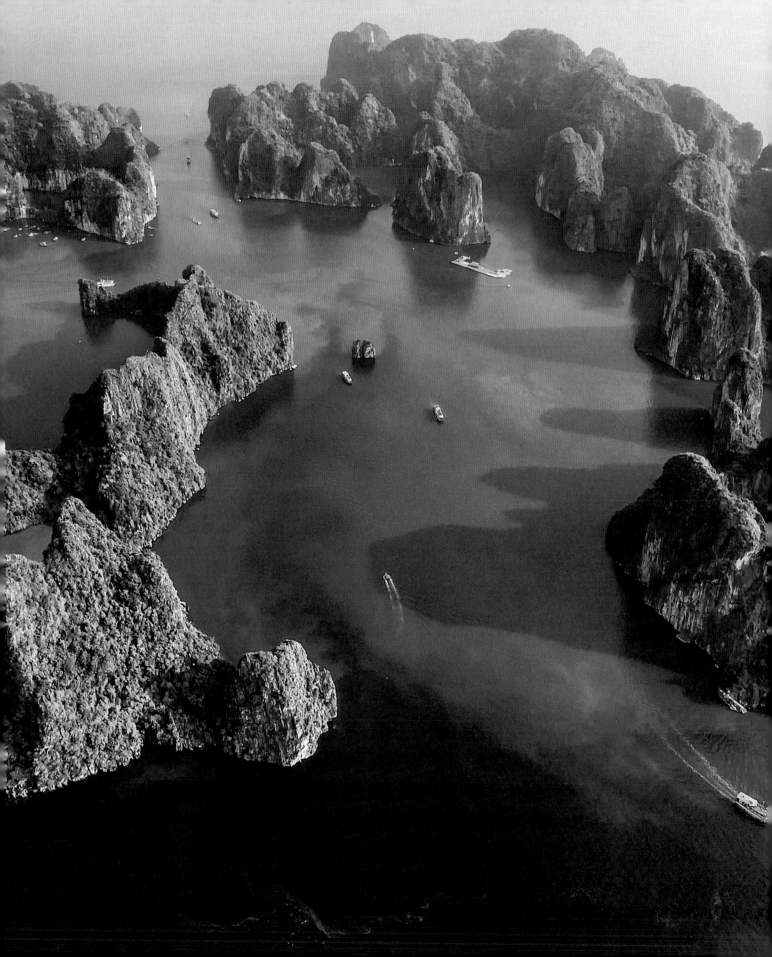

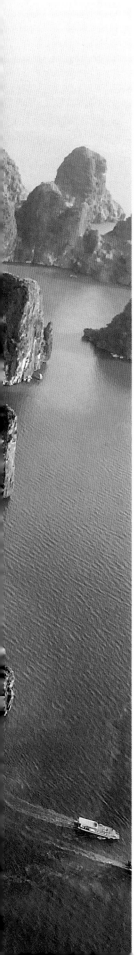

Ha Long Bay, in the Gulf of Tonkin, includes some 1600 islands and islets, forming a spectacular seascape of limestone pillars. Because of their precipitous nature, most of the islands are uninhabited and unaffected by a human presence. The site's outstanding scenic beauty is complemented by its great biological interest.

Ha Long Bay

VIETNAM

Legend has it this area was created by a dragon that lived in the mountains. As its mighty form charged toward the coast, its tail lashed, this way and that, gouging out valleys and crevasses along the way. When it finally plunged into the sea, the area was submerged with water, leaving only the topmost forms visible.

A World Heritage Site since 1994, Ha Long Bay is a group of 775 offshore islands in the northern Gulf of Tonkin in northeast Vietnam, about 102 miles (165 kilometers) east of Hanoi. It is a large bay near the mouth of the Bach Dang

Ha Long Bay's islets.

River studded with a multitude of rocky pillars and
steep forested islets. It is a landscape of limestone
pinnacles, sparsely tree covered, rising from the
emerald sea. In all, there are some 3000 islands and
islets, of which 989 are named, and 775 contained
within the World Heritage Site. Larger islands, ris-
ing to 328 to 656 feet (100 to 200meters), are found
in the south, interspersed with smaller islets only 16
to 33 feet (5 to 10 meters) high.

The oldest rocks are Ordovician (485.4 to
443.8 million years ago), drowned undersea then
raised as mountains and eroded. The present Ha
Long Bay appeared after the maximum trans-
gression in the Middle Holocene, leaving deeply
undercut limestone cliffs 2280 to 40000 years
old. There are many remnants of old caves and
several large caverns: Wooden Stakes Cave is the
largest, and its three large chambers contain many

From left: Ha Long Bay's surreal beauty has made it a popular destination. • Ha Long Bay's limestone karsts jut straight down into turquoise waters.

369

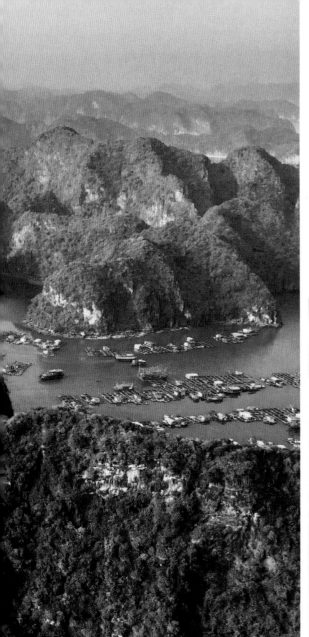

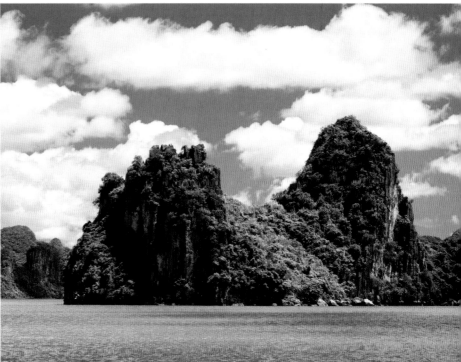

stalactites and stalagmites. Many island names derive from their unusual shapes such as Voi (elephant), Ga Choi (fighting cock), and Mai Nha (roof).

Many archaeological sites have been found dating from 25,000 to 3000 years ago. At Hon Gai the evidence suggests occupation by the Hoa Binh Culture 10,000 years ago. Archaeological sites on Tuan Chau, Ngoc Vung, Cai Dam, Dong Naim, and Cat Ba islands have yielded so many artifacts that they have been grouped as the Ha Long Culture, typical of the northeastern coast of Neolithic Vietnam. Ha Long was a significant port, located on the trade routes between China, Japan, and other Southeast Asian countries.

The bay contains a wide variety of ecosystems: tropical forests, cliff, summit, cave-mouth and seashore communities, mangrove forests, seaweeds, seagrass beds, and coral reefs. Primary tropical

HA LONG BAY

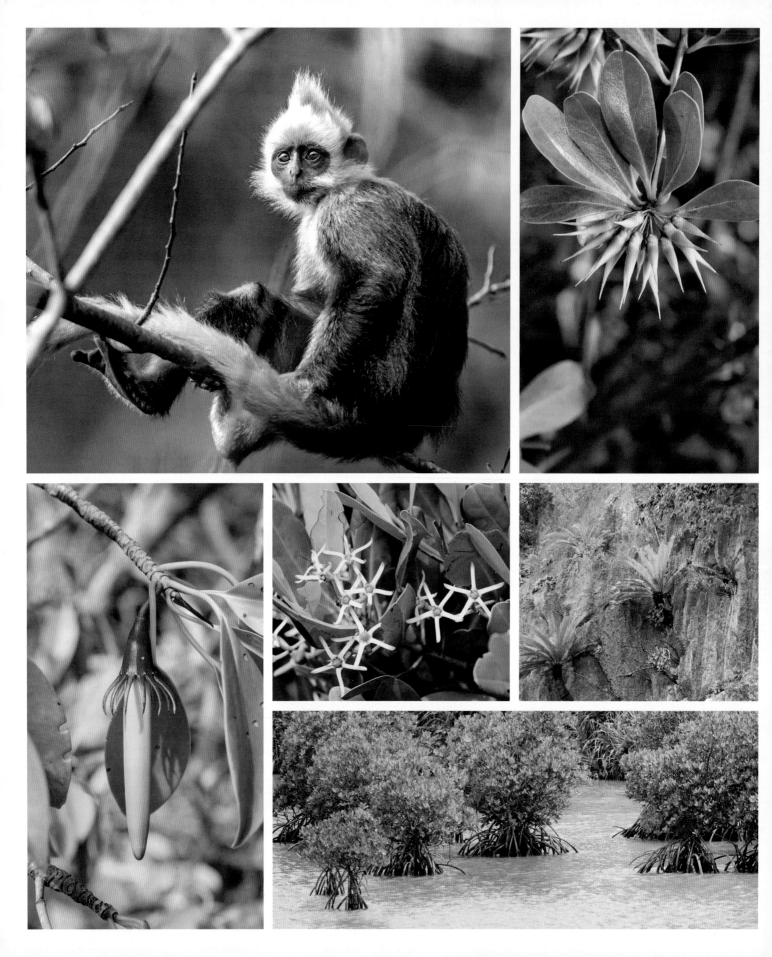

First column: White-headed langur. • Large-leaved orange mangrove (*Bruguiera gymnorhiza*). *Second column: Kandelia obovata.* • *Rhizophora mucronata. Third column:* River mangrove (*Aegiceras corniculatum*). • *Cycas tropophylla* must find a perch to grow on the steep rocks.

371

forest is found mostly on the larger islands like Ba Mun, sparsely on the steep limestone islands and thicker on the less steep islands. Four hundred ninety-nine limestone-adapted plants including 12 species of ferns and seven plants endemic to the bay area have been recorded.

Cycas tropophylla is a smallish cycad up to 3 feet (1 meter) with arching, strongly keeled, deep glossy green leaves up to 4 feet (1.2 meters) long. It forms at best a short aboveground trunk and grows on the bare faces of the steep limestone cliffs, often with no soil at all. *Primulina drakei* is the most common chirita gesneriad at Ha Long Bay. It is a beautiful shrubby plant with silver-gray leaves and large, white tubular flowers with violet lobes. It is found growing on exposed limestone rocks from sea level up to exposed rocky slopes. *Primulina modesta* with panicles of white, purple-lined flowers, is extremely rare and only one small population is found growing around the mouth of Tam Cung Cave.

The Ha Long fan palm (*Livistona halongensis*) is a 30-foot (9-meter) tall robust palm with long lacy panicles of cream flowers in May on stalks that radiate from among the leaves and extended several feet beyond the crown. *Impatiens verrucifer* grows to 3 feet (1 meter) in height and has tough succulent stems. It has deep pink flowers and is conspicuous growing on rocks close to sea level. The gesneriad *Paraboea halongensis*, a bushy shrublet, grows in bare, exposed rocks near the summit of limestone islands and produces white tubular flowers on shoots that die after flowering.

Cat Ba National Park is on a large well-forested island with 800 vascular plant species, 265 of which are timber trees. Its primary tropical limestone forest features *Spondias lakonensis*, a deciduous tree growing 49 feet (15 meters) tall, with spirally arranged pinnate leaves and orange fruit, and species of mangrove—the loop-root mangrove (*Rhizophora mucronata*), the large-leaved orange mangrove (*Bruguiera gymnorhiza*), *Kandelia obovata*, and river mangrove (*Aegiceras corniculatum*). The park is home to one of the most endangered monkeys in the world, the white-headed langur (*Trachypithecus poliocephalus*).

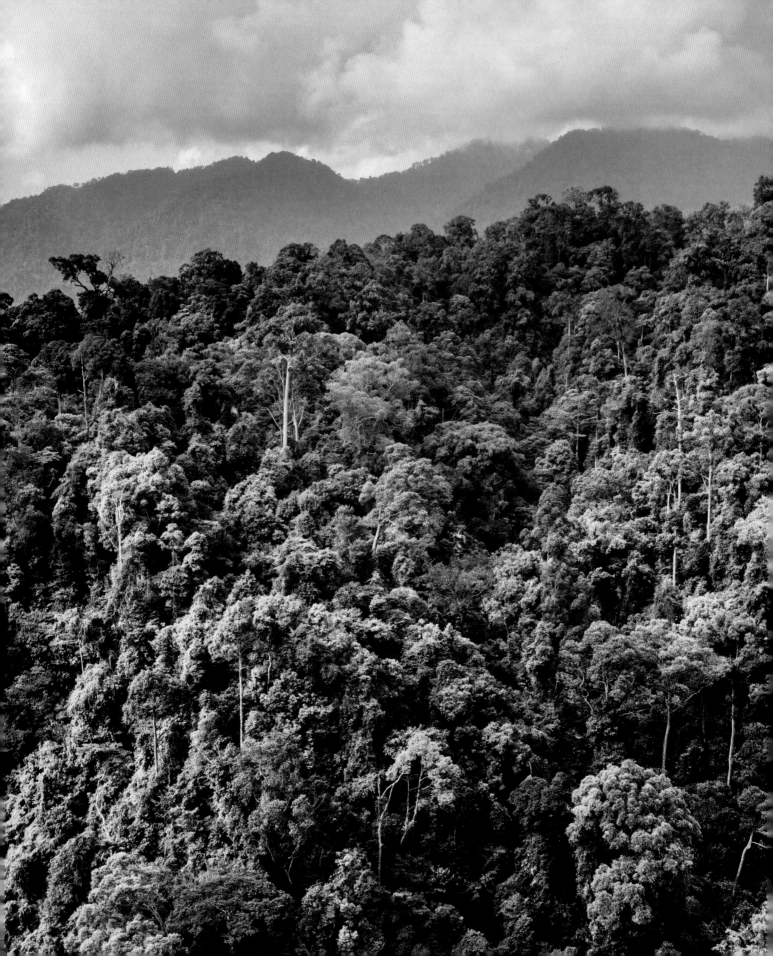

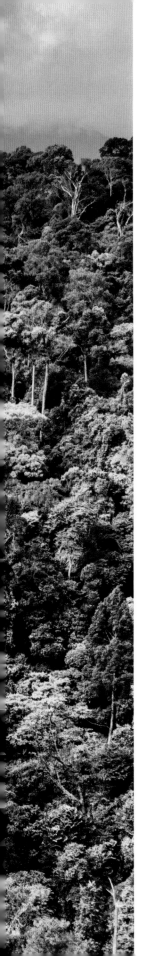

The 6.2-million-acre (2.5-million-hectare) Tropical Rainforest Heritage of Sumatra site comprises three national parks: Gunung Leuser National Park, Kerinci Seblat National Park, and Bukit Barisan Selatan National Park. The site holds the greatest potential for long-term conservation of the distinctive and diverse biota of Sumatra, including many endangered species. The protected area is home to an estimated 10,000 plant species, including 17 endemic genera; more than 200 mammal species; and some 580 bird species, of which 465 are resident and 21 are endemic. Of the mammal species, 22 are Asian, not found elsewhere in the archipelago, and 15 are confined to the Indonesian region, including the endemic Sumatran orangutan. The site also provides biogeographic evidence of the evolution of the island.

Tropical Rainforest Heritage of Sumatra

INDONESIA

At up to 3 feet (1 meter) across, the flowers of *Rafflesia arnoldii* are the largest in the world. It has neither roots or leaves and is parasitic on members of *Tetrastigma*, a genus of vines, from which large buds burst out from the bark of its host to produce white-spotted reddish brown flowers that smell of rotten meat. It flowers between August and November and is pollinated by carrion flies. There are 16 or so species of *Rafflesia* in Sumatra. *Rafflesia atjehensis*, *R. rochussenii*, and *R. micropylora* are notable. Related are the smaller and similar species of *Rhizanthes*, including *R. zippelii* and *R. lowii*. All are endangered.

Gunung Leuser
National Park.

373

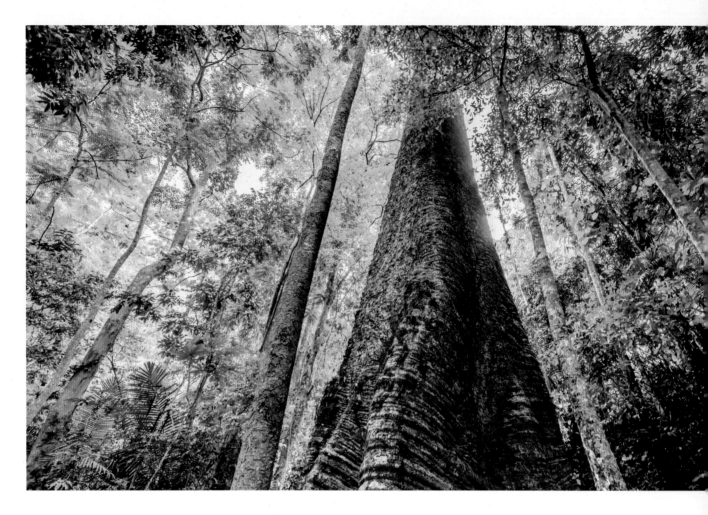

There are about 200 species of *Amorphophallus* growing throughout the paleotropics. The tallest unbranched flower in the world grows in the parks. *Amorphophallus titanum* flowers average 6 to 8 feet (1.8 to 2.5 meters) tall. The spadix is green, the spathe deep red. The flowers are in two layers at the base of the spadix and produce a fragrance that has been described as a combination of rotting wounds, garlic, cheese, and old sweat. This to attract the flies and beetles necessary for its pollination. Corpse flowers—the understandable common name—live 30 to 40 years, and bloom, on average every 7 to 10 years. Despite their foul scent, they are popular show plants in botanic garden conservatories around the world where they garner a lot of attention, large visitor numbers, and lip service to conservation. Meanwhile, in Sumatra, timber harvesting and the creation of oil palm plantations make the plant in danger of in situ extinction.

The Indonesian archipelago contains more than 10 percent of the world's flowering plants and Sumatra, the third largest island, is the location of the Sumatran Islands Lowland and Montane Forests Ecoregion and part of the Sundaland hotspot. Its forests are among the largest tropical rainforests in Southeast Asia, comparable with those of Borneo and Papua-New Guinea. More than 30 percent of Borneo's rainforests have been destroyed over the past 40 years, and it is estimated, although there is considerable debate about the numbers, that half of Papua-New Guinea's forest will be gone in the next few years.

Inscribed as a World Heritage Site in 2004, the Tropical Rainforest Heritage of Sumatra

From left: A giant *Anisoptera costata*. • Gunung Leuser National Park.

375

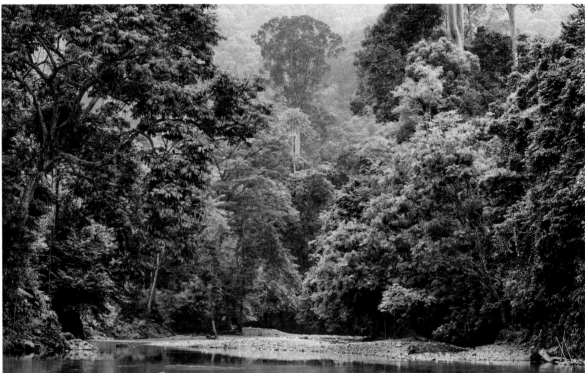

comprises Gunung Leuser National Park, Kerinci Seblat National Park, and Bukit Barisan Selatan National Park.

The diverse flora of Sumatra is largely shared with the West Malaysian region that extends from southern Thailand to the island of New Guinea. North of Lake Toba near Kerinci Seblat National Park there is a distinctive Sumatran flora in the montane and subalpine vegetation. All the parks are species rich, totaling over 4000 species, more than 50 percent of the total plant diversity of Sumatra. Many of the island's *Dipterocarpus*, *Hopea*, *Shorea*, and *Vatica* species are critically endangered or endangered.

There are major differences between the island's lowland and highland vegetation, and between north and south due partly to physical barriers that have encouraged subspeciation. The lowland tropical forest, the most threatened type of forest on the island, is now only 20 percent of its original extent of 61,776,345 acres (25 million hectares). It has been largely destroyed in very recent decades.

Gunung Leuser National Park is the largest block of yet-undisturbed forested wilderness in the north of Sumatra. The distinct subregions that are visible in all the parks are especially obvious at its higher elevations. Tropical conditions extend up to 3280 feet (1000 meters). Five percent of the park's forest is comprised of coastal forest and other varieties of lowland forest from sea level to 984 feet (300 meters); 29 percent is foothill forest from 1312 to 3280 feet (400 to 1000 meters); 30 percent is submontane forest between 3280 and 4921 feet (1000 and 1500 meters), rich in Fagaceae and

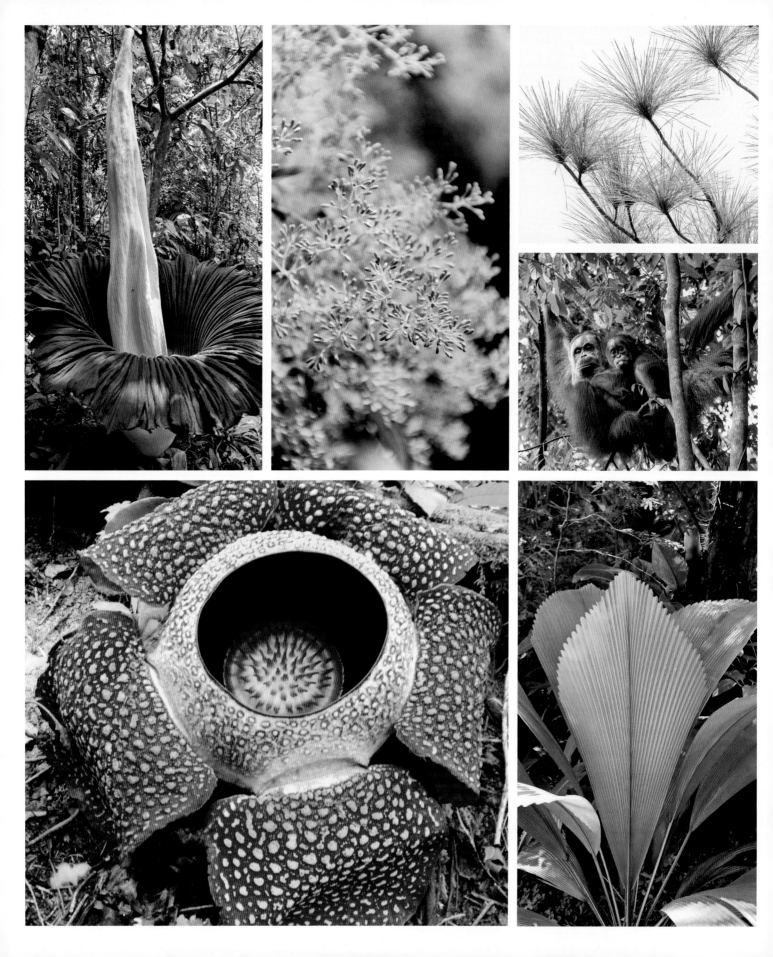

First column: Corpse flower (*Amorphophallus titanum*). • The world's largest flower, *Rafflesia arnoldii.* *Second column:* A member of the *Hopea* species. *Third column:* Sumatran pine (*Pinus merkusii*). • Orangutans are one of the island's most charismatic—and endangered—species. • Joey palm (*Johannesteijsmannia altifrons*).

377

Lauraceae; 35 percent is montane forest to around 8202 feet (2500 meters), of which the lower 15 percent rich in climbing palms (rattans), palms, and mosses, and the upper 20 percent with acid-loving plants; the remainder is low subalpine forest and ericoid scrub. Four thousand species are claimed to exist in the park, 92 being locally endemic. It contains 12 percent of all Sumatran species and 17 percent of its genera are endemic. The Joey palm (*Johannesteijsmannia altifrons*) has huge leathery, diamond-shaped, serrated leaves pleated along their 20-foot (6-meter) length. This palm can grow 10 to 20 feet (3 to 6 meters) tall and 10 to 15 feet (3 to 4.5 meters) wide. It is without doubt one of the most beautiful palms in the world. Sadly, it is endangered due to habitat loss.

Kerinci Seblat National Park is one of the most important rainforests in Asia, with mountains covering 70 percent of the area. Its eight vegetative zones are lowland forest, hill forest dominated by *Hopea beccariana*, submontane forest with Myrtaceae and Fagaceae, lower montane forest, midmontane forest, upper montane forest, sedge-peat swamp, and subalpine thickets dominated by Ericaceae. There are several types of forested wetlands and a distinct forest type dominated by the Sumatran pine (*Pinus merkusii*), a two-needled conifer growing up to 164 feet (50 meters) with thick, rough, gray-brown or reddish brown bark.

Threatened species include *Hopea beccariana, Vatica obovata, Shorea ovata, Horsfieldia atjehensis*, and the aforementioned *Rafflesia arnoldii* and *Amorphophallus titanum. Hopea beccariana* can grow up to 148 feet (45 meters) tall, and has fissured bark and glossy green leaves on long petioles. The tree is harvested from the wild for its resin and good-quality timber. *Vatica obovata* is an evergreen dipterocarp that can reach a height of up to 131 feet (40 meters). *Shorea ovata* has a round crown composed of many radiating branches with twigs and leaves covered in rust-colored hairs. All three are critically endangered.

Bukit Barisan Selatan National Park has the last and largest block of the very threatened Sumatran lowland forest. It also has coastal forest, a very diverse lowland forest with *Shorea, Dipterocarpus*, and *Hopea* species; highland forest with trees of the Dipterocarpaceae, Lauraceae, Myrtaceae, and Annonaceae; submontane forest; and montane forest. Critically endangered species include *Anisoptera costata*, a large tree up to 213 feet (65 meters) high, growing above the general canopy; *Dipterocarpus retusus*, growing up to 98 feet (30 meters) tall; and *Knema intermedia*, an evergreen tree growing to 49 feet (15 meters) tall.

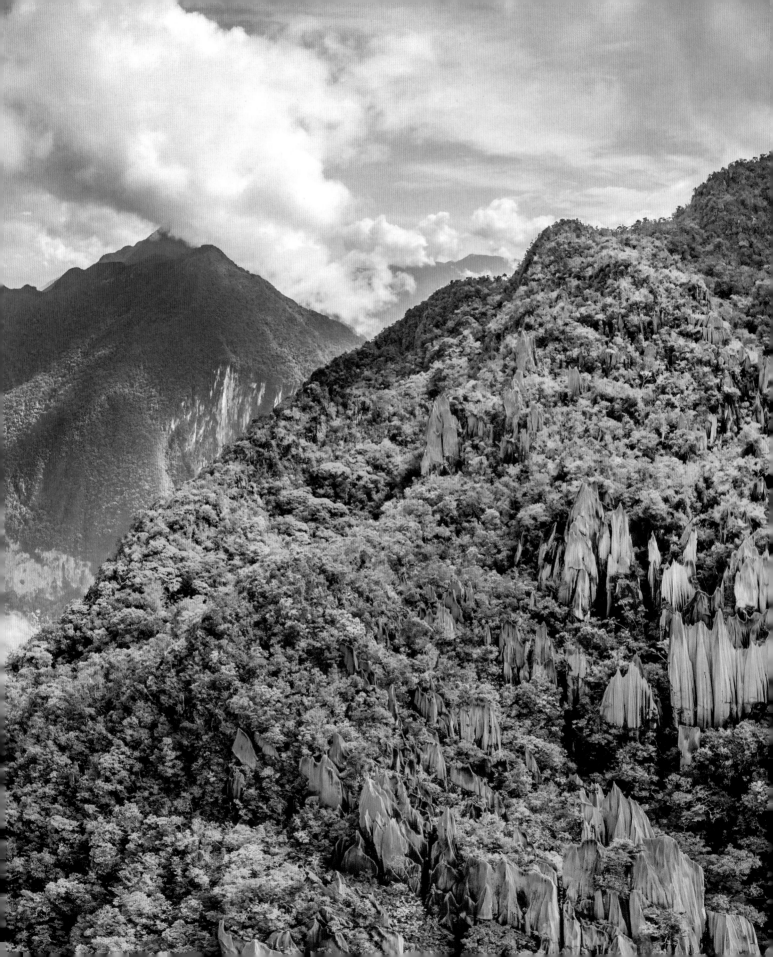

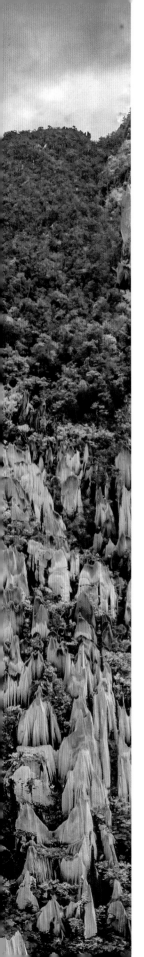

Important both for its high biodiversity and for its karst features, Gunung Mulu National Park, on the island of Borneo in the State of Sarawak, is the most studied tropical karst area in the world. The 130,632-acre (52,864-hectare) park contains seventeen vegetation zones, exhibiting some 3500 species of vascular plants. Its palm species are exceptionally rich, with 109 species in 2000 genera noted. The park is dominated by Gunung Mulu, a 7798-foot (2377-meter) high sandstone pinnacle. At least 183 miles (295 kilometers) of explored caves provide a spectacular sight and are home to millions of cave swiftlets and bats. The Sarawak Chamber, 1968 by 1361 feet (600 by 415 meters) and 262 feet (80 meters) high, is the largest known cave chamber in the world.

Gunung Mulu
National Park

MALAYSIA

Borneo is the third largest island in the world. It is part of the Sundaland hotspot, an area of 17,000 islands covering just over 1 percent of the Earth's land surface but containing 10 percent of the world's flowering plant species. It is an extension of the Southeast Asian continental shelf, an area that also includes Java, Sumatra, and the Malay Peninsula. It is an island of three countries, Malaysia and Brunei in the north and Indonesia in the south. Most of the island is Indonesian territory but the states of Sabah and Sarawak are Malaysian. The tiny country of Brunei adds

The famous
Pinnacles.

379

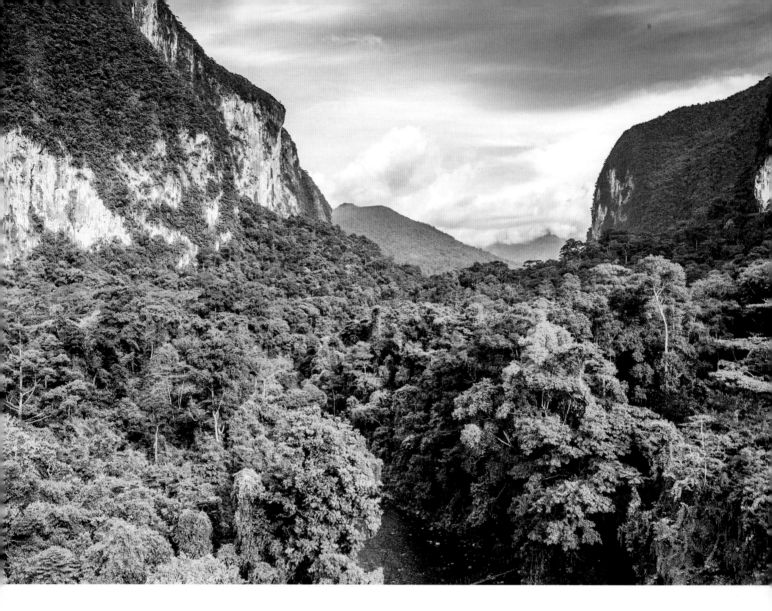

to the political mix. Straddling the equator, it is an island of ancient rainforest, estimated to be 130 to 140 million years old. Over the last 50 years, much of the forest has been impacted by legal and illegal logging, palm oil plantations, nonnative tree pulp wood production, and fire at twice the rate of the rest of the world's tropical forests. Between 1980 and 2000 more wood was harvested from Borneo than from Africa and the Amazon combined. There is little virgin forest left and that which exists is protected in preserves. In Sabah and Sarawak, forest protection amounts to about 8 and 3 percent, respectively.

Borneo is home to the biggest flower in the world—*Rafflesia arnoldii*, sometimes called the corpse lily because it smells like decaying flesh, attracting flies and other meat-eating pollinators. It is also home to the biggest orchid in the world, *Grammatophyllum speciosum*. One adult clump can weigh up to 1 ton with flower stems up to 10 feet (3 meters) long with yellow flowers spotted maroon or dark red.

Members of the family Dipterocarpaceae are the dominant trees, with some species emerging singly above the forest canopy in great crowns of leaves and flowers and two-winged fruit. Their height and

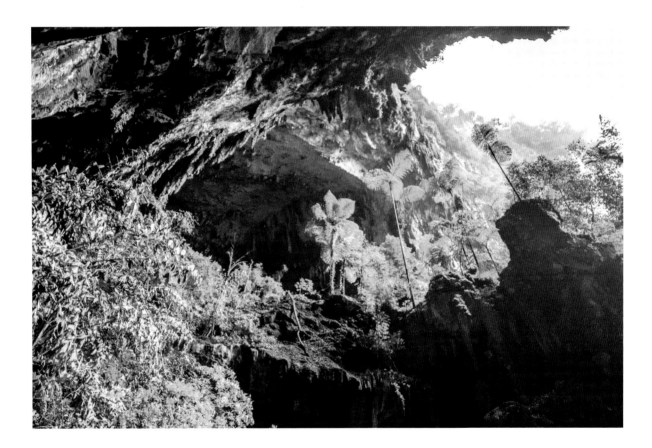

straight trunks are their undoing—they make excellent lumber. Many species have an oily resin and are bitter tasting, protecting the wood from fungi and insects, an evolutionary advantage until chain saws come to call. The tallest tropical tree (and the world's tallest known flowering plant) is a dipterocarp, *Shorea faguetiana*, topping out at 331 feet (100.8 meters), and growing in a forest in Sabah.

The island is also home to iconic species of fauna. The Bornean orangutan (*Pongo pygmaeus*), the proboscis monkey (*Nasalis larvatus*), and the Bornean elephant (*Elephas maximus borneensis*) are all, sadly, highly endangered.

Facts and statistics are only one small part of the story. To walk in the forest of Gunung Mulu is to experience a great humbling. Everything seems bigger and more complex than you are, even if it is a tiny moss or a begonia flowering at the base of a tall tree. It is dark, even at midday. It is never dry and always hot. Even sweat sweats. A deep green silence surrounds you, yet the forest is loud with the metallic scrapings of insect's wings, the whoop of unseen birds, the what-what chorus croak of frogs, and the slither of something you hope isn't too close. But then it is close, a Bornean keeled pit viper, completely uninterested in you, curls along a

GUNUNG MULU NATIONAL PARK

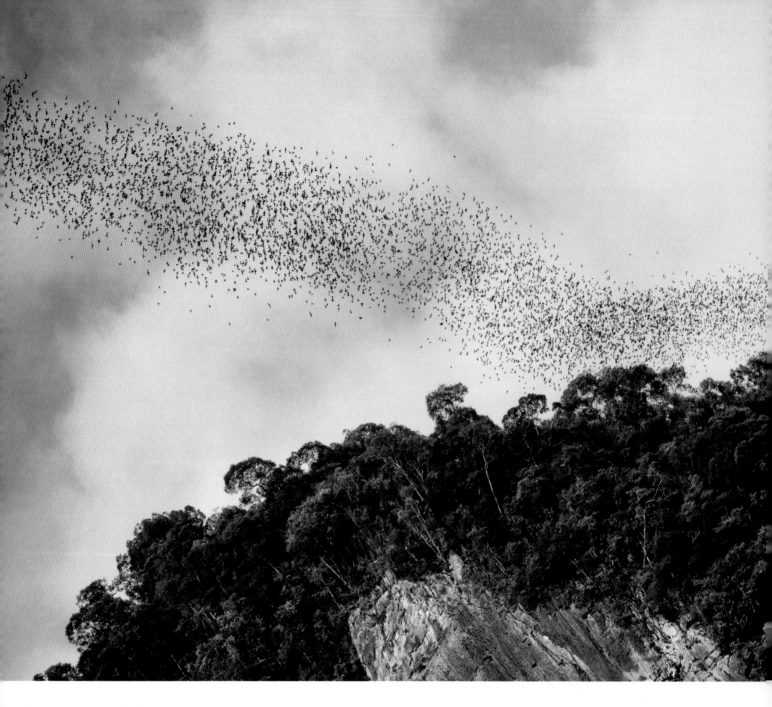

branch close to you, its blue-green color making it almost invisible, its bejeweled scales making it more beautiful than any princess.

And yet, if you are not bitten, stung, scratched, or scraped, your fear of the forest recedes, and you look around. The waterfall of your own sweat does not matter. A slight breeze high above opens up the canopy and you see a stately bintuang tree (*Octomeles sumatrana*) dressed with bird's-nest ferns (*Asplenium nidus*); home to a vibrant green tree frog, Wallace's flying frog (*Rhacophorus nigropalmatus*), who has been looking down at you all this time with a wary but almost smug look on its face.

On one side of a boardwalk, a large cluster of *Nepenthes ampullaria,* their detritus-consuming

Opposite: Famous swarms of bats leave the caves, beginning their nightly hunt for food.

Below, clockwise from top left: Lantern bug. • Bird's-nest fern (*Asplenium nidus*). •
Perhaps the most beautiful of palms, *Licuala orbicularis.* • Bornean keeled pit viper.

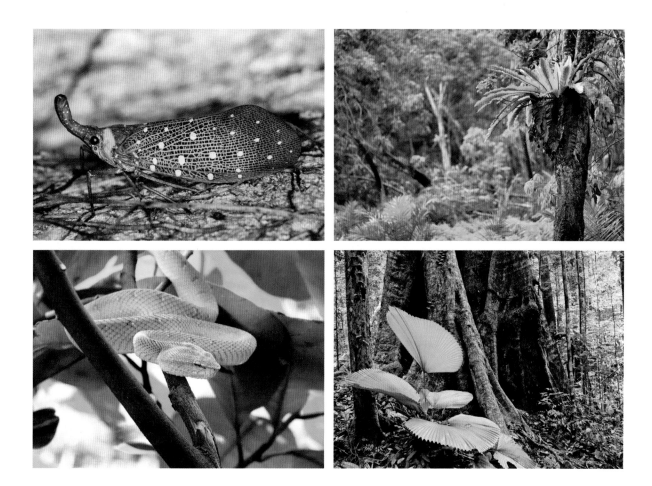

yellow-green pitchers covering the ground. On the other, a small fig tree, *Ficus rosulata*, its trunk covered in small, sticky figs, to be eaten by small *Cynopterus* fruit bats later in the day. Clusters of *Licuala orbicularis* fan palms, one of the most beautiful palms in the world, with pleated circular leaves, grow in the shade of tall trees. On one leaf, a giraffe-necked weevil; on another, an elegant bronze back snake, green, black, and bronze, its red tongue testing the air. A faint knocking sound comes from a hollow-stemmed shrub, biting ants delivering a warning to any adventurous vegetarian that there is

danger inside. Proboscis, long-tailed macaques, and silver langur monkeys jump from tree to tree while a somnolent flying lemur waits for the dimming of the day.

And if you are silent, still and observant, you begin to see how efficient the forest is. Leaves are arranged to capture as much sunlight as possible. Plant climbs upon plant, insects and wind pollinate, birds, bats, mammals eat fruit and, in the digestive process, scarify the hard-shelled seeds. Leaves fall to the ground to be consumed by plants, insects, and fungi. Thin, almost invisible strands of mycelium

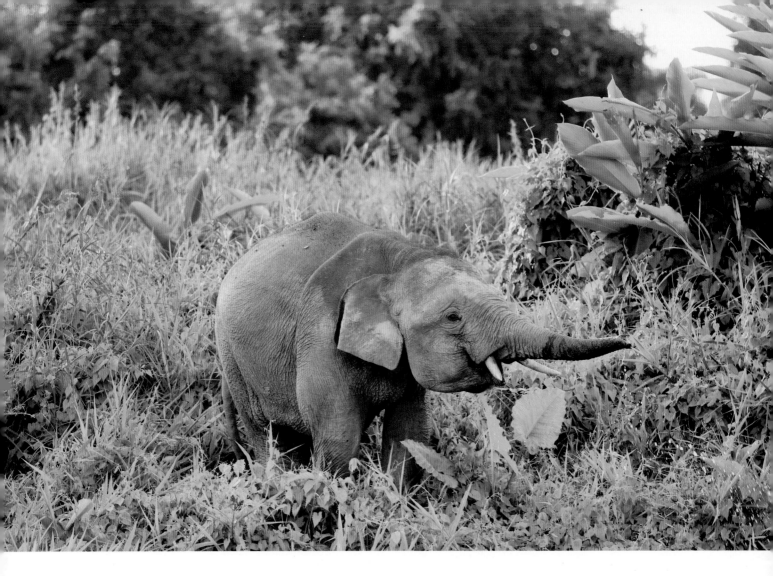

connect everything. Layer upon layer, each con-
nects, each is dependent on the others.

Inscribed as a World Heritage Site in 2000,
Gunung Mulu National Park is the crown of creation
in Borneo, famous for its hundreds of thousands
of bats that come out to feed from Deer Cave. It is
130,632 acres (52,865 hectares) in size containing
seventeen vegetation zones, with some 3500 species
of vascular plants. It is well-organized with board-
walks to protect the forest floor and a long canopy
walk designed to show the visitor the epiphytes
that grow high in the trees while at the same time
giving them a sense of swaying vertigo. The park
headquarters on the left bank of the Melinau River
include a visitor registration building, interpretation

center, gift shop, and restaurant. All visitors need a
permit to enter and must be accompanied by a park
guide. About 90 percent of the park and 95 percent
of caves are closed to visitors. These regulations
ensure that the forest is protected and that the visi-
tors get the best educational experience possible. It
works very well.

Most visitors make their way to Deer Cave,
the largest cave passage in the world and home to
millions of bats and cave swiftlets. At dusk, the bats
and birds pour out of the cave to hunt for insects,
and the visitors, sitting in a small amphitheater,
applaud the spectacle. At the entrance to the cave,
prehistoric-looking fishtail palms (*Caryota no*)
permit admittance. Palm species are particularly

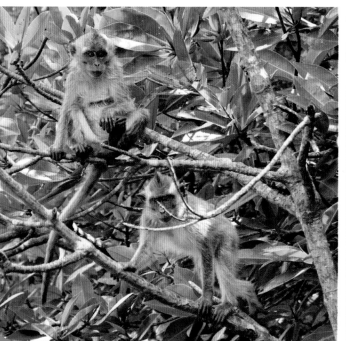
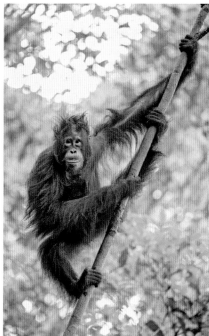
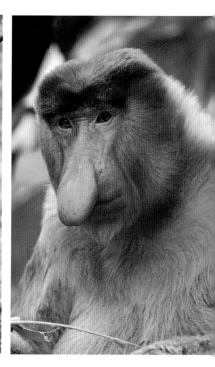

prevalent in the park, with 109 species noted. There are 182 species of orchids including *Paphiopedilum sanderianum,* a rare orchid with 3-foot (1-meter) long reddish brown petals, and 15 species of carnivorous pitcher plants have been identified. The great variety is overwhelming.

What many do not see are the scars of cuts on a tall tree, *Antiaris toxicaria,* that are remains of latex tapping used by nomadic Penan people to make blowpipe dart poison. Or a plant with a single leaf, *Monophyllaea pendula,* growing in the low light of the entrance to Clearwater Cave. Or a pitcher plant thought to be extinct, *Nepenthes campanulata,* but recently discovered growing on limestone karst cliffs 820 feet (250 meters) above the tree canopy.

There are many species of pitcher plants in the park, *N. muluensis, N. faizaliana, N. lowii,* and *N. rafflesiana,* to name a few.

It is a tough two-day climb to reach the Pinnacles, a unique formation of limestone spires cutting through the canopy of the jungle. The beginning of the trail passes through lowland dipterocarp rainforest and then up to moss forest and the mountain peak. Trees become smaller. It is a near-vertical climb to get to the top but there are orchids and rhododendrons such as the golden-flowered *Rhododendron lowii,* and many species of *Vireya* rhododendrons to see.

The mountain flora of Borneo comes from both Asian and Australian families, making it one of the

GUNUNG MULU NATIONAL PARK

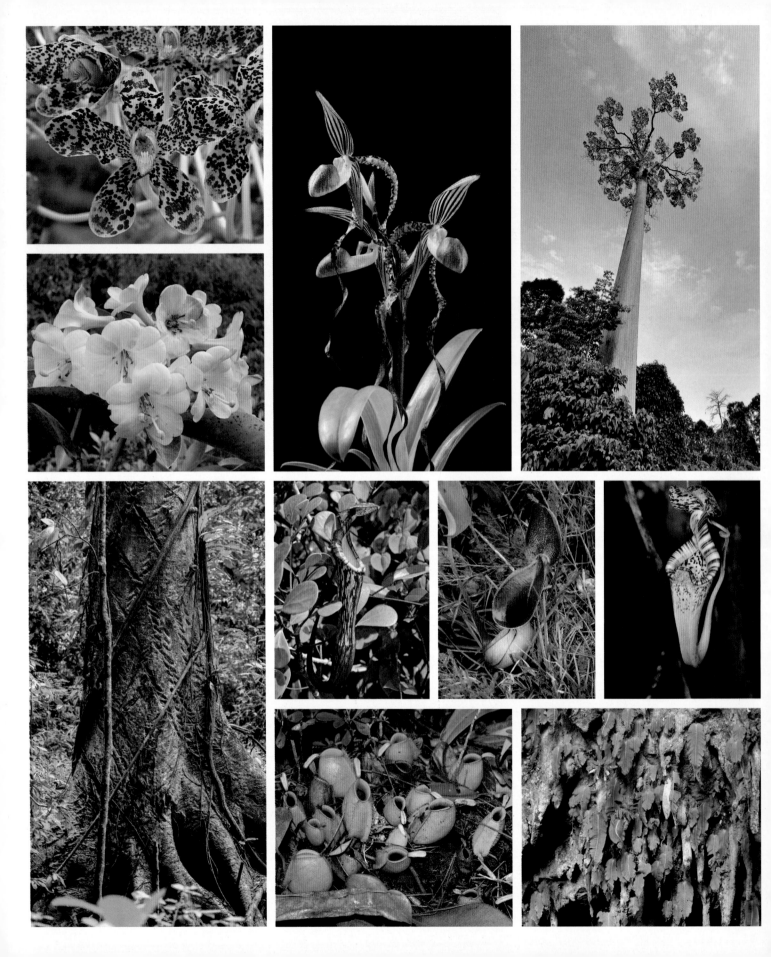

First column: *Grammatophyllum speciosum.* • A *Vireya* rhododendron, *Rhododendron lowii.* • Many trees are marked with the scars of being tapped for poisons or latex. *Second column:* A rare orchid, *Paphiopedilum sanderianum.* • *Nepenthes faizaliana.* • *Nepenthes lowii.* (center) • *Nepenthes ampullaria.* *Third column:* Flowers are few and far between underneath the dense canopy of trees. • *Shorea faguetiana.* • *Nepenthes rafflesiana.* • Cave stalactites host ferns whose whole body is one frond.

Below: Gunung Mulu Cave.

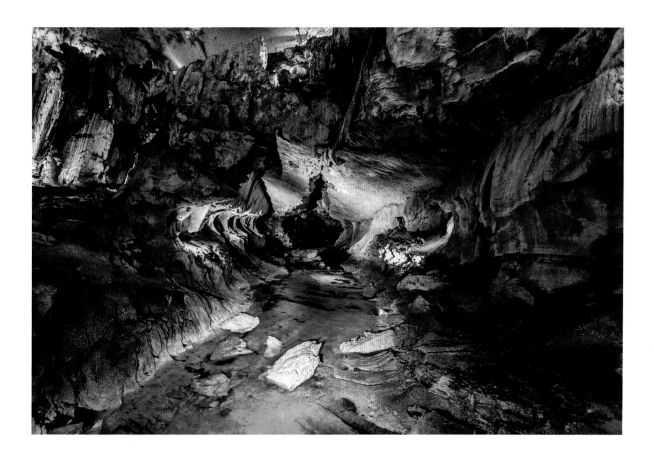

most diverse on Earth. Araucariaceae, Ericaceae, Lauraceae, Clethraceae, Fagaceae, Myrtaceae, Podocarpaceae, Symplocaceae, and Theaceae are all commonly found. In lower elevations oak (*Quercus*), stone oaks (*Lithocarpus*), and chestnut (*Castanopsis*) forests dominate.

Should we weep for the destruction of the mother of forests? Yes, of course we should. But while the primary forests have largely disappeared, it does not mean that biodiversity is lost completely.

Secondary growth forests harbor an enormous diversity of species but without the thousand-year old trees. Species adapt and survive and unless the whole island is turned into sterile palm-oil and Australian native black wattle (*Acacia mangium*) plantations, it is possible that the extraordinary layers of life in the forest will survive. It is to be hoped that we will not say a final farewell to the orangutans and the pitcher plants, the dipterocarps and flying frogs.

GUNUNG MULU NATIONAL PARK

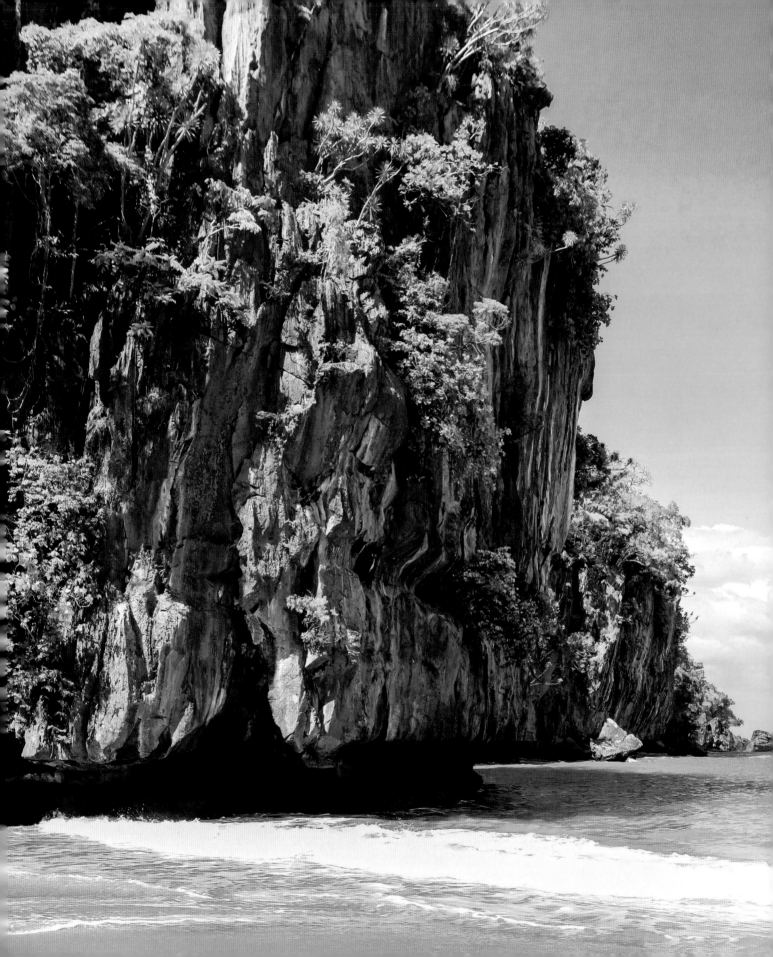

This park features a spectacular limestone karst landscape with an underground river. One of the river's distinguishing features is that it emerges directly into the sea, and its lower portion is subject to tidal influences. The area also represents a significant habitat for biodiversity conservation. The site contains a full "mountain-to-sea" ecosystem and has some of the most important forests in Asia.

Puerto-Princesa Subterranean River National Park

Inscribed as a World Heritage Site in 1999, the park is on the north coast of Palawan Island in the far southwest of the Philippine archipelago, in the Saint Paul Mountain Range, 50 miles (80 kilometers) northwest of the city of Puerto Princesa. It is bounded on the north by Saint Paul's Bay and by the Babuyan River to the east. The park centers around the Cabayugan River, which runs underground for 5 miles (8 kilometers) through a massive cave, flowing directly into the sea at Saint Paul's Bay. It is tidal in its lower reaches. The park comprises various landforms from flat plains and

A beach near Puerto Princesa.

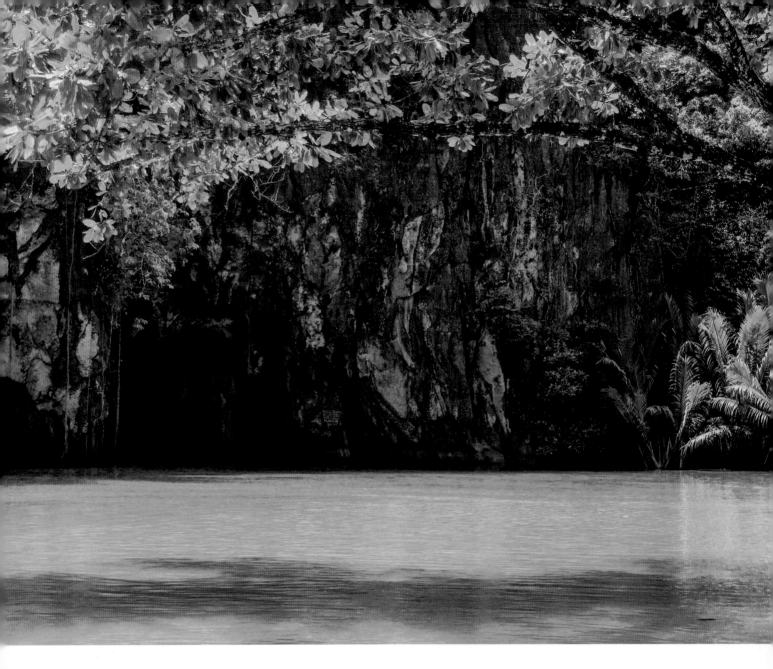

rolling hinterlands to hills and mountain peaks. The most impressive of these is the geologically young karst limestone mountain landscape of the Saint Paul Range, which is part of a series of rounded limestone peaks aligned north-south along the western coast of Palawan. More than 90 percent of the park is comprised of sharp karst limestone ridges around Mount Saint Paul. A cathedral-like cave includes major formations of stalactites and stalagmites, and there are several large chambers up to 394 feet (120 meters) wide and 197 feet (60 meters) high.

The rich flora of Palawan is radically different from that of the rest of the Philippines, preserving relicts of the period when the island was connected by a land bridge with Borneo. There are 800 recorded plant species, 295 of them trees. Three forest formations are present: lowland rainforest, karst forest, and limestone forest. The lowland forest is part of the Palawan Moist Forest, one of the

The beginning of the world's longest navigable underground river.

391

WWF Global 200 Ecoregions, and is noted as having the richest tree flora in Asia. Its canopy trees grow to 115 feet (35 meters) high. Approximately two-thirds of the reserve's vegetation is natural, dominated by *Dipterocarpus grandiflorus* and Moluccan ironwood (*Intsia bijuga*). Large specimens of Pacific walnut (*Dracontomelon dao*), *Swintonia foxworthyi*, and *Atuna racemosa* are also found.

Thinly vegetated karst covers a third of the park but karst forest with epiphytes and lithophytes is restricted to small pockets where soils have developed. Typical species in this kind of forest are of the genera *Antidesma*, *Drypetes*, *Sterculia*, and *Pipturus*. Coastal forest covers no more than 10 acres (4 hectares). It is dominated by large specimens of *Calophyllum inophyllum*, *Pometia pinnata*, and *Palaquium dubardii*. Stands of large mangroves are a major feature of Ulugan Bay.

Palawan, surrounded by the Sulu and South China Seas, is long and narrow. It is a mountainous island averaging 3497 feet (1066 meters) in altitude with Mount Matalingahan, the highest peak, rising to 6798 feet (2072 meters). Palawan still contains more than 50 percent of its forest cover because much of it is not easily accessible. The forest is thick with tall *Ficus* species, dipterocarps, palms, the tall grayish green–leaved conifer *Agathis philippinensis*, philodendrons, and many species of orchids. About 1500 species of flowering plants are native to the island, an extraordinarily high number for such a small island.

The mountains are home to high species diversity, and, on Mount Victoria, one of the most unusual and rare plants, *Nepenthes attenboroughii*. Plant hunters Stewart McPherson, Alastair Robinson, and Volker Heinrich discovered the plant growing among scrub and rock close to the summit of the mountian in 2007 and named it in honor of Sir David Attenborough, the great British naturalist.

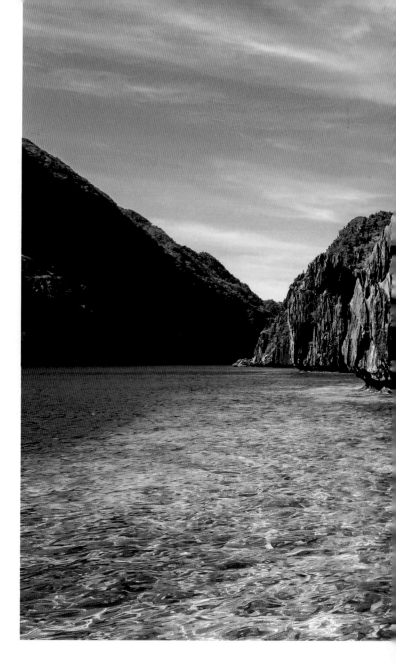

Nepenthes are carnivorous plants with the tips of each leaf a tendril that ends in a large and lipped (peristome) pitcher. A colorful lid is hinged to the pitcher and angles above it. The plant will close its lid when humidity is too low or the temperature is too high, preventing the digestive fluids from evaporating. The lid also attracts insects and other prey by secreting a sugary substance and by its bright colors. It is a trap. Within the pitcher is a sweet viscous liquid that attracts insects, which drown and are then digested. Some of the pitchers grow on the ground while others hang down from tall lianas. So large is *N. attenboroughii* that it is able to trap small rodents in its sugary brew. Able but rarely. All plants of the genus *Nepenthes* are included in Appendix II of the Convention on International Trade in Endangered Species of Wild Fauna and Flora. It is illegal to take them from the wild. With a range of isolated mountains running through the island, there is no doubt that there are more rare and wonderful plants to be discovered. That is, if they can be protected from plant poachers, palm oil plantations, and nickel mining.

Down from the mountains and along the rivers and coast is another biome that needs protection, mangrove. It is a rare pleasure to paddle a bangka—an outrigger canoe—up the Langogan River, through forested hills dotted with coconut groves and small plantations of bananas. Tropical forests are never silent. The electric scream of millions of insects fills the day and night, parrots screech, and if you are lucky, an Asian small-clawed otter will plop into the river as you pass by. On the edge of the water grows nypa palm (*Nypa fruticans*), common to coastlines and riverine habitats of the Pacific and Indian Oceans, it is one of the oldest species of palm in the world. Only the leaves and the flower stalk are above the surface, the trunk grows beneath the surface of the mud. In the Eocene (56 to 33.9 million

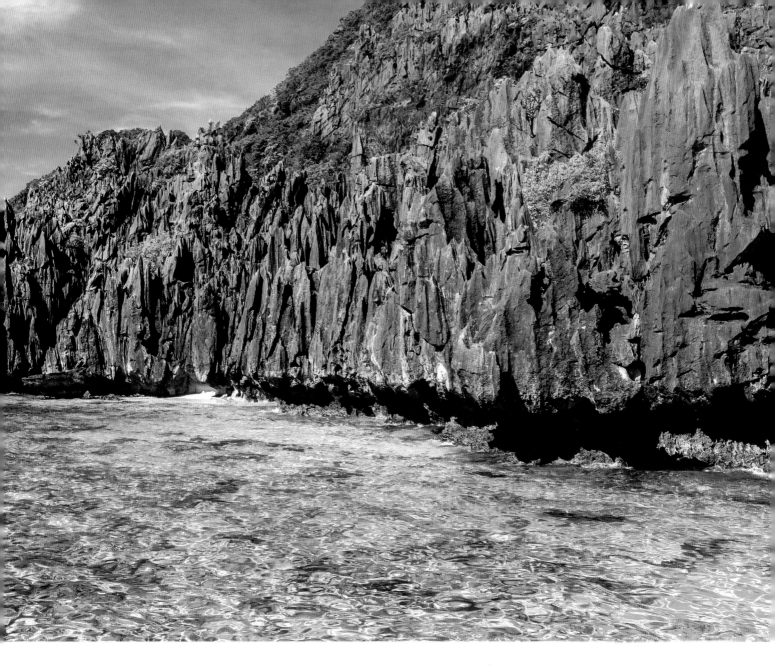

years ago) the genus had pantropical distribution. Evolution and adaptation have confined it to a single species.

Behind the palms grows the mangrove forest, with some species arching over the palms to touch the water. There are 39 species of mangrove in the archipelago. There are about 110 species worldwide. The most widespread belong to the genus *Rhizophora*. One very large red mangrove (*Rhizophora mangle*) specimen growing near

Langogan has been dated to be 350 years old. Mangroves are extraordinary biomes in themselves. They grow in salty water, managing to filter up to 90 percent of the salt and excrete it through their leaves. Some grow breathing tubes (pneumatophores) that act like snorkels when the tides rise, as well as aerial roots and stilt roots. Aerial roots obtain oxygen from the air and stilt roots helps stabilize the tree in the soft mud. In what is an unusually difficult environment for plants; flooding,

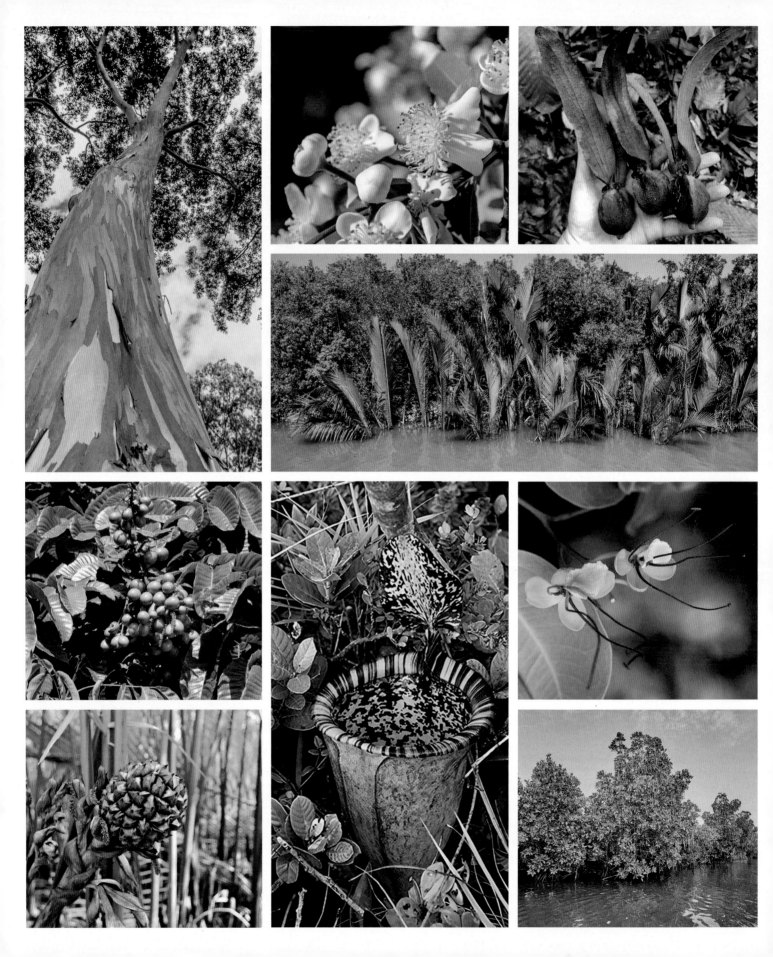

salt water, and unstable soils, mangroves are an extremely successful example of adaptation. They also have an unusual way of propagating, forming germinated seedpods on the tree that fall spearlike into the mud and then grow up 24 inches (60 centimeters) in a year. Mangroves are breeding grounds for much of the world's fish, shrimp, and shellfish. They are nesting sites for millions of birds. They stabilize the shoreline and protect against extreme coastal weather. They are of great importance to the environmental stability of the world but are among the most threatened habitats. According to the International Union for Conservation of Nature more than one in six mangrove species is in danger of extinction. Over half of the world's mangrove forests have been lost during the last 50 years largely due to shrimp farming and intrusive development. Governments and conservation organizations are working hard to save what is left. It is a hard task.

Unlike most of the Philippine islands, Palawan is west of the Wallace line and its flora is more closely associated with that of Borneo. Named after Alfred Russel Wallace ("the father of biogeography"), the Wallace line is an imaginary line that marks the transition zone between the Asian and Australian biogeographical regions. West of the line mammal species are similar or come from species found in Asia. East of the line, species are of Australian descent. The Wallacea region has a total land area of 130,886 square miles (338,994 square kilometers) over thousands of islands, notably Sulawesi, Timor Leste, the Moluccas, and the Lesser Sundas. To the west is Sundaland, to the south and east Australia and New Guinea. Nearly 15 percent of the flora is endemic and comprises tropical rainforest and some dry woodland. Despite the ongoing work of botanists, there is a paucity of information about the flora of the region and research continues with a sense of urgency, but one remarkable native tree, the only eucalyptus to occur naturally north of the equator, is well known. The rainbow eucalyptus (*Eucalyptus deglupta*) is a fast-growing tree reaching a height of 249 feet (76 meters) with peeling rainbow-colored bark in shades of orange, red, lime green, purple, and blue-gray. To see it in large stands along the riverbanks in Mindanao in the Philippines, is to experience one of the most botanically psychedelic moments in life. In LariAnn Garner's words, "As the newly exposed bark slowly ages, it changes from bright green to a darker green, then bluish to purplish, and then pink-orange. Finally, the color becomes a brownish maroon right before exfoliation occurs. Since this process is happening in different zones of the trunk and in different stages, simultaneously, the colors are varied and almost constantly changing. As a result, the tree will never have the same color pattern twice, making it like a work of living art."

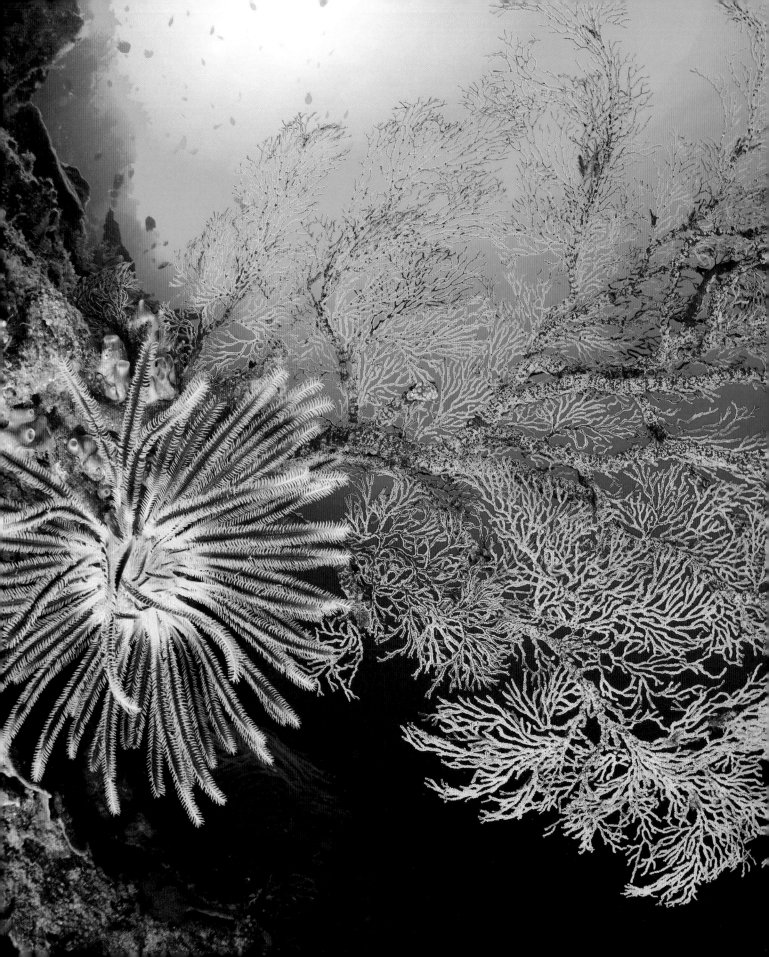

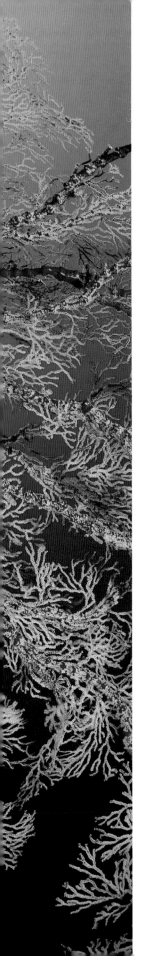

The Tubbataha Reef Marine Park covers 239,267 acres (96,828 hectares), including the North and South Atolls and the Jessie Beazley Reef. It is a unique example of an atoll reef with a very high density of marine species; the North Islet serving as a nesting site for birds and marine turtles. The site is an excellent example of a pristine coral reef with a spectacular 328-foot (100-meter) perpendicular wall, extensive lagoons, and two coral islands.

Tubbataha Reefs Natural Park

PHILIPPINES

The Sulu Sea is bounded by Borneo in the southwest, the southwestern islands of the Philippines, including Palawan, in the west and northwest, Busuanga and Mindoro in the north, Panay and Negros on the east, and Mindanao and the Sulu Archipelago on the southeast. A fracture line, bisecting the sea from northeast to southwest, is evidenced by the coral atolls surrounding Mapun island, the Tubbataha Reefs, and the volcanic Mapun island group. The Tubbataha Reefs were designated a World Heritage Site in 1993. In

Fan corals in a colorful reef.

From left: This area is an important protected nesting place for sea birds. • Hawksbill turtle. • Sea rosemary (*Heliotropium arboreum*). • Tubbataha.

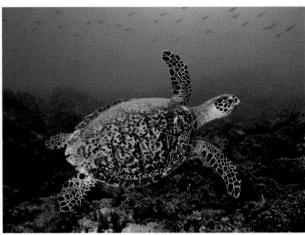

2009 the boundaries of the site were extended to triple its original size.

The park lies in a unique position in the center of the Sulu Sea, and includes the Tubbataha and Jessie Beazley Reefs. It protects 239,267 acres (96,828 hectares) of high-quality marine habitats containing three atolls and a large area of deep sea. It is home to a great diversity of marine life. Whales, dolphins, sharks, turtles, and Napoleon wrasse are among the key species. The reef ecosystems support over 350 species of coral and almost 500 species of fish. The reserve also protects one of the few remaining colonies of breeding seabirds in the region.

The atolls have two very different main habitats: outer reef slope and lagoon. The North Atoll is an oblong platform which completely encloses a sandy lagoon. The South Atoll is a small triangular-shaped reef. Both islets are lightly vegetated and provide nesting sites for seabirds and marine turtles.

The reefs, in the Indo-Pacific faunal province, are in the world center of coral diversity where their remoteness preserved them almost untouched until the 1980s. The reef system is healthy despite the ravages of the 1998 El Niño event. Tubbataha has a higher species diversity per square meter than the Great Barrier Reef. By 2005 it had almost recovered from the 1998 El Niño devastation.

The marine life is very rich. Sharks, turtles, and rays are seen in the lagoons; 11 species of cetaceans (all listed in the Convention on International Trade in Endangered Species of Wild Fauna and Flora) and 11 sharks are recorded. Big schools of pelagic fish such as species of barracuda (*Sphyraena*), giant trevally (*Caranx sexfasciatus*), tuna (*Thunnus obesus*), manta ray (*Mobula diabolus*), spotted eagle ray (*Aetobatus narinari*), black-tip shark (*Carcharinus melanopterus*), and whale shark (*Rhincodon typus*) are common in the outer waters. The area also supports the world's highest densities of whitetip reef sharks (*Triaenodon obesus*). The presence of top predator species such as tiger shark (*Galeocerdo cuvier*) and hammerhead shark (*Sphyrna lewini*) validate the ecological balance of the reef. There

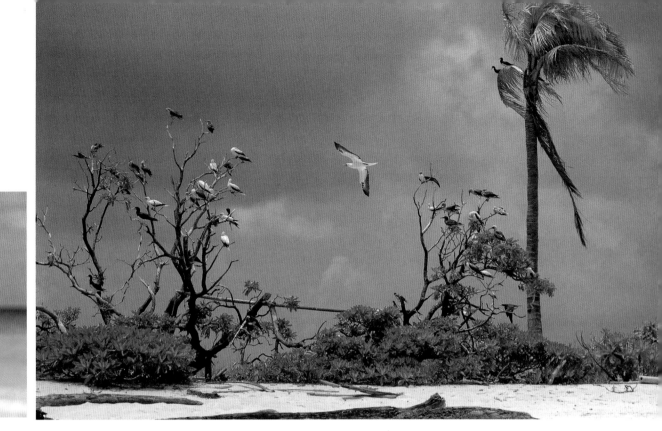

are 479 species of fish. Rare species include giant wrasse (*Cheilinus undulatus*). The endangered hawksbill turtle (*Eretmochelys imbricata*) and green turtle (*Chelonia mydas*) nest on the islets.

The park is one of the few remaining refuges for a diversity of seabirds in Southeast Asia. Ninety-nine species of birds, resident and migrant, have been recorded on the cays. Seven species of seabirds breed there and are found only in the park, one being an endemic subspecies of the black noddy tern (*Anous minutus* subsp. *worcestri*). The endangered Christmas Island frigate bird (*Fregata andrewsi*) is a regular visitor.

Four species of trees grow on the islets. Sea almond (*Terminalia catappa*) is a large tree that can get 115 feet (35 meters) tall, bearing fruits that are green at first, then yellow, and then red when ripe.

White popinac (*Leucaena leucocephala*), a native of Mexico, Belize, and Guatemala, has naturalized on the islets, and is a large shrub there. It grows to a height of 6½ feet (2 meters) or so. The leaves are bipinnate—like a mimosa. Pale yellow pom-pom flowers appear in the leaf forks. The grand devil's-claws (*Pisonia grandis*) is so named because the green flowers produce sticky, barbed seeds that stick to bird feathers. It can grow to a height of 66 feet (20 meters). Sea rosemary (*Heliotropium arboreum*) is a shrub or small tree to 13 feet (4 meters) with spirally arranged egg-shaped, velvety grayish leaves, and numerous white flowers.

Four species of herbaceous plants grow on the atolls, the butter daisy (*Melampodium divaricatum*) blooms with solitary daisylike yellow flowers on plants growing to 12 inches (30 centimeters), *Portulaca oleracea*, the common purslane, is an annual succulent with yellow flowers. Windmill grass (*Chloris inflata*) provides nesting material and seed for many birds, as does bristlegrass (*Setaria parviflora*). The shallower reef flats have extensive beds of 10 species of seagrass, the 4 dominant species being Pacific turtlegrass (*Thalassia hemprichii*), paddleweed (*Halophila ovalis*), narrowleaf seagrass (*Halodule uninervis*) and needle seagrass (*H. pinifolia*).

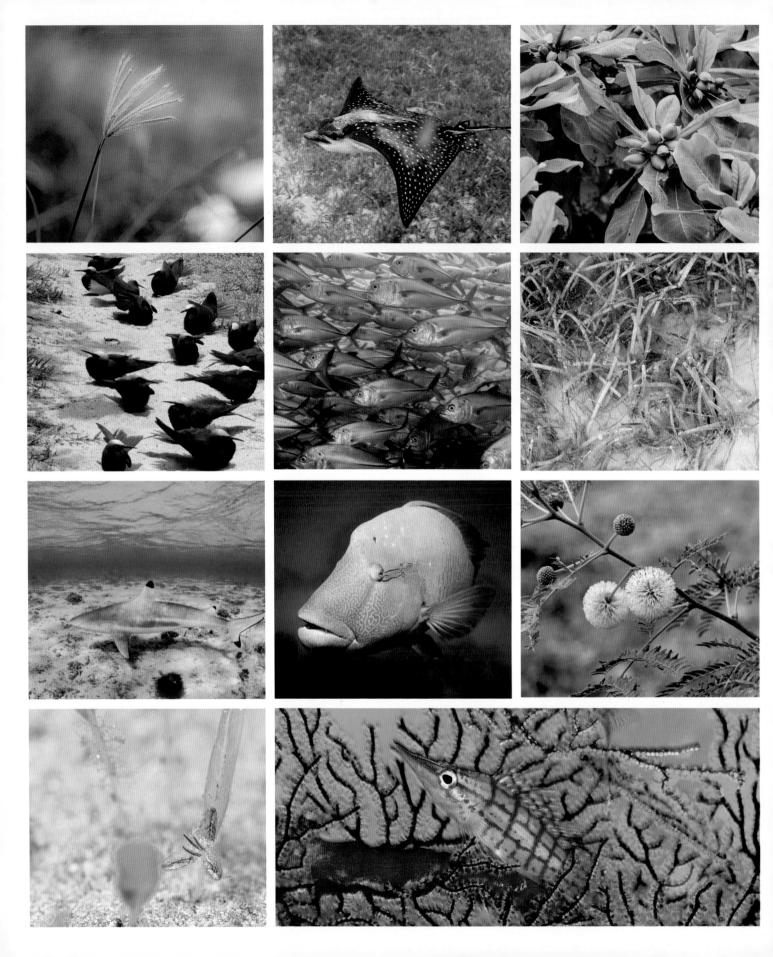

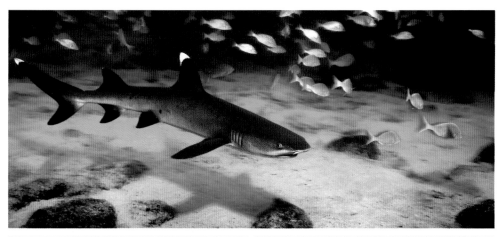

First column: Windmill grass (*Chloris inflata*). • Black noddy tern. • Blacktip reef shark. • Paddleweed (*Halophila ovalis*). *Second column:* Spotted eagle ray. • Giant trevally. • A curious giant wrasse. • Longnose hawkfish. *Third column:* Sea almond (*Terminalia catappa*). • Seagrass (*Halodule* sp.). • White popinac (*Leucaena leucocephala*). *Fourth column:* Whitetip reef shark. • Christmas Island frigate bird. • Whale shark. • Bristlegrass (*Setaria parviflora*). *Fifth column:* Common purslane (*Portulaca oleracea*). • Pacific turtlegrass (*Thalassia hemprichii*).

Situated in the mountains of northern Honshu, this trackless site includes the last virgin remains of the cool-temperate forest of Siebold's beech trees that once covered the hills and mountain slopes of northern Japan. The black bear, the serow, and 87 species of birds can be found in this forest.

Shirakami-Sanchi

JAPAN

The remote Shirakami Mountains are a vast forested wilderness of steep hills with summits between 3280 and 3937 feet (1000 and 1200 meters). More than half of the area is composed of deep interlaced valleys. They extend over 173 square miles (450 square kilometers) and are mainly granite with sedimentary and intrusive rocks that were rapidly uplifted 2 million years ago, resulting in a dynamic landscape with numerous faults and waterfalls.

Shirakami-Sanchi is on the border between Aomori and Akita Prefectures, 9 miles (15 kilometers) inland from the

A forest of Siebold's beech trees.

Sea of Japan. It consists of 25,054 acres (10,139 hectares) of core area with an undesignated buffer zone of 16,882 acres (6832 hectares). It became a World Heritage Site in 1993. The climate is moist and cool with heavy snow during the winter due to the proximity of the Sea of Japan and cold air masses that move in from Siberia. The area is largely a wilderness with no access trails or man-made facilities. Almost no logging of beech trees has been carried out on the property due to lack of access, precipitous topography, and the successful fight against the proposed construction of a forest road in the 1980s. Tourism activities are limited mainly to the areas near the boundary or the

the forest has an undisturbed native flora of more than 500 plant species, of which 108 have specially protected status.

Fagus crenata is a deciduous tree growing to 115 feet (35 meters). The bark is smooth and gray. The young shoots are sparsely hairy at first, becoming hairless as they mature. The leaves are green above, pale green below, and are hairy when young, especially on the edges and veins. In autumn the leaves turn rich yellowish brown. They remain on the tree throughout the winter and are pushed off by the emerging leaves in spring. Regarded as one of the symbols of the forest, a 400-year-old specimen—the Mother Tree—can be seen from one of the few paths designated for visitors.

The beech is named after Philipp Franz Balthasar von Siebold (1796–1866), a German physician and botanist. In 1823 he travelled to Japan, where he established a medical practice. He founded a medical school in Nagasaki and began to collect specimens of the flora and fauna throughout Japan with his collection of native plants eventually numbering over 1000. After he had been expelled from Japan under suspicion of espionage, he returned to Holland and set up the first botanical garden in Leiden. Along with the beech, many plants have been named after him: *Acer sieboldianum*, a maple, *Calanthe sieboldii*, an evergreen orchid, *Corylus sieboldiana*, a hazel, *Hosta sieboldii, Magnolia*

surrounding areas of the property. Consequently, the property is preserved with little human intervention.

The forest is comprised of the last remaining large stand of Seibold's beech forest (*Fagus crenata*) virtually unaffected by man. Having escaped glaciation and established itself over 8000 years ago,

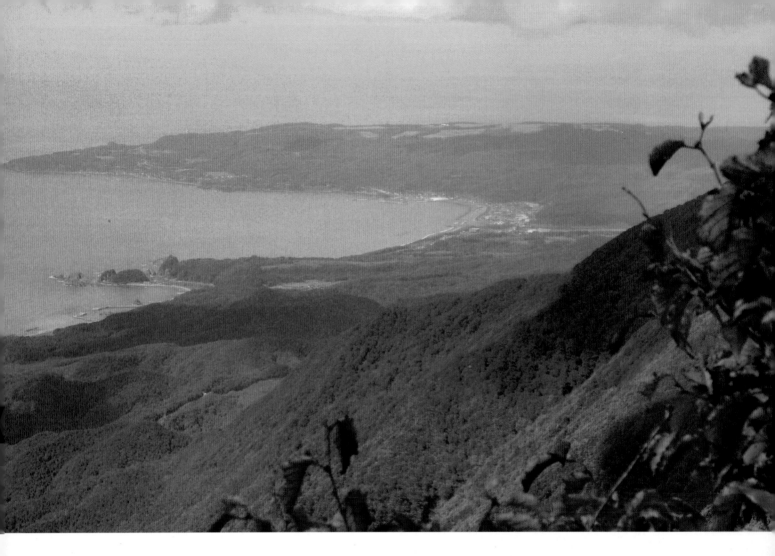

sieboldii, and *Primula sieboldii*, a woodland primula; to name a few.

Apart from beech trees, katsura (*Cercidiphyllum japonicum*), castor aralia (*Kalopanax septemlobus*), Mongolian oak (*Quercus mongolica*), and Japanese hop-hornbeam (*Ostrya japonica*) are found in the forest. Japanese clethra (*Clethra barbinervis*) and willow-leaved magnolia (*Magnolia salicifolia*) are common understory trees. Undergrowth is dominated by the evergreen bamboo *Sasa kurilensis*, with narrow canes and a vertical growing habit of up to 8 feet (2.5 meters). The leaves are dark green but turn paler to a light olive green when mature.

Cercidiphyllum japonicum is a deciduous tree growing to a height of 98 feet (30 meters). It is notable for its heart-shaped leaves that turn yellow, orange, and pink in autumn. The fallen leaves give off a pleasant aroma of burnt sugar. The *Kalopanax septemlobus* looks tropical, but it is not. It is a large deciduous tree growing to a height of 90 feet (27.4 meters), with a trunk up to 4 feet (1.2 meters) in diameter. The lush leaves are large, up to 14 inches (35 centimeters) long, and are palmate. The branches have yellowish prickles while the flowers are white and produced in numerous umbels in an inflorescence up to 24 inches (60 centimeters) across. *Quercus mongolica* can grow up to 98 feet (30 meters) tall and has oblong, dark green leaves to 8 inches (20 centimeters) or more with rounded lobes. *Ostrya japonica* is an elegant deciduous tree in the birch family (Betulaceae) growing up to 79 feet (24 meters) high, with flaking gray

From left: Shirakami-Sanchi. • One of the
12 lakes of Shirakami. • The dense, deciduous
forests of Siebold's beech cover much of the
mountains and valleys.

407

bark. It produces attractive seedpods that look like
paper lanterns.

Underneath the large trees, *Clethra barbinervis*
blooms with sweetly fragrant white flowers in long
clusters in late summer and autumn. It is a bushy
shrub with lavender, gray, and cream peeling bark.
Magnolia salicifolia has white, fragrant flowers
emerging in early spring before the leaves. Both
leaves and bark smell of lemon when crushed. In the
forest, it can reach up to 49 feet (15 meters) tall.

Shirakami-Sanchi is rich in herbaceous plants.
Some are rare, such as *Ranzania japonica*, a small
spreading perennial with triangle-shaped leaves
that are green on top and blue-green underneath.
Drooping, round, pale blue flowers are borne on
long stalks in mid- to late spring, followed by white,
round berries. *Calanthe nipponica* is a rare orchid
with pleated leaves surrounding six to eight flower
spikes that have white to yellow lips surrounded by
lime green tepals. *Sasa nipponica*, another bamboo,
is endemic to the forest. It is an evergreen bamboo
that can grow to 31 inches (80 centimeters). It is
a running bamboo in that new canes are produced
some distance from the main clump, quickly forming
a thicket of slender, erect culms topped by a loose
canopy of large, spreading leaves.

The forest floor is also covered in ferns. *Blechnum nipponicum* is an evergreen fern with two
distinct frond types, fertile and sterile. The sterile
fronds grow in a rosette with an elegant arching
form to them. The fertile fronds grow vertically. The
croziers start out bright green to deep red, growing
progressively darker green.

Shirakami-Sanchi is a place where humans are
not allowed to tread, where life grows without us.
It is a counterbalance to our frantic scrabbling, a
treasure that we cannot open, and in being so, it is a
priceless gift.

SHIRAKAMI-SANCHI

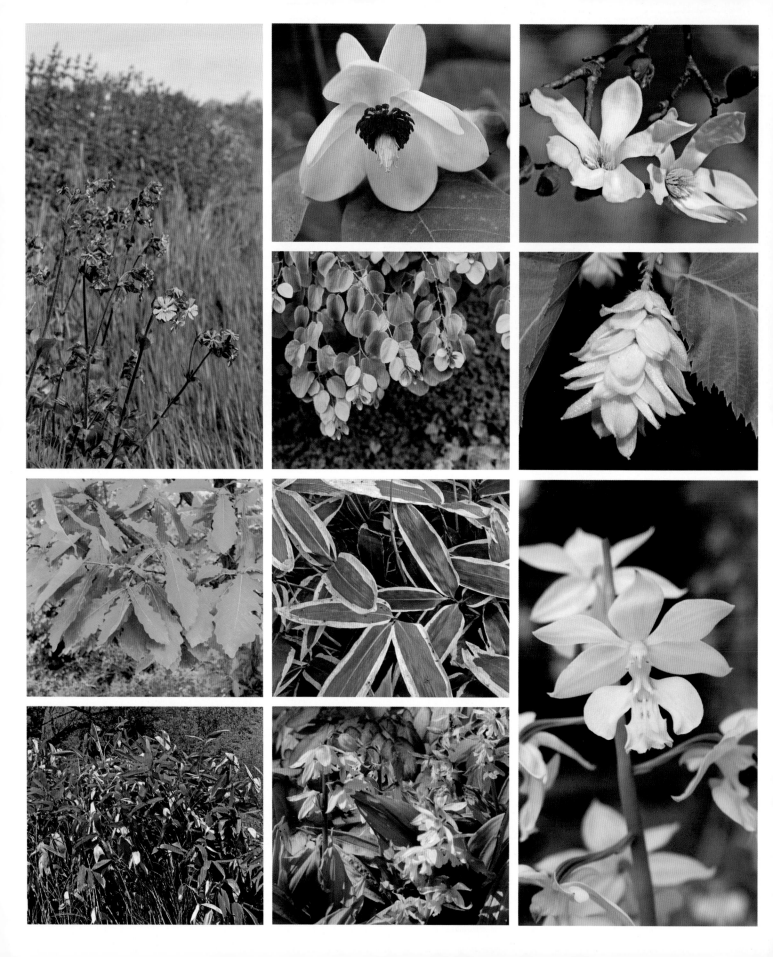

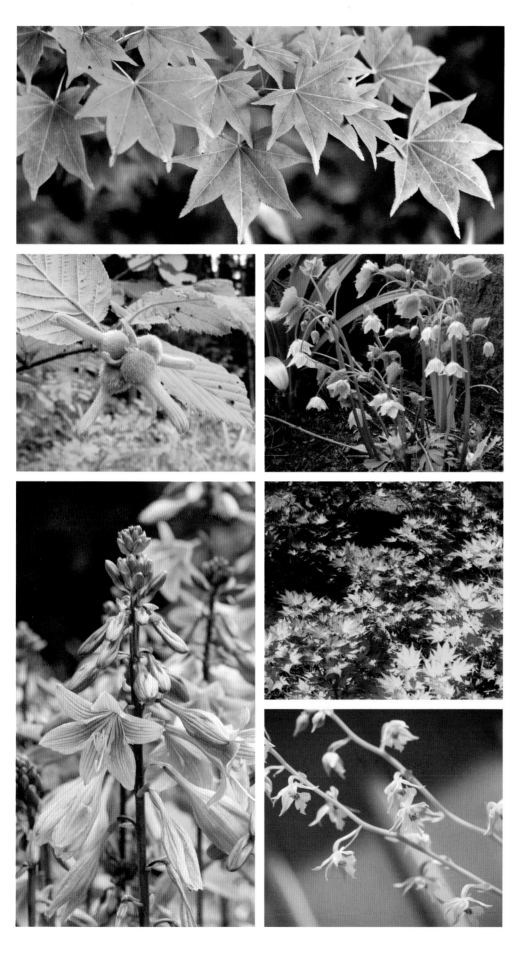

First column: *Primula sieboldii.* • Mongolian oak (*Quercus mongolica*). • The most northern-growing bamboo in the world, *Sasa kurilensis.* *Second column:* *Magnolia sieboldii.* • The great and fragrant katsura (*Cercidiphyllum japonicum*). • *Sasa nipponica.* • *Calanthe striata.* *Third column:* Willow-leaved magnolia (*Magnolia salicifolia*). • Japanese hop-hornbeam (*Ostrya japonica*). • *Calanthe sieboldii.* *Fourth column:* Castor aralia (*Kalopanax septemlobus*). • *Corylus sieboldiana.* • *Hosta sieboldii.* *Fifth column:* Shade-loving *Ranzania japonica.* • Dwarf Siebold maple. • *Calanthe nipponica.*

Acknowledgments

I wish to thank my editor, Stacee Gravelle Lawrence, for her unstinting faith in this book, and her perspicacious editing skills.

The entire staff of Timber Press—including Michael Dempsey and Matthew Burnett in editorial; Sarah Milhollin, Kevin McConnell, and Carole Smith in photo editing; Hillary Caudle and Stacy Wakefield Forte in design—have been nothing but supportive.

The publications staff of UNESCO, headed by Cristina Puerta, have also been crucial to my well-being and to the well-being of this book.

I have been supported by my partner, Julie Loquidis, and I am touched and completely grateful.

A few around the world have helped me, and I would like to thank Rosa and Mike Davison in New Zealand, Dan Bishop in Australia, Ximena Nazal in Chile, Bob Price in Mexico, Ann Wiggins and Mary Linde in the United States, Callum Rae in Scotland, Francesco Ferrini in Italy, Sheila Wilson in Cambodia, and Rik Gadella in Laos.

Further Resources

The full list of all UNESCO's 897 Cultural, 218 Natural, and 39 Mixed Sites, along with interactive maps, full descriptions, and additional photos, as well as links to supporting research and documentation and related publications can be found at whc. unesco.org.

Photography Credits

BGCI, pages 90 (right, bottom), 356 (left, top)

Blandine M.I. Nacoulma, page 232 (left, bottom)

Clivid, page 383 (right, bottom)

Des Callaghan, page 222 (center, second)

Emeline Assede, page 235 (left, second)

Ilya Smelansky, page 326 (left, middle)

IUCN/SSC/Mediterranean Plant Specialist Group, page 194 (center, third)

João Medeiros, page 110 (right, bottom)

Nicolás Baresch Uribe, page 118 (top, right)

P. Lowry /Missouri Botanical Garden, page 288 (left, bottom)

Robert v. Blittersdorff, page 232 (left, top)

Sheila Gregory © RBG Kew, pages 258 (center, top and third)

Stefan Porembski, pages 232 (right, top), 250 (right, third)

Te Papa, page 40 (top, center)

Terry Jennings, page 296 (left, bottom)

Tilman Jaeger, page 65

Zoya Akulova-Barlow, page 100 (right, bottom)

Alamy

Adrian Muttitt, page 234 (center, bottom)

agefotostock, pages 136 (left), 139, 222 (center, top), 245 (right)

Anka Agency International, photographer: Koos Van Der Lende, page 258 (left, third)

Craig Lovell, page 68 (center, second)

David Fleetham, page 398 (middle)

Diego Grandi, page 120

DigitalVues, pages 68 (top, right), 288 (center, top)

Guy Oliver, page 278

Hemis, pages 150 (left, bottom), 372

Hervé Lenain, pages 182 (right, center), 183

IK Lee, page 346

John Barger, page 8 (left, bottom)

Luis Gutierrez/NortePhoto.com, page 67 (right)

Mike Hardiman, page 62

Nature in Stock, page 138 (center, third)

Nature Picture Library, page 66

Oyvind Martinsen, page 102

Roberto Nistri, page 95 (left)

Trevor Penfold, page 375

WaterFrame, pages 396, 400 (center, bottom)

Xinhua, page 244

Zoonar GmbH, page 172 (center, top)

Dreamstime

Adikpixxx, page 90 (right, top)

Aditya Riski Aziz, page 124 (left, bottom)

Adrian Ciurea, page 188 (right, bottom)

Aiisha, page 146

Albertoloyo, page 170 (left)

Alcaproac, pages 341 (left, top), 344 (center, top)

Aleksandar Todorovic, page 86

Alessandra Rc, page 68 (left, second)

Alessandrozocc, page 209 (right, bottom)

Alex Scott, page 158 (top, center)

AlexanderZam, page 158 (right, third)

Alexandragiese, page 136 (right)

Alexey Kamenskiy, page 344 (left, second)

Alfotokunst, page 48 (right)

Alfredo Garcia Saz, pages 165 (left, middle; right, top)

Amaiquez, page 98

Amandacomarim, page 94 (left)

Ammit, page 112

Ams22, page 171 (right)

Anastasiia Tymashova, page 72

Anatoliy Berislavskiy, page 337 (right, middle)

Anatoly Kazakov, page 30 (right, bottom)

André Labetaa, page 166 (right, bottom)

Andrei Gabriel Stanescu, pages 55 (left), 60 (left, top and second; right, second), 69 (right)

Andrew Allport, page 265

Andromeda17, page 158 (left, top)

Angela Macàrio, page 138 (right, second)

Angela Perryman, page 118 (left, second)

Annacarpendale, page 208 (center, top)

Annemiersch, page 145 (left)

Anotnio De Azevedo Negrão, page 138 (center, second)

Anthony Baggett, pages 60 (left, bottom), 337 (left, top)

Apirati333, page 40 (center, third)

Apugach5, pages 158 (right, bottom), 182 (right, bottom), 327 (left, bottom)

Armando Frazão, page 222 (center, bottom)

Artushfoto, page 288 (right, third)

Atosan, page 288 (center, bottom)

Attila Jandi, page 385 (left)

Awcnz62, page 30 (left, bottom)

Azahara Perez, page 166 (center, bottom)

Baramee Temboonkiat, page 401 (third row)

Barmalini, page 350 (left, bottom)

Bayazed, page 82 (left, bottom)

Belizar, page 238 (right, middle)

Bentaboe, page 40 (left, third)

Betta0147, page 138 (left, bottom)

Bgminer, page 400 (center, third)

Bidouze Stephane, pages 364 (left, top), 383 (right, top)

Birute Vijeikiene, page 200 (right, top)

Bogdan Lazar, page 172 (center, second)

Bogdan Wańkowicz, page 188 (left, second)

Bryan Chute, page 264

Callan Chesse, page 238 (left, top)

Carmen Hauser, page 408 (center, second)

Carradore, page 318 (center, second)

Cathywithers, page 268 (left, middle)

Chatchai Somwat, page 362 (left, bottom)

Chistopheb, page 400 (left, second)

CHloe7992, page 69 (left), 275 (left)

Chris Dale, page 50 (left, top; right, bottom)

Chris Hill, page 280 (right, third)

Chris Rinckes, page 177

Chriskiely, page 68 (right, bottom)

Christian Edelmann, pages 257 (left, top), 384

Christian Mueringer, pages 26–27, 28

Christian Schmidt, page 89

Christian Weiß, pages 110 (top, right), 178 (lower left), 188 (center, second; right, top), 258 (right, top), 310 (left, bottom), 327 (right, bottom)

Christina Moreau, page 82 (center, bottom)

Chrkaehler, page 87 (right)

Chun Ju Wu, page 24

Chuyu, page 310 (center, bottom)

Claudia Tillmanns, page 184 (left, top)

Cowboy54, page 362 (right, top)

Creativenature1, page 159 (left, bottom)

Damian322, pages 263 (left), 284, 285, 288 (left, top)

Danciaba, page 194 (center, bottom)

Danilo Mongiello, page 80

Danperte, page 408 (right, top)

Daria Kochetova, pages 342, 344 (left, bottom; center, middle)

Darius Dzinnik, page 200 (left, bottom)

Davebrotherton, page 273 (left)

David Hayes, page 68 (right, top and second)

David Hughes, page 142

David Sanchez Paniagua Carvajal, pages 164, 167 (right)

David Schneider, page 68 (right, third)

Debu55y, page 269 (right, top)

Dennis Jacobsen, page 315 (right)

Dennis Van De Water, pages 8 (top, right), 286 (top, right), 288 (right, top)

Devesh Soam, page 331

Dhammika Ranasinghe Arachchige, page 344 (left, third)

Digitalimagined, page 158 (right, second)

Dirkr, pages 162 (right), 370 (left, bottom)

Discovod, page 318 (left, top)

Donyanedomam, page 376 (right, middle)

Dorota Grabowska, page 199

Dr. Ajay Kumar Singh, page 82 (right, second)

Earnesttse, page 325 (left)

Ecophoto, page 258 (right, third)

Eddydegroot, page 124 (top, right)

Eduardo Huelin, pages 233 (center), 226

Efeather, page 257 (right, bottom)

Efired, page 354 (left)

Eg004713, page 122 (left)

Ekaterina Tsvetkova, page 286 (right, bottom)

Elena Lyamina, page 188 (left, top)

Elisa Bistocchi, page 214 (center, bottom)

Emma Grimberg, page 305 (right, top)

Emma Jones, pages 16–17

Empire331, page 188 (center, third)

Eric Buell, page 58 (right)

Eric Gevaert, page 176

Ethan Daniels, pages 60 (center, bottom), 76, 78

Evgenly Fesenko, pages 192, 394 (right, bottom)

Eyeblink, page 370 (center, bottom)

Fallsview, pages 49, 52

Feathercollector, pages 341 (right), 356 (right, bottom)

Felix Friebe, page 309

Flaviano Fabrizi, page 194 (right, center)

FootageLab, page 222 (right, third)

Fotokon, page 144

Frank Fichtmueller, page 145 (right)

Frans Van Erp, page 179 (left)

Franziska Krause, page 136 (left), 208 (right, second)

Frizzantine, page 259

Gabi Wolf, page 188 (center, top)

Gabriela Fojt, pages 82 (top, right), 124 (left, center)

Georgios Kouvelis, page 209 (right, second)

Gerald D. Tang, page 409 (right, third)

Gert Lamprecht, page 265 (left)

Gherzak, page 214 (left, bottom)

Gillian Hardy, page 124 (center, bottom)

Goryslav, page 182 (left, middle)

Gringocurt, page 99 (left)

Hamik, page 214 (center, middle)

Hamizan Hassan, page 344 (left, top)

Hanna Kurczyna, page 376 (left, top)

Harold Stiver, page 132 (right, bottom)

Hecke01, page 344 (center, third)

Hel080808, page 132 (right, center)

Hellmann1, page 30 (top, left)

Henk Van Den Brink, pages 30 (center, top) 187

Henri Faure, page 298

Henri Koskinen, page 158 (center, bottom)

Hilmawam Nurhatmadi, page 40 (right, bottom)

Hiro1775, page 407 (left)

Hoang Bao Nguyen, pages 386 (left, bottom), 388, 393

Hoatzinexp, page 400 (center, second)

Holger Karius, page 262 (left)

Horst Lieber, page 296 (left, top)

Huijzer, page 179 (right)

Hupeng, page 351 (left)

Hwongcc, page 110 (left, third)

Ian Redding, page 150 (left, second)

Icon72, page 90 (right, second)

Ihervas, page 172 (center, bottom)

Ihor Martsenyuk, page 326 (center, top)

Intrepix, page 318 (right, top)

Irina Borsuchenko, pages 214 (right, bottom), 318 (right, second), 408 (left, bottom), 409 (top)

Irina Mouravieva, page 118 (center, middle)

Irina Opachevsky, page 310 (center, top)

Irina274, page 35 (center)

Irisff, page 326 (right, top)

Iryna Kurilovych, page 118 (right, third)

Isselee, page 273 (right)

Ittipon, page 222 (center, third)

Iva Vagnerova, page 326 (left, top)

Iva Villi, pages 166 (left, third), 209 (left, second)

Ivan Kokoulin, page 107

Jaahnlieb, page 47

Jaap Bleijenberg, pages 280 (left, middle), 280 (right, bottom)

Jaimie Tuchman, page 82 (right, third)

Jaka Suryanta, pages 394 (left, middle), 400 (right, third)

Jana Telenská, page 218

Jared Quentin, pages 55 (right), 60 (center, third)

Jason Row, page 196

Javarman, page 198

Jekaterina Sahmanova, page 140–141

Jeremy Christensen, page 68 (left, third)

Jesus Eloy Ramos Lara, pages 64, 70

Jinwen Xue, page 350 (right, top)

Jixin Yu, page 370 (left, top)

Jj Van Ginkel, page 268 (left, top)

Jjfarq, page 184 (left, center)

Jlindsay, page 280 (left, top)

Jnkoste, page 185 (right)

Joan Egert, pages 178 (top, left), 238 (left, bottom)

Johannes Hansen, page 200 (left, top)

John Anderson, page 83

Johncarnemolla, page 20 (center)

Johncox1958, page 188 (left, bottom)

Jolanta Dabrowska, page 318 (center, bottom)

Juan Francisco Moreno GÁmez, pages 166 (right, second), 166 (right, third)

Juan Francois, page 269 (left, bottom)

Juergen Wallstabe, page 260

Juliengrondin, page 369

Juliovazquez00, page 170 (right)

Kaewmanee Saekang, page 364 (center, bottom)

Kajornyot, page 362 (right, bottom)

Kalypsoworldphotography, page 114

Karin De Mamiel, page 269 (left, third)

Karl Ander Adami, pages 150 (right, bottom), 172 (right, third)

Kaspri, page 150 (center, bottom)

Ken Griffiths, page 30, (top, right)

Ken Wolter, page 61

Kierran Allen, page 267 (right)

Klemen Cerkovnik, page 209 (left, top)

Klomsky, page 256

Konstik, page 90 (left, bottom)

Krisztian Miklosy, page 210

Kseniya Ragozina, page 115 (left)

Laupri, page 310 (left, top)

Lauracieslak, page 30 (center, top)

Leliadraws, pages 172 (top, right), 208 (left, top)

Lessy Sebastian, page 401 (left, second)

Letloose78, pages 38–39

Lightfieldstudiosprod, page 297

Liumangtiger, page 30 (center, bottom)

Lostafichuk, page 200 (center, middle)

Luboslav Ivanko, page 288 (right, bottom)

Luis Leamus, page 149

Lukas Blazek, page 60 (center, top)

Lukas Vejrik, pages 378, 380, 381, 383 (left, top)

Lysh2006, page 74 (right, center)

Maksims Grigorjevs, page 60 (right, third)

Marc Witte, page 20 (left)

Maria Luisa Lopez Estivill, page 168

Maria Victoria Herrera, page 82 (top, left)

Mariagroth, page 269 (left, top)

Mariavonotna, page 185 (left)

Marija Gajic, page 318 (right, third)

Marijanamijakovic, pages 194 (left, top), 310 (left, second)

Marinodenisenko, pages 310 (right, third), 350 (left, middle)

Mario Krpan, pages 172 (right, second), 336 (right, top)

Mariongib, page 36

Mariusz Prusaczyk, page 345

Martin Schneiter, page 68 (left, bottom)

Matauw, page 208 (center, middle)

Mathilde Receveur, page 32

Matyas Rehak, pages 106 (right), 202

Mcanerciftci, page 111

Mckenna843, page 68 (center, bottom)

Mersant, page 158 (left, second)

Michael Bogner, page 82 (center, top)

Michael Meijer, pages 158 (left, third), 310 (right, top)

Micheal Smith, page 159 (top, right)

Michele A Burgess, page 286 (left, top)

Michelvalette88, page 229 (right)

Mircea Bezergheanu, page 117 (right)

Mircea Dobre, page 132 (top, right)

Mirekdeml, page 200 (left, center)

Mirkorosenau, pages 280 (right, top and second)

Mohammad Barahouei, page 82 (center, second)

Moori, page 280 (center, bottom)

Morten Normann Almeland, page 356 (left, bottom)

Mrehssani, pages 312, 314, 315 (left), 316, 317, 318 (left, bottom), 319

MrLis, pages 252, 255

Nancy Anderson, page 394 (left, top)

Narinbg, page 394 (left, bottom)

Narongrit Dantragoon, page 364 (right, top)

Naruedom Yaempongsa, page 26 (left)

Nataliavo, page 238 (right, top)

Near SM, page 376 (left, bottom)

Nehru, page 212

Nguyen Quang Ngoc Tonkin, page 366

Nikonomad, page 137 (right)

Ninahassa, page 258 (right, bottom)

Niuniu, pages 8 (right, middle), 349

Noracarol, page 386 (right, top)

Nublee bin Shamsu Bahar, page 394 (right, middle)

Oleksandr Korzhenko, page 147 (top, left)

Olga Gordeeva, page 178 (left, middle)

Ondřej Prosický, pages 99 (right), 249, 325 (middle)

Oskanov, page 323

Otrokovice, page 188 (right, third)

Ottochka, page 209 (left, third)

Ottovanrooy, page 274 (right, third)

Pablo Escuder Cano, page 165 (left, top)

Paop, page 282

Parawat Isarangura Na Ayudhaya, page 132 (left, middle)

Parin Parmar, pages 336 (left, bottom; center, third), 400 (right, second)

Patricio Hidalgo, page 119

Paul Brady, pages 42–43

Paul Vinten, page 302 (right)

Paul99915, page 408 (left, top)

Peeraya Jakkaew, page 310 (right, bottom)

Pipa100, page 194 (center, second)

Pnwnature, page 60 (center, second)

Positivesoundvision, page 386 (left, top)

Prasert Meeintha, page 213

Praveen Kumar, page 324

Prin Pattawaro, page 362 (right, middle)

Pstedrak, page 30 (right, center)

Puripat Penpun, page 364 (left, middle)

Rafal Cichawa, pages 104, 302 (left)

Rafał Gadomski, page 166 (center, third)

Rainer Klotz, page 263 (right)

Rasool Ali, page 308

Rebecca Picard, page 79

Rechitan Sorin, page 147 (right, bottom)

Riccardo Biondani, page 8 (top, left)

Rightdx, page 56 (left)

Rinus Baak, page 59 (right)

Rob Lumen Captum, pages 158 (left, bottom), 172 (left, bottom), 326 (center, second), 409 (left, bottom)

Robertlasalle, pages 27 (right), 401 (top)

Roberto Dani, page 110, (right, top), 280 (left, bottom)

Rontav123, page 304 (left, bottom)

Rudolf Ernst, page 90 (left, middle)

RukiMedia, page 172 (left, third)

Saintdags_Photography, pages 92, 96

Salparadis, page 382

Samuel Areny, pages 172 (left, second), 173, 183 (top, left)

Sander Meertins, pages 178 (center, third; right, middle), 204

Sandra Standbridge, page 159 (right, bottom)

Sarit Richerson, page 303 (right)

Sarot Chamnankit, page 364 (left, bottom)

Satori13, page 280 (center, middle)

Sburel, page 274 (center, middle)

Seadam, pages 14–15, 37, 82 (right, bottom)

Sekarb, page 100 (left, third)

Serge Goujon, page 94 (right)

Sergey Mayorov, page 288 (center, top)

Sergey Uryadnikov, pages 178 (center, second), 385 (middle)

Sharkphoto, pages 190, 386 (right, bottom)

Sharon Jones, page 22 (right, bottom)

ShiwKumar Tadam, page 234 (right, middle)

Siegfried Werginz, pages 84, 87 (left)

Simon Eeman, page 257 (left, bottom)

Simona Pavan, pages 60 (left, third), 166 (right, bottom), 182 (top, right), 200 (center, bottom), 401 (right, second)

SimonDannhauer, page 81

Sinlapachai Jaijumpa, page 376 (right, top)

Sjankauskas, page 294

Skorplonik00, page 310 (right, second)

Sl Photography, page 100 (top, right)

Sleepyhobbit, page 188 (center, bottom)

Slowmotiongli, page 166 (upper left)

Smellme, page 385 (right)

Smokelmt, page 123 (right)

Snyfer, page 56 (right)

Sofya Dushkina, page 150 (center, top)

Somkak Sarykunthot, page 232 (left, middle)

Soniabonet, pages 100 (center, top), 268 (center, bottom)

Sophia Granchinho, page 50 (center, bottom)

Sova004, page 300

Sstoll850, page 22 (right, top)

Stephankerkhofs, page 400 (center, top)

Stevanovicigor, page 206 (left)

Steve Allen, page 254 (left)

Steve Carroll, page 82 (left, second)

Stockthor, pages 327 (left, top), 350 (center, third)

Sudhakar Bisen, page 231

Suerob, pages 233 (left and right)

Sumikophoto, page 68 (center, third)

Susan Peterson, page 123 (left)

Swisshippo, page 286 (left, bottom)

Tanes Ngamsom, page 364 (center, middle)

Tanisorn, page 361 (left)

Tanya Keisha, page 272

Tapan Kumar Choudhury, page 337 (right, top)

TasFoto, page 306

Tashulia, page 390

Teddy viscious, page 220

Tenrook, page 327 (left, third)

Thawats, page 178 (top, right)

Theerawut Sindam, page 310 (left, third)

Tim Heusinger Von Waldegge, page 194 (left, bottom)

Timurk, page 90 (center, middle)

Tom Meaker, page 337 (right, bottom)

Tomas Nevesely, pages 44, 48 (left)

Tomas1111, page 147 (left, bottom)

Tomi Tenetz, pages 290–291

TravelFaery, page 8 (left, middle)

Tupungato, page 50 (right, top)

UlyssePixel, page 110 (center, third)

Unkas1978, page 350 (left, top)

Unofficialnaturegraphy Choudhary, page 232 (right, bottom)

Val Bakhtin, page 59 (left)

Verastuchelova, pages 150 (right, top), 310 (center, second)

Vg Bingi, page 110 (center, bottom)

Victor Mukherjee, page 334

Victor Suárez Naranjo, pages 221 (right), 274 (center, bottom)

Vinesh Kumar, page 328

Vivek Renukaprasad, page 332

Vladimir Blinov, page 131

Vladimir Cech, page 117 (left)

Vladimir Melnik, page 200 (center, top)

Vnikitenko, page 326 (center, third)

Volodymyr Kucherenko, page 178 (center, top)

Vorasate Ariyarattnahirun, page 361 (right)

Wagner Campelo, pages 88 (right), 90 (center, bottom)

Whiskybottle, pages 150 (center, second), 214 (left, top), 326 (center, bottom)

Wirestock, pages 60 (right, top and bottom), 304 (right, middle)

Wrangel, page 247 (right)

Xishuiyuan, page 348

Yakthai, page 337 (left, middle)

Yingboon Chonhsomchai, page 364 (right, third)

Yongkiet, pages 394 (center, top), 398 (right)

Yorozu Kitamura, page 408 (center, top)

Yu Zhang, page 351 (right)

Yujie Chen, page 172 (right, bottom)

Yulan, page 336 (right, third)

Yuliia Yurasova, page 257 (right, top)

Yuriy Barbaruk, page 50 (center, top)

Yuriy Brykaylo, page 207 (right)

Yuriy Lukin, page 340

Zayacskz, page 296 (right, top)

Zeedevil, page 148

Zerenz, page 40 (center, second)

Ziggymars, page 402, 407 (right)

Zoya Kurenkova, page 376 (center, top)

Zrfphoto, page 54

Flickr

Albert Vervueren, page 318 (right, bottom)

Alexey Yakovlev, page 242 (center, bottom)

Alvesgaspar, page 200 (center, middle)

Amadej Trnkoczy, page 209 (right, top)

Andrey Zharkikh, page 50 (left, bottom)

anjahennern, page 386 (right, middle)

Anne Elliott, page 50 (right, second)

Arisaema jacquemontii, page 336 (left, second)

ashitaka-f, page 258 (center, bottom)

Ashley Basil, page 221 (left)

Augustin Konda Ku Mbuta, page 242 (right, bottom)

Barry Hammel, page 250 (left, bottom)

Bart Wursten, page 242 (left, top)

Benoît HENRY, pages 40 (top, right), 35 (left), 40 (left, top), 41

Bernard DUPONT, pages 132 (left, top), 229 (left), 235 (left, bottom), 238 (right, bottom)

BigHonkinRat, page 50 (left, middle)

Björn S, page 208 (right, third)

Bobbruxelles, page 408 (right, middle)

Carmen Paixão, page 138 (left, middle)

Cerlin Ng, page 394 (right, top)

Chad Husby, page 40 (right, second)

Cyril Nelson, page 110 (left, bottom)

Dadonene89, page 318 (left, third)

Dalvenjah FoxFire, page 57

David Hamon, page 150 (left, third)

devra, page 58 (left)

Didier Descouens, page 235 (right)

Dinesh Valke, page 336 (left, third)

Dr. Alastair Robinson, page 394 (center, bottom)

Dr. Horst Vogel, page 242 (center, top)

Eric Bronson, page 138 (top, left)

Eric Hunt, page 386 (left, middle)

Forest and Kim Starr, pages 115 (right), 401 (left, bottom)

Franz Xaver, page 100 (center, second)

gailhampshire, page 100 (center, third)

Gene Spesard, page 68 (center, top)

Gerardo G. Casanova (endemicascanarias.com), page 222 (left, second)

Hanne Christensen, page 110 (right, second)

Helena Cistotov, page 90 (right, third)

Ingrid Skoglund, page 318 (center, top)

James Gaither, page 222 (right, bottom)

Jean Louis Verbruggen, page 166 (center, top)

John Dransfield, page 250 (center, middle)

John Tann, page 258 (center, top)

Jorge Íñiguez Yarza, page 305 (left, middle)

Kerry D Woods, page 50 (center, third)

Kerry Schneider, page 288 (right, second)

Kyle Wicomb, pages 97 (right), 288 (left, middle)

Leo Klemm, page 250 (left, middle)

Linda De Volder, page 222 (left, bottom)

Mark Gurney, page 172 (center, third)

Markus Branse, page 22 (left, third)

Matt Lavin, page 50 (center, second)

Mihkel Pärn, page 304 (center, bottom)

Mmcknight4, page 40 (center, bottom)

Motohiro Sunouchi, page 409 (right, bottom)

Naoki Takebayashi, page 386 (center, top)

Paco Garin, pages 68 (left, top), 100 (left, second; right, second and third), 110 (right, third)

Paul Latham, pages 250 (right, top), 274 (left, middle)

peganum, page 356 (left, center)

Plantaholic Sheila, page 222 (left, top)

Reinaldo Aguilar, page 100 (center, bottom)

Robert Carney, page 337 (left, bottom)

Roger Steeb, page 100 (left, top)

Royal Botanical Gardens, Kew, page 318 (left, second)

SAplants, page 258 (left, top)

Scott Zona, pages 88 (left), 95 (right), 235 (left, top)

Shawn O'Donnell, page 370 (right, middle)

Siddarth Machado, page 74 (center, third)

Suzi Bond, page 124 (right, bottom)

Tarciso Leao, page 74 (left, middle)

Tatters, page 258 (right, second)

Todd Boland, page 118 (left, bottom)

xulescu_g, page 209 (left, bottom)

iStock

chuvipro, page 270

claffra, page 156

Esra Ozturk, page 296 (right, bottom)

fotoVoyager, pages 152, 155 (right)

Givaga, page 292

jacquesvandinteren, page 163

JeffGoulden, page 105 (middle)

muthardman, page 295

Nuttaya99, page 358

Oleh_Slobodeniuk, page 360

Poliorketes, page 304 (left, center)

Richard Heath, page 155 (left)

RollingEarth, page 157

Steve Woodford, page 154

stockstudioX, pages 12–13

weisschr, page 258 (left, second)

zodebala, page 387

Nature Picture Library

David Tipling, page 106 (left)

Paul Williams, page 134

Pete Oxford, page 82 (left, third)

Shutterstock

Agustin Parada Soria, page 132 (center, second)

AlbinRaj, page 274 (left, bottom)

Alexander Yu. Zotov, page 124 (left, top)

Andrew Fletcher, page 336 (left, top)

Anthony Panopio, page 352

Arjen de Ruiter, pages 126, 130

arousa, page 166 (right, top)

ArtMediaFactory, page 325 (right)

beibaoke, pages 354 (right), 355

Belinda Turner, page 22 (left, top)

bluecrayola, page 174

Bravo Ferreira da Luz, page 268 (center, second)

Carlos Leopardi, page 74 (left, bottom)

Cyrille Redor, page 394 (center, middle)

Daimond Shutter, page 400 (right, top)

Deejays, page 336 (right, bottom)

dennys requenez, page 105

divedog, page 400 (left, bottom)

Doikanoy, page 110 (left, second)

DragonWen, page 234 (right, top)

Earth and More, page 383 (left, bottom)

Ethan Daniels, page 400 (left, third)

evenfh, pages 224–225

Gergo Nagy, page 338

Gregory A. Pozhvanov, page 118 (right, second)

guentermanaus, pages 128, 242 (left, bottom)

Hansie Oosthuizen, page 230

HaruKaeru, page 194 (left, center)

Heinsdorff Jularlak, page 158 (center, third)

Henri Koskinen, pages 166 (center, second), 326 (left, bottom)

Irfan M Nur, page 400 (left, top)

islavicek, page 214 (right, top)

jena028Kan, page 344 (center, top)

John Keselyak, page 274 (left, top)

John R Martin, page 408 (center, bottom)

Jorge Eddy, page 124 (right center)

Juan Carlos Munoz, pages 165 (left, bottom; center, right), 166 (left, second)

juerginho, page 158 (center, second)

Kanokwann, page 362 (left, center)

Kasnawati Kasim, page 40 (right, third)

KeriG, page 8 (right, bottom)

Life Collection Photography, page 74 (center, top)

LukaKikina, page 320

Mateusz Sciborski, page 150 (right, center)

Maxim Petrichuk, page 327 (right, center)

Mr-E, page 110 (left, top)

Natalia van D, page 132 (center, bottom)

Nathalia F. G., page 250 (center, bottom)

Nektarstock, page 276

Nicholas Case Wightman, page 242 (right, top)

Nublee bin Shamsu Bahar, page 370 (right, top)

Pat Tr, page 363

pongwit sanongboon, page 344 (center, bottom)

quiggyt4, page 74 (center, second)

Radek Borovka, page 275 (left)

Roger de Montfort, page 160

rontav, page 305 (left, bottom)

Sachi_g, page 166 (left, bottom)

sakhorn, page 109

Sergey Berestetsky, page 222 (right, top)

shepherdsatellite, page 336 (center, top)

shiro_ring, page 408 (center, third)

Somrerk Witthayanant, page 374

Sylvie Lebchek, pages 23 (center, middle), 124 (center, middle)

T.Sahl, page 279

TigerStocks, page 362 (left, top)

Tom Jastram, pages 18–19

topimages, page 370 (center, middle)

Torsten Pursche, page 322

Uzi Dagan, page 305 (left, top)

Vankich1, page 194 (center, top), 326 (right, bottom)

wld, page 216

Wagner Campelo, page 376 (right, bottom)

Wiert nieuman, page 268 (left, bottom)

UNESCO

© CBNPD, page 184 (right, center)

© Comunità del Parco, pages 184 (left, bottom), 186

© D'AmicisBruno, page 184 (right, top)

© JU NP Paklenica, pages 188 (left, third; right, second)

© Ko Hon Chiu Vincent, pages 193, 341 (left, bottom), 343, 344 (center, bottom)

© Sieghartsleitner Franz/ NATIONALP, pages 184 (right, bottom), 189

© Snorri Baldursson, page 151

© Thorvardur Arnason, page 147 (right, top)

© UNESCO, 162 (left), pages 167 (left), 206 (right), 236, 240, 398 (left), 399 (right)

Wikimedia

Abalg, pages 158 (right, top)

Abu Shawka, page 268 (center, top)

Álvaro Siabatto and José Próspero Hurtado Caro, page 118 (center, top)

Andrew Massyn, page 268 (center, third)

Aporia.j, page 208 (right, bottom)

Ariel Rodríguez-Vargas, page 110 (center, top)

Bernard DUPONT, pages 267 (left), 386 (center, bottom)

C T Johansson, pages 118 (right, bottom), 124 (center, top)

Christian Fischer, page 178 (right, bottom)

Ckonramos, page 132 (left, bottom)

Coliner, page 100 (left, bottom)

Consultaplantas, page 234 (right, bottom)

Daderot, pages 74 (right, bottom), 408 (left, middle)

Dalgial, page 408 (right, bottom)

Denis.prévôt, page 356 (right, middle)

Dinesh Valke, page 22, (right, bottom)

Dwergenpaartje, page 269 (right, bottom)

Eitan f, page 304 (left, top)

Eric Freyssinge, page 250 (center, top)

Ernst Gügel, page 214 (left, center)

Eugene Zelenko, page 35 (right), 58 (center)

Filo gèn', page 138 (right, bottom)

Forest and Kim Starr, pages 90 (left, top), 118 (left, top), 234 (left, bottom)

Gaurav Verma, page 336 (center, second)

Gernot Molitor, page 298 (left, middle)

Ghofar Ismail Putra, page 401 (right, bottom)

Giancarlo Dessì, page 326 (right, third)

Gideon Pisanty, pages 304 (right, top), 305 (right, middle)

Goete Svanholm, page 409 (right, second)

Guettarda, page 74 (right, top)

H.-U. Küenle, page 222 (right, second)

Hansueli Krapf, page 150 (center, third)

Hardyplants, page 74 (left, top)

Hedwig Storch, page 222 (left, third)

Holger Krisp, page 208 (right, bottom)

Hüseyin Cahid Doğan, page 304 (right, bottom)

Jabea Tongo Etonde, page 250 (left, top)

Jane Cooper Orkney, page 159 (left, top)

Jean-Philippe DANIEL, page 34

JeremiahsCPs, pages 386 (center, both middle)

Ji-Elle, page 250 (right, second)

JMK, page 234 (center, middle)

John Robert McPherson, page 22 (left, center)

Ken and Nyetta, page 268 (right, middle)

Krzysztof Ziarnek, pages 30 (left, center), 118 (center, bottom), 208 (center, bottom), 265 (center), 327 (right, top), 350 (center, bottom)

Lamiot, page 310 (center, third)

Lazaregagnidze, page 350 (right, bottom)

Lei Feng, page 350 (center, top)

Marco Schmidt, pages 228, 235 (left, third)

Mark Marathon, page 234 (left, top)

Monofruit, page 40 (left, bottom)

Motohiro Sunouchi, page 269 (right, second)

Nick Helme, page 274 (right, top)

Qwert1234, page 409 (left, second)

Renjusplace, page 344 (center, second)

Robert Flogaus-Faust, page 208 (right, top)

Rotational, page 234 (left, center)

Rupak73, page 22 (center, top)

Salvor Gissurardottir, page 150 (left, top)

SAplants, pages 268, (right, top), 269 (left, second; right, third), 274 (right, second), 275 (right)

Scott Zona, page 40 (left, second)

Siliurp, page 194 (right, top)

Simon A. Eugster, page 182 (left, bottom)

Stickpen, page 326 (right, second)

Syrio, page 258 (right, bottom)

Tamaki Seto, page 406

Tarciso Leão, page 90 (center, top)

Vinayaraj, pages 234 (center, top), 336 (center, bottom), 336 (right, second), 364 (right, second)

Yuvalr, pages 304 (center, top), 327 (left, second)

Ziegler175, page 172 (right, top)

Σ64, page 318 (center, third)

Index

Abell, Paul, 272
Aboriginal people, 17, 23
Acacia, 23, 255
Acacia conspersa, 23
Acacia raddiana, 301
Acacia seyal, 275
Acacia sublanata, 23
Acantholimon saxifragiforme, 295
Acanthus hirsutus, 295–297
Aceolorraphe wrightii, 75
Acer sieboldianum, 405
Achillea fragrantissima, 301–302, 305
acorn, 58, 101, 129
Acrocomia aculeata, 75
Acropogon bullatus, 41
acuña cactus (*Echinomastus erectocentrus* var. *acunensis*), 69
Adanson, Michael, 281
Adansonia, 281
Adansonia digitata, 281
Adansonia kilima, 281
adder's tongue (*Ophioglossum vulgatum*), 155, 159
Aechmea, 75
Aeolian Islands, 190–195
Aeolus, King, 192
African birch (*Anogeissus leiocarpa*), 229, 235
African blackwood (*Dalbergia melanoxylon*), 273–275
African bristlegrass (*Setaria sphacelata*), 259
African-Eurasian migratory waterbirds, 176
African gray parrot (*Psittacus erithacus*), 249, 251
African locust-bean (*Parkia bicolor*), 239

African long-snouted crocodile (*Crocodylus cataphractus*), 251
African mesquite (*Prosopis africana*), 229
African myrrh (*Commiphora africana*), 273
African Parks Foundation, 233
African peach (*Nauclea latifolia*), 230, 235
African pearwood (*Baillonella toxisperma*), 246
African quinine (*Rauvolfia caffra*), 273, 275
African raffia (*Raphia sudanica*), 230
African whitewood (*Triplochiton scleroxylon*), 239, 246
African wild dog, 253, 254
afromosia (*Pericopsis elata*), 229
Afrostyrax lepidophyllus, 246–247
Afrotrilepis pilosa, 239
Afzela xylocarpa, 365
Afzelia bipindensis, 246
agarwood (*Aquilaria malaccensis*), 363, 365
Agathis, 37
Agathis philippinensis, 391
Ageratina, 99
Agrostis, 117
Agrostis capillaris, 159
aguacatillo (*Alchornea latifolia*), 89
Agua Dulce, 66
aguaje, 133
Ahwar of Southern Iraq, 306–311
Akita Prefecture, 403
Albania, 181, 210–215
Albera Massif, 183
Albizia, 287
Albizia niopoides, 111

Albizia niopoides var. *niopoides*, 108
Alborz Mountains, 313, 316, 319
Alchemilla faroensis, 147
alder (*Alnus*), 125, 154, 187
Alejandro de Humboldt National Park, 84–91
algae, 37, 61, 204, 215
Alkanna orientalis, 297
Alkanna orientalis var. *leucantha*, 297
Alligator Rivers region, 18–19
Allium cappadocicum, 297
Allium shelkovnikovi, 319
Allosyncarpia ternata, 23
Alnus glutinosa subsp. *barbata*, 315
Aloe, 289
alpenrose (*Rhododendron ferrugineum*), 173
alpine glacier poppy (*Papaver pygmaeum*), 48, 51
alpine larch (*Larix lyallii*), 49
Alsophila dregei, 239, 243
Alstonia congensis, 251
Altai Mountains, 349
Altos de Quia, 104
amaranth, 163
Amazon, 71, 115
Ambergris Caye, 78, 80
Amborella trichopoda, 35
American Indians, 59
Amerindians, 109
amethyst meadow squill (*Scilla litardiere*), 209
Ammopiptanthus mongolicus, 351
Ammopiptanthus nanus, 351
Amolar Mountains, 136
Amorphophallus, 374
Amorphophallus titanum, 374, 377
amphibians, 94
Amsinckia menziesii, 69

Anacardium excelsum, 111

Anadelphia, 239

Ancient Beech Forests of
Germany, 180–189

Ancient Maya City and Protected
Tropical Forests of Calakmul,
Campeche, Mexico, 70–75

Andean alder (*Alnus acuminata*
subsp. *acuminata*), 117

Andean cock-of-the-rock
(*Rupicola peruvianus
aequatorialis*), 117, 119, 133

Andean condor (*Vultur gryphus*),
117, 119

Andean walnut (*Juglans
neotropica*), 125

Andes, 104, 113–115, 117, 119, 121,
123, 125, 284

Andohahela National Park, 285

Andringitra National Park, 285

Androcymbium palaestinum,
303, 305

Androlepis skinneri, 101

Anemone obtusiloba, 333, 337

Anemone polyanthes, 330

Angola, 253

Añisclo canyon, 170

Añisclo Cave, 170

Anisoptera costata, 375, 377

an-marrenarnak, 23

antelope, 51, 233, 254, 255, 275

Antennulariella, 281

Anthemis, 295

Anthemis aeolica, 193

Anthurium, 101

Anthurium caperatum, 95, 101

Antiaris toxicaria, 385

Antidesma, 391

Aomori Prefecture, 403

Aotearoa (land of the long white
cloud), 27

Aparisthmium cordatum, 91

Apollonias barbujana, 219, 223

apple, 325, 351

Aptosimum elongatum, 259

Araucaria, 33, 37

Araucaria nemorosa, 37, 41

arctic bumblebee (*Bombus
polaris*), 199, 201

arctic poppy (*Papaver
radicatum*), 199, 201

arctic thyme (*Thymus praecox*
subsp. *arcticus*), 148

arctic willow (*Salix arctica*), 47,
51

areca nut, 341

Argentina, 29

argillite, 47

Arisaema jacquemontii, 333, 337

arrowroot (*Maranta
arundinacea*), 247, 251

Arroyo de la Madre de las
Marismas del Rocío, 162

arta (*Calligonum comosum*), 301,
305

Artemisia, 323

Artemisia gracilescens, 323

Artemisia lercheana, 323

Artemisia lessingiana, 325

Artemisia nitrosa, 325

Artemisia pauciflora, 325

Artemisia shrenkiana, 325

arundinella (*Arundinella
nepalensis*), 231, 235

Ásbyrgi, 144

Asian elephant (*Elephas
maximus*), 365

Asian spruce (*Picea
schrenkiana*), 349, 351

Askja, 144, 147

asparagus, 75

aspen, 45, 51

Aspidosperma spruceanum, 73,
75

Asteropeia amblyocarpa, 289

Asteropeia labatii, 289

Asteropeia multiflora, 287, 289

Asteropeia rhopaloides, 287

Astrocaryum paramaca, 130

Atalantia rotundifolia, 345

Atillo lagoon, 114

Atrato River, 105

Atriplex holocarpa, 311

Atriplex micrantha, 311

Atropa pallidiflora, 316

Atsinanana, 283–289

Atsinanana pitcher plant
(*Nepenthes* "Atsinanana"),
289

Attalea cohune, 75

Attenborough, David, 391

Attenborough's pitcher plant,
391–392, 395

Atuna racemosa, 391

Australia, 12, 14, 17–23, 29, 31,
395

Australopithecus afarensis, 272

Australopithecus anamensis, 272

Austria, 181

autumn crocus (*Sternbergia
clusiana*), 303, 305

Avicennia germinans, 79

avocado (*Persea americana*), 97,
129, 223

axlewood (*Terminalia
phillyreifolia*), 365

Axonopus fusiformis, 136

Axonopus purpusii, 136

Azerbaijan, 314

Babiana, 267

baboons, 233

Bacalar Chico National Park and
Marine Reserve, 77

Bactris cubensis, 91

Baillonella toxisperma, 251

Baissea multiflora, 230

bajos, 75

bald eagle, 45

Balsas River, 104, 108, 109

balsa tree (*Ochroma lagopus*), 119

bamboo, 97, 98–99, 273, 287, 406, 407, 409

bamboo orchid (*Arundina graminifolia*), 345

banded tree anole, 89

Banks, Joseph, 23

Banksia, 23

Banos de Agua Santa, 114

baobab (*Adansonia digitata*), 281

Barbary nut (*Moraea sisyrinchium*), 303, 305

Bárðarbunga, 143

Barisan Selatan National Park, 375

barn swallow, 167

barracuda (*Sphyraena*), 398

barradjungga, 23

barrier reef, 14, 76–83

basket grass (*Schoenoplectus corymbosus*), 257

Basselinia gracilis, 38

Bassia saxicola, 195

Bates's weaver (*Ploceus batesi*), 251

bats, 383

bay cedar (*Suriana maritima*), 81, 83

Bayinbukuke, 347, 351

bear, 45, 49

beargrass (*Xerophyllum tenax*), 49, 51

Beaucarnea pliabilis, 75

Bedouin people, 300–301

beech, 29–31, 183–187, 205, 405–406

beechwood sickener (*Russula nobilis*), 189

beech woodwart (*Hypoxylon fragiforme*), 189

bees, 264

beetles, 189, 264, 374

Befotaka-Midongy National Park, 285

begonia, 125

Begonia, 125

Begonia brevicyma, 101

Belgium, 181

Belize, 76–83, 399

Belize Barrier Reef Reserve System, 76–83

bellflower, 205

bell heather (*Erica cinerea*), 154, 159

Betula nana, 198, 201

Bienertia, 311

big-leaf maple (*Acer macrophyllum*), 56

Bingham, Hiram, 122

Bininj Mungguy people, 23

bintuang tree (*Octomeles sumatrana*), 382

birch (*Betula*), 145, 154, 187, 199, 406–407

BirdLife International, 88, 251

bird plum (*Berchemia discolor*), 229, 233, 235

bird's-nest ferns (*Asplenium nidus*), 382, 383

bitter leaf (*Vernonia amygdalina*), 251

black alder (*Alnus glutinosa*), 205, 209

black bear, 45

black beech (*Nothofagus solandri* var. *solandri*), 29–31

black crowberry (*Empetrum nigrum*), 145, 151

Black Dragon River, 354

Black Drim, 215

black-headed gull (*Larus ridibundus*), 179

Black iris (*Iris nigricans*), 303

black kite, 167

black mangrove (*Avicennia germinans*);, 107

black-necked grebe, 215

black noddy tern (*Anous minutus* subsp. *worcestri*), 399, 401

black olive (*Terminalia buceras*), 75

black rhinoceros, 253

Black River, 204

black sage (*Salvia mellifera*), 58, 61

black-tailed godwit, 167

blackthorn (*Senegalia mellifera*), 273

black-tip shark (*Carcharinus melanopterus*), 398, 401

black wattle (*Acacia mangium*), 387

black-winged stilt, 167

Bladder campion (*Silene vulgaris*), 337

bladderwort (*Utricularia minor*), 206

Blechnum buchtienii, 99

Blechnum nipponicum, 409

bloodwood (*Haematoxylum campechianum*), 75

blueblossom ceanothus (*Ceanothus thyrsiflorus*), 61

bluebunch wheatgrass (*Pseudoroegneria spicata*), 51

blue delphinium (*Delphinium brunnianum*), 330

bluedicks (*Dichelostemma capitatum*), 69

bluegray mbuna, 281

blue-headed parrots (*Pionus menstruus*), 95

blue heron, 164

Blue Hole Natural Monument, 77–78

blue macaw, 139

blue morpho butterfly (*Morpho menelaus*), 95, 101

blue oak (*Quercus douglasii*), 58, 59

blue palo verde (*Parkinsonia florida*), 67, 69

blue panic grass (*Panicum coloratum*), 275

Blue River, 39

Blue River Provincial Park, 37–39, 41

blue water lily (*Nymphaea violacea*), 21, 23

blue-winged kookaburras, 23

blushing bride (*Serruria florida*), 266, 269

bobbejaanklou (*Leucospermum cordifolium*), 269

bog bilberry (*Vaccinium uliginosum*), 145, 147, 151

Bogda, 347

bog plants, 27

Boland Mountain Complex, 262

Bolivia, 135

Bolivian Chaco, 136

Bombacopsis quinata, 111

Bombax ceiba, 21

Bombax costatum, 229, 235

bongo, 107

Bonpland, Aimé, 86

borage, 297

Borassus akeassii, 233

Boreray blackface sheep, 157

Bornean elephant (*Elephas maximus borneensis*), 381, 385

Bornean keeled pit viper, 383

Bornean orangutan (*Pongo pygmaeus*), 381, 385

Borneo, 374, 378–387, 395

Bosnia-Herzegovina, 181, 203

Bosnian maple (*Acer opalus* subsp. *obtusatum*), 205

bossiestroop ("bush syrup"), 265

Bossou Hills, 243

Botanic Gardens Conservation International, 357

Botswana, 252–259

bottlenose dolphin, 179

Brahma, 332

brahma kamal (*Saussurea obvallata*), 332

Brazil, 127, 135–139

Brazilian rose (*Cochlospermum vitifolium*), 108

breadnut (*Brosimum alicastrum*), 75

bristlegrass (*Setaria parviflora*), 399, 401

British people, 26–27

brittlebrush (*Encelia farinosa*), 69

brittle naiad (*Najas minor*), 311

broad-leaved paperbark, 21, 41

Brochoneura acuminata, 287

Bromelia balansae, 91

bromeliad, 99, 101

bronze back snake, 383

Brown's saxifrage (*Saxifraga brunonis*), 337

Brugmansia, 125

Brunei, 379–380

Brunsvigia, 267

bryophytes, 55, 148, 285, 289

Bryum, 204

buckbrush (*Ceanothus cuneatus*), 61

buckhorn cholla (*Cylindropuntia acanthocarpa*), 66–67

buckthorn, 61

buckwheat (*Eriogonum*), 58, 81

Buddha, 353–355

Buddhism, 354

Buddleja incana, 117, 119, 125

Buddleja nitida, 99, 101

buffalo, 275

buffalo thorn (*Ziziphus mucronata*), 233

buffel grass (*Cenchrus ciliaris*), 275

Bukit Barisan Selatan National Park, 373, 377

Bukovske Vrchy (Beech Hills), 183

Bulbine abyssinica, 259

bulbs, 263, 267, 302–303, 319

Bulgaria, 181

bull moose, 45

bulrush (*Typha capensis*), 254–255

bumblebees, 215

Bupleurum candollei, 333, 337

buriti, 133

Burma padauk (*Pterocarpus macrocarpus*), 365

"bush tucker", 20

Busuanga, 397

buttercup, 163, 205

buttercup yellow rockrose (*Halimium commutatum*), 164–167

butter daisy (*Melampodium divaricatum*), 399

butterflies, 58, 95, 101, 189, 363

butterspoon tree (*Cunonia capensis*), 263, 269

butterwort (*Pinguicula vulgaris*), 206, 209

button fern (*Woodwardia radicans*), 221, 223

Cabbage, 302

cabbage palm (*Anthocleista nobilis*), 249

cabimo (*Copaifera panamensis*), 108

cacti, 66, 67, 69

Cai Dam Island, 369

cajaput tree (*Melaleuca cajaputi*), 21

Calakmul, Campeche, 71–75

Calamagrostis, 99, 117

Calanthe nipponica, 407, 409

Calanthe sieboldii, 405, 409

Calanthe striata, 409

calcium carbonate, 25

California bay (*Umbellularia californica*), 56

California lilac, 59–61

California quail (*Callipepla californica*), 58, 61

Calliandra surinamensis, 130, 133

Calophyllum inophyllum, 391, 395

camel's foot tree (*Piliostigma thonningii*), 229

camel thorn (*Vachellia erioloba*), 255, 257

Cameroon, 251

Campeche logwood, 75

Campylocentrum, 75

Canada, 12, 42–51

canangucho, 133

cannonball tree (*Couroupita guianensis*), 129, 133

canoegrass (*Paspalum acuminatum*), 136

canopy trees, 111

Canthium henriquesianum, 239

Cape beech (*Rapanea melanophloeos*), 263, 269

Cape Floral Region, 260–269

Cape Fold Mountain, 262

Cape holly (*Ilex mitis*), 263, 269

Cape Maclear, 279

Cape Peninsula, 262, 265

caper (*Capparis spinosa*), 195, 311

Capnodendron, 281

Cappadocia, 293–297

Cappadocian maple (*Acer cappadocicum*), 297, 319

capuchin monkeys (*Cebus imitator*), 95

caranday palm (*Copernicia alba*), 136, 137

Carapa guianensis, 89, 91

carbon emissions, 11–12

cardamom, 341

carnation, 297

carnivorous plants, 31, 171, 206, 233, 385, 392

Carpathian willow (*Salix silesiaca*), 187

carpetgrass, 136

Carvalho Resende, Tales, 12

Casentinesi Nature Reserve, 185, 187

Caspian locust (*Gleditsia caspica*), 319

Caspian poplar (*Populus caspica*), 315

Caspian Sea, 313, 315

castor aralia (*Kalopanax septemlobus*), 406, 409

Cat Ba Island, 369

Cat Ba National Park, 371

catfish, 251, 254

Cathariostachys capitata, 287

Cathariostachys madagascariensis, 287

Catherine-wheel pincushion (*Leucospermum catherinae*), 265, 269

cativo (*Prioria copaifera*), 108, 111

cattle egret, 167

Caucasian alder (*Alnus subcordata*), 315, 357

Caucasian oak (*Quercus macranthera*), 317

Caucasian wingnut (*Pterocarya fraxinifolia*), 315, 319

Caucasian zelkova (*Zelkova carpinifolia*), 316

Cavanillesia platanifolia, 109

Ceanothus, 59–61

Ceanothus gloriosus, 61

Cecropia, 125

cedar, 45

Cederberg Wilderness Area, 262

Cedrela, 125

Cedrela angustifolia, 125

Cedrela odorata, 125

Ceiba pentandra, 111

Celestial Mountains, 347

Celmisia incana, 31

Celtis timorensis, 343, 345

Centaurea, 295, 323

Centaurea aeolica subsp. *aeolica*, 193

Centaurea behen, 323

Central Asian flyway, 321

Central Suriname Nature Reserve, 126–133

Centropogon trachyanthus, 119

cerrado, 136

Cerro Chirripó, 93, 98

Cerro Malí, 111

Cerro Pirre, 106

Cerro Tacarcuna, 104–105, 111

cetaceans, 179

Cetti's warbler, 167

Ceylon ironwood (*Mesua ferrea*), 343, 345

chalk cliffs, 181

Chamaedorea, 97

Chamaedorea linearis, 97, 101

Chambeyronia macrocarpa, 38

chameleon, 341

chamomile, 193

chaffinch, 167

chaparral, 66

Chara, 215

charcoal burner (*Russula cyanoxantha*), 189

Chatham Islands, 26

cheetah, 253, 254

chena (cheese curds), 339

chenopods, 66

chestnut (*Castanopsis*), 387

chestnut-leaved oak (*Quercus castaneifolia*), 315, 316, 317

Chihuahuan Desert, 63

Chile, 29

chimpanzees, 249, 251

China
 Leshan Giant Buddha Scenic
 Area, 352–357
 Mount Emei Scenic Area,
 352–357
 Xinjiang Tianshan, 346–352
Chinese arborvitae (*Platycladus
 orientalis*), 315
Chiquitana forest, 136
chirita, 371
chive, 201
Chondropetalum tectorum, 269
Christmas Island frigate bird
 (*Fregata andrewsi*), 399, 401
Chrysopogon zizanioides, 229
Chunyang Temple, 355
Chuquiraga, 117
Chuquiraga jussieui, 117, 119
Church of St. John at Kaneo, 211
Chusquea subtessellata, 97, 98–99
cichlids, 279–281
Cienfuegosia digitata, 259
cinder cones, 67
Cinnamomum zeylanicum, 289
cinnamon, 341
Cirque de Gavarnie, 170
Cirque of Soaso, 170
Clark Range, 47
Clarkson, Chris, 17
Clearwater Cave, 385
Clematis connata, 333, 337
climate change, 12, 51, 99
climbing butcher's broom (*Semele
 androgyna*), 220, 223
Clinosperma macrocarpa, 38
cloves, 341
clumping bamboo (*Chusquea
 tovarii*), 117
coastal sage scrub, 58
coastal wood fern (*Dryopteris
 arguta*), 56
coast live oak (*Quercus agrifolia*),
 56–58
coast redwood, 61

coconut, 83, 339
coco plum (*Chrysobalanus icaco*),
 80, 83
Codonopsis viridis, 333
coffee, 89, 341
Cola, 247
Cola laurifolia, 233
Colombia, 107, 111
Columbia manzanita
 (*Arctostaphylos
 columbiana*), 59
Columbus, Christopher, 121
Comarostaphylis arbutoides, 99
common alder (*Alnus glutinosa*),
 201
common crane, 167
common goldeneye, 215
common manzanita
 (*Arctostaphylos manzanita*),
 59
common oak (*Quercus robur*),
 183, 185
common pale iris (*Iris
 douglasiana*), 61
common purslane (*Portulaca
 oleracea*), 399, 401
common redstart, 167
composites, 66
coniferous trees, 28–29, 35, 49,
 167
Conocarpus erectus, 79, 83
Conservation International -
 Conservation Hotspot, 88,
 101, 122, 161, 341
Convention on International
 Trade in Endangered Species
 of Wild Fauna and Flora,
 392, 398
Cook, James, 27, 36
Copaifera aromatica, 108
coral reef araucaria (*Araucaria
 columnaris*), 37
coral reefs, 11, 33, 36, 41, 83, 86,
 369, 397–398

cordgrass (*Sporobolus anglicus*),
 177–179
Cordillera, 114–115
Cordillera de Juradó, 104
cork oak (*Quercus suber*), 164
corms, 263, 267
corn bunting (*Miliaria calandra*),
 179
corn lily, 49
Cornulaca, 311
corozal palm, 75
corpse flower, 374, 377
corpse lily, 380
Corylus sieboldiana, 405, 409
Corypha lecomtei, 365
Costa Rica, 92–101, 106
Costa Rican blueberry
 (*Vaccinium consanguineum*),
 99, 101
Côte d'Ivoire, 237–243
Côte d'Ivoire Strict Nature
 Reserve, 243
cottongrass (*Eriophorum
 vaginatum*), 154–155, 159
Council of Europe, 219
Couratari, 133
coyol palm, 75
craters, 63, 64, 65, 67
Cratoneuron, 204
creeping bent grass (*Agrostis
 stolonifera*), 154
Croatia
 Paklenica National Park, 185,
 189
 Plitvice Lakes National Park,
 202–209
 Primeval Beech Forests, 181
crocodile, 257
Crocosmia, 267
crocus, 302–303, 305
Crocus cancellatus, 302 303
Crocus gilanicus, 319
crowfoot (*Ranunculus baudotii*),
 163

crucifix orchid, 125
Cryptocarya, 287
Cuba, 84–91
Cuban pine (*Pinus cubensis*), 89
Cuban royal palm (*Roystonea regia*), 91
Cuchillas del Toa Biosphere Reserve, 85
Cuiabá River, 135, 139
cuipo, 107
cultivated rice (*Oryza sativa*), 233
Cusco, Peru, 121
cushion plant, 117
Cyathea, 287
Cycas tropophylla, 371
Cynometra vogelii, 233
Cynopterus, 383
Cyperus polystachyos, 254–255, 259
Cypripedium himalaicum, 333
Cytisus aeolicus, 193–195
Czech Republic, 181

Dacrycarpus dacrydioides, 28–29
an-dadjek, 23
Dadu River, 354
Dalbergia, 287, 289
Dalmatian pelican, 321, 325
Danae racemosa, 316, 319
dandelion, 147
Daphne blagayana, 207, 209
Darién National Park, 102–111
Darwin, Charles, 83
Darwin stringybark (*Eucalyptus tetrodonta*), 19
Darwin woollybutt (*Eucalyptus miniata*), 19, 23
date plum (*Diospyros lotus*), 316, 319
David, Armand, 357
Dead Sea Fault, 299
deer, 51

Deer Cave, 381, 384
delphinium, 330
Demanson's cichlid, 281
Democratic Republic of the Congo, 230
Denmark, 174–179
Deplanchea speciosa, 39
depression, 12–13
Derby eland, 227
Déré Forest, 243
desert barrel cactus (*Ferocactus cylindraceus*), 69
desert ironwood (*Olneya tesota*), 67, 69
desert poplar (*Populus euphratica*), 311
desert saltwort (*Atriplex cana*), 325
Dettifoss Waterfall, 144, 149
devil's grass (*Cynodon dactylon*), 257
devil thorn (*Tribulus zeyheri*), 259
diamond leaf willow (*Salix planifolia*), 47, 51
diana monkey (*Cercopithecus diana*), 239, 241
Dierama, 267
Diospyros, 247, 287
Dipterocarpus, 375, 377
Dipterocarpus grandiflorus, 391, 395
Dipterocarpus hispidus, 343
Dipterocarpus retusus, 377
Dipterocarpus zeylanicus, 343
Dipteryx panamensis, 111
Disa welwitschii, 239, 243
Dja Faunal Reserve, 244–251
Dja River, 245
Dja river catfish (*Synodontis pardalis*), 251
Dolmen de Tella, 170
domestic apple (*Malus domestica*), 325

Dominica, 12
Doñana National Park, 160–167
Dong Naim Island, 369
Dong Phayayen-Khao Yai Forest Complex, 358–365
Dong Yai Wildlife Sanctuary, 360
Douglas fir (*Pseudotsuga menziesii*), 49, 56
Douglas iris (*Iris douglasiana*), 56
dove tree (*Davidia involucrata*), 357
downy birch (*Betula pubescens*), 145–147, 323
Draba, 99
Drosera arcturi, 31
Drosera binata, 31
Drosera spatulata, 31
Dryander's grevillea (*Grevillea dryandri*), 23
Drypetes, 247, 391
duckmeat (*Spirodela polyrrhiza*), 311
duckweed (*Lemna*), 309, 311
dunlin, 167
dwarf birch (*Betula glandulosa*), 48–49, 51
dwarf eelgrass (*Zostera noltii*), 179
dwarf mountain pine (*Pinus mugo*), 189
dwarf pine (*Pinus mugo*), 187
dwarf Russian almond (*Prunus tenella*), 323–325
dwarf Siebold maple, 409

Eagle ray, 81–83
eared willow (*Salix aurita*), 187, 189
earthquakes, 25
East African redwood (*Hagenia abyssinica*), 273, 275
East Atlantic Flyway, 176

East Carpathian Mountains, 183
Echinodium setigerum, 223
Ecuador, 112–119
Ecuador laurel (*Cordia alliodora*), 119
edelweiss (*Leontopodium alpinum*), 171, 173
Edraianthus tenuifolius, 205, 209
eelgrass (*Zostera marina*), 179
egusi (*Cucumeropsis mannii*), 251
eight-petalled mountain avens (*Dryas octopetala*), 151
El Altar, 113–114
eland, 227, 275
elder-flowered orchid (*Dactylorhiza sambucina*), 215
Elegia capensis, 267, 269
Elegia tectorum, 265, 267
elephant, 254, 255, 257, 275
elephant dung, 365
Eleutherodactylus, 91
Elierts de Haan Gebergte Nature Reserve, 127–129
elk, 49
elm (*Ulmus*), 154
El Nido Island, 392
El Pinacate and Gran Desierto de Altar Biosphere Reserve, 62–69
Emei River, 354
Empakaai Crater, 272
Empodisma minus, 31
Encyclia, 91
Encyclia navarroi, 91
endangered species, 89, 153, 253, 332, 348, 349, 373, 377, 392, 398
Endemic Bird Areas, 88, 103, 122, 275, 341
Engelmann spruce (*Picea engelmannii*), 49
Epidendrum, 75

Epidendrum secundum, 125
epiphytes, 239, 285, 391
Erica ciliaris, 164
Erica quadrangularis, 266, 269
Eriochrysis brachypogon, 231
Eriogonum, 58
eru (*Gnetum africanum*), 249–251
Erysimum brulloi, 193, 195
Erythophleum, 233
Erythrophleum suaveolens, 233
Escallonia myrtilloides, 95, 99
Escuain Cave, 170
Escuaín gorge, 170
eucalyptus, 19, 23
Eucalyptus, 19
euphorb, 111
euphorbias, 66
Euphrates River, 307, 308
European ash (*Fraxinus excelsior*), 183, 187, 319
European beech (*Fagus sylvatica*), 173, 183, 205, 315
European blueberry (*Vaccinium myrtillus*), 145, 147
European box (*Buxus sempervirens*), 315
European fan palm (*Chamaerops humilis*), 195
European hop-hornbeam (*Ostrya carpinifolia*), 205, 209
European hornbeam (*Carpinus betulus*), 185, 316, 317
European smoketree (*Cotinus coggygria*), 205, 209
European spruce (*Picea excelsa*), 205, 209
European stonechat (*Saxicola rubicola*), 164
European yew (*Taxus baccata*), 315, 319

Fagus, 181
fairy chimneys, 297
fairy slipper (*Calypso bulbosa*), 56, 61
false staghorn fern (*Dicranopteris linearis*), 345
fan palm, 20, 91, 108, 383
Farallones de Moa, 87
Faramea luteovirens, 111
feathergrass, 322, 323, 325
feather palm, 131, 137
feltleaf ceanothus (*Ceanothus arboreus*), 61
ferns, 164, 187, 205, 221, 239, 254, 287, 289, 345, 387, 407
fescue, 51
Festuca, 99, 117
Festuca novaezelandiae, 31
Festuca rupicola, 322, 325
Festuca valesiaca, 322
Ficus, 119, 391
Ficus rosulata, 383
fiddleneck (*Amsinckia menziesu*), 69
field gentian (*Gentianella campestris*), 155, 159
field maple (*Acer campestre*), 183, 185
fig, 97, 119, 383
Fijnboch, 263
fine-leaf wadara, 133
fine-textured bent grass (*Agrostis capillaris*), 154
fingergrass (*Digitaria* spp.), 136
fir, 49, 205
fire heath (*Erica cerinthoides*), 266, 269
fireweed, 51
fish, 33, 36, 55, 63, 81, 95, 215, 251, 254, 277, 279, 295, 398–399
fish eagle, 257
fishtail palms (*Caryota no*), 384

Fissidens nobreganus, 223

flamethrower palm
 (*Chambeyronia*
 macrocarpa), 41

floating (rooted) leaved aquatic
 vegetation, 309

floodplains, 19, 20–21

flying frog, 382, 387

flying lemur, 383

footprints, 272

Forbidden City, 357

Forest Research Institute, 332

foxglove (*Digitalis purpurea*),
 201

France
 New Caledonia, 33–41
 Primeval Beech Forests, 181
 Pyrenees—Mont Perdu, 168–
 173

Fraser, John, 86

free-floating vegetation, 309

Fremont's star (*Toxicoscordion*
 fremontii), 56, 61

French Guiana, 127

Freziera forerorum, 111

Fritillaria olivieri, 319

Fritillaria roylei, 335

frog's pulpit (*Nymphaea nouchali*
 var. *caerulea*), 257, 259

fruit bats, 383

fuchsia, 101

Fuchsia, 125

Fuchsia paniculata, 101

fulmars, 159

fungi, 187, 189, 223, 239

fynbos ("fine bush"), 263, 265,
 267

Galichica National Park, 215

gamba grass (*Andropogon*
 gayanus), 229

gannets, 157, 159

garapa, 137–139

Garnerm LariAnn, 395

Garwhal Himalayas, 330

Gaudinia hispanica, 167

gazelle, 271

Geiger, John, 83

Geiger tree (*Cordia sebestena*),
 79, 83

Geirangerfjord, 197–198, 201

Genista tyrrhena subsp.
 tyrrhena, 193, 195

Genlisea africana, 233

gentian (*Gentiana bellidifolia*), 31

Gentiana sino-ornata, 335, 337

geranium, 330

Geranium madarense, 223

Geranium maderense, 221–223

Geranium palmatum, 221, 223

Geranium wallichianum, 337

Germany, 174–179, 185–189

gesneriad, 371

Giant Buddha of Leshan, 353,
 354–355

giant Himalayan balsam
 (*Impatiens sulcata*), 333, 337

giant kelp (*Macrocystis pyrifera*),
 61

giant reed (*Arundo donax*), 309,
 311

giant star grass (*Cynodon*
 plectostachyus), 275

giant tree fern (*Sphaeropteris*
 intermedia), 39–41

giant trevally (*Caranx*
 sexfasciatus), 398, 401

giant trillium (*Trillium*
 chloropetalum), 56, 61

giant wrasse (*Cheilinus*
 undulatus), 399, 401

Gilan Province, 314

Gilbertiodendron dewevrei, 247

Gin Ganga, 342

giraffe, 233, 255, 275

giraffe cichlid, 281

giraffe-necked weevil, 383

Glacier National Park, 45, 47, 51

glaciers, 51, 93, 143–144, 147, 171

gladioli, 263

glasswort (*Salicornia*
 ramosissima), 163, 176

Global Centers of Plant Diversity,
 261

Glovers Reef Marine Reserve, 78

godwit, 167

golden apple lily (*Lilium*
 carniolicum), 207, 209

golden jackal, 275

golden pagoda (*Mimetes*
 chrysanthus), 265–266, 269

goldfinch, 167

Golestan Province, 314

Gondwanaland Cretaceous flora,
 35

Gonimbrasia belina, 257

Goreme National Park, 293–297

Gorigor Swamp, 271

Grammatophyllum speciosum,
 380, 387

Gran Altar Desert, 63, 64

grand devil'sclaws (*Pisonia*
 grandis), 399

Grant's gazelle, 275

grasses, 27, 31, 66, 99, 117, 136,
 154, 167, 187, 229, 239, 254,
 257–259, 267, 275, 322, 323,
 325, 399

gray alder (*Alnus incana*), 201

gray heron (*Ardea cinerea*), 164,
 167

gray-necked rockfowl
 (*Picathartes oreas*), 251

gray rhebok, 267

gray seal, 179

gray willow (*Salix atrocinerea*),
 164, 167

Great Barrier Reef, 14

Great Basin Desert, 63

Greater Blue Mountains Area, 12

greater flamingo, 167

greater spotted cuckoo, 167

great hornbill, 363

Great Rift Valley, 271–272

great skua, 159

great woodrush (*Luzula sylvatica*), 155, 159

great yellow bumblebee (*Bombus distinguendus*), 155, 159

Greece, 213

green alder (*Alnus viridis*), 183, 187

green chameleon, 287

greenfinch, 167

green heather (*Erica scoparia*), 164, 167

green turtle (*Chelonia mydas*), 36, 399

Grevillea, 23

Grevillea angulata, 23

Grevillea gillivrayi, 39, 41

Grevillea heliosperma, 23

Grímsvötn, 143, 145

grizzly bear, 49

Groot Winterhoek Wilderness Area, 262

Guadalquivir River, 161, 162, 163

guanacaste (*Enterolobium cyclocarpum*), 107, 111

guano, 157

Guatemala, 399

guava crape myrtle (*Lagerstroemia calyculata*), 365

guayabo de charco (*Terminalia amazonia*), 101

Guianan cock-of-the-rock (*Rupicola rupicola*), 133

guibuk, 23

Guinea, 237–243

Guinea plum (*Parinari excelsa*), 239

Guinea Strict Nature Reserve, 243

Gulf of San Miguel, 104, 108

Gulf of Tonkin, 367

gum arabic tree (*Vachellia nilotica*), 231

gumbo-limbo (*Bursera simaruba*), 80, 83

gun-god, 23

Gunnera, 95, 101

Gunnera insignis, 95, 101

Gunnera talamancana, 101

Gunung Leuser National Park, 373, 375–377

Gunung Mulu National Park, 378–387

Guyana, 127

Habenaria, 75

habitat destruction, 243

Haemanthus, 267

Haew Narok Waterfall, 361

Hainich National Park, 183

hairy gray heather (*Erica canaliculata*), 266, 269

hairy sedge (*Carex pilosa*), 187, 189

Half Moon Caye Natural Monument, 77, 78–79

Halimium halimifolium, 167

Hall's totara (*Podocarpus laetus*), 28

Halodule, 401

Ha Long Bay, 366–371

Ha Long fan palm (*Livistona halongensis*), 371

halophytic vegetation, 311, 325

hameli/hamelí, 107

hammada, 301

hammerhead shark (*Sphyrna lewini*), 398

Handroanthus chrysanthus, 139

haplochromine cichlids, 279–281

harbor porpoise, 179

hard beech (*Nothofagus truncata*), 29

hardy ginger (*Roscoea purpurea*), 333

hartebeest, 275

hawksbill turtle (*Eretmochelys imbricata*), 398, 399

hazel (*Corylus*), 154, 405

heart-leaf adina (*Haldina cordifolia*), 363

heath, 59, 163, 263, 266

heather (*Calluna vulgaris*), 145, 154

Hebridean sheep, 159

Heinrich, Volker, 391

Helichrysum, 323

Heliconia, 91

Heliconia caribaea, 91

heliconias, 91

helophytic vegetation, 311

Hemarthria altissima, 231

Hemkund Sahib, 331

hemlock, 45

Hercules, 173

Herðubreið, 144

Heritiera utilis, 239–241

Hibiscus noldeae, 239

Hieracium, 295

Himalayan bergenia (*Bergenia stracheyi*), 333, 337

Himalayan birch (*Betula utilis*), 332, 333

Himalayan maidenhair (*Adiantum venustum*), 333, 337

Himalayan slipper orchid, 333

Himalayan trillium, 335

Hindu mythology, 332

hippo, 254, 257

Hljóðaklettar, 144

Hoa Binh Culture, 369

Holcus lanatus, 154, 159

holly (*Ilex hyrcana*), 316

holly oak (*Quercus ilex*), 195

holm oak (*Quercus rotundifolia*), 173

Homo, 272

Honduran mahogany (*Swietenia macrophylla*), 345

Honduras, 12

honey, 31, 341

Hooker, Dalton, 125

Hopea, 375, 377

Hopea beccariana, 377

hop-hornbeam, 205

hornbill, 365

horse-eye jacks, 83

horsetail (*Equisetum*), 267

Horsfieldia atjehensis, 377

Hosta sieboldii, 405, 409

hot lips plant (*Palicoura elata*), 111

hoverflies, 31

howler monkey, 95, 101

Huayna Picchu, 122

Hugo, Victor, 170

Humboldt, Alexander von, 85–86

Humboldt oak (*Quercus humboldtii*), 111

hummingbirds, 58

hureim (*Zygophyllum simplex*), 303

Hvannadalshnjúkur, 144

Hypericum costaricense, 99, 101

Hyphaene petersiana, 255

Hyrcanian Forests, 312–319

Iceland, 142–151

Icelandic hawkweed (*Pilosella islandica*), 147, 151

Iceland moss (*Cetraria islandica*), 149, 151

Idaho fescue (*Festuca idahoensis*), 51

Ilex chiriquensis, 101

illegal logging, 101, 125, 345, 380

Impatiens verrucifer, 371

Important Bird Area, 251

Inca Empire, 121

India, 328–337

Indian paintbrush (*Castilleja miniata*), 51

Indo-Australian plate, 26

Indochinese tiger (*Panthera tigris corbetti*), 363, 365

Indonesia, 12, 29, 372–377, 379

International Dark-Sky Association, 47

International Dark Sky Park, 47

International Peace Park, 45

International Union for Conservation of Nature (IUCN), 12, 395

ipé, 139

ipé-amarelo (*Handroanthus chrysanthus*), 137

ipé-roxo-damata (*Handroanthus impetiginosus*), 137

Ipomoea chiriquiensis, 101

Iran, 312–319

Iraq, 306–311

iris, 263, 319

Iris meda, 319

Iris postii, 303

iron ore, 243

ita, 133

Italy, 181, 190–195

itchytree (*Barringtonia acutangula*), 19, 23

Itea omeiensis, 357

ité palm, 133

IUCN Red List of Threatened Species, 129, 343, 349

Ixia, 267

Jabiru, 139

jackalberry (*Diospyros mespiliformis*), 231, 233, 235

Japan, 402–409

Japanese clethra (*Clethra barbinervis*), 406, 407

Japanese hop-hornbeam (*Ostrya japonica*), 406, 409

jatobá tree (*Hymenaea courbaril*), 136–137, 139

Jessie Beazley Reef, 397, 398

jewelled campan, 289

Jiaopenba underground river, 354

Jiulaodong karst cavern, 354

Joey palm (*Johannesteijsmannia altifrons*), 377

jointed anabis (*Anabasis articulata*), 301

jointed glasswort (*Halocnemum strobilaceum*), 325

jökulhlaups, 145

Jökulsá á Fjöllum, 149

Jordan, 299–305

Julianatop, 133

jumping cholla (*Cylindropuntia fulgida*), 67

Junegrass (*Koeleria macrantha*), 51

Juniperus sabina, 351

Kaan, 72

kahikatea (*Dacrycarpus dacrydioides*), 29, 31

Kaikoura earthquake, 26

Kakadu National Park, 16–23

Kakaramea-Tihia Massif, 28

Kalahari Desert, 253

Kalajun-Kuerdening, 347, 351

Kalanchoe, 289

Kalkalpen National Park, 185, 189

Kalu Ganga, 342

Kandelia obovata, 371

kapok tree (*Ceiba pentandra*), 109, 111, 129, 130, 133

Kappel savanna, 133

katsura (*Cercidiphyllum japonicum*), 406, 409

Kazakh milkvetch (*Astragalus kasachstanicus*), 325

Kazakh Rolling Hills, 321

Kazakhstan, 320–327

kelp, 56

Kenyan Rift Valley, 275

Kerinci Seblat National Park, 373, 375, 377

Khao Yai National Park, 359, 361, 363, 365

kingfisher, 257

king protea (*Protea cynaroides*), 263–264, 269

Kirgiz birch (*Betula kirghizorum*), 323

kittiwakes, 159

Knema intermedia, 377

koghis kauri (*Agathis lanceolata*), 35, 37–38, 39, 41

Koolpinyah Surface, 19

Korana River, 204

Korana Valley, 204

Korat Plateau, 359, 361

Korgalzhyn State Nature Reserve, 321, 323

krummholz, 47

Ktunaxa (Kootenai) people, 47

Kuba people, 230

kunai grass (*Imperata cylindrica*), 257

Kurrajong (*Brachychiton paradoxus*), 20

Kverkfjöll, 144

Labyrinthula zosterae, 170

lace lichen (*Ramalina menziesii*), 56

Lachenalia, 267

lady's mantle (*Alchemilla faeroensis*), 147, 151, 201

lady's slipper orchid (*Cypripedium calceolus*), 206–207, 209

Laetoli, 272

"The Laetoli Footprints", 272

Lagerstroemia calyculata, 361

Laguna Pintada, 114

Laguncularia racemosa, 79

Laiyanai Forest, 273

Lake Eyasi, 272, 273

Lake Magadi, 275

Lake Makat, 271

Lake Malawi National Park, 276–281

Lake Ohrid, 210–215

Lake Prespa, 213

lakeshore bulrush, 163, 325

Lake Taupo, 27

Lake Tengiz, 323

Lake Toba, 375

Lake Yaté, 39

Landolphia dulcis, 230–231

Landoltia punctata, 309

Langogan River, 392, 393

lantern bug, 383

lapwing, 167

large-leaved orange mangrove (*Bruguiera gymnorhiza*), 371

large purple orchid, 41

Laughing Bird Caye National Park, 77

laurel, 219, 223

Laurisilva of Madeira, 216–223

Laurissilva do Barbusano, 219

Laurissilva do Til, 219

Laurissilva do Vinhático, 219, 223

Laurobasidium lauri, 223

Laurus novocanariensis, 220, 221

Leach's petrel, 159

leadwood (*Combretum imberbe*), 257

Leakey, Mary, 272

leek orchid (*Prasophyllum colensoi*), 31

legumes, 66, 246

Lemna gibba, 309

Lemna minor, 309, 311

Lemna perpusilla, 309, 311

Lemna trisulca, 309

lemur, 287

Leontodon oxylepis, 297

leopard, 254

Leptolaena abrahami, 287

Lerai Forest, 273

Leshan Giant Buddha Scenic Area, 352–357

lesser bulrush (*Typha angustifolia*), 311, 325

lesser flamingos, 164

lesser kestrel, 167

lesser kudu, 275

Lesser Sundas, 395

Leucadendron, 264, 265

Leucospermum, 264

Leucospermum cordifolium, 265

Lewis, Meriwether, 51

Lewis Overthrust, 47

Lewis Range, 47

Lewis's monkeyflower (*Erythranthe lewisii*), 51

liana, 111, 239, 343

Liberia, 237

Licania hypoleuca, 111

lichen, 31, 56, 115, 149, 151, 185, 189, 239, 285, 289

Licka Pljesevica, 203

Licuala orbicularis, 383

Lighthouse Reef, 78

lilac orchid, 345

Lilium chalcedonicum, 215

lily-of-the-valley tree (*Clethra arborea*), 221, 223

lime tree (*Tilia platyphyllos*), 319

Limonium gmelinii, 325

limpo grass (*Hemarthria altissima*), 235

Linaria tursica, 167

linden, 185–187

lion, 253, 254, 275

lithophytes, 391

little egret, 167

Livingston Range, 47

Livistona humilis, 20

Livistona inermis, 20

llama, 125

lodgepole pine (*Pinus contorta*), 49

loggerhead (*Caretta caretta*), 36

Loliondo Game Control Reserve, 272

Lombrives Cave, 173

long-leaved butterwort (*Pinguicula longifola*), 171–173

Longmendong Gorge, 354

long-nosed whip snake, 341

longnose hawkfish, 401

long-tailed macaques, 383, 385

loop-root mangrove (*Rhizophora mucronata*), 371

Loudetia kagerensis, 239

Lovejoy, Thomas, 11

lowland gorilla (*Gorilla gorilla gorilla*), 251

lowland rainforest, 19

Loxococcus rupicola, 345

Loyalty Islands, 33, 37

lupine, 117

Lupinus, 99

Lupinus alopecuroides, 117, 119

lycopods, 239

Maasai people, 271

Mabea occidentalis, 111

Macedonian pine (*Pinus peuce*), 215

Machu Picchu, 120–125

Madagascar, 89, 283–289

Madascar ocotillo (*Alluaudia procera*), 289

Madeira orchid (*Dactylorhiza foliosa*), 223

Madeira wood fern (*Dryopteris maderensis*), 221

madrone (*Arbutus menziesii*), 59, 61

magnolia, 89

Magnolia, 91, 357

Magnolia cristalensis, 91

Magnolia cubensis, 91

Magnolia omeiensis, 357

Magnolia sieboldii, 405–406, 409

mahogany (*Swietenia macrophylla*), 89, 125

maidenhair fern (*Adiantum novae-caledoniae*), 41

Makarut Mountain, 273

Makha tree (*Afzelia xylocarpa*), 363–365

Mala Kapela, 204

Malawi, 276–281

Malaysia, 12, 379

mallow, 111

Malus sieversii, 325

manaca palm, 75

manatee grass, 83

manatee, 81

mangrove, 19, 20, 21, 36, 75, 79, 80, 83, 106, 107, 275, 371, 391, 393–395

manta ray (*Mobula diabolus*), 398

manuka (*Leptospermum scoparium*) is, 31

Manx shearwater, 159

manzanita (*Arctostaphylos* spp.), 59

Māori people, 26–27

Mapania, 247

maple, 405

Mapun, 397

maquis, 36, 39, 41, 161, 193

Marantochloa purpurea, 247–249, 251

maripa palm (*Attalea maripa*), 131, 133

Marojejya darianii, 287, 289

Marojejy National Park, 285, 287

marram grass (*Ammophila arenaria*), 163

Masoala National Park, 285, 287

massif, 28, 63, 64, 86, 169–170, 183, 185, 271, 287, 313

matgrass (*Nardus stricta*), 187

Maya, 71–73

Mazandaran Province, 314

mbuna (rockfish), 279, 281

McPherson, Stewart, 391

meadow saffron (*Colchicum tunicatum*), 303

meadow squill (*Scilla litardierei*), 205

Meconopsis aculeata, 332, 337

medicinal plants, 351

Mediterranean cypress (*Cupressus sempervirens* var. *horizontalis*), 315

Mekong River, 360

Melaleuca, 21

Melaleuca viridiflora, 21

Melinau River, 384

Merian, Maria Sibylla, 133

Meriania, 133

Mesoamerican Barrier Reef, 14

Mesopotamian cities, 306–311

mesquite, 66

Mexican giant cactus (*Pachycereus pringlei*), 67, 69

Mexican ponytail palm (*Beaucarnea pliabilis*), 75

Mexico

 Ancient Maya City and Protected Tropical Forests of Calakmul, Campeche, Mexico, 70–75

 El Pinacate and Gran Desierto de Altar Biosphere Reserve, 62–69

 native plants, 399

Miconia cernuiflora, 117

Miconia cinnabarina, 117

Miconia dimorphotheca, 117

Miconia dulcis, 117

Miconia salicifolia, 117

microplastics, 11

Micropyropsis tuberosa, 167

migratory birds, 176, 321

millet (*Echinochloa*), 229

Mimetes, 264

Mimosa pigra, 231, 235

Mindanao, 395, 397

Mindoro, 397

mineral deposits, 35

mining, 243, 345

Minjiang, 354

miriti, 133

Miscanthus, 254

Miscanthus junceus, 257

Missouri Botanical Garden, 107

Mojave Desert, 63

mollusk, 281

Moluccan ironwood (*Intsia bijuga*), 391, 395

Moluccas, 395

Mongolia, 12

Mongolian oak (*Quercus mongolica*), 106, 109

Monnina crassifolia, 117, 119

Monophyllaea pendula, 385

Monterey ceanothus (*Ceanothus rigidus*), 56

Monterey cypress (*Hesperocyparis macrocarpa*), 56

Monterey pine (*Pinus radiata*), 56, 58

Month of May River, 39

Mont Perdu, 168–173

moon orchid, 195

moonwort (*Botrychium lunaria*), 155, 159

moose, 45, 49

mopane (*Colophospermum mopane*), 256–257

Moraea, 267

Moraea villosa subsp. *elandsmontana*, 267

Mora oleifera, 107, 111

moriche palm (*Mauritia flexuosa*), 133

Morina longifolia, 333, 337

moss, 145, 148–149, 187, 204, 223, 239

"mother of laurel", 221, 223

mountain avens (*Dryas octopetala*), 48, 51, 148

mountain beech (*Nothofagus solandri* var. *cliffortioides*), 31

mountain cedar (*Libocedrus bidwillii*), 29, 31

mountain imperial pigeon (*Ducula badia*), 365

mountain palm (*Prestoea acuminata* var. *montana*), 89–91

mountain pine (*Pinus mugo* subsp. *uncinata*), 173

Mount Blakiston, 47

Mount Cleveland, 47

Mount Cook, 95

Mount Emei Scenic Area, 352–357

Mount Galichica, 213

Mount Galichica National Park, 211

Mount Matalingahan, 391

Mount Ngauruhoe, 27–28

Mount Nimba Strict Nature Reserve, 241, 243

Mount Ruapehu, 27–28

Mount Saint Paul, 390

Mount Tongariro, 27–28

Mount Victoria, 391

Mouriri parviflora, 111

Muhlenbergia, 99

muschelkalk, 187

mushrooms, 341, 345, 365

myrrh (*Commiphora myrrha*), 275

Myrrhidendron maxonii, 101

myrtle, 239

Myrtus communis, 117, 119

Nam Mun River, 360

Nanda Devi, 329, 330

Nanda Devi National Park, 329, 330

nanoplastics, 11

Naroyfjord, 199–201

narrowleaf seagrass (*Halodule uninervis*), 399

narrow-leaved ash (*Fraxinus angustifolia*), 164

National Natural Reserve of Massane, France, 183

National Register of Valuable Cultural Landscapes, 197–198

National Trust for Scotland, 148

Natura 2000 Network, 219

Natural Reserve of the Desertas Islands, 217

Natural Reserve of the Selvagens Islands, 217

Naurzum State Nature Reserve, 321, 322

Ndolé, 249

Nectandra, 125

Nectandra reticulata, 139

needle seagrass (*Halodule pinifolia*), 399

Negros, 397

Nepenthes, 382

Nepenthes ampullaria, 382–383, 387

Nepenthes attenboroughii, 391–392, 395

Nepenthes campanulata, 385

Nepenthes faizaliana, 385, 387

Nepenthes lowii, 385, 387

Nepenthes muluensis, 385

Nepenthes rafflesiana, 385, 387

neptune grass (*Cymodocea*), 37

Netherlands, 174–179

Neurada procumbens, 301, 305
New Caledonia, 26, 29, 33–41
New Caledonian barrier reef, 14
New Guinea, 29, 395
New Zealand, 25–31
Ngoc Vung Island, 369
Ngorongoro Conservation Area, 270–275
Ngorongoro Crater, 271
Ngorongoro Crater flamingos, 275
nightblooming cereus (*Peniocereus greggii*), 69
Niitsitapi (Blackfoot) people, 47
Niokolo-Koba National Park, 226–235
Noble Eightfold Path, 355
Nomocharis nanum, 330
Nomocharis oxypetala, 330
North Atoll, 397, 398
northern green orchid (*Platanthera hyperborea*), 147, 151
Northern Ireland, 152–159
northern lapwing (*Vanellus vanellus*), 179
North Macedonia, 181, 210–215
Norway, 145, 196–201
Norway maple (*Acer platanoides*), 183, 185, 187
Norway spruce (*Picea abies*), 199, 201
Nothofagus, 28, 29–31
nurse sharks, 83
nutmeg (*Myristica fragrans*), 139
Nymphaea candida, 325
nypa palm (*Nypa fruticans*), 392, 395

Oak (*Quercus*), 56–58, 69, 111, 129, 154, 164, 173, 183, 185, 387
oak of Virgil (*Quercus virgiliana*), 195

oceans, 11
Ocotea, 287
ocotillo (*Fouquieria splendens*), 67, 69
Oenocarpus bacaba, 129, 131
Oenocarpus mapora, 111
Ohrid, 210–215
oil palm, 374
Okavango Delta, 252–259
Okavango River, 253
Oldeania alpina, 273
Oldeani Mountain, 273
"old man's toe", 139
Oldupai Gorge, 272
Oleandra articulata, 89
Olifants River, 262
olive (*Olea europaea*), 164, 192, 193
Oncocyclus, 319
Oncosperma fasciculatum, 345
onion, 319
onionwood (*Cassipourea malosana*), 273, 275
Onobrychis ("devoured by donkeys"), 297
Onobrychis elata, 297
Onosma, 295
Ophrys lunulata, 195
Öræfajökull, 144
orangutan, 377, 387
orchids, 31, 56, 99, 123, 125, 147, 195, 206–207, 209, 215, 223, 239, 263, 289, 345, 385, 387, 391, 405, 407
Ordesa canyon, 170
oribi, 275
oriental beech (*Fagus orientalis*), 315
oriental hornbeam (*Carpinus orientalis*), 317–319
ornamental pincushion (*Leucospermum cordifolium*), 269
osprey, 167

oxtongue (*Anchusa milleri*), 303

Pachira aquatica, 111
Pachira sessilis, 111
Pachylobus buettneri, 247
Pachypodium, 289
Pacific coast iris, 61
Pacific lychee, 395
Pacific plate, 26
Pacific turtlegrass (*Thalassia hemprichii*), 399, 401
Pacific walnut (*Dracontomelon dao*), 391
paddleweed (*Halophila ovalis*), 399, 401
paddyfield warbler (*Acrocephalus agricola*), 179
Paeonia mascula, 207, 209
Paklenica National Park, 185, 189
Palaquium dubardii, 391
Palawan, 390–395, 397
Palawan Moist Forest, 390
Pallas's fish eagle, 321, 325
palm, 35, 38, 41, 75, 89–91, 108, 111, 125, 130–131, 137, 230, 287, 289, 345, 365, 371, 377, 383, 384–385, 391, 392–393
Pamirs, 349
Pamir-Tian Shan Highlands, 348
Panama
 Darién National Park, 102–111
 Talamanca Range-La Amistad Reserves / La Amistad National Park, 92–101
Panay, 397
Pancratium sickenbergeri, 305
Pandanus, 289
Pang Sida National Park, 360, 363, 365
panic grass (*Panicum repens*), 257
Pankhurst, Richard, 155

Pantanal Conservation Area, 134–139

paperbark swamp, 19

Paphiopedilum sanderianum, 385, 387

Papua New Guinea, 29, 374

papyrus (*Cyperus papyrus*), 254, 309

Paraboea halongensis, 371

Paraguay, 135

Paraguay River, 135, 139

Parahebe, 31

parahebe snowcap (*Parahebe catarractae*), 31

Paramaribo City, 127

páramo, 97, 98–99, 119

Parkia bicolor, 243

Parnassia omeiensis, 357

Paspalum orbiculare, 229

Passiflora, 125

peacock flower (*Albizia gummifera*), 272–273

peacock moraea (*Moraea villosa*), 267, 269

peat, 31, 136, 287

peewit, 179

pelargonium, 263

pencil cedar (*Juniperus procera*), 273

peony, 207

perennial glasswort (*Arthrocnemum perenne*), 103

Pernettya prostrata, 99

Persea indica, 223

Persian ironwood (*Parrotia persica*), 316–317, 319

Persian juniper (*Juniperus polycarpos*), 315

Persian leopard (*Panthera pardus tulliana*), 313, 315

Persian silk tree (*Albizia julibrissin*), 316, 319

Peru, 120–125

Peruvian magic tree (*Cantua buxifolia*), 125

petrino, 107

petticoat palm (*Copernicia macroglossa*), 91

Peyrieras pygmy, 289

Phanom Dongrek escarpment, 359

Philenoptera violacea, 255, 259

Philippia, 289

Philippines

 Puerto-Princesa Subterranean River National Park, 388–395

 Tubbataha Reefs Natural Park, 397–401

philodendron, 391

Philodendron, 101

Phoebe zhennan, 357

Phoenician juniper (*Juniperus phoenicea*), 302

Phragmites australis, 254, 311, 325

Phryna ortegioides, 297

Pierce, Richard, 125

Pihanga, 27, 28

pijio, 107

Pilea rugosissima, 101

pileated gibbon (*Hylobates pileatus*), 363, 365

Piliostigma thonningii, 235

Pinacate Shield, 63, 65, 66, 67

pine, 49, 58, 89, 164, 187, 205, 351

pineapple, 125

pine cone, 58

Pineta valley, 170

pink-footed geese (*Anser brachyrhynchus*), 144

pink heather, 159

pink tamarisk (*Tamarix ramosissima*), 325

Pinnacles, 385

Piper ecuadorense, 117

Piper pinoganense, 111

Piptadeniastrum africanum, 239, 243, 246, 251

Pipturus, 391

pitcher plant, 289, 345, 385, 391–392, 395

Plantago rigida, 117, 119

plantain-leaved leopard's-bane (*Doronicum plantagineum*), 215

plastic, 11

Platypodium elegans, 111

Playa Muerto, 109

pleurocarp moss, 223

Plitvice Lakes National Park, 202–209

Plitvice Plateau, 203

plume poppy (*Bocconia frutescens*), 114, 117

Poa, 117

poaching, 233, 321, 392

Poa colensoi, 31

Podocarpus, 28, 289

Podocarpus angustifolius, 89

Podocarpus glomeratus, 125

Podocarpus oleifolius, 101, 117, 119

Poland, 181, 183, 201

polar willow (*Salix polaris*), 198, 201

Polemonium caeruleum, 330, 337

Polylepis pepei, 125

Polylepis subsericans, 125

Polylepis tomentella, 117, 119

Polystachya microbambusa, 239, 243

Pometia pinnata, 391

poor man's umbrella (*Gunnera talamancana*), 101

poppy, 332

Portugal, 216–223

Portuguese oak (*Quercus faginea*), 173

Potamogeton, 215

potto (*Perodicticus potto*), 241

Pouteria amygdalina, 73–75
Prachinburi River, 360
Prasophyllum, 31
pretino, 107
Primeval Beech Forests of the
 Carpathians, 180–189
primula, 209
Primula kitaibeliana, 207
Primula sieboldii, 406, 409
Primula wigramiana, 335
Primula wulfeniana, 207, 209
Primulina drakei, 371
Primulina modesta, 371
proboscis monkey (*Nasalis
 larvatus*), 381, 383, 385
Prosopis juliflora, 108, 111
protea, 263–264
Protea, 264
Protea nitida, 264
Pterocarpus erinaceus, 229
Pterocarpus officinalis, 107
Puccinellia tenuissima, 325
Puerto-Princesa Subterranean
 River National Park, 388–
 395
puffins, 159
puff-throated bulbul, 363
pungara (*Garcinia macrophylla*),
 139
"pura vida", 101
purple-faced langur, 345
puya, 125
Puya dasylirioides, 99
Puya herrerae, 125
Puya raimondii, 125
Pyrene, Princess, 173
Pyrenean saxifrage (*Saxifraga
 longifolia*), 171, 173
Pyrenean violet (*Ramonda
 myconi*), 171, 173
Pyrenees—Mont Perdu, 168–173

Qingyi River, 354
Quaint Harbor, 265
quaking aspen (*Populus
 tremuloides*), 45, 51
Quenual Forest, 125
Quercus copeyensis, 101
Quercus costaricensis, 101
quetzal (*Pharomachrus
 mocinno*), 97, 99
quinine (*Cinchona* spp.), 125

Racomitrium canescens, 148
Racomitrium ericoides, 148
Rafflesia, 373
Rafflesia arnoldii, 373, 377, 380
Rafflesia atjehensis, 373
Rafflesia micropylora, 373
Rafflesia rochussenii, 373
rainbow eucalytptus (*Eucalyptus
 deglupta*), 395
Rainforests of the Atsinanana,
 283–289
"rain frogs", 91
Rakwana Mountain, 342
Ralleighvallen Nature Reserve,
 129
rams, 159
Ranomafana, 287
Ranunculus peltatus subsp.
 baudotii, 167
Ranunculus thora, 205, 209
Ranzania japonica, 407, 409
Raoulia albosericea, 31
Raphia hookeri, 251
rattan, 341
red acacia, 273, 275
red alder (*Alnus rubra*), 56
red algae (*Trentepohlia* spp.), 56
red beech (*Nothofagus fusca*),
 29, 31
red ceiba (*Bombacopsis quinata*),
 108, 111

red colobus monkey, 239
red-faced parrot (*Hapalopsittaca
 pyrrhops*), 119
red fescue (*Festuca rubra*), 154,
 159, 187
red ironwood tree (*Lophira
 procera*), 239
red kite, 167
red-leaved fig (*Ficus ingens*), 229,
 235
red lemur palm (*Lemurophoenix
 halleuxii*), 287, 289
red mangrove (*Rhizophora
 mangle*), 83, 107, 393, 395
redshank (*Tringa totanus*), 179
red-tailed black cockatoos, 23
red thorn (*Vachellia lahai*), 273
red-throated-bee-eater, 233
red tussock grass (*Chionochloa
 rubra*), 31
redwood, 53, 55–56
Redwood National and State
 Parks, 52–61
redwood sorrel (*Oxalis oregana*),
 56, 58, 61
reed, 254–255, 257, 266–267,
 309, 325
reindeer (*Rangifer tarandus*),
 144, 145
reindeer lichen (*Cladonia
 rangiferina*), 149, 151
religious sites, 27
reptiles, 94, 251
Reseda armena, 297
Restio multiflorus, 265, 267
retem (*Retama raetam*), 301, 305
Reykjavik ("Smoke Cove"), 145
rhinoceros, 253, 255
Rhizanthes, 373
Rhizanthes lowii, 373
Rhizanthes zippelii, 373
Rhizophora, 36, 393
Rhizophora mangle, 79
Rhizophora mucronata, 371

rhododendron, 385

Rhododendron campanulatum, 332, 337

Rhododendron hemsleyanum, 357

Rhododendron lowii, 385, 387

rice, 233

ring-tailed lemur, 287

ring-tailed vontsira, 287

Rio Platano Biosphere Reserve, 12

riparian vegetation, 311

river mangrove (*Aegiceras corniculatum*), 371

roan antelope, 254, 275

"robber frogs", 91

Robinson, Alastair, 391

rock art, 20

rock carving, 297

rock hyrax (*Procavia capensis*), 239, 243

rock jasmine (*Androsace pyrenaica*), 171, 173

rock orchid (*Orchis musvula*), 223

rock plants, 27

Rocky Mountain fir (*Abies lasiocarpa*), 49, 51

Rocky Mountains, 47

Romania, 181, 183

Roraima sandstone savanna, 133

Rosa banksiae, 357

Roscoea purpurea, 337

rosemary (*Salvia rosmarinus*), 167

Rose Valley, 295

Rotula aquatica, 231, 235

rough fescue (*Festuca altaica*), 51

roundleaf bellflower (*Codonopsis rotundifolia*), 337

round-leaved sundew (*Drosera rotundifolia*), 206, 209

rowan (*Sorbus aucuparia*), 145, 147, 151, 201

Royal Botanic Garden Edinburgh, 155

Royal Botanic Gardens Kew, 281

rubber, 339, 343

ruff, 167

Ruscus hyrcanus, 316

Russian Federation, 12

Rytidostylis gracilis, 101

Sabal mauritiiformis, 108, 111

sacred garlic pear (*Crateva religiosa*), 233

saddle-billed stork, 257

sage, 58–59, 69

sagebrush, 323

sago pondweed (*Stuckenia pectinata*), 311

saguaro (*Carnegiea gigantea*), 67

Sagu-Baracoa mountains, 86

Saiga antelope, 321, 323

sainfoin (*Onobrychis*), 297

Saint Paul Mountain Range, 389

Saint Paul's Bay, 389

Salicornia ramosissima, 167

Salina, 195

Salix omeiensis, 357

Salsola, 311

salt grass (*Sporobolus spicatus*), 259, 275

saltmarsh rush (*Juncus gerardii*), 177, 179, 325

Salvia, 295

Salvia columbariae, 69

Salvia jurisicii, 215

samaras, 187, 205, 257

Sambú River, 104

samphire, 19

sandstone rainforest, 19

Sangay, 113–114

Sangay National Park, 112–119

sapodilla (*Manilkara zapota*), 75

Sapodilla Cayes Marine Reserve, 78

Sarawak, 378–387

Sarawak Chamber, 379

Sarcophrynium brachystachyum, 247

sardines, 279

Sardinian warbler, 167

Saribus jeanneneyi, 35, 41

Saryarka – Steppe and Lakes of Northern Kazakhstan, 320–327

Sasa kurilensis, 406, 409

Sasa nipponica, 407, 409

Sateska River, 213–215

savanna bamboo (*Oxytenanthera abyssinica*), 229

saxifrage, 171

scarlet gum (*Eucalyptus phoenicea*), 23

scarlet macaw (*Ara macao*), 95

Schoenoplectus lacustris, 163

Scilla bifolia, 215

Scirpus lacustris, 325

Scorzonera, 295

Scots pine (*Pinus sylvestris*), 173, 199–201, 205, 207, 323

screw pine (*Pandanus balansae*), 41

scrub limber pine (*Pinus flexilis*), 49

scrub turpentine (*canarium australianum*), 21

sea almond (*Terminalia catappa*), 399, 401

seabirds, 157–159

seablite (*Suaeda corniculata*), 325

sea clubrush (*Bolboschoenus maritimus*), 163, 167

sea grape (*Coccoloba uvifera*), 80–81, 83

seagrass, 36–37, 81, 399, 401

sea lavender (*Limonium vulgare*), 177, 179

seals, 179

sea mango (*Cerbera manghas*), 41
Sea of Japan, 404
sea palm (*Postelsia palmaeformis*), 56
sea rosemary (*Heliotropium arboreum*), 398, 399
sea thrift, 167
sea turtles, 36
sedge, 239, 255
seepweed (*Suaeda vera*), 163, 167
Selaginella, 119
Selinum vaginatum, 335
Senecio, 99
Senecio pinacatensis, 66
Senegal, 226–235
Senegalese bushbaby (*Galago senegalensis*), 239, 241
Senegalia fleckii, 256, 259
Senegalia nigrescens, 256, 259
Senegal mahogany (*Khaya senegalensis*), 229, 233
Serengeti, 271
serin, 167
Serranía de Darién, 104–105
Serranía del Jungurudó, 104
Serranía del Sapo, 104
Serranía de Pirre, 104
Serranía de Setetule, 104
Serruria, 264
sessile oak (*Quercus petraea*), 173, 185, 187
Seven Sisters Waterfall, 201
shank, 167
sheep, 155–157
Shirakami Mountains, 403
Shirakami-Sanchi, 402–409
Shisungou karst forest, 354
shoalgrass (*Halodule wrightii*), 81
Shorea, 375, 377
Shorea faguetiana, 381, 387
Shorea ovata, 377
short-toed eagle, 167
short-toed treecreper, 167

shrubby water fig (*Ficus verruculosa*), 257
Siamese crocodile (*Crocodylus siamensis*), 365
Siamese fireback pheasant (*Lophura diardi*), 365
Siberian fir (*Abies sibirica* subsp. *semenovii*), 351
Siberian garlic (*Allium sibiricum*), 201
Siberian ligularia (*Ligularia sibirica*), 206, 209
Siberian spruce (*Picea obovata*), 201
Siberian white crane, 321, 325
Sichuan Province, 353
Sichuan Provincial Institute of Natural Resource Sciences, 357
Sicily, 193
Siebold, Philipp Franz Balthasar von, 405
Siebold's beech (*Fagus crenata*), 403, 405
Sierra del Pinacate, 65
Silene, 323
Silene hicesiae, 193
Silene splendens, 297
Silene tatarica, 323, 325
Silesian willow (*Salix silesiaca*), 189
silky grevillea (*Grevillea pteridifolia*), 19–20, 23
silver beech (*Nothofagus menziesii*), 29, 31
silver birch (*Betula pendula*), 147, 323
silver fir (*Abies alba*), 173, 187, 189, 205, 209
silver langur monkey, 383
silver-leaved paperbark (*Melaleuca argentea*), 20
silver pheasant (*Lophura nycthemera*), 365

silver spike (*Helichrysum thianschanicum*), 323, 325
silver tree (*Leucadendron argenteum*), 265, 269
Sinharaja Forest Reserve, 338–345
Sitka spruce (*Picea sitchensis*), 56
Skaftafell, 145
Skeiðará, 145
sky pilot (*Polemonium viscosum*), 48, 51
Slovakia, 181, 183
Slovenia, 181
small-leaved holly (*Ilex canariensis*), 220, 223
small-leaved mahogany (*Swietenia mahagoni*), 125
small plover, 167
smooth-coated otter, 363, 365
Smythe, Frank S., 330
Snæfell, 144
snow lotus (*Saussurea involucrata*), 351
snow totara (*Podocarpus nivalis*), 31
Soay sheep, 155–157, 159
Sobralia dichotoma, 123, 125
Sonoran Desert, 63, 64, 66
Sonoran pronghorn, 63
Sonoyta River, 66
sooty mold fungus, 281
South Africa, 260–269
South Atoll, 397, 398
South China Sea, 391
southern beech, 29–31
southern tamandua (*Tamandua tetradactyla*), 95, 99
southern wax myrtle (*Myrica cerifera*), 79–80
South Water Caye Marine Reserve, 78
Spain
 Doñana National Park, 160–167

Primeval Beech Forests, 181

Pyrenees—Mont Perdu, 168–173

Spanish cedar (*Cedrela odorata*), 117, 119

Spanish imperial eagle (*Aquila adalberti*), 164, 167

Spanish lavender (*Lavandula stoechas*), 167

Sparaxis, 267

Spathoglottis plicata, 39

spear grass (*Sorghum intrans*), 20

Sphaeropteris intermedia, 35, 39–41

Sphagnum cristatum, 31

spider flowers, 23

spider mangrove (*Rhizophora stylosa*), 21

spikemoss (*Selaginella sericea*), 119

spiny tree fern (*Alsophila mariana*), 230, 243

spiny zilla (*Zilla spinosa*), 302, 305

Spirodela polyrrhiza, 309

Spondias lakonensis, 371

spoonbill, 167

spotted eagle ray (*Aetobatus narinari*), 398, 401

spotted hyena, 275

spring gentian (*Gentiana verna*), 215

spruce, 49, 205, 351

Sri Badrinathji Yatra, 330

Sri Lanka, 338–345

Sri Lankan blue magpie, 341

Stac an Armin, 157

Stachys, 295

steppe cherry (*Prunus fruticosa*), 325

Sterculia, 391

Sterculia setigera, 229, 235

Stewart Island, 26

"stinking toe", 139

stinkwood (*Ocotea foetens*), 220–221, 223

Stipa, 117

Stipa capillata, 322, 323, 325

Stipa lessingiana, 322

Stipa parviflora, 323

Stipa pennata, 323

Stipa sareptana, 322

Stipa zalesskii, 323

St. Kilda, 152–159

St. Kilda dandelion (*Taraxacum pankhurstianum*), 155

St. Kilda sheep, 157

St. Kilda wren (*Troglodytes troglodytes hirtensis*), 159

stone oak (*Lithocarpus*), 387

stone pine, 162

Storckiella pancheri, 39, 41

storm petrel, 159

stratovolcanoes, 113–114

strawberry tree (*Arbutus unedo*), 164, 167

striped hyena, 275

striped sun orchid (*Thelymitra cyanea*), 31

Suaeda maritima, 176, 179

submerged aquatic vegetation, 309

succulents, 263

sugarbird, 264

sugarbush (*Protea repens*), 264–265, 269

suicide apple, 41

Sulawesi, 395

Sulu Archipelago, 397

Sulu Sea, 391, 397, 398

Sumatra, 372–377

Sumatran pine (*Pinus merkusii*), 377

sunbird, 264, 267

Sundaland, 395

sundew, 31

sunflower, 215

sunshine conebush (*Leucadendron salignum*), 265, 269

suraka silk moth, 289

Suriname, 126–133

Suzuki, David, 13

Sveti Naum, 213

swamp banksia (*Banksia dentata*), 20, 23

Swartzia panamensis, 109

sweet chestnut (*Castanea sativa*), 195, 317

sweet vernal grass (*Anthoxanthum odoratum*), 154, 159

Swertia mannii, 239

Swintonia foxworthyi, 391

Swiss cheese plant (*Monstera deliciosa*), 95, 101

Switzerland, 181

sycamore (*Acer pseudoplatanus*), 187

Symmeria paniculata, 133

Symphonia, 287, 289

T abebuia, 111

Tabebuia rosea, 109

Table Mountain National Park, 262

Tacarcuna gentryi, 111

Tafelberg Nature Reserve, 129, 133

Taklimakan, 347

Taklimakan Desert, 347

Talamanca Mountains, 92–101

Talamanca Range-La Amistad Reserves / La Amistad National Park, 92–101

talipot palm (*Corypha lecomtei*), 365

tall woodland sugarbush (*Protea madiensis* subsp. *occidentalis*), 239, 241

Talysh Mountains, 316

tamarisk, 311

Tamarix gallica, 311

Tamarix ramosissima, 325

Tambourissa, 287, 289

Tanzania, 270–275

taperabá (*Spondias mombim*), 137, 139

Ta Phraya National Park, 359, 360

Tarahumara oak (*Quercus tarahumara*), 69

Tarahumara people, 69

tarfa (*Tamarix nilotica*), 301

Tasman, Abel, 27

tauari (*Couratari guianensis*), 129

tea, 339, 341, 343

tea-leaved willow (*Salix phylicifolia*), 145, 151

teddy bear cholla, 69

Telipogon, 99

Tell Eridu, 307, 308–309

Terminalia amazonia, 101

Terminalia chebula, 345

Tetracentron sinense, 357

Tetrastigma, 373

Thailand, 358–365

Thamnobryum fernandesii, 223

Thap Lan National Park, 360, 365

Thomson's gazelle, 275

threats, 243, 259, 289

Thymus praecox, 159

Tianshan birch (*Betula tianschanica*), 349

Tianshan mountain range, 347–348

tigerfish, 254

tiger shark (*Galeocerdo cuvier*), 398

Tigris River, 307, 308

tilapia, 254

tilapiine cichlids, 279

Tilia cordata, 187

Tilia platyphylla, 185

Tillandsia, 75

Timor Leste, 395

toadflax, 167

Toa River, 87

Tomur, 347

Tongariro Alpine Crossing, 27

Tongariro National Park, 25–31

topi, 275

tourist tree, 83

Trachyphrynium braunianum, 247, 251

traveller's palm, 289

tree fern, 35, 39–41, 99, 221, 223, 239, 243, 287, 289

tree frog, 382

tree spurge (*Euphorbia dendroides*), 195

triangle tree (*Auracaria heterophylla*), 35

Trillium govanianum, 335

Tristachya, 239

troglodyte dwellings, 295

Tropical Rainforest Heritage of Sumatra, 12, 372–377

trout, 215

trumpet trees, 137

trumpetwood (*Cecropia peltata*), 125

Tuan Chau Island, 369

Tubbataha Reefs Natural Park, 397–401

tubers, 263

tufted hairgrass (*Deschampsia caespitosa*), 187

Tuira River, 104, 108, 109

Tulipa alberti, 323, 325

Tulipa greigii, 323, 325

Tulipa suaveolens, 322–323, 325

Tulipa urumiensis, 323, 325

tuna (*Thunnus obesus*), 398

tundra swan, 45

Tungurahua, 113–114

Turanian steppes, 349

Turgay Plateau, 321

Turkey, 293–297

Turkmenistan, 313

Turk's-cap lily, 207

Turneffe Islands, 78

turtlegrass (*Thalassia*), 37

turtles, 36, 81

turtle seagrass (*Thalassia testudinum*), 81, 83

tussock grass, 27, 31, 99, 117

Uholka-Shyrokyi Luh massif, 185

Ukraine, 181, 183, 185

Ulugan Bay, 391

umbrella thorn (*Vachellia tortilis*), 256, 257, 259, 273

United Kingdom of Great Britain, 152–159

United Nations Educational, Scientific, and Cultural Organization (UNESCO)

Biosphere Reserve, 88, 101, 161, 251, 275

founding, 10

mission, 10

United Nations World Food Program (WFP), 289

United States

Redwood National and State Parks, 52–61

Waterton Glacier International Peace Park, 12, 42–51

United States Geological Survey, 243

Ur, 307, 308–309

urucuri palm (*Attalea phalerata*), 137, 139

Uruk, 307, 308–309

US National Park Service, 51

Uvs Nuur Basin, 12

Uxul, 73

Vachellia luederitzii, 256
Vachellia seyal, 273
Vachellia tortilis subsp. *raddiana*, 301
Valiha diffusa, 287
Valiha perrieri, 287
valley oak (*Quercus lobata*), 58
Valley of Flowers National Park is, 328–337
vascular plants, 35, 66, 127, 129, 179, 237, 262, 313, 315, 349, 371, 379, 384
Vatica, 375
Vatica obovata, 377
Vatnajökull National Park—, 142–151
Veitch's begonia (*Begonia veitchii*), 125
Veitch's masdevallia (*Masdevallia veitchiana*), 123, 125
velvet maple (*Acer velutinum*), 319
vetiver, 229, 235
Vetiveria zizanioides, 235
Victoria, Queen of of the United Kingdom of Great Britain and Ireland, 139
Victoria amazonica, 135, 139
Vietnam, 366–371
Viola allchariensis, 215
Viola arsenica, 215
Vireya, 385, 387
Virola glaziovii, 139
Vitex altissima, 343, 345
Vitex cymosa, 111
Vitex glabrata, 20
Viti, 147
Voanioala gerardii, 287
volcanoes, 27–28, 63–65, 113, 143–144, 191–192, 193
Voltzberg Dome, 129, 130, 133
Vulpia fontquerana, 167

Wadden Sea National Park, 174–179
Wadi Rum, 299–305
Wallace, Alfred Russel, 395
Wallace line, 395
Wallace's flying frog (*Rhacophorus nigropalmatus*), 382
wasting disease, 179
waterberry (*Syzygium guineense*), 257
water fig (*Ficus verruculosa*), 259
water hyssop (*Bacopa monnieri*), 311
water lettuce (*Ottelia ulvifolia*), 257, 259
water lily, 135, 139, 257, 325
Waterton Glacier International Peace Park, 12, 42–51
wattles, 23
Weinmannia, 287, 289
Weinmannia racemosa, 29, 31
Weinmannnia, 125
West African chimpanzee (*Pan troglodytes verus*), 239, 241
West African red colobus (*Piliocolobus badius*), 241
western azalea (*Rhododendron occidentale*), 56
western chimpanzee (*Pan troglodytes troglodytes*), 251
western giraffe (*Giraffa camelopardalis peralta*), 233
western pied colobus (*Colobus polykomos*), 241
western swamphen (*Porphyrio porphyrio*), 164
western sword fern (*Polystichum munitum*), 56
western tree hyrax (*Dendrohyrax dorsalis*), 243
West Himalayan fir (*Abies pindrow*), 332, 337

West Indian tongue fern (*Elaphoglossum crinitum*), 89
West Norwegian fjords, 196–201
Westoniella, 99
Whakapapa sun orchid (*Thelymitra* "Whakapapa"), 31
whale shark (*Rhincodon typus*), 398, 401
wheat, 192
wheatear, 167
wheatgrass, 51
whinchat, 167
whitebark pine (*Pinus albicaulis*), 49
white blueberry (*Corema album*), 163, 167
White Dragon River, 354
white fig (*Ficus virens*), 21, 23
white foxglove (*Digitalis alba*), 31
white-headed langur (*Trachypithecus poliocephalus*), 371
white mangrove (*Avicennia marina*), 21, 36, 41, 75
white paperbark (*Melaleuca leucadendra*), 19, 21, 23
white popinac (*Leucaena leucocephala*), 399, 401
white poplar, 167
white rhinoceros, 253
White River, 39, 204
white sage (*Salvia apiana*), 59
white saxaul (*Haloxylon persicum*), 301, 305
white stork, 164, 167
white sun orchid (*Thelymitra longifolia*), 31
white-tailed deer, 58
whitetip reef shark (*Triaenodon obesus*), 398, 401
white water lily (*Nymphaea alba*), 309, 311
white-winged tern, 325

white wormwood (*Artemisia herbaalba*), 302, 305

wild apple (*Malus sieversii*), 325, 351

wild apricot (*Armeniaca vulgaris*), 351

wild bergamot, 49

wild cashew (*Anacardium excelsum*), 111

wild cherry (*Prunus avium*), 319

wild date palm (*Phoenix reclinata*), 257, 259

wildebeest, 271

wildfires, 12, 51, 135–136

wild onions (*Allium*), 297

wild peach (*Terminalia carpentariae*), 23

wild pineapple, 345

wild rice (*Oryza brachyantha*), 233

wild service tree (*Sorbus torminalis*), 319

wild silver cactus, 365

wild syringa (*Burkea africana*), 229, 235

wild thyme (*Thymus praecox* subsp. *britannicus*), 154

wild tulip, 322–323

wild walnut (*Juglans regia*), 351

willow (*Salix*), 125, 201

willowherb (*Chamaenerion angustifolium*), 51

willow-leaved magnolia (*Magnolia salicifolia*), 406, 407, 409

willow of the brook (*Salix acmophylla*), 311

willow warbler, 167

windmill grass (*Chloris inflata*), 399, 401

Wooden Stakes Cave, 368

woodland sugarbush, 243

wood melick (*Melica uniflora*), 187, 189

woodrush, 155, 159

woolly fringed moss (*Racomitrium languinosum*), 148–149, 155

woolly tree fern (*Culcita macrocarpa*), 221, 223

World Resources Institute, 12

Wright's paspalum (*Paspalum wrightii*), 136

WWF Global 200 Freshwater Ecoregion, 122, 251, 275, 341

WWF Global 200 Marine Ecoregion, 88, 161

WWF Global 2000 Ecoregion, 197, 391

WWF/IUCN Centre of Plant Diversity, 101, 115, 122, 161, 237, 251

wych elm (*Ulmus glabra*), 187, 189, 319

Xenophyllum humile, 117

xeriphyte, 301

xerophytes, 66, 289

Xinjiang Tianshan, 346–352

Xinjiang tulip (*Tulipa sinkiangensis*), 349–351

Yangtze River, 354

yellow fever tree (*Vachellia xanthophloea*), 273

yellow pea (*Bryaspis lupulina*), 233

yellow rose (*Cochlospermum vitifolium*), 111

Yellow Water (Ngurrungurrudjba) wetlands, 19

yellow water lily (*Nuphar lutea*), 325

yellowwood (*Podocarpus latifolius*), 273

Yixiantian Gorge, 354

Yosemite National Park, 12

Yucatán Platform, 78

Zagros Mountains, 308

Zahamena National Park, 285, 287

zebra, 271, 275